ASIAN ART

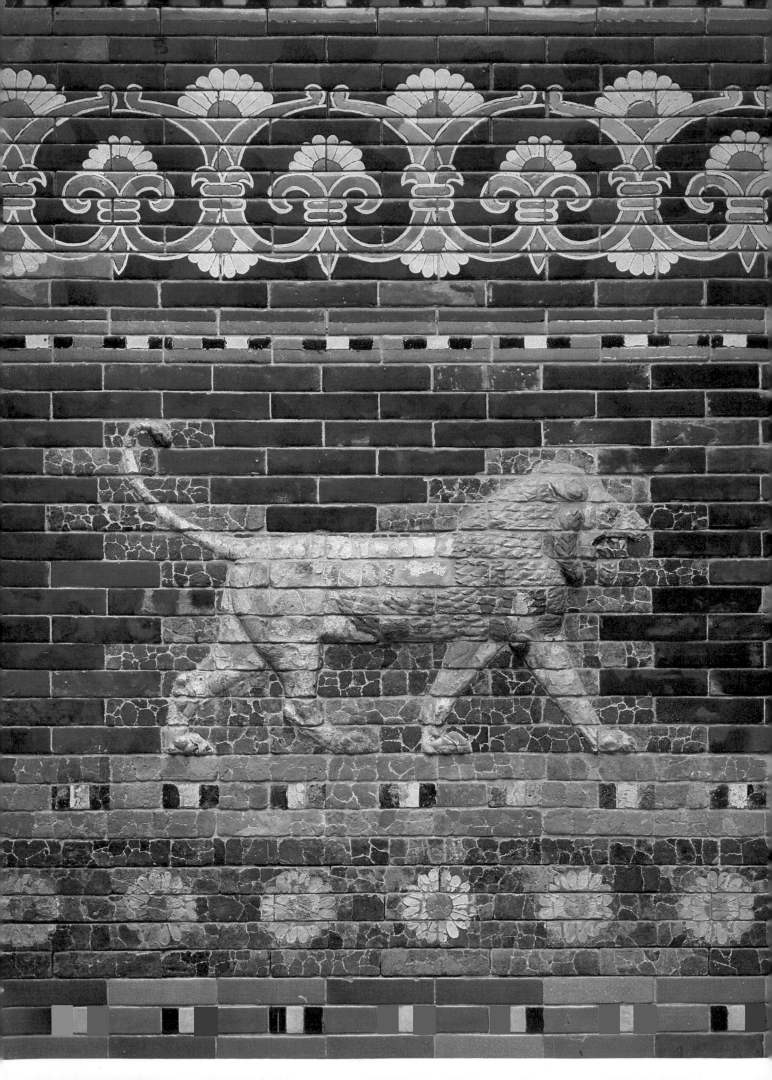

ASIAN ART

AN ILLUSTRATED HISTORY OF SCULPTURE, PAINTING & ARCHITECTURE

HAMLYN

General Editors
Bernard S. Myers
New York

Trewin Copplestone
London

Contributors

Ancient Civilisations of Western Asia
Based on a text by Professor Giovanni Garbini,
Institute of Near Eastern Studies, University of Rome

The Oriental World
Jeannine Auboyer, formerly Chief Curator, Musée Guimet, Paris
Professor Dr Roger Goepper, Director of the Museum of Far Eastern Art,
Cologne

The World of Islam
Dr Ernst J. Grube, Professor of Islamic Art, University of Venice

Title page: **Detail from the façade of the throne room at the palace of Babylon**.
Reign of Nebuchadnezzar II (604–562 BC). Staatliche Museen zu Berlin.

Original text copyright © The Hamlyn Publishing Group Limited 1966, 1967
This revised edition copyright © The Hamlyn Publishing Group Limited 1987

This edition first published 1988
by The Hamlyn Publishing Group Limited
Michelin House, 81 Fulham Road,
London SW3 6RB.

ISBN 0 600 55109 1

Printed in Spain

CONTENTS

ANCIENT
CIVILISATIONS
OF WESTERN ASIA

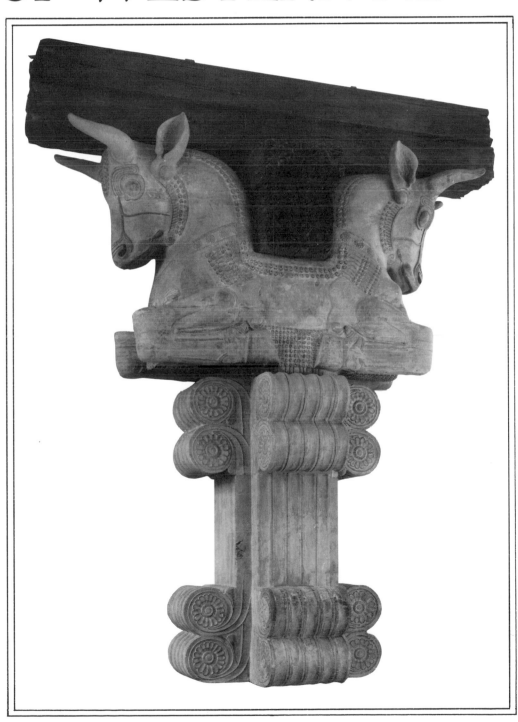

Art and Civilisation

The numbers in the margins refer to the illustrations to Ancient Civilisations of Western Asia: heavy type for colour plates, italics for black and white illustrations.

'Civilisation' is one of those terms more difficult to define than to understand. We have a good idea of what we mean by it, but it is impossible to state exactly what it comprises. We would say of our earliest human ancestors, sheltering in caves, using signs rather than words and adopting sticks and bones as tools, that their society was not civilised. Equally, we would say of the people of ancient Ur or Babylon, with their great buildings, cities, languages and artefacts, that they were civilised.

We can indicate some of the things that go towards making civilisation, such as a written language, without which knowledge cannot be passed from one generation to the next. A settled existence, which becomes possible with the development of agriculture, is another necessity. There is no such thing, for example, as architecture in a nomadic society. A settled life permits diversification and specialisation: it is no longer necessary for everyone to spend the bulk of his or her time in securing food. Warriors, craftsmen, indeed artists, provide their services in exchange for the food grown by farmers. Society becomes more complex and — this seems to be a vital characteristic of civilisation — more amenable to change.

Some people would say that art is also a product of civilisation. This depends what one means by 'art' and, while some forms of art are absent in primitive, or 'pre-civilised' societies, others are evidently not. Can we exclude the creators of prehistoric cave paintings from the category of artist? Certainly they were not indulging in an aesthetic exercise. The precise purpose of such paintings is a matter of argument, but we can be sure that they were not intended to be beautiful. Nor, however, were the works of the earliest civilisations. We may assess a marble head from Uruk in aesthetic terms, but we should remember that our terms of reference are totally meaningless in the context in which that marble head was fashioned. For the ancient Sumerians sculpture had a practical purpose — to glorify a god, to mark a victory, etc. No doubt in its execution there was at work something like what we would call an aesthetic sense, but it cannot be separated from the true purpose of the work. 'Art for art's sake' is a concept without meaning in early civilisations. A separate notion of beauty would have seemed, if not totally incomprehensible, certainly irrelevant. Yet art, like religion, is a characteristic of the human race, not of civilisation specifically.

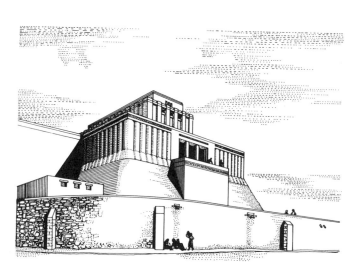

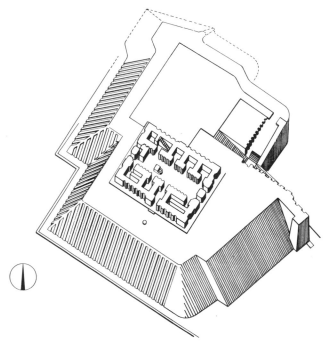

1a. **Reconstruction of the temple at Eridu.** Predynastic period. The oldest Sumerian religious structure has been found at Eridu (modern Abu Shahrein). Built on an artificial platform which anticipates the ziggurat proper, it had buttressed walls. When excavated a quantity of fishbones were found on the floor of the cella, and it has been suggested that the temple was dedicated to Enki, the 'lord of the earth', later called by the Semites Ea, the 'house of sweet waters'.

1b. **Plan of the White Temple at Uruk.** Predynastic period. *c.* 3200–3000 BC. The White Temple, so called because of its whitewashed sides, surmounted the 'Anu ziggurat', the second important predynastic sanctuary at Uruk. The central room is flanked by five side rooms to the north-east. Entry was through a door in the south-western side, leading through a vestibule to the long cella. In one corner stood a platform or altar and, a few feet in front, an offering table of brick with a semi-circular hearth.

BC	EGYPT	SYRIA-PALESTINE	ANATOLIA	MESOPOTAMIA	IRAN
6000		*JERICHO*	*ÇATAL HÜYÜK*	*JARMO*	
			HACILAR		
5500					
5000				HASSUNA	BAKUN I / SIYALK I
	FAIYUM 'A' and TASIAN			SAMARRA	SUSA I
4500				HALAF	
4000	BADARIAN AMRATIAN				
				'UBAID	SUSA I
3500	GERZEAN	*GHASSUL*			
				PREDYNASTIC	
3000	EARLY DYNASTIC		*TROY* *BEYCESULTAN*	TRANSITION *2700*	SUSA II and GIYAN IV
				1st EARLY DYNASTIC	
2600		*KHUERA*	*ALACA*	2nd EARLY DYNASTIC	
2500	OLD KINGDOM			*2350*	ELAMITE KINGDOM
		MARDIKH		AKKADIAN *2150*	
	FIRST INTERMEDIATE			GUTI	
2000	*1991*	*MARI* *ALALAKH*	*KÜLTEPE*	UR III ISIN-LARSA	
	MIDDLE KINGDOM			DYNASTY OF BABYLONIA	ELAMITE KINGDOM
	SECOND INTERMEDIATE *1570*		HITTITE OLD EMPIRE		
1500		*UGARIT* *HAZOR*	HITTITE NEW EMPIRE	KASSITE DYNASTY	
	NEW KINGDOM		*1190*		IRANIAN INVASIONS
	1085	Syro-Hittites			
1000		Phoenicians Israelites	Phrygians Urartu	NEO-BABYLONIAN PERIOD	
	LATE PERIOD				ELAMITE KINGDOM
		ASSYRIAN and BABYLONIAN DOMINATION			*612* Persians
500		PERSIAN DOMINATION			

(Note: "Amorite Kingdoms" appears vertically in the Syria-Palestine column around 2000–1500 BC; "Assyrians" appears vertically in the Mesopotamia column around 1500–600 BC.)

2 (below). **The rock sanctuary of Yazilikaya.** Hittite Imperial Period. *c.* 1350–1250 BC. About two miles to the north-east of Hattusas, on the site of a natural spring, lies the impressive rock sanctuary of Yazilikaya. Deep clefts in the limestone made a setting for religious cult ceremonies. The two main recesses or chambers are carved with numerous reliefs of gods, goddesses and kings. Before the opening into the sanctuary to isolate and protect the inner chambers were a gate-house and a temple.

3 (opposite). **Golden head of a bull decorating the front of a lyre from Ur.** Early Dynastic II Period. 2600–2400 BC. Gold on a wood core, h. $11\frac{5}{8}$ in. (29·5 cm.). Iraq Museum, Baghdad. The bull's head demonstrates the high standards that the art of the metal-worker achieved at this period, together with an obvious delight in inlay work.

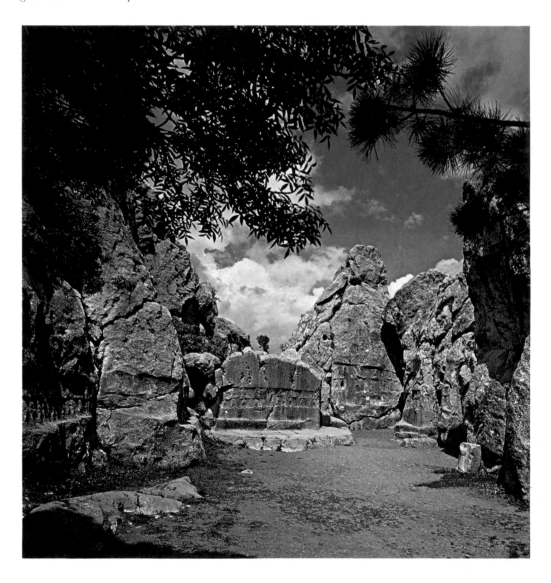

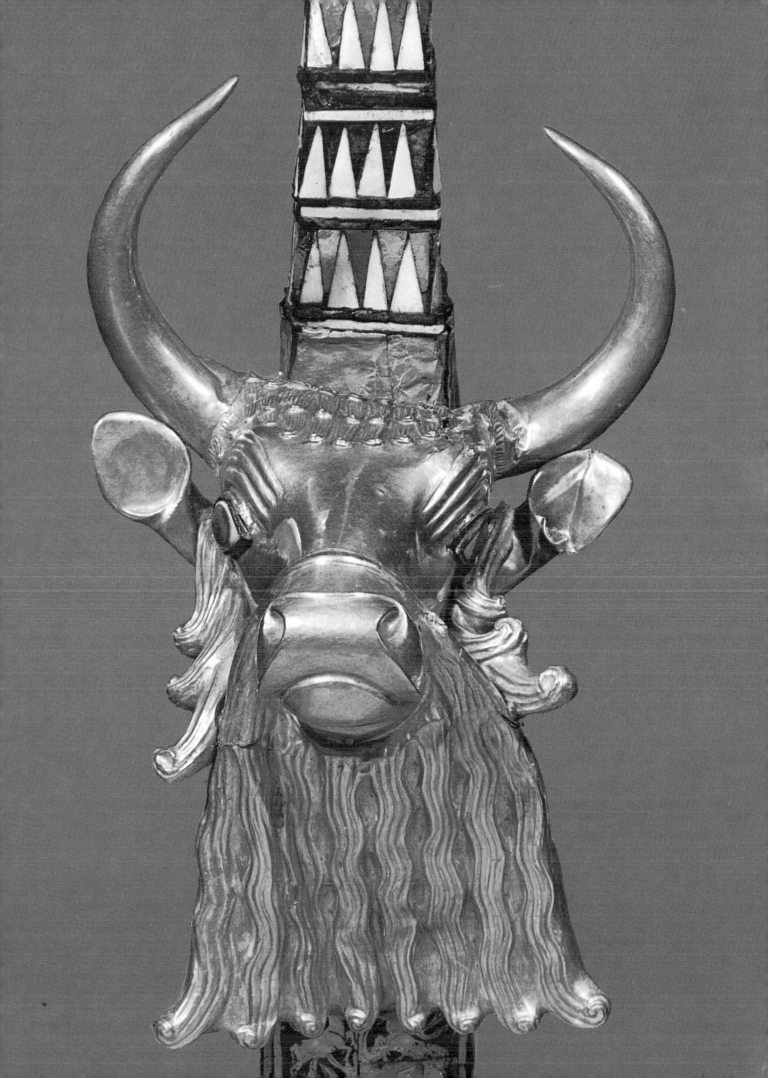

Mesopotamia

Farming first began in western Asia, more precisely in the area watered by the Tigris and Euphrates rivers known as Mesopotamia and roughly equivalent to modern Iraq. Shortly afterwards the same thing happened in other river valleys — the Nile in Egypt and the Indus in southern Asia.

In Mesopotamia the climate was more suitable for farming 5000 years ago than it is today. Village life probably began when people gathered the wild grasses which were the ancestors of modern cereals. With a stone sickle it was possible for a family to cut enough wild wheat when it was ripe to last them the whole year, and this permitted them to stop wandering and to settle down. After some centuries they must have noticed that some types of grass were more productive than others. What seems to us a giant step — from gathering wild grains to planting crops — was probably a gradual development, though farming seems to have spread quite rapidly from its place of origin, assisted by the growth of trade which was another by-product of a settled existence. Domestication of animals

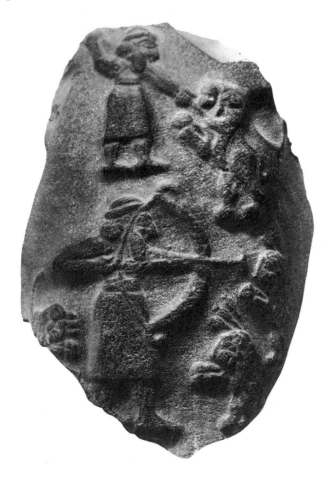

4. **'Hunting stele' from Uruk.** Predynastic period. *c.* 3200 BC. Granite. 30¾ in. (78 cm.). Iraq Museum, Baghdad. This rare surviving fragment of early Sumerian sculpture shows two episodes in a lion hunt. Above a king attacks the animals with a long spear, below with a drawn bow. The scene may have either an historical or a symbolic meaning, or possibly both.

probably began even earlier. Evidence from Africa suggests that cattle were kept well over a thousand years before men began to sow seeds and grow crops.

Southern Mesopotamia is not a region of prepossessing scenery. The land is flat and swampy and, since the two rivers are subject to flooding, the construction of dykes and canals was necessary to control the water supply and prevent inundation. However, the alluvial soil, irrigated by canals, was extremely productive, and it was here that the first cities were built.

THE SUMERIANS

The people who occupied this area in the second half of the 4th millennium BC were immigrants, probably from the highlands of Iran. They supplanted or absorbed the native inhabitants, while adopting their way of life in farming communities dependent on grain, date palms, cattle and sheep. This way of life is illustrated on the earliest Sumerian carvings. At an early stage the Sumerians, who brought their own language with them, developed a pictographic form of writing (the characteristic Sumerian cuneiform script developed later), introduced the potter's wheel, and adopted metal-working (though they did not initiate it). These developments had a profound influence on their culture.

Of even greater importance was the effect of organising the little farming communities in order to carry out the large-scale public works which were necessary for greater agricultural productivity. This required a strong central power, which took the form of a theocracy. The centre of Sumerian civilisation was the temple, and the god who resided there was the ruler of the city. The king was his representative not, as in many other early civilisations, a divine figure himself. The concept of the ruler as a dutiful man of peace, who built temples for the gods and canals for the people, was vital throughout the Sumerian period for well over a thousand years.

EARLY SUMERIAN ART

It is very difficult to follow the story of Sumerian art throughout this long period. The evidence is naturally scarce. It is, moreover, unbalanced, with many examples from a particular period or of a particular type and many periods and sites almost unrepresented. Dating is another problem, with experts disagreeing sometimes by a considerable span.

URUK

Uruk, the first great city of the Sumerians, called Erech in the Bible, retained its importance as a religious centre throughout the Sumerian period. It was here that in the late 4th millennium BC the first great buildings arose.

This region of lower Mesopotamia is not well endowed with building materials. There is no native stone nor timber. There was, however, a plentiful supply of mud, and the Sumerians built with mud bricks, dried in the sun and set in mortar also made of mud. Even when the Sumerians

used imported limestone, they kept to the forms of brick
construction, with walls supported by hefty buttresses
(originally invented to support high wooden buildings). An
early example, known as the Limestone Temple, is found in
the earliest sacred complex at Uruk. At its heart is a large,
T-shaped chamber, with smaller rooms adjoining and
several entrances on the longer sides. The overall plan is
strictly symmetrical, an effect enhanced by the regularly
placed buttresses, which turn the walls into three-
dimensional elements. Sumerian temples were built on
great artificial platforms, anticipating the later form of the
ziggurat, since the gods were seen as dwelling on a
mountain, raised above the mundane affairs of men — and
also out of danger from floods. Walls and columns were
decorated by pressing coloured clay cones into the plaster in
geometric patterns, patterns still to be seen in rugs woven
by nomadic tribes in the present century. Next to the
Limestone Temple, but at right angles to it, is a second
temple, and the two are linked by a large courtyard with
raised columns on the short side.

The second great religious complex at Uruk during this
period (which is known as the Predynastic period) is the
Anu-Ziggurat, completed before the end of the 4th millen-
nium BC. The 'ziggurat' is actually a high platform, with
sloping sides, on which stand the sacred precincts of the
1b White Temple, so named because it was painted white.
This is different in plan from the Limestone Temple. The
central chamber is rectangular and the rooms are less
strictly symmetrical in arrangement.

These monumental buildings indicate a high standard of
cultural development by about 3000 BC. At another site,
1a Eridu, there is a Predynastic religious complex, again sited
on a massive platform with buttressed walls. The two-tiered
base of this structure clearly anticipates the ziggurat.

PREDYNASTIC SCULPTURE

The advanced state of Sumerian civilisation in this era is
confirmed by the work of the sculptors. Most Predynastic
sculpture is in the form of stone reliefs, and shows such
scenes as a lion hunt, a battle, religious ceremonies and
farming scenes. The style is realistic and, if some of the
scenes appear a trifle static, there is much vigour and
liveliness in the depictions of animals and birds.

4 A stele from Uruk of about 3200 BC shows two scenes
from a lion hunt. In one, the king draws his bow at a lion,
which manifests lively dismay. In the other, which appears
above, he kills it with a spear. The second scene is shown on
a smaller scale. The whole may have some symbolic
meaning which now eludes us, or possibly it is merely an
illustration of the technique of lion-hunting.

Such relics are of course extremely rare. One splendid
5 survival is a slim cylindrical vase, slightly tapered and
standing on a foot, carved in alabaster with four bands of
encircling relief. The bands show (i) growing corn, (ii)
sheep and goats, (iii) human figures bearing the fruits of the
harvest and (iv), at the top, presentation of the fruits to a

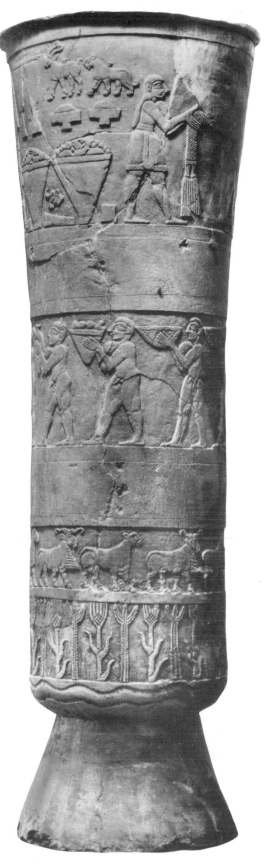

5. **Vase from Uruk.** Predynastic period. *c.* 3200–3000 BC.
Alabaster. h. 36 in. (92 cm.). Iraq Museum, Baghdad. This
elegant vase was found in the precinct containing the Limestone
Temple. It celebrates, on the bands of its relief, the offering of
the fruits of the earth to the goddess of fertility. The sense of
volume evident here is also present in the sculptures illustrated
as figures 9 and 11.

6 (below). **Relief of Imdugud from 'Ubaid.** Early Dynastic II Period. *c.* 2600–2400 BC. Sheet copper on a wooden core. w. 7 ft. 9¾ in. (238 cm.). British Museum, London. Imdugud, the benevolent lion-headed eagle of Sumerian mythology, is shown with wings outspread, protecting two stags. This masterpiece of metalwork displays the creative vigour and technical ability of Sumerian artists in the Early Dynastic II Period.

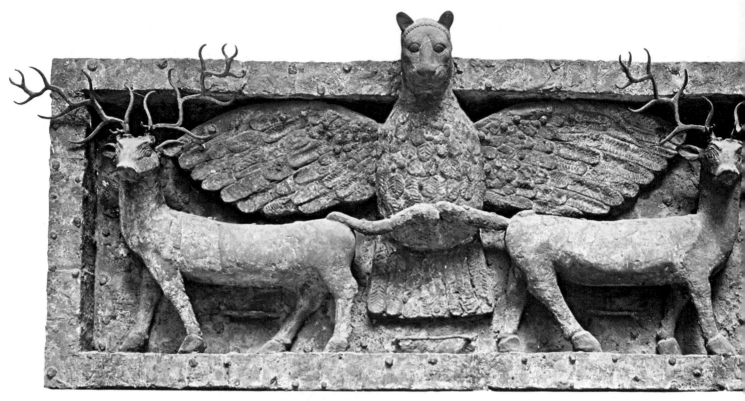

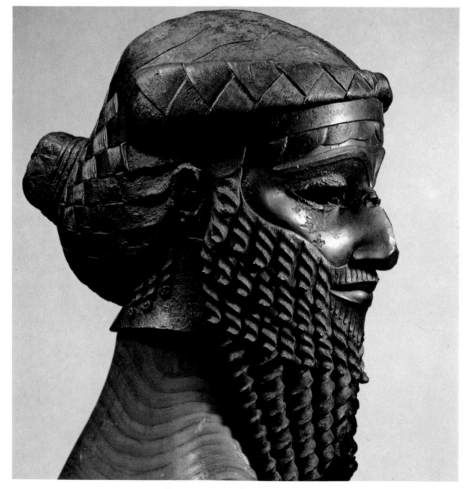

7 (left). **Bronze head from Nineveh.** *c.* 2350–2150 BC. h. 14⅜ in. (36·6 cm.). Iraq Museum, Baghdad. This famous example of Akkadian sculpture, possibly representing Sargon, expresses a new idea of kingship. The proud head has a dignity and nobility hitherto unknown. The hair is bound in the Sumerian fashion, plaited, wound round the head and gathered in a chignon.

8 (opposite). **Offering stand from Ur.** Early Dynastic II period. *c.* 2600–2400 BC. Gold, silver, lapis lazuli, shell and red limestone. h. 20 in. (50 cm.). British Museum, London. Often referred to as the 'ram caught in a thicket' and apparently a fertility symbol, this strange figure was found in the great death-pit at Ur. The ram is shown hobbled to the branches of a flowering tree. The technique of building up a figure from so many precious and contrasting materials reaches its apogee in works such as this.

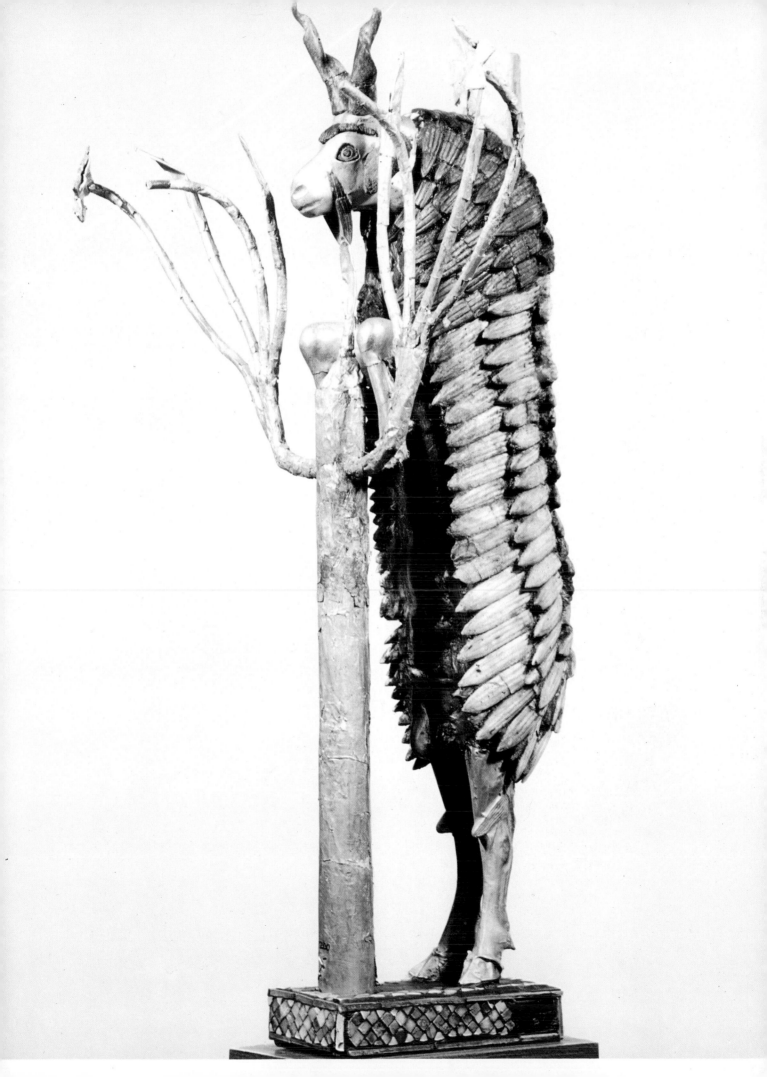

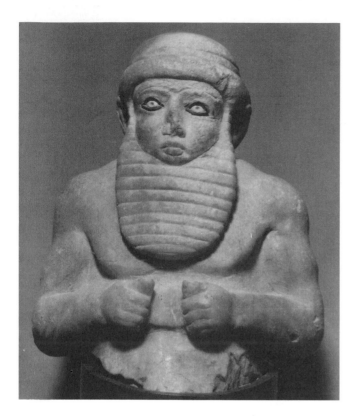

9. **Statuette of bearded man from Uruk.** Predynastic period. *c*.3200–3000 BC. Alabaster. 7⅛ in. (18 cm.). Iraq Museum, Baghdad. This early predynastic figure is one of the first examples of Sumerian sculpture in the round. The beard is clearly shown to be artificial. The eyes are of shell, with pupils of lapis lazuli. This is the earliest example of the typically Sumerian cult statue representing a king or priest in prayer before a divinity.

goddess. This accomplished piece tells us, incidentally, that agriculture was a primary occupation of the Sumerians at this time, and also conveys a sensitive comprehension of scale and volume, a love of symmetry already noted in temple buildings and a fine sense of naturalism.

The most striking sculptural works, however, are figures in the round, which are clearly connected with the little clay figurines of an earlier culture in spite of being vastly more mature in style and displaying a completely different

spirit. Indeed, from our vantage point these remarkable works seem to spring unheralded upon the world, but there can be no doubt that they were preceded by many years of experiment and endeavour.

A marble figure of a king or priest, from before 3000 BC, *9* shows a sophisticated grasp of form. The eyes are made of inset shell and the beard is clearly artificial, a fashion also current in Egypt. The sensitive modelling of the human form and the apparent awareness of the effects of the play of light and shadow are almost startling in works made 5000 years ago.

Perhaps still more striking is the famous head from *11* Predynastic Uruk known as the 'Lady of Warka' (i.e., Uruk). This suggests an extremely thorough grasp of the problems of sculpture in the round. It was probably once part of a complete figure of a goddess (the back of the head is flat and provided with holes, presumably for pegs). The extremely delicate modelling of the features, hardly to be exceeded for over 2000 years, has an especially strong impact on us today.

SEALS

Our knowledge of ancient civilisations depends on what the archaeologists dig up, and in the case of Predynastic Sumeria, the most common examples of art objects — and the most characteristic of Mesopotamian art generally — have been seals (or the clay tablets bearing their impressions). Unlike the seals of most other civilisations, which

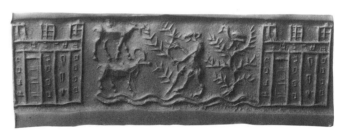

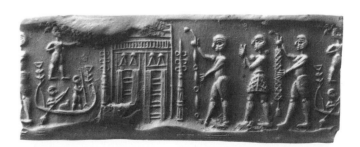

10 *a–c.* **Predynastic cylinder seal impressions from Uruk.** Iraq Museum, Baghdad. Predynastic cylinder seals are remarkably free in their composition, and lively in manner. A variety of scenes shows (*a*) animals and a mythological figure before the walls of a temple, (*b*) offerings brought by land and water to a shrine, (*c*) a procession of animals of the sacred herd, three of them emerging from wooden byres. Representations of buildings on cylinder seals (*b*) are important for they are our only source of knowledge of the actual appearance of structures otherwise known only from foundations.

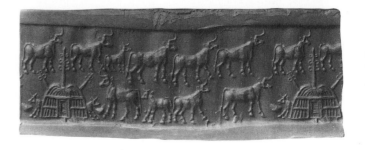

were in the form of a stamp, Mesopotamian seals were cylindrical, with the pattern all over the outer surface of the cylinder. Because they have survived in relatively large numbers, cylinder seals enable us to follow the progress of artistic development in a way that would be impossible with the rare, larger works.

10 Cylinder seals of Predynastic Uruk show the same motifs as the sculptured reliefs of the period and similar stylistic qualities; if anything, they are livelier and more naturalistic. Typically, they show scenes of religious ritual, warfare and — often — animals, some of these being apparently of purely decorative intent. They also provide valuable evidence for social customs, dress and other features of Sumerian civilisation, even buildings.

THE EARLY DYNASTIC PERIOD

About the end of the 4th millennium BC Sumerian civilisation entered a crisis which lasted for some three centuries. The reasons for it remain unknown; the Biblical Flood has been suggested as one possible cause. Art objects from about 3000 BC to about 2700 BC are rarer and of inferior quality. The style becomes more expressionist, and there is an awareness of man's conflict with fate or nature. Much of the old, calm order and symmetry is lost.

The classical period of Sumerian civilisation, known as the Early Dynastic period, began about 2700 BC. It included elements from the transitional phase as well as from the older, Predynastic tradition. The old naturalism never fully returned, and there was a more intellectual approach to art, although this did not become apparent for some time. A feature of this intellectualism was the development of cuneiform.

12 The earliest known form of writing was in very simple pictograms, with things represented by fairly obvious symbols. This developed into a form of sign-writing which only gradually evolved into the very rigorous system known as cuneiform. (This step was of course never taken in the parallel civilisation of Egypt, where pictographic forms were retained.)

ARCHITECTURE

This was a great age of building. The Sumerian cities, incidentally, remained independent states: there was never a Sumerian kingdom in the sense of a single political entity, at least until the days of the Third Dynasty of Ur. The large and impressive building programmes undertaken in Sumerian and Sumerian-influenced cities after about 2700 BC is the best evidence we could have of the revival of society after the mysterious recession of the early 3rd millennium.

In the successive rebuildings of the temples, it is possible to trace architectural evolution. For instance, the Temple of Sin at Khafajah shows the emergence of a new scheme, with two central chambers of unequal size surrounded by an irregular arrangement of smaller rooms and courtyards. The temple is no longer raised above the city on a high platform but rests at the same level, divided by a high wall from the surrounding buildings. Different plans appear in

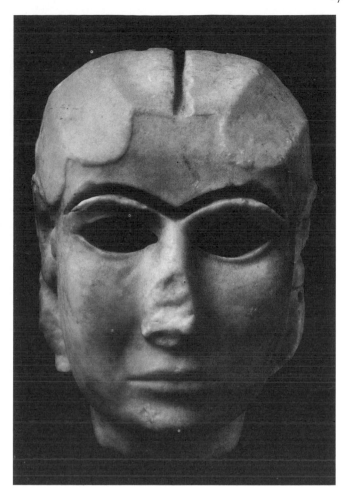

11 (above). **Female head from Uruk.** Predynastic period. *c.* 3200–3000 BC. White marble. 7⅞ in. (20 cm). Iraq Museum, Baghdad. This famous head, known as the 'Lady of Warka', shows a developed understanding of the problems of sculpture in the round. Possibly part of a complete figure representing a goddess, it is, however, flat at the back and provided with holes to attach it to a vertical surface. The soft face and intense expression have a moving effect.

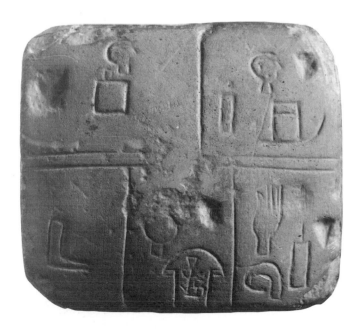

12. **Limestone tablet from Kish.** *c.* 3500 BC. Ashmolean Museum, Oxford.

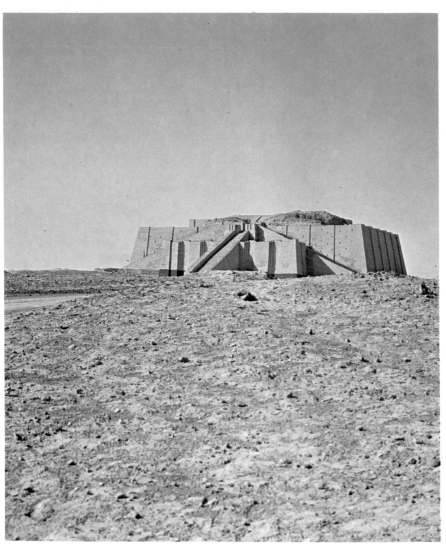

13 (left). **The Ziggurat at Ur.** Ur III period. *c.* 2150–2050 BC. The imposing ziggurat at Ur owes its fine state of preservation to the fact that the entire staged tower was given a brick facing. It was built in the reign of Ur-Nammu, founder of the Third Dynasty of Ur, and was probably surmounted by a temple dedicated to the moon god Nanna, but no traces of this remain. Approached by three staircases, its sloping walls are broken with shallow articulations.

14 (below). **Wall-painting from the palace of Zirimlim at Mari.** *c.* 2040–1870 BC. Paint on plaster. h. 5 ft. 7 in. (1·7 m.). Louvre, Paris. One of the earliest surviving Mesopotamian wall-paintings. On the left mythological creatures beside a sacred tree. In the centre (above) the king before the goddess Ishtar, and (below) deities holding vases from which issue streams of water. To the right is a delightful narrative detail with two figures climbing a date palm.

15 (opposite). **Terracotta plaque from Kish.** Old Babylonian. *c.* 1800 BC. h. 4 in. (10 cm.). Ashmolean Museum, Oxford. This relief shows a bearded god holding a sceptre in each hand. Many terracotta figures and plaques were produced at this period showing musicians, mythological figures, and gods. Such objects were probably associated with folk cults.

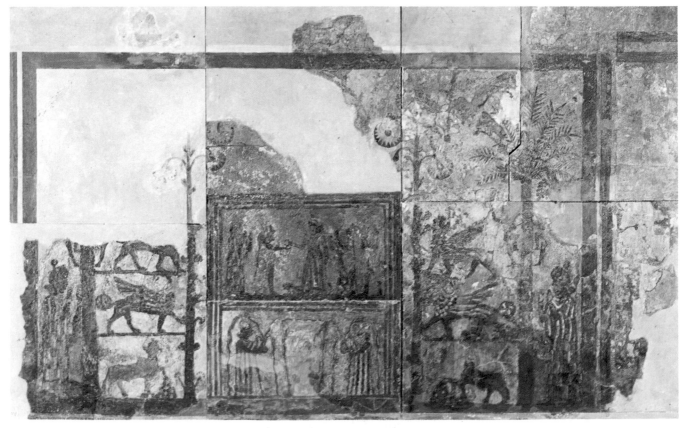

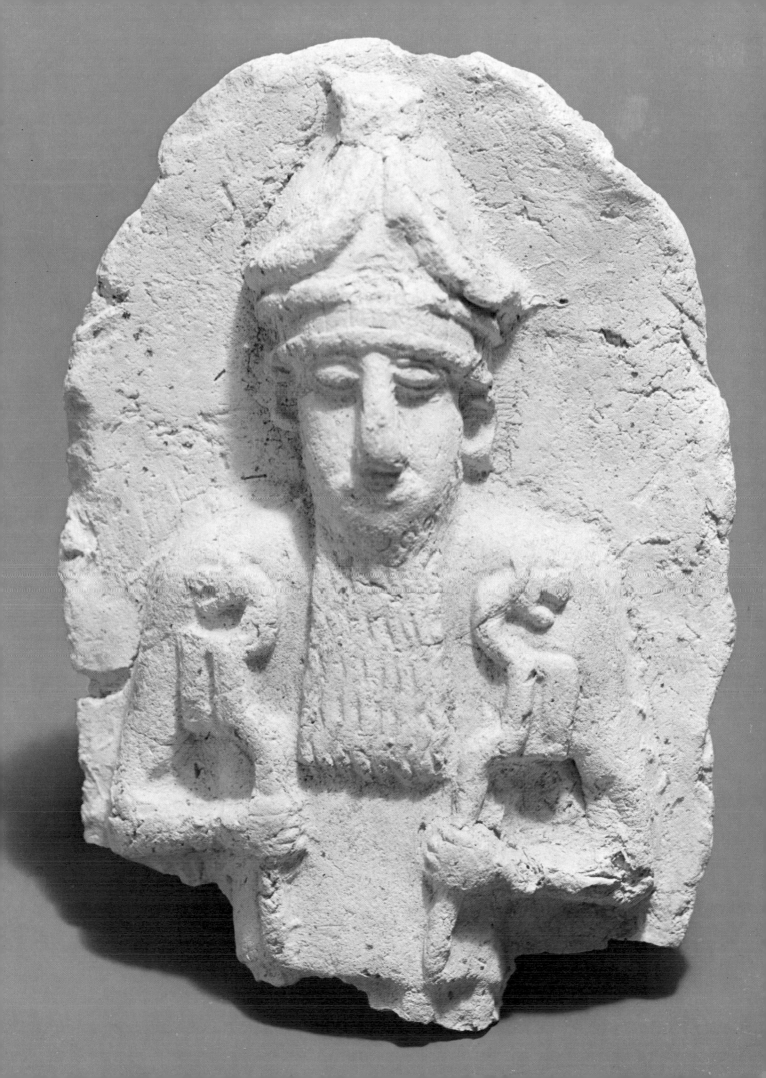

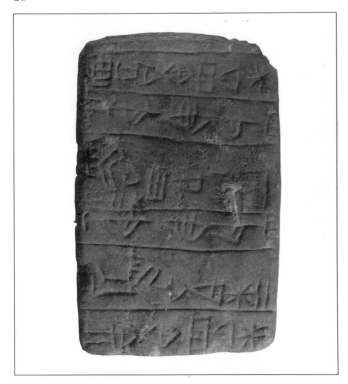

16. **Foundation tablet of Aannepadda.** *c.* 2600 BC. British Museum, London.

other cities, but a common objective seems to have been to make the inner sanctuary as completely cut off as possible. This is evidence of a change in religious belief since, in the Predynastic temple, the sanctuary was clearly accessible, though set off from the city by its height above the general level.

In the Early Dynastic period, large secular buildings — palaces — made an appearance. One of the first was found at Kish, a major city at this time. This was a complex of buildings, made up of several distinct groups, together forming the royal palace. In one of these groups we see a plan which was to become common in secular architecture in Mesopotamia. It consists of a large, central courtyard with rooms around the sides. The whole complex is surrounded by a wall forming a regular rectangle.

Another important feature of ancient city planning which is first revealed in Early Dynastic Sumer is the massive city wall. The earliest cities seem to have managed without walls, whether because they were not necessary or because the idea of such a defence had not yet occurred to their inhabitants it is impossible to say.

SCULPTURE

In sculpture, the common theme was that of the worshipper in an attitude of prayer or offering, usually standing with folded hands. These statues were placed inside the temples so that the god had a permanent 'congregation'. Sculptors lavished much attention on the face, shown gazing intently at the object of worship. Uruk was no longer the cultural capital, yet these statues, found over a wide area, manifest close similarities of style, which, if it cannot justly be called 'abstract', has certainly lost the naturalism of the Predynastic period. In the case of a particular group of figures from Tell (i.e., 'Mount') Asmar, the concern with geometric form is clearly apparent.

The figures of the Tell Asmar group, which represent *18* worshippers in the temple, are especially notable for the intense gaze of their large eyes, which to modern observers is a little unsettling. They wear long tunics exposing much of the upper part of the body. The men have long beards and, except for some who are bald, their hair descends in

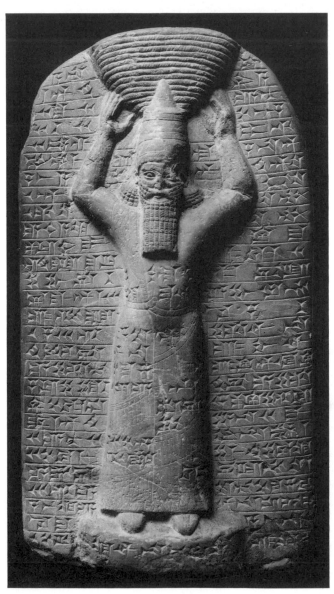

17 (left). **Stele of Assurbanipal.** 7th century BC. British Museum, London. The development of writing can be seen in these three examples of widely differing periods. Figure 12 shows the earliest known picture writing with a sign for a hand, a foot, a threshing sledge. Figure 16 shows the Sumerian form of the cuneiform wedge-shapes which initially were abstract versions of the earlier 'sign writing'. Here, the script has acquired a new and very different form. With its sharp angles it differs from the elegant archaicising form used in Babylonia. This stele bears a fragment of the Gilgamesh epic in the Assyrian version and a description of the Flood.

18 (opposite). **Statues of worshippers from Tell Asmar.** *c.* 2700–2600 BC. Veined gypsum. h. 28¾ and 23¼ in. (72 and 59 cm.). Iraq Museum, Baghdad.

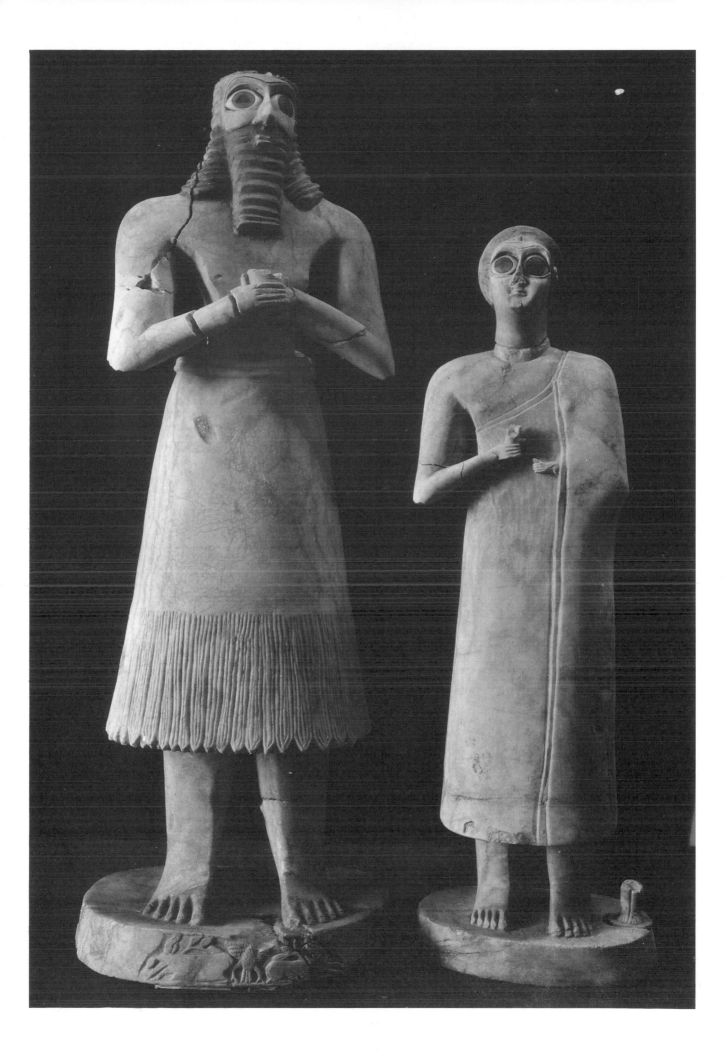

19 (below). **Lioness attacking an Ethiopian boy in a papyrus grove.** Last quarter of the 8th century BC. Ivory overlaid with gold, and encrusted with lapis lazuli and cornelian. h. 4 in. (10 cm.). British Museum, London. This ivory was found, with others, in the palace of Assurnasirpal at Nimrud. It is one of a pair, thought to have decorated a piece of furniture. Phoenician and Syrian ivories were exported and have been found over a large area. This exquisite ornament is one of the finest examples of Phoenician workmanship, and is unusual in its naturalistic rendering of a narrative scene.

20 (opposite). **Ivory panels from Nimrud.** Syrian. 9th–8th century BC. h. *c.* 4 in. (10 cm.). These were found in the North-West palace of Nimrud, together with a number of other pieces which seem to have been parts of a single decorative scheme. In the right-hand panel the beardless youth, clad in a costume based on that of the Egyptian kings, grasps the stalk of a tree formed by a giant lotus flower. The other hand is raised in adoration to the sacred tree.

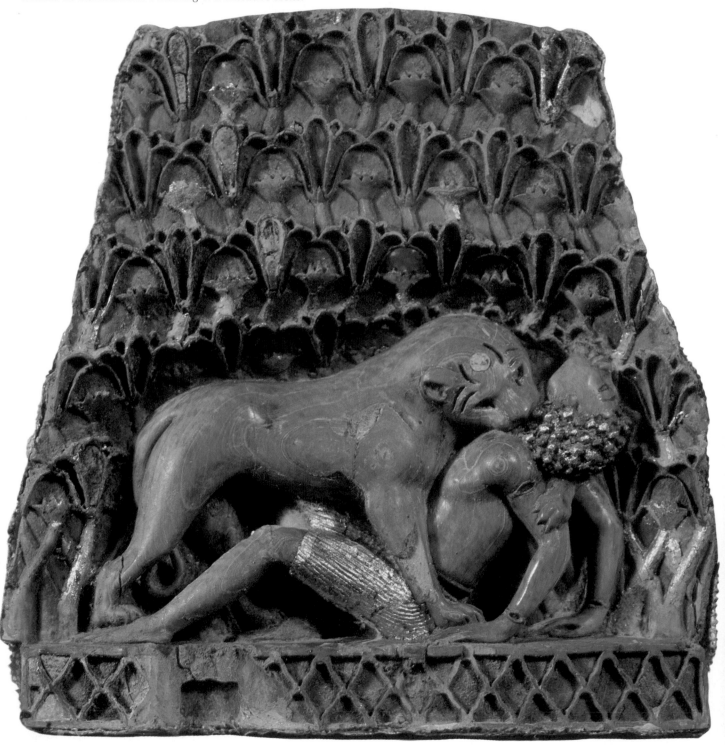

orderly scrolls to the shoulder. The women wear a long, plain tunic leaving the right arm bare.

In the fairly numerous sculptures of this period from Khafajah several styles can be distinguished. The geometric emphasis of the Tell Asmar figures is sometimes apparent, in a cruder form, but in some cases it is entirely abandoned in favour of an unbridled if ill-executed realism. Yet other examples, however, bear witness to a technique at least equal to that of the Tell Asmar figures.

Other cities have left fewer examples, although enough to reveal further local variations in style, while a small group of bronze statuettes suggest that Sumerian sculptors worked more easily in this medium than in stone.

EARLY DYNASTIC II SCULPTURE

Towards the middle of the 3rd millennium there was a noticeable change in style, sufficient to speak of a new period — Early Dynastic II. In the forefront were the comparatively new cities, such as Lagash and, although the subjects are little altered (there are more seated figures and figures of couples, changes in dress, etc.), the style is more expressive, with heightened realism and more emphasis on volume, suggesting a more heroic concept of man in his conflict with fate and nature. It is clear that the crisis preceding the Early Dynastic period had been fully overcome.

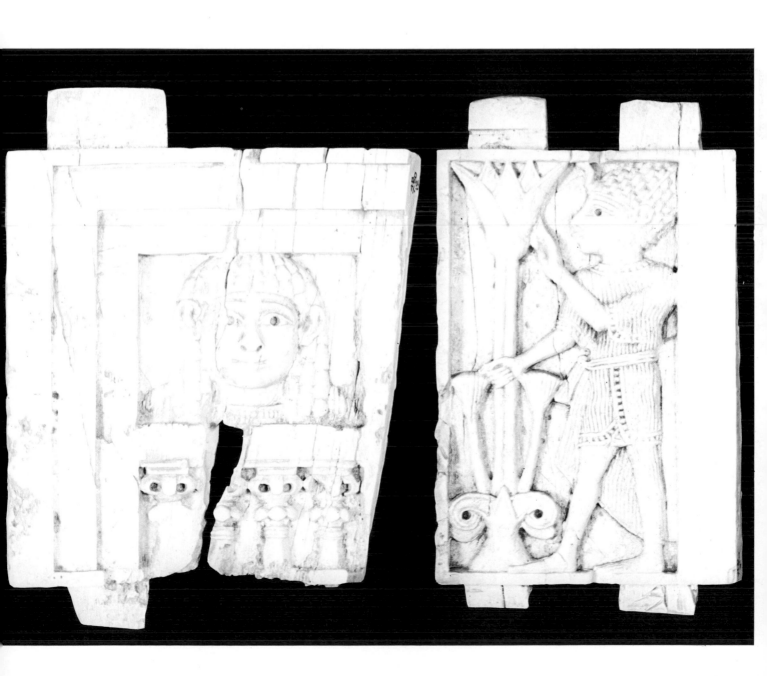

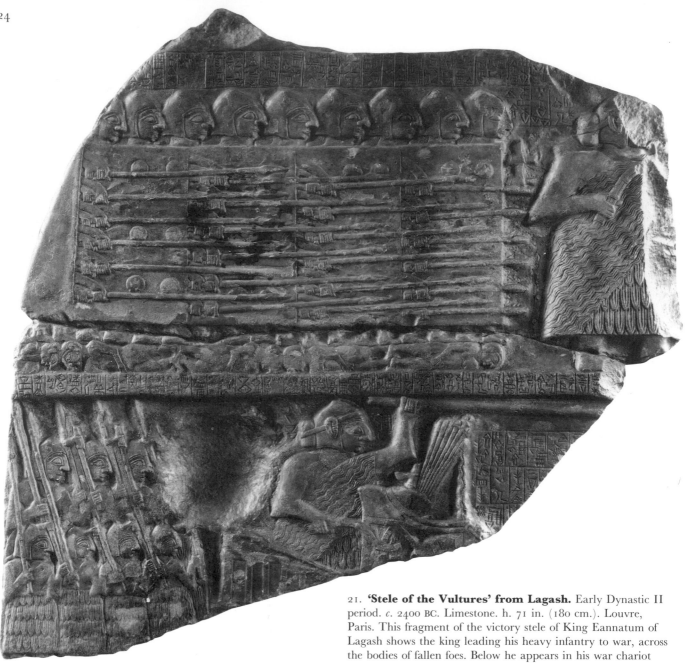

21. **'Stele of the Vultures' from Lagash.** Early Dynastic II period. *c.* 2400 BC. Limestone. h. 71 in. (180 cm.). Louvre, Paris. This fragment of the victory stele of King Eannatum of Lagash shows the king leading his heavy infantry to war, across the bodies of fallen foes. Below he appears in his war chariot raising a spear in his left hand. In another fragment, vultures devour the heads of his enemies – hence the name that the stele has acquired.

In the seated figure of 'Kurlil' from Ubaid, carved in basalt and originally painted, which is now in the British Museum, a certain confidence in man's control of his fortunes can be discerned. Yet the most remarkable work of this period comes from Mari on the middle Euphrates, a city outside Sumeria proper, where the heroic quality in male figures is paralleled by the grace and spirit of female figures. The stimulating effect of Syria on these works may be surmised.

As in the earlier period, relief sculpture was generally of inferior quality to free-standing sculpture, although it tells us more about Sumerian society, and the well-known 'Stele of the Vultures' in the Louvre, dating from about 2400 BC, is probably the earliest known narrative of historical events. It commemorates a victory of King Eannatum of Lagash and derives its name from a scene in which vultures devour the heads of the dead.

Such a piece is a rare survival, but there are a number of clay slabs, of unknown purpose though probably connected with religious observances, which portray banquet scenes, figures offering tribute and scenes of war. Occasionally, the figure of a god or a king is shown on a larger scale.

The new artistic tradition is also evident in seal carving. Here the subject matter is expanded to include narratives and mythological scenes, carefully composed and foreshadowing an interest in rhythm and volume which was to be characteristic of the later, Akkadian period.

Sumerian metalwork of the Early Dynastic II period, known to us through the excavation of the 'royal tombs' at Ur, is perhaps the most remarkable of all the evidence of the high standards of art and craftsmanship at this time. These chambers of brick or stone contained many gold objects, **8** axes, daggers, spears, statuettes, jewellery and even musical instruments — as well as the grisly evidence of extensive

human sacrifice. That the quality of Sumerian metal and inlay work was extremely high is demonstrated many times over, for instance in the superb bull's head terminal, gold leaf on wood, which decorated a lyre, or in the astonishing 'Standard of Ur', illustrating scenes of war and peace and worked in shell, red limestone and lapis lazuli, inlaid in bitumen. The purpose of this extraordinary piece, now in the British Museum, remains uncertain.

THE AKKADIAN PERIOD

About 2350 BC Mesopotamia was conquered by Sargon of Akkad (or Agade), the name of the capital city he built near the place where the Tigris and Euphrates approach each other. Sargon was the leader of a Semitic people who had been moving into the region over a long period, and the Akkadian conquest did not break Sumerian cultural traditions. On the contrary, it had the effect of spreading them more widely, and of bringing to a high point of achievement trends inherent in the Early Dynastic period. The Akkadian period in art is characterised by a wider-ranging approach to life, greater interest in the mundane affairs of men and women, and less fearful superstition. (A parallel has been drawn between the Akkadian period in Mesopotamia and the 15th century in Italy.)

Unfortunately, surviving works from this remarkable period are few; in architecture they are practically non-existent. The sculpture which had been retrieved is of the highest quality, though our judgement must often be based on mere fragments, like the headless figure from Assur or the lower half of a statue of Sargon's son Manishtusu. The fact that many pieces come from places far distant from Sumer, notably Susa, suggests that they were valued as highly in their own time as in ours.

Perhaps the most famous example is the bronze head believed to be of Sargon himself, a worldly portrait of great dignity, which suggests a new idea of the nobility of kingship. The sandstone stele of Naram-Sin, king of Akkad and Sumer, of about 2300 BC is the finest example of Akkadian relief sculpture. It shows a fine sense of composition, with subtle indications of landscape and a skillfully executed upward movement of figures towards the enlarged figure of the king himself. The Elamites thought so well of it that they carried it off after one of their invasions.

Akkadian cylinder seals, as usual, provide the best available record of artistic development, and corroborate the impression gained from larger works of a new feeling for nature, carefully balanced composition and all the old Sumerian mastery of volume. The inscriptions, which were formerly enclosed in a cartouche, are now incorporated in the composition and become part of the design — a development foreshadowed in the Stele of the Vultures. Traditional themes are illustrated, such as the hero overcoming a fierce beast, but they are treated in a more overtly decorative way. The religious or mythological subjects are obscure in meaning since few texts have survived from this period, but there is more evident enjoyment in the depiction of stories like the myth of Etana, the shepherd who was

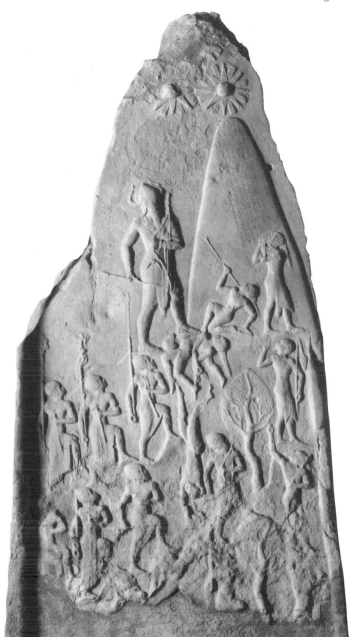

22. **Stele of Naram-Sin, King of Akkad.** *c*. 2300 BC. Red sandstone. 78¾ in. (200 cm.). Louvre, Paris. Naram-Sin, wearing the horned helmet of divinity, stands alone before a stylised mountain, one foot resting on slain enemies. A tree below indicates a wooded area. Soldiers ascend a mountain path. This stele was so valued in antiquity that the Elamites later carried it to Susa as part of the spoils of war, adding an inscription which can be discerned along the peak of the mountain.

seized by an eagle and carried off to heaven (probably the ancestor of the Greek story of Ganymede, similarly kidnapped for the benefit of the deities). Religion seems to have been a less oppressive influence in Akkadian times.

THE NEO-SUMERIAN PERIOD

At the end of the reign of Naram-Sin, Sumer was under attack from a nomadic Iranian people, the Gutians, who overran northern Mesopotamia. Although they endeavoured to continue the tradition of Sargon's dynasty,

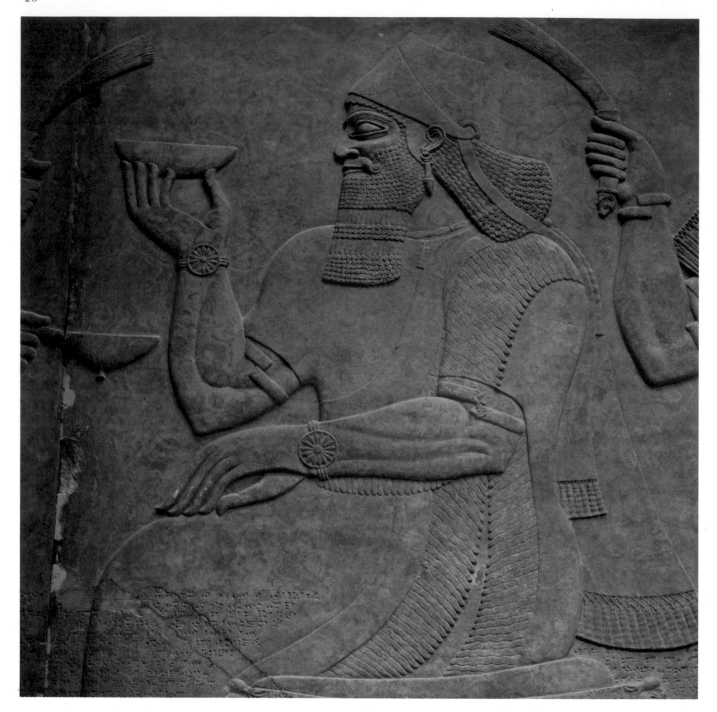

23. **Relief from the North-West Palace at Nimrud.**
Assurnasirpal II sits enthroned at a ritual banquet. British
Museum, London.

they were culturally primitive and under their influence art
deteriorated.

However, a revival of Sumerian culture occurred in the
south under the Third Dynasty of Ur, which for a short but
glorious period of about 100 years controlled a territory
that was little smaller than Sargon's Akkadian empire.
During that time the cultural attainments of Sumer were
spread over a large part of western Asia.

During the century or so spanning the end of the 3rd and
the beginning of the 2nd millennium, Sumerian civilisation
witnessed a return to the quieter, less splendid world of the
Early Dynastic period, perhaps as a reaction to the political

instability following the fall of the Akkadian empire and the
invasions of the Amorites, a Semitic people who founded
the Amorite kingdom of Babylon about 1900 BC.

This comparatively brief period was nevertheless a
creative one. It was the age of the ziggurat — a temple set
on top of a series of receding platforms. The ziggurat was a
form harking back to the first flourishing of Sumerian
civilisation, yet it was also a reflection of the Akkadian era
in its monumentality and symmetry. The core of the
ziggurat was usually of mud bricks, the exterior whitewash-
ed or even painted. Gigantic staircases led from one level to
the next, until the sanctuary at the top was reached.

13

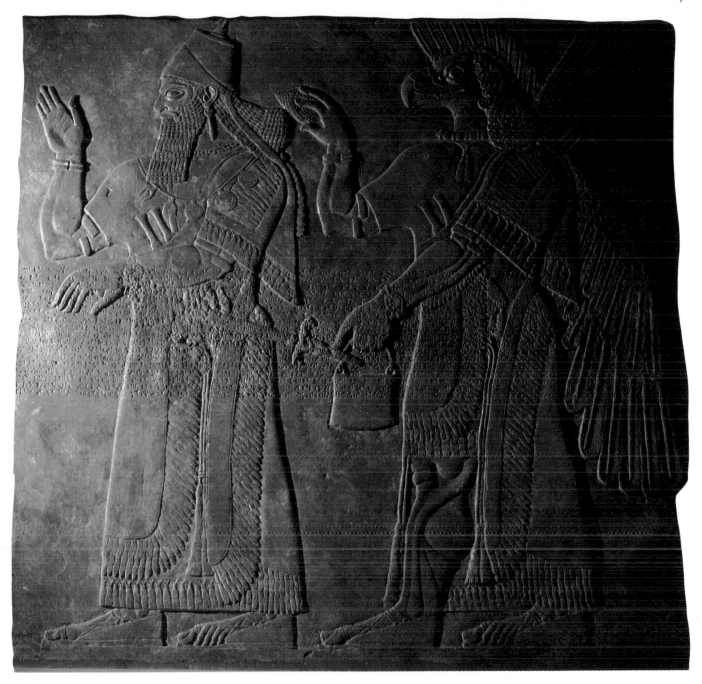

24. **Relief from the North-West Palace at Nimrud.**
Assurnasirpal II at prayer while a winged genius bestows
fertility upon him. British Museum, London.

In the sculpture of the last great Sumerian epoch, the
return to earlier conceptions is evident in the reappearance
of the figure of the worshipper, replacing the heroic figures
of the Akkadian Period. Equally interesting, and hard to
interpret, is the imagery of the cylinder seals (again the
most numerous survivals), in which the rich mythology so
prominent in the Akkadian period is altogether
abandoned.

BABYLON

Sumerian civilisation lived on in Babylon and Assyria,
although the Sumerians themselves gradually disappeared.

In the 18th century BC, under the Amorite king Ham-
murabi, the Babylonians were a mixed people (including
the conquered Sumerians). They took over many features
of Sumerian civilisation, including cuneiform writing.
They had their own language but adopted many Sumerian
words. In fact the name of the Babylonian god, Marduk, is
Sumerian.

The city of Babylon itself stood on the Euphrates about
60 miles south of Baghdad. It was a large, brick-built city
surrounded by fertile fields and irrigated by canals which
often ran above the level of the land. Long journeys in and
around the city were made by boat. It was an orderly
society with a high degree of private enterprise. Money, in
the form of silver bars, could be borrowed or lent, formal

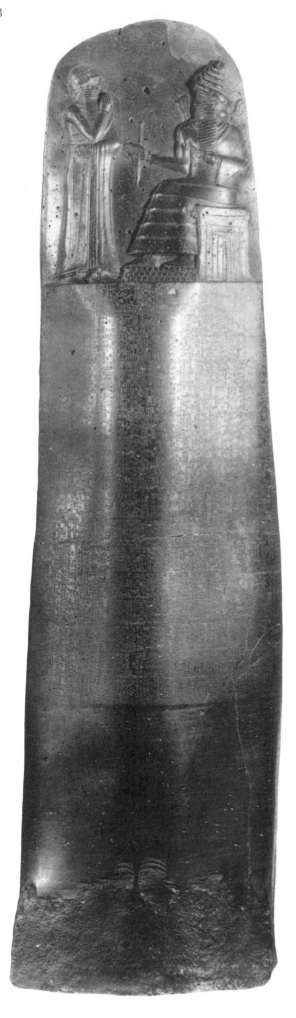

25 (left). **Stele of Hammurabi.** Old Babylonian period. 18th century BC. Basalt. 88⅝ in. (225 cm.). Louvre, Paris. Hammurabi, King of Babylon and 'lawgiver', is shown before the sun-god, Shamash, who holds the ring and staff in his hands. On the shaft of the stele, in minutely engraved cuneiform script, is the famous 'Code of Hammurabi', which is the first known of the so-called 'codes'. We now know of several codes which pre-date Hammurabi's. They in fact represent a literary genre which had started in the Sumerian period, and which described the social ideals of the ruler in a literary form.

26. **Akkadian cylinder seal impression.** 2350–2150 BC. British Museum, London. The seals of the Akkadians reflect the same masterly sense of composition as was evident in the stele of Naram-Sin. Mythological scenes such as this, though prevalent, cannot be explained because of the loss of contemporary literary texts.

27. **Neo-Sumerian cylinder seal and impression.** c. 2150–1950 BC. British Museum, London. This scene shows a worshipper being presented by a divine sponsor to a great god who is seated on an elegant throne. The script is now adjusted into neat columns.

business agreements could be made, property registered and wills certified. There was an 'incomes policy', and temples sometimes acted as places of business, although priests were less powerful in government and economy than they were in most other early civilisations. The famous Stele of Hammurabi confirms that this was a solid, well-to-do state which flourished under the rule of law, harsh though that law may seem to us.

Technique in sculpture in the Old Babylonian period generally strikes us as clumsier and less lively than that of the Neo-Sumerian period. Seals show the influence, in motifs, of Syria as well as Sumer, but the craftsmanship is not of the finest.

25

The Assyrian Period

After the fall of the first Amorite Babylonian dynasty in the mid-16th century BC, the Kassites, a people originating in the region of the Zagros Mountains, established themselves in Babylon and ruled the whole of Mesopotamia for over 300 years. Opinions differ concerning their cultural influence, but most would agree that they brought, at least, an infusion of vigour, especially in art. There are traces of an architectural revival in the ancient city of Uruk among other places, the façades of the buildings being adorned with sculpture showing more life and spirit than the rather cold, uninspired works of Amorite Babylonia. One new feature they introduced was the *kudurru*, a kind of boundary stone, carved in relief, of which the Stele of Hammurabi was possibly a precursor. An interesting feature of these stones is that gods are now nearly always represented by symbols, rather than depicted as human figures. They display a fine feeling for composition, though the handling of volume is perhaps less distinguished than in the Sumerian reliefs of the Akkadian period.

THE ASSYRIANS

During the Kassite period a new people, the Assyrians, were establishing themselves in northern Mesopotamia. They were originally nomadic herdsmen, who had adopted a settled existence before 2000 BC and took their name from their early capital city, Assur, which was also the name of the chief Assyrian god. About the middle of the 2nd millennium BC they controlled a considerable empire and it is in this period that a distinctive Assyrian art appears, together with massive buildings — ziggurats, temples and palaces — at Assur and other cities, although the Assyrians, the first people with a regular army, did not conquer Babylon until the 8th century BC.

Assyrian art of the early period appears most accomplished in the carving of seals. It has an original style, owing more to Mitannian tradition in Syria than to southern Mesopotamia, and in composition and figure-handling rivals the finest seals of the Akkadian period.

The great buildings of the later Assyrian period, from the 11th to the 6th century BC, seem to have been constructed in bursts of activity, generally in times when there happened to be a particularly successful king on the throne, for the Assyrians were constantly engaged in wars. However, in spite of long periods when all work of this kind was abandoned, artistic continuity seems to have been preserved virtually unbroken. The subject matter is not particularly original, but the execution is always skilful. Statues in the round are rare and, like the early seals, they show a western influence, bearing a striking resemblance to works from Egypt executed in the same medium. The greatest works of the Assyrian court sculptors are the huge rock-carved reliefs, like those at Bavian and Maltai celebrating the achievements of Sennacherib.

NIMRUD

Another great Assyrian king, Assurnasirpal II, was responsible for rebuilding the city of Nimrud, where he

28

32

28. **Boundary stone of Melishipak II from Susa.** Kassite period. *c.* 1140 BC. Louvre, Paris. Kassite boundary stones, known as *kudurrus*, bore the reliefs of gods to protect the boundary, or of kings who guaranteed possession of the land to the owner. Many reliefs of a religious character were depicted, but gods were by this time represented almost exclusively by symbols.

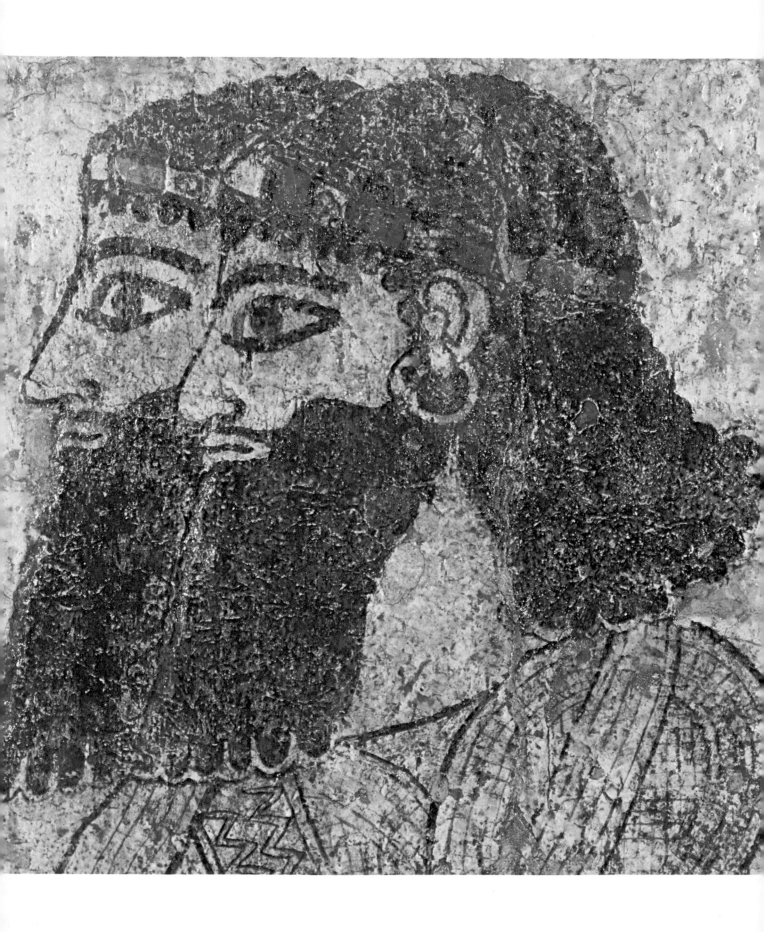

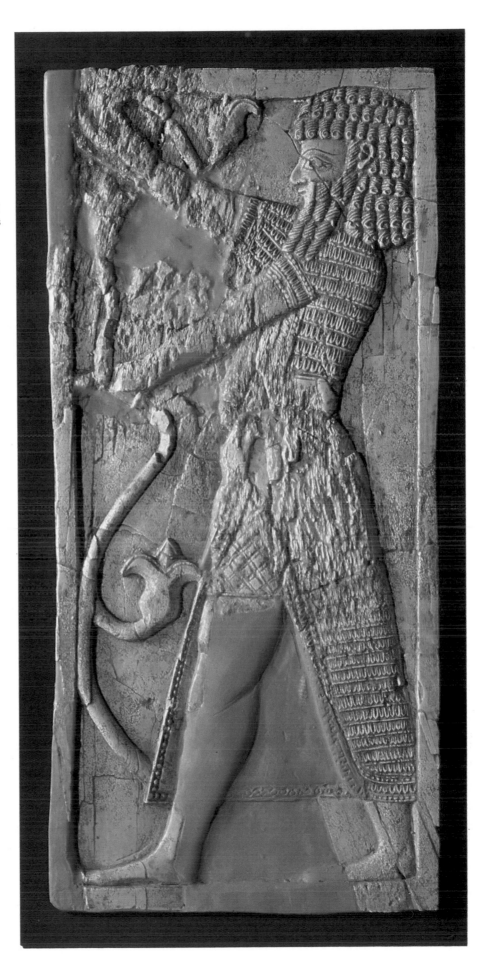

29 (left). **Two official dignitaries.**
Neo-Assyrian. Probably reign of
Tiglathpileser III (744–727 BC). Painting
on plaster. $29\frac{3}{4}$ in. (75·6 cm.). Aleppo.
Museum. This fragment of painting was
found in the palace of the governor at Til
Barsip on the Euphrates. The two officials
are shown in profile. They are dressed in
formal court apparel with headbands,
earrings and embroidered robes. The
painted heads with the thick black
outlines make a powerful pattern against
the whitish background.

30 (right). **Ivory panel from the
Assyrian palace at Fort
Shalmaneser.** It shows the king in his
role as protector of the Tree of Life.
The piece is of Phoenician
workmanship and was made for a royal
Assyrian patron in the 8th century BC.
Ashmolean Museum, Oxford.

erected a large palace. The guardians of the palace gates were gigantic figures of winged bulls with human heads, which display both a sense of imperial might and a painstaking attention to the tiniest detail. Because the forelegs are placed together, seen from the side these creatures would have appeared to have only three legs. They were therefore provided with a fifth leg, visible from the side, so that the beast has a different stance depending on the angle from which it is viewed.

The walls of the palace of Assurnasirpal II are decorated

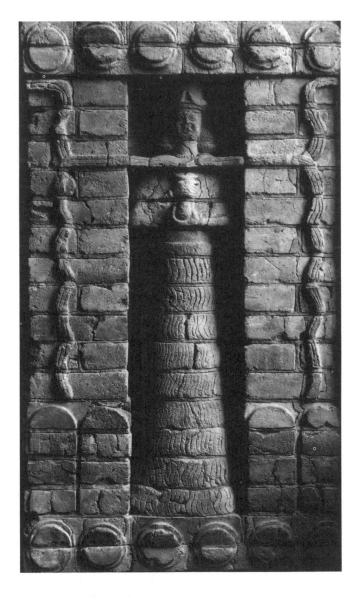

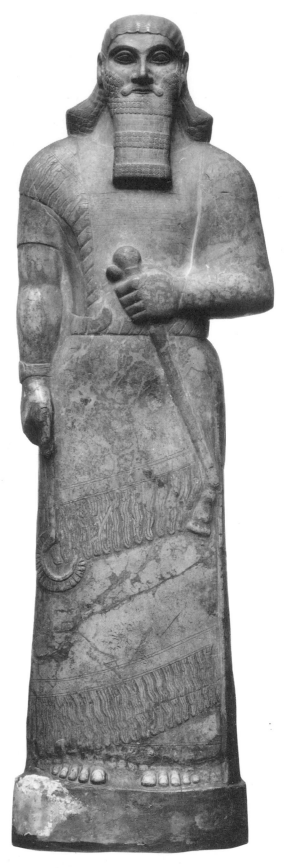

31. **Detail of temple façade at Uruk.** Kassite period. *c.* 1600–1100 BC. Staatliche Museen zu Berlin. This temple was built by the Kassite king Karaindash at the end of the 15th century BC, and dedicated to the mother goddess, Inanna. The outer walls were constructed of moulded bricks with niches enclosing the figures of gods. Here a deity holds the 'flowing vase' from which issue streams of water, a well-known motif (see also, for example, figure 14).

32. **Statue of Assurnasirpal II from Nimrud.** 883–859 BC. Limestone. h. 41¾ in. (106 cm.). British Museum, London. This coldly formal statue of the king bears an inscription giving his name, title and victorious campaigns. He holds a curved crook-axe and a sceptre, royal attributes which are markedly similar to those of the Egyptian kings. This is in no sense a personal portrait. The head is impassive and the features generalised.

with large reliefs of the king at war, hunting, performing some religious ritual, etc. Typically those scenes in which the king does not appear have greater freedom and liveliness. The king's presence imparts a certain formal rigidity, less attractive to us but presumably then regarded as conferring a superior status. Narrative scenes are also more free-flowing and more softly modelled than depictions of a single religious scene, where a stiff, hieratic quality takes over.

The very high quality of these Assyrian reliefs is not easily explained. The derivation is not Mesopotamian, and it seems that although the idea, at least, of narrative reliefs may have come from the north-west, perhaps Anatolia, the development of the technique to the high standard displayed in Assurnasirpal's palace was probably an Assyrian achievement. The paucity of surviving works from an earlier period makes this thesis difficult to prove, but what

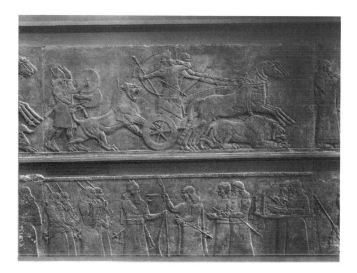

33. **The Lion Hunt of King Assurnasirpal.** Relief from the North-West Palace of Assurnasirpal at Nimrud. 883–859 BC. h. c. 36 in. (93 cm.). British Museum, London. This shows the king drawing his bow at a lion. Hunting episodes such as this are much freer both in composition and in movement than the religious scenes. The lion hunt motif had a religious and symbolic meaning in ancient western Asia. It lasted from the fourth millennium BC until Sassanian times. The king personified the good, vanquishing the powers of evil.

evidence there is certainly supports it.

The progress of this new narrative style can be seen in the bronze doors — a fortuitous survival — of Balawat, which date from the reign of Assurnasirpal II's successor, Shalmaneser III. The story is told in long, narrow bands, like a comic strip, and the length of the bands obviously posed problems for the artist in the integration of the scenes. He sometimes resorted to lines of identical figures, and in other examples he used the seated figure of the king to unite two halves of the band. Although in terms of invention there is no advance on the reliefs of Assurnasirpal, the artist of the bronze doors displays a new interest in landscape, which is usually ignored in the Nimrud reliefs.

Thereafter, a gap appears in the record lasting nearly a century, until Assyria prospered under another victorious king, Tiglathpileser III. From his reign in the second half of the 8th century BC come more reliefs from the palace of

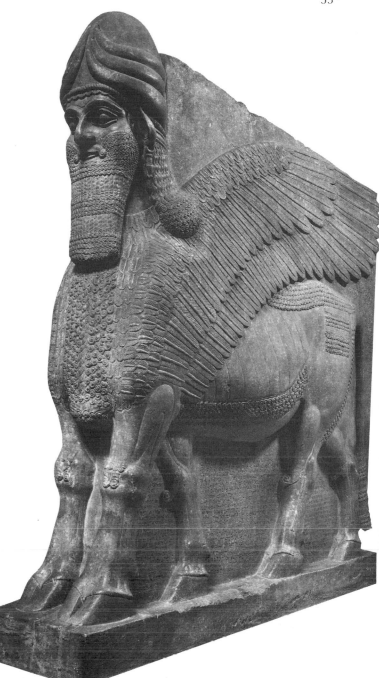

34. **Winged human-headed bull from Nimrud.** Period of Assurnasirpal II. Alabaster. h. 10 ft. 4 in. (3·14 m.). British Museum, London. This colossal figure guarded a doorway of Assurnasirpal's palace at Nimrud. It marks the climax of Assyrian relief-carving in its majestic power and minute attention to delicate detail.

Nimrud, though unfortunately they are mainly fragments. The subject matter is unaltered — the usual battles, lion hunts, etc. — but there is a new conception of space which some observers, over-boldly perhaps, have seen as a rudimentary attempt at perspective. The fact that blank areas are present at all is remarkable enough, showing an awareness of space, although the particular difficulty presented by these reliefs for the spectator—that of following the chronological progress of the narrative—suggests that the various scenes were fitted in more or less arbitrarily.

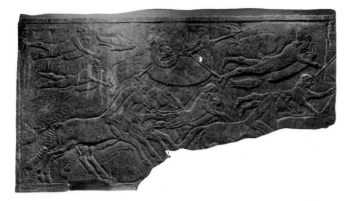

35 (above). **Soldiers crossing a river.** From the palace of Assurnasirpal at Nimrud. 883–859 BC. Scenes from which the king is absent achieve a greater vivacity and are perhaps more attractive to modern eyes. Here soldiers are shown crossing a stream on inflated skins. Note the stylisation of the river which contrasts with the lively execution of the figures.

NINEVEH

That the apparent concept of space was not an isolated occurrence is confirmed by some of the reliefs in the new capital of Khorsabad, founded in the late 8th century BC by Sargon II. For example, in a scene showing timber being transported by sea (pleasantly represented by sets of scrolled lines set at angles) the figures of the sailors are sometimes superimposed, indicating recession.

A further stage is reached in the reliefs of the palace of Nineveh, which became during the last great era of the Assyrian empire the country's capital (as it had been under Assurnasirpal II). In reliefs made in the reign of Sennacherib (705–681 BC), landscape reappears, and the

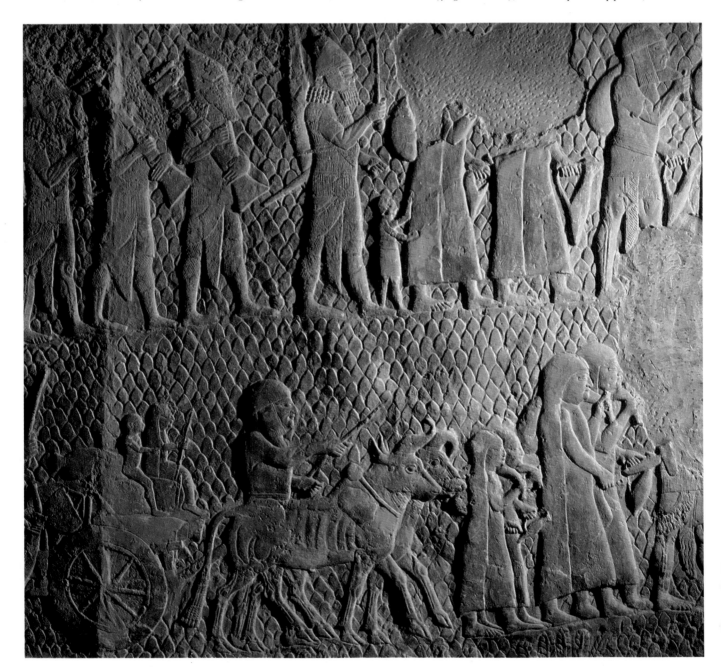

figures are skilfully integrated into the physical setting, with a clear feeling for perspective. But these reliefs are even more interesting for another reason — a new concern for human beings. Some figures are caught in a spontaneous gesture and, although they still frequently appear in series showing limited differentiation of individuals, now and again there is evident a human sympathy not expressed before, and not, on the whole, to be expected in the harsh society of the Assyrians. But there can be no mistaking the feeling of the artist for a weary prisoner hauling a monolithic statue, or for the fearful family hiding among reeds from pursuing soldiers.

38

This new sensitivity to individuals — slaves and prisoners

moreover — is less evident in later Assyrian reliefs, although in a scene of wild horses being hunted with dogs, from Assurbanipal's palace at Nineveh in the mid-7th century BC, the artist clearly feels some sympathy with the hunted animals, depicted with striking finesse. The dominant subject of these reliefs is war, with piles of corpses and square-bearded Assyrian warriors indulging their taste for slaughter and cruelty on all sides. Occasionally one catches a glimpse of less martial feelings, as in the scene of a captured, deserted city, with columns of prisoners making their weary way into exile.

39

40

Although there is no notable advance in artistic technique in Assurbanipal's reliefs, there is much greater detail

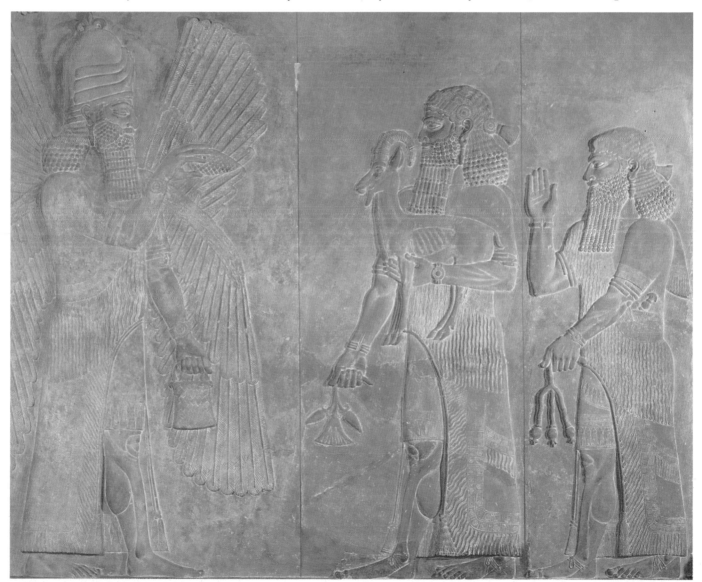

36 (opposite). **Assyrian relief from the palace of Sennacherib at Nineveh.** 700 BC. Israelite captives being taken from the city of Lachish after its fall to King Sennacherib. British Museum, London.

37. **Assyrian relief from the palace of Sargon II at Khorsabad.** 8th century BC. The drooping lotus signifies the death or grievous illness of the king, and the kid is for sacrifice. The larger figure, the king, offers expiation to a winged genius on behalf of his people.

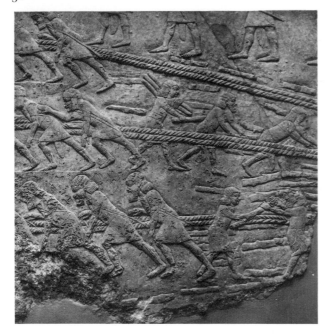

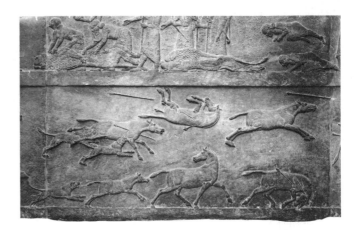

38. **Relief from the palace of Sennacherib at Nineveh.** 704–681 BC. British Museum, London. In this scene slaves are dragging a colossal statue to the palace. The formality of the royal reliefs is altogether absent in this lively narrative detail.

39. **Wild asses hunted with mastiffs.** Detail of a relief from the North Palace of Assurbanipal at Nineveh. 668–626 BC. h. 21 in (53 cm.). British Museum, London. This poignant rendering of animals in flight suggests a sympathy on the part of the sculptor with the fate of the wild asses.

which, with the accompanying inscriptions, offers valuable evidence about how people lived — the clothes they wore, the way their houses looked and so on.

Court art was bound by convention, and scarcely permitted the expression of human emotions. The figure of **23, 24** the king himself, whether hunting, fighting or engaged in religious ritual, is always a still, stiff representation of royal dignity. However, the artist enjoyed greater licence when it came to portraying servants or animals, and the livelier poses here serve to emphasise the formal nature of the central figure.

These works are of high artistic quality, carved in very low relief so that the modelling is practically invisible but for the play of light. There is some evidence that the artist prepared the work by making a model in clay, in much higher relief, the figures then being flattened. But there is no attempt in these reliefs to convey background scenery, as in those of Sennacherib's reign. Possibly the increased command of composition rendered this line of development redundant.

As in other early civilisations, sculpture proved more durable than painting. Nevertheless, some fragments of **29** Assyrian painting survive from Khorsabad and one or two other sites. The subject matter is the same as in the relief sculptures, with court scenes and sea battles, and the style is similar, with figures outlined in a thick line and the use of black and strong reds imparting a sense of richness against a light background.

ASSYRIAN CITIES

Assyrian ideas of city planning are most easily seen in the remains of Sargon II's unfinished city of Khorsabad. The bounds were fixed by a large wall, roughly square, pierced by seven gates and enclosing an area about the size of the medieval City of London. The main complex of buildings was situated near one corner, with another, smaller complex near the opposite corner. Each of these complexes was built on a raised platform and surrounded by an inner wall. Some of the gates were guarded by winged bulls with human heads, like those of Assurnasirpal II's Nimrud, or a large figure in relief of a hero strangling a lion, a motif deriving from the Sumerian legend of Gilgamesh. The main buildings were the royal palace, a ziggurat and various temples. The liking for regularity evident in the overall plan of the city also appeared in the layout of the palace, its rooms ranked around two large courtyards. It is interesting to note that the chamber containing the royal throne was planned in the same manner as the temples. Another building, in the smaller citadel guarding the south-west, had a porch with columns of a type known in Hittite Syria. There is no doubt of the derivation, since an inscription by Sargon explains that this was indeed the source for the building.

Nineveh and Nimrud were excavated in the 1840s by Sir Henry Layard, who was responsible for the unique collection of Assyrian art in the British Museum in London. **19,** Although the narrative reliefs of battle, hunts, etc. are the most striking of these treasures, there were other equally interesting finds. For instance, thousands of cuneiform tablets were discovered in the library of Assurbanipal's palace. Among them was the best surviving version of the legend of Gilgamesh, translated from Sumerian. Despite the long sections of reliefs celebrating that great king's martial exploits, Assurbanipal was apparently also a scholar.

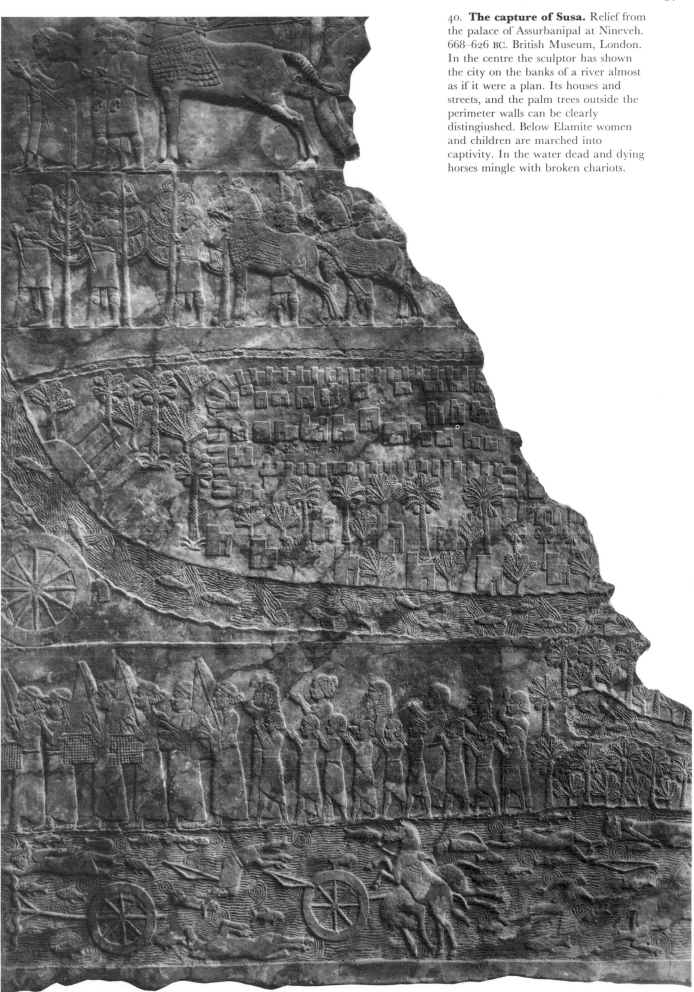

40. **The capture of Susa.** Relief from the palace of Assurbanipal at Nineveh. 668–626 BC. British Museum, London. In the centre the sculptor has shown the city on the banks of a river almost as if it were a plan. Its houses and streets, and the palm trees outside the perimeter walls can be clearly distingiushed. Below Elamite women and children are marched into captivity. In the water dead and dying horses mingle with broken chariots.

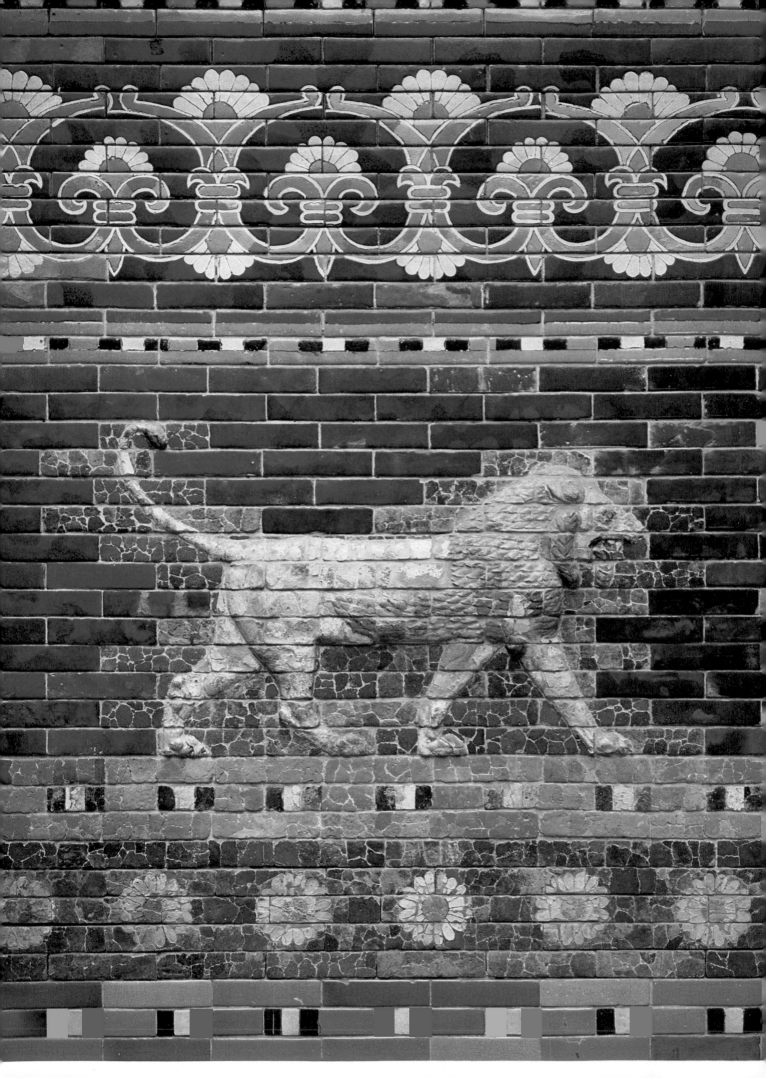

41 (opposite). **Detail from the façade of the throne room at the palace of Babylon: polychrome lion.** Reign of Nebuchadnezzar II, (604–562 BC). Staatliche Museen zu Berlin. The main gates into Babylon and the side walls of the Processional Way were faced with glazed bricks in rich colours. The heraldic animals were first modelled on a rectangular panel of clay. While still soft, the panel was cut up into separate small bricks, which were glazed, fired and then reassembled on the façade. The great crenellated walls must have presented a dazzling sight; the technique so impressed the Achaemenians that they imported Babylonian craftsmen to produce similar effects on the walls of Susa.

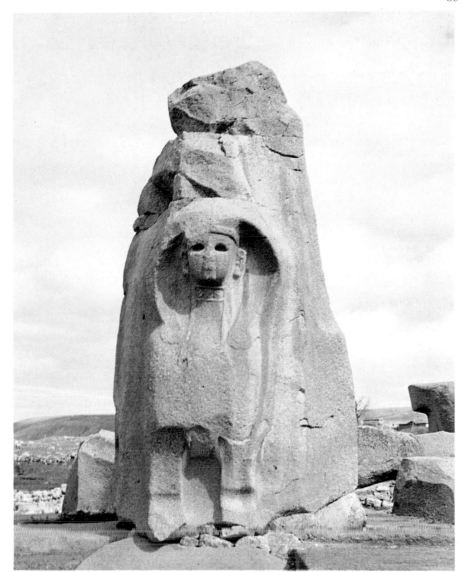

42, 43 (above right and below right). **Sphinx from the Sphinx Gate at Alaca Hüyük.** Hittite Imperial Period. Middle of the 14th century BC. The Sphinx Gate, like the Lion Gate at Hattusas, guarded the entrance to the city. The sphinx motif probably reached Anatolia from Egypt via Syria, but it is transformed from a male symbol into a female one. If the idea of guardian creatures originated in Mesopotamia, it was developed by the Hittites in a monumental way which was to find echoes in Assyria centuries later.

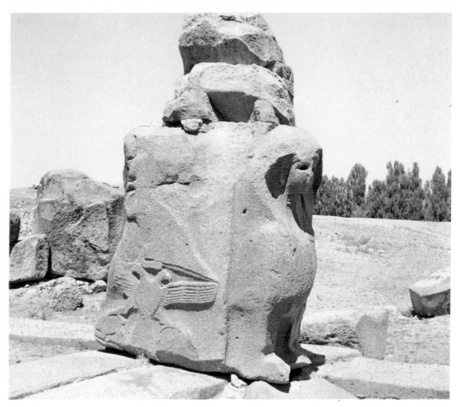

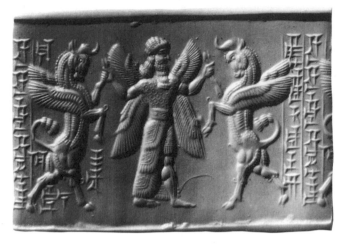

44. **Relief from the palace of Sargon at Khorsabad.** Neo-Assyrian. 721–705 BC. Alabaster. h. of detail *c.* 38 in. (96·5 cm.). Louvre, Paris. This detail shows wood being transported by sea. The heavy timber is supported on the prow of a rather fragile-looking boat. The figurehead is carved as a horse's head.

45. **Late Assyrian cylinder seal impression.** 9th–7th centuries BC. British Museum, London. Assyrian cylinder seals seem to have played some part in religious rituals, particularly those of the New Year Festival. Here a winged genius stands between confronted winged bulls.

The Assyrians reached the height of their power in the 8th century BC, when Babylon was defeated and the Assyrian empire stretched as far as Egypt. But this remarkable political structure, crossed by an efficient system of post roads, was not to last much longer. The rise of the New Babylon in the 7th century and the alliance of the Babylonians with the Medes, a powerful Iranian people, brought disaster for the Assyrians. By the end of that century their empire had vanished, their artistic tradition was cut short and, like many another race of conquerors, they mysteriously disappeared from history.

NEW BABYLON

Although some Assyrian influence continued in the arts of the Near East in later times, Assyrian art was court art and therefore did not survive the fall of the empire. In the 1st millennium BC Babylon became again the centre of Mesopotamian civilisation. Although nearly a thousand years had passed since the fall of the first Babylonian empire, under Nabopolassar and his successor, Nebuchadnezzar II, Babylon was restored to its former greatness, with Babylonian civilisation largely intact. Marduk still ruled over gods and men. The old temples were restored and rebuilt.

The city of Babylon revealed by archaeology is in fact essentially the city of the New Babylonian period, much of it being constructed by Nebuchadnezzar II during the first half of the 6th century BC. It formed a rough square, surrounded by a double brick wall, the outer wall being some 20 ft (6 m) thick and the inner wall about 13 ft. (4 m.), wide enough to serve also as a raised roadway. Between them lay a moat about 23 ft. (7 m.) in width. The walls were penetrated by monumental gateways, the most famous of these being the Ishtar Gate, at the beginning of a ceremonial way leading into the city. The gate is flanked by

twin towers faced with coloured (predominantly a rich blue) glazed bricks in which are set heraldic animals in relief. This was not a new technique, though nothing quite so grand had been seen before. The animals, some real, some mythological, were modelled in damp clay on a panel. When the clay dried it was cut up into bricks to match the rest of the wall. The bricks were then separately glazed and fired and reassembled in place on the wall. The total effect must have been quite remarkable.

The most impressive buildings of New Babylon were in the sacred precinct of Marduk, itself surrounded by a substantial brick wall, buttressed at frequent intervals, and containing a smaller, walled sanctuary. Within this was the temple of Marduk and the famous five-tiered ziggurat, approximately 300 ft. (90 m.) in height and the same along each side. This was almost certainly the Biblical Tower of Babel, and indeed we know from Babylonian sources that Hebrew slaves helped to build it. The Hanging Gardens, one of the Seven Wonders of the Ancient World, ascribed to the legendary queen Semiramis, appear (from what seem to be the remains) to have been rather less impressive than their reputation, although it is difficult to visualise the effect now.

The architecture of New Babylon was certainly on a grand scale, but there was not much creative originality at work. After the fall of Old Babylon to the Assyrians, the Babylonians became inward-looking, cultivating their ancient traditions which went back to Sumer, and otherwise merely following Assyrian example. Some see a very gradual decline setting in after the Kassite period which was essentially continuous down to the Persian conquest. The powerful New Babylonian dynasty, which was represented most notably by Nebuchadnezzar II, was known as Chaldean. It was of Aramaean origin, and the Ar-

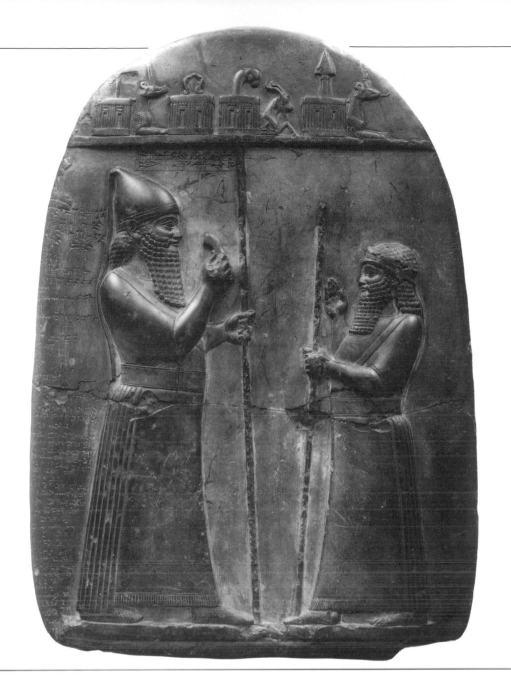

46. **Stele of Mardukpaliddina.** Neo-Babylonian period. *c.* 721–703 BC. Black marble. h. 18½ in. (46 cm.). Staatliche Museen zu Berlin. The Neo-Babylonian boundary stones are in the tradition of Kassite art, and have scarcely any affinities with Assyrian sculpture (see figure 28). The rounded form and the greater depth of the relief recall the stele of Hammurabi (figure 25).

amaeans were a Semitic people from North Syria who had no artistic contribution of their own to make. In fact New Babylon did not offer any innovations comparable with the achievements of the Assyrians.

However, it must be said that apart from architecture, extremely little survives of New Babylonian art. There is, for example not a single statue. The reason for this is undoubtedly vandalism. The Babylonians preferred metal to stone as the material for sculpture and such sculptures are notoriously vulnerable to the attentions of anyone looking for a cheap supply of metal. There are stories of gold images of Babylonian gods being carried off by the Persians,

and many works of art that once furnished the palaces and temples no doubt fell prey to looters.

What remains in the form of reliefs, clay figures and boundary stones — and there is rather little in these categories too — generally harks back to Kassite and Neo-Sumerian traditions. The stele of Mardukpaliddina (late *46* 8th century BC), now in Berlin, recalls the stele of Hammurabi, 1000 years earlier, and owes little or nothing to the Assyrian tradition. The Chaldean kings were enthusiastic adherents of the Babylonian heritage, and their impressive building programmes might be compared with the zeal of the Victorians in building large new churches in the style of the English Middle Ages.

The conquest of Babylon by the Persians did not result in the extinction of Babylonian art as happened in Assyria, but it did increase the rate of decline already in progress. The heart of western Asian civilisation shifted to Iran, and Babylon began to wither away. By about 300 BC it was little more than a great village, with animals grazing and crops growing in the shadow of the great buildings of Nebuchadnezzar.

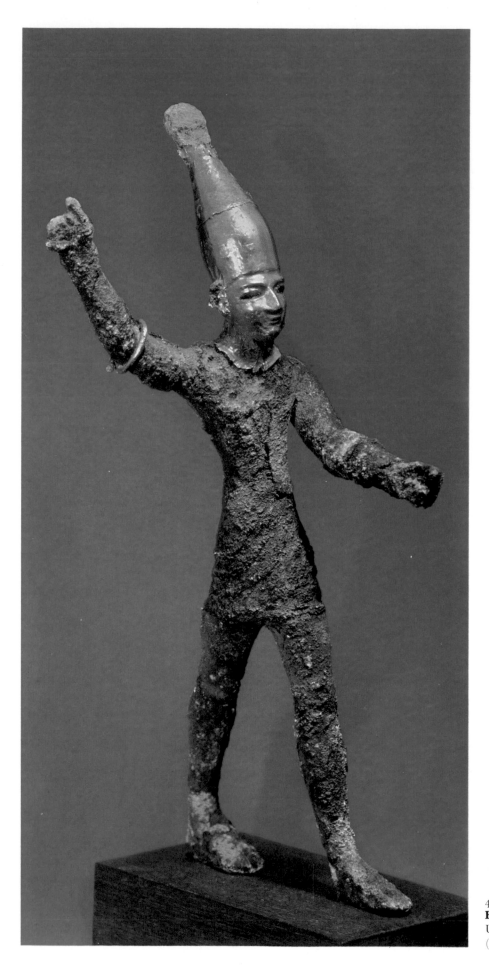

47. **Bronze figurine of the god Baal.** 14th century BC. Syrian, from Ugarit (Ras Shamra). Louvre, Paris. (See also page 47.)

Beyond the Two Rivers

Mesopotamia, generally flat and low-lying, is surrounded on three sides by more mountainous regions, lacking a great river system. Here civilisation appeared at an early date, sometimes influenced by Mesopotamia but displaying individual characteristics. This great arc of territory, differing considerably in various regions, can be divided into three. In the west lay Syria, an area bounded east–west by the Mediterranean and Mesopotamia and north–south by the Taurus mountains and the Sinai desert (and including Palestine). It formed an intermediate region between the great civilisations of Mesopotamia and of Egypt, and at different times was influenced by both. In the north lay Anatolia, equivalent to Turkey in Asia today, containing the sources of the two rivers and merging with northern Mesopotamia. In the west lay Iran, the largest of the three regions, closely linked with Mesopotamia in the south-west, where the Elamites were in touch with Mesopotamian civilisation from the 3rd millennium. Still farther east, in what is now Pakistan, lay the Indus valley, where an early civilisation arose independently of Mesopotamian developments.

Civilisation, as manifested in the existence of a complex urban society, is traditionally regarded as beginning in the 4th millennium BC, but archaeological research has tended to show that, in all these areas, urban society originated at a much earlier date and, in order to trace the origins of Near Eastern art, it is necessary to go back to the 7th millennium.

JERICHO

Jericho is sometimes described as the oldest city in the world. A Neolithic shrine existed there in the 9th or 10th millennium BC. Relatively permanent settlement began before 8000 BC, and by the end of the 8th millennium it could be described as a town, having a number of simple round houses surrounded by a moat cut in the rock and a wall some 13 ft. (4 m.) high. It has been suggested, perhaps too hopefully, that these were not fortifications but flood defences, and it is hard to explain them — or the most remarkable feature of this first city, a stone tower which even now is about 26 ft. (8 m.) high — as having no defensive intention.

The population may have numbered as many as 2000, and clearly agriculture was practised to feed such a number (carbonised grains are evidence of this), but so large a settlement must have had some additional source of wealth, and this was probably trade. The Dead Sea, not far to the south, would have offered several valuable commodities, notably salt, and obsidian was imported from Anatolia.

This early culture lasted nearly 1000 years, but the city was then deserted, for unknown reasons, and resettled in the 7th millennium by another people, who built rectangular rather than round dwellings.

The first inhabitants of Jericho were obviously skilled builders. The stones of which the tower is constructed are of great size, and the quality of the work is attested by its survival. They were also sculptors of some ability. Clay figures have been found of a type occurring over a wide area

of western Asia at an early date but, more interesting than these, are the human busts which were made by modelling in plaster on an actual skull. This curious technique was no doubt connected with some kind of ancestor cult, and it was executed with great finesse. Of course the basis of the bone is a great help, but the features fashioned on that base are skilfully modelled, and convey the actual appearance of these unknown people very well. The eyes were inset with shells, and the heads were apparently painted.

48

CATAL HÜYÜK

At this site in southern Anatolia a number of shrines have been found which date from the 7th millennium BC. They are especially interesting because the walls are decorated with reliefs and paintings, the first known paintings of western Asia so far discovered. The earliest examples are mainly geometric in style, although it is possible to distinguish, for example, a scene of men and large birds. Later paintings show hunting scenes and religious rituals, mainly in shades of red and black on a light ground. Male figures are slender and lively, female figures heavier, less fluid and painted in white. Among the reliefs, bulls' heads are a common design, and also found within these shrines

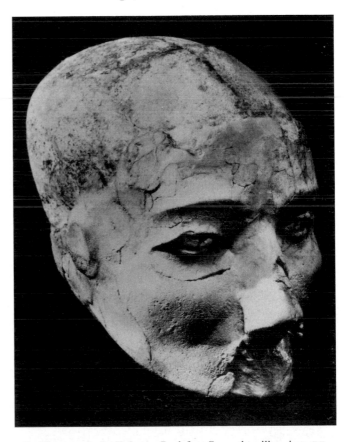

48. **Plastered skull from Jericho.** Seventh millennium BC. Amman Museum, Jordan. Ten such skulls have been discovered during excavations at Jericho. The plaster is skilfully modelled upon the skull to represent human features, and the eye sockets are set with cowrie shells. Probably relating to an ancestor cult, some of the skulls preserve traces of paint.

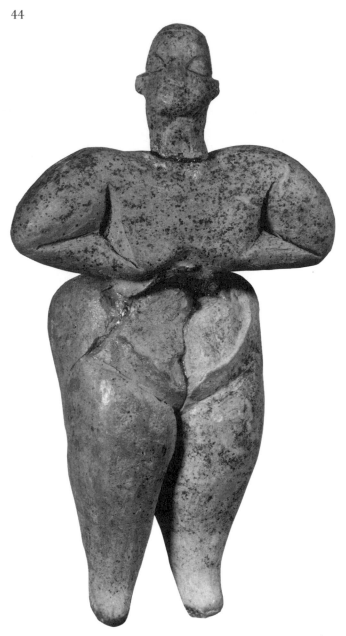

49. **Mother Goddess from Hacilar, Anatolia.** *c.* 5700–5600 BC. Baked clay. h. 4⅛ in. (10.5 cm.). Archaeological Museum, Ankara. This figurine has pronounced thighs, buttocks and upper arms. The eyes are incised. Terracotta figurines of this kind were widespread in ancient societies from the Mediterranean to India and known in other parts of the world also.

were small female figures in stone or clay — young women, mothers and old women — many with exaggerated hips or breasts and no doubt connected with the cult of a mother goddess which was still current in Anatolia in historical times.

49 Another important site in southern Anatolia is Hacilar, some miles to the west of Catal Hüyük. Similar figures, frequently steatopygous, have been found here, but the most interesting finds at Hacilar are of pottery dating from the 7th millennium. It is possible that this was the source of the art of pottery, which became widespread throughout the ancient Near East about 6000 BC, and, even if the pottery of the Zagros Mountains region in southern Iran was earlier, it seems certain that these two areas mastered the art independently. The ceramics of Mesopotamia were

undoubtedly derived from Iran, but Anatolia was probably the origin of Syrian pottery, as well as of that of the Balkan region.

By the second half of the 6th millennium BC the art had reached an advanced stage in Hacilar. Bulbous vessels with 50 double handles, and cups and shallow dishes are among the commonest types. The decoration is geometric — spirals, triangles, etc. — painted in red on a cream ground, or sometimes white on red.

EARLY IRANIAN POTTERY

Painted pottery of geometric design recovered from sites on the Iranian plateau and from Tell Hassuna in Mesopotamia has been ascribed to a date before 5000 BC. Its spread from east to west, as far eventually as Syria and Anatolia, can be traced and provides evidence of commercial relations over a considerable distance at that period. Soon after 5000 BC a new type of pottery appeared in Tepe Siyalk. Of a more sophisticated design, usually in geometric bands, it was similar to the pottery of the Samarra culture 51 in Mesopotamia. Of the latter not much is known; it may indeed have been of Iranian origin. Somewhat later, stylised, almost abstract animal figures make their appearance in Iran.

ELAM

From the second half of the 4th millennium BC the standard of civilisation was carried forward by Sumer, and adjacent regions to some extent reflected the art of southern Mesopotamia. At a time when Sumerian metalwork was well advanced, neighbouring areas were still Neolithic in culture, but this very cultural gap itself was the reason for certain original variations among the societies to the east.

Elam is the mountainous region immediately to the east of Mesopotamia. A state developed there during the 4th millennium BC with its capital at Susa, and in the 3rd millennium Elam was constantly in conflict with the Sumerians and Akkadians, sometimes dominated, sometimes dominating. Similar pottery, of the type known as Ubaid ware, was made at Susa and in Mesopotamia in the 4th millennium BC, although the Iranian examples are generally more elegant in their geometric decoration. Thereafter, constant interchange between the two regions is apparent, with Sumer usually the dominant influence. The early Elamites created their own distinctive pictographic script, which is not yet fully deciphered. In the course of time their descendants adopted the Sumerian cuneiform. Cylinder seals were also in use at an early period; in fact, it 52 has been suggested that they originated in Iran rather than Mesopotamia.

Although almost no traces of buildings have so far been discovered, some Elamite sculpture of the 3rd millennium BC has been unearthed. There are examples of the common type of small female figures in clay, with their breasts and buttocks of generous size, symbolising fecundity. Figures in stone, including one of an ape, recall Predynastic Sumerian sculpture, but more recent finds include works which bear

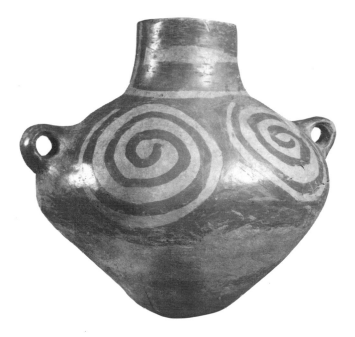

50 (above). **Terracotta jar from Hacilar.** End of the sixth millennium BC. h. 13⅜ in. (34 cm.). Archaeological Museum, Ankara. This jar is characteristic of the pottery of the late Hacilar period which was decorated in white on red or red on white. This example is painted with spirals.

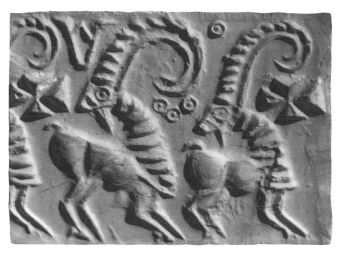

52. **Proto-Elamite cylinder seal impression.** End of the fourth millennium BC. British Museum, London. These stylised goats with long curving horns are designed in a frieze rather than confronted in the Mesopotamian manner. Proto-Elamite motifs were imitated in Mesopotamia.

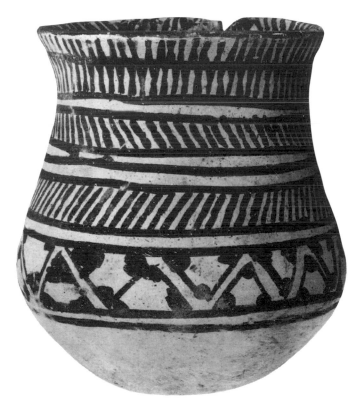

51. **Vase from Samarra.** Fired clay, painted. Staatliche Museen zu Berlin. The origins of the Samarra culture are still disputed, but it has affinities with the earliest painted pottery of the Iranian plateau. Named after a site on the Tigris, Samarra ware is found over a large area, even as far west as northern Syria. It is characterised by narrow bands filled with geometric ornament, and dates from about the first half of the fifth millennium BC. The culture of Samarra was preceded in northern Mesopotamia by that of Tell Hassuna, and was followed by the rich Tell Halaf culture.

little trace of Sumerian influence and suggest an interest in the grotesque which can also be discerned in some early Elamite seals. A vivid, rather grim imagination is at work here which is not evident in the quieter works of the Sumerians.

Painted pottery from 3rd-millennium Susa often employs stylised animal motifs, especially birds. There is no real counterpart in Mesopotamia, where vessels thus decorated are rare at this period, but neither is it similar to the pottery of eastern Iran.

The Akkadian invasions of Elam in the second half of the 3rd millennium BC resulted in greater Summerian influence — in effect straightforward imitation of Mesopotamian art. The figure of the triumphant king towering over his enemies, familiar in the stele of Naram-Sin, appears in Iran but, it is interesting to note, carved in the natural rock of a mountain. This was a form of art which was to become familiar in Iran thousands of years later. It occurs also in Hittite Anatolia, about the 14th century BC.

Sculpture in the round also followed the Sumerian example and in general Iranian art continued to be largely dependent on Mesopotamia until late in the 2nd millennium BC.

THE INDUS VALLEY

The valley of another great river, the Indus, provided the fertile soil in which the earliest Indian civilisation took root. The two main cities were Mohenjo Daro and Harappa, which are nearly 1000 miles apart, but there were many other towns, the majority of which have not yet been excavated. In fact serious excavation did not begin in the Indus Valley until 50 or 60 years ago (in Victorian times the buildings of Harappa were plundered by engineers building the Lahore–Karachi railway). This civilisation, which

53. **Head from Tell Brak.** *c.* 3000 BC. White alabaster. 7 in. (17·8 cm.). British Museum, London. One of the earliest known pieces of North Syrian sculpture, this head is boldly modelled and has a prominent nose and wide eyes—features also seen in contemporary metal figures from Tell el-Judeydeh. Like the famous 'Lady of Warka' (figure 11), the head is flat at the back and grooved for attachment to a flat surface. Nevertheless it is quite independent of the Sumerian tradition and marks the beginning of Syrian sculpture in the round.

lasted from roughly 2500 BC to 1500 BC, was recognisably 'Indian'. Some of the gods worshipped there are clearly the forerunners of the Hindu gods, and statues at Mohenjo Daro show, especially in details of clothing, headdresses, etc., a strong resemblance to Indian art of comparatively recent times.

The main cities were built of brick. They had formidable defensive walls and towers, and a large citadel. The streets were wide and followed the grid pattern — a very early example of this kind of town planning — and, although there are no vast monumental buildings on a Babylonian scale, the houses of the rich were solid and spacious. The pictographic script, still largely a mystery, is known through numerous seals, and the most attractive examples of Indus art that have been recovered in some numbers are the small sculptures of human figures and animals which have much of the 'feel' of the statues that centuries later adorned Hindu temples.

The prehistoric cultures of the Indus Valley had trade links with Sumer and there is plenty of evidence of the cultural influence of Mesopotamia and Iran. The building technique in mud bricks was presumably derived from the west, and decorative motifs on pottery also show obvious Iranian influence. These links were broken by the invasion of the Aryan peoples around 1500 BC which destroyed, though it did not obliterate, the civilisation of the Indus Valley. (See also page 67.)

THE BEGINNINGS OF CIVILISATION IN SYRIA

At the beginning of the Bronze Age there existed in Palestine a rich culture which is known from carved ivories and other evidence, but in general the region between the Mediterranean and the Euphrates valley was much less advanced in the 3rd millennium BC than the regions to east and west. For example, no form of writing had developed. Nevertheless, this was an area which offered tempting possibilities to both Mesopotamia and Egypt, whose more advanced cultures dominated the diffuse and disunited local cultures, although without submerging all native characteristics.

In the later centuries of the 3rd millennium many large towns were built. They were, however, destroyed around 2000 BC by the invasions of the Amorites, the founders of Babylon. There were periods of foreign rule, under Sargon and the Third Dynasty of Ur, which indicate both the weakness of local political organisation and the desirability of the region in the eyes of empire builders.

SCULPTURE

The most important surviving Syrian art from the period before the Amorite invasions is sculpture. Mesopotamian influence is generally dominant, but there is often a different spirit at work and, even at time when the links were especially close, the Syrian work manifests significant differences in style and execution.

The art of a city like Mari is especially interesting, because this city on the Euphrates was within the area of direct Mesopotamian influence. Statues from Mari have a certain earthiness, even humour, which is foreign to the Sumerian art of the period and may be classed as 'Syrian'. Reliefs at Tell Mardikh display advanced stylistic qualities, and the design of certain seals suggests the advanced state of this particular art in Syria in a later period. At Tell Brak in northern Syria, east of the Euphrates, there are some remarkable stone heads dating from the end of the 3rd millennium. These very early examples of sculpture in the round from this region have almost nothing in common with Sumerian models, but in spirit bear a certain resemblance to the well-known figures of the Cyclades.

ANATOLIA

Anatolia is a region of very complex patterns of culture and, although knowledge about it advances almost annually, the overall picture of the region in the 3rd millennium BC is still hard to grasp. The best-explored sites, at Troy in the

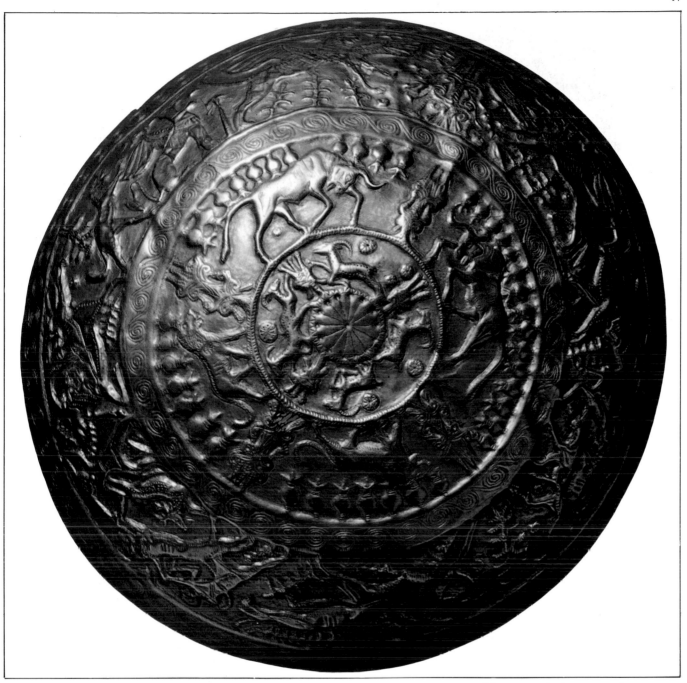

54. **Bowl from Ugarit** (modern Ras Shamra). 14th century BC. Gold. diameter 6¾ in. (17 cm.). Aleppo Museum. Egypt exercised a strong influence on Syria during the second millennium BC, and it is probable the Syrian metalworkers learned their fine technique from Egyptian craftsmen. This small repoussé bowl is decorated in concentric bands. In the outermost band, scenes of lion hunts are depicted together with winged mythical beasts. In the second band, two bulls and two lions are separated by stylised trees bearing pomegranates. Gazelles and goats surround the central rosette. Here a certain lack of sophistication is evident in the poor compositional balance.

north-west, Alaca Hüyük on the north-central plateau and Beycesultan east of Ephesus, all provide evidence of great cultural diversity in the Bronze Age. Thus the earliest culture at Troy is connected with the Balkan region, while contemporary evidence from Alaca Hüyük reflects an eastern — Iranian — orientation.

Artistically, the most remarkable finds come from Alaca Hüyük, where a series of royal tombs dating from between 2400 and 2100 BC have been discovered. The supposition that they were 'royal' results from the richness of the contents, which included large numbers of vessels and ornaments of gold and silver, battleaxes, gold-mounted

maces and several curious standards — poles mounted with bronze figures of bulls or deer inlaid and mounted with gold or silver. A gold-hilted dagger with an iron blade is one of the earliest examples of iron working.

The remarkable quality of the metalwork revealed in the tombs of Alaca Hüyük has never been fully explained. The aesthetic sense of those who made these objects was also remarkably advanced. It is assumed that these still very mysterious people had links with the Caucasus, a mining region, and were the direct predecessors of the Hittites (see below).

At Beycesultan have been found further examples of that

55. **Lion rhyton from Kültepe.** 18th century BC. Fired clay, painted. 7 in. (17·8 cm.). Louvre, Paris. This vessel, found at the Assyrian trading settlement of Kültepe, is an example of 'Cappadocian' ware. It was probably intended for a ritual libation ceremony and is decorated in black on a grey slip with lively patterns. The spout is at the back of the lion's open mouth.

stylised form of the human figure, in the form of marble 'idols', which is associated with the islands of the Cyclades. Thus, the three best-known sites in 3rd-millennium Anatolia, all show quite separate cultural connections, and have little in common with one another. More recent finds have tended, if anything, to make a complex picture still more complicated.

The Cycladic civilisation seems to have derived from Anatolia, and probably the famous civilisation of Minoan Crete was also indebted to this region, at least in its early stage. In a sense, the European cultures of the Bronze and Iron age all depended on Anatolian developments, and not the least important aspect of Anatolia was its role as a transmitter of culture to Europe via the Aegean.

The various peoples who over the course of time moved into Anatolia from the east tended on the whole to follow routes to the north of the Mesopotamian plain. This explains the connection, of which there is evidence as early as the 3rd millennium BC, between Anatolia, Iran and central Asia, especially southern Russia. This region was not only culturally fruitful itself but an important transmitter of influences across a great distance.

THE COMING OF THE HITTITES

Important changes were taking place in western Asia in the early centuries of the 2nd millennium BC. Sumerian culture remained dominant in southern Mesopotamia, southwestern Iran and, very largely, in Syria, but elsewhere in the region new and dynamic groups of people were appearing from the east and settling in areas where old cultures had formerly flourished. They included the Hur-

rians (also known later as the Mitanni, although the latter were actually their rulers), who reached the height of their power about the middle of the 2nd millennium BC and were soon afterwards conquered by the Hittites.

Another group was the Kassites, from central Iran, who possibly introduced the horse into the area when they settled in southern Mesopotamia.

The third main group, and probably the largest, was the Hittites themselves, a people who have given rise to more and stranger theories than almost any other, and who were builders of a great empire capable of challenging the long-established might of Egypt itself.

These new groups, who appear to have been numerically rather small, shared certain characteristics and were all associated with highland areas, hence the name sometimes given to them collectively of 'mountain peoples'. Unlike predecessors such as the Gutians and the Amorites, they had a dramatic effect on the areas in which they settled and, culturally, they were responsible for a change of direction, bringing a new unity to civilisation in western Asia.

ANATOLIA UNDER THE HITTITES

In 2000 BC there was no written language in Anatolia, and the origin of the Hittites has long been a subject of speculation and debate. The earliest written records are the archives of the Assyrian merchants who set up an important trading colony at Kanesh. From these notes Anatolia is revealed as a country of numerous city-states governed by native princes and peopled by a variety of different races speaking various languages, the Hittites among them. From this and other evidence it seems certain that there was no dramatic Hittite conquest of Anatolia. The Hittites probably entered the region in stages over a long period, slowly acquiring the ascendancy in certain areas and adopting many of the local beliefs and customs.

At this time (the beginning of the 2nd millennium BC) there was, for example, a form of pottery common throughout much of Anatolia called Alishar II ware (later known 58 as 'Cappadocian'), consisting of mainly slender vessels with geometric decoration and sometimes animal figures. Contemporary pottery in the form of animals belongs to a different, simpler culture, while at Beycesultan another style was current. It is clear that there was no cultural hegemony at this time.

There is a longish gap in the records until shortly after 1700 BC, at which time a Hittite kingdom had been established. The capital was at Hattusas, where archaeologists have been active since the early years of this century, although a full picture of the Old Kingdom of the Hittites has hardly yet emerged.

Between about 1450 and 1200 BC the Hittites achieved dominion over Anatolia and a large part of Syria. Although the artistic evidence for this period is less sparse, it is largely confined to three sites only, including Hattusas. Consequently Hittite art remains largely an assortment of examples, not a complete picture.

HITTITE BUILDING

The Hittites are remembered especially for their metal-work, notably their early, extensive use of iron, and for their architecture. They brought a new conception to architecture, which for them was not, as in earlier cultures, building decorated with reliefs and sculpture, but an artistic fusion of the two arts, the sculpture being part of the building.

Hittite monumental architecture is perhaps best studied in the mighty walls of Hattusas and Alaca Hüyük. They are built of enormous blocks of stone and display a thorough understanding of military requirements, with gates of a type well designed for defence. Reliefs on either side of the entrances are intended to repel evil spirits, while carved friezes, largely decorative in purpose, line the bases of the walls on either side of the gates. The subjects of the flanking reliefs include animals, lions and sphinxes (probably derived from Egypt) and a war god.

The idea of a gate guardian was probably derived from Mesopotamia, but nothing like these figures had been seen before in Mesopotamia or elsewhere. The lions of the famous Lion Gate at Hattusas are carved out of single, huge blocks of stone, and they appear to spring out at the observer. The relief is very high: the warrior god at Hattusas protrudes three-quarters of the way, so that in his face, portrayed in profile, both sides of his nose are carved.

This technique raised some technical problems and it is worth examining this warlike figure on the King's Gate (or Warrior Gate) in more detail. He is depicted with the head and lower part of the body in profile but the torso facing the front, a common convention throughout the ancient Near East and in Egypt as well as Asia. In his right hand he holds an axe, the handle of which crosses the point of transition from frontal to profile view. At that point the handle, clearly straight in real life, takes on a curve. If the artist had made it straight, it would have looked as though it were held upright, instead of at an angle of about 45 degrees. A similar problem is created by the short sword, worn at the waist. To cope with the transition from frontal to profile, it is made to curve outwards in what, it must be said, is a rather unnatural way. Had the natural, frontal view prevailed, the sword would have disappeared around the back of the figure, but seen in the lower plane, this would have suggested that it was worn in an unreachable position somewhere in line with the backbone!

This figure again, like the lions, carved in a monolith, is now in a museum, where one can no longer admire the skilful way in which it locks into the walls of masonry.

Another illustration of the way the Hittites used sculpture to enhance structure is provided by the reliefs of Yazilikaya, not far from Hattusas. They depict series of gods and animals with kings and religious symbols and, apart from their aesthetic interest, they have some documentary value, as do the reliefs forming a frieze on the lower walls at Alaca Hüyük, adjoining the Gate of the Sphinxes. These are low reliefs, with virtually no modelling other than the outlines of the figures, which are engaged in

56. **The Warrior Gate, Hattusas.** 14th century BC. h. 78¾ in. (200 cm.). Archaeological Museum, Ankara. The Warrior, or King's Gate guarded the eastern entrance to the Hittite capital city of Hattusas. The figure of a god protector, shown here from the front and from the side, is carved in high relief, projecting so far that the head is about three-quarters modelled. The curious mixture of profile and frontal view is disturbing in that it produces ambiguities, such as in the slanting of the battleaxe which appears to be bending inwards at the waist. The sculpture has now been removed to the Ankara Museum, and the skilful way it interlocked with the walls cannot be seen.

hunting and religious ceremonies. Details are indicated by incised lines only. As with the great sculptures of the guardian figures, it is possible to detect influences from Mesopotamia and Egypt, but the Hittite treatment is so original that derivations seem relatively unimportant. The Hittite reliefs are also significant precursors of later reliefs found in various North Syrian cities in the Neo-Hittite period.

MITANNI

The 15th century BC was a period of Hittite weakness, when their empire was beset by various hostile neighbours. However, during the first half of the 14th century the

57. **View of Persepolis from the Gate-House of Xerxes.** 518–460 BC. Entrance to the city was by a gate-house which was guarded on the inner side by a pair of human-headed bulls. In the middle foreground is the staircase leading to the audience hall of Darius I, the columns of which still stand. Beyond is the palace of Darius.

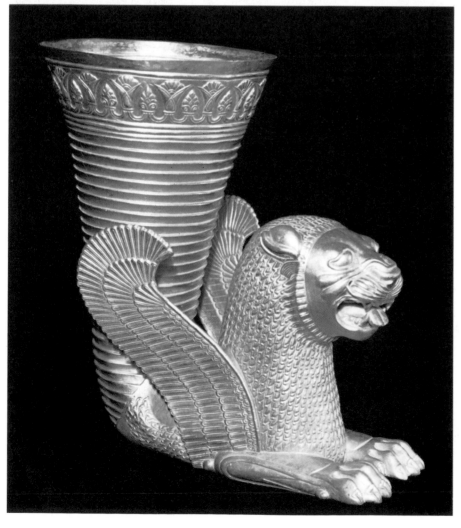

58. **Rhyton cup from an unlocated Achaemenian treasure.** 5th century BC. Gold. Archaeological Museum, Teheran. In all the Persian metalwork one notices a particular fondness for the animal form, and a skilful adaptation of the form for decorative uses. This exquisite winged-lion rhyton, discovered only in 1955, is one of the finest examples of Achaemenian metalwork.

59 (opposite). **Phoenician ivory from Nimrud.** Head of a woman, possibly Ishtar. Iraq Museum, Baghdad.

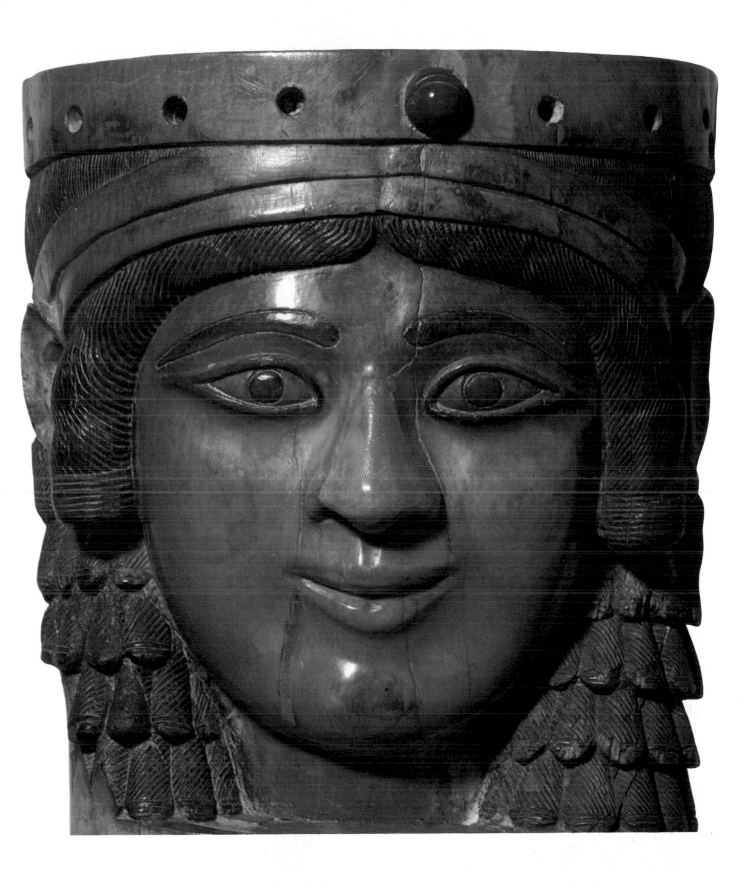

position was restored by King Suppiluliumas, who challenged the powerful Hurrian kingdom of Mittani, at that time dominating Syria.

The capital city of Mitanni has not yet been discovered, and little of the art of this kingdom is known. Nevertheless, it must have been an influence on Assyria, and this may account for the character of Assyrian art, as it appeared about the 14th century, in a form so different from Sumerian and Babylonian tradition.

What we know of Mitannian art comes chiefly from pottery and seals, and in pottery especially there are notable innovations. Hitherto, the predominant products had been monochrome wares, sometimes with geometric decoration, but in the Mitannian period in Syria a new type of pottery was produced — rather elegant vessels with decoration in white on a black ground. The motifs are sometimes geometric, sometimes stylised animal and plant forms, and are drawn from Anatolian and Syrian traditions, although some elements echo Aegean art. Minoan affinities seem to be present, but this is hard to explain in view of the gap of several centuries between the supposed Minoan models and the appearance of the Mitannian wares.

Mitannian seals are of the cylinder type traditional in Mesopotamia, unlike Hittite examples which are mainly stamp seals. The motifs include mythological animals, stylised plant forms, palmettes and spirals, as well as scenes like the destruction of the demon Humbaba which is known in Mesopotamia as early as the 3rd millennium BC. There are also surviving fragments of painting and clay figures of animals, but these meagre examples do not suggest a distinctive Mitannian style.

FALL OF THE HITTITE EMPIRE

Hittite hegemony over a large empire was almost constantly under attack, and in the 13th century BC a combination of enemies confronted the Hittite kings and overwhelmed them. The circumstances surrounding the actual fall of the Hittite empire are still a mystery. We know that towards the end of the 13th century most of the Hittite cities were sacked and burned, but there is some doubt about who was responsible. Assyrian records suggest it was the Phrygians, later to create an Anatolian empire of their own under King Midas. Egyptian sources blame the 'People of the Sea', who were later to cause such trouble to Egypt itself.

NEO-HITTITE CITIES

A number of small Hittite city-states continued to survive under Assyrian rule, building walls and palaces in the Hittite style, with sphinx-like gate guardians and wall friezes in low relief. The most important of these was 60 Carchemish, whose sculptured walls are among the greatest achievements of Neo-Hittite art. The 'Long Walls of Sculpture' at Carchemish, dating from the second half of the 10th century BC, depict figures of gods and warriors riding in chariots. Somewhat later examples — the chro-

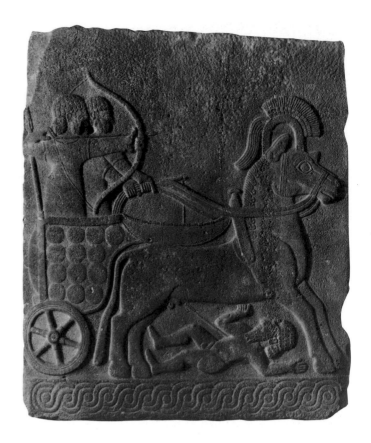

60. **Orthostat relief from Carchemish.** Beginning of the first millennium BC. Basalt. h. *c.* 69 in. (175 cm.). Archaeological Museum, Ankara. Carchemish was more closely associated with the Hittite Empire than any of the other North Syrian cities. The orthostat reliefs recall the Hittite ones from the point of view of technique. The subject matter, however, is new and was to be employed later by the Assyrians, who particularly favoured scenes with battle chariots.

nology is undecided — show gods in the form of monsters, and later still court scenes appear on the 'Royal Buttress' celebrating King Araras. They have the old Hittite fondness for figures emerging sharply from the background, which is also apparent in the treatment of inscriptions in the Hittite language. The characters are carved in relief rather than, as in other ancient scripts, simply incised.

Other north Syrian cities under Hittite influence produced similar works though of less distinction. The figures at Zincirli are lifeless and the faces have no individuality. 61 Those at Tell Halaf are much livelier, employing motifs 62 that can be traced back in Syria as far as the end of the 3rd millennium, but the treatment is less refined than at Carchemish and some of the figures in fact verge on the grotesque.

ELAMITE REVIVAL

Although, yet again, the evidence so far uncovered leaves many questions unanswered, it is clear that there was a great cultural revival, echoing the political advance, in western Iran during the second half of the 2nd millennium BC. Important architectural remains have been found at Dur-Untashi, near Susa, a city built by the Elamite king Untash-Khuban, in the 13th century BC. Archaeologists have found a sacred precinct with the remains of four small temples, but by far the most notable building is an

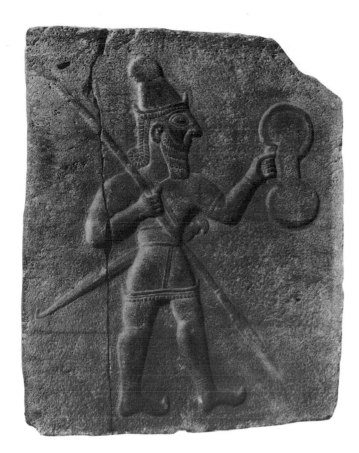

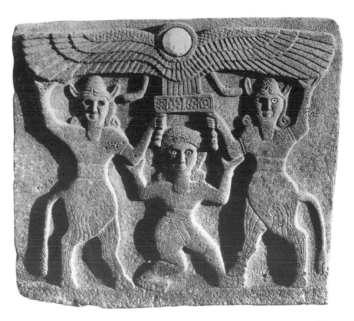

61. **Warrior from Zincirli.** *c.* 850 BC. Basalt. h. 56 in. (142 cm). Staatliche Museen zu Berlin. The sculptors at Zincirli included some deities among their reliefs. Here a warrior god is shown in Hittite dress, with tall hat, short kilt and pointed shoes. The relief is perhaps less successful than those found at Carchemish.

62. **Orthostat relief from Tell Halaf.** 9th century BC. Basalt. h. 36 in. (60 cm.). Aleppo Museum, Syria. The palace of Kaparu at Tell Halaf was elaborately decorated both with free-standing sculpture and orthostat reliefs. This detail shows three supporters of a winged sun disc, and recalls a motif common on Mitannian seals. The figure of the bull-man belongs to a Syrian tradition reaching back to the reliefs of Tell Mardikh at the end of the third millennium.

enormous, five-stage ziggurat, fairly well preserved and the easternmost example of this type of building. In structure it is different from Mesopotamian examples, however, lacking (for instance) the great external stairway. Instead, it possessed five internal staircases, three of which may still be seen.

Relief carvings at Susa of about this period display an affinity with the Kassite examples at Uruk, though spread over a wider surface. The inscriptions are incorporated in the composition in a way that shows an advance over earlier work.

A few bronze statues have also survived from 13th-century BC Elam, most notably a statue of Queen Napirasu from Susa, now in the Louvre, Paris. A life-size figure, it unfortunately lacks the head, yet still retains an impressive presence. It was cast in two stages — first an outer shell about $1\frac{1}{4}$ in. (3 cm.) thick, this being subsequently filled with metal. An inscription on the skirt identifies the subject as the wife of King Untash-Khuban, and there is a curse which promises retribution for any thief or vandal — in this case, apparently, not a wholly ineffective device for ensuring preservation.

This tradition of Elamite metalwork may have been responsible for the adoption of bronze (or gold) as the material for statues of the gods in Babylonia in the 1st millennium BC.

CONTINUING TRADITION IN SYRIA

Syrian art of the 2nd millennium BC continued the tradition established in the 3rd millennium, i.e. following Mesopotamian models, albeit with local variations. With the decline of Mesopotamian culture in the first half of the 2nd millennium, Syrian works were often superior to their models, and this is especially noticeable in Syrian seals of the period, which display great finesse. The destructive invasions of the Amorites about the end of the 2nd millennium had little effect on art. Having established themselves in those cities that were still habitable, the Amorites adopted the superior culture of the conquered peoples and, as in other periods of conflict, the artists and craftsmen continued much as they had done before but under new patrons.

SYRIAN ARCHITECTURE

The art form which, in general, is least affected by foreign influence is architecture, since it is by its very nature to some extent dependent both on the availability of materials and on local meteorological and topographical conditions.

With this in mind, the three buildings in Palestine belonging to the 3rd millennium BC — at Tel Gat, Ay and Megiddo respectively — are of special interest. A large courtyard fronts a room with piers at regular intervals. It is

63

54

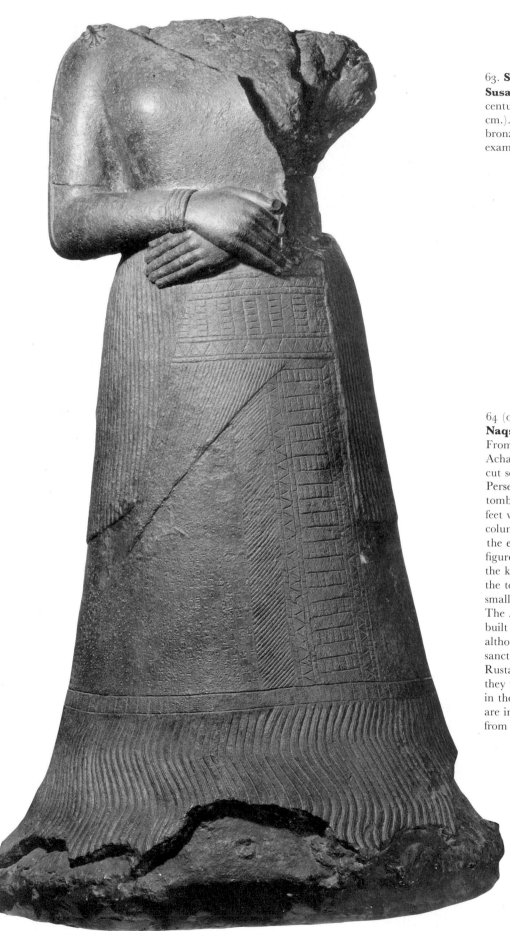

63. **Statue of Queen Napirasu from Susa.** Middle Elamite. Mid-13th century BC. Bronze. 4 ft. 2¾ in. (129 cm.). Louvre, Paris. This magnificent bronze statue is the finest surviving example of Elamite metalwork.

64 (opposite). **Achaemenian tomb at Naqsh-i-Rustam, near Persepolis.** From the time of Darius, all the Achaemenian kings were buried in rock-cut sepulchres at Naqsh-i-Rustam near Persepolis. This is one of four similar tombs. The façades, approximately sixty feet wide, are each faced with four columns, with a central doorway. Above the entrance is a frieze with two rows of figures. Surmounting this is the figure of the king standing before an altar. Near the tombs is a fire temple consisting of a small square tower with a single room. The Achaemenians are said not to have built imposing temples for public worship although several single-roomed sanctuaries survive, of which the Naqsh-i-Rustam fire temple is one. It seems that they worshipped their god Ahura Mazda in the open air, for the altars known to us are in the country, some distance away from city or shrine.

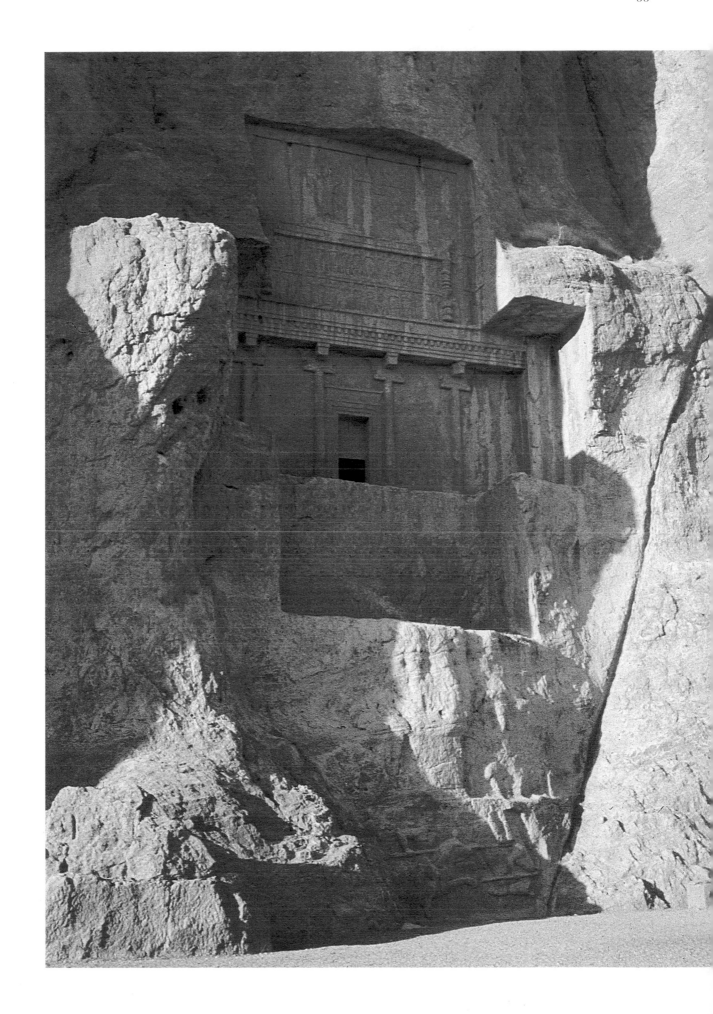

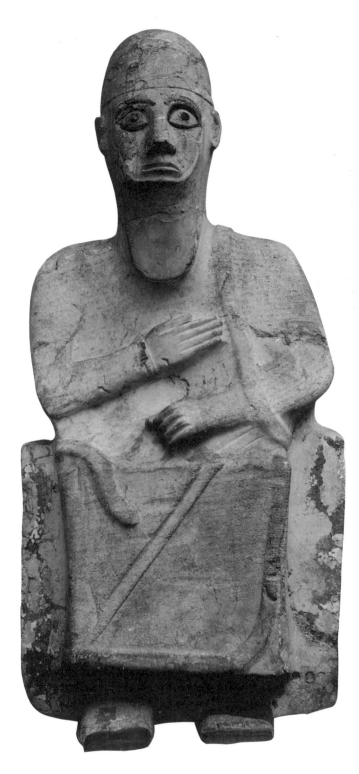

65. Idrimi, King of Alalakh. Middle Syrian. 15th century BC. Whitish stone figure, basalt throne. h. 41 in. (104 cm.). British Museum, London. This rather primitive-looking sculpture is principally of interest for the long inscription engraved upon it. The many vicissitudes of the king's career (including seven years of exile in Canaan) are enumerated, culminating in a successful expedition against the Hittites as a vassal of the Mitanni. The booty he collected enabled him to set up a court, where he reigned for thirty years.

a plan not so far discovered elsewhere and the purpose of the buildings is uncertain. At Alalakh on the coast, dating from about 2000 BC are the remains of a palace which has brick columns in the Mesopotamian manner and a temple of the Syrian type. However, it appears that the temple consisted of two sanctuaries at different levels, a plan not known anywhere else in western Asia.

Syrian architecture continued to maintain an independent tradition during the 2nd millennium BC. The palace at Alalakh, dating from the 18th century BC, is quite different from the roughly contemporary palace at Mari. Its main feature is the *hilani*, a spacious hall of audience with bands of relief sculpture adorning the lower walls.

Another palace was built at Alalakh about 300 years later. It is similar to the earlier building, but with certain differences, being more regular in plan, in fact almost square, with large, square rooms. It appears to represent an intermediate stage between the earlier palace and the fully developed *hilani* type which became general in the 1st millennium BC.

The architecture of temples also shows some variation on the basic scheme of courtyard plus cella and considerable originality. The temple at Byblos had three rooms leading out of each other, preceded by a great courtyard in which sat gigantic figures of gods and kings in stone. Later temples, more numerous, are also more varied. The temple at Alalakh resembles the Byblos building but has no preceding courtyard. A new type appears in Palestine, where the temple of Lachish consists of a square room with central piers opening into a small sanctuary situated at a slight angle, a plan probably deriving from Egypt, long dominant in this region.

SYRIAN SCULPTURE

During the 3rd millennium Syrian sculpture had generally followed the Sumerian tradition and, when it did show some originality, the work was usually of rather poor quality. In general, this is also true of the later period. The most distinguished work of 2nd-millennium Syrian art tends to belong to the Sumerian tradition. Seals are the prime example of this, often superior to their Mesopotamian prototypes. Insofar as a purely native figurative tradition was established, it produced works that are distinctly primitive by Mesopotamian standards. The well-known seated figure of Idrimi, king of Alalakh, is an example of this. It owes its fame not to any artistic distinction, though the head has a powerful impact, but rather to its inscription, which relates fascinating details about the king's changing fortunes during his long career.

In marked contrast to the Idrimi figure is another famous sculpture from Alalakh, believed to be the head of King Yarim-Lim and dating from some two centuries earlier. The technical confidence evident in this head is proof that a mature artistic tradition existed in Syria which had absorbed the technique of late Sumerian sculptors. Another highly effective head of about the same date comes from Jabbul. It is, however, quite different in style from the bust

of Yarim-Lim and, although more characteristically 'Syrian', suggests the influence of Egyptian statues. In general, the finest achievements of Syrian sculptors seem to have been made when they based their work on foreign models, even though they reworked those models in their own way. And, since court art, however non-slavishly, followed foreign example, it inhibited the development of a

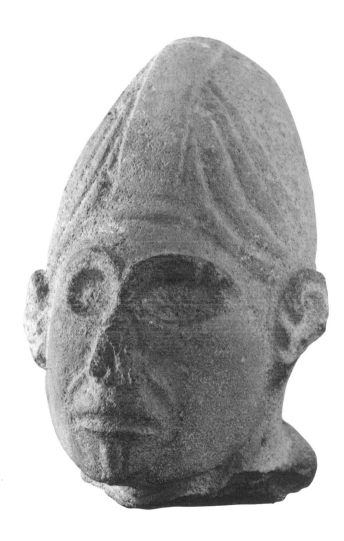

66. **Head of a deity from Jabbul.** *c.* 1800 BC. Basalt. h. 13⅜ in. (34 cm.). Louvre, Paris. This striking head, although generally Syrian in feeling, shows some Egyptian influence. Despite being damaged, the piece has unmistakeable force.

purely independent tradition at a higher level than the merely workmanlike, by humbler sculptors.

The importance of foreign influence is also shown in Syrian metalwork. Small figures of kings, etc., in bronze, with gold leaf hammered on, have charm but no sophistication, and show no real advance over similar figures made in the 3rd millennium BC. On the other hand, a gold bowl **54** from Ugarit (Ras Shamra), decorated in repoussé bands showing a lion hunt, bulls and mythical beasts and stylised trees, is, if a little unbalanced in composition, a very fine piece which would seem to belong to another culture altogether. Its quality is explained, probably, by the craftsman's knowledge of Egyptian technique.

Syria in the 2nd millennium BC also produced numbers of steles carved in low relief, in which the figures are clearly of Egyptian origin even if they are, for instance, Syrian gods. Egyptian influence on Syria and Palestine in the late 2nd millennium is also shown in the sarcophagus of King Ahiram, from Byblos. The scene carved in low relief on the sides shows the funeral feast of the king, as in similar Egyptian examples, and the decorative frieze above is based on the lotus-bud motif so popular in Egypt, though there is also a suggestion of later Hittite reliefs.

SYRIAN CARVING

The high quality of Syrian seals in the 2nd millennium has already been mentioned. The craft was an ancient one in the region, dating from the Chalcolithic period, but it reached its height during the 2nd millennium. As in other forms of Syrian art, there is much evident borrowing from other areas, but at the same time an original Syrian contribution is usually evident. Basically, Syrian seals are of the cylinder type originated by the Sumerians, and often the motifs are also Mesopotamian — for instance, the figure of a creature half bull and half man, which occurs in Syrian **67** seals, is known from Ur. The presence of a sphinx is the most obvious example of Egyptian influence, particularly strong in Ugarit. One also finds the 'pillar-of-life' motif which appears on Mitannian seals.

In spite of — or, in the case of ancient Syrian art perhaps because of — the varying sources of the motifs, Syrian seals of this period have their own character and achieve a unique artistic integrity. They have more feeling for composition and greater liveliness, especially in the poses of the figures, than contemporary Mesopotamian seals. A particular Syrian characteristic is the arrangement of the cylinder in registers which are divided by *guilloche* bands, rosettes and roundels.

Different centres produced different schools of design. Ugarit, for example, tended to adopt a more strictly linear approach, with fairly flat figures. In the south a more ornamental style developed, with animal motifs more common and delicately wrought arabesques.

In the later centuries of the 2nd millennium BC another, more ancient, type of carving acquired new life. This was ivory carving, a minor art with a rich future, which was

58

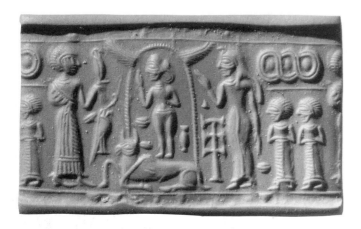

67. **Syrian cylinder seal impression.** British Museum,
London. Syrian cylinder seals, while borrowing motifs from
Egypt and Mesopotamia, achieved none the less an
individuality and high quality of carving which were all their
own. The nude fertility goddess, enclosed in what may be a
rainbow, is shown with a bull, the cult-animal of her associate,
the fertility and storm-god Adad.

stimulated by Egypt. As in seal carvings, Syrian craftsmen adopted Egyptian technique and motifs but added their own elements, especially a typically Syrian feeling for ornament.

Metalwork, too, especially in gold and silver, made a considerable advance at this time, the plate from Ugarit being a fine example of this art. Syrian metalwork and ivories, together with coloured glass, were to become famous in the 1st millennium BC and the subjects of widespread commerce.

SYRIAN DEVELOPMENTS AFTER 1200 BC

About 1200 BC life in western Asia was disturbed by the invasions of the 'People of the Sea'. One result was that the Egyptians were driven back to the Nile. The Hittite empire collapsed under this new onslaught (possibly from other causes also), and many of the Syrian cities, such as Ugarit, were sacked. A period of confusion followed in which new peoples like the Aramaeans and the Hebrews settled in Syria and Palestine, and the comparative unity of Syrian culture was destroyed, at least partially. The cohesive effect of the cities had disappeared, and the advent of new peoples broke up the country into smaller regions.

From this confusion, three main regions emerged, each culturally distinct. The most important of these was North Syria, where the older population of Hittite and Hurrian stock mingled with the Aramaean settlers in a number of eventually quite powerful and independent city-states. Here the traditions of the 2nd millennium BC were pre-

served through times of serious upheaval, and the rulers of the emergent city-states expended the fruits of their prosperity on patronage of the arts. In this region the old Mesopotamian tradition was severed, and the connection with the 'mountain peoples' of the east was more strongly marked.

The second main region, Phoenicia, also succeeded in maintaining much of the traditions of the 2nd millennium, but except on the coast the region was dominated by the culturally simple Aramaeans. The Phoenicians of the coast, though of the same racial background, were more advanced, and their strong links with Egypt meant that eventually Egyptian influence again became dominant in the arts.

The third region, Palestine, had been generally backward and dependent on Egypt, culturally as well as politically, but from this time onward became more closely linked with its northern neighbours, Phoenicia especially. Palestinian craftsmen tended merely to imitate Phoenician products, and these in turn were essentially commercial objects, designed for trade. Some of these objects are rich and splendid, but for artistic innovation and creativity, North Syria was the most promising of the three regions.

NORTH SYRIA

The early years of the 1st millennium BC saw the full development of that type of princely palace described as the *hilani*, the prototype of which has already been encountered in the palace of Yarim-Lim at Alalakh. The audience hall, which is the distinctive feature of these buildings, is wider than it is long and is preceded by a columned portico and a flight of steps. Examples of such buildings have been discovered at Tell Halaf, Tell Tayanat, Zincirli and other places. The columns of the portico were made of wood but stood on stone bases carved in the form of a pair of lions. The lower walls were decorated with bands of reliefs in the Hittite manner, though the subjects depicted are similar to those of Syrian seals in the 2nd millennium BC. This is even true of the reliefs in the Neo-Hittite cities themselves, such as Carchemish.

Ivory carving, as mentioned earlier, became an import- **49** ant minor art in the 1st millennium BC. Although more common in Phoenicia than North Syria, ivories from (probably) Hamal in North Syria can be distinguished from Phoenician products by greater variation of subject and stronger carving.

PHOENICIA

What evidence there is for Phoenician architecture is more literary than archaeological. Some idea of Phoenician temple building, for instance, can be gathered from the Biblical description of Solomon's temple in Jerusalem, which was built by Phoenician craftsmen. The three-room plan echoes earlier Syrian practice, and several minor palaces of this type have also been found in Palestine.

Phoenician sculpture is in equally short supply, partly as

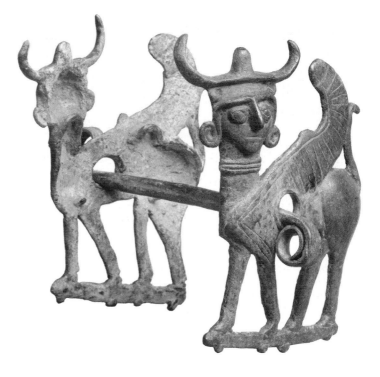

68. **Painted sherd from Ramat Rahel.** 7th century BC. 4⅞ in. (12·5 cm.). Fired clay. Department of Archaeology, the Hebrew University of Jerusalem. This pottery fragment represents an enthroned man. The work is probably Phoenician, although the inspiration is Assyrian. The subject, probably a king, is shown with arms outstretched and is perhaps receiving tribute. This, with a further fragment also from Ramat Rahel, is the only extant example of Syro-Palestinian painting of the early first millennium.

69. **Bronze ornament from Luristan.** *c.* 900 BC. h. 7 in. (17·8 cm). British Museum, London. The rich and varied collection of bronzes, usually horse trappings, which have been discovered in northern Luristan belonged to the tribes of mounted nomads from the plains of Central Asia. The piece illustrated is a horse's bit. Among other examples, ornamental standards are the best-known.

a result of the inhibition against portrayals of divine figures which was current in Palestine but spread also to Phoenicia. The Phoenicians produced, however, a variety of luxury goods for trade. Of their textiles nothing survives, but Phoenician coloured glass, ivories and metalwork, including silver cups and plates, have been retrieved from a wide area. Some of these pieces may well have been produced in other parts of the Near East, including North Syria, which seems likely to have been responsible for the better-quality metalwork. Syrian crafts were widely imitated about the 8th–7th centuries BC throughout the eastern Mediterranean area. Ivories, sometimes inlaid and painted, are the richest surviving category of Phoenician trade goods. They were used to decorate furniture and depicted both Egyptian and Syrian motifs.

IRAN

The renewed artistic vigour of Elam, evident about the 13th and 12th centuries BC, did not last long, as shifting populations carried the cultural centre farther east, but there was a remarkable development, shortly after this, in the region to the north of Elam — Luristan.

The famous Luristan bronzes have been found in tombs

throughout the region, their great numbers partly accounting for their fame. The commonest examples are horse trappings, such as bits and bridle pieces, although there are also weapons and purely decorative items as well as some vessels. They are the work of a horse-riding, nomadic people of mixed racial stock, connected with similar groups in south Russia. Motifs often reflect Mesopotamian tradition — for instance, the myth of Gilgamesh reappears in various forms. However, the most remarkable characteristic of Luristan bronzes is the air of fantasy, the indifference to naturalism they display, which is combined with an intense care for symmetry and composition.

THE PERSIAN EMPIRE

In the mid-6th century BC, after the confusion that followed the fall of the Hittite and Assyrian empires, the Achaemenian king Cyrus ruled over the Persians, but as a vassal of the king of the Medes. Median rule was resented by the Persians, who inhabited the high plateau of Iran, and Cyrus was the man who transformed them from a discontented vassal people into the rulers of what became the largest empire the world had seen. At its height it stretched from Libya in the west to India in the east.

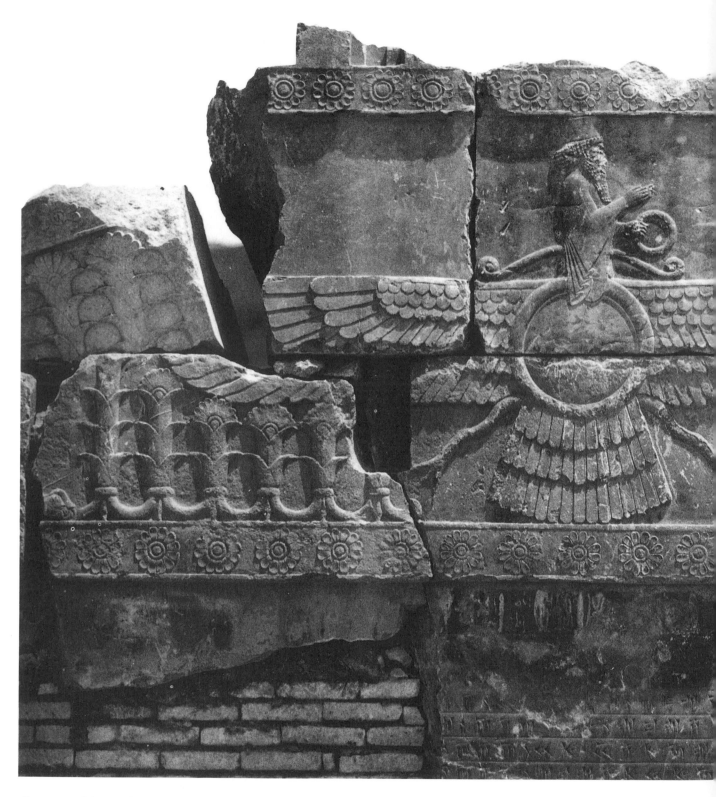

From one point of view the Persian empire appears as the last and greatest of the succession of imperial powers in western Asia, in which the whole experience of Middle Eastern civilisation since Predynastic Sumer was combined. Certainly, the empire founded by Cyrus the Great was the successor to those of Sargon, Hammurabi, and Nebuchadnezzar, but there were important differences. For one thing, the dynamic heart of civilisation no longer beat in Mesopotamia or in Iran but farther west, in the

Greek city of Athens. For another, the Persians were themselves culturally too different from their predecessors. Their religious and political ideas had little in common with the traditional spirit of west Asian civilisation. There was no great cultural synthesis under the Persian empire.

PERSIAN ART

Although developments begun in Cyrus's time outlasted the Persian empire that he founded, and continued, long

after the Hellenistic conquest, into Sassanian times, there
was no great surge of creativity. Though in its way unique
and remarkable for both monumental achievements and
stylistic refinement, Achaemenian art was, in the words of
Ugo Monneret de Villard, 'not an art that contained even
embryonically the outlines of a new and glorious future, but
the concluding episode of the age-old traditions of the
ancient Middle East. The burning of Persepolis by
Alexander's followers was not the holocaust of a living
culture, but the funeral pyre of a wraith.'

Perhaps 'wraith' is not quite the most suitable word for
the remains, even as they appear now, of the vast building
complexes of Susa and Persepolis. Standing on immense
platforms, these ruined palaces with their huge columned
halls and monolithic gate guardians still convey a powerful
impression of the might of empire. The Achaemenian god
Ahura Mazda bestrides the sun disc (in the Assyrian *70*
manner) and, lining the stairways, row upon row of figures *71*
bear tribute to the divine monarch. Battles with monsters
present the king as the conqueror of evil, a version of the old
Assyrian theme of the king, representing good, who slays
the lion, representing evil. In Persian, unlike Assyrian,
reliefs, the figure of the king is shown larger than others,
yet, clearly, the Persian reliefs owe much to Assyrian
eminence in that form. The workmanship, however, is
Greek, as an inscription at Persepolis confirms. The vast
halls with their orderly forests of columns are of Egyptian
inspiration, although the capitals, formed from the front
half of animal figures (most commonly bulls), are derived *73*
from old Sumerian and Elamite tradition. Sometimes
Assyrian and Egyptian influences are unexpectedly com-
bined, as in the winged genius of Pasargadae.

The old Iranian tradition of reliefs carved in the natural
rock finds expression in the royal tombs of Naqsh-i Rustam, **64**
but here there is a more advanced conception of space and
proportion. This extremely attractive aspect of Ach-
aemenian art was to be taken further in Sassanian times.

Among other artistic survivals of the Persian empire,
perhaps the most distinguished are metalwork. A surprising **58,** *72*
number of precious objects — gold and silver — have
escaped melting down, and they display both highly skilled
technique and a very 'Persian' delight in ornament for its
own sake.

SYRIA: THE RESULTS OF CONQUEST

As we have seen, the art of the city-states of Syria was
essentially a court art, and thus vulnerable to political
changes. When Syria (and Palestine) were conquered by
the Assyrians and later by the New Babylonians, many
cities were destroyed and populations were forcibly moved
(the Israelites being perhaps the best-known example).
These upheavals resulted in the virtual destruction of
native Syrian art. Even in places where the population
survived, the disappearance of the cities meant that art had
no function, and in any case the economic distress which
ensued scarcely permitted the practice of any but the most
basic crafts.

70. **Relief of Ahura Mazda at Persepolis.** 5th century BC.
This relief of the Achaemenian god Ahura Mazda shows him
riding a winged sun-disc, like the Assyrian god, Assur. The
motif also occurs at Naqsh-i-Rustam and elsewhere. But while
the iconography is Persian (with Assyrian precedents) the
carving was undertaken by Ionian craftsmen.

With the gradual return of stability under the Persian empire, the situation improved, but the intervening period had lasted too long for local traditions to survive. As artistic tradition was re-established, it took on the themes and styles of more powerful cultures — Hellenistic and Persian. Although Syria never became completely Hellenised, there was virtually no characteristically 'Syrian' art during the 1st millennium BC.

71. **Syrian tribute bearers.** Relief from the stairway of the Tripylon or Council Hall at Persepolis. 5th century BC. The ruins of the huge palace at Persepolis are still impressive. The magnificent stairway to the Tripylon is decorated with friezes showing tributaries from many parts of the Empire. Here Syrian emissaries are depicted bringing objects of precious metal—vases, bowls and armlets—to the king.

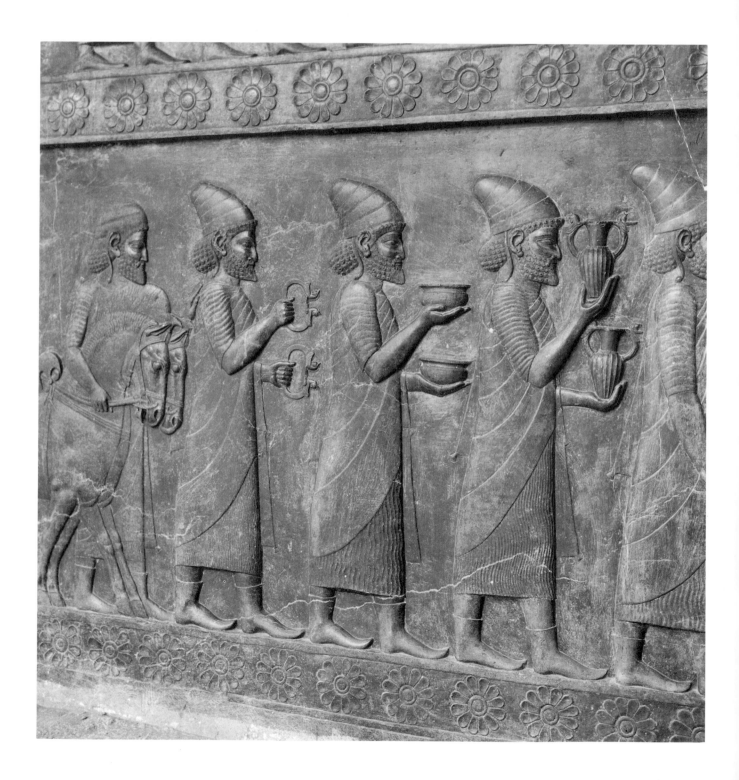

PHOENICIA

The cities of Phoenicia were more fortunate. Although native traditions were suffocated there too, the important commercial and maritime functions of the Phoenicians were only temporarily interrupted. The Achaemenian kings encouraged them, since they needed a Mediterranean naval presence and a link by sea with their Egyptian province.

Commercial and cultural revival was rapid. Nevertheless, artistic tradition had been disrupted, and the Phoenicians also looked to other cultures. They adopted some Persian motifs, but the integration of Egypt within the Persian empire, and the constant passage of men, goods and ideas between Asia and Africa through the Phoenician ports, encouraged the revival of an older tradition — that of reliance on Egypt itself.

The revival of Egyptian influence in the region from about the 6th century BC is evident in architecture, which had previously followed North Syrian models. The Phoenician sanctuary at Marathos, for example, follows the design of a typical Egyptian shrine. The Phoenicians also adopted the Egyptian practice of burial within a sarcophagus which reproduces the form and appearance of the body inside.

Towards the end of the 1st millennium, Hellenistic influence became steadily stronger, but there is always evident in Phoenicia — indeed in Syria generally — the persistence of west Asian ideas. Even in the apparently most Hellenistic of works, an eastern affinity is often observable. The famous Roman temples of Syria, in one aspect the most emphatically Hellenistic of buildings, nevertheless preserve a trace of west Asian traditions, partly no doubt the result of anti-Greek feeling in Asia. Even where style, motif and function are most obviously 'Greek', the end result bears in one way or another the mark of the far older traditions of Mesopotamia and Syria.

72. **Armlet from the Oxus treasure.** 5th century BC. Actual size. Gold. h. 5 in. (12·3 cm.). British Museum, London. This armlet would originally have been encrusted with precious stones. It displays two confronted griffins—a favourite Persian motif—and is a triumph of the metalworker's art. Similar armlets are being offered by the tribute bearers of figure 71.

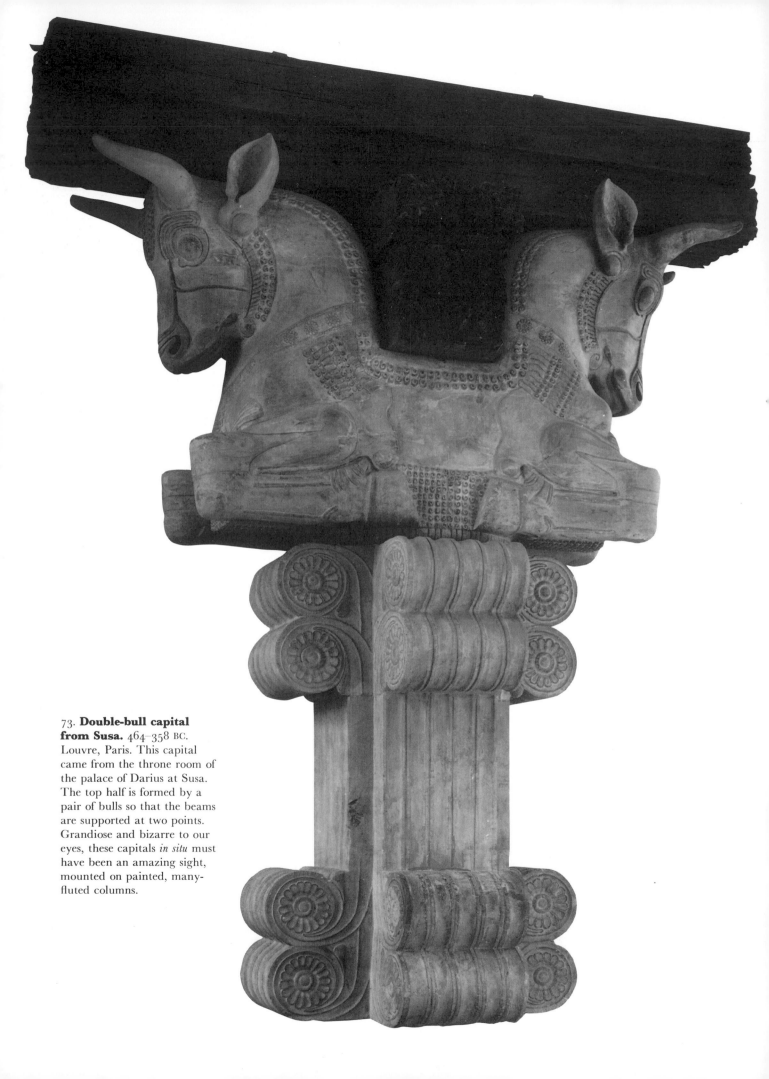

73. **Double-bull capital from Susa.** 464–358 BC. Louvre, Paris. This capital came from the throne room of the palace of Darius at Susa. The top half is formed by a pair of bulls so that the beams are supported at two points. Grandiose and bizarre to our eyes, these capitals *in situ* must have been an amazing sight, mounted on painted, many-fluted columns.

THE
ORIENTAL WORLD
INDIA AND
SOUTH-EAST ASIA

Introduction

The numbers in the margins refer to the illustrations to The Oriental World: *heavy type for colour plates, italics for black and white illustrations.*

In spite of redoubtable natural defences, India was subject to invasions via the north-west frontier, which penetrated the north-west and centre, driving the original inhabitants further south. Aryan invaders from the Iranian plateau destroyed the ancient civilisation of the Indus valley about 1500 BC and settled between the Indus and Ganges. They brought the Sanskrit language, the Vedic religion and other elements of Indian culture. Nearly one thousand years later, the north-west became part of the Persian empire, the fall of which to Alexander the Great brought some Greek influence to that region.

Merchants also used the mountain passes. From the 3rd millennium BC there were commercial contacts between the Indus valley and Mesopotamia, and by about the 1st century BC ships sailed regularly between Egypt and India via the Red Sea. Trade soon extended farther, Indian fleets sailing as far as Borneo in the 5th century. Merchants and immigrants spread Indian influence over a wide area.

About the 3rd century BC Iranian influence increased as a result of the attacks of the Sassanians, which resulted in the isolation of India from the Mediterranean world and eastern Asia. India was first united under a national dynasty, the Gupta, in the 5th century. Finally, about 1000, Muslim forces reached the Indus valley and spread steadily eastward.

RELIGION

In ancient India religion was the basis of the social structure. The earliest known religious texts are those of the Veda. The central object of the Vedic religion was sacrifice, and the gods personified natural phenomena — fire, water, sky, etc. They apparently derived from the same origin as the Iranian Avesta. The universe was divided into three zones; heaven was the world of pious action, and hell was reserved for evildoers.

Brahmanism, the most 'Indian' of all religions, arose from commentaries on the Veda. Service replaced sacrifice, and the concept of the individual soul assumed central importance. The basis of the new religion was the identification of the individual soul with the universal Self. Obedience to a strict code made Brahmanism, essentially a religion of the elite, also the source of social order and hierarchy.

In the 6th century BC two new religions were born in reaction to the inflexible Brahmins. One was Jainism, based on ascetism and *ahimsā* (non-violence). The other was Buddhism, destined to have a future of the utmost importance throughout Asia. The Buddha ('Enlightened One') preached charity to all creatures, the equality of all beings and the practice of moderation in all things. He rejected the caste system but retained the doctrine of transmigration of the soul and recognised the Brahmanic pantheon, so that someone could adopt the Buddhist rule without renouncing religious beliefs. Buddhism was essentially an ethical system, with a powerful missionary element.

Brahmanism underwent changes, becoming more theistic and developing a heroic tradition, manifest in the great epics (*Ramayana, Mahābhārata*), while Buddhist teaching took a more mystical turn. A split between the 'orthodox' Theravada and the 'Great Vehicle,' Mahāyāna, which offered the worship of bodhisattvas ('saints'), took place in the 2nd century, and a synthesis of Buddhism and Brahmanism resulted in the proliferation of sects.

A slow but steady evolution led Indian religion from polytheism to mystical pantheism. Numerous examples can be cited to prove both the diversification of the One with its implicit contradictions, and the chanelling of the Many towards the One, in which all contradictions are ultimately resolved.

ART AS THE REFLECTION OF CIVILISATION

Art expresses Indian civilisation which, essentially conservative, is unique in possessing a continuous cultural evolution from prehistory to the present. In spite of a notorious lack of chronological landmarks, the development of Indian art can be reconstructed quite coherently. It evolved slowly, by a process of accumulation, juxtaposing old and new, in a manner perhaps reflecting both the tempo of rural life and the conservative influence wielded by the Brahmins. Among the fluctuations of taste and fashion, a line of development can be traced for a period of more than two thousand years until, through too rigorous respect for the rules, it culminated eventually in decadence.

Conscious aesthetic intent cannot be incontrovertibly identified until the Maurya dynasty, about 300 BC. At first, under Asoka, it seems to have been primarily imperial rather than religious in character. Later, it became particularly identified with Buddhism, until the time came when it reflected both the complexity and solidarity of Indian civilisation.

Indian architecture is essentially religious. The temple is conceived as a model of the universe, itself a reflection of the mundane world, and every architectural work is infused with religious symbolism.

Sculpture, which occupies an essential place in Indian art, illustrates aspects of both religious and everyday life, in a style usually somewhat idealised. The sculptor had to follow rigid iconographical canons, but he was able to transcend these limitations and produce masterly works of art. Throughout its entire development, Indian sculpture was an expression of the artist's feeling for the beauty of the human figure and his need to glorify it.

Painting also reflected ritual, and had an important place in social life from early times. It formed part of the education of the upper classes but also had descriptive and didactic functions. Only fragments of the ancient mural paintings have survived, and no panel paintings from earlier than about 1100. Nevertheless, painting is one of the finest manifestations of Indian art.

Prehistory, Protohistory and Early History

The existence of man in India in the palaeolithic period (the Son 'culture') is attested by tools of the Chelleo-Acheulean type, generally made from quarzite. They are similar in form to those that we know in Europe—from the the Acheulean axe of an elongated almond shape, to the pointed implement sharpened only along the edges and left rough at the handle. Some of the pieces are elliptical, others circular.

The neolithic culture is characterised by tools made from carved or polished silex, remarkable for their variety of form and similar in every way to those of western Asia or Europe.

In the northern regions, a new influx of populations introduced an industry based on pure copper. This is represented by a large number of objects: flat celts, spear-heads, daggers, swords, axes, arrow-tips, bracelets. A whole series of 'civilisations' flourished, particularly in Baluchistan. They seem to have provided a link between those of Iran and those of western Asia and India itself, where, in the third and second millennia, there emerged the highly developed Indus valley civilisation.

THE GREAT PROTOHISTORIC CITIES

The Indus valley civilisation is so called because the first two sites to be explored, Harappā in the Punjāb and Mohenjo-daro in Sind, are situated in the valley of the Indus. Later excavations have revealed nearly a hundred sites of the same type. Harappā and Mohenjo-daro are nonetheless typical of this period. Although separated from each other by some three hundred and seventy miles, they are similar in their stratigraphy. They mark the beginning of Indian protohistory, for a great many inscribed seals were discovered there which, unfortunately, have so far remained undeciphered. Their town planning was elaborate and seems to have been the work of experienced architects. The towns' foundations were built with unbaked bricks while baked bricks were employed for the buildings themselves. The streets intersected at right angles and were bordered by houses, most of which had a well and many a bathing pool: The wells and baths were supplied with water channelled from the nearby river; there was also an efficient drainage system.

The remains of quays seem to indicate that these towns practised river trading. They were defended by a fortified citadel and, in addition, comprised public buildings with colonnades, a bathing establishment, large residential buildings, a craftsmen's quarter, flour mills, public ovens, collective granaries and cemeteries. The articles and tools that have been found there are of a wide variety of materials: gold, silver, copper, brass, steatite, semi-precious stones, bone, ivory and shell. The pottery, which was turned on the wheel, is often painted. Some of these articles have definite aesthetic qualities: a male bust, hieratic and stylised, with Semitic features, wearing a garment decorated with trefoil motifs; stone figurines in subtle relief, which remind one of ancient Greek art; brass statuettes that are

very Indian in feeling; striking silhouettes of animals. The numerous carvings which have been found also display an advanced technique in the portrayal of animals; they are shown in profile, which already anticipates the naturalism that Indian art was later to develop with such mastery.

That relations existed between this Indus valley civilisation and Mesopotamia is shown by the finds of steatite seals, identical with those of the Indus valley, at various sites in Mesopotamia, while a Sumerian seal has been found at Mohenjo-daro.

THE END OF PROTOHISTORY

In the Deccan, however, the neolithic phase lasted until about the 2nd century BC; it is characterised by a large number of megalithic tombs and by red and black pottery.

Comparison between Indus valley and later sites reveals a distinct deterioration, from the point of view of both town planning and culture generally. Most of the buildings were constructed in perishable materials. But stone was not

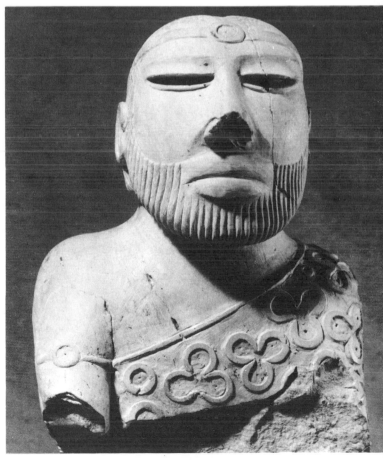

1. **Bust of a man from Mohenjo-daro.** 3rd millennium BC. Steatite. h. 6¾ in. (17 cm.) National Museum of Pakistan, Karachi. This bust of a bearded man belongs to the Indus valley civilisation. It has undoubted aesthetic quality and recalls the art of Mesopotamia. The treatment is stylised, the features Semitic. The detail of his headdress and garment are carefully observed: a headband ornamented with a single circular jewel, and a robe decorated with a raised trefoil motif.

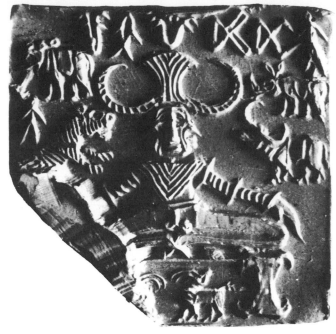
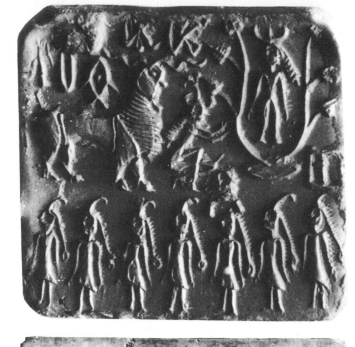
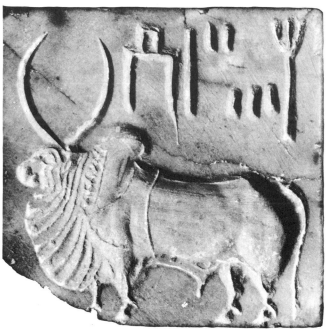

2a, b, c, d. **Seal impressions from Harappā.** Third to second millennia BC. Museum of Central Asiatic Antiquities, New Delhi. Finds from the Indus valley include many steatite seals like these. Most of them show animals in profile. Others suggest the existence of a pre-Sivaite cult, but since the characters cannot yet be deciphered this remains hypothetical.

entirely absent for parts of the enormous wall that defended the town of Rājagriha have been found. There is, however, no sign of any artistic activity. The art of this period is of a popular, domestic kind and consists mainly of terracotta effigies of human figures or animals, probably used in fertility cults.

EARLY HISTORY

The movement of the Aryans towards the east of the Ganges plain in about 800 BC shifted the centre of gravity of the conquered lands to the region between the Ganges and its tributary, the Jumna—a rich area which was to be a cause of dispute throughout the history of India. The establishment of Aryan kingdoms continued steadily. India was soon to look like a mosaic of states of different sizes, some of which tried to dominate others. Magadha (southern Bihār) ruled over the whole of the Ganges valley in the 6th and 5th

centuries BC and was the true political and religious cradle of ancient India. Its kings were converted to Buddhism by the Buddha himself and are known for their role in Buddhist literature.

At this time, north-western India, which had been conquered by Achaemenian Iran and turned into satrapies, was strongly marked by Persian influences, traces of which were to persist in a number of fields: administration, a metric system, writing and, above all, architecture.

THE MAURYA DYNASTY

Towards the end of the 4th century BC, the Nanda dynasty was reigning in Magadha; from them perhaps sprang the Maurya who, in about 320, succeeded in founding the founding the first pan-Indian empire. A young Magadha general, Chandragupta, known to the Greeks as Sandrakottos, revolted against his sovereign just as Alexander the

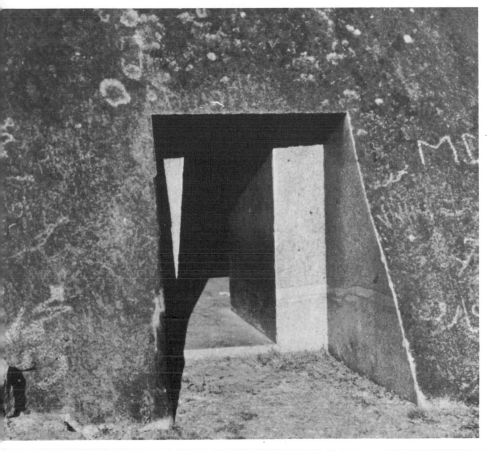

3. **Cave sanctuary in the Barabār Hills.** 3rd century BC. The caves cut into the hillside of Barabār constitute the most ancient sanctuary that has come down to us. Situated near Bodh Gayā, in Bihār, some of the caves bear inscriptions dating from the Maurya period. The plan, which combines rectangles and circles, is quite unusual.

Great of Macedonia was reaching the banks of the Indus—and, according to Plutarch (*Alex.*, LXII), solicited the help of the Greek conqueror. For various reasons, Alexander, who had had to confront the imposing army of Poros, an Indian sovereign who probably reigned in the Punjāb, was unable to accede to the request. Chandragupta was to play a very considerable role in the destiny of India. In about 313–12, he came to the throne of Magadha, overthrowing the Nanda dynasty and inaugurating that of the Maurya. His empire soon stretched from the Indus to the Ganges. The administration seems to have been efficient; it was supervised by imperial inspectors and facilitated by the good state of the roads. Seleucus, satrap and conqueror of Babylon, founder of the kingdom and dynasty of the Seleucids, sought an alliance with Chandragupta when he arrived in the Punjāb, in the footsteps of Alexander, in about 305. Seleucus left the territories beyond the Indus to Chandragupta and even gave him the hand of a Greek princess in marriage. It was then that India emerged as one of the great world powers. Megasthenes, Seleucus's ambassador at the Maurya court, left in his *Indika* a very interesting description of their capital, Pātaliputra, a large and beautiful city, situated at the confluence of the Ganges and one of its tributaries, the Son. It was over nine miles long and nearly two miles wide, and the public buildings, the palace (inspired, it is said, by that of Darius at Persepolis) and the great city walls, were made of wood. The

abundant forests, which at that time covered a far larger area than today, and the relative scarcity of quarriable stone probably explain this use of wood.

Of the reign of Bindusāra, Chandragupta's son, very little is known, but it appears that he conquered central India and a large part of the Deccan. The Maurya dynasty reached the height of its power with Bindusāra's son, the famous Emperor Asoka (*c.* 264–27 BC), who is known above all for the edicts that he had engraved in public places throughout his territory and which reveal a high moral tone and a strong personality. He seized power in about 264 BC and after his bloody conquest of Kalinga (which stretched from the delta of the Godavari to that of the Mahanadi), he experienced a spiritual crisis and was converted to Buddhism. This conversion was to have incalculable repercussions for India. In his hands, Buddhism became a powerful civilising influence; with his encouragement it spread to Kashmir, to the Hellenised territories and even as far as Ceylon. He constantly made pilgrimages to the Buddhist holy places. Yet his zeal did not prevent him from recommending religious toleration; indeed, he sometimes favoured sects other than his own. On two occasions, he gave several rock sanctuaries situated in the Barabār hills to the non-Buddhist sect of the Ājīvikas. His empire comprised the whole of north and north-west India and extended as far as the country of the Āndhras (the lower valleys of the Godavari and the Kistna). He was on

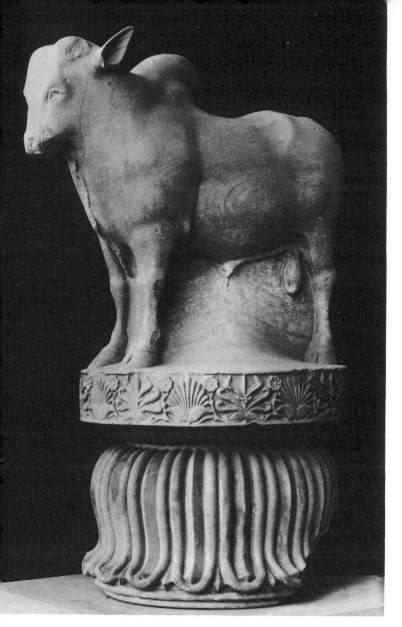

4 (left). **Capital from Rāmpurva.** Maurya period. Polished sandstone. h. 6 ft. 6 in. (2 m.). Indian Museum, Calcutta. This capital surmounted one of the columns on the shaft of which the Emperor Asoka ordained that moral codes should be inscribed. Such columns which combine imperial and cosmological symbolism recall those of Persepolis with their bell shape and polished surface.

5 (above). **Mother goddess.** Maurya period, c. 3rd century BC. Terracotta. h. 9 in. (23 cm.). Archaeological Museum, Mathurā. This statuette is particularly typical of the ancient period of Indian art. It belongs to a long series of examples which cover a considerable period of time. They were probably connected with fertility rites which played an important part in the early rural and agrarian life of India.

diplomatic terms with Syria, Cyrenaica, Egypt, Macedonia, Epirus and Corinth.

THE APPEARANCE OF MONUMENTAL ART

It was in the reign of Asoka that true sculpture sprang into life, using, apparently for the first time, durable materials. The impetus thus given to the production of works of art in India was to last for many centuries; moreover Maurya art contained within itself the essence of the styles that followed. Several quarries, particularly that of Chūnar, near Banāras, were developed. It was these that supplied stone for the commemorative columns, sometimes 42 feet high, that were scattered throughout his empire. The shafts of these columns were crowned with bell-shaped capitals based on those of Persepolis and surmounted by one or several animals joined together: the foreparts of a bull, lions etc. The style of these sculptures is close to that of Hellenistic Iran. It seems evident that the sculptors of this period learned a great deal from Irano-Parthian and Greek artists, while retaining nevertheless a pronounced Indian feeling. Apart from monumental sculpture, small, terracotta figurines have been found.

The artificial caves built as sanctuaries and as living quarters for monks were excavated mainly in the Barabār hills (Bihār). They reproduced in minute detail the rec-

tangular or circular buildings, with wooden walls and thatched roofs that must have existed at that period. The walls and columns of the sanctuaries were carefully polished. This polishing seems to have been peculiar to the Maurya period, and it has been suggested that it was achieved by burnishing the stone surfaces with agate. The cave that bears the modern name of Sudāma is rectangular in plain; its interior measures about 33 feet by 18 feet wide, with a semi-circular recess at the back measuring 18 feet in diameter and 5 feet 6 inches high. The walls are scratched in imitation of real timbers, and surmounted by a hemispherical, thatch-like roof. It is a replica in stone of a double building comprising a rectangular construction (or an enclosure of that shape) and a circular hut, placed at the end of this enclosure, which served as the sanctuary.

Brick and wood were not abandoned for open-air constructions, as is confirmed by the fragments of Asoka's palace at Pātaliputra. These remains testify to a remarkable technical accomplishment—the teak platforms, for example, were thirty feet long and composed of beams that were adjusted with the greatest precision and care. An examination of the exterior walls of the temple at Bairāt, ascribed to the 3rd century BC, shows that the bricks of the period were large, about 19 inches by 12 inches, but only 2 inches thick.

Ancient Schools
and Transitional Styles

HISTORY

After the death of Asoka, the Maurya empire gradually broke up; the centre of power moved westwards and was concentrated on Malwa and Magadha under the dynasty of the Sungas (c. 176–64 BC), then under that of the Kānvas (c. 75–30 BC). For about a hundred years—the duration of their supremacy—events occurred in the north-west that were to have a profound effect on the future of India. Indo-Greek kingdoms were founded in Bactria, Gandhāra and Kapisa. One of the kings of Bactria, Demetrius, undertook the conquest of India in about 189 and reached as far as Pātaliputra. His successor, Menander, celebrated in Buddhist tradition for the 'Questions' he asked the master Nāgasena, retained a kingdom in the Punjāb. It was the Sungas who drove the Indo-Greeks beyond the Indus. In about 80 BC, the Greek kingdom of Bactria fell under the attacks of semi-nomads who had been driven from central Asia by the advance of the Huns from Mongolia. The Greek influence was followed by that of the Scytho-Parthians, nomadic peoples from central Asia much influenced by Iran. Confronted by these invasions, the Sunga kings, who were already being threatened by the growing power of the Āndhras in the Deccan, were unable to maintain the unity of the India of the Ganges and it soon fell back into the political disunity from which the Maurya had saved it.

This period, so complicated in its political environment, was nevertheless one of the most fruitful in the field of sculpture. It saw the establishment of the great styles of Indian art, the creation and gradual development of the Buddhist iconography and the fusion of foreign influences with Indian elements into an artistic whole. Although the works of this period are exclusively Buddhist, they are above all typically Indian. Buddhism gives them their grace and smiling gentleness, but they are also a faithful expression of the life and temperament of the Indian peoples.

ART, ARCHITECTURE AND SCULPTURE

Both categories of Indian architecture are represented in this period: monolithic, rock-cut buildings and free-standing constructions. It seems likely that the basic principles of rock-cut architecture were laid down by Brahmanism (Barabār) and by Jainism (Udayagiri and Khandagiri in Orissā), but it was the fact that it was Buddhist that explains its magnificent development and that provided it with an artistic character quite unknown to the other two religions. The monasteries (vihāra) consist basically of cells and one or more fairly small chapels. The sanctuaries, such as that at Bhājā (in the Western Ghats), have a basili- 6 cal ground-plan, with a central nave and two half side-

6. **Façade of the chaitya at Bhājā.** c. 1st century BC. This sanctuary is a faithful reproduction in stone of the wooden structures which are represented on the reliefs of the period.

The façade is broken by a large horseshoe-shaped bay, and the sanctuary is apsidal in plan.

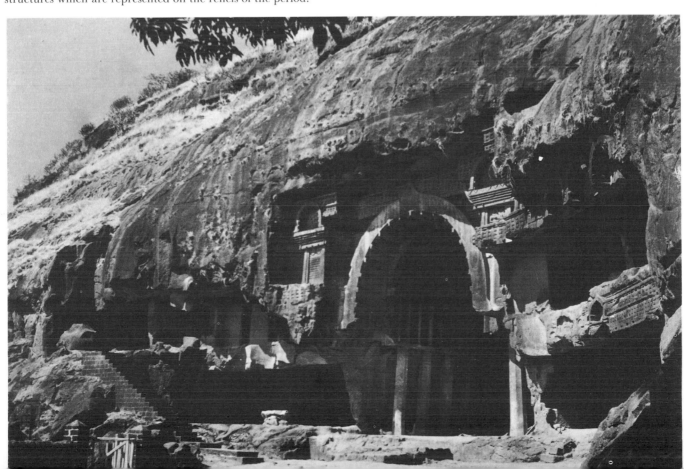

7. **Detail of a balustrade from Bhārhut.** *c.* 2nd century BC. Sandstone. Indian Museum, Calcutta. This detail from one of the upright supports to the balustrade at Bhārhut is carved with a *Yakshinī* or female tree spirit *(salabhañjika)*. Her left arm encircles the trunk of the tree, while in her right hand she holds a branch. With her relaxed pose, she possesses a simple dignity.

naves, usually with very low ceilings. They are bordered with pillars, simple shafts quarried out of the rock, without either bases or capitals. Above a wide frieze and spanning the pillars is the curve of a barrel vault whose original wooden beams have been carefully imitated. Towards the end of the sanctuary is the *stūpa*, which is relatively small in size, and which must be honoured by making the ritual circumambulation around it. These sanctuaries are open to the façade in the form of a broad, horseshoe-shaped bay. The technique used in the hollowing out and carving of these sanctuaries is not described in contemporary texts; only an examination of the works themselves will enable us to reach some conclusions. The work must have begun at the top and proceeded downwards.

The free-standing architecture is represented by the stūpa built out of stone and brick. These sturdy constructions were designed to contain holy relics, to indicate the sacred character of the places on which they were built, or to commemorate an important event. They consisted of a hemispherical calotte, or flattened dome, placed on a low, square base and surmounted by a sort of small railed balcony *(harmika)*. The stūpa itself was enclosed by railings

pierced by from one to four openings, and with monumental gates *(torana)*. The uprights, horizontals, hand-rails, pillars and lintels were assembled on a mortise and tenon principle, like pieces of wood. The most typical stūpa are those of Sānchī (central India); of those at Bhārhut and Bodh Gayā, which are obviously contemporary, only fragments of the carved railings remain. The narrative reliefs which decorated the hand-rails, uprights and horizontals of the railings (Sānchī II, Bhārhut and Bodh Gayā), and the lintels over the gateways (Bhārhut, Bodh Gayā, Sānchī I and III) were designed to teach the many pilgrims who visited the site the virtues of Buddhism. These vivacious and charming illustrations of Buddhist legend are among the jewels of Indian art. Moreover, they are very instructive for the study of Indian civilisation, for the sculptors depicted their legendary characters in the clothes of their own time. At Bhārhut the perspective is rather naive, but at Sānchī I and III it is much more subtle. The planes are still vertically imposed but they often overlap, thus creating an impression of greater depth. The Indian artist is already displaying his gifts as a portrayer of animals that are to characterise him throughout the history of his national art. One cannot but admire the naturalism, often coupled with a profound feeling for form, the simple, spontaneous stylisation and the attentive, loving observation of nature. Following an iconographical rule that was still not very explicit, the Buddha himself was never depicted: his presence was represented by symbols.

The statues of this period are hewn from a single block of stone. The earliest of these preserve a frontality that was not without distinction. Here too, every detail of dress and ornament is carefully observed. Apart from large-scale, probably official statuary, small figures of stone or terracotta were made, which were more spontaneous in style.

THE DYNASTY OF THE KUSHANS IN THE NORTH

In the 1st century AD, a new force was being built up in the north-western regions, that of Tokharian nomads, the

(Continued on page 89)

1 (opposite). **Relief from Bhārhut.** *c.* 2nd century BC. Indian Museum, Calcutta, h. 1 ft. 7¼ in. (49 cm.). Of the stūpa at Bhārhut only fragments of the carved balustrade now remain. These are important, however, for one can discern already all the essential traits of Indian art: a strong feeling for narrative, vivacity, directness, a concern to render detail precisely, and a tendency towards stylisation. This medallion depicts incidents from an earlier life of the Buddha *(Ruru Jātaka)* when he lived as a golden stag in the Ganges valley.

2 (opposite, below). **Stūpa I at Sānchī.** 2nd century BC – 1st century AD. The Buddhist site of Sānchī is famous for the beauty of its sculpture. There are three main stūpa, of which Stūpa I is the most typical. The decoration of the four gateways or *torana* is regarded as central for the study of ancient Indian art.

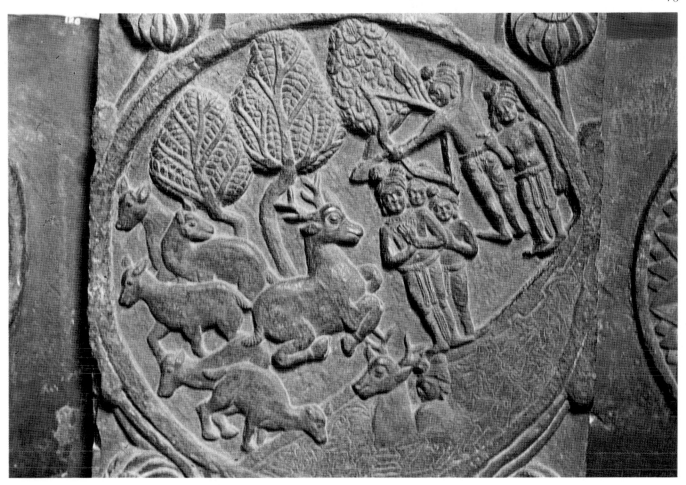

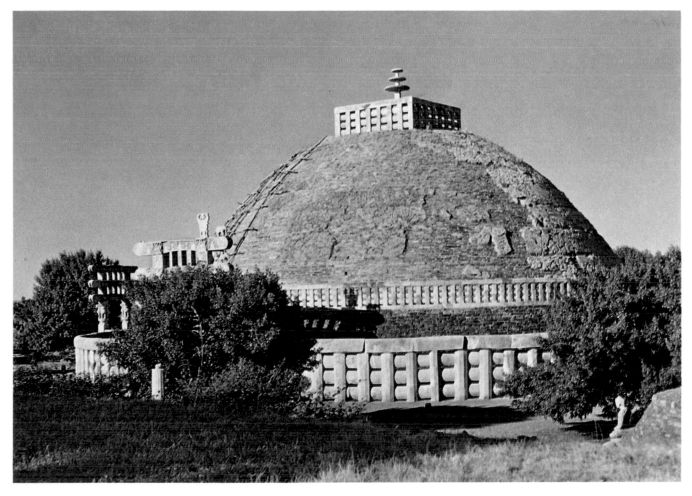

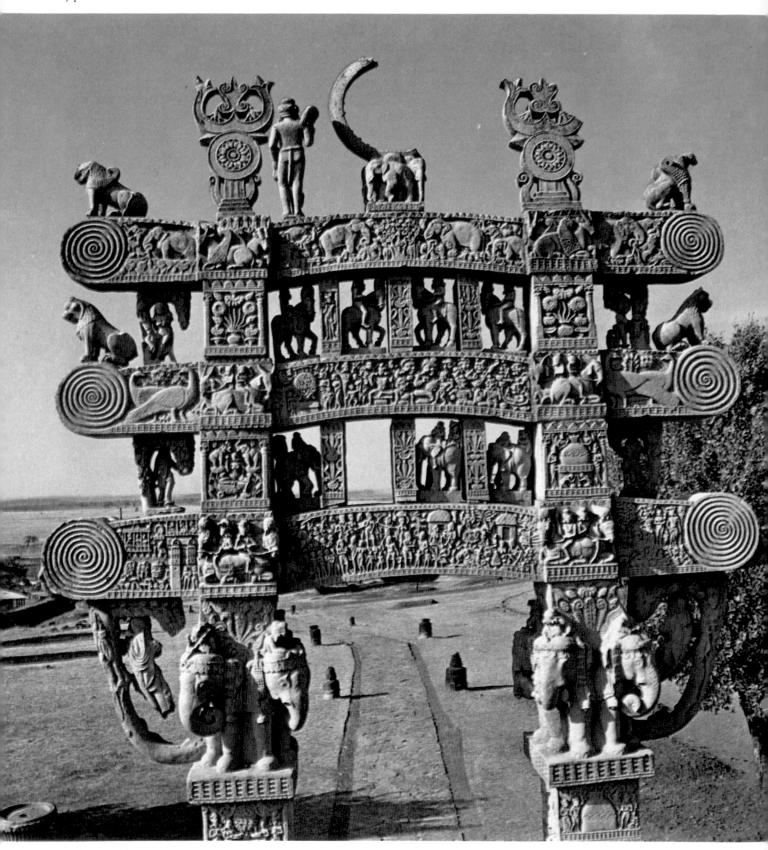

3. **North torana of Stūpa I at Sāñchī.**
2nd century BC – 1st century AD. The
sculptural technique of this *torana*
clearly derives from the art of the
woodcarver. It is covered with reliefs
and sculpture in the round, and one can
see at once how far the sculptor has
progressed since the Bhārhut era (see
plate 1). The relief is more pronounced,
the perspective more elaborate and the
composition more orderly.

4. **Pediment of the Gandhāra school.**
c. 2nd century AD. Schist. 1 ft. 10 in. × 2 ft. 1½ in. (56 × 65 cm.). Musée Guimet, Paris. This pediment is typical of the tympana of the Gandhāra school. While the form and subject-matter are Indian, the style is still Hellenistic. Adoration scenes are depicted in each of the three registers. At the top, the object of worship is the Buddha's begging bowl, and in the lower two registers the Buddha himself receives homage.

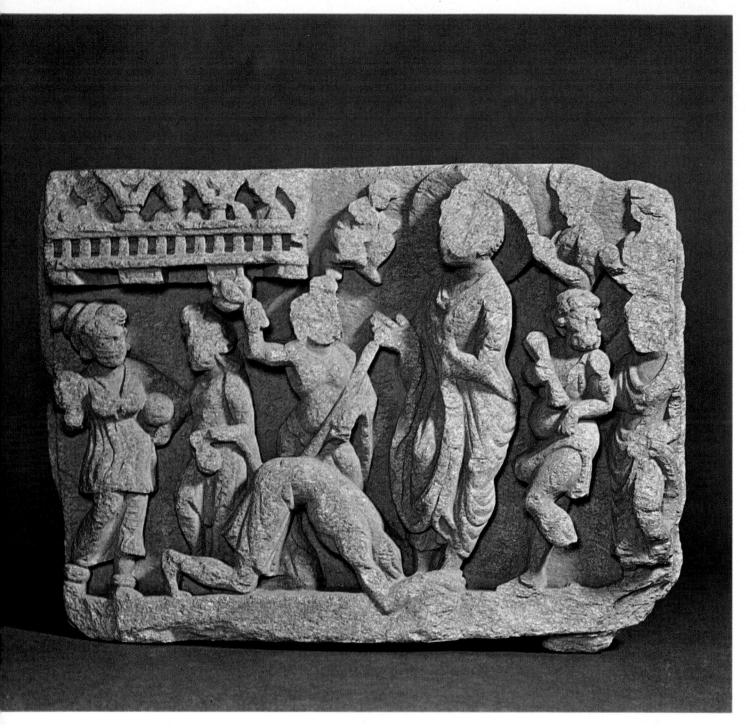

5. **The story of Dīpankara.** Narrative
relief of the Gandhāra school. *c.* 2nd
century AD. Schist. $10\frac{5}{8} \times 14\frac{1}{2}$ in.
(27 × 37 cm.). Musée Guimet, Paris.
This is one of many reliefs which
decorated the walls of Buddhist buildings
of the Gandhāra school. They are
devoted to scenes from the life of Buddha,
whether in his ultimate incarnation as the
Buddha Sākyamuni, or from one of his
previous lives. Here the future Buddha is
shown as a student. Megha prostrates
himself before the Buddha Dīpankara,
spreading his hair beneath his feet.

6 (opposite). **Bodhisattva of the
Gandhāra school** from Shabaz-Garhi.
c. 2nd century AD. Schist. h. 3. ft. 11 in.
(120 cm.). Musée Guimet, Paris. The
Buddhism of Mahāyāna, or the 'Great
Vehicle', appeared at the beginning of
the Christian era. In this latter theistic
form of Buddhism, the person of the
Buddha was deified, and Bodhisattvas, or
ministering spirits, were created,
characterised by their charity. They also
acted as intermediaries between god and
man. In Indian iconography they are
depicted in princely costume, richly
jewelled.

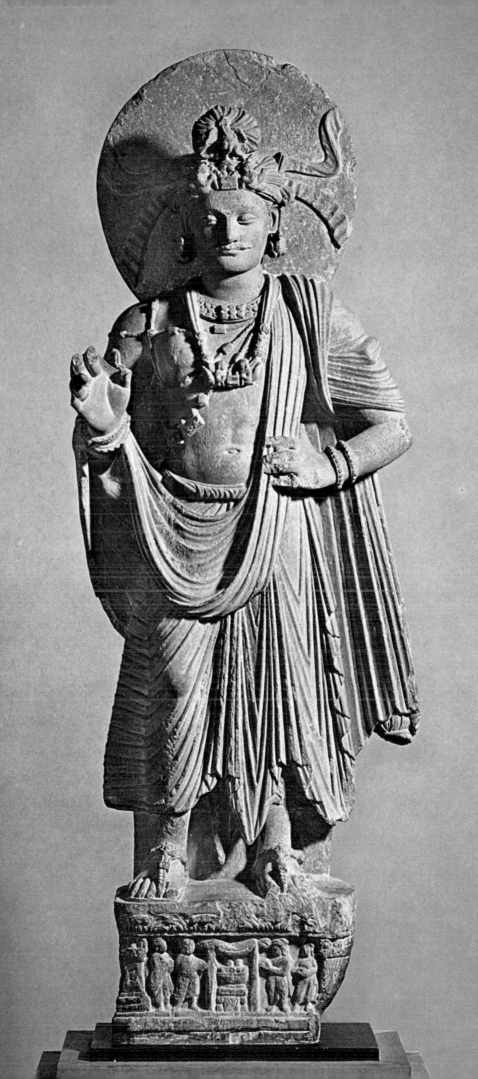

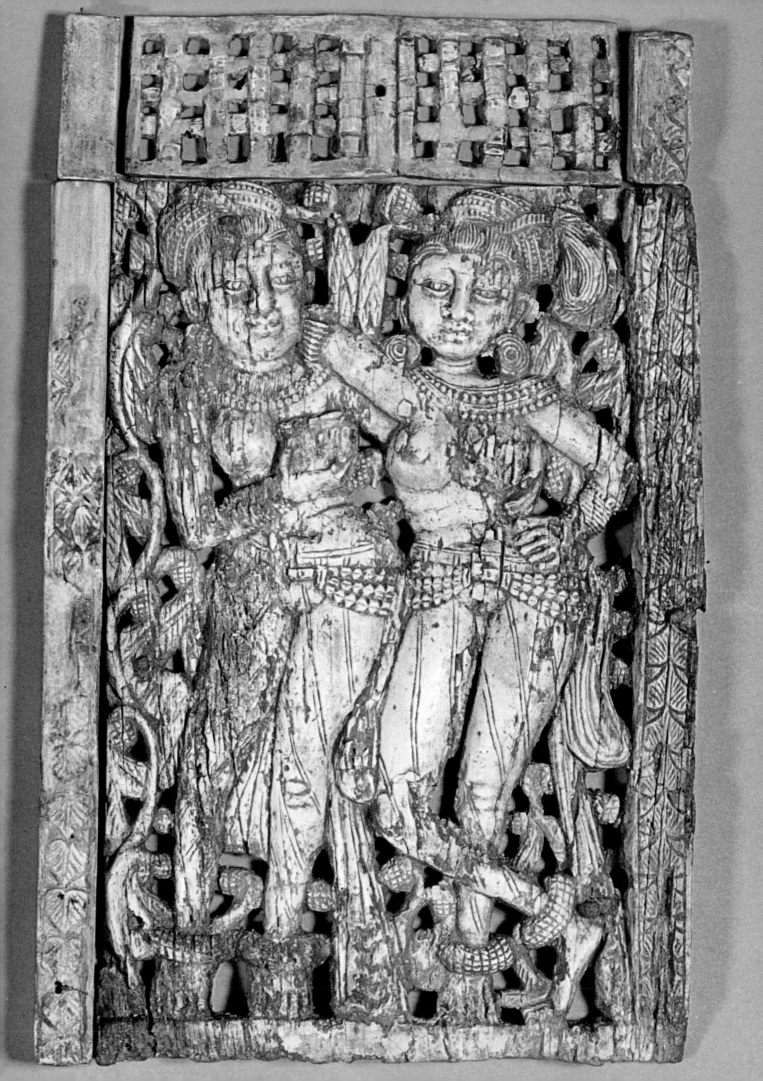

7 (opposite). **Ivory plaque from
Begrām.** *c.* 2nd century AD. h. 13⅜ in.
(34 cm.). Musée Guimet, Paris. A series of
ivories of the 2nd century have been
discovered at Begrām (see also plate 8).
Since there is an almost total absence of
male figures among the carvings, it is
assumed that they were designed for the
private apartments of women. Here we
see two women shown in the pose of triple

flexion. They are dressed in pleated
skirts or *dhotī* held at the hips by a belt of
several rows of pearls fastened in front
with a jewelled clasp. Their other
adornments include necklaces, bracelets,
anklets, and earrings, and on their heads
they wear striped turbans decorated with
rows of pearls and with the branches of
asoka.

8. **Ivory fragment from a chair.**
Begrām. *c.* 2nd century AD. h. 9 in.
(23 cm.). Musée Guimet, Paris. This
ivory fragment bears a carved
representation of a woman riding a
leogryph, a fabulous animal, part bird,
part lion. It originally formed part
of a chair of the type to be seen in the
reliefs of Mathurā and Amarāvatī. Such
chairs had rectangular backs, the
horizontal member being joined to the
vertical by means of arc-shaped pieces
like this one.

9 (opposite). **Nāgarāja, or serpent-king.** School of Mathurā. *c.* middle of the 2nd century AD. Red sandstone. h. 3ft. 9¾ in. (116 cm.). Musée Guimet, Paris. The Nāgarāja was the king of the nāga or water spirits, protectors of cisterns and sacred waters. He is often represented in the form of a man resting against the coils of a great serpent. The serpent raises its many heads behind him to form a halo about his head and shoulders. He raises his right hand in an appeal for rain, and in his left he holds a drinking cup.

10 (right). **Chakravartin.** Amarāvatī school. *c.* 1st century BC. Veined limestone. h. 3 ft. 8 in. (112 cm.). Musée Guimet, Paris. King Chakravartin is 'he who turns the Wheel' *(Chakra)*, that is, the sovereign of the world who holds in sway the entire universe, for the wheel symbolises the sun which dominates all space. The Seven Jewels of his office are grouped about him: the Wheel, the jewel, the elephant, the horse, the woman, the ministering priest and the general.

11. (right). **The Attack of Māra.** Amarāvatī school. *c.* 2nd century. Veined limestone. h. 4 ft. 1¼ in. (125 cm.). Musée Guimet, Paris. This relief illustrates an episode in the life of the Buddha. After years of abstinence he is about to attain to the state of Enlightenment when the Buddhist devil, Māra, tries to prevent this happening. First he sends groups of devils and monsters to molest him and then tries to tempt Buddha by offering him young girls, but Buddha resists him. In this instance Buddha himself is depicted only by symbols: an empty throne is placed beneath the tree of Enlightenment *(bodhi)*, and the footstool bears the imprint of his feet.

12 (next page). **Head of Buddha.** Amarāvatī school. *c.* 2nd century. Marble. h. 8¼ in. (21 cm.). Musée Guimet, Paris. The Buddhas of the Amarāvatī school display a certain elongation of the facial features which is characteristically Dravidian. Here the cranial protuberance can clearly be seen. Like the rest of the head, it is covered with small flat curls, arranged according to ritual from left to right.

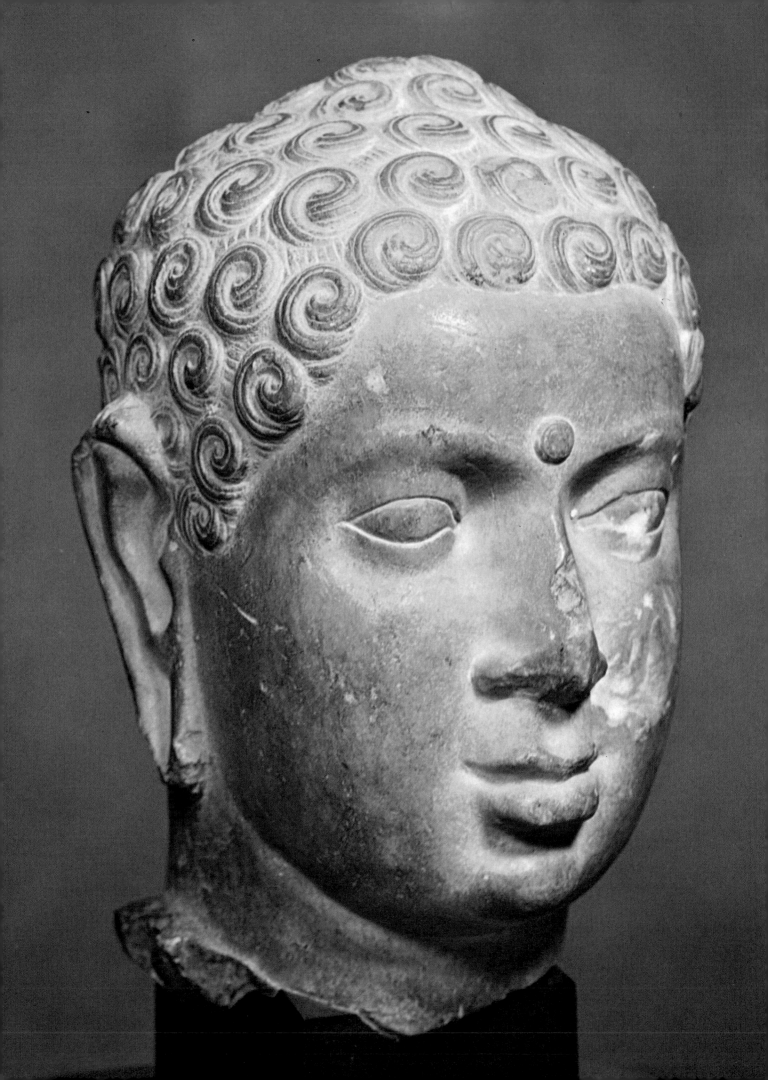

13 (previous page). **Torso of a Bodhisattva.** Gupta style. 5th century. Red sandstone. h. 2 ft. 10¼ in. (87 cm.). Victoria and Albert Museum, London. The sacred images of the Gupta reflect this style at its purest. Here all the stylistic features are blended together in a perfect whole. The curve of the figure is as subtle as the softness of the modelling, and in its balance it demonstrates the consummate skill of the Gupta sculptors.

14 (right). **Head of the Bodhisattva Avalokitesvara.** Gupta style. *c.* 5th century. Red sandstone. h. 5⅞ in. (15 cm.). Musée Guimet, Paris. The cult of Avalokitesvara, the merciful Bodhisattva, was one of the most popular, spreading not only throughout India, but also to the other countries which adopted the Buddhism of the 'Great Vehicle'. He is shown here wearing a magnificent diadem. On top of this a small Buddha is seated in the Indian fashion, flanked by two lions, with garlands of pearls streaming from their mouths.

15 (opposite). **Great Bodhisattva.** Fresco in Cave I at Ajantā. 6th century. This is one of the two great Bodhisattvas which frame the entrance to the sanctuary of Cave I. With his gentle expression and calmness of attitude the Bodhisattva shows his compassion towards man. The technique used at Ajantā was a kind of tempera which amounted almost to *fresco secco*, that is to say, the pigment was applied to dried plaster. The painting was done in four stages. First the surface was prepared, then the outlines of the design were sketched on to the plaster. The paint was then applied to bring colour and modelling to the basic shapes. Finally touches of gold were added, the contours were sharpened, the decorative details emphasised and the whole surface was burnished.

16. **The Mriga Jātaka.** Detail of fresco in Cave XVII at Ajantā. 5th–6th centuries. The composition of the Ajantā frescoes seems at first sight overcrowded and complicated. But when one grows accustomed to looking at them, the different groups of figures become distinct from one another, a pattern emerges, a harmony is revealed. Each detail is fascinating in itself, as for example this servant who is holding a dog on a leash. He is part of the suite of King of the *Mriga* in pursuit of the sacred deer (see also plate 1).

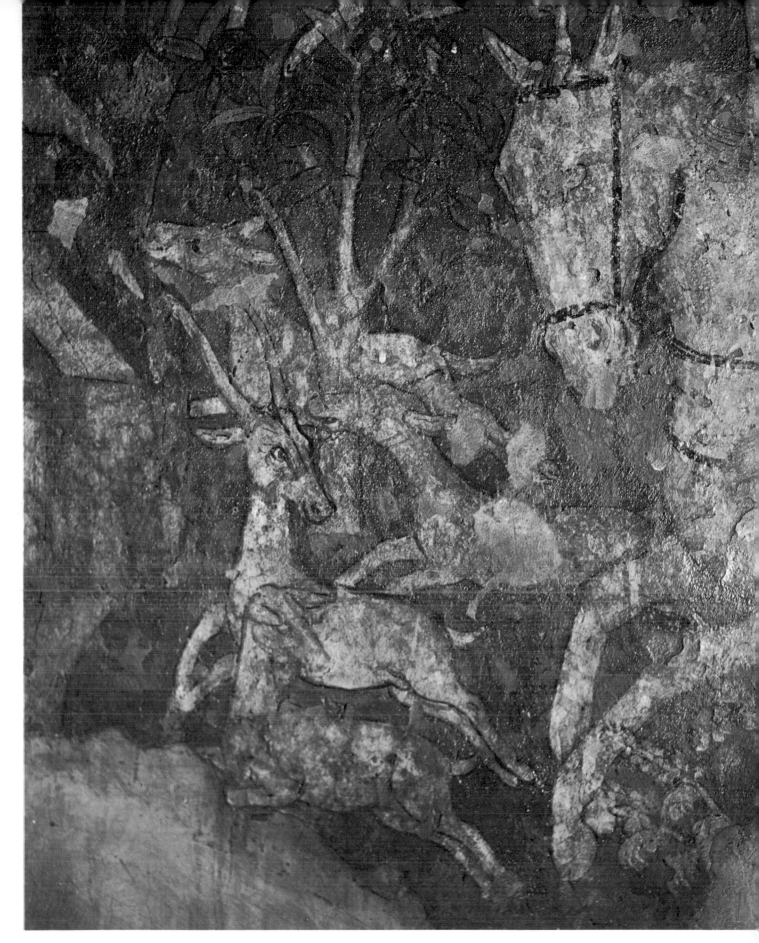

17. **The Sutasoma Jātaka.** Detail of
fresco in Cave XVII at Ajantā. 5th–6th
centuries. This detail forms part of a
hunting scene illustrating a previous
life of the Buddha *(jātaka)*. The bounding
deer are full of vigour and movement,
reflecting the Indian artist's delight in
animal life, a characteristic which was
already evident as early as the Indus
valley civilisation of the third
millennium BC (see figure 2).

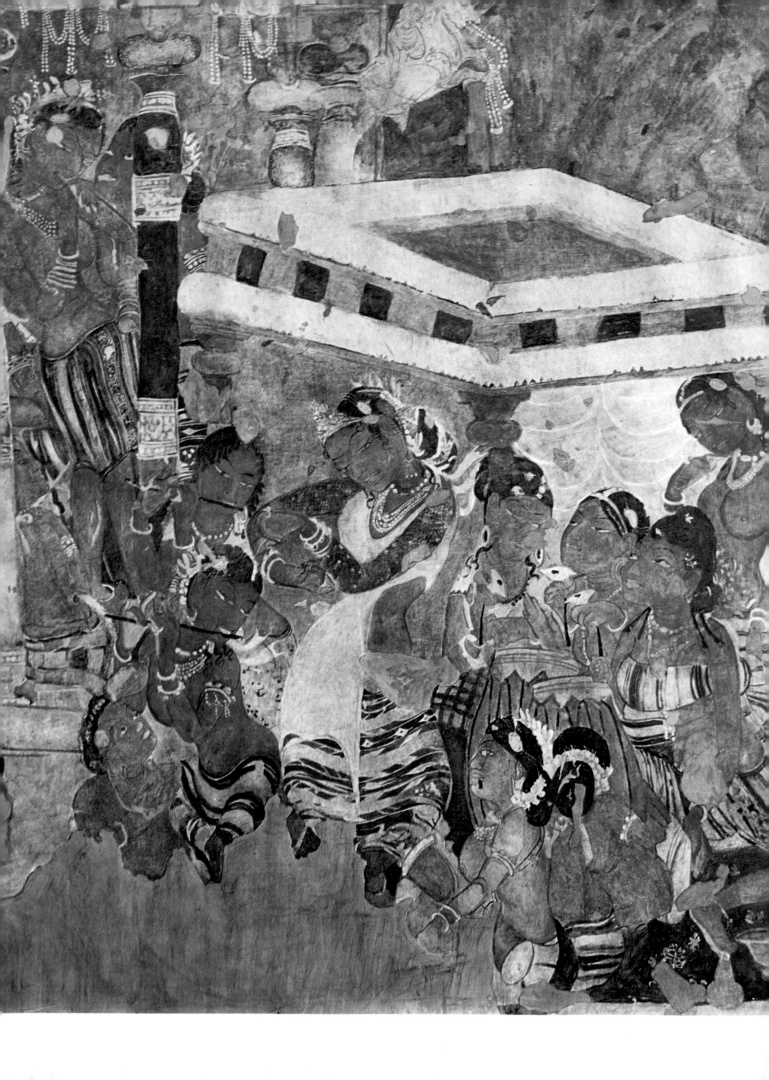

8. Detail of a handrail, Bhārhut. *c.* 2nd century BC. Sandstone. h. 17 in. (42 cm.). Indian Museum, Calcutta. This detail from the balustrade of the stūpa at Bhārhut illustrates part of a narrative which is identified by the short inscription in the frieze immediately above. Each episode is enclosed within a garland of curving branches decorated here and there with flowers, fruit or even jewels. The upper frieze combines little merlons, or fortifications with lotus blossoms. This relief demonstrates not only an interest in rendering narrative but also a taste for the picturesque, a preoccupation with minute detail and a finished execution.

Kushans, who had come from Khotān in central Asia, and had affinities with the people of eastern Iran. Under able and well-advised leaders they conquered the Parthians, seizing Kabul, Arachosia and the whole of the Punjāb, and thrust out towards the east and south. Their empire extended from the Oxus to the Ganges plain, thus uniting under their authority the former possessions of the Indo-Greeks and the Sunga. The height of their power coincided with the reign of Kanishka, their third sovereign. Although his dates are not precisely known, he seems to have lived for about forty years in the middle of the 2nd century. Eclectic in his tastes, he applied himself to the spread of Buddhism, to which he was converted, but also gave protection to Jainism and Brahmanism. He was the first Indian sovereign to depict the figure of the Buddha on his coins, but he also depicted Iranian deities on them. He adopted the Indian imperial title of Mahārāja, or 'Great King', the Parthian title of Rājatirāja ('king of kings') and the Chinese title of Devaputra ('son of heaven'). In his official portraits he retained his tribal costume: Iranian tunic, Scythian cap and the tall boots of the nomadic horseman. We learn from an inscription written in Eteo-Tokharian, which was derived directly from the spoken Greek in use in Iran in the Parthian period, that he founded the temple of Surkh Kotal, a dynastic temple built at the top of a hill and which was approached by three successive terraces. Yet the Buddhist art contemporary with his reign, which is particularly that of Mathura, continues in the style of the earlier period, without bearing the marks of any outside influence.

THE KINGDOMS OF THE DECCAN

As in the north, the Dravidian territory of south India saw the rise of kingdoms that were to enjoy great brilliance. Most of these had been founded in the preceding period and the most important was that of the Āndhras, who inhabited the region situated between the lower reaches of the Godavari and the Kistna. Traces of a brilliant civilisa-

9. Medallion from the balustrade at Bhārhut. *c.* 2nd century BC. Sandstone. d. 19½ in. (49 cm.). Indian Museum, Calcutta. This medallion, in which a human head is placed within a circle of lotus petals, shows the decorative skill of the Bhārhut sculptors.

10. Medallion with a peacock, Bhārhut. *c.* 2nd century BC. Sandstone. d. 19½ in. (49 cm.). Indian Museum, Calcutta. This exquisite stylised peacock again reflects the decorative skill of the Bhārhut artists. Such medallions decorated the upright members of the balustrade.

18 (opposite). **The story of Prince Mahājanaka.** Detail of fresco decorating the left-hand wall of the entrance to Cave I at Ajantā. (Photograph taken from a copy of the fresco by G. C. Haloi.) 5th–6th centuries. This is one of innumerable scenes in Indian iconography depicting dancers and musicians. The instruments consist of two transverse flutes, two pairs of cymbals, a pair of bulbous drums, another drum shaped like an hour-glass, and an arched harp (which can only just be distinguished). The dancer moves her hands in ritual gestures or *mudrā*, which symbolise in mime mystical power or action.

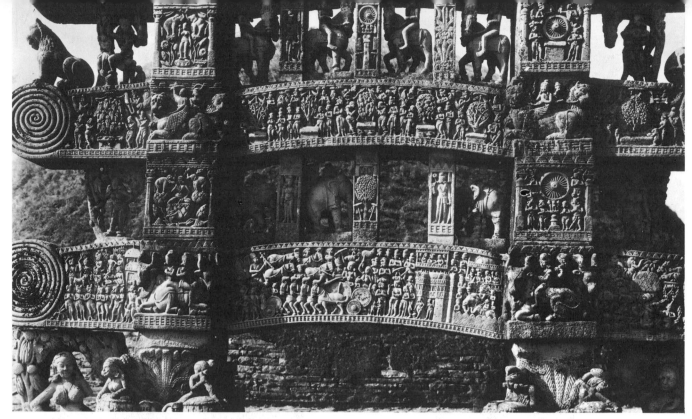

11. **Detail of the eastern torana, Stūpa I, Sānchī.** 1st century BC–1st century AD. On the upper lintel of the torana the previous lives of the Buddha are illustrated—the Buddha of the jātaka being represented as a flowering tree surmounted by a parasol. Each 'tree' is flanked by a pair of worshippers and above hover two winged genii. The lower lintel shows scenes from the life of the Buddha Sākyamuni—the prince Vessantara who, in his renunciation of the world, not only distributes gifts but also abandons his wife and children to the Brahmins.

12. **Reliefs from the northern torana, Stūpa I, Sānchī.** 1st century BC–1st century AD. These two panels from one of the upright members of the torana show episodes from the life of Buddha—the Enlightenment symbolised by a throne placed beneath the sacred tree, and the crossing of the Ganges. The second episode relates to the Buddha's journey to Banāras to preach the doctrine. Having no money to pay the boatman he leaps across the river in a single bound.

13. **Yakshinī on the eastern torana, Stūpa I, Sānchī.** The theme of the tree woman who symbolises fertility is connected with the popular cult of tree worship which was drawn into the Buddhist iconography. This Yakshinī is finely sculpted and possesses all the grace of Indian womanhood. She is shown in the canonic pose of the *tribhanga* or triple flexion, one of the attitudes laid down in the treatises of the time.

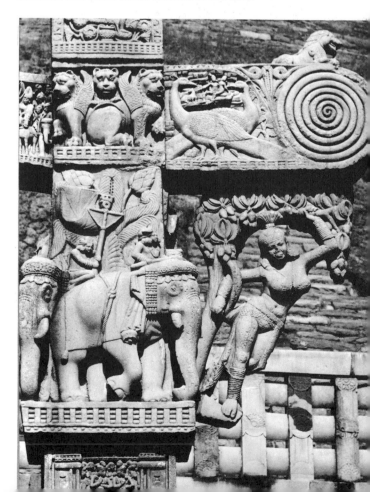

14. **Yaksha from Patna.** 2nd century BC. Sandstone.
h. 5 ft. 11½ in. (182 cm.). Indian Museum, Calcutta. The
earliest cult statues to have come down to us are the Yaksha,
popular deities which derive from ancient animistic cults and
which were adopted by Buddhism. They are characterised by
their hieratic stance, a corpulent body and rather static quality.
A delight in rendering detail is reflected in the careful
observation of the costume and the jewellery.

15. **King Kanishka.** School of Mathurā. Probably mid-2nd
century AD. Sandstone. h. 6 ft. (1 m. 85 cm.). Archaeological
Museum, Mathurā. Thanks to the inscription engraved on the
skirt of the garment, this statue can be identified as that of the
Kushan King, Kanishka. Although the Kushans had been
established in the north of India for over a century, the King
still preserves in his official portraits the costume of his tribe.
He wears a conical cap, a long frock-coat and heavy felt boots
—the apparel of a mounted nomad of the steppes.

tion, centred on Amarāvatī, testify to the existence of a
strong state in this region. They may have had as vassals
the powerful Satavāhana who ruled over a large part of
the Deccan stretching as far as Malwa and Mahārāstra.

TRANSITIONAL STYLES

Although Brahmanic art, which had hitherto played no
part in Indian culture, now made its appearance, the art
of this period was still almost exclusively Buddhist. It con-
tinued the ancient traditions, represented at Bhārhut and
Sāñchī, but at the same time foreshadowed the new style
that was to follow. Qualified as 'transitional' it was a highly
productive period in which new iconographical themes
were invented, and a new aesthetic quality developed. Art
reflected most accurately not only the political complexity

of the time but the triumph of Buddhism to whose glory it
was dedicated. Throughout India, Buddhist art was in full
flower, preserving the narrative character that makes it so
valuable for a study of this period. The most important
feature of this art is the appearance of the Buddha's image,
which is represented now for the first time. There were
three, roughly contemporary artistic schools: that of the
former Indo-Greek possessions (present-day Pakistan and
Afghanistan), known as the school of Gandhāra, that of
Mathurā and the Ganges plain—corresponding to the ter-
ritory conquered by the Kushans—and, in the south-east,
the school of Amarāvatī, which corresponded to the terri-
tory of the Āndhras.

The image of the Buddha seems to have made its appear-
ance simultaneously in Gandhāra and Mathurā; it ap-

16 (above left). **Buddha preaching.** From Loriyan Tangai. Gandhāra school, *c.* 2nd century. Schist. h. 2 ft. 9½ in. (85 cm.). Indian Museum, Calcutta. Indo-Greek syncretism is particularly well borne out in Buddha figures of this type, in which Hellenistic and oriental features are intermingled. The grave, pensive face with its faraway look reflects majestically the Buddhist ideal of an upright and charitable life, in which all desire is suppressed and total detachment achieved.

17 (above). **Standing Buddha from Nāgārjunakonda.** *c.* 2nd century AD. Government Museum, Madras. This Buddha of the Amarāvatī school is dressed in a monastic robe leaving the right shoulder bare. The raised left arm lifts the drapery so that it falls in regular curving folds.

18 (left). **Female figure in the Greco-Buddhist style.** *c.* 2nd century AD. Schist. h. 4 ft. 3½ in. (131 cm.). Archaeological Museum, Mathurā. Although found at Mathurā, not Gandhāra, this is undoubtedly a Gandhāran piece. The facial features, wavy hair and treatment of the drapery recall Hellenistic sculpture. The statue is thought to be of the deified Kambojikā, queen of the Rājuvula satrapy.

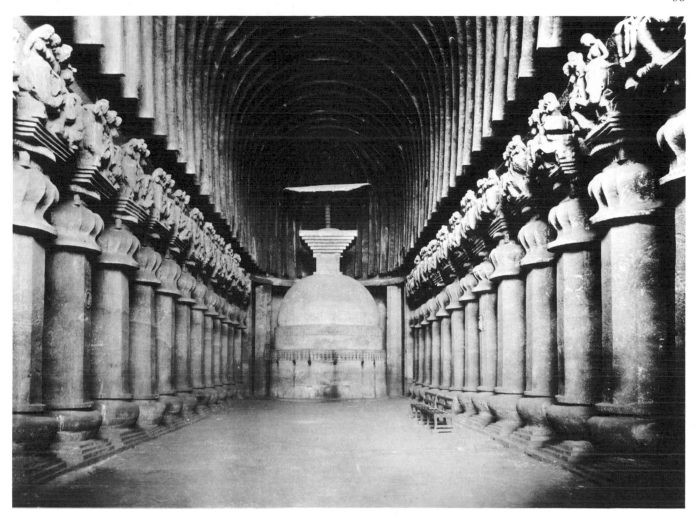

19. Interior of the chaitya at Kārlī. 1st–2nd centuries AD.
The evolution of the chaitya was a slow one. Gradually the
structure acquired larger proportions—the nave at Kārlī is
59 feet high, 121½ feet long and 43 feet wide. The chaitya was
originally a timber construction (see also figure 6) and the

structural features though stylised now still reflect this ancestry
of wooden architecture. The bases of the columns are of vase
form. The elaborate capitals, with their combination of human
figures and animal heads, remind one of Achaemenian art.

peared in Amarāvatī a little later. It is possible that the
idea was Greek and that the image itself was created by
Greco-Roman artists from western Asia. It introduced a
focal point into the composition of scenes, which became
increasingly symmetrical, although the general repertoire
of motifs did not change noticeably.

THE TYPES OF THE BUDDHA

In the so-called Greco-Buddhist school of Gandhāra, the
figure of the Buddha possesses from the start all the usual
Hellenistic characteristics, blended with a few more speci-
fically Eastern features. He is represented as a young man
of Apollonian type, with a straight nose continuing the
line of the forehead and a firmly drawn mouth, but with
heavy eyelids half obscuring the very protruding eyes; a
fleshy face with the lobes of the ears lengthened by the
weight of jewels. He bears the distinctive signs of his sacred
nature: between his eyes is the *urna*, or coil of hair, and he
holds in the palms of his hands the *chakra*, the sacred wheel
that symbolises the progression of the Buddhist law. His
evenly waved hair is gathered at the top of his head in a tight
knot secured by a gold cord. The knot was later misunder-
stood and came to be represented by a cranial protuber-

ance *(ushnīsha)*, which has been included in all the images
of the Buddha throughout Asia down to our own time. He
wears the monastic robe and cloak of flowing drapery.

The school of Mathura also had this Apollonian type of
Buddha, but there was also a very different type, quite
peculiar to this school. He has a round head and a smiling,
doll-like expression. On his shaven head he wears a skull-
cap that hides the topknot. His monastic dress is of a finer
material than at Gandhāra; it clings closely to the body
and the light relief is rendered by parallel folds bordered by
a faint double outline; the right shoulder is left uncovered.
He is fairly heavily built and makes simple gestures that
were later to become the ritual gestures or *mudra*. This
Buddha is close to the image of *yaksha* of the previous
period and belongs entirely to Indian tradition.

Like that of Mathurā, the Buddha of the school of Ama-
rāvatī is profoundly Indian in appearance, inheriting the
lessons of the past. However, from the very beginning, it is
more highly developed and closer to the type that was to be
adopted by later schools. The long face is characteristically
Dravidian. The cranial protuberance, like the rest of the
head, is covered by small, flat curls arranged from left to
right in accordance with ritual conventions. His monastic

20 (above left). **The young Ekashringa.**
Detail from the upright member of a
Buddhist balustrade. School of Mathurā.
c. 2nd century. Pink sandstone. h. 2 ft.
7½ in. (80 cm.). Archaeological Museum,
Mathurā. The simple modelling and the
clear lines of this piece bring emphasis to
the facial features which are much more
individual than was the case with
sculpture of preceding periods.

21 (above). **Kushan coin.** Gold. d. $\frac{13}{16}$ in.
(2 cm.). Musée Guimet, Paris. Kushan
rulers are represented on the obverse of
their coins while on the reverse Iranian
or Indian deities are depicted. Here the
god Siva is shown standing before his
mount, the bull Nandin.

22 (left). **Three Yakshi.** Detail from a
Buddhist balustrade at Mathurā. School
of Mathurā, *c.* 2nd century AD. Pink
sandstone. h. 3 ft. 11 in. (120 cm.).
Indian Museum, Calcutta. The use of
such profane figures for the decoration of
religious buildings may seem to us
inappropriate. But these sculptures, with
their marvellous understanding of balance
of form and harmony of line, reflect the
artist's belief in the importance of grace
and vitality.

17 cloak again leaves the right shoulder bare and falls in regular folds, held in at front and back, from the left shoulder to the chest. The right hand makes the gesture of fearlessness *(abhaya-mudrā)*. In the reliefs of this school, one notices the use of two iconographies, that in which the Buddha is replaced by symbols and another in which he is represented without the traditional signs. Amarāvatī seems to have played a particularly important role in exporting Indian works of art to the countries of the South Seas. Buddhas in the Amarāvatī style have been found scattered over such countries as were reached by Indian navigators and local imitations of these Buddhas have also been found, particularly in northern and central Thailand.

DIVERSITY AND SIMILARITY OF STYLES

A real unity is to be found in the art of this period in spite of its variations. There are elements common to all three schools: the architectural forms and the characteristics of sculpture and painting were only slightly affected by differ-
4,5 ing local customs. But the school of Gandhāra is nonetheless outside the main stream of Indian aesthetic development on account of its attachment to the Hellenistic world.
6,18 Whether executed in schist or in stucco, a whole repertoire of classical decoration is perpetuated in the treatment of the subsidiary figures accompanying the Buddha. These figures represent with great liveliness the physical types that then peopled the Eurasian world. This Hellenistic style from India's north-west frontier was to be particularly influential throughout Asia, where it was drawn into the repertoire of Buddhist art and continued long after the disappearance of the political structures that had given it birth.

Rock-cut architecture is practically the only type of building to survive. The sanctuaries retain the same ground-plans as before and still imitate the forms of wooden
19 constructions, although with some stylisation (Kārlī, Kanherī, Nāsik III). The stūpa, of which unfortunately only fragments remain, were larger than usual. We know from relief representations that they were taller, the base being higher and the dome more spherical.

9 It was sculpture that achieved true perfection, as much from the aesthetic as from the technical point of view. It is
20 very varied, because each school was imbued with a different artistic feeling and also because of the size and diversity of the materials used. The art of Mathurā reproduces both
15 the grave majesty of the Kushan kings and the delightful sensuousness of Indian women whose ample bodies are
22 shown in the graceful ritual pose of the *tribhanga* or triple flexion. The red sandstone used by this school gives its
7,8 sculpture an additional charm. Carved and engraved ivory
23 plaques, discovered in Afghanistan, at Begrām or Kapisa, the former Kushan capital, seem to share the same style. The technical and stylistic refinement of these plaques confirm the reputation of the Indian ivory workers, who were so widely praised in ancient literature.

The Amarāvatī school is quite different: the style of this

school was at once more dynamic, yet less robust and more 24, 25 refined than that of Mathurā. It was in the narrative relief that it reached its height: executed in the marble-like lime- 10, 11 stone of the region, this is often of great beauty, not only in the subtlety of the composition but also in the confidence of the modelling. The figures are most elegantly posed—the attitude of prostration being among the most beautiful in 26 Indian art.

These differing characteristics are also to be found in the pictorial art, in the paintings of Cave X at Ajantā for example, where one can observe the same confident modelling and the same dexterity in the attitude of the figures.

This period of transition, so rich in new achievements and experimentation, carried to a peak of perfection the qualities inherited from the past and paved the way for the full flowering of the Gupta period.

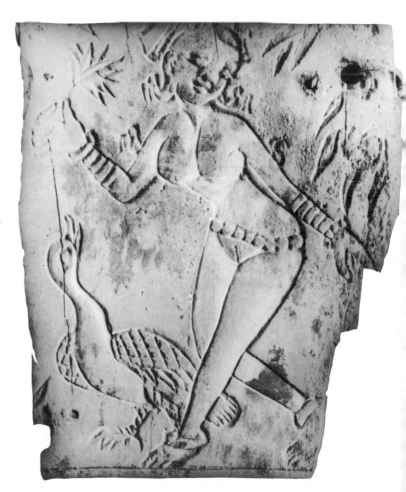

23. **Girl playing with a goose.** Incised ivory plaque from Begrām. *c.* 2nd century AD. 3 × 2½ in. (7·5 × 6·5 cm.). Kabul Museum, Afghanistan. This graceful girl is naked apart from her jewellery. In her right hand she holds a flower which seems to attract the goose, whose head is raised towards it. Geese are numbered among many domestic animals which lived in the private apartments of the women.

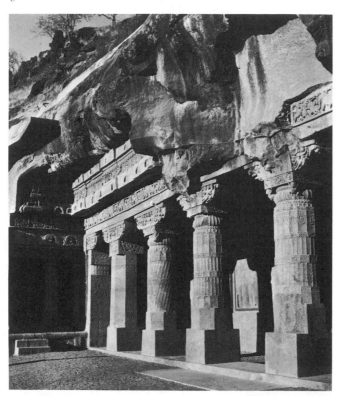

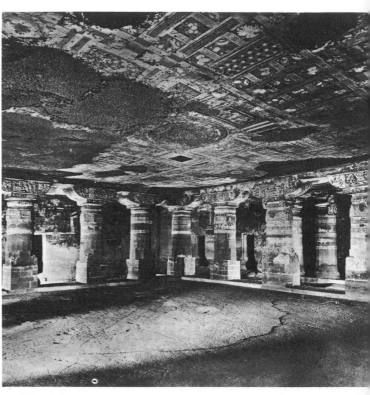

28 (above). **Façade of Cave I at Ajantā.** *c.* 6th century. Cave I is a monastery. It has a square plan, opening on to a veranda. The columns supporting the roof have richly carved capitals and brackets worked in great detail.

29 (above right). **Interior of Cave I, Ajantā.** *c.* 6th century. The main hall is surrounded by columns forming a square, the shafts and brackets of which are richly sculpted. The flat ceiling is painted to resemble coffering. On the walls, between the doors which lead to the chapel, are the frescoes which are numbered among the masterpieces of Indian art (see plates 15–18).

30 (right). **Façade of Cave XXVI, Ajantā.** *c.* 6th century. Rock-cut architecture reached its peak in the Gupta period. The sanctuary preserves its essential characteristics but is now covered with sculpture and decorative motifs which invade every surface including the columns.

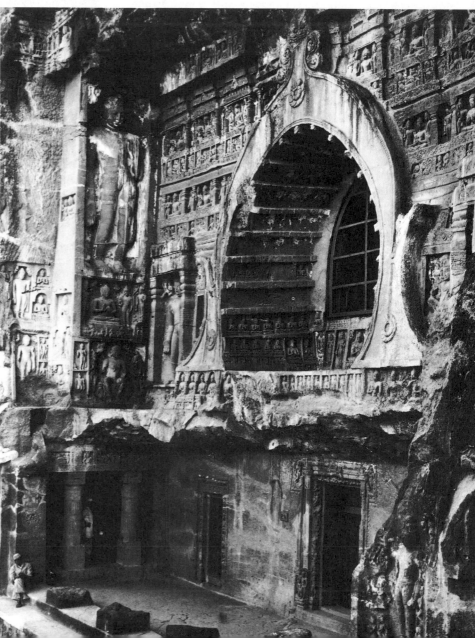

Meanwhile, the kingdoms of the Deccan continued to increase in power, particularly the Pallava in the Tamil regions and the western Chālukya in Mahārāstra. The Chālukya and their successors, the Rāshtrakūta, filled their kingdom with priceless art treasures, the most famous of which are to be found at Ajantā, Aihole, Bādāmī, Nāsik, Elephanta and Ellūrā. In the 7th century, in the south-east, the Pallava erected the remarkable architectural complex of Māmallapuram. Thus the splendour of the Gupta was sustained until the medieval period.

GUPTA AND POST-GUPTA STYLES

From the artistic point of view, the Gupta period is marked by the emergence of a new style that is nevertheless related to the styles that preceded it. It forms one of the most important stages in Indian aesthetic development. Looking at its many masterpieces one can appreciate fully the system of gradual change that is so typically Indian, in which a single decorative repertoire may cover a wide variety of interpretations. In sculpture the Chālukya and Pallava styles adopted Gupta themes, transforming them according to the laws of mutation that characterise Indian art: but they betray a different spirit, owing, perhaps, to the development of Brahmanic art. Indeed, the distinction between the aesthetic conceptions of the Buddhists and of the Hindus was to widen: the first being dominated by a spirit of peace and serenity and the second by dynamic power and a feeling for divine majesty. This difference is naturally more apparent in the narrative compositions than in decoration and single figures. Hindu high relief in particular reveals a remarkable sense of the monumental.

As in previous periods, architecture consisted of stūpa and rock-cut sanctuaries. But a great change came about: for the first time, free-standing structures were built out of durable materials.

The Huns destroyed practically all the stūpa of this period; the oldest of these (Chārsada, Mirpur Khas), built of brick covered with stucco, were a continuation of the Gandhāra style. Others (Sārnāth, Rājagriha, Nālandā) are of brick and stone, sometimes braced by iron tenons. The outline of these buildings changed considerably: the dome became bell-shaped or bulbous and merged into its circular base. It was this type, brought to the Indianised countries by the Gupta, that was to be perpetuated throughout South-East Asia.

The rock sanctuaries resumed their previous shape (square or apsidal in plan), but with much more carved decoration, particularly on the abaci of the capitals. The most famous are those of Ajantā, several of which are decorated with admirable frescoes, Bādāmī and Ellūrā.

The earliest free-standing sanctuaries varied in form, but were always simple and quite small. The solutions that were to be used by the architects of the medieval period can already be discerned. These involve either square cellas covered by a flat roof and preceded by a pillared porch (Cave XVII at Sānchī), ground-plan covered by a barrel

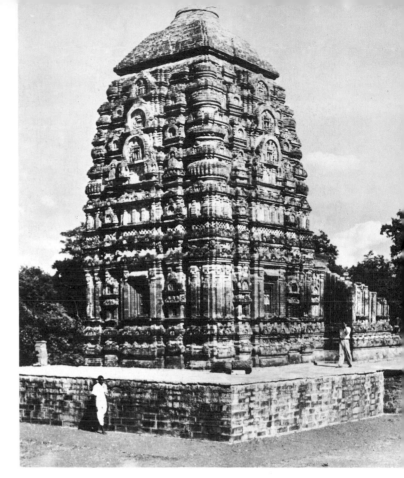

31. **Temple of Lakshmana, Sīrpūr.** 6th–7th centuries. This temple appears to have been the prototype for the sanctuary with an inward curving silhouette that was to become widespread during the medieval period (see figures 42, 43, 44). This was partly achieved by placing ribbed cushions (amalaka) at the corners of the building, thereby softening the angles.

vault (as in the temple of Kapotesvara at Chezarla, the temple of Trivikrama at Ter and the temple of Durgā at Aihole), or square towers surmounted by a pyramidal roof in two parts (as in the temple of Gop, in Kāthiāwād). The architectural style is characterised both by the transformation of certain ornamental forms and by the elaboration of certain themes such as that of the roof. Thus the horseshoe-shaped bow window, translated at a very early date from wood into stone, finally became a decorative motif in its own right and the different 'storeys' of the roof were embellished with miniature buildings. The undeniably original effect obtained seems to be more within the province of a sculptor than of an architect; furthermore it reflects the cosmos in following the dictates of the sacred texts. In spite of the importance which was attached to sculpture at this period, architecture and sculpture are always complementary and perfectly balanced, one with the other. The rocks of Māmallapuram, hewn to the shape of a temple, hollowed out and carved, are really enormous sculptures in the round, as is also the case with the Kailāsanāth of Ellūrā which stands within the quarry from which it was carved, enclosed by walls of living rock.

Another type of sanctuary with a square plan seems to have appeared in about the 6th and 7th centuries. Prompted, perhaps, by the use of brick, its 'storeyed' roof gradually curves inwards towards the summit and is decorated with finials in the form of ribbed cushions (āmalaka). One of the oldest of these is the temple of Lakshmana at Sīrpūr

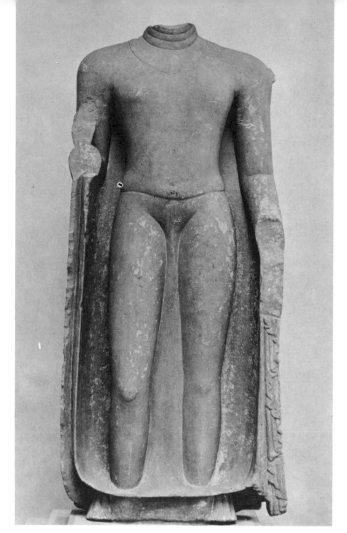

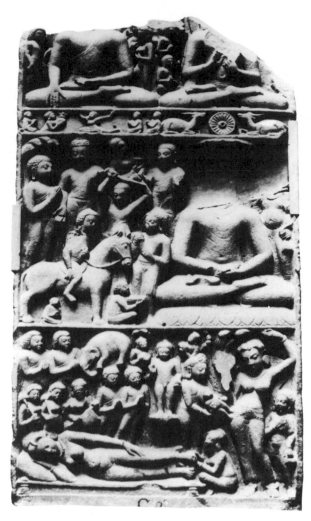

32. **Buddha in the Gupta style.** 4th–6th centuries.
Sandstone. h. 2 ft. 11½ in. (90 cm.). Musée Guimet, Paris.
Gupta art took the human body as its principle theme. This
was treated with great simplicity, while preserving the
sturdiness of the form. The Buddha's garment is rendered with
a total absence of folds in the drapery, so that he appears to be
naked.

34. **Head of a Gupta Buddha.** 4th–6th centuries. Sandstone.
Musée Guimet, Paris. The classical Gupta style can be seen to
perfection in the smiling detachment of this Buddha, with his
reflective and mysterious expression.

33. **Relief from Sārnāth.** Gupta style. 5th–6th centuries.
Limestone. h. 2 ft. 11 in. (89 cm.). National Museum of India,
New Delhi. This relief, which illustrates the main episodes in
the life of the Buddha, dates from the end of the Gupta period.
The lively invention and fertile imagination of the Gupta
sculptor was giving way to a more conventional approach. This
stele illustrates the conception, birth, first steps, the great
renunciation, the cutting of the hair, and the Enlightenment.
The Earth's witness of his approach to Buddhahood, and the
first sermon are illustrated in the top register, now badly
damaged.

that may be regarded as the archetype of the sanctuaries
with curved roofs *(sikhara)*.

Between about 600 and 750, regional styles began to
develop covering vast areas of territory. The sikhara make
their appearance in Orissā. At the same time, the Dravidian
order, characterised by its pyramidal roofs, developed
under the Chālukya (Bādāmī, Pattadakal), then of the
Rāshtrakūta (Ellūrā). It also developed in the kingdom of
the Pallava (Māmallapuram, Kānchīpuram). Versions <inline_image />19,29
of the same temple were to develop increasingly differing
forms.

In sculpture, as in painting, the Gupta artists used the
human figure as their main subject-matter. They expressed
in a majestic way the tranquil detachment proper to
Buddhism; the nude appears almost transfigured, yet pre-
serves a majestic, serene expression, and an almost regal
grandeur. There are two types of statue: the Buddha,
which continues according to previous traditions, and the
Bodhisattva and Brahmanic deities, whose princely
adornments contrast with the simplicity of the Buddha.

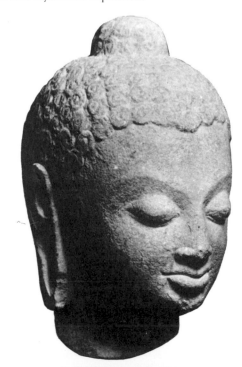

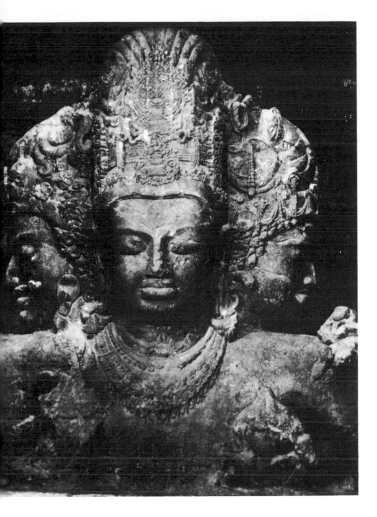

35. **The Maheshamūrti, Elephanta.** End of the 6th–beginning of the 7th century. The island of Elephanta, facing Bombay, has a rock sanctuary containing the colossal effigy of the Maheshamūrti, the Brahmanic triad, which unites on one body the three heads of Siva. He is represented in his three aspects: the majestic one, the feminine one and the terrifying god. This is the most magnificent example of post-Gupta rupestrian sculpture, as much from the point of view of size as for its emotional effect.

36. **Detail from the Descent of the Ganges.** Relief at Māmallapuram. 7th century. The Brahmins, most peaceful of men, wait at the river's edge. They carry vases to be filled with holy water, and worship the river with the rapt dedication of priestly men.

The most beautiful examples of this art were produced principally by two schools, those of Sārnāth and Mathurā. The Buddhas are often very tall, have broad circular haloes and are set against steles. From about the 5th century, the drapery is no longer indicated by folds of material but adheres closely to the body to reveal its form. The Bodhisattvas and Brahmanic deities wear a simple skirt held to the waist by a belt, leaving the upper half of the body bare; their adornments, though few in number, are observed in minute detail.

From the 6th–7th centuries, the Gupta style developed into what is known as the Post-Gupta style: gradually its qualities change, the outlines become thicker, the iconographical rules more numerous and more stringent, the ornament more complicated and the physical types more impersonal. The Post-Gupta Buddha nevertheless retains the iconographical characteristics of the Gupta Buddha; and thousands of examples of this type are to be found throughout India and even in the countries of South-East Asia.

In the reliefs, the narrative sense of earlier sculptors continues, but is more adroitly executed. There is less picturesque detail, but a greater mastery of composition. If Buddhist relief tends to degenerate into stereotypes, Brahmanic relief is characterised by a remarkable sense of the monumental, and is much affected by the taste of the period tempered at first by Buddhist elegance and restraint. In the 6th and 7th centuries it acquired its full power and beauty. The great centres were Elephanta, near Bombay (end of 6th–beginning of 7th century), Māmallapuram, on the east coast of the Deccan (first half of 7th century), and Ellūrā, in Mahārāstra (7th–8th centuries). Each of these sites has its own characteristics: purity of line and form at Elephanta, cool elegance, naturalism and dignity at Māmallapuram, power and intensity at Ellūrā.

Wall-painting also reached its height at this time, as much through the beauty of its composition as in its perfection of form, its confident draughtsmanship and brilliant use of colour. The frescoes of the Ajantā group are of outstanding quality. Those of other sites (Sīgiriya, in Ceylon;

37. **The Sleep of Vishnu.** Relief from the Avatāra cave at Māmallapuram. 7th century. Vishnu lies upon the body of the Serpent of Eternity whose many heads form a kind of canopy about the head of the sleeping gof. The majesty of the god is counterbalanced by the peaceful, marvellously rendered figure of the kneeling woman praying at his feet.

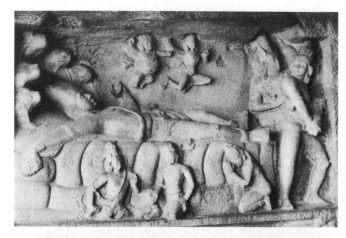

Bāgh, Bādāmī, Sittanavāsal) are less fine, although they have interesting characteristics of their own.

The themes illustrated are religious (Buddhist at Ajantā, Sīgiriya and Bāgh, Jain at Sittanavāsal, Brahmanic at Ellūrā). But these frescoes also provide us with a wealth of information about the life of the time, from the sumptuousness of official ceremonies to the intimacy of family scenes; sacred and profane were constantly intermingled in the social life of ancient India. Ajantā is the most perfect expression of the refined, elegant art of the Gupta period and probably presents a faithful picture of life at court, as described in the rather mannered literature of the time.

The painting occupies the whole of the available surface, without either linear division or any break in the continuity. Among these masses of figures and detail, it is difficult at first sight to make out a guiding thread. Gradually, however, the eye gets used to distinguishing between different groups. Led from one to another by a subtle play of gestures and planes, it finally moves freely from one to another. The link between one group and the next is achieved through the subsidiary figures, just as in relief the half-tones form a transition between light and shade.

Following age-old principles, the Ajantā artists use several vanishing points in the same composition, which gives a certain mobility to the composition. This kind of perspective is similar in every way with the idea of movement implied in a circular composition. Indeed, many of the groups are arranged within a circular or oval scheme that is apparent only in the disposition of the figures, the direction of a limb or of a glance and in the movement of curves and lines. Each group is turned inwards to a centre, like the petals of a flower on to its calyx. The artists of Ajantā handled the circular composition with incredible subtlety. It had first appeared during the Bhārhut period and was to attain ultimate perfection at Amarāvatī. Apart from its aesthetic values, this form of composition also possesses a mystical quality that is rich in meaning, for it is a magic circle, an abstraction of the *mandala*, the imagined shape of the cosmos. In this form, as in narrative relief compositions, there is one unifying idea: to penetrate towards a centre—in the mandala, so that the initiate may encounter the divine, in relief groups to discover the principal figure of the scene. In both cases, it is a question of movement, whether physical or psychological.

The favourite subject of the Ajantā artists is the female body, whose poses not only have an aesthetic value, but correspond to a vocabulary that probably derived from the theatre or from the dance and followed very closely the requirements of the canonical treatises *(sāstra)*. As in choreography, every gesture, every facial expression has a precise meaning intended to provoke precise and documented emotions. But this mimed language is full of hints and subtleties; for the initiate, a mere frown, a movement at the corners of the mouth or a half-closed eye has a particular meaning.

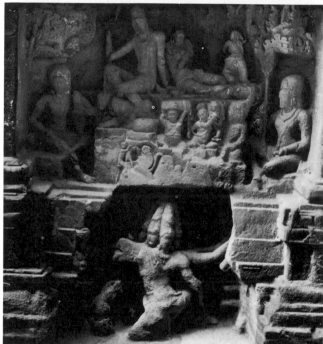

38 (above). **Rāvana shaking Mount Kailāsa.** Kailāsanāth temple, Ellūrā. 8th century. The Kailāsa temple was intended as a replica of the sacred Mount Kailāsa, on the summit of which Siva resided with his wife Pārvatī. With his many arms the giant Rāvana presses upwards and outwards to dislodge the foundations. But Siva with one touch of his foot restores the balance of the mountain, imprisoning the giant in the depths of the earth.

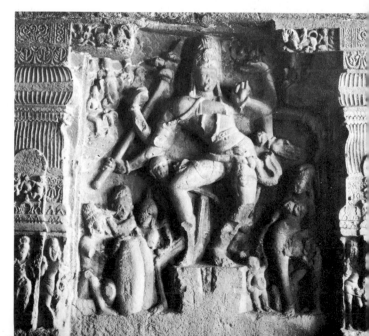

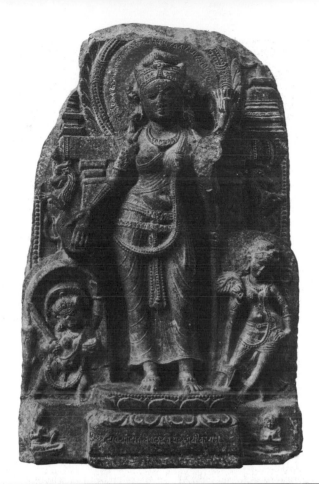

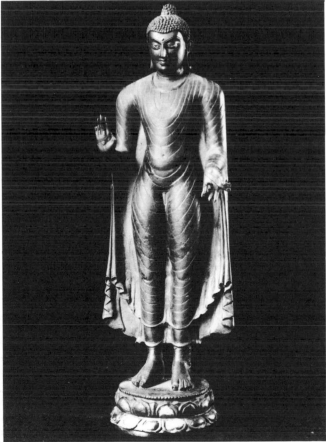

40 (left). **Stele in the Pāla style.** *c.* 9th century. Sandstone. h. 1 ft. 11½ in. (60 cm.). Musée Guimet, Paris. This stele depicts the Buddhist divinity Tārā, the female counterpart of the Bodhisattva Avalokitesvara, 'the compassionate one'. In style it is still close to post-Gupta art. Tārā is placed against a stele with a rounded top. The smaller scale rendering of her supporters accentuates the importance of the central figure.

41 (below, left). **Bronze Buddha from Nālandā.** 9th century. Archaeological Museum, Nālandā. Many bronzes have been found at the Nālandā site. They all belong to the Pāla period, or, more precisely, to the 9th century. Cast by the *cire perdue* method, the bronze alloy consists of eight different metals combined in various proportions. They have affinities with Javanese bronzes and testify to the cultural links between Bengal and the East Indies. The *cire perdue* or 'lost wax' method of bronze casting is achieved in the following way. The work is modelled in wax on a clay core, the wax corresponding to the thickness of the final bronze product. The finished wax model (to which vents and pouring channels are added) is then encased in an 'envelope' of some inflammable material which will burn when the mould is fired. In the firing process the wax melts, leaving the mould into which the metal is poured.

THE PĀLA STYLE

Bengal remained the last bastion of Buddhism, which, as it retreated before the advance of Brahmanism, took refuge in the region that had given it birth. The Pāla sovereigns (*c.* 765–1086) made the university of Nālandā prosper once again and built monasteries there. Their successors, the Sena, on the other hand, protected Hinduism. But the Muslim invasion was spreading slowly eastwards from the Indus valley, and the Pāla-Sena empire was unable to resist its pressure. At the beginning of the 13th century, the Buddhist holy places were sacked and surrounded for a time by a Muslim state.

The Pāla style of Bengal (8th–12th centuries) may be regarded as the true repository of the Gupta style, even if it was unable to revive the creative power of its progenitor. For the 350 years that it lasted, the Pāla style developed on its own, almost sealed off from any outside influence that might have revitalised its wholly conventional forms.

The great Gupta statuary culminated in those stone images which depict a tall central figure flanked by much smaller subsidiary figures, the whole group backing on to a stele. In spite of the great care that was taken to produce pure form and line, they are little more than lifeless reproductions, the work of men whose over-riding concern was to conform to the canons of the past. It is a technically accomplished art, but one that had lost all its sparkle and spontaneity.

From the end of the 8th to the beginning of the 10th century, the sacred images remained very close to the Post-Gupta style. In the course of the 10th century, they became more varied. The figures became taller and more slender, the facial features thicker and heavier, the modelling more slack. This style persisted up to the 11th and 12th centuries, becoming increasingly heavy, dry and mannered.

The bronze images, whose production centred around the famous site of Nālandā, were produced by the *cire perdue* method. Placed in the traditional manner against steles, they are nevertheless set forward from this background so that they can be seen in the full round. Such statues date generally from the 9th century.

40

41

39 (opposite). **The Cave of Rāvana, Ellūrā.** *c.* 7th century. Siva Natarāja, the 'master of dance', possesses eight arms, the symbols of his power. Here he dances to the music of drums and flutes. This particular manifestation of Siva is widely illustrated in reliefs and bronzes. He symbolises the creation of the world, or, more precisely its 'setting in motion'.

The Medieval Period

HISTORY

The Gupta period, with its prolongations, gradually leads Indian art towards a medieval period (*c.* 9th–16th centuries), during which time the political map of India was constantly changing according to the relative power of the different political groups. After the dissolution of the Harsha empire, states that had developed locally made more or less serious attempts to gain control and the struggles between different alliances and coalitions began. Art, in this period, enjoyed unprecedented patronage, each dynasty wishing to outdo another in the number and size of its temples. Regional differences became more marked, and northern India pursued a different course from the south. Certain states stand out particularly—Kashmir, under the Utpāla dynasty, was responsible for some of the most interesting temples of the region. In Kathiāwād and Gujarāt, famous sanctuaries were erected under the Solanki dynasty. Malwa, under the Paramāra dynasty (about the beginning of the 10th century), witnessed a true literary renaissance, particularly during the reign of the poet-king Bhoja (*c.* 1010–65). In Bundelkhand, the Chandella dynasty built the famous temples of Khajurāho (*c.* 1000).

In south India, Mahārāstra saw a succession of great dynasties. After the Chalukya and the Rāshtrakūta, who built the Kailāsa of Ellūrā, the second Chālukya held sway until 1190, when the empire was broken up by the Hoysala,

who were then reigning in Mysore. Lastly the Carnatic, already enriched by the buildings of the Pallava, saw the rise and fall of the Cholas and the Pandyas. The Cholas reached the height of their power between 985 and 1052 and built, among others, the famous temple of Tanjore.

THE DEVELOPMENT OF ART: FORMS IN ARCHITECTURE

The gradual abandonment of rock-cut architecture and the use of free-standing structures made of durable materials such as stone and brick allowed the prevailing rules of sculptural development to be interpreted more freely and broadly, gradually leading Indian architecture towards increasingly ambitions constructions.

This period saw an increasing diversity of architectural forms based, in principle, on their function and upon the nature of the site, but certain types were nevertheless to dominate in certain regions. In all of them, characteristics from previous periods are to be found. The Hindu temple preserved its characteristic of space limited on all sides, enclosed within a thick shell of masonry. Half-light reigns almost everywhere, blurs the decoration and envelops the visitor with its mystery, forming a violent contrast with the reliefs of the exterior, which, vibrant with light, tend to raise one's eyes towards the top of the building. This contrast helps to emphasise the feelings of respect and fear that overcome the worshipper as he enters the temple and impress upon him the idea of the mysterious and divine. Corbelling in horizontal layers—a type of vault adopted almost exclusively by the Indians—tends to accentuate this feeling of mystery. Most buildings have a square ground-plan, covered either by a pyramidal or a curvilinear roof. These derive from an earlier type that originated in the 7th century. It was at this time in fact that the Brahmanic temple began to reveal certain permanent characteristics. Laid out on a single base, and developing from a single support, on a single axis, are a pillared porch, a vast pillared hall, a vestibule and a square sanctuary around which runs a narrow corridor, which enables the worshipper to make the ritual circumambulation. Until the beginning of the 10th century, this plan, with some variations, was common to both north and south. The strongly angular form of its different components distinguished it from the ground-plans of the following period. Confronted with the problem of inscribing within space a work which was to be both beautiful and based on the traditional rules, the Hindu architect succeeded, with unerring taste, in creating a complex of niches, foliated cusps and pilasters that broke up any monotony in the general lines by the addition of an abundance of ornamental or architectural sculpture.

From the 10th century, particularly in Orissā (Bhuvanesvar, Konārak) and in Bundelkhand (Khajurāho), the main parts of the temple merge into each other: the porch preceded by a flight of steps that spans the basement, is covered by a roof supported by pillars and leads into a

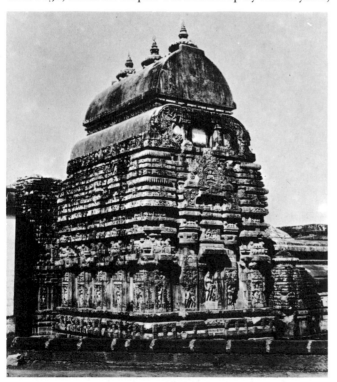

42. **Vaital Deul, Bhuvanesvar.** 8th–9th centuries. The sanctuary of Vaital Deul is rectangular in plan, and is covered with a barrel vault. Flanked by four smaller chapels, it forms the prototype of the *panchayatana* i.e. the arrangement of five buildings in a quincunx—a central structure with four auxiliary buildings placed at the corners of the basement.

25,2
34,3

(Continued on page 121)

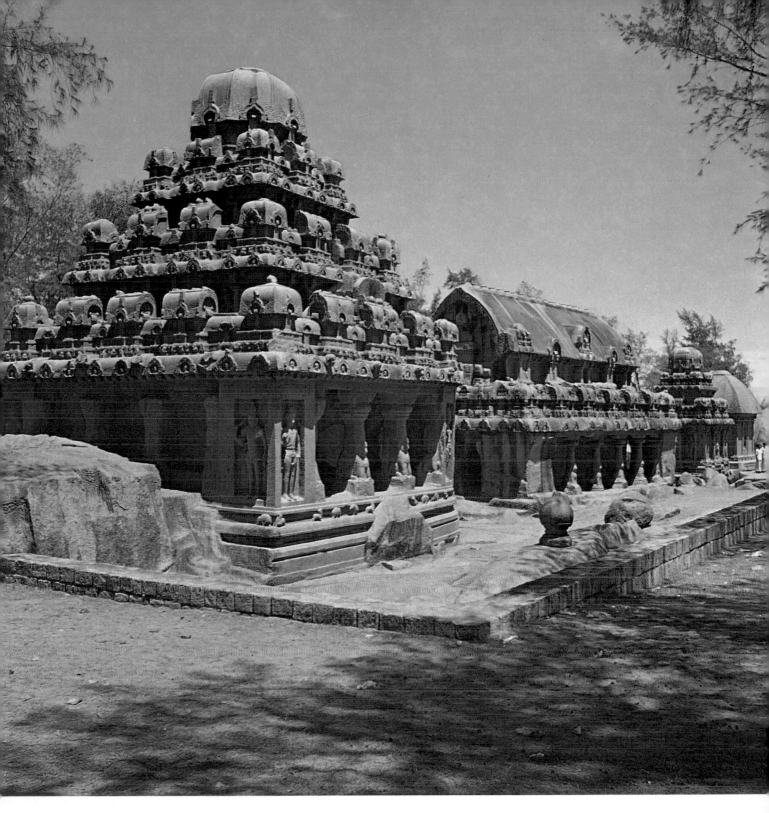

19. **The temples at Māmallapuram.**
7th century. The craftsmen of the
Pallava Kingdom carved a long outcrop
of rock into the shape of a group of
temples and then proceeded to sculpt the
surfaces and hollow out the interior.
Side by side can be seen sanctuaries with
pyramidal roofs and those with barrel
vaults which were to lead respectively
to the most ambitious architectural
achievements of southern Indian in
medieval times.

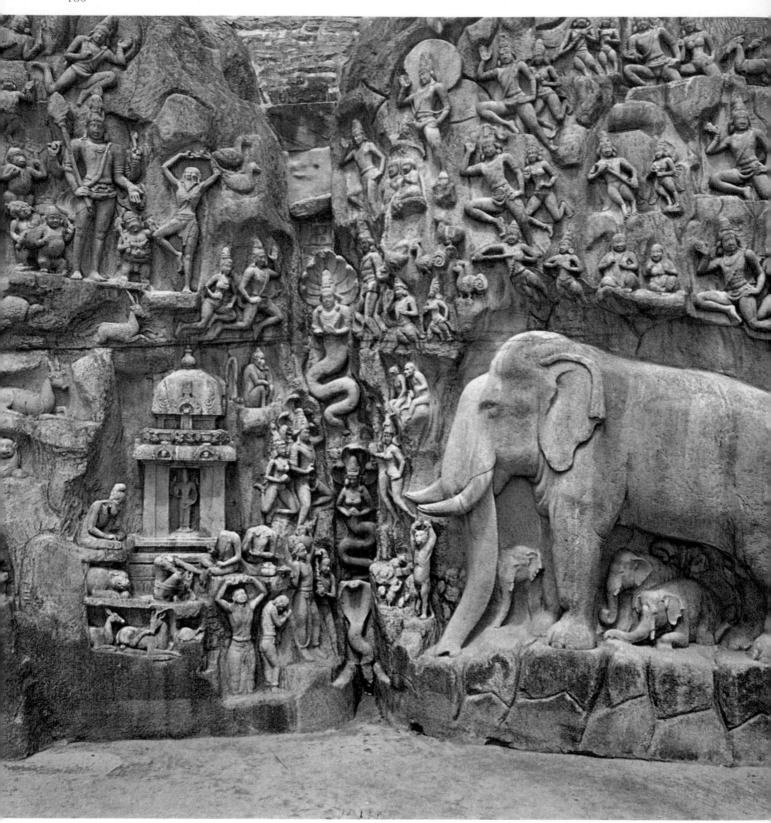

20. **The Descent of the Ganges.**
7th century. Relief at Māmallapuram.
The river, in the guise of serpent-men,
is the focal point of the entire
composition, and all sorts and conditions
of men in prayer, and all kinds of
animals are moving towards it. These
converging movements give the
composition an overall unity, but each
part is interesting on its own, and the
mass of individual detail is astounding.

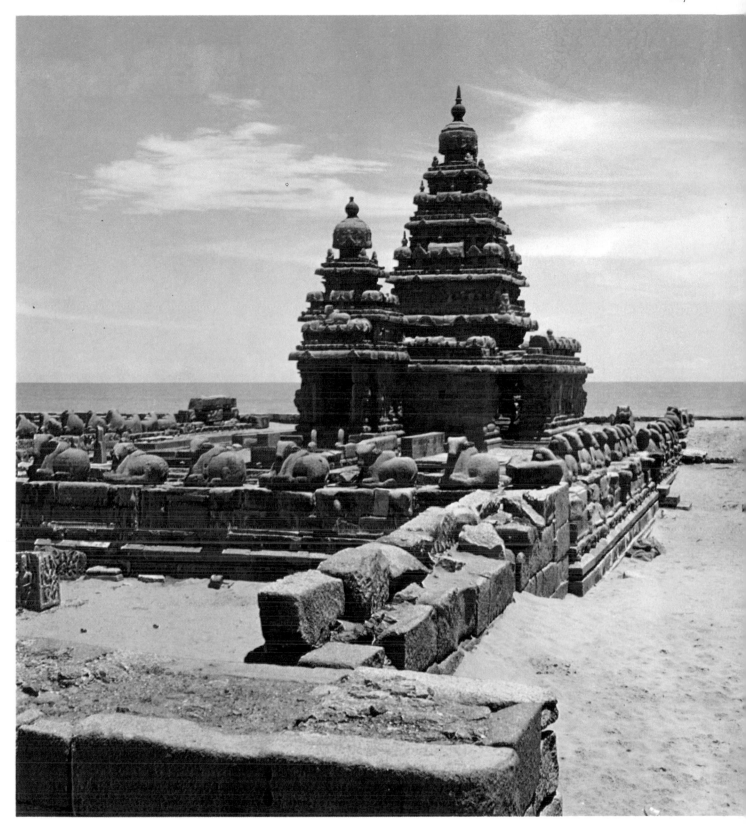

21. **Shore temple, Māmallapuram.**
8th century. This temple consists of a
building square in plan, covered by a
polygonal dome and with a columned
porch *(mandapa)* in front. In the Indian
fashion, an increasing number of 'storeys'
are interpolated between the main body of
the building and the summit of the roof.

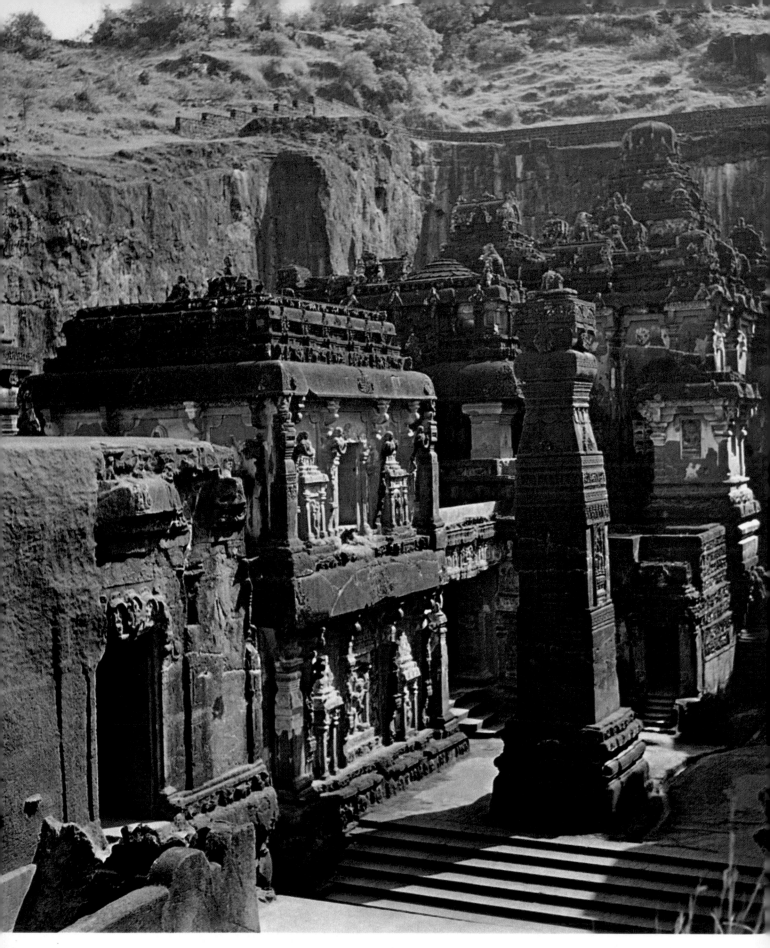

22. **Kailāsanāth temple, Ellūrā**.
8th century. The various temple buildings
are composed of vast masses of living rock
which were separated from each other by
the craftsmen and carved individually in
a long slope of the hillside. The sanctuary
is 100 feet high and represents the cosmic
mountain which was the residence of the
god, Siva.

23. **Sculpture at Kumbakonam.**
8th century. The sculpture of the Pallava
Kingdom is rooted in the past, but it also
has affinities with medieval Dravidian art.
Its main characteristics are the elegance
of the forms, quiet dignity and a rather
cool formality.

24. **The monastery at Ratnagiri.**
9th century. Buddhism flourished in
Orissā, as in Bengal, in the centuries
preceding the Muslim invasion, and the
Buddhist monasteries there such as
Ratnagiri also prospered, though they did
not achieve the fame of the Nālandā
ones.

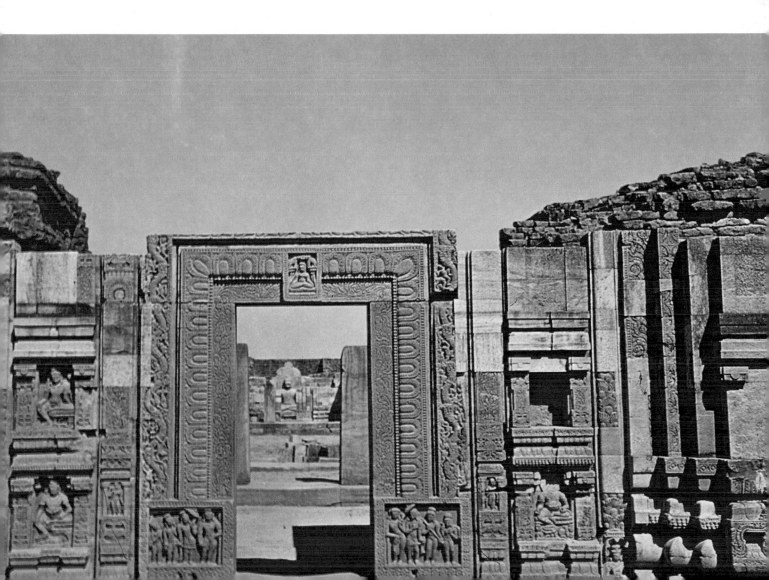

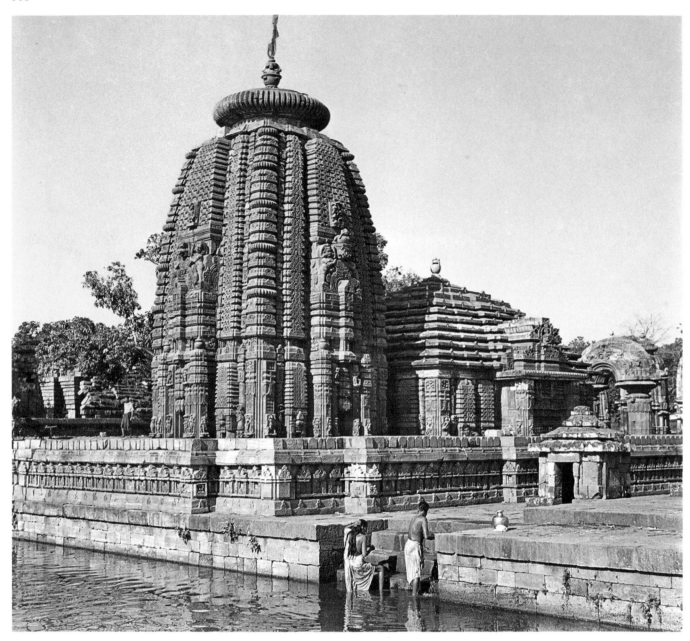

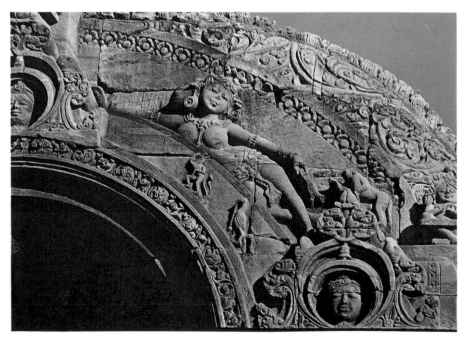

25. **Muktesvara temple, Bhuvanesvar.** 9th–10th centuries. This temple has a roof whose 'storeys' are very close together, giving a ribbed effect to the whole building. The *sikhara* on top of the sanctuary has a vertical feature jutting out from each of its sides, and is surmounted by a large ribbed cushion (*āmalaka*).

26. **Torana of the Muktesvara temple, Bhuvanesvar** (detail). 9th–10th centuries. The *torana* originated in the leafy branch stretched between two posts as a sign of a festival or of homage, which developed into a gateway, first of wood, then of stone, such as the ones at Sāñchī (see plate 3), and the crosspieces were eventually joined into one arch. The arch of the *torana* at the Muktesvara temple is decorated with garlands, with *kudus* and with graceful female figures.

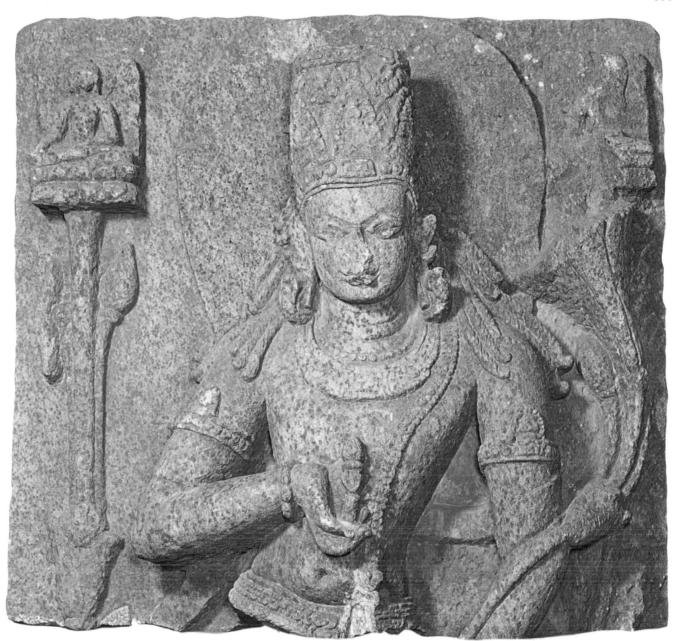

27. **The Bodhisattva Vajrapani,** found at Lalitagiri. 9th century. Granite gneiss. h. 27½ in. (70 cm.). Musée Guimet, Paris. Vajrapāni, 'bearer of lightning', appears in Buddhism from the beginning of the Christian era, and is often to be found near the Buddha on the bas-reliefs of the Gandhāra school. The one illustrated belongs to the post-Gupta art of Orissā.

28 (p. 112). **Mother and Child.** 8th–9th centuries. Sandstone. h. 15¾ in. (40 cm.). Musée Guimet, Paris. This statue is characteristic of the medieval period in northern India, and expresses all the tenderness of Indian women for children. It is small in size, like most of the sculptures decorating the walls of the Orissā temples.

29 (p. 113). **Gopuram of the Kailāsanāth temple, Kānchīpuram.** 8th century. Pallava period. This is one of the first gopura (outer gateways of a temple) in the Dravidian style. It is rectangular in plan, and has a barrel-vaulted roof terminating at each end in a horseshoe-shaped bay. A row of slender vertical features decorate the summit of the barrel vault.

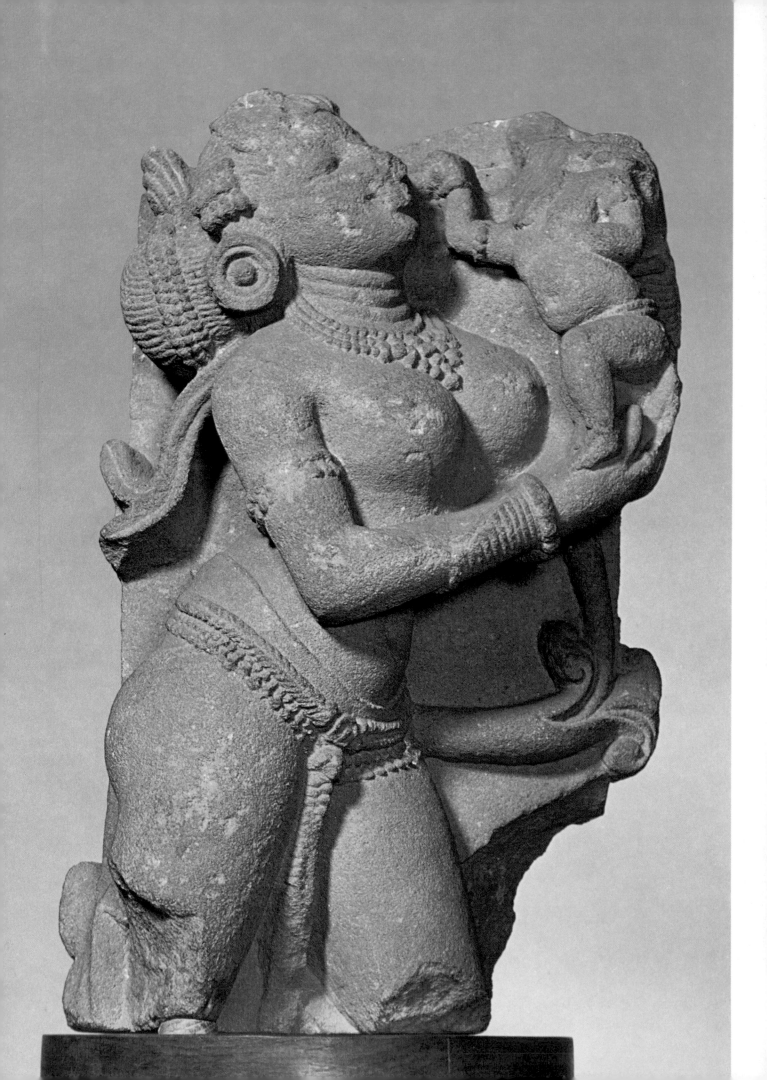

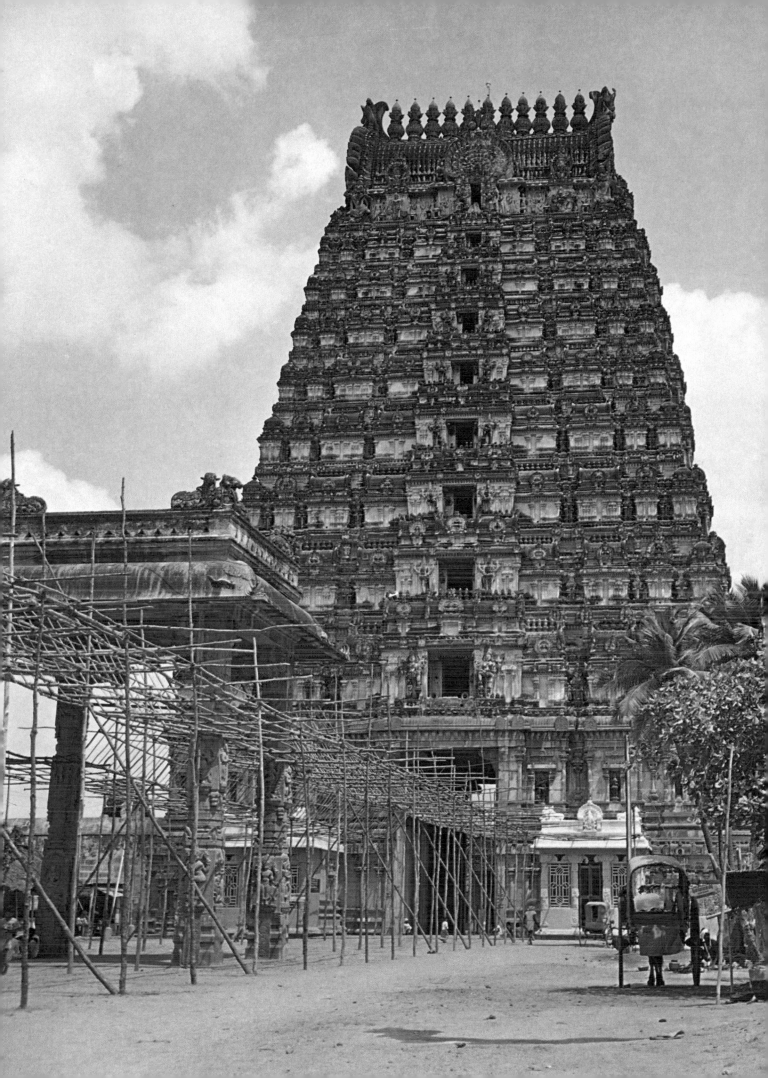

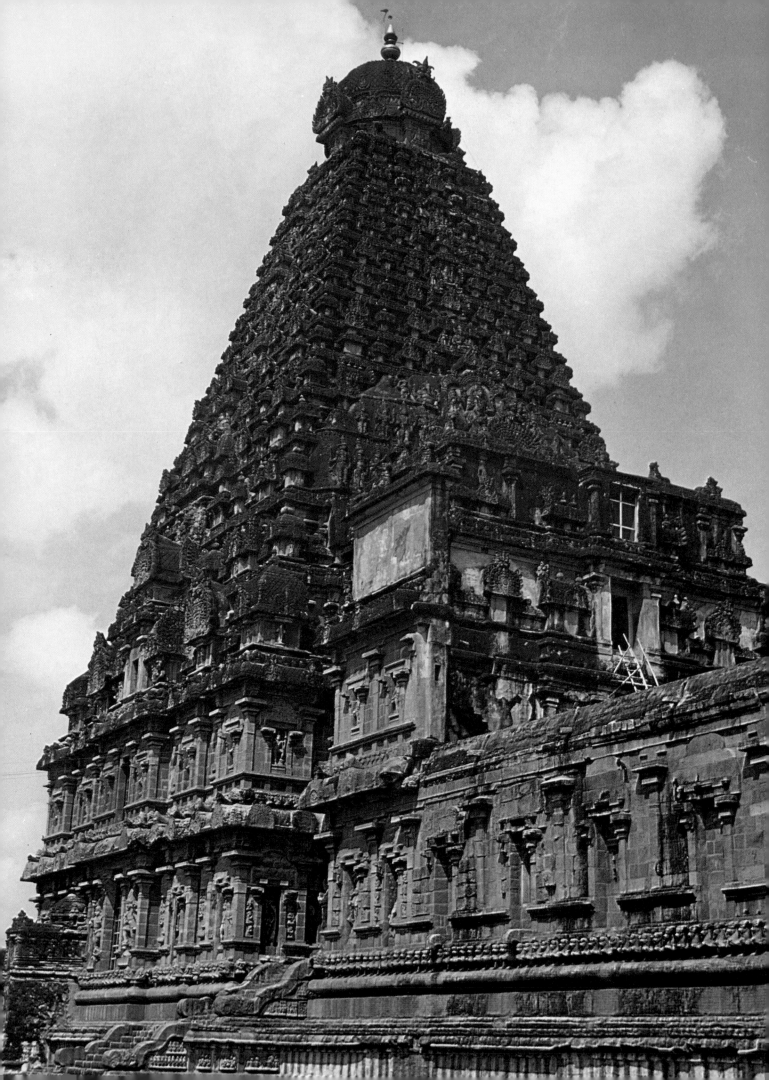

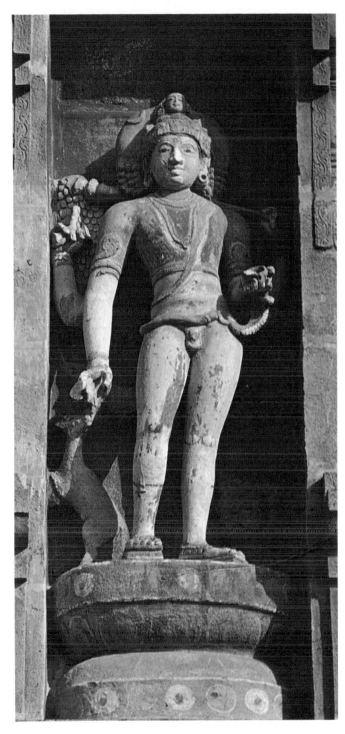 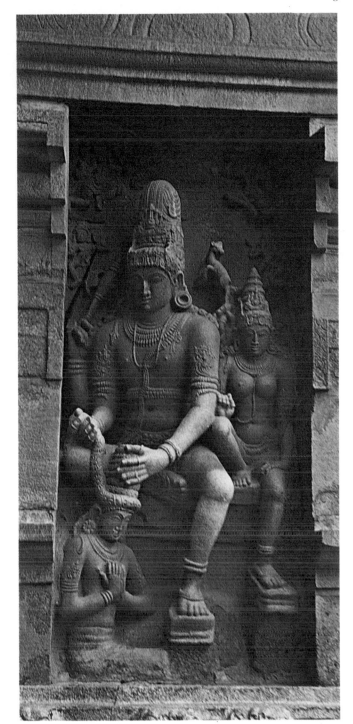

31 (above). **Siva Bhairava, Tanjore.** 10th–11th centuries. This is one of the many figures which decorate the great temple at Tanjore. It is characteristic of the Chola period in its proportions and restraint. The god Siva is shown in his most alarming aspect as Bhairava, 'frightful, terrible, horrible'. The figure is usually naked, the hair stands on end. He is draped in garlands of skulls and serpents, and sometimes accompanied by a dog.

30 (opposite). **Brihadīsvara temple, Tanjore.** 10th–11th centuries. This twin-towered temple is perhaps the most imposing example of the pyramidal from. Each roof comprises a great number of individual 'storeys', and each storey forms a cornice upon which miniature buildings are placed. The ribbed cupola perched up at a giddy height can no longer properly be called a roof, but is a crowning decorative feature.

32 (above). **Relief from the Brihadīsvara temple** at Gangaikondacolapuram. 11th century. King Cola Rajendra I (1012–1044) who conquered territories as far as the Ganges took the title Gangaikondacola: 'Cola who took the Ganges'. He established a new capital with a pyramidal temple like the one at Tanjore. Here he is seen being crowned by the god Siva.

33 (next page). **Siva Vīnādhāra.** 11th century. Bronze. h. 2 ft 1 in. (69 cm.). Musée Guimet, Paris. This representation of the god, which comes from south-eastern India, shows him as Vīnādhāra, the 'master of the arts'. He is shown as a musician, because according to Indian tradition music was not only the quintessential art, but the inspiration of all creation. The bronze was cast by the 'lost wax' method and is a masterly example of that technique. The grace of the gestures and the balance of the silhouette make this figure particularly successful.

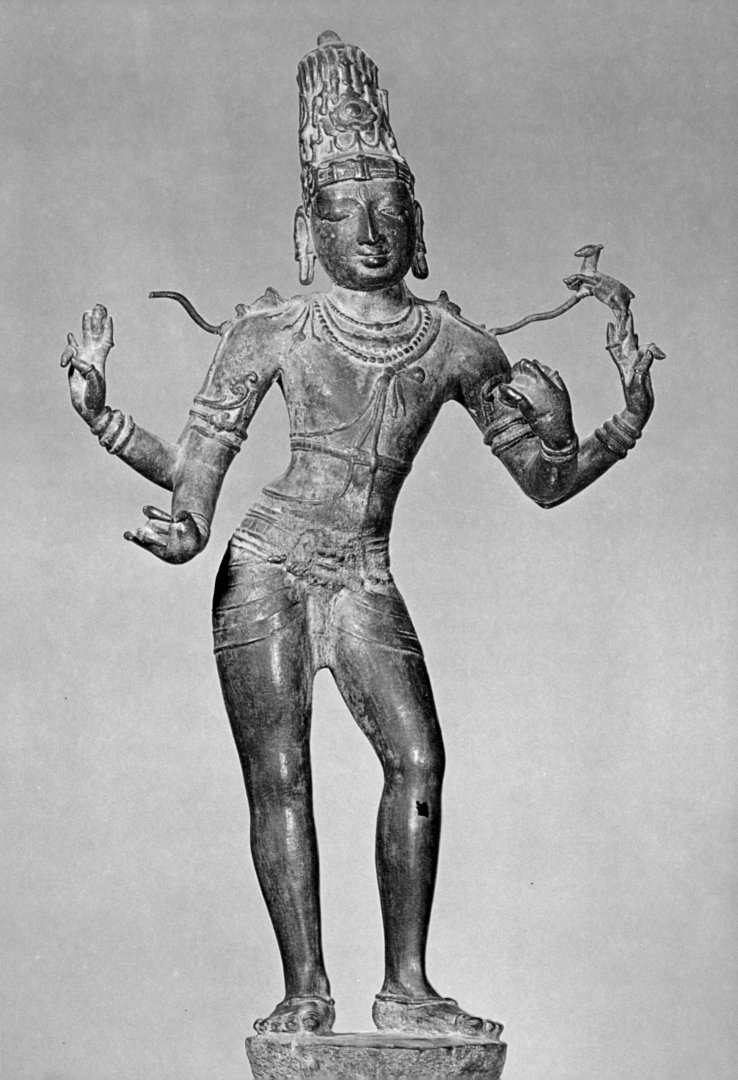

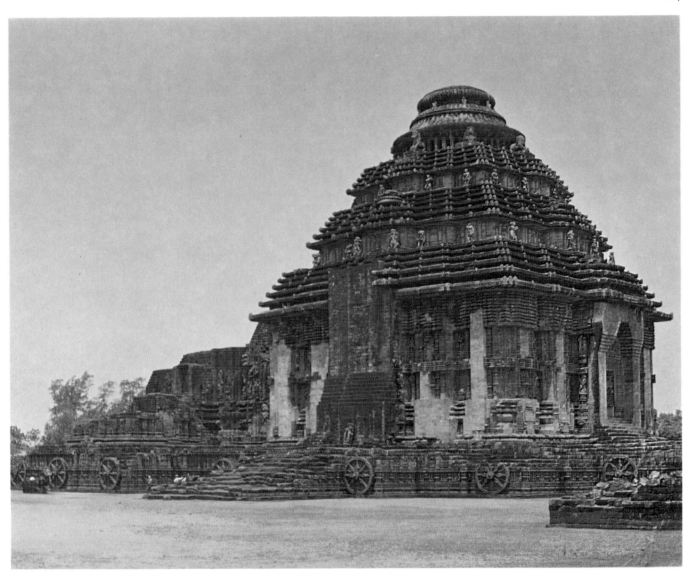

34. **Temple of Sūrya, Konārak.**
13th century. The immense temple of
Sūrya at Konārak in north-eastern
India was built during the reign of King
Narashima-Deva (1238–1264).
Dedicated to the sun-god Sūrya, it is in
the form of a gigantic chariot drawn by
the seven horses of the sun. The base is
decorated with twelve wheels ten feet in
diameter, and on the entrance side with
seven horses.

35. **Detail of a wheel,** Sūrya temple,
Konārak. Like all the temples in
Orissā, the temple of Sūrya, sometimes
called the Black Pagoda, is decorated
with numerous sculptures of mythological
animals and persons, and with erotic
couples. Here one of the wheels can be
seen in detail, the spokes filled with
exquisite decorative carving.

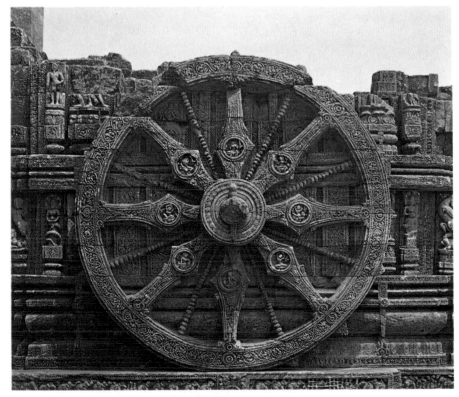

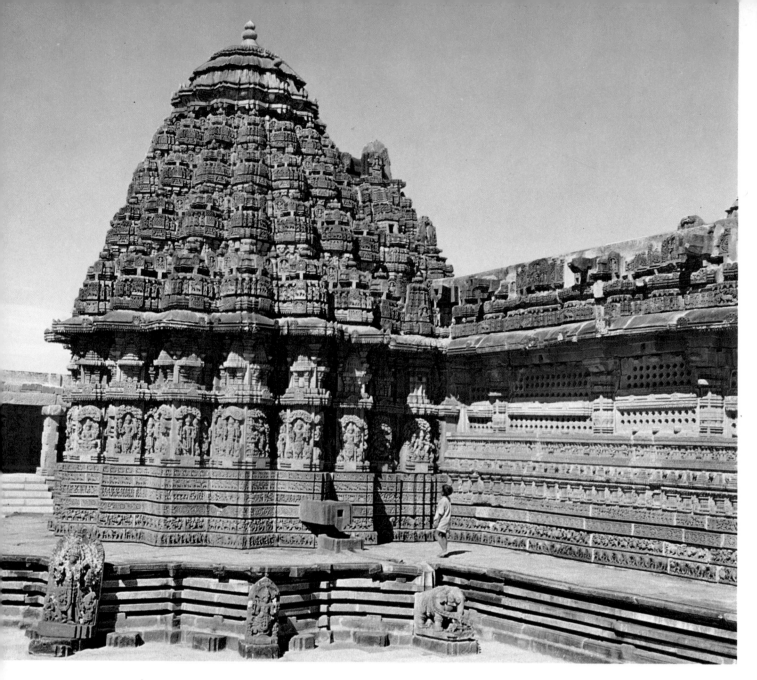

36. **Chenakesvar temple, Belur.** 12th century. The architectural style of Mysore was created by the Hoysala dynasty. The temples are based on elaborate geometric ground-plans of which the star form is the most original. They have flat roofs, perhaps unfinished, or perhaps deliberately left bare. The walls are covered with sculpture, which, although prolific, are really only ornamental.

37. **The story of the Jain monk, Kalaka,** (Kalakacharyakathā). Gujarāt miniature. 14th–15th centuries. $4\frac{1}{4} \times 2\frac{3}{8}$ in. (11×7 cm.). Musée Guimet, Paris. While Jain themes are illustrated in the miniatures of Gujarāt, few references to that religion are to be found in sculpture. These miniatures bear little sign of Mughal influence; they display affinities, rather, with Persian and Chinese painting deriving directly from the first Muslim settlements in India.

38 (opposite). **Vishnu.** Mysore style. 13th century. Basalt. h. 5 ft. (150 cm.). Musée Guimet, Paris. The god Vishnu, 'the sun which traverses space', is represented in Vedic religious art in innumerable different ways, and his cult acquired correspondingly diverse features. He is represented here as a young god with two pairs of arms, bearing in his hands a shell, a sun-disk, and a club.

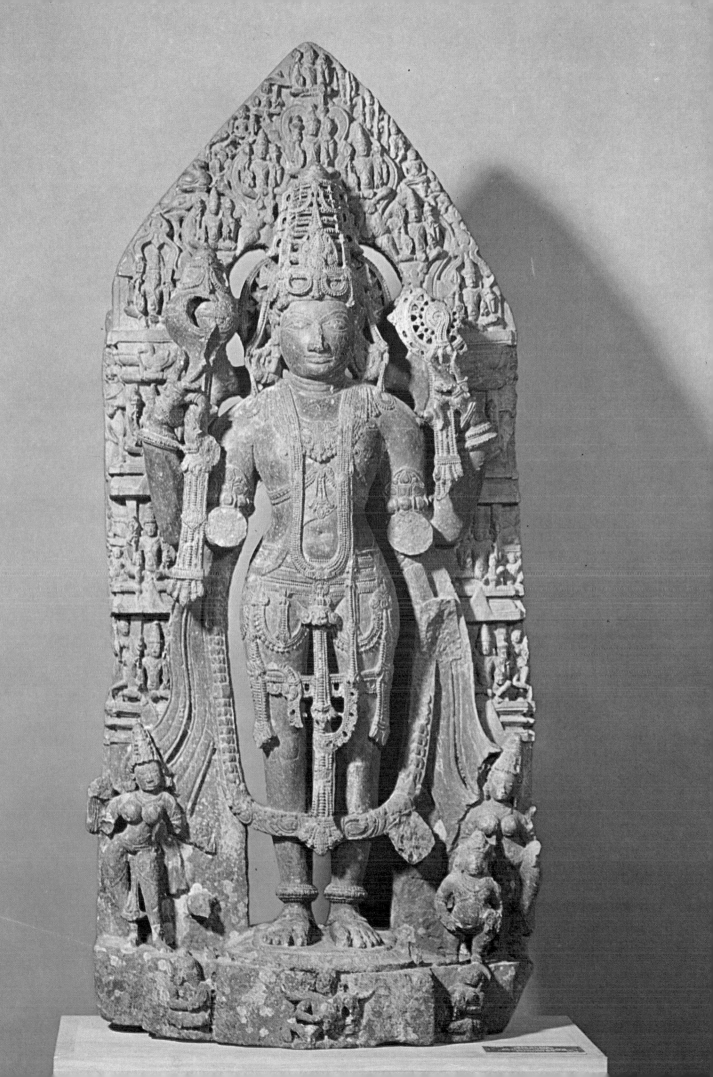

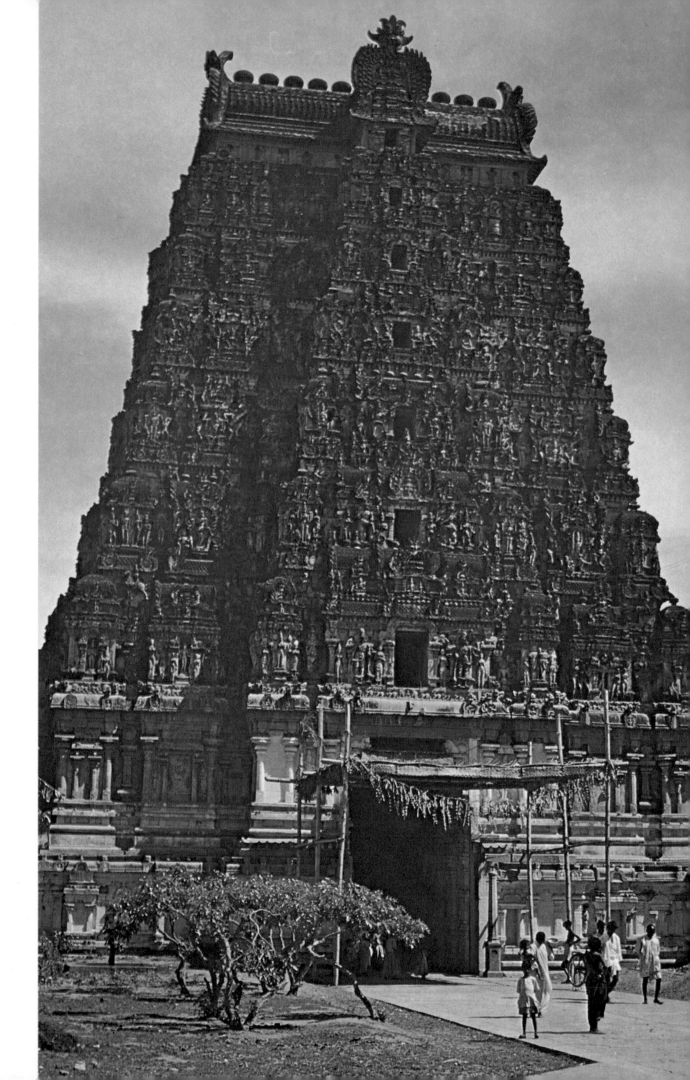

large pillared hall *(mandapa)*, which often has a transept the arms of which were sometimes used as side chapels. Opposite the entrance, the sanctuary vestibule *(antarāla)* gradually narrows until it reaches the cella *(garbha griha)*, which remained small and square in plan. There is not always an ambulatory. These parts are encased in thick masonry, which, from the outside, forms a cross of Lorraine.

An increasing number of foliated cusps mask this general outline. They disguise the angles of the transepts and give each block a circular appearance (as at the temple of Sūrya at Modhera, for example) or a star-shape (as in the temples
36 of Mysore). The main mass of the sanctuary and its subsidiary buildings are constructed of durable materials. With one type, however, separate chapels are placed at the
43 four corners of the main building (as at Kandāriya and Vishvanātha of Khajurāho). This group comprises a *pancha yatana* (five sanctuaries).

Architectural treatises have classified the temples in different ways. Some list them according to region, others to form. The first classification distinguishes three main groups: *nagara* (the provinces of northern India, comprising a region between the Himalayas and the Vindhya mountains), *vesara* (central India, stretching from the Vindhya to the river Kistna) and *dravida* (south India, situated between the Kistna and Cape Comorin). This classification has the disadvantage of restricting each type of temple to over-rigid geographical boundaries and is moreover contradicted by the facts; it may indicate no more than the origin of the different types and not their later distribution. It would seem preferable therefore to confine ourselves to the forms of the temples themselves, while referring to the texts when necessary.

The temple with pyramidal roof derives from Post-
19 Gupta sanctuaries such as those of Māmallapuram or Ellūrā. It consists of a square body whose outer walls are decorated with pilasters; its pyramidal roof is stepped inwards in imitation of a storeyed building, with miniature buildings placed around each exterior level. It is surmounted by a dome-shaped monolithic block. The miniature buildings, arranged regularly in decreasing scale one above another, echo in a simplified form the standard buildings with their connected pillars and their roofs pierced by false windows that are generally known by the Tamil term, *kudu*. Up to about the 11th century, each 'storey' or stage comprised three or four of these miniature buildings, square at the corners, rectangular in the middle. A dramatic development took place around the year 1000, when this type was enlarged to form a high multi-staged

39 (opposite). **Gopuram of the Srīrangām temple.** South-East India. 15th century. This type of building, which is found in medieval southern India, is a development of the square-plan structure with barrel vault, a development based on the elaboration of the individual elements. Just as the ribbed dome surmounts the pyramidel roof, so here the barrel vault itself is raised to the top of the towering pyramid, no longer serving as a vault but as a cresting to the roof.

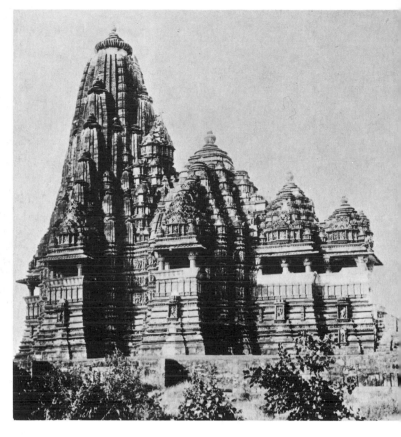

43. **Kandāriya Mahādeo, Khajurāho.** Beginning of the 11th century. This temple is one of the finest examples of curvilinear building construction. In its plan it observes the ritual exigences of Brahmanism and the majesty of medieval architecture. The outer walls of the cella and vestibule are covered with extremely fine sculpture carved in such high relief that it is almost free-standing.

pyramid, the finest example of which is to be found in the great sanctuary *(vimāna)* at Tanjore. The almost continu- 30 ous line of thirteen diminishing storeys gives this sanctuary an emphatically pyramidal outline and enormous height (88 feet). The central kudu now has a purely decorative function, providing a pediment which breaks the monotony of the decoration of the pyramid.

On this basic principle, every region of India was to elaborate endlessly. The most remarkable are those of the south-east, which generally consist of sanctuaries with monumental gateways *(gopura)* covered by barrel-vaults. The gopuram is basically of the same form as the temple 29 with pyramidal roof. Rectangular in plan, its huge roof is crowned by a head-stone carved into the shape of a barrel-vault. Its very ancient origin is easily recognisable in the city gates depicted on the reliefs of the 2nd or 1st century BC. But according to the laws of Indian architectural development, the bold multiplication of the 'storeys' of the roof between the body of the building and the barrel-vault raises the latter to a great height and culminates in the monumental gopura that are among the most original

39,40 creations of south India. The vault that leads to the centre of the whole roof is constructed by corbelling. It is surmounted by storeys that can be reached by internal staircases and are lit by a vertical line of bow-windows placed at the centre of each side and diminishing in size towards the summit. The ribbed vault at the top is decorated with innumerable pinnacles, and with a great horseshoe-shaped gable at each end. The huge roof, often concave in profile, is punctuated by a broad foliated cusp projecting from each side and its structure is almost obscured by the quantity of carved detail. One of the finest is the eastern gopuram of the temple of Siva at Chidambaram which according to a lapidary inscription dates from the 13th century.

The type of sanctuary with a square ground-plan but a curvilinear roof also seems to appear about the 6th and 7th centuries. It may have been brought about by the use of brick; its storeyed roof gradually curves towards the summit and its angles are softened by the addition of spherical features, which look like ribbed cushions, known in Indian architecture as *āmalaka*. This type of roof is called a *sikhara*. Its prototype seems to have been the temple of
31 Lakshmana at Sīrpūr, but there are numerous examples from the 7th and 8th centuries. In about the middle of the
42 8th century, a new development occurs. The roof is composed of tiers that are much closer together than in the pyramidal type, giving the whole building a ribbed look that became more pronounced as time went on; at the corners, placed vertically one above the other, are kudu alternating with ribbed cushions (āmalaka). This superimposition forms a kind of broad beading that softens the corners and which has continued in use until the modern period. A vertical projection stands out on each side; it is decorated at the base with a large kudu that serves as a decorative pediment. The sikhara, curving inwards towards the summit, tends to adopt a tall, ogival shape. The roof becomes higher and culminates in a large āmalaka. Then everything becomes systematic: the kudu form a kind of decorative lattice and the general outline becomes particularly slender (as in the Parsvanātha of Kharjurāho, for example).

In about the 10th century, a second type emerges and it, too, gave rise to numerous variations. Small sikara *(anga-sikhara)*, corresponding to the miniature buildings on the pyramidal roofs, appear. They are placed one above the other, from the base to the summit of the roof, between the projections of each side and the cushions at the corners, as
25 at the Lingarāj at Bhuvanesvar, whose sikhara reaches to a height of 180 feet. Alternatively, the anga-sikhara are
43 placed in regular rows between the projections of each side; or, again, usually fairly large, they are placed on the middle band formed by the projection of each side of the roof and are arranged symmetrically between the projections and the beading at the corners. This type, at first rather heavy, culminates, as in the temple of Lakshmana at Khajurāho, in the magnificent flow of the curved lines of the roof.

The two main architectural types, the temple with a

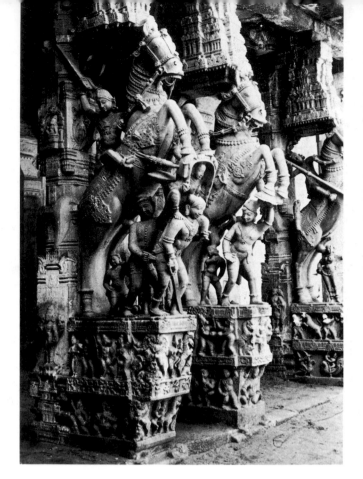

44. The Mandapa at Srīrangām. 15th–16th centuries. During the Gupta period, the mandapa was simply a columned portico. Here, however, it has become a building in its own right, with numerous pillars loaded with sculptural decoration. The rearing horses are characteristic of the Dravidian style of Vijayanagar.

pyramidal roof and the temple with a curvilinear roof, become the main components in the composition of vast architectural complexes—the Brahmanic temples now become veritable religious cities contained within circular **40** walls. They contain several thousand inhabitants and accommodate large numbers of pilgrims. Among the permanent residents are the priests who serve the chapels and sanctuary, the temple servants, whose innumerable duties are listed in the foundation charters, the craftsmen working within the walls, the sacred dancers, whose function is the entertainment of the god, the musicians appointed to mark the hours and add to the celebration of festivals and ceremonies, and the swarming mass of beggars and tradesmen selling garlands of flowers and all kinds of votive offerings and holy relics. These architectural complexes, many of which are still in use, are astonishing accumulations of different buildings arranged in successive courtyards, in many different ways, each temple possessing its own character. The only constant factors are the internal composition of the central mass and the presence of an independent mandapa not far from the eastern gate of the outer wall. In many regions, particularly in the south, building still goes on and still follows the traditional patterns, though with an increasingly lifeless line and a debasement of form.

SCULPTURE

Sculpture has now become more than ever an integral part of architecture. The sanctuary walls are peopled by an

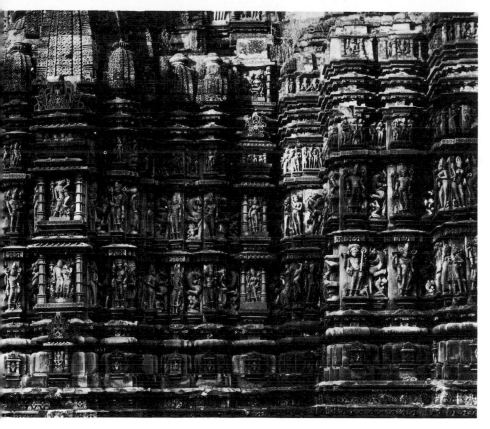

45 (left). **Jagadamba Devi, Khajurāho.** Details of the decoration. 11th century. The temple of Jagadamba Devi is a framework to support a multitude of sculpted figures. With their various attributes, gestures and attitudes, these people lend to the walls of the temple a secret, throbbing life, exposed to or hidden from view by the play of light and shade.

46 (below left). **Heavenly couple from Khajurāho.** c. 11th century. Sandstone. h. 25 in. (65 cm.). Archaeological Museum, Khajurāho. This is one of many pairs of divinities which cover the walls of temples, in which the life of the gods, made in the likeness of men, is celebrated. The tender relationship between the two figures is suggested with wonderful subtlety, and the rhythm, balance and perfect proportions are astonishing.

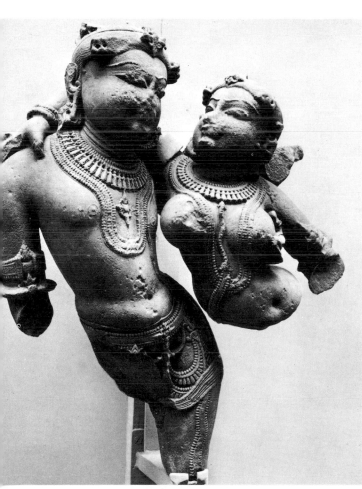

astonishing mass of figures, statues of gods executed almost entirely in the round, with only a small part of the back touching the wall. The Indian sculptors of the medieval period excelled in this technique. The temples of Khajurāho, Bhuvanesvar and Konārak (11th–13th centuries) are covered with sculptural groups of an exceptionally fine quality, sometimes of average size, sometimes quite small, they are delightfully arranged and their gestures, never once repeated, bring the temple walls to life. They are the swan song of Indian sculpture and their rather stylised, exaggerated forms include the arabesques of the tribhanga and the languid attitudes so dear to the earlier periods. The stylisation is apparent in the facial features, in the full nose, the huge eyes sloping upwards towards the temples, the sensual lips and an expression that is at once intense and yet immobile. One sees vast numbers of loving couples and erotic groups. The former, known as *mithuna*, had been part of the Indian artistic repertoire since the 1st century AD. According to the texts that mention them, they seem to have been symbols of good fortune. The erotic groups are treated with a nobility which excludes any idea of coarseness. Prudery was quite unknown to Indian artists, who had no conception of 'the sins of the flesh' with which Western civilisations were so preoccupied particularly in the 19th century. For them, as for all Indians, the act of love was part of Nature and therefore nothing to be ashamed of. It was regarded as essentially symbolic of the mystical union of the soul with the divine, and in the art of Orissā and Bundelkhand it became a natural expression of great beauty.

The sculpture of the southern temples is not of such a high quality. Many of them are signed, and the best sculptures are the bronze figures made by the *cire perdue* method. Sacred images, they conform to a fairly rigid iconography. They nevertheless have great aesthetic quality and are

45, 46, 47

45

46

31, 32
48, 49, **33**

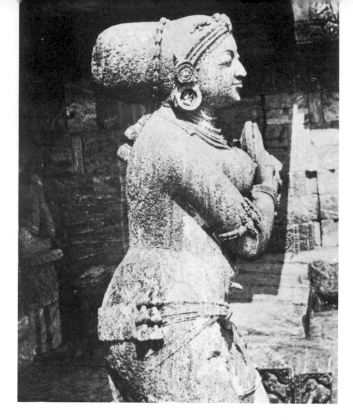

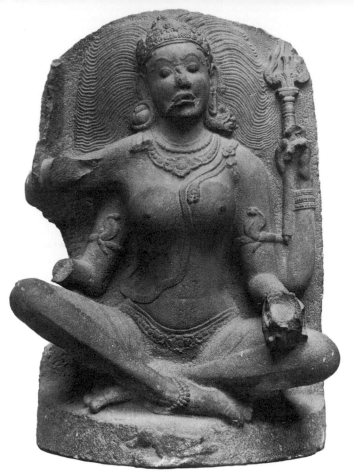

47. **Figure of a divinity, Konārak.** 13th century. This is one of many figures of gods and goddesses which cover the walls of the Orissā temples. The Sūrya temple at Konārak is particularly famous for its sculpture. On the terraces of the roof, punctuating the lines of the cornices, are monumental figures of female musicians and dancers. Intended to be seen at a great distance, they have a majestic beauty.

remarkable for their purity of form and sense of balance and movement.

With the Muslim invasions of the 14th and 15th centuries, a decline occurs in both north and south. Works of art seem to be executed in a lifeless way; the flame has vanished. But the custom of decorating the walls and even the ceilings with a multitude of statues continued. The structure of the gopura of south India almost disappears beneath the mass of carved decoration and, despite their rather poor quality, the effect created by this accumulation of detail makes the whole exterior throb with life. This is the baroque carried to the ultimate extreme, but it shows Indian architectural sculpture in its quintessential role — the temple is truly the support of the celestial world, and its very structure is a pulsating proof of this.

Whereas the art of relief no longer enjoyed the favour it had had in past centuries, mural painting continued to decorate temples and palaces, but it had lost most of the qualities that had brought it to its height during the previous period. It preserved a certain vigour but had become mechanical and there is a poverty of composition, an increasing stylisation in the figures, a simplification in the use of colour and a general naivety of conception. The frescoes of the 10th and 11th centuries at the Kailāsanāth of Ellūrā are marked by a peculiar stylisation of the faces: in a face seen in three-quarter view the nose, which is fairly pointed, is in profile, the eyes bulge, the eye behind the nose being particularly staring. This is a convention that is to be found again in the miniatures of Gujarāt. The frescoes of the **37** *vimāna* at Tanjore (11th century) display quite a spontaneous sense of rhythm and supple, sensitive brush-strokes.

48. **Matrikā.** Dravidian style. 10th–11th centuries. Basalt. $43\frac{3}{4}$ in. (111 cm.). Musée Guimet, Paris. The iconography of the female form constitutes a kind of complement to the treatment of the male divinities (compare figure 49). The Seven Mothers (matrikā) illustrate this difference perfectly. Each of the seven embodies a different female power, from the most imposing to the most gruesome.

49. **Headless figure of Vishnu.** *c.* 11th century. Sandstone. h. $37\frac{3}{8}$ in. (95 cm.). Musée Guimet, Paris. Chola sculpture continues the tradition of the Pallava. Restraint, elegance and simplicity are the characteristics of this dignified art.

Muslim Art

THE MUSLIM CONQUEST

The Muslim invasions interrupted with dramatic suddenness the cultural development of many Indian states. Islam's conquering armies arrived in the Punjāb as early as 775 and gradually reached each of the states in turn. In 1019, Kanauj was sacked by the Turk Mahmud of Ghazni; in 1021, the whole of the Punjāb passed into the hands of the Ghaznavids; and whereas, in 1199, Bihār and Bengal were incorporated into the Afghan kingdom of Ghor, the kingdoms of Banāras and Bundelkhand were included in the Sultanate of Delhi. Kāthiāwād and Gujarāt resisted longer and succumbed only in 1297. The states of the south also saw their dynasties fall beneath the attacks of the Muslims: Mahārāstra was annexed to the Sultanate of Delhi in 1317–18. The Pandyas were wiped out in 1310. Only the dynasty of Vijayanagar, which had succeeded the Hoysala in Mysore in about 1327, resisted until as late as 1565, when the battle of Talikota gave the Mughals effective power.

The Muslim advance brought with it political and religious re-organisation. At the beginning of the 13th century, Muhammad of Ghor founded the powerful Sultanate of Delhi which extended its sovereignty over several states of the south. In the 14th century, however, the Sultanate began to break up into ten or so local dynasties, until, in 1527, it was conquered by the Turk Babur, a descendant of Timur. Babur now founded the Mughal empire. His grandson Akbar (1556–1605) extended his conquests to northern and part of central India. But Akbar was not only a conqueror; he was also a great administrator, and during his reign the arts enjoyed one of their richest and most refined periods. He proved himself to be liberal and tolerant towards Hinduism. He tried to establish officially a kind of higher synthesis and protected the development of an eclectic theism. Akbar's son, Jahāngir (1607–27), and grandson, Shāh Jahān (1627–58), were equally enthusiastic protectors of the arts. But the fierce iconoclasm of Shāh Jahān's second son, Aurangzeb (1659–1707), had grave consequences for the development of Mughal art and its decline can be dated from this time.

Developing the style they had created in Persia, the Muslims provided India with a large number of magnificent buildings, both religious and civil: mosques, tombs, citadels, palaces and monumental gateways. They varied the basic forms with great skill and each region of India developed a style of its own. The Kuwwat al-Islam and Jama'at Kana mosques and Kutb Manar minarets built in Delhi in the 13th and 14th centuries were obviously of Persian inspiration. But in Sind, Gujarāt and Kathiāwād, a style was created that can really be called Indo-Islamic, for the mosques were built with materials taken from the Hindu and Jain temples that had been partly destroyed during the Muslim iconoclastic period. In this way, the principal components of the Hindu temples—pillars and corbelled domes enclosed in thick walls of masonry—were adopted. On the outside, these buildings followed Islamic forms, while preserving within a marked Indian character.

The Mughal style was derived from the purest Islamic forms. Northern India, particularly Agra, Delhi and Lahore, was covered with buildings that were remarkable both for their size and for the richness of their materials. The most famous is the Tāj Mahāl at Agra, the mausoleum of the wife of Shāh Jahān. The architecture has an elegance and a simplicity quite foreign to Indian art proper. A dazzling surface decoration is the only indulgence, but in no way does it detract from the purity of the lines. The decoration of the buildings erected during the reign of Akbar (Sikandra, Fatehpur Sikri) is obviously the work of Indians. The south, too, developed a more or less Indianised style. The best-known buildings are to be found in Gulbarga (14th century), Golconda and Bijapur (16th–17th centuries); they are particularly notable for their bulbous, ribbed domes, which are among the largest in the world.

44, 45

THE MINOR ARTS

Stone and ceramic mosaic, which first appeared in the 13th century, were used for the decoration of buildings and for floors during the Mughal period. Ceramic tile decoration which, sometimes covered surfaces of enormous size, is often very beautiful and represents animals, flowers and geometrical patterns in several colours.

On the whole, the Mughals had a favourable effect on craft techniques, though ancient Indian art had already shown great mastery of goldsmith's work, woodwork and other minor arts. Indeed, metalwork, which had been practised from early times in India, underwent a real revival in the 16th century. Iron and steel were reserved for weapons, some of which are particularly elaborate in design, gold and silver for vessels and jewellery. Usually one metal would be inlaid with another—tonal contrasts being particularly sought after. Damascening was achieved by several methods, the simplest of which consisted of making fine scratches on the surface of the basic metal and filling these with gold or silver thread, which was then carefully hammered. The metal could also be sculpted or chased. Jewellery, which was more varied than in the past, used a wide range of techniques, materials and forms.

50

The production of glass, which had also been brought from Persia, was of fine quality, and goblets and bowls of exquisite delicacy were carved out of rock crystal. Jade was also much used: sword hilts and jewels were often made of jade inlaid with precious stones set in gold.

43

Woodwork is one of the oldest arts in India, but during the Mughal period inlay and marquetry were used with great effect. Mother-of-pearl on ebony was particularly favoured; it was cut out into small pieces according to the pattern required and each piece was fixed on to the wood with tiny pins. Again of Persian origin, enamelling was completely revived under the Mughals, and some dazzling results were achieved. The finest enamels date from the 16th–18th centuries and are executed in *champlevé* on gold or silver.

50. **Ankusha, or elephant hook.** 17th century. Gilt bronze
with enamel inlay. h. 26¾ in. (68 cm.). Musée Guimet, Paris.
Elephant hooks were used by the mahouts, or elephant keepers,
from time immemorial. They can be seen, for example on the
reliefs at Sāñchī. This one is clearly a ceremonial object, not
intended for practical use. The dexterity of the Indian metal-
worker is seen at its most accomplished.

BOOK ILLUSTRATION

It was in the field of book and manuscript illustration that the Mughal occupation made its greatest contribution to the arts of India. This kind of illustration had already existed in India from an early date, although no ancient examples have survived. Until the appearance of paper, probably introduced into India from Iran about the 14th century, paint was applied to cloth, wooden panels or palm-leaves. The earliest miniatures to which precise dates can be given are no older than the 11th and 12th centuries. They belong to the school of Bengal and were obviously influenced by traditions prior to those of Islam or were only slightly affected by it. The subject-matter is Buddhist. The colours are particularly rich, red often being used as a background. The compositions are varied and although naive in spirit are executed with great skill. Landscapes are reduced to a few elements, and the stylisation—especially of the trees—is reminiscent of the ancient reliefs of Bhārhut or Sāñchī. In Nepal, there also existed a school of Buddhist painting, but one more conservative than that of Bengal; only traditional subject-matter was used, and that in an unoriginal way, with strict attention to iconography.

37 The school of Gujarāt (12th–17th centuries), which derived its themes from Jain legends, is somewhat crude in execution but has a personality all its own. With its red or blue backgrounds, its increasing use of gold and stylisation of the faces that derives directly from the Ellūrā frescoes (8th–12th centuries), it is very close to mural painting and in both style and technique serves as a transition between this type of painting and the miniature. (Much of the technique of fresco-painting was still employed, although it was quite irrelevant for the execution of a miniature.) Produced from the late 14th to the 17th centuries, first on palm leaves, then on paper, the Gujarāti miniatures reflect the various influences to which Gujarāt was subjected through its position on trade routes and on the path of invading armies. This region received influences from Chinese Turkestan and Afghanistan and was one of the first to be occupied by the Muslims. These foreign influences merged with the Indian tradition to give these miniatures a curious appearance: the landscapes and animals betray Persian and Chinese influences, the architecture and furniture are of local inspiration, Muslim figures are dressed in their national costumes and their faces are shown full-face, whereas the Jain monks, with faces shown in half-profile, wear their robes, with the right shoulder left bare. The monks have the stylised features that are to be seen in the Ellūrā frescoes (10th–11th century) and which were later used in the puppets of the shadow theatre.

The introduction of paper brought a great increase in the painting of small pictures to illustrate books for the libraries of the emperors and princes, and the influence of the Mughal emperors was to be strongest in the field of illustration. They brought famous Persian painters to their court to depict the great deeds of their heroes, the Mughal conquests and scenes of pageantry, festivals or court ceremonial—in other words, anything that would celebrate the power and wealth of the emperors. The Indianisation of the Iranian style, however, can be seen to have taken place very quickly for Indian artists gradually joined the palace studios and the collaboration of the artists of the two countries meant that their respective ideas and traditions merged. The Mughal style was, after all, 46 rather conventional. The figures were shown in profile or semi-profile, hardly ever full-face, but occasionally from behind. The Persian use of the landscape persisted even after the European influence had introduced chiaroscuro and a treatment of trees and landscapes copied from Western styles of the 17th and 18th centuries. Contrary to usual Indian practice, the Mughal miniatures are often signed.

One miniature was not usually the work of a single artist: the composition was conceived and drawn by a master and the colours applied by other members of the studio, one of whom executed the costumes, another the faces and a third the details of jewellery, weapons and other accessories. A single model was often used for several copies. They were executed from the sketch kept by the master draughtsman and on which the instructions for the colours were noted. These sketches were very highly prized and were carefully preserved by their creators who handed them down to their descendants as family heirlooms.

The Mughal school had a strong influence on all the many regional schools that flourished in the princes' courts in Rājputāna, Bengal and the Deccan. These schools do 50 not always have the refinement and technical skill of the imperial school, but drawing their inspiration from Indian traditions—religious, mythical and popular—they have greater spontaneity, sometimes bolder stylisation and they revive the narrative and pictorial sense that had been the glory of the relief sculptors of the ancient schools. The Rājput school split up into innumerable sub-groups, which were attached to two main groups: the Rājput miniatures known as Rājasthānī, and the miniatures executed 49 in the Himalaya region known as Pahārī, or 'of the moun- 48 tains'. Most of them are anonymous. The Rājput painters belonged to the guild of artisans and could paint murals for buildings as well as miniatures. Belonging as they did to a hereditary profession, they formed what was almost a caste and lived with their families. Design was the dominant element in their work, in which a taste for the picturesque was given free reign. But the general style, the costumes and innumerable other details reveal a close connection with the Mughal school.

A very special category of miniatures belongs to the Rājput school: *rāgamāla*, or music painting. This was an attempt to translate a poetic theme into pictorial terms according to a melodic mode. It is like music seen through poetry—a very Indian way of conceiving a total art.

RELATIONS WITH EUROPE
DECLINE AND RECIPROCAL INFLUENCES

It was during the period of Mughal domination that the European penetration of India, begun by the Portuguese in the 15th century, became more active. The descendants of Aurangzeb, exhausted by internecine struggles, were unable to sustain the Mughal domination and the European powers, in their efforts to re-establish throughout India an order that would benefit their trade, took firm root on the sub-continent. First, they established trading centres. These were soon followed by missionaries whose influence on Indian artists was strong and on the whole felicitous. Western influence was transmitted through copies of engravings, either Biblical or secular, and through the introduction into the Mughal miniature of Western perspective, relief and chiaroscuro imitated from the Italian, Dutch and French schools. The first copies were ordered from the court painters by the Emperor Akbar himself, to whom the Jesuits have given an illustrated Bible. From the 16th century, the Mughal miniaturists often reproduced European engravings, paintings and enamels, applying themselves with praiseworthy effort to the forms and colours of a style so foreign to their own; sometimes they were content to place among the Indian and Muslim figures of their compositions, foreigners whose physique and dress betray their Western origin.

If European engraving influenced the Indian miniature in this way, reciprocally, the direct relations between India and Holland in the 17th century enabled large numbers of Indian works of art, particularly miniatures, to reach Holland. Rembrandt himself was sufficiently tempted by their novelty to make a few copies of miniatures, which are now in several European museums. One painter, Willem Schellinks, a member of Rembrandt's circle, who had many opportunities of seeing Indian miniatures, painted a curious picture, now in the Musée Guimet, Paris, which shows a kind of spectacle taking place on the stage of a theatre. Perhaps the painter wished to depict a masque, of the kind so popular in the 17th century. In doing so, he abandons himself to the exoticism of his period, but in the best sense, since he remains very faithful to his subject-matter even in the smallest details. Because of the extreme precision of the work, one can easily recognise the principle characters: Akbar, Jahangir, Shāh Jahān and his four sons. This identification is confirmed by an inscription in a scroll held by one of the minor figures in the bottom left-hand corner of the picture. Another, very similar work by the same painter has been acquired by the Victoria and Albert Museum.

Later, in the 19th century, painters of the Sīkh school, in the Punjāb, painted portraits of English and Dutch people.

Unfortunately, from the end of the 18th century, Indian painting fell into a decline and the miniaturists of the 19th century, not knowing how to distinguish the value of the European models they encountered, copied poor and superficial works in a slavish and unintelligent way. At the end of the 19th century, however, a reaction set in and an attempt was made to regenerate Indian art by freeing it from the influence of European art and returning to the great lessons of the past. A group of painters, aided by a number of Europeans, notably E. B. Havell, director of the Government School in Calcutta, tried to improve the standard of painting, which had then declined to the stage of providing popular images for pilgrimages. It needed all the conviction and enthusiasm of this movement, which originated in Bengal, to undertake the rehabilitation of Indian art in the eyes of the intellectual elite of its own country. The Tagore family played a leading part in this movement, particularly Abanindranath, the nephew of the poet, who published studies and commentaries of ancient treatises and was himself a painter, paying special attention to problems of technique. He recommended the study of ancient Indian art and a return to traditional subjects. He succeeded in creating a current of interest, and gradually progress became more apparent; a new style was born that tended to combine the technical experience of Europe and the traditional inspiration of India. Rabindranath Tagore himself took up painting at the age of sixty, producing works of great interest and astonishing modernity.

In the course of the 16th–19th centuries, in the fields of architecture and the minor arts, hybrid works were to be found in the European trading centres: and Indo-Portuguese style on the west coat, particularly at Goa; a Louis XV style at Pondicherry and other French centres; an Indo-Dutch style in the same region. Finally, a large number of objects were produced in India intended for export to Europe.

Indianism, the study of the civilisation and art of India, was born in Europe at the end of the 18th century with the foundation at Calcutta by Sir William Jones, of the Asian Society of Bengal in 1784. In 1822, the *Société asiatique de Paris* was founded and in 1862, under the direction of Sir Alexander Cunningham, the Archaeological Service of India, whose important work continued for many years until it was finally handed over to Indian archaeologists.

(Continued on page 137)

40. **The Great Temple of Madura:**
gopuram and cloister. 17th century.
The great Dravidian temple complexes,
such as Madura, consist basically of a
vast walled enclosure pierced at the four
cardinal points by monumental gateways
(gopura), and with a sanctuary at the
centre. This quadrilateral area contains
innumerable buildings arranged
apparently with no regard for order,
together with cloisters and tanks or
basins for the Hindu ritual ablution.
At the centre is an immense courtyard,
designed to hold the crowds which
gathered to see religious processions.
It is truly a city in itself with a maze of
courts and colonnades. In this picture
the scale of the gopura which towered
over the inner city can be appreciated.

41, 42. **Carved wooden panels from processional chariots.** 17th century. Teak. h. 2 ft. 7 in. (80 cm.). Musée Guimet, Paris. The Indian craftsmen of the 17th century produced fine sculpture not only in stone and bronze, but also in wood. These panels originally formed part of the decoration of processional chariots. The god Vishnu, the second member of the Hindu trinity, was often depicted in one of the series of his incarnations *(avatāra)*. There are ten main forms in which he is represented during his 'descents' to earth. On the left he is shown as Krishna, the shepherd-god, who gave birth to a mystique based on 'trusting worship'. On the right Vishnu is shown in animal form as the boar Varahā, immersed in water in order to retrieve the flooded land.

43 (opposite). **Mughal sword hilt in the shape of a horse's head.** 17th century. Jade. l. 16½ in. (42 cm.). Musée Guimet, Paris. This magnificent jade sword hilt is encrusted with precious stones and inlaid with gold. It is typical of the Mughal style, and such pieces are often illustrated in the miniatures of the period.

44. Akbar's column, Fatehpur Sikri. Rising from the centre of the Diwan-i-Khas, the private audience chamber, this pillar supports a circular platform, which is linked to the corners of the building by four bridges. This enabled the Emperor Akbar to reach the platform without being seen, so that he could listen to the discussions between the learned religious leaders, scholars and missionaries who gathered in this chamber. The thirty-six moulded stalactite brackets, which form the capital, and the pierced balconies are of great delicacy.

45. **General view of Fatehpur Sikri.** 16th century. Founded by the Emperor Akbar, Fatehpur Sikri, the 'city of victory', is situated to the south-west of Agra and was completed in a very short space of time. It comprises numerous buildings, palaces and mosques, and is bounded on three sides by a wall and on the fourth by an artificial lake. The city was inhabited only from 1570 to 1585, after which it was abandoned because of a lack of water. It has remained intact to this day. On the left can be seen the Diwan-i-Khas (see plate 44), built of pink sandstone.

46. **The Emperor Babur with Bedi Az-Zamān Mirzā.**
Mughal miniature. End of 16th – beginning of the 17th century.
$9 \times 5\frac{1}{2}$ in. (23×14 cm.). Musée Guimet, Paris. The
miniatures of Mughal India give one a vivid impression of
ceremonial at the courts of the Emperors. Not only the
architecture, but costume and domestic objects, too, are
minutely observed.

47. **Shepherds and their flocks.** Mughal copy of a
European painting. $10\frac{5}{8} \times 7\frac{7}{8}$ in. (27×20 cm.). Musée
Guimet, Paris. Copies of European works of art by Mughal
artists are fascinating both for their careful imitation of the
European style, yet at the same time for their inability to
understand every detail. The 'Flemish' farmhouse has a
Mughal dome, and the faces of the shepherds are distinctly
Indian.

48 (left). **A Prince and his Favourite.** Miniature in the Pahārī style, school of Chambā. 18th century. $10\frac{5}{8} \times 7\frac{7}{8}$ in. (27 × 20 cm.). Musée Guimet, Paris. Inspired by the Mughal court, local princes, whether allies of the Emperor or not, encouraged local schools of painting. While imitating the general style of the Imperial court, certain local differences were preserved, in colour schemes, in choice of subject-matter and in the treatment of motifs.

49 (below, left). **The Planet Saturn.** Rājasthānī miniature of the Bundi school. *c.* 1770. $10\frac{5}{8} \times 7\frac{1}{2}$ in. (27 × 19 cm.). Musée Guimet, Paris. The Rājput school of painting remained faithful in subject-matter to Indian Brahmanic themes. But they adopted the Mughal interest in architecture and landscape, and abandoned line in favour of flat tones.

50 (below, right). **Couple in a garden.** Miniature of the Deccan school. *c.* 1750. (26 × 17 cm.). Musée Guimet, Paris. Persian influence is clearly visible here in the flowered border to the miniature, and in the decorative treatment of the yew-trees and flowering shrubs. The muted colours, characteristic of the local schools of southern India, give this painting a rather sombre feeling which is emphasised by the stiffness of the figures.

51. **Detail from a Burmese
manuscript.** 19th century. Musée
Guimet, Paris. This manuscript, which
is dated 1869, is closely allied to modern
Siamese and Cambodian styles in
painting. It shows the *Nimi Jataka*, one
of the principal earlier lives of the
Buddha. Nimi, the hero, journeys through
heaven and hell. Below, the souls in
torment are subjected to every
imaginable refinement of cruelty. Above,
the celestial hosts are entertained with
music and dance. At the top left, Nimi
can be seen in his chariot traversing the
spheres.

52. **Angkor Wāt.** First half of the 12th century. The temple of Angkor Wāt is the masterpiece of Khmer architecture. In the disposition of its parts it reflects the elements of the cosmos just as the Indian temples do. This relationship between the celestial and terrestrial planes emphasises the direct mystical link between god and man. The temple consists of a vast pyramid on three stages, supporting five towers linked by covered galleries, and surrounded by a moat. The masses are arranged in such a way as to give a wonderfully rhythmic balance to the whole ambitious complex.

53. **Apsaras, or celestial dancer.** Relief at Angkor Wāt. First half of the 12th century. One of the crowning glories of the temple of Angkor Wāt is the series of *apsaras* or *devatâ* which range along the walls of the different courts. The slim, youthful figures of these celestial dancers are placed at the base of the walls. Naked to the waist, they wear a strange kind of clinging skirt with flaring panels carefully carved with incised decoration.

Conclusion

THE GOVERNING LAWS OF THE INDIAN CHARACTER
Indian civilisation is founded upon three basic concepts: the sacred, the universal, the ritualistic. Within its terms of reference everything human can be related to the divine. Art appears not as an aesthetic fact, but as a phenomenon inseparable from the life that it tends to illustrate. It is an image, perhaps even an emanation of the divine. Art evolved in a religious 'climate' that has prevailed throughout history and which provided its essential qualities. It obeys the established laws that are in perfect harmony with the Indian character and to which India owes her real cohesion beneath all her paradoxes and contrasts.

The laws that govern the Indian character are basically strength of tradition, a taste for rules and regulations and a tendency to bring diversity into unity. The strength of tradition has made India into a kind of religious museum; changes come very gradually, by gradual absorption rather than metamorphosis. The taste for regulation extends to almost every field of Indian life. It is this, among other things, that has brought about the caste system, which maintains the social structure in a rigid religious straitjacket, and the creation of a vocabulary of gestures, which apply equally to religious ritual, the theatre and the plastic arts. It is this that explains the peculiarly Indian concept of the cosmos and the identification of the ideal order of the divine and human worlds. Between these two worlds, everything is based upon analogy and everything conforms to a coherent scheme in which universal elements correspond to and are parallel with elements in the social order. This identification of the human and divine enables man to exert his influence upon the gods: the technique of Brahmanic sacrifices is worked out to this end, as are all the Indian ritual techniques, including those on which the creation of works of art are based. The tendency to bring diversity into unity is a focal metaphysical concept despite the contradictions of innumerable sects and local beliefs, and a slow but steady evolution has led India from apparently the most elaborate polytheism to a mystical pantheism. Very different local divinities gradually took on the characteristics and names of great gods, and were then incorporated in the official pantheon, acquiring some of the characteristics of the great god that had absorbed them.

In the artistic field, these laws determined a very slow evolution. Being almost self-sufficient, the effects of foreign influences were minimal, and were invariably absorbed or distorted to become utterly Indian. Canonical texts (*sastra*) set down aesthetic and iconographical rules, and artists were also guided by a whole sculptural vocabulary composed of 'speaking' gestures (*mudra* or *hasta*). These were minutely classified according to subject, colour, line and a system of comparisons or parallel images or associations of ideas, based more on the spirit of the subject than its external qualities. In this way, an artist could create a work that conformed exactly to the aesthetic code.

For the Indians, sculpture is inseparable from other techniques linked to ritualism and they reject the idea of separate fields which we regard as distinct. Although India lays down a hierarchy of the arts, according pre-eminence to music, it nevertheless affirms the existence of a total art and the impossibility of practising one without knowledge of the others. This interdependence of one art form upon another can always be recognised: thus the reliefs and paintings seem to be the faithful reproduction of theatrical scenes, that is, divine scenes mimed by human beings, with all their gestures, attitudes and groupings. In turn, theatrical scenes reproduce a repertoire similar to that of sculpture with all the subtlety of its expressions.

It is also to this dual impulse to diversify the One and to canalise the Many towards the One that some of the iconographical peculiarities created in India must be ascribed. Seeking solutions to the plastic representation of simultaneous actions, of the union of divine opposites and equivalences, artists proceeded in the true Indian way, that is, by arranging natural elements according to an intellectual idea. They did not hesitate to indicate the omnipresence of a god by giving him several faces. Similarly, to affirm his omnipotence, he was given several pairs of arms. The union of opposites is expressed very simply by a character being divided vertically into two halves and being given a double name: thus Harihara unites Siva and Vishnu and Ardhanari represents Siva and his female energy (*sakti*).

The Indian artist worked according to a mental prototype, a transposition of reality, an aspect of the thing recreated and rethought. He did not reproduce the object seen, but the object known. The aim of art was to manifest and thus participate in the 'play' of nature whose forms it exalted and whose effects it suggested. It reproduced unseen, but known objects, basing these upon real forms; the artist's personal feelings were never expressed. It is neither naturalistic, idealistic nor subjective art.

The canons which art had to obey did not paralyse the artists, however, but provided them with a grammar from which they could draw an inexhaustible supply of modes of expression. Their imaginations were free to create endless variations on a few main themes; in this way, no one work was ever identical with another. A balance was maintained between creative thought and the norms defined by the treatises. Encouraged by their mission of bringing the divine down to the world of men, the Indian artists drew inspiration from a mass of lively popular beliefs.

A collective activity created for the community, Indian art reflects both religious life and that of society; it perpetuates the ideal existence of past times, from which incomparable rhythm and beauty emanate.

54

Appendix

51. **Relief at Barabudur.** 11th century. There are nearly two thousand reliefs at Barabudur, covering the concentric walls of the galleries which culminate in the immense pedestal of the stūpa. Astonishingly consistent in style, the reliefs illustrate scenes from the life of Buddha and edifying Buddhist stories. Here the Buddha is shown bathing in the river Nairañjanā.

THE INFLUENCE OF INDIA IN SOUTH-EAST ASIA

Indian culture penetrated the countries of South-East Asia entirely by peaceful means. This was the result of a series of enterprises by traders, adventurers, scholars and monks. Operating from Indian settlements that had been founded in about the 1st century, these men brought the highly refined culture of India to peoples whose way of life was perfectly suited to Brahmanic and Buddhist teachings.

India's interest in these countries was originally based on the trade in gold and spices that was to be found in the South Seas. The use of the monsoon winds—from at least the beginning of the 1st century—the progressive regularisation of the sea-routes and the improvement in transportation made possible a considerable increase of trade in these distant seas. An immense trade route was established linking the main coastal regions and augmented in certain parts by transcontinental tracks or sometimes by a very active river navigation.

The Indian trading settlements were dotted along the coasts and served as ports for the principalities and kingdoms that sprang up around them. Intermarriage also played a considerable role in this Indian colonisation and, according to tradition, it was to one such union that was attributed the founding in the 1st century AD of one of the oldest kingdoms in the Indo-Chinese peninsula, known as Funan, which was situated in the lower valley of the Mekong. At Oc Eo, a trading centre used by foreign merchants has been discovered. Excavations carried out on this site have yielded, apart from objects of Western origin, an Antoninus Pius gold bracteate, cornelian intaglios with typically Roman subjects, a Sassanian cabochon, a great deal of gold jewellery of Indian origin, a fragment of a Chinese mirror and sculptures in wood and stone which represents a curious mixture of Indian and Chinese influences (and which as yet have received little attention).

Bronze Buddhas in the Amarāvatī style have been found in various countries of South-East Asia, in Thailand (Korat and Pong Tük), in Java (Jember), in Sumatra (Palembang) and even in Celebes (Sempaga); but the finest example comes from the east coast of Indo-China, at Dong-duong, in Champa. It is not known whether these works are from Amarāvatī itself or from Ceylon (where this style became very popular) or even whether they were made in the Indian settlements of South-East Asia.

Throughout this area Indianisation took the form of the adoption of Sanskrit as the official and sacred language, the introduction of the Indian religions of Brahmanism and Buddhism, with their myths, philosophical systems and traditions and the establishment of a political structure very close to that of ancient India.

When works of art in durable materials appear in these countries, they are already heavily influenced by Indian characteristics, as if these regions had had no previous art of their own. Nevertheless, it is impossible to know whether the Indian influence caused a radical change or whether it was superimposed upon a pre-existent basis. It seems likely, however, that an extraordinary impetus was given to the arts by the presence of the Indians in these countries.

Architecture, to begin with, bears the unmistakeable marks of Indian influence, in both form and decoration. It must be assumed that the first 'colonists' used local labour to erect sanctuaries in the taste and tradition of their own country. These contacts were to be maintained by travellers and monks in later times.

Indian influence was soon assimilated and formed a basis upon which local work was undertaken despite the increasing resurgence of native elements. It was to be renewed consistently through the centuries. Each of the South-East Asian cultures adapted the Indian forms according to its own particular character, for their art was not a slavish imitation, but genuinely creative. Thus true works of art were produced which possess undeniably original characteristics, while remaining within the Indian tradition.

The Khmer empire was formed between the 6th and 7th centuries, from the fusion of Funan (1st–6th centuries approximately) and of the kingdom of Chen-la further north. This was followed by the establishment of royal authority first in the region of the great lakes (end of the 6th–8th centuries), then in the so-called Angkorian region and finally at Angkor itself (beginning of the 9th–15th centuries).

The first of these developments was characterised by sanctuary-towers made of brick, with square (sometimes octagonal) ground-plans, single or in groups of five within an outer wall (Sambor Prei Kuk). These towers belong to Indian tradition; they have corbelled vaulting over a Brahmanic cella, a door flanked by a pair of round sandstone columns carved with naturalistic garlands and surmounted by a sandstone lintel whose decorative theme is also Indian—a flattened ogee form ornamented with medallions, garlands and pendants, being swallowed at each end by a sea monster *(makara)*. The walls are decorated with reliefs carved in brick which is mounted on a stucco base. The statues of this period, whether Brahmanic or Buddhist, are very beautiful and sometimes of considerable height. At first, very Indian in feeling—they observe the canonical triple flexion *(tribhanga)*—they soon take on a more original character.

During the Angkor period, Khmer art developed an ever increasing originality, while retaining as its basis the pre-Angkor forms. Founded on a politico-religious conception, which was probably of Indian origin and which is to be found with variations throughout the other Indianised countries, the form of the temple-mountain attained its most perfect expression in Khmer territory. Its full flower-

52. **Sanctuary of Siva.** Temple of Lara Jongrang, Prambanan. *c.* 900. The vast complex of Lara Jongrang, near the village of Prambanan, was the last great temple to be built in central Java. It consists of three main sanctuaries dedicated respectively to Siva, Brāhma and Vishnu, and three minor ones dedicated to two particular forms of Siva with his mount, Nandin. A hundred and twenty-four miniature temples are placed around this central core, and the whole complex is enclosed by three walls forming a triple square. The side of the outermost wall measures 426 yards.

ing dates from the reign of Indravarman I (877–99), with the Bakong at Roluos, not far from Angkor, and is in keeping with a series of traditions in which the king is associated with the idea of the cosmic mountain, the centre of the world and the divine residence. It consists of a stone pyramid reached by a terrace of tall steps and, with each succeeding reign, it became larger until it reached its apotheosis in the famous temple of Angkor Wāt, the temple-mountain and mausoleum of King Sūryavarman II (1113–about 1150). Its splendid plan, the balance of its proportions, the elegance of its pillared cloisters and the beauty of its decoration make it one of the masterpieces of world architecture. The temple itself is surrounded on the inside by two concentric walls of which the inner one is decorated with reliefs illustrating with an admirable sense of composition and narrative rhythm the great mythological themes of Brahmanism, such as the theme of 'Heaven and Hell' and the triumphant march of the king at the head of his army.

Single-storey buildings, both royal and private, also added considerably to the splendour of the Khmer civilisation. One could cite as an example the delightful little

53. **Hanumant breaking the trees of Lankā.** Relief from the Panataran temple. 14th century. This relief shows one of the heroes of the *Ramāyana*, the monkey Hanumant. The figure is typical of eastern Javanese art, for, while the subject-matter is Indian, the curving stylisation is inspired by the puppets of the indigenous shadow theatre *(wayang)*.

54. **Harihara.** Phnom Da style. *c.* 6th century. Sandstone. h. 5 ft. 8⅞ in. (175 cm.). Musée Guimet, Paris. This statue represents two of the principal Brahmanic gods: Siva (on the right) and Vishnu (left). This attempt at syncretism originated in India, but was later popular in the Khmer territories. Vishnu is identified by his cylindrical mitre and the wheel. Siva has the Brahmanic chignon and a trident.

temple of Bantéai Srei (967), near Angkor, whose smallest detail reveals a perfect knowledge of the iconographical themes of India and great virtuosity in the decoration.

Sculpture in the round, whether in bronze or stone, follows in the wake of the decorators and sometimes even precedes them. The work of the artists of Bantéai Srei is followed by the Baphuon style (middle of the 11th century). This new development is marked by a certain stylisation, great simplicity, meticulous care in the execution of details and the appearance of a physical type that is much more clearly native than previously.

The last phase of Ankor architecture was dominated by the personality of the Buddhist king, Jayavarman VII (1181–1219). He built vast temples, including the Bayon of Angkor, which was the culmination of the architectural style of the Khmer kingdom and the last temple-mountain to be built in the centre of the royal city. It is a splendid work and a overwhelming success from the point of view of its symbolism and its sculpture.

Its fifty-four towers are each adorned on all four sides with the half-smiling face of Jayavarman VII, represented as the Bodhisattva Lokesvāra (Lord of the World). Gazing out towards the four points of the compass these faces symbolise the omnipresence of both god and king. The idea of a tower with faces is not, however, entirely original: it had occurred in India, particularly at Gujarāt, but in a less well defined form. The Bayon combines the symbolism of the stūpa with the Hindu formula of the cosmic temple.

The sculpture of the reign of Jayavarman VII reveals an often admirable gift for portraiture, for it was the custom of the king and his dignitaries to have statues made in which

they were represented as gods.

Indonesia had continuous relations with India from the first centuries of the Christian era, and Indian influence played the same catalytic role as in the Khmer empire. Indonesian history may be divided into two main phases. The first stretches from the first centuries AD to about the 9th–10th centuries and encompasses part of the Malay peninsula, Sumatra and the western and central parts of Java. The second phase developed in eastern Java and in Bali from about the 10th to the 16th centuries.

In central Java no monument seems to have been built in durable materials before 732. But from their first appearance the sanctuaries are typically Indian: a cella over a crypt preceded by a porch with a flight of steps and pyramidal storeyed roof. The architectural decoration is of Indian origin: a monster's head *(kala)*, linked with two makara. This type survived to the end of Javanese art, and was used both by Buddhism and Brahmanism.

Few temples seem to have been built in the 8th century. Three important groups date from the first half of the 9th century: the famous Barabudur, with the Candi Mendut and Candi Pawon, all Buddhist; the Siva temples of the Dieng Plateau, of which eight are more or less intact; the Candi Sewu composed of four groups around a central cruciform sanctuary. During the second half of the 9th century, a fourth group was built, that of Plaosan, in eastern Sewu. Finally, about 900, the huge Brahmanic temple of Lara Jongrang was built near the village of Prambanan.

The Barabudur temple is exceptional in its originality of conception and the perfection of its decoration. It is a huge five-storeyed pyramid built around a natural hill and con-

141

55. **Siva.** Binh Dinh style. 12th century. Sandstone. h. 5 ft. 5 in. (165 cm.). Musée Guimet, Paris. The Cham style of Binh Dinh betrays a certain decadence which became even more pronounced at the end of the period. This statue of Siva possesses nevertheless an undeniable grandeur.

56. **Dancer.** Mi-son A.1. style. 10th century. Sandstone. h. 2 ft. 5⅛ in. (75 cm.). Musée Guimet, Paris. The Mi-son A.1. style represents the apogee of Cham sculpture. Figures like this dancer possess an elegance, an idealisation of the human form, smiling countenances and lively movement.

sists of a pseudo-hemispherical mass crowned with a central stūpa, surrounded by three concentric circles of smaller stūpa. In the middle of each side of the pyramid, flights of steps placed in the same axis pass under porticos decorated with kāla-makaras and lead to the upper storeys and the top platform. This is an architectural translation of an esoteric form (mandala) which is peculiar to Mahāyāna Buddhism. This building, with its thick-set shape, is not, in itself, an architectural success, but the reliefs with which it is decorated are exceptionally beautiful. They illustrate the main episodes in the last life of Buddha Sākyamuni, events in his 'previous lives' (jātaka) and the various edifying stories (avadāna) of Buddhist tradition. They reveal both the plastic qualities of the Indian-inspired Javanese style and fidelity to the traditions acquired. The well balanced grouping of the figures, their calm and harmonious attitudes, which are reminiscent of the Post-Gupta styles of India, the taste for detail and an assured stylistic sense give this art indisputable value. If these narrative series reflect the life of their times, then their lives must have been impregnated with Indian traditions, for innumerable details of dress, hair-styles and ornament, as well as the forms of everyday objects, betray an Indian origin.

The stone sculpture and small bronze statuary of this style follow the same rules: calm attitudes and dignified gestures, fleshy bodies and moderation in ornament.

The style of eastern Java derives from the previous one, but, as it develops, it takes on Javanese characteristics to an ever more marked degree. In architecture, in which brick is often used, the tower-sanctuary is composed in almost equal parts of a high base with mouldings, a main section with a door on each side and a pyramidal storeyed roof.

The kāla motif surmounting the doors becomes increasingly emphasised and projects in high relief. This development is also apparent in the simultaneous raising of the basement and the roof while the proportions of the cella remain unchanged. Huge terraces decorated with reliefs (Panataran) support the sanctuaries. The surrounding walls have high, narrow doors, surmounted by high, multistaged pyramids.

The cult statues gradually stiffen into complete frontality and are backed on to a stele, the base of which is decorated with floral motifs and subsidiary figures. It is easy to recognise the influence of the Pāla-Sena style of Bengal. On the other hand, the small limestone or clay statuary retains undeniable plastic qualities and great charm both in the faces of well-observed ethnical types and in the supple, graceful attitudes of the figures.

The strong personality of eastern Javanese art is best expressed in the bas-reliefs. These retell the epic themes of Hindu India, particularly those of the *Rāmāyana*. The sculptors created an animated style in which the figures, with their bodies depicted full-face and their heads and feet in profile, were inspired by the puppets of the shadow theatre *(wayang)*—which are still in existence—and are closely related to the dolls cut out of leather that are peculiar to certain regions of India. They move against a rich, yet stylised landscape done in low relief which occupies the entire background.

In the 15th century the Islamic architectural style appeared in Java. The mosques differed from the Brahmanic temples only in their absence of decoration with figures. Nowhere else in the world did the Islamic style adapt itself so completely to local forms.

57 (left). **Prajñāpāramitā.** Bayon style. End of the 12th century. Sandstone. h. 3 ft. 7½ in. (110 cm.). This statue shows the deified queen, Jayarājadevī, wife of Jayavarman VII, represented as Prajñāpāramitā, or 'Perfect Wisdom', as is testified by the effigy of Buddha carved on the front of her headdress. All the spirituality of Buddhism is contained in this figure, as much in the gently spreading smile on the smooth face, as in the meditative, pious, inward-looking expression which is emphasised by the closed eyes.

58 (right). **The temple of Wāt Kukut at Lamp'un.** Wāt Kukut, which was founded in the first half of the 12th century, is a brick temple-mountain, decorated at each level with images of the Buddha in a style which was inspired by the post-Gupta period in India.

59 (far right). **Standing Buddha.** U Thong style. 13th–14th centuries. Bronze. h. 3 ft. 1⅜ in. (95 cm.). Musée Guimet, Paris. The Thai style of U Thong owes much to the Khmer tradition of the Bayon period. This influence is particularly evident in the realm of sculpture where the treatment of the facial features and of the body lend the figures a gentle humanity, as this figure of the Buddha testifies.

Parallel with the development in the Khmer and Javanese territories, which in the sphere of sculpture made the best use of the Indian influence, Champa (Vietnam), Burma and Thailand were also influenced by Indian art and culture and transformed these traditions according to their own temperaments.

A kingdom, known by its Chinese name of Lin-yi, occupied the Hue region about the end of the 2nd century. This was the first nucleus of a Cham political authority and it probably became the kingdom of Champa, mentioned from the 4th century in Sanskrit inscriptions found in the region.

The Champa monarchy possessed Indian characteristics similar to those of the Khmer, but its art never attained the high level of Angkor. The Chams employed neither the staged pyramid, nor the gallery which was used to such effect by the Khmer architects. Their sanctuaries were therefore reduced to isolated towers (kalans), sometimes grouped, but never actually joined together. But Cham art is not without quality, particularly in the field of sculpture. The few surviving ancient works may be attributed to the second half of the 7th century and are strongly influenced by the Indian Post-Gupta style. On a fine sandstone *linga* pedestal, of the Mi-son E.1. style, are to be found architectural, decorative and sculptural elements directly derived from Indian art.

The first sanctuaries appeared from the beginning of the 9th century: these were brick towers with sandstone decoration. Sturdy and simple, crowned with multi-stepped pyramidal roofs, decorated on each side with high pilasters with foliated scrolls, with multi-lobed arcades placed one upon another, these towers are very close to the temples of India. They attain true distinction in the 10th century, with the towers of Khuong-my and Mi-son which are built in a sober, well-balanced classical style, but are already quite different from their Indian prototypes. This difference becomes more obvious with the Ponagar temple at Nhatrang, built in the 11th century. From then on, the outline of the sanctuaries loses its elegance, the roofs their rhythm and the decoration its plant motifs.

In sculpture, the native accent becomes more apparent about 875 in the Dong-duong style, which portrays a deliberately accentuated ethnic type. Then, after a particularly rich period in the 10th century with the Tra-kieu style, which was elegant and naturalistic in a rather idealised way, sculpture gradually deteriorated, except in a series of mythical animals at Thapmam, where the Vietnamese influence revived a popular and no doubt local predilection for bold stylisation.

Apart from Cambodia and Champa, which both enjoyed political unification, the rest of the Indo-Chinese peninsula was engaged in a struggle for power. Populated by Mons, Khmers and Indonesians, the territory now known as Thailand was not politically united until the 14th century; the Thais, who had probably come from the Yünnan border, gradually infiltrated into the country from the 11th century.

The influence of India is apparent from the 2nd–3rd centuries in several sites (Pong Tük, Korat) from Buddhist bronzes of the Amarāvatī style, some of which would appear to be originals imported from India or Ceylon and others copies made locally.

The architectural remains of the 6th–7th centuries are localised in the region occupied at that time by the most

56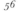

powerful Mon kingdom, known to us by its Indian name of Dvāravatī. They consist mainly of crypts and there is a Buddhist monument built onto a double, tiered basement (Pong Tük), decorated on each side by five Buddhas seated in niches flanked by small columns and pilasters and by large stone wheels *(chakra)* symbolising the first Sermon of the Buddha Sākyamuni in the gazelle park in Banāras. They may be contemporary with Hindu sculptures found at several sites whose style is very close to Post-Gupta art.

Under the Khmer occupation, in the 11th century, a number of buildings were erected at Lopburi. The architecture and sculpture of this period follow very closely the Khmer styles of the period. In Mon country, at Lamp'un, a 58 brick temple-mountain, the Wāt Kukut, was built during the first half of the 12th century. This temple is related to the Sat Mahal Prāsāta at Polonnāruwa, in Ceylon (12th century). Decorated on each side with images of the standing Buddha, this monument is one of the last to be built before the Thais seized power. The Thais introduced a new aesthetic, in which, upon a Mon basis, the Indian influence was no longer a direct one, but transmitted through the arts of neighbouring peoples: the Khmers, the Burmese and the Singhalese.

Burma, which was unified as late as the 11th century, received the Indian influence together with that of Thailand, then under the Khmers. There are few remains earlier than the 9th century and these are strongly influenced by Post-Gupta India. From the second half of the 11th century, Burmese art was given a new impetus by King Aniruddha (1044–77), the greatest of the Burmese kings, who was converted to the Buddhism of the Theravada, which came from Ceylon.

The stūpa preserve the basic Indian forms, learned from models from Ceylon and the Mon-Khmer countries. At first, they were ogival in outline, then bell-shaped and were perched on top of a huge pedestal consisting of successive platforms. But the originality of Burmese art and its borrowings from north-east India, from Bihār and Orissā, is best seen in the Buddhist temples. They form a compromise between the Khmer temple-mountain, the Hindu sanctuary with its sikhara of ogival shape as it appears at Khajurāho (about 1000 AD) and the Thai stūpa, with its very slender spire.

Sculpture in the round, which is on the whole of rather poor quality, reveals the influence of the Pāla-Sena style of Bengal. The reliefs illustrate Buddhist themes with landscapes and figural elements reduced to a minimum; they are more evocative than descriptive. The many mural paintings reflect a number of influences, none of which can be said to be directly and purely Indian. Manuscripts show 51 a delight in colour and decorative effect.

In all the countries of South-East Asia, the acceptance of Indian forms seems to have brought with it the use of durable materials. These forms took root, without eliminating local inspiration, which often reappeared again quite rapidly. Under cover of the Indian religions, a permanent artistic exchange between all these countries began. This was particularly true of the 9th–10th centuries, when the art of Java influenced that of the Khmer countries and that of Champa, and when, in turn, Khmer art influenced Cham art (end of the 10th–13th centuries) and Thai art 59 (7th–8th, then 11th–12th centuries). But India was the inspiration behind all these developments and was present in every exchange.

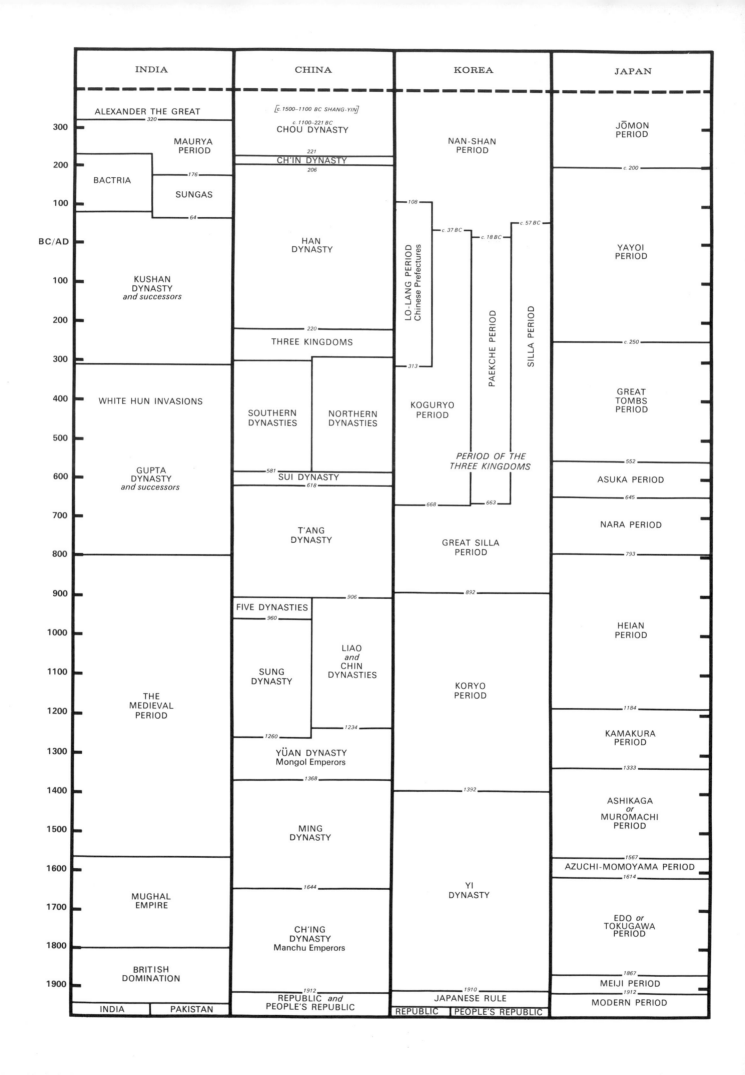

INDIA	CHINA	KOREA	JAPAN

INDIA

- ALEXANDER THE GREAT — *320*
- MAURYA PERIOD — *176*
- BACTRIA
- SUNGAS — *64*
- KUSHAN DYNASTY *and successors*
- WHITE HUN INVASIONS
- GUPTA DYNASTY *and successors*
- THE MEDIEVAL PERIOD
- MUGHAL EMPIRE
- BRITISH DOMINATION
- INDIA | PAKISTAN

CHINA

- [c. 1500–1100 BC SHANG-YIN]
- c. 1100–221 BC CHOU DYNASTY
- *221* CH'IN DYNASTY
- *206*
- HAN DYNASTY
- *220* THREE KINGDOMS
- SOUTHERN DYNASTIES | NORTHERN DYNASTIES
- *581* SUI DYNASTY
- *618*
- T'ANG DYNASTY
- *906*
- FIVE DYNASTIES — *960*
- SUNG DYNASTY | LIAO *and* CHIN DYNASTIES
- *1260* | *1234*
- YÜAN DYNASTY Mongol Emperors — *1368*
- MING DYNASTY
- *1644*
- CH'ING DYNASTY Manchu Emperors
- *1912* REPUBLIC *and* PEOPLE'S REPUBLIC

KOREA

- NAN-SHAN PERIOD
- *108*
- LO-LANG PERIOD Chinese Prefectures
- c. 37 BC
- c. 18 BC
- c. 57 BC
- PAEKCHE PERIOD
- SILLA PERIOD
- *313*
- KOGURYO PERIOD
- *PERIOD OF THE THREE KINGDOMS*
- *668* | *663*
- GREAT SILLA PERIOD
- *892*
- KORYO PERIOD
- *1392*
- YI DYNASTY
- *1910* JAPANESE RULE
- REPUBLIC | PEOPLE'S REPUBLIC

JAPAN

- JŌMON PERIOD
- c. 200
- YAYOI PERIOD
- c. 250
- GREAT TOMBS PERIOD
- *552*
- ASUKA PERIOD
- *645*
- NARA PERIOD
- *793*
- HEIAN PERIOD
- *1184*
- KAMAKURA PERIOD
- *1333*
- ASHIKAGA *or* MUROMACHI PERIOD
- *1567*
- AZUCHI-MOMOYAMA PERIOD
- *1614*
- EDO *or* TOKUGAWA PERIOD
- *1867*
- MEIJI PERIOD
- *1912*
- MODERN PERIOD

Time scale (left axis): 300, 200, 100, BC/AD, 100, 200, 300, 400, 500, 600, 700, 800, 900, 1000, 1100, 1200, 1300, 1400, 1500, 1600, 1700, 1800, 1900

THE ORIENTAL WORLD
CHINA, KOREA
AND JAPAN

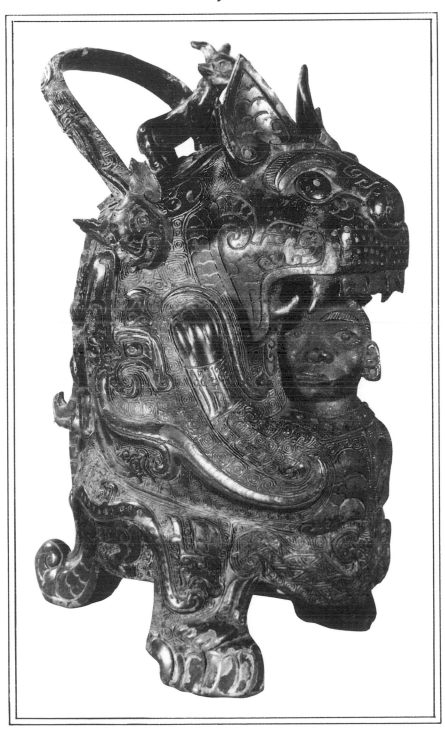

Introduction

Although the use of the term 'Far East' for China, Korea and Japan refers primarily to the geographical distance of these countries from the West, it also suggests a cultural remoteness that may seem hard to bridge. Until now, we in the West have been inclined to treat the various forms of Far Eastern civilisation as negative images, so to speak, of our own deep-rooted preferences. In this way we have come to regard the peoples of the Mongolian race as metaphorical as well as actual antipodeans. This view is not without foundation. In the Far East one begins a book from the back, and white is worn as the colour of mourning; in short, much occurs that is the exact opposite of our own customs.

In the light of this geographical and cultural remoteness it is understandable that the history of relations between the West and the Far East largely amounts to a series of mutual misunderstandings. One-sided ideas of East Asia have persisted even into the 20th century among educated people in the West, producing much confusion and prejudice—inevitably so as situations often arose that could not be fitted into the existing pattern of preconceptions of China and Japan.

This biased attitude appears as early as the time of Marco Polo who, despite his long stay in China from 1275 to 1292, saw some aspects of Chinese civilisation through a distorting mirror, while simply ignoring other important features. Even after the diplomatic Jesuit missionaries of the 17th and 18th centuries had succeeded in gaining a foothold in China where they even penetrated the august sanctuary of the imperial court—thus interrupting a deliberate isolation of several centuries—they succeeded in grasping only certain aspects of China's complex civilisation. Although the precision and scope of Jesuit knowledge of China as revealed by such works as Father Du Halde's comprehensive *Description de l'empire chinois* (1735) are indeed astonishing, the image of China that exercised such a deep influence on the French Enlightenment of the 18th century remained idealised and incomplete. It was based almost exclusively on Confucianism with its emphatically rational social ethic; and in fact the influence of Confucian ideas in France was so powerful that Confucius may with some justification be called the patron saint of the 18th century.

The vast area of Chinese thought that is reflected in Taoism and some aspects of Buddhism (an area which has left a decisive stamp on the art of the Far East) simply did not count for 18th-century Europeans. The influence of Japan on the revolution in Western painting of the 19th century is well known; but this enthusiasm for Japan focussed on a late form of art that was originally little prized by the Japanese themselves. It was only in the 20's and 30's of the present century that several comprehensive exhibitions at last brought the Western public into direct contact with the full range of Chinese and Japanese art.

Conversely there is no doubt that until very recent times the Oriental view of Westerners was no less distorted, for Europeans and Americans have been regarded—with some justification in an age of imperialism—as foreign devils and barbarians.

In view of the conditions that greatly restricted communication between the two extremities of the Eurasian continent—years of patient travel in the face of unbelievable difficulties and dangers were required—such misunderstandings were inevitable. Political and geographical barriers often combined to make direct contact virtually impossible. In antiquity and the middle ages the mountains, steppes and deserts of Inner Asia, crossed only by the tenuous link of the Silk Routes, lay between the West and the Far East. Of course Chinese silk was known in Mediterranean lands in antiquity, but this was traded by a chain of middle men, and thereby any direct contact with the Chinese was prevented. After the victories of the Arab armies over Chinese troops in the 8th century Islam drove Buddhism out of its earlier stronghold in Central Asia and this area became a hostile wedge lying athwart the lines of contact linking the West with East Asia. But in the course of time Islam took up the role of go-between, for the Arabs brought such Chinese inventions as paper and printing to the West, while the fundamentals of Hellenistic mathematics and astronomy were transmitted to China by Moslem scholars.

During the period of the origin, growth and first flowering of Far Eastern civilisation, between the second millennium BC and the birth of Christ, that is, during the age when this civilisation acquired its basic physiognomy, it was practically shut off from contact with other high cultures. The inhospitable steppes, deserts and rugged mountains set almost unsurmountable obstacles to the expansion of the Chinese peasantry to the north and west. These regions were only habitable by nomadic peoples, the immemorial enemies of the stationary Chinese. To the East lay the sea, which rarely tempted the Chinese to voyage into foreign parts. In the south alone was there real scope for expansion, so that during the whole course of Chinese history one must reckon with a slow and steady push southwards, a process that was seldom interrupted. In this way the whole of South-East Asia was eventually imbued with Chinese culture. Here, Far Eastern civilisation came into contact with offshoots of Indian civilisation, creating interesting hybrids in several areas.

Isolation from other high cultures combined with proximity to less civilised peoples goes far to explain the confidence of the Chinese in their innate cultural superiority. In time this proud and refined civilisation, which was unrivalled elsewhere in the world during the medieval centuries, infiltrated Korea to the north-east, important for her intermediary role, and then the islands of the Japanese archipelago.

But much earlier, in the archaic period under the first Chinese dynasties, there came into being the self-centredness of the Chinese people that is characteristically expressed in the term *Chung-kuo*, the 'Middle Kingdom'. The earliest witness for this is the *Shu-ching*, the classic book of

documents which reflects the political and social ethos of the Shang dynasty in the second millennium BC, as mediated by the thought of Confucius (552–497 BC). Here we find that the lands inhabited by the Chinese are regarded as the world navel—the hub of the universe and the home of all true culture. Despite enormous social changes this attitude has survived almost unmodified among the Chinese down to our own day. Anything lying outside the fortunate central zone was barbaric by definition. An outgrowth of this conception is the Great Wall, which is even more significant as a symbol than as a physical bulwark protecting China from the destructive raids of the alien nomads of the Inner Asian steppes.

The characteristic Chinese sense of belonging to a firmly established tradition, a tradition that had forged eternally valid patterns in an earlier classical age, undoubtedly has its roots in the retrospective attitude of Confucianism. In this framework, the historical consciousness that characterises East Asia has grown up. In contrast to the indifference of various old high cultures, notably that of India, to the continuity of their past, the Far Eastern peoples reckoned their history in terms of the reigns of their sovereigns, continuing this practice from one dynasty to the next. In looking backwards into history they could depend on historical events being exactly dated; and in this way they formed a rounded picture of their own historical position and aims.

This profound sense of living at the centre of the world left its mark on the political development of the Far East where the life of the state revolved about the dominating figure of the emperor. Although he often held nominal authority only, he was still the son of heaven and enjoyed the mandate of the supreme powers. His palace stood in the centre of a fortified city and both the city and the imperial residence were planned in accordance with the directions of the universe. The dominant urban culture was at first transmitted by the feudal nobles who owed their position to the emperor, and later by a hierarchically organised bureaucracy, which was also sworn to obey the emperor. In the classical phase, membership of the ruling class of officials was theoretically open to all qualified persons; this class was flexible and could replenish itself from below and in this way could survive over many centuries. Recruits to this elite were not sought from the military class but from scholars, who had to show their ability in arduous examinations. With their extensive literary and general cultural education the officials were transmitters of culture, and indeed often artists in their own right, whether poets, painters, or musicians. Thus the political and social elite was synonymous with the intellectual and cultural elite—a situation unique to the Far East and one that helps us to understand many features of East Asian art. The liberal arts of calligraphy, painting and music, which were practised for the sake of personal enjoyment—arts that early acquired a subtle aesthetic—were exalted above the professional skills of architecture, sculpture and the minor arts, despite the fact that no well-defined boundary separates the crafts from the liberal arts. The concept of an art that, though certainly not practised as 'art for art's sake' was unhampered by religious ties, came into its own in the Far East between the 5th and the 9th centuries. At the same time the various arts acquired their aesthetic and theoretical foundations. An active trade in works of art developed to satisfy the needs of collectors, together with no less active an industry producing forgeries.

The origins and the real development of this fascinating phenomenon lay in China, but it passed with some modifications to the other main centres of Far Eastern culture, Korea and Japan. Geographical, ethnic, historical and social conditions produced particular developments of art in these two countries, which were stimulated and fertilised by the inexhaustible strength of the Chinese civilisation. The Korean people, because of their exposed position in the area of tension between Chinese and Japanese interests, were only occasionally able to develop their own powers undisturbed. By contrast the Japanese in their island home quickly assimilated Chinese influences and made them their own. Hence they created a culture distinguished from the Chinese example in many ways. The various phases of receptivity to foreign influences were followed by periods of Japanese isolation, which brought into being a special type of cultural introversion and self-sufficiency.

The aim of our study is to trace the main lines of the development of art in the Far East against the background of the society that produced it. In view of the richness and longevity of this culture this is not a task lightly to be undertaken. Our account will be mainly confined to the historical epoch, for little is yet known about the social structure of the prehistoric period.

China

THE ARCHAIC PHASE

The first organised state known to us arose in China in about 1500 BC—or in the opinion of Chinese scholars, who follow the date of traditional histories, as early as 1700 BC—from the neolithic phase, which is now relatively well documented by archaeological finds. The culture of this state, which is called Shang or Yin after the two names current for the dynasty, long retained many neolithic traits, at the same time developing an art of bronze casting that is astonishing in its technical excellence and artistic sophistication. Among the neolithic predecessors, the Lung-shan culture in the north-east of the later Chinese area seems to have been particularly remarkable in its contributions to the formation of Shang culture.

It is characteristic of this early historical phase of Chinese development (and indeed for the preceding neolithic and palaeolithic periods) that the culture is largely indigenous, having been pioneered on Chinese soil, in all likelihood by the Mongolian or proto-Mongolian peoples, who preceeded the later Chinese. The geographical centre of the Shang kingdom lay in the northern half of the province of Honan in the great fertile plain of the Yellow River. Until 1373 BC the capital was the walled city of Ao near modern Chêng-chou; thereafter until the fall of the dynasty it lay about 200 miles north-east in the vicinity of modern An-yang. Because of their military and cultural superiority the power of the Shang kings and their vassals spread from the political and cultural centre around the capital far into the central Chinese provinces—and indeed their cultural influence reached much farther.

Characteristic of the phases of the Shang period in so far as they are known to us from archaeological finds is the emergence of an urban culture firmly based on the peasantry who tilled the land. The social pyramid culminated in the person of the all-powerful king, who also acted as the high priest of an agrarian religion with a strict ancestor cult. The divine origin of the ruling family placed the king in a middle position between the powers of nature and creation on the one hand and the peasantry who depended on the fertility of the land on the other. Thus there developed an incipient feudalism, for the king bestowed fiefs and retainers on the members of his house, as well as on the men who served the state.

Beneath the king stood the various ranks of military and civil officials, forerunners of the bureaucrats who were so characteristic of later China. Their chief was a kind of chancellor. The scribes represented a special group that was essential for the working of the state apparatus and for the preservation of tradition. The complex ideographic script, from which the modern characters directly descend, was one of the most important features distinguishing the Shang culture from its neolithic ancestors and competitors. In all probability the Shang capital included a central archive with administrative documents and historical records. But of this material we only know at present the questions inscribed or painted by the priests on bone and tortoiseshell (the 'oracle bones'), together with reports of the results. The king headed a large college of augurs, oracle priests with shamanistic traits within the framework of the agrarian religion. Of course there was a separate class of artisans, among whom bronze founders serving the priesthood and the feudal nobility enjoyed special status. But the vast majority of the population of the Shang kingdom belonged to the peasantry, who did not contribute to the cultural life of the community. Every day the peasant farmers streamed out of the villages to the fields under the direction of overseers; they generally used primitive stone tools, which were distributed from government store-houses.

The centres of power and residence of the Shang kingdom were the walled cities planned in accordance with the heavenly directions. Excavations have shown that as in neolithic times the people normally lived in covered pit-dwellings and that only the platform-based palaces and temples were wooden structures, the exterior walls of which were reinforced with rammed earth and surmounted by double roofs.

As has been explained, this period of high culture was monopolised by the ruling house and the feudal nobility. The remarkable ritual bronze vessels, which rank as China's earliest works of art, were cast for the ancestor cult of the king and the feudal lords. The question of whether the technique of bronze casting was imported from the outside or developed in China itself is still unresolved. The earliest known vessels show a remarkably advanced technique and artistic quality, being cast from clay moulds and subsequently finished with tools. Possibly the smiths responsible for this work had the semi-priestly status known in other ancient cultures.

During the early phase of the Shang dynasty the ritual vessels of the ancestor cult often imitate pottery both in form and decoration, particularly that of Lung-shan ceramics. The vessels are thin-walled, the ornament is sparing and generally confined to a narrow band. Even in more recent Shang pieces the ceramic form sometimes shines through. For the angular vessels of the later An-yang phase, however, wooden prototypes have sometimes been assumed, because the geometrical and animal decoration spreads over the whole surface of the object. The decoration of these containers of sacrificial wine would provide a veritable catalogue of the symbols of ancestral religion and fertility cult—if only we understood its language better. The outstanding motif is a glowering mask, the so-called t'ao-t'ieh, or 'glutton', made up of various animal elements. The mask may have served to ward off evil or was a potent symbol of the powers of nature, comparable to the later Tao. The t'ao-t'ieh appears at the centre of a flat incised or raised relief decoration surrounded with dragons and feline animals, buffaloes and birds. Although we can sense immediately the magical force of these figures, we can only guess at their particular significance. Especially effective are the offering vessels that take figural shapes, such as

61

55

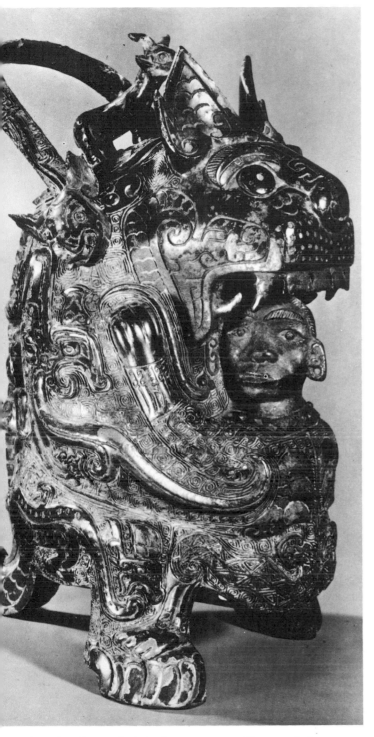

61. **Bronze ritual vessel of the chia type.** Shang period, 12th–11th centuries BC. h. 9¾ in. (24 cm.). British Museum, London. This vessel which dates from the An-yang period is decorated with both flat and raised ornament. *Chia* vessels, used for warming wine, are round or rectangular in shape with splayed legs and with two pillars rising from the lip.

those of owls or tigers, which are overlaid with symbols. 60
These may have been regarded as totemic embodiments of the ancestor spirit who protected the founder of a clan. A good many of these ritual bronze vessels bear short inscriptions dedicating them to a particular ancestor.

With some reservations, the Marxist theory of the slave-holding stage of society can be appropriately applied to this earliest Chinese state. Archaeological finds have shown that as part of the ceremonies accompanying the erection of temples and the outfitting of royal tombs a large number of men—mostly slaves and prisoners-of-war—were killed and buried as a sacrifice. In many cases the individuals were beheaded, perhaps with the huge heavy axes that have been found. Too unwieldy to be weapons, the axes display magical decorations that would suit them to this grisly function. 54

Limits of space forbid more than a passing mention of such other aspects of Shang art as the powerful stone sculpture and the refined jade carving.

After the Chou people, who had been living east of the Shang kingdom to which they were more or less tributary, overran the Shang state with their 'barbarian' allies (be-

60. **Ritual vessel of the ho or yu type.** Shang period. 14th–12th centuries BC. Bronze with shiny black patina. h. 13¾ in. (35 cm.). Musée Cernuschi, Paris. This offering vessel in the form of a tiger protecting a man may represent an ancestor spirit in animal form embracing the oldest member of the clan. The bodies of both the tiger and the man in this expressive group are covered with animal motifs: snakes, dragons and masks. These motifs, which relate to some indigenous fertility cult, stand out in relief from a ground of spirals.

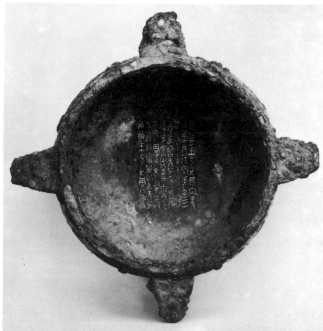

62a, b. **Ritual vessel of the Kuei type.** Early Chou period, late 11th century BC. Patinated bronze. h. 7½ in. (19 cm.). British Museum, London. While the dedicatory inscriptions on ritual bronzes of the Shang period are generally limited to a few words, many vases of the Early Chou period, which are stylistically quite similar, bear long inscriptions. The text on the inside of this *Kuei* states that it was made on the occasion of an award by the Duke of Chou to Marquis Hsing, who was given lands and vassals of three classes in recognition of his services. The Marquis' speech of thanks and a short donation formula complete the inscription.

tween 1100 and 1000 BC), they completely adopted the superior Shang culture, which indeed they seem to have known considerably earlier. The warrior caste of the Chou made use of the expertise of the Shang priests and artisans, so that the archaeological record of the early Chou shows no break from the preceding Shang period. The rationalisation of the feudal system under the new dynasty led to a strengthening of cultural unity in the territory controlled by the Chou king. The Chou king's followers, whom he settled throughout the country as his feudal vassals were instrumental in spreading the culture over a wide area.

Like the Shang, the Chou lords concentrated their might in walled cities. The cultural superiority of the nobility rested on the traditional lore known as the 'six accomplishments' *(liu-i)* or the rites: ritual music, the script, which served to guarantee the continuity of tradition, the art of calculation, important for keeping the calendar in order, chariotry and archery—these last two being indispensable for hunting and war. The Chou period saw a consolidation of religious and political ideology and achievement that was to prove crucially important in the unfolding of Chinese civilisation. The prevailing ideology was finally codified by Confucius (551–479 BC) in a body of detailed ritual prescriptions, the *li*.

The bronze vessels of the ancestor cult (which retained some of the magical repertoire of earlier days but with an increase of distinctively Chou features) must be seen against this background, for it was found that they could be turned into a kind of historical document. The often lengthy inscriptions, whose language is related to the Chou texts of classical Chinese literature, inform the ancestors of the deeds of posterity and the decrees and largesse of the Chou rulers. But the highly developed political organisation of

62a, b

the Chou bore with it the seeds of the dynasty's own disruption. The increasingly powerful magnates, who had become only nominally dependent on the central authority of the Chou king, fought ceaselessly among themselves. A shift of the Chou capital to the east in 770 BC seems to have brought no lasting benefits. The changing fortunes of the feudal states gave rise to a 'proletariate of the nobility', from which a new social class arose, the so-called *shih*, a mixture of political advisers, scholars, philosophers and knights errant. Confucius was the most famous representative of this group. It is symptomatic of the new social order that was coming into being that he took as pupils not only scions of the nobility but also sons of the common people.

In the last phase of the Chou period, the age of the Warring States (Chan-kuo, 475–222 BC), the central authority completely collapsed, but even under semi-chaotic political conditions the highly competitive feudal states were able to create a rich and distinguished culture. Economic growth and an increase of trade between the states brought the once despised merchant class into its own. The western Chinese state of Ch'in increased its power through astute economic policies. Even merchants could become ministers exercising effective political control.

It is not surprising that in these times of changing social, material and intellectual conditions art also should adopt a new path. As early as the Middle Chou period the magical intensity disappears from the decoration of the ritual bronzes. Then, in the period of the Warring States, the surface of bronze vessels was covered with a luxuriant small-scale decoration, the effect of which was heightened by inlays in such precious materials as gold, silver and turquoise. Scenes of some complexity, including hunts with figures, also appear at this time.

56

Despite the relative homogeneity of Chou civilisation the archaeological finds from later phases give evidence of the rise of regional cultures, especially in the southern part of the Chinese area in the valleys of the Huai and Yangtze Rivers. These include the culture of the state of Ch'u with its characteristic lacquer industry, and, on the fringe of Chinese civilisation, the recently discovered Tien culture of Yünnan province with the extraordinary naturalism of its bronze work.

THE UNIFIED HAN STATE AND THE PERIOD OF DISUNION

In the centuries of warfare among the Chou feudal states the western state of Ch'in finally imposed itself through skilful polical manoevering and ruthless energy. In 221 BC its prince proclaimed himself the 'First illustrious Emperor of the Ch'in Dynasty' (Ch'in Shih-huang-ti). Supported by advisers from the severe legalist school of philosophers he pushed through strict reforms and standardised procedures not only in the political and administrative field, but also in cultural and intellectual matters. The rather old-fashioned Ch'in style of writing was decreed as the single script throughout the empire and the classic books, which mirrored conditions under the Chou, were forbidden and burned. In a gigantic engineering project the various small defensive walls of the old Chou states were linked into a monumental fortification in the north-west to secure the frontiers menaced by the barbarian nomads and at the same time to serve as a powerful symbol for the self-confidence and superior civilisation of the Chinese people.

But the achievements of the Ch'in were to have no lasting success. Shortly after the death of the gifted and powerful First Emperor, the dynasty was overthrown and from the general confusion there finally emerged a soldier of peasant origin by the name of Liu Pang, who founded the Han dynasty (206 BC–AD 220). A reaction set in against the tyranny of the Ch'in emperor. The Confucians won influence at court and their classics were henceforward to provide the basis for all education. Towards the end of the Han dynasty the edited and purified text of the Classics was engraved on sixty stone tablets, an undertaking carried out by an academy of officials under imperial order. Although the local administration was at first managed in accordance with feudal precedent, in the course of the Han dynasty a centralised bureaucracy was gradually built up under Confucian influence. Thus there merged a new 'gentry' or cultivated class, recruited from all ranks of society according to natural gifts and abilities. In 165, for the first time, the state subjected aspirants to office to an examination; this procedure became standard practice in the centralised Chinese state, serving to consolidate tradition and promote the longevity of the administration. The academy of the capital, which was responsible for training the higher officials, guaranteed a unified education and culture through the length and breadth of the enormous Han empire, which at its height stretched far into Central Asia. Thus lacquer objects produced in the south-

63. **Terracotta warriors**. Ch'in period, 221–206 BC. The discovery of the treasures associated with the vast tomb of the 'First illustrious Emperor of the Ch'in Dynasty' near the ancient capital of Ch'ang-an is one of the greatest events in modern archaeology. In 1974 farm workers sinking a well about one mile from the Emperor's tomb came upon the first of the life-size, terracotta army, which includes thousands of individually modelled, painted warriors, along with horses, chariots and metal weapons.

64. **Amulet in the form of a tiger.** Han period, 206 BC–AD 221. White jade. l. 7½ in. (19 cm.). Musée Guimet, Paris. As early as the Neolithic epoch, jade was recognised in the Far East as a precious stone endowed with extraordinary symbolic and magical powers. Here the artist has carved a white jade plaque in the form of the White Tiger, the mythical animal identified with the west. Notice the elegant engraving delineating the parts of the animal's body.

western province of Szechuan, the ancient centre of the industry, were used in the military colony of Lo-lang in the far north, in Korea, as archaeological finds attest.

Alongside the definitive establishment of the text of the Confucian classics there emerged that veneration of the written word that was destined to become so characteristic of Chinese culture. Tradition has handed down the names of high officials who were renowned for their calligraphic style; thus Ts'ai Yung is supposed to have written the texts of the stone classics in AD 183. In the Han period, familiarity with the classics and proficiency in the art of calligraphy foreshadows the later role of the Chinese 'man of letters' as the leading exponent of artistic culture. From calligraphy's sister art of painting we also know the names of important masters, though no work by them has survived. Descriptions in the Han dynasty histories indicate that the palaces contained impressive wall-paintings. The great halls were embellished with pictorial cycles of moral and didactic character: scenes of good rulers and faithful civil servants provided ever-present reminders to officials. A more convivial note was struck by scenes of feasts and banqueting, which reveal the extraordinary prosperity of Han China. There were also fine paintings on silk, which the emperor gave to subordinates as a mark of favour. A special bureau established in 29 BC for the care and preservation of paintings and calligraphic works of the court shows both the esteem in which works of art were held, and at the same time demonstrates the equal status accorded to painting and calligraphy. Nevertheless, the painters of the Han dynasty (and for a long time thereafter) did not belong to the social class of the *literati*, but, as in the earlier phases of western art, were craftsmen.

A reflection of the great wall-paintings of the palaces is provided by the frescoes that have survived in tomb chambers, such as those discovered in Liao-yang in southern Manchuria and in Wang-tu in Hopei province. In these paintings the artists first drew the contours of the picture and then filled in the colours. The well-known painted tiles from a tomb chamber now in the Boston Museum of Fine Arts show a type of line drawing that is closely related to calligraphy. The repertoire of subject-matter found in the rare fragments of Han painting is supplemented by the many stone engravings in their tombs, particularly in the Shantung province, and by the tiles with lively relief scenes of daily life that have come to light in Szechuan.

The sculpture of Han China is also known from funerary art. Work of this kind includes the monumental, but still primitive stone sculptures of the avenue of approach, the so-called 'spirit path' *(shên-tao)* leading to the tomb of general Ho Ch'ü-ping, as well as the winged lions at the tomb of Kao I in Szechuan, a motif that reached China from western Asia, though exactly how they arrived is not yet known. Symbolic figures of fired clay which replaced the earlier sacrifices of men and horses: glazed vases, jewellery and other offerings, are outstanding in the rich inventory of grave goods. The wealth lavished on burial and on the cult of the dead by officials and their families led to such a weakening of the otherwise unassailable economy of the late Han dynasty, that after the break-up of the dynasty into smaller states, successive rulers imposed a ban on luxurious tomb furnishings.

Although no single monument of architecture has survived, extensive excavations in the old metropolis of Ch'ang-an, together with the evidence supplied by terracotta models provide us with a clear idea of Han building. A basic feature of architecture, and one which was to remain important in later periods was a rectangular hall placed on a podium with wooden pillars and a trussed frame to support the heavy, projecting tile roof. The walls formed screens between the pillars but had not structural function. These halls, grouped around a sequence of courts or following one another along a central axis and with the entrance on the long side instead of on the narrow gable front provided the main feature of the extensive palace compounds. Even the various kinds of tower took the form of houses one placed on top of the other with a separate roof crowning each storey.

The sophisticated way of life of the Han society is reflected in various crafts. Bronzes lose the magical quality of the archaic phase: forms become simple, clear-cut and often rather sober. The most frequently occuring shape is the holder for toilet articles. There are also incense burners with pierced covers taking the form of a hill with animals, a scheme that reflects the Han affection for nature and landscape. Elegant gilded specimens of these incense burners survive, sometimes inlaid with precious stones. A speciality of the Han dynasty is lacquer work, which was produced commercially in the provinces of Szechuan and Hopei under state supervision. Silk was a Chinese monopoly and its products were exported westwards across Central Asia along the Silk Routes leading to Syria and Rome. The highly sophisticated art of jade carving continued the traditions of the Chou period; from this famous precious stone of the Far East the craftsman produced elegant pendants for ceremonial costumes and powerfully designed animal amulets.

58

57

64

The three and a half centuries between the final break up of the Han dynasty and the reunification of China under the Sui and T'ang dynasties are an age of change and new beginnings, culturally as well as politically. Admittedly the teachings of Buddhism had already entered China during the Han period and found some adherents, but in art the new faith began to make itself felt only during this period of transition.

At the beginning of the 4th century non-Chinese people pushed into the weakened north Chinese area, becoming the rulers of the native population that was culturally more sophisticated. The prestige of Chinese civilisation, however, soon cast its spell over these invaders and after a few generations they became largely absorbed into the Chinese way of life. Several states emerged, the most important one

(Continued on page 169)

54 (above). **Ceremonial axe.** Late Shang period.
12th–11th centuries BC. Bronze 11⅜ × 13¾ in. (30·4 × 35 cm.).
Ostasiatische Kunstabteilung, Staatliche Museen, Berlin. This
axe is rare among Shang bronzes because it shows a human
mask in fairly high relief upon both sides. The usual motif
was a more or less abstract animal ornament. The piece is
too heavy and unwieldy to have been used as a weapon for
practical purposes, but it may have been employed for ritual
executions.

55 (left). **Ritual vessel of the lei type.** Late Shang period.
13th–12th centuries BC. Bronze with green patina. h. 20⅛ in.
(52 cm.). Staatliches Museum für Völkerkunde, Munich. The
vessel, which bears a character on the inside made of the
components 'bird' and 'halberd', served as a container for
the fragrant wine offered to the ancestors. It reputedly comes
from the tomb of a Shang king of the bird clan near An-yang,
the final capital of the first Chinese dynasty. It is cast with
consummate mastery and the surface teems with a whole
catalogue of magical motifs, including a large *t'ao-tieh* mask,
and rows of dragon-like animals and birds.

56 (above). **Ritual vessel of the hu type.** Middle Chou
period. 8th–7th centuries BC. Patinated bronze. h. 2 ft. 4¾ in.
(73 cm.). Musée Guimet, Paris. Owing to a decline in belief
in the magical religion, the decoration of animal motifs
characteristic of the Shang and Early Chou periods gave way
in the Middle Chou period to a ribbon and interlace decoration
incorporating animal heads and other zoomorphic elements.
The function of this new repertoire seems to have been
largely aesthetic. It is significant that Confucius's rationalistic
doctrine was formulated only a little later.

57. Covered toilet box, or lien. Han period. Lacquer. h. (with lid) 4 in. (10 cm.). British Museum, London. The astonishing water-resistant quality of lacquer led to its use on a whole range of objects during Han times. It was applied either to wood, or to wood covered with hemp cloth, or to the cloth alone. This toilet box, obviously a luxury object, was made by applying successive layers of lacquer to a hemp core. Originally black, it has now acquired a greenish tone, and is decorated with animals and delicate scroll patterns in yellow and red, some motifs (e.g. the armed rider) being inlaid with silver.

58 (right). **Incense burner.** Han period. 2nd–1st centuries BC. Gilt bronze inlaid with stones. h. 6⅞ in. (17.5 cm.). Freer Gallery of Art, Washington, D.C. The design of openwork censer covers of this type symbolises the land of the immortals with animals running through the mountains and genii staging hunts. This so-called *po-shan-lu* in the Freer Gallery with its fine decoration and inlay is a key example of the metalwork of the first half of the Han dynasty.

59 (opposite). **Stele with Sākyamuni and Prabhūtaratna.** Wei period, dated 518. Gilt bronze. h. 9⅞ in. (25 cm.). Musée Guimet, Paris. The group represents the mystical conversation between Prabhūtaratna and the historical Buddha Sākyamuni. This elegant piece displays the mature style of the Wei period, which results from a Chinese transformation of elements from the Buddhist art of Central Asia. Characteristic of the developed Wei style are the subtle play of the drapery and the stylised flames of the two haloes, as well as the slender, graceful figures with their 'archaic' smile.

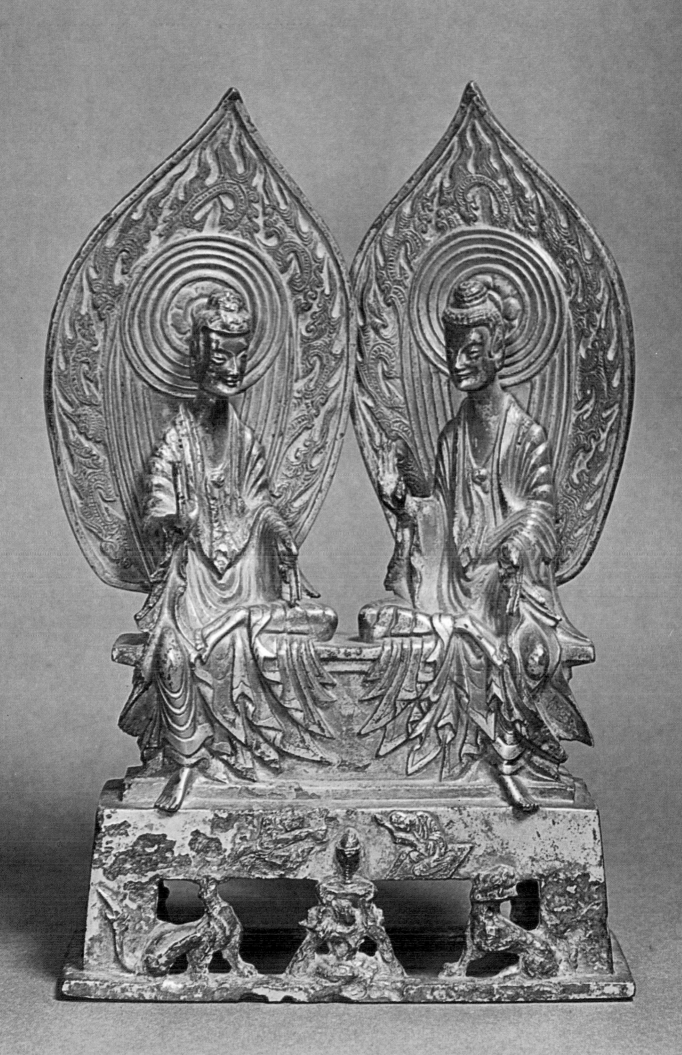

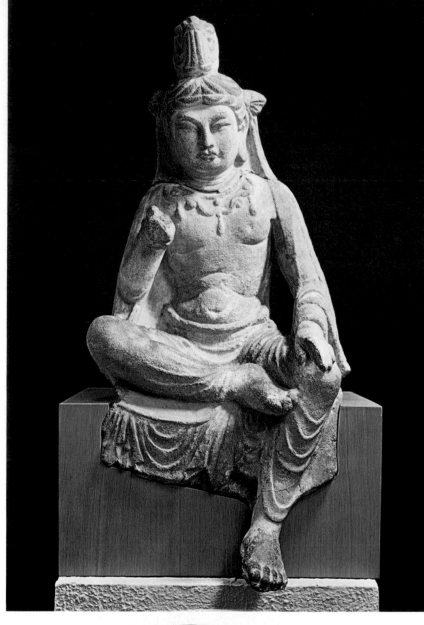

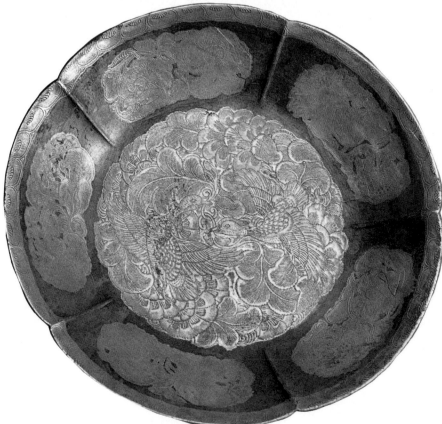

60 (left). **Bodhisattva.** T'ang period. Probably 8th century. Sandstone. h. 3 ft. 3⅜ in. (101 cm.). Rietberg Museum, Zurich. The figure comes from the rock sanctuary of T'ien-lung-shan in the province of Shansi. In contrast to the linear austerity of the sculpture of the Wei period (see plate 59) this Bodhisattva seated in the 'pose of indolence' *(lalitāsana)* represents the mellow and full-bodied style of T'ang sculpture.

61 (below left). **Silver plate with gilding.** T'ang period. 618–906 AD. Diameter 8½ in. (21·5 cm.). Musée Guimet, Paris. The prosperity of the T'ang civilisation is reflected in its fine gold- and silverwork. Decorative motifs derived from Persia are common. But the lobed plant forms and the pair of mandarin ducks betray the Chinese style of the second half of the T'ang period.

62 (opposite). **Seated court lady holding a mirror.** T'ang period. 618–906 AD. Fired terracotta with coloured glazes. h. 12½ in. (31·8 cm.). Victoria and Albert Museum, London. The practice of providing the dead with ceramic figures of women, entertainers, horses, dogs and so forth as symbolic companions in the after-life replaced the custom of human and animal sacrifice several centuries before Christ. In this small figure the elegance of the T'ang way of life speaks to us with astonishing freshness.

63 (p. 158). **Lotus and Ducks.** Hanging scroll. Late Sung or Yüan period. 13th–14th centuries. Colour on silk. 4 ft. 2⅜ in. × 2 ft. 6¾ in. (128 × 78 cm.). Ostasiatische Kunstabteilung, Staatliche Museen, Berlin. Paintings of this kind are not simply views of natural scenes, but a particular type of Buddhist cult image. The pure lotus growing up from a swamp is a prime symbol of Buddhism. Professional painters executed these pictures in pairs or sets for temple use.

64 (p. 159). **The Great King of Mount T'ai.** Hanging scroll. Late Sung or Yüan period. 13th–14th centuries. Ink and colour on silk. 33½ × 19⅞ in. (85 × 50·5 cm.). Ostasiatische Kunstabteilung, Staatliche Museen, Berlin. This painting comes from a series showing the ten infernal rulers of Chinese Buddhism. In the foreground sinners are tortured, while a demon takes the soul of a woman with her child to the terrible judge, wearing a collar of shame about her neck. In the 13th and 14th centuries Hell pictures of this kind were made by particular guilds of painters in the neighbourhood of the city of Ning-p'o, in Chekiang province.

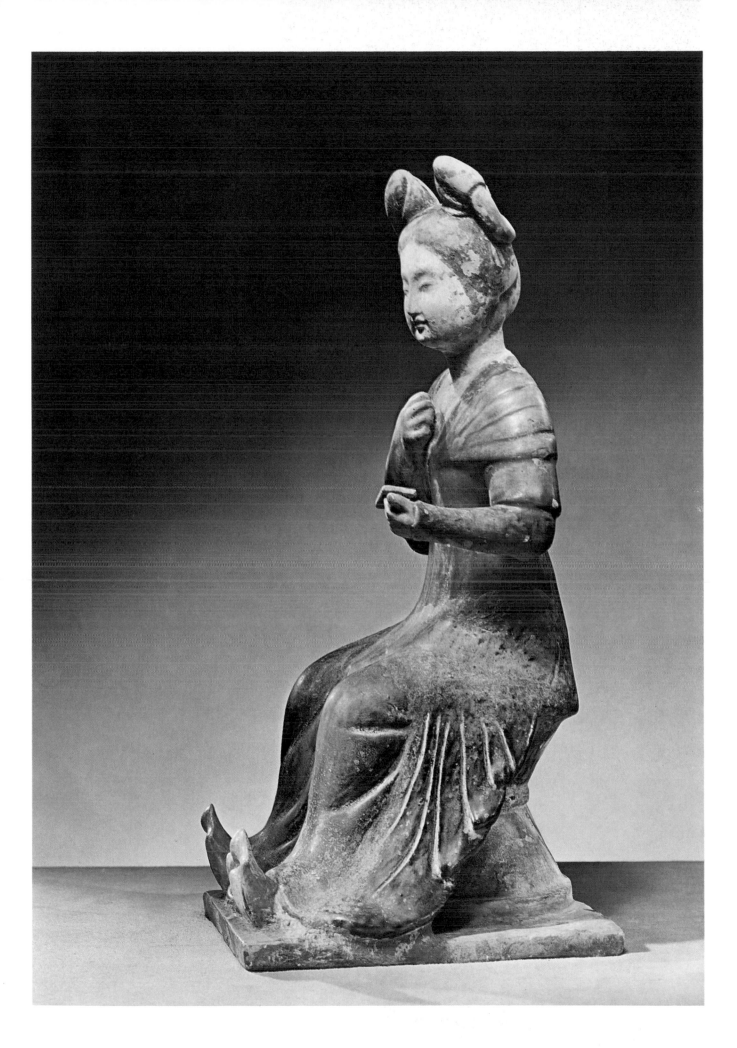

65. **Kuan-yin, the Bodhisattva of Mercy.** Yüan or early Ming period. Late 14th century. Wood, partly gilded. h. 5 ft. 7 in. (170 cm.). Private Collection, Lucerne. On loan to the Rietberg Museum, Zurich. This magnificently sculpted piece probably dates from the Yüan or early Ming period, for it usually found in sculpture of the Sung period. The Kuan-yin or Avalokitesvara is represented with all the gentleness and compassion associated with that deity. The beautifully rendered drapery adds to the serene air of the figure.

66 (opposite, above). **The Hall of Supreme Harmony.** Inner City, Peking. Ming dynasty (1627), restored and rebuilt under the Ch'ing. This main ceremonial hall, the *T'ai-ho-Tien* or Hall of Supreme Harmony, stands on a double-tiered marble terrace approached by two flights of steps and ramps of white marble. It was here that the Emperor sat enthroned at the great mass audiences of the year. The building style of the Imperial City was based on the disposition of ceremonial halls along an axis, separated by wide courtyards. If the decoration is sumptuous, the basic plan is simple enough, and is typical of Ming or Ch'ing structures. It consists of a simple oblong, the columns inside set out on the chancel-and-aisle principle. The overhanging roof covers a pillared portico, and is surmounted by a second roof, both of curved section and covered with blue tiles.

67 (opposite, below left). **Chün ware bottle.** Northern Sung dynasty. 960–1127. Stoneware with blue glaze and purple stippling. h. 11½ in. (29 cm.). Percival David Foundation, London. The best Sung ceramics are characterised by a supreme elegance of form. One-colour glazes were generally preferred, accompanied by flecks in another colour that appear to have been distributed almost at random. In this way they adhered to an ideal of simplicity that was especially prized by Japanese adepts of the tea cult.

68 (opposite, below right). **Vase in Mei-p'ing form.** Tz'e-chou ware. Sung dynasty. 960–1279. Stoneware with incised decoration under a green glaze. h. 15¾ in. (39 cm.). British Museum, London. In many pieces of this north Chinese ceramic group, T'ang traditions persisted, and their latent effects were felt as late as the Ming period. The brightness of the colours, the solidity of the form and the elegance of the decoration achieve a harmonious balance in this piece.

69 (above). **Wu Pin.** *The Coming of Spring.* Detail from a handscroll. Late Ming period, dated 1620. Ink and colour on paper. Size of entire scroll 1 ft. 3 in. × 4 ft. 3¾ in. (38 × 131·5 cm.). Cleveland Museum of Art, Ohio. In this work, one of the so-called individualists of the late Ming period unfolds with epic breadth and in minute detail a whole panorama of landscape in which he captures the lively activity of towns and villages at the beginning of spring. Wu Pin was a secretary in the government and a court painter, but he also belonged to the social elite of the literary artists who were not obliged to earn their living by their craft.

70 (left). **Shoulder jar.** Ming dynasty, Chia-Ching period. 1522–66. Porcelain with yellow glaze and iron-red pigment. h. 8¼ in. (21 cm.). Ostasiatische Kunstabteilung, Staatliche Museen, Berlin. This piece, which was fired in several stages, bears a powerfully drawn dragon, an emblem indicating that it was made in an Imperial factory. Porcelain decoration of this kind preserved its freshness and immediacy into the middle of the 16th century.

71 (p. 163). **Ch'iu Ying.** *Emperor Kuang-wu fording a river.* Detail of hanging scroll. Ming period, first half of the 16th century. Colour and ink on silk. Size of entire scroll 5 ft. 17⅜ in. × 2 ft. (171 × 65·5 cm.). National Gallery of Canada, Ottawa. An ideal landscape with steeply vertical mountain peaks in the manner of the Sung master Chao Po-chü shows in the foreground an Emperor of the Han dynasty with his retinue, fording a river. In typical Chinese fashion the figures are subordinated to, and absorbed into the main theme of the landscape. This strongly coloured landscape style was favoured by professional painters, of whom Ch'iu Ying was one; historically, Chinese taste has generally preferred the landscapes of the literary dilettante painters.

72 (opposite). **Offering Hall at the Altar of Heaven,** the *Ch'i-nien-tien,* Peking. Ming period. First built in 1420, reconstructed in 1889. This hall, in which the Emperor offered seasonal sacrifices to the God of Heaven, stands on a triple terrace symbolising heaven. Eight flights of steps approach the terrace from the eight cosmic directions. The hall itself is full of numerical symbolism. In accordance with the *yang* number of heaven the building has a three-stage roof, the twelve supporting columns representing the months of the year. In early Chinese history the *Ming-t'ang,* or Imperial ancestral hall, was built on similar cosmological principles.

73. **Offering Hall at the Altar of Heaven: interior of the dome.** First built in 1420. Reconstructed 1889, restored early 20th century. The magnificent interior of the Offering Hall is painted in a glowing mixture of blues, red and gold. The coffered dome encircling the lantern is covered in gold leaf, while the brackets are painted blue against a red background. Although the paintwork is much restored, it gives an accurate impression of Chinese Imperial splendour during Ming and Ch'ing times.

74 (opposite). **Seated figure of Lo-han.**
Ming period, 16th century. Light
grey terracotta with coloured glazes.
h. (without base) 3 ft. 1 in. (94 cm.).
Ostasiatische Kunstabteilung, Staatliche
Museen, Berlin. The figure belongs to a
set of sixteen or eighteen Lo-hans, the
chief disciples of the Buddha. These
groups were generally arranged on
stone benches along the side walls of the
hall of Chinese temples. In them the
rigorous iconographic prescriptions of
later Buddhist sculpture were relaxed
in favour of a relatively free and
naturalistic rendering.

75. **Lacquer throne.** Ch'ing dynasty,
Ch'ien-lung period. 1736–96. Wood
core with carved red lacquer decoration.
h. 4 ft. (122 cm.). Victoria and Albert
Museum, London. An outstanding
document of the Imperial majesty of the
Ch'ing, the throne originally stood in the
Nan-hai-tze before the Yung-ting Gate
in Peking, the hunting palace of the
Manchu Emperor Ch'ien-lung. The
piece is covered with good luck symbols,
which are carved deep in the thick layer
of red lacquer, exposing the underlayers
of olive-green, brown and yellow lacquer.

76. **K'un-ts'an.** *Landscape.* Ch'ing dynasty. Ostasiatische Kunstabteilung, Staatliche Museen, Berlin. The monk-painter K'un-ts'an, also known as Shih-ch'i, lived *c.* 1625–1700. He entered the priesthood as a young man and spent most of his life in Buddhist institutions, becoming friends with many of the *literati* who had gone into voluntary exile at the fall of the Ming (1644). His work is characterised by a rather sombre atmosphere, and a complicated brushwork which gives his landscapes, with their jagged mountains and twisted trees, a restless quality. He appears to have been a simple, unambitious man of great piety. In this work a Buddhist priest is shown in his mountain retreat. The landscape, although complicated, is totally un-mechanical and reflects the painter's deep feeling for nature.

77. **'Famille Rose' bottle.** Ch'ing dynasty, Yung-chêng period. 1723–35. Porcelain with coloured enamel decoration. h. 11½ in. (29·4 cm.). Percival David Foundation, London. During the reign of the Manchu Emperor Yung-chêng, the porcelains of the Imperial factories of Ching-tê-chên reached an unsurpassed peak of technical refinement and brilliance. Pieces of the quality of this bottle were probably not intended for export but were made for use in the Imperial palace.

being set up under the leadership of the Toba clan as Northern Wei (386–534). Many Chinese nobles and with them members of the bureaucracy fled before the barbarian inroads south of the Yangtze River. In the south too a number of states arose, the most important of which had its capital at Chien-k'ang, modern Nanking. Here the educated classes strove to maintain cultural and intellectual life according to the traditional pattern.

The political collapse and the breakdown of the old social order dealt nevertheless a heavy blow to traditional Confucianism and encouraged the growth of Taoism, especially in South China. Thinkers of this school had always regarded Confucianism as an over-rationalistic system; in its place they preached a return to the simple ways of nature. In general, a certain vaguely Taoist kind of escapism seemed to catch the spirit of the times in the south.

Scarcely less attractive than Taoism—and indeed more so for the common people—was the new religion of Buddhism with its elaborate metaphysics, a dimension that was lacking in the classical religio-philosophical systems of China. From the Central Asian trading cities, which were also flourishing centres of Buddhist missionary activity, the new faith trickled into north China via the Silk Routes. In South China it came by way of South-East Asia with its own active cradles of Buddhism, notably the kingdom of Funan.

The monastic aspect of Buddhism, which was utterly alien to the traditional Chinese social system, offered comfort and security to the rootless and dispossessed from all sectors of society. And the unaccustomed practice of honouring cult figures with religious rites and ceremonies produced a flood of pious foundations to shelter the holy images. In sculpture and painting as well as in architecture, artists had to come to terms with models from Central Asia and from India herself; the acquisition and spread of these forms created whole new branches of Chinese art. The earliest known examples of Chinese cult images in bronze for Buddhist use depend closely on Central Asian prototypes **59** and were generally small in size. But the native Chinese capacity for assimilation and transformation brought about a fusion with earlier Chinese forms so that a new and homogeneous art emerged. This constitutes the so-called 'archaic' stage of Buddhist sculpture in China which is usually **65** termed the Wei style after the dynasty founded by the Toba clan.

In accordance with the monastic rule of Buddhism the monks used to spend the summer months in missionary work begging for their food in the countryside, while they passed the winter in the monasteries. Following Indian precedent and Central Asian prototypes their *viharas*, or monasteries, often consisted of a series of caves cut in the side of rocky cliffs. The Toba nobles vied with one another in founding these cave sanctuaries and in providing them with a wealth of painting and sculpture; such works of piety were encouraged by the nature of Buddhism which was a religion of salvation. The caves of Yün-kang and Lung-mên with their thousands of sculptures are justly famous.

65. **Maitreya.** From the cave sanctuary at Lung-mên, Honan province. Wei period, early 6th century. Limestone. h. 21¼ in. (54 cm.). Rietberg Museum, Zurich. Like a statue from a Romanesque church portal the Buddha of the future sits with crossed legs on a lion throne. The slenderness of the figure and head, the archaic freshness and the linear manner of execution make the piece an outstanding example of the early phase of Chinese Buddhist sculpture. Many such figures were carved as pious offerings on the walls of the cave sanctuaries.

By contrast the sanctuary on the mountain of Mai-chi-shan **66** in the south-west corner of the western Chinese province of Kansu lay forgotten for many years and was only recently rediscovered. While the cave temples of the central area boasted stone sculpture of large, even colossal dimensions, here the images were moulded in stucco following Central **67** Asian practice. The need to make the figure accord with iconographical rules formulated in India was new to the Chinese artists. But they soon adjusted themselves to this idea and in the 6th century created forms of an astonishing **65** inner force and beauty that recall the sculpture of the earlier middle ages in Europe. In the predilection for the sinuous folds of the draped figure the Chinese feeling for **59** calligraphic line took on a new life. In cases where the iconography called for nude forms, however, as in the fierce guardian figures, the sculptors were tempted to exaggerate the musculature and to ignore softness of the human **68** body. In painting also Buddhism brought new elements. The paintings of the cave temples of Tun-huang (executed

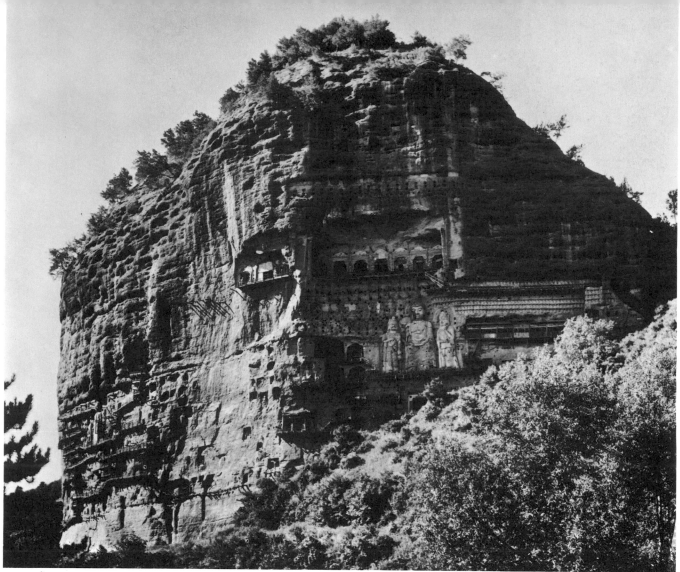

66. **The cave temples of Mai-chi-shan, Kansu.** 6th
century AD. Mai-chi-shan was a holy site as early as the 5th
century. The sanctuary comprises over 190 separate caves
hollowed out of the rock. The work began in the Northern Wei
period and continued until 1000 AD. Since the type of rock was
unsuited to sculpture, the innumerable figures which decorate
the sanctuary were modelled in clay over stone or wooden cores.

67. **Detail of sculpture, Mai-chi-shan.** The sculpture at
Mai-chi-shan represents an important stage between the early
examples at Lung-mên (see figure 65) and the full flowering
of the T'ang style. The figures are far more naturalistic than at
Lung-mên. The huge figure of the Buddha was constructed by
inserting wooden armatures into the walls so as to support the
projecting members such as the arms.

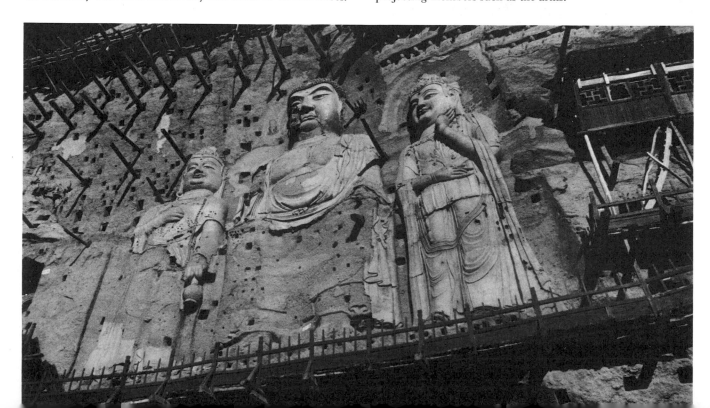

between the last quarter of the 5th and the first half of the 8th century) show clearly the way in which the Chinese gradually brought their own aesthetic to bear on Buddhist religious painting.

Alongside this Buddhist world, the indigenous tradition of wall-painting lived on, as we know from examples in Manchuria and Korea. In the south, in Chien-k'ang, numerous painters and calligraphers were at work under the patronage of the Eastern Chin dynasty (317–420). We can get some idea of their art from a scroll in the British Museum ascribed to Ku K'ai-chih (c. 344–406). This period saw the appearance of the typical Far Eastern scroll which took the form of an ancient book or rotulus. Painting was now freed from bondage to architecture and brought into the intimate setting of the refined connoisseur who would unroll the scrolls for his own pleasure. This was part of the cultivated life of the nobles and literati of the southern dynasties who enjoyed and themselves practised the fine arts—poetry, music, calligraphy and painting. Painting no longer played the didactic role attributed to it in Confucian thought, for it was no longer intended for the instruction of the general public, but was the special preserve of a social elite, whose members derived exquisite pleasure from its practice and enjoyment. Consequently in about 500 we find the first indications of a conscious critical theory of art. At the same time political vicissitudes and the growth of Taoism promoted an interest in nature—an interest reflected both in the poetry of T'ao Yüan-ming (365–427) and in the beginnings of pure landscape painting, of which unfortunately there are no surviving examples. The architecture of this period blended the form of the Indian *stupa* with the indigenous tower to produce the characteristic Buddhist stone pagoda. Monastery and temple layouts made use of the old Far Eastern hall type, placed in and around courtyards. In the crafts the creation of proto-celadon ranks as an important innovation.

78

68. **Dvarapāla.** From Pei Hsiang-t'ang, Hopei-Honan border district. Northern Ch'i period, second half of the 6th century. Limestone. h. 3 ft. 6⅞ in. (109 cm.). Rietberg Museum, Zurich. This figure is one of a pair of door guardians from the famous cave sanctuary of Pei Hsiang-t'ang, where their fierce forms flanked one of the entrances, to ward off devils and evil influences. The musculature of the athletic figure has been turned into a kind of ornamental pattern that betrays the uncertainty of the Chinese sculptor (who was accustomed to making draped figures) as to how to render the naked human body.

69. **Ta-yen-t'a, the Great Gander Pagoda.** Sian-fu, formerly Ch'ang-an. T'ang period, c. 704 AD. This brick pagoda, one of the most important remains of the T'ang capital Ch'ang-an, was erected in honour of the famous pilgrim Hsüan-tsang in his monastery of Tz'e-ên-sze. The building, which originally had five storeys, was rebuilt about 704 with seven storeys. Its simple, clear forms are generally regarded as the classical expression of T'ang-period building. Pagodas of this kind were erected more as commemorative monuments than for any practical purpose.

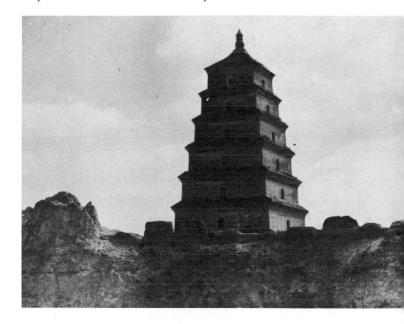

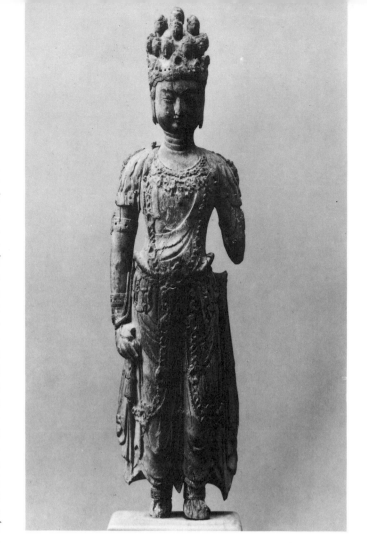

THE CLASSIC AGE OF THE SUI AND T'ANG DYNASTIES

The reunification of the far-flung Chinese territories under the short-lived Sui dynasty (581–618), followed by the consolidation and extension of the state to the gates of Persia under the rule of the T'ang emperors (618–906), may justly be regarded as the golden age of Chinese culture. The initial toleration, even support of the Buddhist faith—with its almost bewildering variety of sects—on the part of the imperial house, produced a flowering of Buddhism that was unprecedented in the Far East. The art of block printing which began during the T'ang period and which was practised with great dedication and outstanding ability by Buddhist monks, played an important part in spreading Chinese versions of the creeds and texts of the faith throughout the empire. The number of monks who had renounced their families and society for the meditative life in a monastery, grew rapidly, much to the disgust of the worldly and practical Confucians. Through pious donations the great monasteries acquired vast holdings of land worked by tenant farmers. In the same way bronze suitable for coinage flowed into the temples where it was made into cult images which lay outside the grasp of the imperial treasury. Not surprisingly the Buddhist monasteries took on the role of banks, accumulating large funds from the high interest rates they charged on loans to members of the commercial and agrarian classes. The Buddhist church was on the way to becoming a state within a state, thereby gravely undermining the basic Confucian structure of the government. When Buddhism penetrated the heart of the palace, it became the focus of family intrigues. The situation eventually reached a breaking point and the Confucian state apparatus reacted with a drastic measure: an imperial edict of 845 let loose an avalanche of compulsory secularisation. As a result of this persecution some 4600 large temples and 40,000 shrines were destroyed and an incalculable number of monks and nuns were forced to return to the world. This blow destroyed the power of Buddhism to control the development of society; when tolerance or support returned, as they did in later times, the earlier vigour could not be recaptured.

Our only picture of the imposing temples of the capital of Ch'ang-an in the first half of the T'ang dynasty comes from contemporary literary descriptions. Some stone pagodas of typically Chinese form alone escaped the fury of destruction. The lost palace halls must have abounded in sculpture in wood, dry lacquer and, most notably, bronze; their classic style is echoed in some pieces of the same period that have survived in Japan. Wall-painting, too, achieved a style of international standing characterised by harmonious design and balanced compositions. This style reached far beyond China's borders, as is affirmed by the examples of 711 in the Japanese temple of Hōryū-ji—unfortunately largely destroyed in a recent fire. Such renowned painters as Wu Tao-tzŭ (active 720–60), who was attached for a time to the imperial court, created pictorial cycles on temple walls, but unfortunately none of these have survived.

70 (above). **Eleven-headed Bodhisattva Kuan-yin.** Found at Toyoq, Turkestan. 9th–10th centuries. Wood, formerly mounted. h. 15 in. (38 cm.). Indische Kunstabteilung, Staatliche Museen, Berlin. Though found outside China proper, this small, finely carved piece may be regarded as a good example of Chinese sculpture between the late T'ang and early Sung periods, of which hardly any large-scale wood sculpture survives. The Bodhisattva of compassion was probably originally revered in the cult ceremonies of a Tantric sect.

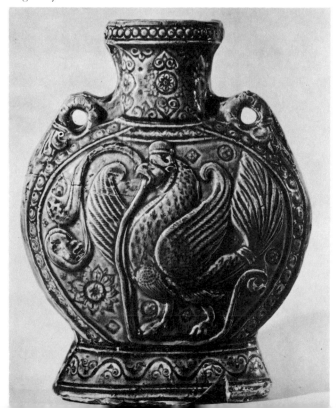

Provincial versions of the great wall-paintings of this period appear among the wall-paintings of the Tun-huang caves, which lie on the edge of Central Asia, far from the hot-houses of classical culture in such great cities as Ch'ang-an and Lo-yang. As the finds show, designs were transferred on to the walls from pricked cartoons. This device facilitated the execution of carefully measured iconographical compositions, but it tended also to restrict the artists' imagination. Stipulations of this kind explain the attitude of disdain felt by the literati-artists towards religious work of this kind.

Stone sculpture lined the walls of cave sanctuaries or took the form of the ever-popular steles or cult images. It **60** reveals a maturity and fullness of form partly achieved through a natural process of evolution from the styles of the 6th and 7th centuries, and partly through the new wave **70** of influence from the Indian homeland of Buddhism.

In its heyday the T'ang imperial court showed a liberal cosmopolitanism only rivalled, if at all, under the Mongol rulers of the 13th and 14th centuries. The metropolis of Ch'ang-an, which had some two million inhabitants according to the census of 742, formed the eastern end of the long caravan route passing through Central Asia; at the same time it was linked with the Chinese coastal regions as far as Canton through a network of natural and artificial waterways. Here, at the heart of the administrative system and the seat of the emperor, foreign tribute goods both from home and abroad arrived in a ceaseless flow. The city teemed with merchants, monks, craftsmen and artists from Central Asia and points farther west. Western motifs ap-**71** pear in ceramics even before the founding of the T'ang dynasty as well as in the gold and silverwork of which we **61** have a number of examples showing a fusion of Sassanian stylistic features with native decorative elements. Until the persecution of 845, Zoroastrians, Nestorians, Manichaeans, Jews and Moslems could practice their religions freely in Ch'ang-an.

The sophistication of life under the T'ang still speaks direct-**62** ly to us in the lively modelling of the ceramic figurines, partly glazed with colour, which were made as grave goods: elegant harem ladies, Central Asian merchants and camel drivers, noble breeds of horses imported from **72** Ferghana for hunting and polo, dwarfs employed as court entertainers and many other subjects.

The aim of the first T'ang rulers, who came from a north Chinese family, was to achieve a homogeneous culture for the whole far-flung empire, which was to be based mainly

71 (opposite). **Pilgrim's Bottle.** Sui or early T'ang period, 6th–7th centuries. Heavy stoneware with bright green glaze. h. 7¼ in. (18 cm.). Ostasiatische Kunstabteilung, Staatliche Museen, Berlin. So-called 'pilgrim's bottles' of this type show Western influence in shape and generally in decoration as well. The pearl band and the bird in a roundel on this piece recall Sassanian metal objects, though these are somewhat later; this disparity may indicate a common Central Asian origin. The motifs testify to the cosmopolitan spirit of this period.

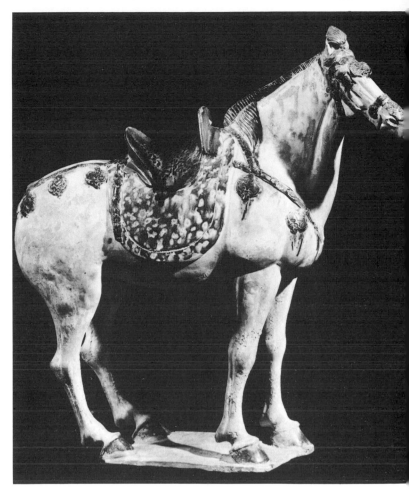

72. **Horse.** T'ang period, 618–906. Ceramic with colour glazes. h. 24⅜ in. (62 cm.). H. König Collection, Cologne. Although the majority of the terracotta grave gifts of the T'ang period were mass-produced from moulds, some of the larger pieces reach the status of independent works of art. The 'blood-sweating' horses of Ferghana, which were used in polo and equestrian displays, were among the most popular imports into the T'ang empire. It is therefore not surprising that these horses occur frequently among the tomb figures.

upon the continuing traditions of the refined south. Particularly effective were the measures of the emperor T'ai-tsung (627–49), who sought to consolidate and purify the lately rather muddled tradition of the Confucian classics that had persisted in the south; he held this revitalised tradition up to the nobility and the bureaucracy as an educational model. T'ai-tsung was an almost fanatical admirer of the calligraphic school of the southern dynasties that had grown up around the figure of Wang Hsi-chih (c. 307–65). To his favoured academy of Hung-wên-kuan in Ch'ang-an he summoned as leading scholars and calligraphers the literati Ou-yang Hsün and Yü Shih-nan, both of whom had reached a venerable age. The theory and aesthetic of calligraphy were firmly grounded in the T'ang period, though in the second half of the dynasty a certain reaction took place against the traditionalism of the dominant Wang school. Characteristic are the severe writing style of Yen Chên-ch'ing (709–85) and the rather fantastic expressive script of the monk Huai-su, who seems inten-**73** tionally to have flouted the classical rules. While the calligraphers became well established in the upper ranks of the social hierarchy, the painters were still unable to free

73. **Huai-su.** Part of an autobiography. Dated 777. Handscroll. Ink on paper. h. 9⅝ in. (24·4 cm.). National Palace Museum, T'apei, Taiwan. Huai-su (725–*c.* 787) of the T'ang period practised an idiosyncratic version of the *Ts'ao-shu* or 'Grass Style'. His characters, which tend to be joined, have an extraordinarily expressive quality.

74. **The Emperor Hui-tsung.** *Beginning of a poem on autumn flowers.* Handscroll. Ink on silk. h. 10¾ in. (27·2 cm.). National Palace Museum, T'apei, Taiwan. Hui-tsung (1082–1135; reigned 1101–25), the last ruler of the Northern Sung dynasty, was a gifted poet, painter and calligrapher. This example is written in 'Slender Gold', an aristocratic variation he created from *Hsing-shu* or the 'Running Style'. The elegant strokes often end in a hook—a characteristic feature of Slender Gold.

themselves entirely from the fetters of craft work. On the one hand such painters as Wu Tao-tsŭ and Li Sze-hsün enjoyed esteem and were able to acquire official recognition—the latter was a minister of state—but on the other the head of the Ministry of Works, Yen Li-pên bitterly complained of the imperial commissions he had received and he cautioned his son against taking up such an occupation. Unfortunately no signed work survives from these artists' hand nor from that of the poet-painter Wang Wei (699–759), who seems to have played an important role in the development of brush drawing and who had a great reputation as a landscape painter. In general, the T'ang dynasty saw the appearance of the distinctively Chinese artistic figure—men who belonged to the social elite and were not obliged to earn their living by painting.

THE FIVE DYNASTIES AND THE SUNG PERIOD

Like the Han before it, the T'ang empire split into a number of successor states. And just as before this political fragmentation was accompanied by a shift in the cultural centre of gravity towards the Yangtze River and farther south. While the north was risen by chaotic economic and political conditions, the south at first enjoyed an economic resurgence based on an increasing production of rice, tea and salt and extensive trade connexions.

Under the last ruler of the short-lived Southern T'ang dynasty, the sensitive poet Li Yü (937–98), (reigned 961–75), the refinement of life reached new heights. The academy of Li's court was illuminated by such figures as Chou Wen-chü, who painted elegant figure scenes in the style of the great T'ang period. At the same time the ruler fostered a new category of painting, a kind of 'nature still-life' with scenes of plants and animals acutely observed and finely executed. Other figures at work in this period include the founders of a branch of monumental landscape painting, Ching Hao, Kuan T'ung and the monk Chü-jan. Another monk Kuan-hsiu, became famous for his expressive pictures of Buddhist saints.

The aesthetic refinement of the court of Li Yü was also reflected in the art of print making. The paper produced in the imperial workshop was long regarded as the best and commanded high prices. Ceramics also enjoyed a new flowering in southern China.

After reunification had been achieved once more, the new Sung rulers sought to recreate the state and culture of the T'ang, though less effectively. The new bureaucracy and leisured classes of the Sung came, however, mainly from the civil population and not from the military aristocracy as under the T'ang. The art and culture of the Sung dynasty (960–1279) was marked by the rise of a new urban bourgeoisie. Often the members of this bourgeoisie, who might hold high office within the government hierarchy or occupy themselves with trade matters, were also big landowners with estates worked by peasant farmers under the supervision of a bailiff. This double aspect—urban society with its burden of community responsibility on the one hand and carefree life in the country on the other—typifies the life on the educated class under the Sung. In the early part of the dynasty several men of strong personality left a decisive stamp on the image of the literati. These figures include the politically somewhat unfortunate Su Tung-p'o (1036–1101) and the successful Mi Fu (1051–1107). Alongside their official duties these men cultivated in their private lives the liberal arts of poetry, calligraphy, painting and music. Their critical and theoretical writings proved decisive in establishing the concept of the literary artist *(wên-jên)*, which later became almost a cliché. Firmly linked to the state hierarchy was the artist who belonged to the Academy of Painting *(Hua-yüan)* of the imperial court and who bore official titles. Under the patronage of the politically weak emperor Hui-tsung (reigned 1101–1126) the academicians produced detailed pictures of plants and animals as well as landscapes. But there were also schools of painters comprising largely anonymous masters who continued a long-established tradition in this

74

75 (above). **Hsü Tao-ning.** *Fishing in the Mountain Stream* (detail). Northern Sung period, *c.* 1000. Handscroll. Ink on silk. Whole size 19 × 82½ in. (48 × 210 cm.). William Rockhill Nelson Gallery of Art, Kansas City. This is one of the finest landscapes that have come down to us from the Sung dynasty. It was painted by a former herbalist who, under the protection of a minister, made a name for himself in aristocratic circles as a painter. The artist develops and varies his landscape theme like a musical composition in a sequence of motifs running from right to left; the work was intended to be enjoyed, not only in its entirety, but also in sections as it was unrolled on a table in the privacy of a scholar's study.

genre. These were professional artists organised in corporations or guilds who often worked for Buddhist patrons. **63** The increasing artistic influence of the bourgeoisie is evident in the figure of the painter Hsü Tao-ning, who lived in the first half of the 11th century. Originally an apothecary who only painted in his spare time, Hsü eventually received a flood of commissions, ultimately becoming a minister's protege. Although to our eyes his powerful land- **75** scape paintings seem to belong among the most effective works of their kind they were characteristically considered 'vulgar' by the contemporary art critic Mi Fu.

Another feature of Sung painting—especially during the second half of the dynasty when the Chin dynasty established by the nomadic Jurchen usurped the north, forcing the Sung to move the capital to the southern city of Hang-chou—is the increasing influence of the Ch'an (Zen) sect of Buddhism. Many literati were attracted by its teachings and particularly towards the elegantly simple way of life of this meditative school. In the first half of the 13th century several monks of the Ch'an sect became famous as painters; they developed a style of their own characterised by immediacy of expression, simplicity of means and individuality of brush-stroke. Outstanding among the Ch'an painters is Liang K'ai, who at first worked at the imperial **76** academy in Hang-chou. When he was awarded the Golden Belt by the emperor he left it hanging in the hall of the palace and quit the capital. He spent the rest of his life in the solitude of Ch'an temples, where his art acquired the style so characteristic of the monk painters. Also standing apart from official painting were such local schools as that of Ning-p'o in Chekiang province—a school famous for **64** its scenes of hell.

In sculpture T'ang tradition persisted, but the weakening of links with Buddhism is unmistakeable. Wood sculpture in particular freed itself almost entirely from Indian tutelage; it tended either towards excessive elegance or **65** towards naturalism.

Ceramics offer the finest witness of the technical and artistic achievements of Sung crafts. The vases produced in the state factories for palace use possessed a classic perfection of form and colour scarcely rivalled anywhere else **67** in the world. At the same time factories in northern China adapted the old traditions of colour glazing and painting to the taste of the age. The cult of the tea ceremony which **68** had grown up in association with Ch'an Buddhism created

76 (left). **Liang K'ai.** *Ch'an Patriarch Cutting a Bamboo Pole.* Sung period, first half of the 13th century. Hanging scroll. Ink on paper. 29⅝ × 12½ in. (72 × 32 cm.). National Museum, Tokyo. Liang K'ai, who first worked as an academic painter at court, later withdrew from the world to live according to the spirit of Ch'an (Zen) Buddhism. Not only did he take the themes of his painting from the school, but his style itself, with its immediacy and simplicity, accords with Ch'an ideals. This work represents the sixth Chinese patriarch Hui-nêng, whose enlightenment was no obstacle to his carrying on everyday activities.

77. **Huang Kung-wang.** *The Fu-ch'un scroll* (detail). Yüan period, dated 1350. Handscroll. Ink on paper. Whole size 13 in. × 20 ft. 10¾ in. (33 × 673 cm.). National Palace Museum, T'apei, Taiwan. This famous scroll is the artist's masterpiece and it can appropriately be placed at the forefront of the later phase of Chinese painting. After a short official career Huang lived as a Taoist priest in the mountains near Hang-chou; in this painting he offers a panoramic view of these mountains. Stylistically he depends on masters of the early Sung period, yet in his work the mountain and rock formations take on a crystalline character that found much favour among later literary painters.

78. **Ts'ao Chih-po.** *Pavilion with Ancient Pines.* Yüan period, first half of the 14th century. Hanging scroll. Ink on paper. 18¾ × 17⅝ in. (47 × 45 cm.). Musée Guimet, Paris. Unlike the revolutionary Huang Kung-wang, his friend Ts'ao Chih-po (1272–*c.* 1362) followed the style of the Sung masters in his landscapes and tree pictures. Initially, the painter served an official bureau under Kubilai Khan, but he later retired to devote himself to Taoist studies and to painting.

its own aesthetic with a tendency to simplicity and unobtrusiveness, which may have influenced the so-called Temmoku ware.

THE RECENT PERIOD: FROM THE MONGOL PERIOD UNTIL THE PRESENT TIME

Through its incorporation in the vast Eurasian empire of the Mongols, who ruled in China under the name of the Yüan dynasty from 1260 to 1368, China emerged from its isolation as never before or since. The cosmopolitan atmosphere of the Mongol imperial court in Peking led to the introduction of foreign ways of thinking, particularly in the natural sciences. Since the Mongols, especially under the reign of Kubilai Khan, sought to assimilate as much as possible of the culturally superior Chinese civilisation and since the Eurasian 'Pax Mongolica' assured a period of tranquility, many of the literati decided to collaborate with the conquerors. Pre-eminent among them was the calligrapher, painter and connoisseur Chao Mêng-fu, who exercised a great influence on the cultural life of his time, ultimately becoming director of the Han-lin academy.

Other Chinese literati and artists, however, true to their Confucian heritage, practised a kind of passive resistance to the 'barbarian regime'. They refused to accept offices and lived as outsiders in temples or on their estates according to their means. Among these was Huang Kung-wang (1259–1354), whose Taoist leanings prompted him to wander over the countryside expressing his feeling of union with nature in landscape paintings. Together with three other artists he can be regarded as the founder of later Chinese painting. In Huang's pictures the rendering of immediate perceptions yielded to an emphasis on individual brush-work, and a manneristic tendency to reduce landscape forms to a series small repetitive devices. His friend Ts'ao Chih-po (1272–1355) at first held a minor office but later he too adopted a life of leisure. In contrast to Huang, this artist's landscapes and trees are still fairly close to the style of the Sung period.

The national Chinese dynasty of the Ming cast off the foreign domination of the Mongols, initiating an uninterrupted rule of almost three centuries (1368–1644). Its

77

78

79 (below). **The Sacred Way heading to the tomb of the Emperor Yung-Lo.** Ming dynasty, *c.* 1403–1424. His tomb lies some twenty-five miles north of Peking at Nan-k'ou. A broad avenue leads to the tomb, lined with monumental figures of warriors and animals carved in limestone. Among these are lions, camels, elephants and horses. Although these sculptures derive from T'ang models, they lack, perhaps because of their size, some of the delicacy and subtlety of T'ang examples.

80 (right). **Limestone figure of a warrior.** One of the sculptures lining the Sacred Way (see figure 79), this official is dressed in a coat of mail with a helmet reaching to his shoulders. In his right hand he holds his baton of office and with his left he clasps his sword hilt. The rich surface decoration of this figure makes it particularly splendid.

81. **Burial temple of the Emperor Yung-lo, near Peking.** *c.* 1424. This interior is typical of the temple halls of the Ming dynasty. The traditional Chinese system of beam and pillar construction is observed, the beams being morticed and tenoned together so that the stress on the massive columns is reduced. As this is a broad building, additional columns are needed within the hall. The overhanging roof protects the exterior walls from the weather so that these can be light and insubstantial.

rulers sought to return to older Chinese ways and to reject the cosmopolitan spirit of Mongol times. During the second half of the dynasty, however, European traders succeeded in gaining a foothold on the south China coast and then, towards the end of the Ming period, large-scale exports of such Chinese goods as porcelain and silk began to flow to the Middle East, Europe and Latin America.

The imperial majesty of the first Ming rulers is still proclaimed today in the imposing tombs approached by 79,80,**72** avenues lined with colossal stone statues, and by the 81,**66** grandiloquent architecture of their ancestral halls.

The dictatorial attitude of the earlier Ming emperors towards the artists attached to the court is notorious. Some seventy or eighty artists worked in loose association in the palace workshops which were supervised by eunuchs. There was not academy as such; instead the authorities hit on the expedient of giving military ranks to many of the painters. Some artists of the imperial workshops paid with their lives for conspicuous lack of application or zeal.

A real advance in the art of painting could not occur in this oppressive setting; rather the progressive spirits flocked to the old centres of the fine arts in the south. The city of Suchou in Kiangsu province sheltered not only such important professional painters as Ch'iu Ying, who was **71** obliged to make his living from the sale of his pictures and whose works as a result were often tailored to meet the customer's requirements so that they cannot be regarded as evidence of the true dilettante painting, but also a circle of famous literati painters who played an important part in *82*

the development of the genre. Although the members of this group are often known collectively as the 'Wu school' after an old name for Suchou, they form more of a literary circle, held together more by common interest than by the bonds of a regular artistic school. Many regarded painting as the least of the arts they practiced, and consequently even today they are better known in China as calligraphers and poets. They generally belonged to well-to-do families; consequently few of them were obliged to accept office in order to live. The central figure of the Wu school, Shen Chou (1427–1509), consulted an oracle when an office was offered him, rejecting the post when a negative answer was forthcoming. In his landscapes the natural atmosphere is even less evident than in the work of Huang Kung-wang, which he took as his model. His highly personal brush-work is of particular interest and the landscape elements become taut and stylised.

This new tendency was carried to an extreme by Tung Ch'i-ch'ang (1555–1636), a calligrapher, painter and critic active towards the end of the dynasty; he served as head of the Ministry of Rites and reflected the official taste of the time. Tung Ch'i-ch'ang was responsible for the theoretical elaboration of the concept of the literary painter *(wên-jên)*. Another group of artists was at work in the last decades of the Ming period: the so-called 'individualists'. The outward appearance of their landscape paintings ranges from tranquil reserve to a conscious striving for monumentality.

Craft productions reached new heights, reflections in their richness the exalted claims to majesty made by the dynasty itself. In the province of Kiangsu the flourishing state porcelain factories of Ching-tê-chên supplied not only the national market, but were also able to meet an increasing volume of orders from the West. The same is true of the flourishing lacquer industry.

The weakness of the Ming empire in the first half of the 17th century could not fail to tempt the Manchu, a people stemming from Jurchen stock, who first occupied Manchuria with their strong cavalry forces and then the whole of China. For two and a half centuries they ruled the country under China's last imperial dynasty, the Ch'ing (1644–1912). The Manchu tried from the beginning to absorb the most important elements of Chinese civilisation and in this they were more successful than earlier conquerors. Some of the early Ch'ing rulers painted pictures in Chinese style and the Emperors K'ang-hsi (1662–1722) and Ch'ien-lung (1736–95) became fanatical enthusiasts of Chinese art and culture. Although a certain latent hostility towards the conquerors persisted among educated Chinese, a real understanding developed between the two peoples, giving rise to a new flowering of art and culture.

Nevertheless one cannot help noticing a certain tendency towards empty display and self-conscious rigidity in the official art of the court. The traditional Chinese court ceremonial, which was intentionally fostered by the conquerors, called for a worthy setting; and this necessitated the expansion and luxurious outfitting of the Peking palace

(margin numbers: 83, 77, 82, 69, 70,74, 66,72,73)

82. **Shêng Mao-yeh.** *Noble Pines and a Venerable Tree of Life.* Late Ming period, dated 1630. Hanging scroll. Ink and pale colours on silk. 5 ft. 1¾ in. × 3 ft. 3 in. (156 × 99 cm.). Ostasiatische Kunstabteilung, Staatliche Museen, Berlin. A native of Suchou, this artist was one of the 'individualists' of the late Ming period. This 17th-century painting shows the persistence of the tradition of close attachment to nature—the literatus' sense of absorption into the natural environment.

83. **Shên Chou.** *Scene from Tiger Hill, Suchow.* Ink and colour on paper. Cleveland Museum of Art, Cleveland, Ohio. Shên Chou (1427–1509) is generally regarded as the founder and outstanding member of the Wu school of painting, the name deriving from that of the province in which he worked; Wu is modern Kiangsu. Shên Chou came from a family of scholars. He led a reserved life surrounded by congenial friends, refusing always to take payment for his work. His paintings are characterised by the boldness of their lines.

complex, which was organised according to an old pattern as a series of halls on imposing stone terraces placed along a central axis through a sequence of courts. In the work of the imperial porcelain factories, on whose industrial methods we are well informed thanks to the report of a Jesuit missionary, we are again struck by the almost incredible technical perfection and the elegance and richness of the **77** vases and other containers. The Manchu productions 'in the Chinese style' recall the rarified luxury of the Byzantine court and seem more Chinese than the Chinese art itself.

Lacquer-work also supplied the demand for courtly display, though the details of the ornament have lost the **75** pleasant softness of the earlier Ming pieces.

The establishment and rapid growth of the trading posts of the British East India Company in Canton caused a sudden increase in the export of porcelain and lacquer to Europe. Many Chinese merchants made their fortunes as middlemen in this trade. But the volume of export and the differing taste of the European market led in the course of time to a decline in technical and artistic quality.

Western influence was felt even at the court, where Jesuit missionaries had succeeded in gaining entry, taking advantage of the Emperor Ch'ien-lung's curiosity. Some of the Jesuits worked in the palace workshops, where they made clocks and astronomical instruments, painted and even designed palace buildings in the rococo style of Europe. But Chinese society remained strongly nationalistic, and withdrawn under Manchu rule, and the initiative taken by Manchu rulers were to have no lasting effects on later Chinese culture.

In the Peking palace workshops of Ju-i-kuan and Yang-hsin-tien Chinese and Manchu painters were enlisted and invested with court titles, although they did not form an academy as in Sung times. The Emperor Ch'ien-lung took an active interest in their work, which he liked to criticise and correct. Under this well-intentioned, but too rigorous and one-sided control, the court painters generally drifted towards an empty eclecticism, repeating and varying standard motifs until their work became mechanical and meaningless.

As had happened several times before, the driving forces in the evolution of the art of painting were at work far from the court in the provinces, where circles and schools of independent painters appeared. While many of them lived in the usual way on the generosity of their families, and did not have to serve the official hierarchy to make a living, others did accept appointments. But many chose the modest but unrestricted life of the Buddhist monastery—often as a protest against foreign rule.

Among the monk painters were some remarkable individuals, such as Pa-ta-shan-jên or Chu Ta (*c.* 1625–1705), **84** who came from a branch of the imperial Ming family, but preferred to live an eccentric and remote life under the Manchu usurpers. Whether his madness was genuine or feigned is difficult to say, but in his expressive painting he mocked every rule of the classical tradition. More normal in his personal life and artistic style was the monk K'un-ts'an **76** or Shih-ch'i (1617–*c.* 1680), who preferred the quiet retreat of a monastery where he could commune with nature, though he was often in financial difficulties.

The two basic tendencies, on the one hand towards eclectic traditionalism and on the other to decisive rejection of time-honoured forms in favour of individual expression, characterise the development of Chinese painting in the 18th and 19th centuries. The increasingly uncompromising attitude of the educated classes produced a greater formality and rigidity in the art they patronised. In the 19th century, however, the focus of interest of the literati was directed less towards the cultivation of the liberal arts than towards a antiquarian interest in China's past. Scholars concerned themselves with collecting old texts and with studying the primitive beauty of obscure or newly rediscovered forms of script with the aid of the sciences of palaeography and archaeology. In this scholarly preoccupation with China's historical traditions, revolutionary ideas found favourable soil, eventually leading to the overthrow of the empire in 1912. Even under the communist regime scholars of this kind still play an important role in shaping cultural policy.

Chinese art of the 20th century, however, oscillates between a cultivation of classical tradition, which has no real social validity and a still tentative effort to adopt and develop cultural stimuli from Western Europe and Russia. Under present circumstances a satisfactory solution to these problems and dichotomies is probably not yet to be expected.

84. **Chu Ta.** *Rocks with plants and fish.* Ch'ing period, late 17th century. Handscroll. Ink on paper. Size 11½ in. × 5 ft. 2 in. (29 × 157 cm.). Cleveland Museum of Art, Cleveland, Ohio. Like many earlier calligraphers and painters, Chu Ta usually created his works under the influence of wine. He is best known for his ink paintings of birds and flowers. The economic means of expression, the skilful use of space, the apparently spontaneous brush strokes give his work immediacy and particular charm.

Korea

The history of Korean art was shaped almost entirely by the country's geographic position at the meeting point of the power and interests of the gigantic Chinese empire with those of Japan's island kingdom, which repeatedly sought to establish a continental bridgehead in the Korean peninsula. The Tungus element dominates the make-up of the Korean people, whose language is a remote branch of the Altaic family, overlaid since the 8th–9th century by a Sino-Korean literary and cultivated speech derived from T'ang China.

In the neolithic culture of the centuries before Christ we find objects imported from the steppe art of Inner Asia and the transitional stage leading to the metal age is characterised by two types of dolmen. During the late Chou period the north-eastern Chinese state of Yen made its influence felt in part of the peninsula.

In the time of the powerful Han empire the whole peninsula was incorporated into China, being divided into four prefectures, which were finally (c. 75 BC) combined into the single province of Lo-lang with its centre at the present city of P'yongyang. Rich finds in this area have brought to light characteristic Han objects of high quality.

57 The lacquer pieces, which have become famous, were imported from their place of manufacture in south China. Other objects such as the splendid jewellery in granulated gold- and silverwork may have been produced in Korea itself. Although these products of an advanced civilisation may have been exclusively intended for the use of the Chinese ruling class, they exercised an influence over the indigenous culture of the peninsula as a whole – an influence that reached as far as Japan.

Aggressive nationalist states finally drove the Chinese out of Korea, freeing Lo-lang in 313 and initiating the period of the Three Kingdoms (313–668). The most powerful of these kingdoms was the northern Koguryo, which extended its sphere of influence far into Manchuria. The patrons of art belonged to a privileged military nobility, which fell under the intellectual spell of Chinese Confucianism in the second half of the 4th century of our era. Buddhism, however, was the state religion. (It will be recalled that this is the period of the great spread of Buddhism in north China). The most important evidence of Koguryo culture is found in the tombs in the plain of T'ung-kou on the Manchurian border and in the vicinity of P'yongyang; many of these tombs have chambers contain-
78 ing well preserved wall-paintings. Although subject-matter and technique were undoubtedly borrowed from contemporary Chinese art, these paintings give us a fascinating glimpse into the daily life of the feudal nobility of Koguryo in the 5th and 6th century with its numerous hunts and festivities.

In the south-western corner of the peninsula several hereditary principalities coalesced to form the kingdom of Paekche. In keeping with its geographical location this kingdom played an important part in bringing Chinese culture to Japan. The peasantry, and the craftsmen who

85. **Fragment of a tile, with a Buddhist figure.** Old Silla period (668–918). 7th century. Terracotta. h. 21 in. (53 cm.). National Museum of Korea, Seoul. This tile comes from the temple of Sach'onwang-sa, near Kyong-ju. Buddhism probably came to Silla in the 5th century, but it was only accepted officially under King Phophung (527). This figure, which perhaps represents a Bodhisattva, shows how the Korean sculptor adopted the decorative and iconographic features of Buddhism, while giving the relief a liveliness which is characteristically Korean.

were organised into guilds formed the economic basis of the country and were ruthlessly exploited by the nobles to support a courtly culture influenced by China. From what must have been richly furnished tombs of the Paekche princes only terracotta tiles decorated with reliefs have survived; with their landscape scenes, these show an astonishing similarity to earlier Chinese tiles. There are also well-executed figural examples. The advanced Buddhist 85 art of Paekche exercised a strong influence on the sculpture of Japan. The ethereal Paekche sculptures in turn reflect the stimulus of Chinese schools, probably those of the Northern Ch'i dynasty. The gilt-bronze work was cast with great technical knowledge, showing the high level of 80 achievement of the Korean craftsmen.

The third state, which is the most important for future development, was the kingdom of Silla in the south-east. The ruler was at first a kind of shamanistic priest-prince, who only in the 6th century took the title of king. A symbol of the old priestly kingship may be the crowns of gold or 79 gilt-bronze found in tombs of the 5th and 6th centuries; the characteristic open-work motif may derive from the so-called shaman-tree or from antlers.

After internal warfare in Korea in the 4th and 5th centuries and the expulsion of a Japanese colony, the politically gifted Silla Kings succeeded, with the help of Chinese armies of the Sui and T'ang dynasties, in conquering first Paekche and then powerful Koguryo. Afterwards they managed to drive out the ambitious Chinese, welding the

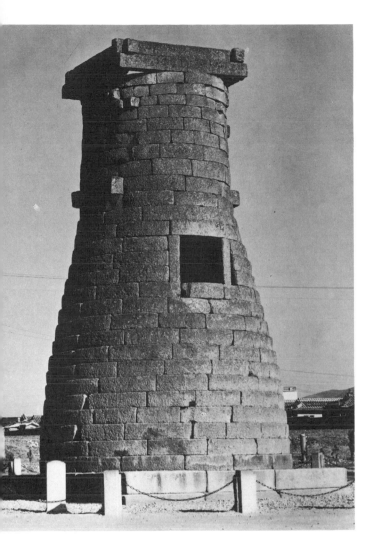

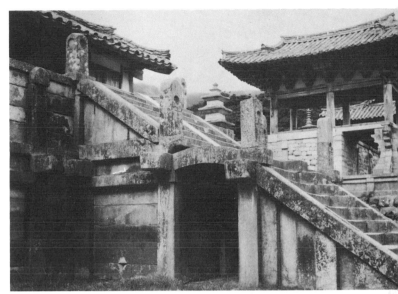

86 (left). **Observatory at Kyong-ju.** Old Silla period, early 7th century. h. about 30 ft. (9·14 m.). This bottle-shaped observatory tower *(Chʻomsong-dai)*, built in the reign of Queen Sondok (632–46), supported astronomical instruments on an upper platform, of which the stone frame has been preserved. It is one of the rare surviving monuments of the period, providing evidence of the highly developed astronomical science of the Far East.

87 (above). **Stone Stairs and Pavilion of the Pulguk-sa Temple near Kyong-ju.** Great Silla period, 7th–8th centuries. Apart from the two pagodas (see plate 81), only foundations remain of the old buildings of this famous Silla temple. The first section of the double flight of stairs passes over a true barrel vault in stone. Many details of the terrace façade and the understructure imitate wood construction in stone.

whole of the peninsula south of P'yongyang into a unified state (668–892).

The Silla population was organised according to a complicated class system. The dominant class of free men comprised the ruling clan and the high officials. Also free were the feudal magnates who formed the military nobility, but the mass of the people worked in conditions of near slavery. The Chinese pattern was of course adopted for the state apparatus, and land ownership was entirely in the hands of the state, that is, of the king, who conferred it to the nobility in the form of fiefs. In Silla, culture and scholarship, which flourished primarily in the capital of Kyong-ju, the influence of T'ang was dominant. Nobles and monks were sent to China to study, where they sometimes stayed to take the state examinations like any Chinese official. The calligraphy of Ou-yang Hsün was imitated throughout Korea, and the cultivated life of the nobility and the ruling clan followed the T'ang example as far as local resources would allow. The famous 7th-century observ-
86 atory tower at Kyong-ju provides evidence of their scientific ambitions. Kyong-ju and the neighbouring area became a flourishing centre of Buddhist culture, much evidence of which remains. The monks rivalled the nobles as patrons of the arts.

The terrace and the celebrated vaulted stairs of the
87 Monastery of Pulguk-sa founded in 751 in the vicinity of the capital partly imitated wooden prototypes in stone.
81 The same goes for the Prabhūtaratna pagoda *(Tabo-tʻab)*

of the same temple, which is unique in all of East Asia. Apart from the great monasteries which were generous patrons of art and scholarship, the Buddhist tendency to withdraw from the world was decisive in influencing the character of their architecture. Witness of this is the cave temple of Sokkul-am, founded in 752 by the minister Kim Taesong, who also founded Pulguk-sa, situated high on a mountain near that monastery. This temple was not cut from the living rock, but constructed of stone masonry and covered over with earth. It is uncertain whether the present form of the building, which was restored by the Japanese, corresponds to the original. The fine stone sculpture re- calls that of the mature T'ang style in China. The ceramics *88* of Silla developed vigorous forms, which have many points in common with earlier Chinese and with later Japanese work, perhaps representing a link between them. The grey Silla ceramic wares were hard-fired and only towards the end of the period provided with glazing. Characteristic are the figural grave gifts, which seem somewhat primitive in *89* comparison with their Chinese counterparts.

Peasant risings undermined the power of the Silla kingdom, which finally split into several small states, after which the north Korean Koryo dynasty (918–1215) was able to weld them together to form a new unified state with its capital at Kaesong. In the organisation of the state the Koryo rulers retained the Silla institutions that were of proven value, though they adopted Confucian practice by setting up an official class in place of the hereditary nobility.

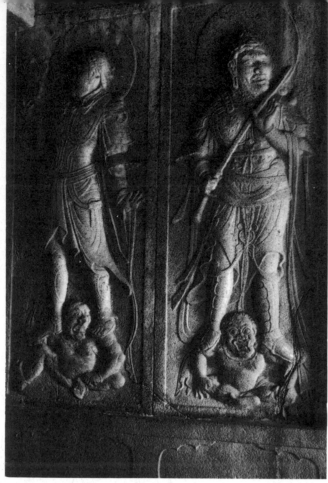

88. **Guardian figures at the cave sanctuary of Sokkul-am.** North Kyongsang province. Great Silla period, 8th century. Granite. h. *c.* 6 ft. 4 in. (193 cm.). The minister Kim Taesong, who also endowed the Sokkul-am temple, founded this sanctuary high on a mountain in 752. Unlike its Chinese counterparts, the complex was not hewn from the living rock, but constructed in masonry and covered with earth. In the interior is a colossal figure of the Buddha Sākyamuni, while the round inner wall bears reliefs of Lo-hans and Bodhisattvas. The sanctuary was protected externally by guardian figures. The style of the figures corresponds to the T'ang style of China.

89. **Vessel in the form of a rider.** From the Tomb of the Golden Bell. Old Silla period, 5th–6th centuries. Grey stoneware. h. 9½ in. (24 cm.). National Museum of Korea, Seoul. This figure of an armoured warrior on his horse imitates a vase type that was in actual use. The piece has an opening for filling behind the rider and a spout on the horse's chest. It was intended to serve as a tomb offering, rather than for practical purposes.

The practice of granting land as fiefs was now limited to the lifetime of the recipient in order to inhibit the growth of great estates. Trade, even when conducted in association with foreign partners, lay exclusively in state hands so that private initiative could not develop as a basis for a middle class. Buddhism was once more the state religion, and art and scholarship were primarily cultivated within the walls of the many great monasteries. Stone pagodas commemorated pious foundations.

During the golden age of the Koryo dynasty in the 11th century a growing Sung influence was evident, providing almost unbelievable luxury in the royal court and its dependencies, a development that was to have catastrophic effects on the economy of the country. Revolts among the dissatisfied peasantry and attempts to avoid taxation endangered the foundations of the dynasty which, although it was apparently saved by severe measures on the part of the Ch'oe family, sank into a kind of twilight existence.

The high artistic level of the Koryo period is reflected in the art of ceramics, which adopted and developed influences from the north Chinese celadon both in form and in the greenish colour of its glazes. A characteristic Korean

technique is a decoration in black-and-white slip beneath the glaze, known as *Sanggam*, in which the monochrome glazing was enriched with charming colour contrasts.

In the 13th and 14th century Korea was repeatedly overrun by Mongol armies, which devastated the country, destroying much of its artistic patrimony forever. Most of the architecture of the period went up in flames. For a while a shaky Korean government-in-exile maintained itself on the island of Kanghwa, but for most of the time between 1215 and 1356 the Koryo kingdom was subject to Mongol rule.

After the collapse of Mongol power in East Asia, Korea was governed by the Yi dynasty (1392–1910), which moved the capital to Seoul, prudently recognising the overlordship of the Ming in China. On the whole it can be said that Korean art of this period is an offshoot of that of the Ming dynasty. An initial uprising of the economy, together with increasing trade with Japan and China provided the early Yi rulers with the means to create a bureaucratic state on the Confucian pattern. While Buddhism was systematically stripped of influence, its adherents being persecuted and hindered from practising their faith, state examinations were introduced for officials and

86

90. **Interior of the Throne Hall.**
Kyungbok-gung Palace, Seoul. Yi
period, 1395 (rebuilt 1867). The Throne
Hall stands on a double-tiered granite
terrace surrounded by carved marble
balustrades (see plate 84). The gallery
and ceiling are supported on sixteen
enormous wooden columns nearly a yard
in diameter, the centre one being forty
feet high. The throne was so placed that
when the king was seated there he could
see the broad highway beyond his palace.
In scale and in technique, the hall is an
outstanding example of Yi-dynasty
architecture.

91. **Kim Tu-ryang** (attributed to).
Autumn Landscape. Detail from one of a
pair of handscrolls. Ink and colours on
paper. $3\frac{1}{8} \times 72\frac{1}{2}$ in. (8×184 cm.).
Duksoo Palace of Fine Arts, Seoul. Kim
Tu-ryang (1698–1764) excelled in a style
of landscape painting that was clearly
based on that of the contemporary or
slightly earlier Chinese literati painters.
He often introduced scenes with many
figures into his landscapes, but more
according to Chinese tradition than to
the contemporary style of Korean genre
painting.

92. **Kang Hui-an.** *Sage in Meditation.* Early Yi dynasty. Ink and light colours on paper. 9 × 6¼ in. (23 × 15·8 cm.). National Museum of Korea, Seoul. Kang Hui-an was a man of aristocratic family, a poet, calligrapher and painter. He was born in 1419, passed the government examination in 1441, and entered the *Chiphyon-jon*, the academy to which all scholars were attached. He served under three kings and is reputed to be one of the scholars who helped to devise the Korean alphabet. He made many visits to China, and was directly influenced by Ming painters.

93. **Portrait of Song Si-yol.** Yi period, 18th century. Hanging scroll. Ink and colour on silk. Size 35½ × 26 in. (90 × 66 cm.). Duksoo Palace Museum of Fine Arts, Seoul. This portrait, by an unknown court painter, shows a high official and influential scholar who was born in 1607. Although his talents brought him to the vice-premiership, he was disgraced in 1689. The garment, which is indicated in a few precise lines, contrasts with the lively treatment of the dignified face. An inscription added later states that the picture hung in the Confucius Temple of Seoul.

throughout the land there appeared private—though state supported—Confucian academies *(sowon)*, intended to replace Buddhism as the dominant intellectual force. The cultivation of dogmatic Confucian learning was supplemented by a study of Chinese-influenced natural sciences. In 1446 scholars created the national Korean alphabet, which is still in use. Moreover, printing with moveable characters was pioneered more successfully than in China itself, where it had been invented and then forgotten again.

The ambitions of the new dynasty found an outlet in large-scale building activities in the new capital of Seoul. **82,84** The Kyungbok-gung palace, a large complex with a **90** central throne hall, is a small-scale version of a Ming-dynasty theme. This building, intended for state functions, was completed by wings containing studios, libraries and apartments for the court retinue. The adjacent palace of **83** Ch'angdok-gung had a large secluded garden with little retreats and pavilions where the court ladies of the palace could arrange delicious outings.

The cultivated upper class dependent on the patronage of the royal family, was divided into two separate sub-classes. High officials and bureaucrats were recruited exclusively from the dominant caste of the *Yangban*. The lower class of the so-called *Chung'in* had no prospects of rising to *Yangban* status, but provided incumbents of lesser offices. The *Chung'in* were educated along Confucian lines and from their ranks came scholars and artists. Under the dominant Confucian ethos Korea developed the familiar literary-artist type, who wrote or painted for his own pleasure.

The landscapes and the flower-and-animal pictures of these painters occasionally followed the Chinese style of the Southern Sung period, as for example the work of the famous savant Kang Hui-an (1419–65) who had visited **92** China. Later Korean literary painting was dominated by the Ming and Ch'ing masters of China. Finally in the 18th

(Continued on page 193)

78. **Mural from the Tomb of Uhyon-ni, near P'yongyang, Korea.** Koguryo dynasty, 6th–7th century AD. The wall-paintings in the tomb chambers of the P'yongyang region date from the latter part of the Koguryo dynasty. They are mainly earthern constructions with stone chambers inside. Outstanding among them is the Tomb of Uhyon-ni. Although the tomb was looted of any transportable objects, the paintings remain in a remarkably fine state of preservation. The subjects include the deities of the Four Cardinal Points: the Red Phoenix, the Green Dragon, the White Tiger and the Tortoise entwined by a Snake. Such symbols had been imported from Han China, but are depicted in a way which can be regarded as authentically Korean.

79. **Gold crown with pendant ornaments.** Old Silla period. 5th–6th centuries. Gold and jade. h. (without pendants) 17⅜ in. (44 cm.). National Museum of Korea, Seoul. In 1921 three golden crowns were found amongst other jewellery in stone tombs near Kyong-ju. This one, from the tomb now called the 'Tomb of the Golden Crown', must have belonged to a king or nobleman. It consists of an outer circle with five upright features, and an inner cap with branch- or antler-like projections. The outer part is made of cut sheet gold, ornamented with punched dots. From this, small jade ornaments dangle on lengths of twisted wire. These comma-shaped jade pieces also occur in Japan. The 'antlers' may connect with shamanist beliefs.

80 (next page). **Bodhisattva Maitreya.** Old Silla or Paekche period. Early 7th century. Gilt bronze. h. 3 ft. 2¾ in. (91 cm.). Duksoo Palace Museum, Seoul. The play of drapery in this figure seated in meditation recalls the sculpture of the Northern Ch'i in China. The comparatively high number of surviving bronze images of Maitreya from this period—this is by far the finest of them—suggests that his cult was especially popular. The type was imitated in Japan.

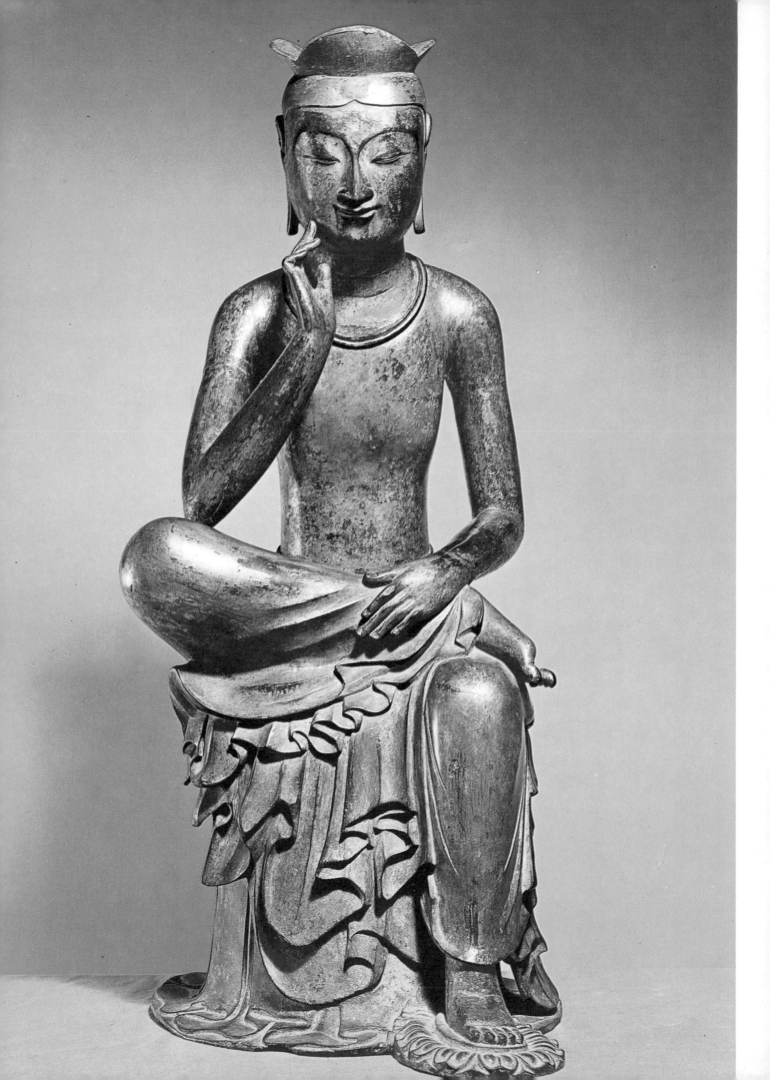

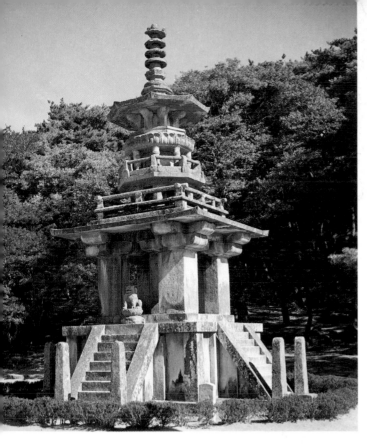

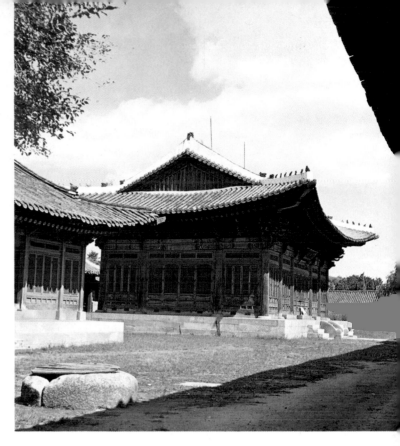

81 (above). **Prabhūtaratna Pagoda** *(Tabo tʻab)*. Pulguk-sa Temple near Kyong-ju. Great Silla Period, mid-8th century. Stone h. *c.* 33 ft. (10·05 m.). The westernmost of two pagodas before the main hall of the big Silla temple is unique in the history of Far Eastern art. The shape is similar to the small gilt-bronze pagodas made as reliquaries, while other features of this stone building, including the balustrade and the system of support, imitate wooden architecture.

82 (above). **Palace buildings, Kyungbok-gung, Seoul.** Early Yi period. The Kyungbok Palace was built during the third year of Yi Sunggye (1394). It consisted of nearly a hundred independent buildings surrounded by a palace wall. In this picture two of the wooden pavilions can be seen. These were restored under the Prince Regent Taewun-gun in 1867.

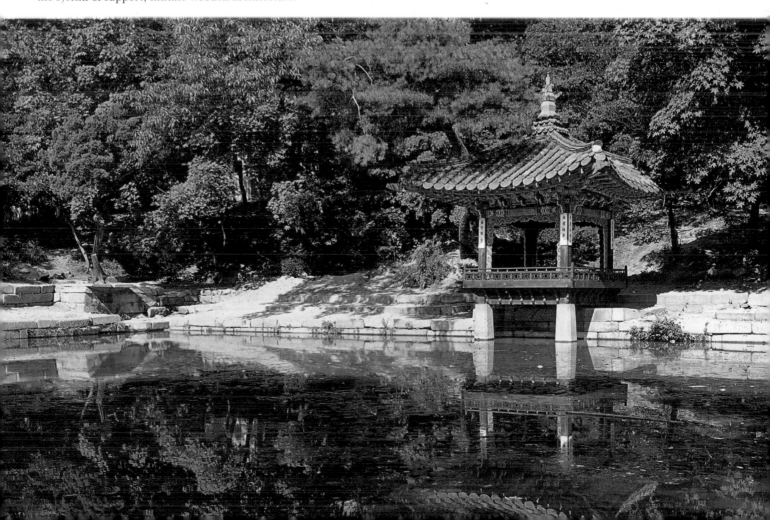

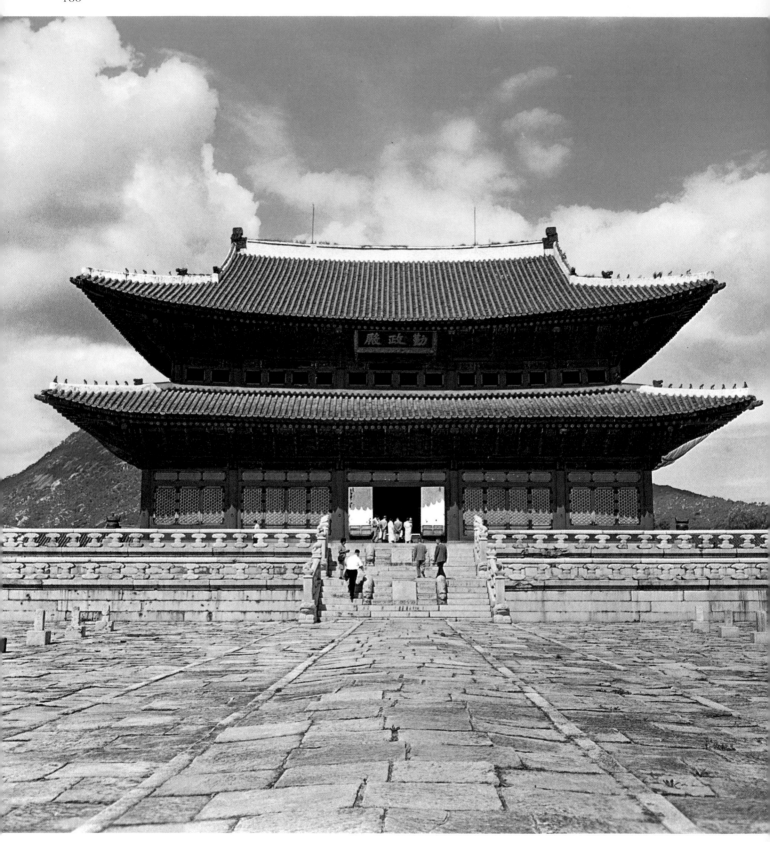

83 (previous page). **Pavilion in the
Secret Garden** *(Pi-won)*. Ch'angdok-
gung Palace, Seoul. Late Yi period. The
large garden behind the palace contains
an assortment of small villas, pavilions
and gazebos in rustic style that served for
festivals, banquets or for tranquil
gatherings of the king and his palace
ladies. In contrast to the artificial

arrangement of gardens in China, the
fine natural landscape has been left
largely undisturbed.

84. **Throne Hall** *(Keunjong-chon)*.
Kyungbok-gung Palace, Seoul. Early
Yi period, 1395 (rebuilt 1867). The
imposing Throne Hall with its heavy
double roof was originally built by the

founder of the Yi dynasty, but it was
destroyed during the Japanese invasion
in the 16th century. It was only fully
restored in 1867. The stone piers in the
paved courtyard before the hall mark
the places where the officials stationed
themselves according to rank during
audiences and ceremonies.

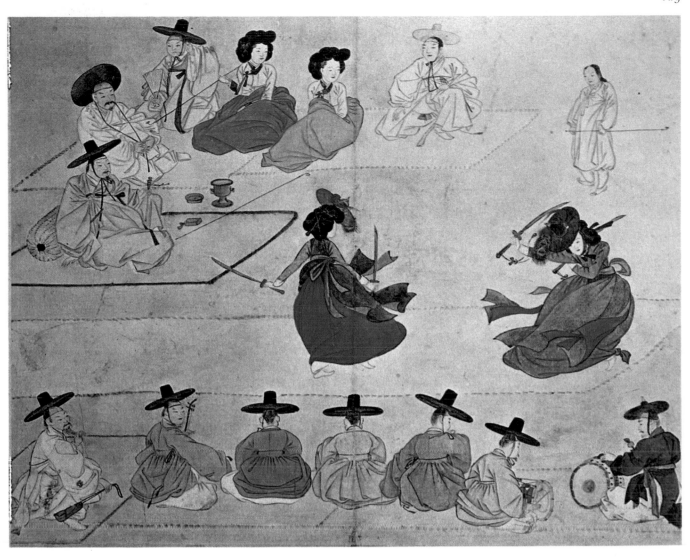

85. **Sin Yun-bok.** *Genre scene.* Yi period, *c.* 1800. Ink and colour on paper. 11 × 13¾ in (28 × 35 cm.). Hyung-pil Chun Collection, Seoul. This illustration is from an album by Sin Yun-bok, who worked under the professional name of Hewon and who lived from 1758 to about 1820. He was one of the leading masters of the genre trend that flourished in the Yi period. In this delightful album, one of his best works, he depicted various scenes from the Korean upper-class life of his time.

86. **Wine pitcher.** Koryo period, late 12th century. Stoneware with celadon-type glaze and slip inlay. h. 9 in. (23 cm.). Ostasiatische Kunstabteilung, Staatliche Museen, Berlin. This elegant vessel was made in the *sanggam* technique, in which the decoration was incised into the surface and filled with a slip in another colour, a practice popular in celadon ware of the Koryo period. The centre of production seems to have been in the vicinity of Kangjin in the extreme south of Korea. The flower pattern often occurs in the 12th- and 13th-century ceramics.

87 (opposite). **Japanese bell, or dōtaku.** Yayoi period.
300 BC–AD 300. Patinated bronze. h. 27 in. (69 cm.). Museum
für Ostasiatische Kunst, Cologne. The bronze bells of the
Yayoi period are evidence of Japan's short-lived bronze
culture. The production was centred in the provinces near the
present city of Kyōto, but their date is uncertain. The bells are
decorated with line ornament in low relief, sometimes
geometric, sometimes showing hunting scenes.

88. **Haniwa head of a woman.** Old Tomb period, late
Yayoi. 3rd–6th centuries AD. Fired clay. h. 7½ in. (16.3 cm.).
Matsubara collection, Tokyo. The most interesting objects of
the late Yayoi period in Japan are the *haniwa* figures which
were erected in circles around burial mounds (*hani* means
clay and *wa* circle). Among these are simple cylinders, human
figures, animals and houses. This female head has minimal
modelling, the features being indicated in the briefest manner.

89. **Pagoda of Yakushi-ji, Nara.** Nara period. *c.* 700. The
pagoda, on the right in this picture, actually comprises three
storeys, although the building gives the effect of six because of
the introduction of mezzanines *(mokoshi)* with their own roofs.
The resulting differences in scale produce an attractive
rhythmic alternation. The central mast *(shimbashira)* running
through the whole building and supported by a foundation
stone containing relics is not linked directly to the individual
storeys, but serves to stabilise the building as a whole in case
of earthquake.

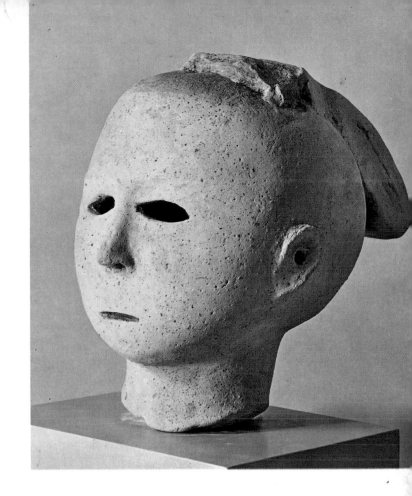

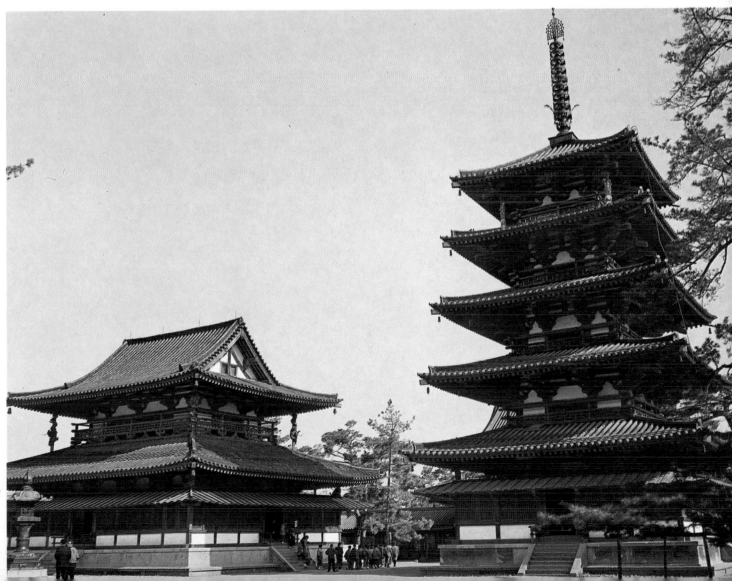

94*a, b.* **Tea bowl.** Yi period, late 16th or early 17th century.
Fired clay. d. 5⅞ in. (15 cm.). Ostasiatische Kunstabteilung,
Staatliche Museen, Berlin. The simple, rather rustic pottery
made in Korea during the middle Yi period contrasts strongly
with the sophistication of contemporary Chinese ware.
Korean pottery of this type exercised a strong influence on the
forms taken by the ceramics of the Japanese tea ceremony.

85 century there appeared a characteristically Korean genre
painting of great freshness and vitality.

Yi Korea had an official art bureau *(tohwa-so)* with
professional painters of the *Chung'in* class permanently at-
tached to it, but they belonged to the lowest rank of offi-
cialdom and were poorly paid. They had to execute
93 portraits of the *Yangban* to order and were not very much
respected as artists.

Before long the struggles of rival political groups began
to cast lengthening shadows on the Yi regime. The Japa-
nese invasion of Korea in the last decade of the 16th
century devastated the exhausted country. Cities, villages
and most of the buildings of consequence were gutted and
countless works of art were destroyed. Deportation of
Korean craftsmen to Japan was a heavy blow and the
losses almost brought ceramic production to a standstill.
94 On the other hand the rather rustic pottery of local Korean
craftsmen exercised a decisive influence over Japanese tea
ceramics. Moreover, the great simplicity and authenticity
of their work contrasts with the sophistication of contem-
porary Chinese porcelain. Characteristic of this phase is
the blue-and-white ware made in Korea for court use, as
95 well as the pottery painted with iron oxide.

From 1637 to 1894 Korea was a vassal of Manchu China.
Renewed struggles for power, corruption in the adminis-
tration, heavy taxation and repeated failures of their
crops caused deepening misery among the hard-pressed
Korean people. After a period of withdrawal from the
outside world and some terrible persecutions of the newly
implanted Christianity, the country became a pawn in the
hands of foreign powers. From 1905 to 1910 it was a
protectorate, then (until 1945) a colony of the Japanese
empire. It is only too clear that the traditional arts could
not flourish under these conditions. Now that peace seems
to have been established in the divided country, the author-
ities are seeking partly to revive the remains of the ancient
crafts and partly to create entirely anew. The future will
tell whether these efforts can succeed in a radically altered
social and cultural setting.

90 (opposite). **The Priest Ganjin.** Nara period. 8th century.
Painted dry lacquer. h. 2 ft. 8½ in. (81.7 cm.). Tōshōdai-ji,
Nara. Ganjin was a Chinese monk who, having made a
number of unsuccessful attempts to reach Japan by sea,
finally succeeded after he had become blind. He founded the
famous Tōshōdai-ji Temple in Nara. This figure is made of
linen saturated in lacquer modelled over a core that was
later removed. It ranks as one of the earliest and most moving
portraits in the history of Japanese art.

95. **Porcelain jar with clouds and dragon.** Yi period.
17th–18th centuries. Grey porcelain with iron-oxide under-
glaze decoration. h. 14⅛ in. (36 cm.). Duksoo Palace Museum
of Fine Arts, Seoul. In bold, energetic strokes the potter has
depicted a dragon and cloud motifs in a brownish hue before
applying the transparent glaze. In a Korea impoverished by
Japanese invaders the costly blue preferred in the older under-
glaze painting became almost unobtainable, so that potters
often fell back on the cheaper iron-oxide pigment.

Japan

Until the present geological epoch, the Japanese archipelago was linked to the mainland of Asia in a crescent-shaped peninsula stretching down into the Holocene. Even after the land bridge with Asia had sunk below the sea, invaders continued to reach Japan, ultimately fusing to make up the present population. The main ethnic components of the Japanese of today come from Tungus, Sinic and Palaeo-Mongolian stocks. Traces of an originally much larger stratum of Caucasian peoples are found among the Ainu of the northern Island of Hokkaidō.

PREHISTORIC JAPAN

As a result of extensive finds from many parts of the islands we are now fairly well informed about the two main prehistoric cultures. The neolithic Jōmon culture, which apparently enjoyed more than two thousand years of uninterrupted predominance, gave way in about 200 BC before the men of the Yayoi culture who pushed in from the

south (probably from Korea) via the Island of Kyūshū. Many mainland elements came in with the Yayoi people, notably bronze casting (the short Japanese Bronze age began in about AD 300). The Yayoi phase passed without transition into the semi-historical Old Tomb period; but even before this shift some of the countless Japanese principalities had come into contact with Han China. Iron soon appeared and the princes were buried in gigantic tomb mounds, the building of which may have required the toil of as many as five thousand men for a year. The ceramic cylinders known as *haniwa* with the upper part modelled in human or animal form (in an astonishing and wholly Japanese style) were set up around the mounds. Similarly Japanese in character are the so-called *dōtaku*, bronze bells that seem to have had a religious use. The social unit of this period was the clan, and craftsmen were already organised in closely-knit guilds *(be)*, in which membership was hereditary. The pottery shapes, which show a similarity

88

87

96. **The Izumo shrine.** Last rebuilt in 1744, Izumo is the most ancient sacred precinct of the Shinto religion. The great shrine of *Taisha* has been successively rebuilt since the 7th century when it became obligatory to rebuild the entire complex every twenty years. Its origins are much earlier. It is recorded that the Emperor Suinin rebuilt the sanctuary some time in the 1st century 'in the same shape as the Emperor's

palace'. In any case the ground plan and the architectural features of the latest rebuilding (1744) preserve the essentials of the archaic period, although the cross-beams above the ridge are no longer projections of the barge boards but merely scissor-shaped ornaments to the roof. Nor would the original structure have had the curved roof which suggests later Buddhist influence.

with those of the Korean Silla kingdom, point to close cultural links with the peninsula.

Among the numerous principalities Yamato with its centre near the present city of Nara eventually proved the strongest. Yamato created the first Japanese state system. The old shamanistic nature religion was fused with concepts of an ancestor cult and a large pantheon of nature and clan gods came into being. In the climate of this early Japanese religion of *Shintō* (but also stimulated by the Chinese emperor's status as the son of heaven), there developed the idea of the *Tennō* (exalted heavenly ruler), who was regarded as a direct descendant of the sun goddess Amaterasu Omikami. Despite powerful later influences from the well-organised Buddhist church, the native religion of Shintō ('the way of the gods') has kept many traits of a primitive nature and ancestor cult until the present day. With their simple form and structure, the Shintō temples still retain memories of prehistoric nature and ancestor shrines that constituted the holy places of the clans.

96

THE ASUKA AND NARA PERIODS

Although the beginnings and development of the Yamato state are described in some detail in the first Japanese historical chronicles written in the early 8th century, the true historical period begins only with the introduction of Buddhism. A fixed point of reference is provided by the dispatch of a statue of the Buddha accompanied by texts, from the Korean kingdom of Paekche to the Japanese imperial court in AD 552. A lively debate arose among the nobility as to the merits of the new religion, which ultimately triumphed, being firmly established under the special patronage of the ruling house. In the Asuka period (538–645), named after the first fixed capital, Yamato underwent a powerful mainland influence, which came not only from Korea, but from China itself. Confucian ideas penetrated in strength and stimulated the creation of a real governmental apparatus. Then, too, the adoption of the Chinese script greatly facilitated the introduction of Chinese ways and forms.

The extent of this process of assimilation appears in the seventeen articles of the prince regent Shōtoku Taishi (604), a kind of draft constitution for the youthful Japanese state, as well in the Taika reform of 645, which affirmed Confucian influence in the political field. Shōtoku Taishi was also an ardent supporter of Buddhism; in 607 he decided to send Japanese monks to study in China of the Sui dynasty, and he summoned Chinese artists to his court. In the same year he founded the Hōryū-ji temple as the main centre of Buddhist study and teaching. The plan of the temple, which follows a venerable Korean or perhaps even Chinese model, juxtaposes a pagoda to house relics and a main hall *(kondō)* in a rectangular court. Both of these still stand, ranking as the oldest wooden buildings in the world. The main cult image of the *kondō* is a triad with historical Buddha Sākyamuni in the centre. Set up in 623 in memory

97. **The Sākyamuni Triad.** Asuka period, dated 623. Bronze. h. (of main figure) 34⅛ in (86.7 cm.). Hōryū-ji Kondō, Nara. An inscription states that this group is a pious offering in recognition of the recovery from illness of the Crown Prince Shōtoku Taishi. The name of the sculptor, Tori, is also given. Tori, a descendant of immigrant Chinese craftsman, was given a grant of land in recognition of his services. The style of the figure stems from Continental sculpture of the 6th century.

of Shōtoku Taishi, the group's dedicatory inscription mentions the name of the sculptor Tori, the grandson of a craftsman who had emigrated from Korea. As a reward for the successful casting of this outstanding work, which clearly descends from the Chinese Wei style, the empress gave Tori the noble rank of *Daijin* and an estate in Sakata. This shows the high value attached to outstanding artists even in this early period.

After the shift of the capital to Nara, which gives its name to the following Nara period (710–84), the influence of the rich culture of T'ang China became dominant. The new capital was a copy of the Chinese metropolis of Ch'ang-an on a smaller scale in a rectangle measuring 2¾ by 3 miles. Since it was now possible to deal directly with the great mainland civilisation which had reached the height of its glory, and Korean Paekche was no longer needed as a go-between, influences were received in a fresh and undiluted form. Intense curiosity prompted the dispatch of a series of embassies. With one of the official missions the famous Chinese monk Ganjin (Chinese: *Chien-chên*), who had become blind as a result of repeated attempts to reach

98. **The Hōryū-ji temple complex at Nara.** 7th century. This picture shows the Hōryū-ji complex from the south-east. The pagoda and kondō are enclosed on three sides by covered corridors and on the fourth by the Lecture Hall (extreme right). A single entrance gateway pierces the southern corridor (left). The complex is unusual in that the kondō and pagoda are not placed on the axial line but alongside each other. This asymmetry is compensated for by the placing of the entrance gateway one 'bay' nearer the western end. (See plate 89.) The 10th-century Lecture Hall replaces an earlier dormitory building which must have been set further forward to complete the originally simpler rectangular form to the compound.

Japan for the faith, arrived at Nara in 754, where he became high priest in the great temple of Tōdai-ji. The portrait made a few years after Ganjin's death in the complex 'dry-lacquer' technique ranks among the earliest and most effective Japanese portrait sculpture. An eloquent witness of the highly cosmopolitan character of Nara art and culture is the collection in the Shōsō-in treasury attached to the Temple of Tōdai-ji, founded in 756 and completed in 760. Here thousands of objects were assembled, comprising the entire personal property of the dead Emperor Shōmu, willed by this widow to the temple of the imperial house. The furniture, works of art and domestic objects in this oldest museum in the world included the products of China, Japan and even Persia. They give an impressive picture of the luxurious and cultivated court of a Japanese emperor at this period.

The intellectual and practical influence exercised by Confucianism resulted in the elaboration of a bureaucracy along Chinese lines, which was intimately linked to the feudal aristocracy, whose members held an exclusive right to high office, as well as to the brilliant retinue of the emperor himself. More strongly than in China, where from T'ang times onwards the hierarchy of the officials fluctuated and could be replenished from below through the examination system, in Japan privileges of office were reserved for definite social groups bound together in noble clans.

In the Nara period, Buddhism consolidated its position as the leading faith of the land. Buddhist priests were accorded a special position in society. The imperial house was especially devoted to the religion that had come from the west, perhaps because the highly developed ritual practices of the faith offered almost unlimited scope for

pomp and ostentation, a feature that was lacking in the more primitive Shintō cult. The imposing Nara Tōdai-ji temple, of which only a gateway survives from the 8th-century constructions, became the official temple of the imperial house and was richly furnished. A special bureau within the temple was responsable for the work of outfitting and decoration. In the *Zōbutsu-jo* (sculpture department) many sculptors and their assistants were employed in making cult images. A system of division of labour was in force. An unusually expensive undertaking even for such a wealthy temple, was the casting of a Roshana Buddha image fifty-three feet in height, which was finally dedicated in 752 in an impressive ceremony witnessed by the reigning empress. Often restored in the course of its eventful history, the great figure sits today in the main hall of the temple. The Shōsō-in preserves many objects used in the dedication ceremony.

An imperial decree of 741 ordered the building of 'official provincial monasteries' *(kokubun-ji)* throughout the realm; these monasteries were placed under the jurisdiction of the Tōdai-ji administration. The temples in the capital were particularly splendid. A good example is the Yakushi-ji, dedicated to Yakushi, the Buddha of healing, which was established as early as 680 in Asuka as a thank-offering for recovery of an empress from illness, and transferred to the new capital in 710. Of the old buildings one of the two pagodas has survived (718). Built in wood with plastered walls, the three stories of the building look like six because each storey has a kind of mezzanine with its own roofing. With its clear articulation and harmonious proportions, the Yakushi-ji pagoda ranks among the finest examples of its kind in East Asia. The chief cult image, a triad with Yakushi in the centre, dominates the main hall of the

temple. The three figures, originally gilded but now showing the soft brilliance of a dark lacquer patina, were cast in bronze about 720. In their perfection of form they descend directly from T'ang dynasty models which influenced all areas of Japanese culture at this time. The figures of the triad are rare in Far Eastern art in their mastery of sculpture in the round, without resource to linear aids. (Similarly, the paintings of Hōryū-ji—unfortunately almost completely destroyed by fire in 1949—embody the international style dominant in the Buddhist art of East Asia.)

It is possible that the casting of the giant Buddha of Tōdai-ji, which consumed enormous quantities of bronze, explains the fact that many of the sculptures of the first half of the 8th century in the same temple were modelled in terracotta or in dry-lacquer technique instead of being cast in metal. A characteristic example is the Shukongō-shin, who brandishes a thunderbolt in his right hand, a guardian divinity of fierce aspect executed life-size in terracotta and painted in colours.

Under the pressure of the preeminent Buddhist church (a significant indication of which is Emperor Shōmu's abdication in favour of his daughter in 749, in order to become a monk) it is not surprising to see the first hints of Shintōism's later effort to imitate or even fuse with the ritual and organisational apparatus of its more powerful rival.

THE HEIAN PERIOD

The increasing might of the Buddhist monasteries in Nara finally induced the emperor to move his capital once more. After preparations had been under way in Nagaoka for a decade, a different site was finally chosen at the present Kyōto, where the new city of Heian was founded in 784. Ten years later the emperor moved to his new residence, but work continued there for a long time. Here again the layout followed the Chinese model: a grid of broad main streets and smaller parallel ones divided the city into a regular chequerboard plan. At the centre were the imperial palace and the big new monasteries. The years from 784 to 1192 are named after this city, which was the cultural and political centre of Japan throughout this long period.

After the aboriginal Ainu had been drived northwards into Hokkaidō the whole of the main island of Honshū was subjected to the central government, which was organised according to Chinese practice. Peace prevailed in the country for a long time, so that social and cultural life were able to develop freely. Of course the stream of civilising influence from the mainland did not diminish, but the Japanese were no longer content with uncritical imitation of things Chinese. Political unrest and the decline of the T'ang empire did not go unnoticed by Japanese visitors and a sense of national identity took root in the islands. After the 838 embassy to the T'ang emperor, official contacts were discontinued and upon the return of this embassy

99. **Yakushi Nyorai.** Nara period, c. 720. h. 8 ft. 4¾ in. (2·55 m.). Yakushi-ji, Nara. The triad with the Buddha of healing in the centre flanked by two standing Bodhisattvas is surely one of the most beautiful bronze groups in the world. The pliant modelling of the figures betrays the influence of Chinese sculpture of the Sui or early T'ang period, when the metropolitan style of Buddhism centred in Ch'ang-an stimulated the entire Far East.

100. **Poem on Decorative Paper.** Heian period, 12th century. Ink on paper prepared as a collage. h. 7⅞ × 12⅝ in. (20 × 32 cm.). Nishi Hongan-ji, Kyōto. The elegant line of the Japanese *Hiragana* script, which contemporaries dubbed the *Onna-de* 'Women's Style', was especially suited to short poems. The collection in the Nishi Hongan temple comprises some 3,000 leaves, none quite like another. The fine calligraphy of this specimen is doubtless from the hand of an aristocratic writing-master. The paper in this example was first wood-blocked with a design of flowers and plants and then overlaid with coloured papers to form a sky-line and foreground The poem was written across the background 'landscape'.

101. **The Animal Scrolls** (detail). Heian period, 12th century. Ink on paper. h. 11⅞ in. (30·2 cm.). Kōzan-ji, Kyōto. The detail comes from the finest of the four scrolls preserved in the Kōzan-ji that were formerly ascribed to the priest-artist Tōba Sōjō. With a sure sense of line the artist shows animals engaged in human activities. The choice of subjects indicates that the scrolls are a satire on late Heian society, focusing particularly on abuses in the Buddhist Church. Although there are overtones of caricature elsewhere in late Heian painting, these scrolls are nevertheless unique in the art of the Far East.

to Japan, the imported Chinese goods were distributed for the last time in a special sale attended by members of the court. Certainly private contacts with the continent continued through the activity of Chinese and Korean merchants, but diplomatic relations were only fully resumed after about AD 1000, when the powerful founders of the Sung dynasty had firmly established their line in China.

The phase of imitation of Chinese models by the nobles and the Buddhist church in Japan between the 6th and the 9th century, was followed by a period of progressive naturalisation of imported models in every field of art, a process that was to remain characteristic of Japanese culture. Phases of assimilation and transformation of foreign stimuli have generally occurred in periods when Japan retired into seclusion from her neighbours, turning her entire attention inwards.

A characteristic development from this point of view is the flowering of native Japanese syllabic scripts during the Heian period. Even in earlier times the Japanese had used Chinese characters according to their sound value to write Japanese texts phonetically. Thus through a refinement of rapidly written Chinese characters, the so-called *Hiragana*, a highly cursive type of syllabic script, arose in court circles in the 8th and 9th centuries. Then towards the end of the Heian period the angular *Katakana* was created by abstracting individual graphic components from regular Chinese characters. The former script remained dominant in as much as it was much more attuned to the elegance of contemporary taste. Since it was extensively cultivated by court ladies who largely determined the literary atmosphere of the time, and who wrote some of the most important works, and since its form fully met the needs of the precious letter-writing style of amorous dalliance, the *Hiragana* is also called the *Onna-de*, or 'Women's Style'. Different coloured papers were arranged in collage fashion to produce delightful effects in which the elegance of the narrow swooping line achieved its full value, contrasting strongly in its feminine delicacy with the more robust Chinese script.

After the first emperors of the Heian era, who were gifted and successful rulers, the effective power of the sovereign declined: he was caught up more and more in the pomp of official ceremonies, while the machinery of government fell into the hands of ambitious nobles. In the general struggles for power at court and in the government, the Fujiwara clan gained the upper hand through its marriage ties with the royal family; ultimately the Fujiwara occupied almost all important offices. From this clan came not only leading politicians, but also great scholars, poets and artists. Behind the façade of imperial majesty the real affairs of state took place among the regents and councillors *(sesshō-kampaku)*. The greatest and most capable of the regents was Fujiwara Michinaga (died 1028), who retained his position through a number of brief imperial reigns. The domination of the entire spectrum of official and cultural life by the Fujiwara became so obvious that the second part of the Heian era is justifiably termed the Fujiwara period (967–1191).

The less fortunate noble families retired into the provinces, where they succeeded in acquiring vast tracts of land that were exempt from taxation. These provincial nobles, including the competing clans of the Taira and the Minamoto who rose to prominence at the end of the Heian period, were constantly increasing their economic power. In the eastern provinces their autonomous tendencies were particularly evident. Since taxes and compulsory labour were appreciably lighter there than under the severe and often corrupt control of the central government, the peasants tended to flee to the protection of the powerful clans.

Towards the end of the Heian era these families, notably the above-mentioned Taira and Minamoto, became the real political power. Rival factions of the Fujiwara fell into civil strife and violence, losing all control over the country.

As a consequence the emperor regained political stature after the voluntary abdication of Shirakawa Tennō in 1087 to become a monk. For over forty years, under three emperors, Shirakawa Tennō was successful in controlling politics from behind the scenes, working methodically towards the destruction of Fujiwara power. But the real victors in this struggle were the Minamoto, and with them there emerged a new social group made up of their followers, who formed the basis for the warrior class that was to determine the character of the succeeding Kamakura period.

As a result of these changes, the art and culture of the later Heian period was more strongly influenced by the taste of the aristocracy than had previously been the case. State and private academies, which favoured a Chinese-oriented curriculum, were open only to aristocrats; a few of the public schools maintained after 828 by the new Buddhist sects were accessible to other classes, but there the training imparted was, of course, predominately Buddhist.

Japanese national trends made themselves felt even in the official architecture of palaces. Instead of being paved, the floors of the courts were covered by mats; the buildings were raised slightly above ground level on posts, and the roofs no longer displayed glazed tiles as in China but were covered with a thick layer of fine shingle. The houses of the nobles also took on a new character. The style known as *Shinden-zukuri* called for the arrangement of buildings in a garden setting with an artificial lake, the various pavilions being linked by covered passageways.

Courtly and aristocratic life reached a peak of luxury in the capital of Kyōto. Exile from the city was a much-dreaded punishment for the courtiers and nobles, for whom it amounted to a loss of human dignity. The pursuit of luxury and refinement became a conscious 'cult of the beautiful'. A lyrical, slightly melancholy note permeated all aspects of this civilisation. An almost sentimental sympathy with 'things' *(mono no aware)* is a characteristic feature of its highly feminine nature. Amorous dalliance became the preoccupation of social life and cultivated ladies were the arbiters of literary taste. From their ranks we have sensitive diaries, which provide us with many details of daily life, as well as the first narrative works, the most famous of which is an enormous novel dealing with the loves and adventures of Prince Genji and his descendants, written about 1000 by Lady Murasaki as a faithful mirror of the courtly life of her own time. Such books were well suited to illustration in a congenial Japanese style, the *Yamato-e*. Although this depends ultimately on Chinese sources, it followed its own paths from the 9th century onwards. One of the triumphs of this category of painting was the cycle of illustration made **93** in the first half of the 12th century for the *Tale of Genji* in which the brilliance and melancholy of the late Heian period are blended.

Poetry is possibly even more important for Heian literature, and this medium also saw the flowering of a native Japanese form, the *waka*, a kind of lyrical poem. Corres-

pondence was often conducted in this form, and was full of tender allusions. Those who could not write poetry were regarded as uneducated. The emperor himself arranged anthologies of *waka* and a bureau, the *Waka dokoro*, was set up in 951 to preserve and collect them. Poetry competitions were set in either Japanese or Chinese style *(uta-awase* and *shi-awase)* in the palace on the occasion of the spring flower show or during the ceremony of moon-viewing. The finest works produced were written on screens and sliding doors in the palace and commonly supplemented with illustrative paintings. The aesthetic appreciation of this verse is seen in the development of poetic theory.

The rapid growth of the Japanese *Yamato-e* style of painting took place in close association with the illustration of novels and poems. This was practised at court in the Painting Bureau *(e-dokoro)* founded in 886. From painting on walls and sliding doors the court artists turned to the illustration of horizontal scrolls *(e-makimono)*, where text and image blend to make a single whole. Alongside the courtly and elegant manner, which was decorative in the best sense, exemplified by the brightly coloured and flatly designed Genji scrolls, court painters turned their attention also to scenes of popular life, which they often burlesqued in broad caricature. Expressive line was an important feature of such pictures. A famous example, and indeed a unique achievement of Japanese art, is represented by the satirical animal scenes of the 12th century from the Kōzan-ji Temple, which probably satirise abuses among the Budd- *101* hist priesthood.

Lacquer objects offer eloquent testimony of the refined and luxurious life of the Heian nobility. They, too, are emancipated from Chinese tutelage, following a highly decorative manner that is all their own. The contrast of gold, silver and mother-of-pearl inlays against a black ground makes a rich impression. **94**

The brilliant opulence of the aristocracy and the imperial court was supported on a basis of peasant labour. Grinding poverty led to outbreaks of banditry not only in the provinces, but also in the capital, reaching the walls of the imperial palace itself.

Only two decades after the foundation of the capital of Heian, two Buddhist sects newly imported from China obtained a powerful following: the *Tendai* school of the monk Saichō, which strove to reconcile the various contradictory Buddhist divisions and which enjoyed the patronage of the imperial house, and the *Shingon* school of Kūkai with its esoteric doctrines *(mikkyō)* and its rich pantheon of gods borrowed from Indian Tantrism. Secret mystical rites and the veneration of images played a large part in the cult practices of these sects, leading to a new flowering of Buddhist art. Not only craftsmen but also the monks themselves worked in the monastic workshops as priest-painters *(e-busshi)*, where they made the elaborate diagrams of the celestial spheres, *(mandara)*, and the often terrifying, even demonic figures of gods with many heads **95** and hands.

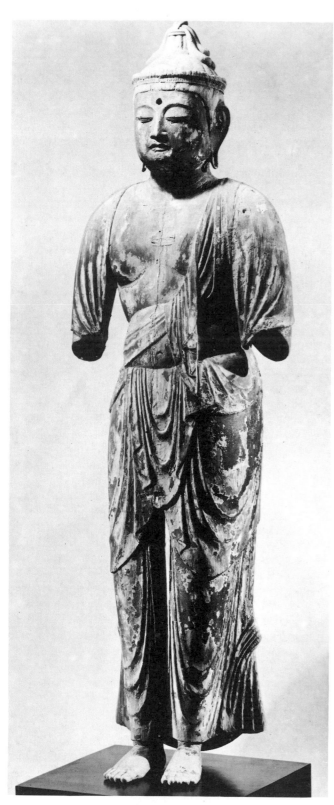

102. **Bodhisattva (Bosatsu).** Fujiwara period, middle of the 12th century. Wood with remains of gold lacquer decoration. h. 3 ft. 4 in. (101·5 cm.). Ostasiatische Kunstabteilung, Staatliche Museen, Berlin. This sculpture was probably the side figure of a Buddhist Triad, and may represent the Bodhisattva of Mercy, or Kannon Bosatsu.

A third important new trend in Heian Buddhism was the Amida cult of the priest Genshin (942–1017). This school emphasised spiritual sincerity and the believer's genuine, if rather simple-minded faith in the Buddha Amida. Promising even the humblest of believers a rebirth in the Paradise of Amida, the sect found a ready response not among the aristocracy, but among the generally literate middle-class. This tendency only became really effective under the priest Hōnen at the inception of the following Kamakura period, but many Heian nobles founded Amida temples for the salvation of their souls. Thus in 1052 the regent Fujiwara Yorimichi converted the estate of his father at Uji near Heian into the Byōdō-in Temple, of which the Phoenix Hall or Hōō-dō represents one of the few remaining examples of Heian architecture. The building, whose proportions are of great subtlety, is set at the edge of a lake; in form it depends upon palace architecture rather than upon 11th-century temple construction. 96, g

Buddhist sculptors of the Heian period worked mainly in wood. At first they were accustomed to carve statues from the single trunk of a tree but later they joined several blocks of wood together in the so-called *yosegi* technique. The rather heavy, massive style of early Heian times ultimately gave way to a 'Japanese style' *(wa-yō)* in keeping with the elegant taste of the age; this reached its peak in the work of Jōchō (died 1057) and his school. Many pieces of the 10th and 11th centuries are signed by the sculptors, which in itself is significant since it reflects their improved social status. The Buddhist sculptors *(busshi)* were often not just craftsmen, but monks in workshops run on guild lines *(bussho)*. The prestigious Jōchō, in addition to enjoying the favour of the nobles, was the first artist to receive the high ecclesiastical title of *Hokkyō* (Bridge of Doctrine). His gentle but distinguished style was widely diffused and imitated in Japan. 102

In spite of the militant attitude of a few of the Buddhist monasteries, Heian Buddhism is generally characterised by its tolerance, and aspects of Shintōism were drawn into its orbit. In the so-called *Ryōbu* Shintō, which was especially favoured by the Shingon sect of Buddhism, the old Shintō nature gods were welcomed into the Buddhist pantheon as manifestations of Buddhist divinities. From the second half of the 9th century this amalgamation of beliefs was reflected in sculpture. Although the attributes are Shintō, the style follows contemporary Buddhist sculpture. Obviously the 103

(Continued on page 217)

91 (opposite). **Biwa.** Nara period. 8th century. Wood with inlay in mother-of-pearl, amber and tortoiseshell. l. 3 ft. 8½ in. (113 cm.). Shōsō-in, Nara. This handsome five-stringed lute comes from the household furnishings of Emperor Shōmu, given after his death to the imperial temple of Tōdai-ji in Nara. The diverse origin of the pieces included in the gift—they range from Persia through China to Japan itself—and the refined craftsmanship of many of them attest to the luxury of Nara court life.

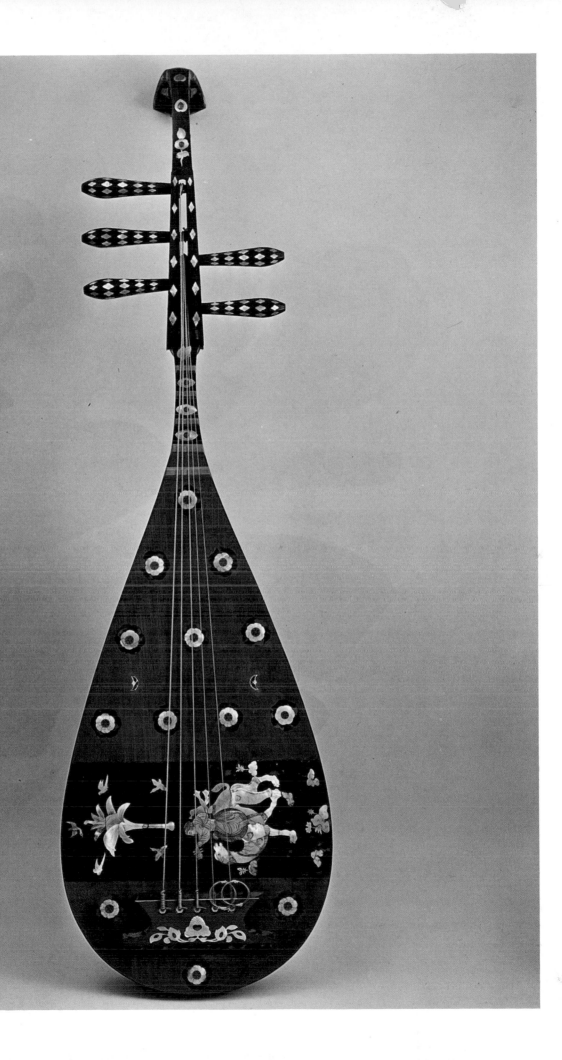

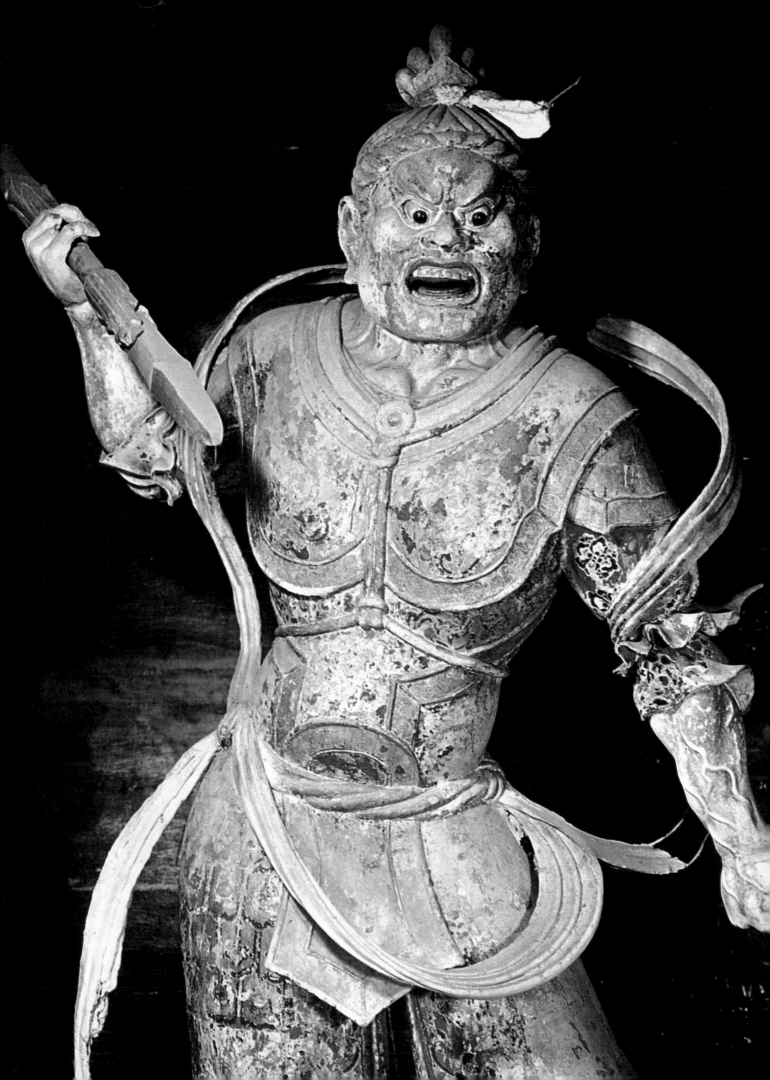

92 (opposite). **Shukongō-shin.** Nara period. 8th century. Painted terracotta. h. 5 ft. 6 in. (167·5 cm.). Hokke-dō, Tōdai-ji, Nara. Since this figure of Vajrapāni wielding a thunderbolt was formerly locked up in a shrine as a 'secret image', it is well preserved, despite the fragility of the material. The piece represents a fierce guardian deity of Buddhism, in full armour and with swirling drapery.

93 (above). **The Tale of Genji.** Detail from the Genji scroll. Late Heian period. h. 8⅝ in. (22 cm.). Tokugawa Museum, Nagoya. The surviving pieces of the Genji scroll are attributed to Takayoshi, a mid-12th-century painter who lived a century after the death of Lady Murasaki, the author of the story. This section illustrates the illness of Kashiwagi, who dies of love for Genji's consort, Nyōsan.

94 (below). **Cosmetic box.** Heian period. 12th century. Wood with *maki-e* decoration and mother-of-pearl inlay on black lacquer. h. 9 in. (13·5 cm.). National Museum, Tokyo. Against a background of alternating blue-black and reddish gold tones, the groups of wheels half submerged in the water *(katawa-guruma)* provide a rhythmic pattern. The cosmetic box is a fine example of Heian luxury objects.

95 (opposite). **Batō Kannon.** Heian period. 11th century. Colour and ink on silk. h. 5 ft. 5⅜ in. (166 cm.). Museum of Fine Arts, Boston. Kannon, traditionally the goddess of compassion, is seen here in her more terrible aspect with a small horse's head surmounting three human heads: she has become one of the esoteric deities of the Tantric *Shingon* sect. The figure comes from a series depicting six different manifestations of Kannon.

96, 97. **The Phoenix Hall** (Hōō-dō), Byōdō-in, Uji near Kyōto (and detail). Heian period, erected 1053. After the Regent Fujiwara Yorimichi had transformed the villa of his father into a Buddhist monastery dedicated to Amida, he built the Phoenix Hall there in 1053. The name refers either to the bronze figures on the roof or to the plan which suggests a bird with outstretched wings. Within the middle block is the famous Buddha image by Jōchō. The sophistication of the building's design with its lateral pavilions and linking corridors suggests a palace rather than a temple.

98. **Amida Buddha.** Kamakura period, mid-13th century. Bronze. Height 42 ft. 6 in. (12·95 m.). Kōtoku-in, Kamakura. Voluntary contributions collected by the monk Jōkō made possible the casting of this colossal image of Amida. It was erected in Kamakura, the seat of the military government, as a counterpart to the giant Buddha of the Nara period in Tōdai-ji. The temple hall that originally contained the cult image was destroyed centuries ago.

99 (above). **The Adventures of Kibi in China.** *Kibi Daijin Nitto E-Kotoba* scroll (detail). Late Heian—early Kamakura period. Late 12th–early 13th century. Scroll painting in colour on paper. h. 12⅝ in. (32·2 cm.). Museum of Fine Arts, Boston. This scroll illustrates the story of the Japanese courtier Kibi no Makibi who was sent as an envoy to T'ang China. He was set a series of intellectual tasks by the T'ang court, and was assisted in solving these by the ghost of an earlier diplomatic messenger disguised as a demon. The scroll, which in all measures eighty feet, is full of colour and humorous incident.

100 (below). **Tosa Hirokata.** *The Tale of the Young Heavenly Prince* (detail). (*Amewakahiko no sōshi.*) Kyōto, Muromachi period. *c.* 1450. Ink and colour on paper. h. 12⅝ in. (32·2 cm.). Ostasiatische Kunstabteilung, Staatliche Museen, Berlin. This scroll contains the second part of the text and seven illustrations to the story of the human wife of a heavenly prince, who after various trials was allowed to meet her husband once a year. In various versions, this story spread throughout the Eurasian continent. The text was written by Emperor Go Hanazono personally and the illustrations are by a court painter of the Tosa school, who worked at the Painting Bureau with the rank of *E-dokoro-azakari*.

101. **Rock gardens of the Daisen-in,** Daitoku-ji, Kyōto.
Muromachi period, *c.* 1509. This layout is one of the most
famous of the so-called 'dry landscape gardens' *(kare-sanzui)*.
It was probably laid out by the Abbot Kogaku himself in front
of his living quarters in the Daisen-in. As contemporary ink
paintings show, these gardens were of modest size, employing
symbols—pebbles indicate water—to 'translate' a natural
landscape into one of highly condensed form. Such gardens
were not entered, but viewed from a veranda as if they were
paintings.

102. **The Golden Pavilion** *(Kinkaku-ji)*, Kyōto. Muromachi
period, erected 1397 (reconstructed). Shogun Askikaga
Yoshimitsu built this pavilion on the edge of a lake to serve
partly as a villa and partly as a monastery. The building was
covered with rich gold leaf. After the regent had officially
renounced his governmental responsibilities in order to
manipulate politics from behind the scenes, he lived a leisured
life indulging his aesthetic inclinations in this splendid villa,
where he even received visits from the Emperor.

103 (above). **Portuguese arriving in Japan.** Six-fold screen. Early Edo period. 17th century. Musée Guimet, Paris. The arrival of the Jesuits in Japan in 1542 aroused great interest in the manners and customs of the Western world. These screens called *Namban Byōbu* (screens of the southern barbarians) reflected all the excited curiosity that was felt at that time. Portuguese merchants, bearing the produce of the West, land from their ship accompanied by missionaries.

104 (below). **Hasegawa Kyūzo** (attr.). *Cherry Blossom.* Momoyama period. Late 16th century. h. 68½ in. (173 cm.). Chishaku-in, Kyōto. This painting is attributed to Hasegawa Tōhaku's son, Kyūzo, who died at the age of twenty-six. It bears obvious resemblances to the father's work, though the general treatment is perhaps more gentle. It is possible that Kyūzo assisted his father in the production of the famous folding-screen paintings in the Buddhist temples at Kyōto.

105. **Ogata Kōrin.** *Plum Blossom.* Middle Edo period. 18th century. Pair of two-fold screens. Colours on gold paper. Each screen 5 ft. 5⅜ in × 5 ft. 7¾ in. (166 × 172 cm.). Atami Museum, Shizuoka. Kōrin belonged to a family of prosperous drapers who also produced Nō costumes at Kyōto. He is generally regarded as one of Japan's greatest decorative artists. These screens show his work at its purest. He was at pains to render plant and flower forms accurately, yet arranged in a perfectly balanced composition. When the screens are joined the stylised river joins to become a single stream, opening out in the foreground to form a wide pool.

106. **Honnami Kōetsu.** *Album leaf with calligraphy.* Early 17th century. Ink and pale colours on paper. 7¼ × 6⅜ in. (18·3 × 16·2 cm.) Ostasiatische Kunstabteilung, Staatliche Museen, Berlin. Kōetsu was a potter, lacquer worker and calligrapher, but it is upon his calligraphy that his reputation rests. The album of which this page is an example is considered to be among his outstanding works. Here he writes, in his intensely personal style, a 12th-century poem by Kamo no Chomei, which was included in a famous Japanese anthology compiled in the 13th century. A literal translation would be: 'The autumn wind is blowing through all the villages/but my sleeve is wet because of the tears falling from my heart like the dew of the evening.' Only the calligraphy is Kōetsu's. The background painting of ears of rice in water are by another hand.

107 (opposite). **Atsu-ita,** male costume
for the Nō theatre. Momoyama or early
Edo period, about 1600. l. 4 ft. 8 in.
142·3 cm.). National Museum, Tokyo.
In contrast to the conservative content of
the Nō drama and its highly stylised
methods of performance, the costumes
and masks of the actors often have an
extraordinary splendour. The text
running diagonally across the garment is
a Heian poem celebrating the arrival of
spring.

108 (above). **Tea Bowl** *(chawan).*
Painted Shino ware, Mino province.
Momoyama period, *c.* 1600. Ceramic
with opaque greyish-white glaze and
underglaze painting. Height 4⅜ in.
(10·1 cm.). Ostasiatische Kunstabteilung,
Staatliche Museen, Berlin. The few
known painted examples of Shino ware
are among the earliest examples of
Japanese underglaze decoration. The
shapes of these thick-walled tea bowls are
lively and free, for they are formed by
hand and not on the wheel. They were
especially prized in the tea cult of the
Momoyama period.

109 (below). **Nonomura Ninsei.** *Vase
with red plum blossom.* Early Edo period.
Mid-17th century. Ceramic with gold
and enamel colours. h. 11¾ in. (30 cm.).
National Museum, Tokyo. In the style
chosen for the painting of this vase,
Ninsei, one of the most famous Japanese
potters, has gone to the decorative
paintings of the Kanō school. The form
and decoration of the piece are purely
Japanese in character and no influence
from Chinese porcelain is discernible.

110. Porcelain ewer with dragons.
Ko-Kutani ware. Tokugawa period.
Late 18th–early 19th century. h. 8 in.
(20·3 cm.). Victoria and Albert Museum,
London. Kutani enamelled porcelain
has a highly individual style. The
colours are strong and the brushwork has
a freedom which is particularly attractive.

111 (opposite). **Suzuki Harunobu.**
Woman with a Fan at the Garden Fence. Left
leaf of a diptych. Edo period, 1766–70.
Colour woodcut. 10¾ × 8¼ in.
(27·4 × 20·9 cm.). Kunstbibliothek,
Staatliche Museen, Berlin. This diptych,
of which the left-hand panel is illustrated
here, alludes to the 'Yugao' chapter of

the *Tale of Genji*. Harunobu is famous as
the creator of elegant feminine figures,
which rank alongside actors and the later
landscapes as leading aspects of the
'floating world' of Japanese prints. At the
left side of the print is written 'Sakei', the
name of the leader of a circle of poets
who gave Harunobu many commissions.

東洲齋寫樂画

same body of sculptors was responsible for both categories of work.

THE KAMAKURA PERIOD

After Minamoto Yoritomo had driven the Taira clan from power, he moved the seat of his new military dictatorship or shogunate far from the distracting metropolis of Heian to Kamakura to the north-east. Since political life was now centred in this city the years between 1192 and 1338 are called the Kamakura period. The legitimate Tennō monarchy continued a shadowy existence in Kyōto, while Yoritomo held the upper hand with the support of warriors from his local district. But with the extinction of the Minamoto family the shogun himself also became a puppet, and true power lay with the regent *(shikken)* of the Hōjō clan. Although two Mongol assaults were repulsed (1274 and 1281), the prestige of the Hōjō declined steadily because of the excesses and cruelty of its leaders.

For the first time Japan had two cultural centres: the old imperial city of Kyōto (Heian) and Kamakura, where new fashions were decreed by the lords of the warrior caste. The military government intentionally kept its followers away from the softening ways of Kyōto. Closer links with the China of the Sung and Yüan dynasties opened the way to a new wave of mainland influence. Nevertheless Kamakura culture presents a number of inward-looking traits. Scholarship flowered, and the famous Kanazawa Library was founded in Musashi in 1275. But Buddhism acted as the real guardian of literary traditions: its teaching of the transience of all earthly things appealed to the military lords, to whom it offered a spiritual basis for the knightly virtues of courage and fidelity. Legends of Buddhist saints, folk tales and heroic romances were composed. The newly-awakened interest in the *Manyōshō*, the poetry collection of the Nara period, was paralleled in art by restoration of the Nara temples and their sculptures, which had been damaged by fighting.

New tendencies were at work among the Buddhist sects. The priest Shinran (1173–1262) elaborated the Amida teachings, emphasising the equality of all men in the sight of the Buddha. The Amida cult flourished especially in the north and the east. Although the school's new trend stressed devotion to images less than the earlier teaching had done, some important sculpture appeared, notably the colossal Amida of Kamakura, which was cast in 1252 in imitation of the giant Buddha of Nara and installed in a

98

112 (opposite). **Sharaku.** *The Actor Morita Kanya VIII in the Role of Uguisu no Jirōsaku.* Edo period, 1794. Colour woodcut. 14⅝ × 9¾ in. (37·3 × 24·8 cm.). Kunstbibliothek, Staatliche Museen, Berlin. This half-length portrait shows the actor playing the part of a sedan-chair bearer in the Joruri drama *Hana-ayame omoi no kanzashi* ('Iris Headdress of Remembrance'), which was performed in the Kiri-za Theatre in the fifth month of 1794. In these half-length portraits the print-maker Sharaku succeeded in capturing the personality of a theatrical performer in a few economical strokes.

103. **The Shintō Goddess Nakatsu-hime.** Heian period. 9th century. Painted wood. h. 10½ in. (26·7 cm.). Yakushi-ji, Nara. This small figure shows the Shintō goddess in Japanese court dress. Some features, the full face for example, suggest the influence of T'ang sculpture. The piece undoubtedly comes from the circles of sculptors working for the great Buddhist temples.

104. **Bokusai** (?) *Portrait of Ikkyū Sōjun.* Muromachi period, second half of the 15th century. Hanging scroll. Ink and light colour on paper. 6⅛ × 10½ in. (16·2 × 26·7 cm.). National Museum, Tokyo. This painting is probably a sketch made from life for a larger portrait of the famous Zen monk Ikkyū, and may perhaps have been executed by a pupil of Bokusai. It is consequently more intense and immediate than the usual type of portrait *(chinzō)* of Zen priests, examples of which were awarded as a kind of graduation diploma to successful students of the masters.

105. **Reliquary in the shape of a pagoda.** Kamakura period, 13th century. Gilded copper. h. 14 in. (37 cm.). Saidai-ji, Nara. A *shari-tō* is a miniature pagoda to contain the *shari* or sacred ashes of the Buddha. Inside the pagoda is a container of vase form, reputedly holding grains of the sacred ashes. The veneration of the *shari* or *sarira* became a popular cult in the late Heian and early Kamakura periods. Many such reliquaries were made, though this is probably the finest.

vast temple hall that was later destroyed. This colossus shows the style of Kaikei, who, with the celebrated Unkei was the leading sculptor of the age. In the second half of the 13th and in the 14th century Buddhist sculpture enjoyed a last great flowering in the powerful realism of Kamakura statuary. The effort to render things as they really are—the use of rock-crystal eyes to make faces life-like—betrays a certain influence of Sung work. After the 14th century the vitality went out of Japanese monumental sculpture; only portraits and the masks carved for the Nō theatre are of real interest.

A new Buddhist sect that enjoyed wide popularity among the people was the Hokke founded by Nichiren in 1252. (The sect was named after the Hokke *sūtra*, which is the central focus of its teachings.) With Nichiren a vehement, even fanatical element appeared in the otherwise rather pietistic Buddhist church. Nichiren sought to influence the course of politics through petitions to the government, but he received only exile for his pains.

Of the greatest importance for the further development of Japanese art, and indeed for the whole civilisation of her people is the appearance of Zen Buddhism, which penetrated in strength from Sung China at the first half of the 13th century. The attainment of mystical enlightenment through concentrated spiritual exercises and meditation,

together with the absolute simplicity of the cult and of monastic life, which eschewed all display, and finally the close relationship with nature—all these features appealed strongly to the members of the warrior caste, who made the Zen teachings their own. The shogunate actively fostered this school, whose tone was set more by individual human contact than by any organisational structure, so that the sect could never threaten to become a state within a state. In 1202 the government established the venerable abbot Eisei in the Kennin-ji Monastery in Kyōto, which became the centre of Zen Buddhism.

Many Japanese monks journeyed to late Sung China where they could study Zen teachings first-hand; a little later Chinese monks fled to Japan before the ravages of the Mongol invasion. So it is not surprising that the buildings of Zen monasteries depend directly on Sung prototypes, and that their architecture should be termed 'Chinese style' *(kara-yō)*. The Tōdai-ji in Nara was rebuilt in a south Chinese form somewhat misleadingly called 'the Indian style' *(tenjiku-yō)*.

The spirit of Zen is most easily seen in the monochrome ink paintings *(suiboku-ga)*. The first approach to the Chinese monochrome technique is found in the 13th-century Takuma school, but this new style reached its full flowering only in conjunction with far-reaching aesthetic reforms in the 14th century that affected many aspects of art. A special category of Zen paintings is priest portraiture *(chinzō)*, which strove to convey the living presence of the great spiritual masters. These works were often provided with an inscription and presented to students as a kind of diploma to mark an advance in spiritual progress. The adepts thus honoured were accustomed to practise meditation before the picture as if in the presence of the master himself. In keeping with the personal nature of this branch of painting the interest focused largely on the realism of the face, whilst the drapery was handled in a conventional manner. A later example which shows the forcefulness and immediacy that were so much prized is a portrait of the great monk Ikkyū made by one of his students in the late 104 15th century.

In the Kamakura period the narrative scrolls *(e-maki-mono)* enjoyed especial favour at court and in the monasteries. The painters of the increasingly powerful Amida monasteries produced terrifying pictures of illness, suffering and hellish torments, directing their work to a large public in order to awaken the hearts of the people to the need for salvation in the Paradise of Amida. In addition, the monastic painters excelled in broadly conceived scenes of the lives of famous monks. The court painters were also drawn to themes close to daily life, for which the turbulence and variety of the heroic romances gave them ample scope. Court artists also liked to illustrate poetic works and **99** novels of the Heian period. This trend towards the objective rendering of reality reached its height in the second half of the 13th century; in the following century it declined into a series of clichés and repetitions. Nevertheless

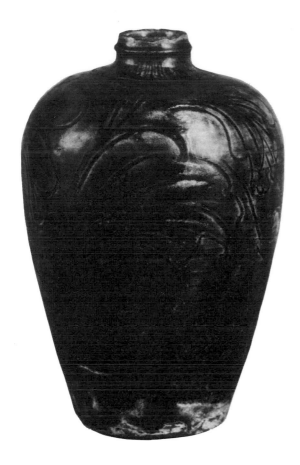

106. **Vase with design of chrysanthemum leaves.**
Kamakura period, 13th century. Fired clay with blackish glaze.
h. 9½ in. (24·2 cm.). National Museum, Tokyo. The pottery
jars of the Kamakura period display certain links with Sung
ware. But the vigorous drawing of the chrysanthemum leaves
and the sturdy yet graceful appearance of the vase is typically
Japanese.

107. **Mokuan.** *The Four Sleepers*. Muromachi period, 14th
century. Ink on paper. 27½ × 14⅛ in. (70 × 36 cm.). Maeda
Ikotokukai Foundation, Tokyo. Mokuan was a Japanese priest
who visited China in the 1320s to study Zen Buddhism. He
was much influenced by the style of the Southern Sung artist
Mu Ch'i. *The Four Sleepers* shows the Chinese Zen priest Feng-
kan with his pet tiger and two disciples, fast asleep.

one court painter of the 15th century—well into the fol-
lowing Muromachi period—succeeded in illustrating a
folk tale with true poetic feeling.

While workers in metal preserved much of the elegance
and luxury of the late Heian tradition, Japanese potters of
the Kamakura age began to pioneer entirely new paths.
Admittedly the potter Katō Tōshirō had perfected his
technique during a stay in China before he made Seto in
Owari province the centre of native ceramics (from 1227),
but the potters active there were soon able to use Chinese
methods to produce a powerful style of their own.

THE MUROMACHI AND MOMOYAMA PERIODS

The Emperor Go Daigo, aided by the powerful warrior
family of the Ashikaga, and taking advantage of the general
unrest and dissatisfaction with the Hōjō regents, was finally
able to break their domination and to annihilate the clan.
However, Ashikaga Takauji, an ally of the emperor who
was disappointed by the rewards of his cooperation, de-
cided to deprive the Tennō emperors of the fruits of vic-
tory by making himself shogun. Since he moved the cap-
ital back to the Muromachi quarter of Kyōto, the period
beginning at this time is called the Muromachi or Ashi-
kaga era (1338–1578). This period saw a further concen-
tration of power in the hands of the warrior clans, whose
loyalty went primarily to their feudal lords, rather than to

the shogunate. Under the politically weak Ashikaga sho-
guns the provincial feudal lords *(daimyō)* became in-
creasingly autonomous finally creating independent
governments for their own lands in the early 16th century.
The *daimyō*, whose power depended on their vassals and
armies, became embroiled in struggles for power degener-
ating into a series of ruinous civil wars waged almost in-
cessantly from 1465 to 1600.

An extraordinary phenomenon in Japanese history is
the fact that the arts continued to flourish throughout this
tempestuous age. As many Chinese emperors had done
before them, the Ashikaga, who proved indifferent rulers,
threw themselves wholeheartedly into the patronage of art.
The Hana no Gosho palace at Kyōto provided the setting
for their ostentatious court. The third Ashikaga shogun,
Yoshimitsu (1358–1408) cast off his governmental respon-
sibilities and indulged his artistic tastes in a pleasure pavil-
ion covered with gold leaf. This building, erected in a
delightful garden setting, was later converted into the
Kinkaku-ji, the 'Temple of the Golden Pavilion'. Behind
the scenes, however, Yoshimitsu still manipulated the
reins of power: in the year of his death he received a
ceremonial visit from the emperor.

As at the Heian court, in Ashikaga Kyōto the various
aspects of a cultivated and aristocratic way of life were
carefully elaborated to make up an aesthetic whole. This

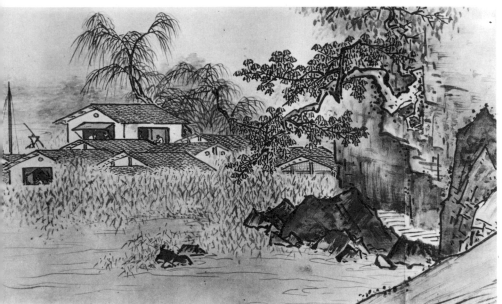

108. **Sesshū.** *Landscape scroll* (detail). Muromachi period, dated 1486. Ink and pale colour on paper. h. 14 in. (37·9 cm.). Mori Collection, Yamaguchi. This famous landscape scroll was painted when the artist was sixty-seven. Although apparently conventional or even academic in treatment, this painting reflects the artist's deep understanding of nature, and shows his ability to render the delicacy and movement of the trees and rice fields even within the terms of the precise, calligraphic style.

109. **Box for writing materials.** Muromachi period, 15th century. Black lacquered wood with *maki-e*. 9 × 8⅛ in. (22·7 × 20·8 cm.). Nezu Art Museum, Tokyo. The scene on this box illustrates a poem praising the beauty of the cherry blossom at Shirakawa. Three characters from that poem are written in gold on the trunk of the tree. 'Poem pictures' like this were popular in Japan from the Heian period.

landscape gardening, which grew up at this time alongside monochrome landscape painting, was pioneered by the monasteries of this sect. Besides the planted areas, the gardeners liked to create the so-called 'dry landscape' *(kare-sanzui)* before the abbot's quarters. Made up of carefully selected picturesque stones and beds of raked pebbles, these dry landscapes may be fittingly compared with the ink paintings since they represent a kind of abstraction of nature achieved in a small area and by simple means.

The ink painting of the Muromachi period remains the art most deeply affected by Zen. Some Japanese painter-monks had studied in China itself and they brought the works of Chinese masters into Japan. Mokuan, one of the early masters, went to China in 1326, dying there three years later. With swift sure strokes that look like writing, Mokuan captured the image of the half-legendary T'ang monk, Fêng-kan with his two famous attendants and his tame tiger.

In the art of Sesshū (1420–1506), monochrome ink painting achieved a maturity of expression and a characteristically Japanese form. Sesshū spent two years travelling in China, but he did not care for the work of contemporary painters, preferring the inspiration of earlier masters and even more the stimulant of the majestic landscapes themselves. He excelled not only in the free, expressive technique deriving from the Sung masters but also in a more conventional academic manner. The latter provided the model for the painter family of the Kanō who were active from the beginning of the 16th century onwards. The academic artists patronised by the shoguns came mainly from this family. Their paintings on sliding doors and screens integrated the classic Sino-Japanese precision of the ink line

climate nourished the Nō drama, which was suffused with the Buddhist spirit of withdrawal from the world. In the Nō, all the main characters wear masks so that they are reduced to types. The great theoretician of this drama was Seami (1363–1443). In the middle of the 15th century the tea ceremony took shape in close conjunction with the art of flower arrangement. Connoisseurs developed exquisite ways of appreciating works of art: rooms had a special place for exhibiting them, the alcove of the *toko-no-ma*, where they displayed individually, one at a time.

This courtly way of life was strongly imbued by the Zen spirit. In Muromachi times the Zen monasteries became the true centres of spiritual life. Their influence spread not only among the nobility and the military, but was carried by the latter to the common people who appreciated Zen simplicity. During this period, Zen so deeply affected the structure of Japanese life and society that its influence is still clearly discernible among the Japanese people today. Poetry and poetic theory were shaped by Zen. The art of

110. **Himeji Castle.** Himeji, Hyōgo prefecture. Momoyama period, completed 1608. Under the influence of European techniques, stone castles of this type were built in the late 16th and 17th centuries following the introduction of firearms, which made the older wooden redoubts obsolete. The form of these castles shows a mixture of European elements and Chinese city-fortification practice. The main part of the castle was the keep which has several storeys *(tenshu)*.

111. **Hasegawa Tōhaku.** *Pine trees.* Momoyama period, late 16th century. One of a pair of six-fold screens, l. 5 ft. 1¾ in. × 11 ft. 4⅝ in. (156 × 346 cm.). National Museum, Tokyo. This famous pair of screens were probably painted by Tōhaku when he was in his mid-fifties. Although certain technical features show the influence of Sung China the artist has absorbed these to produce a work which is entirely his own, exploiting to the full the poetic possibilities of ink painting.

into a composition marshalling broad flat surfaces in a highly decorative manner, thus opening the way to the decorative painting of the 17th century. In contemporary lacquer work, which catered for the luxurious requirements of the courts of the shoguns and the *daimyō*, the occasional appearance of Chinese reminiscences in scenes following the Yamato-e style is unmistakable.

In the course of the bloody *daimyō* wars towards the end of the Muromachi period General Oda Nobunaga occupied Kyōto in 1568. With the assistance of his henchman Toyotomi Hideyoshi he subjected most of the feudal lords to his will. After his master's death Hideyoshi continued the work of unifying the realm, a task which could be regarded as complete by 1590. The brief time from 1573 to 1615 is called the Momoyama period after the site of one of Hideyoshi's palaces near Kyōto. Culturally the period was marked by the ostentatious taste of the great war lords. Typical of the Momoyama architecture are the imposing castles of the regents and the *daimyō* clans, which were erected under European influence as fortified towers with heavy masonry.

Contact with the West had begun somewhat earlier. In 1545 the Portuguese Fernão Mendez Pinto brought the first firearms to Japan, where they were soon adopted by the Nobunaga army. In 1549, the celebrated Francis Xavier reached Japan, where he converted many people to the Christian faith, first in Kagoshima and later in Kyōto itself. Trade with the West was carried on by the shogun, by the

feudal lords in western Japan and by the great monasteries. The Europeans, the so-called southern barbarians *(namban)*, brought more guns, medical knowledge and instruments for astronomy and navigation, stimulating the interest of the Japanese in the natural sciences. But these influences did not affect the broad mass of the people, whose life was rigidly circumscribed: in 1591 a law forbade anyone to change his status in any way, thus confirming the traditional social order.

The new castles of the war lords with their big reception rooms called for an art form that could hold its own in such a setting, and the Momoyama artists developed a type of decorative painting that was typically Japanese. The purely decorative qualities of painting on screens and sliding doors, exemplified by a work of the Kanō masters, were intensified. Against a bright ground of gold leaf the artists worked with strong colours applied in a flat manner. Compositions are bold and at the same time well balanced. However, a certain tendency to overloading and to dry standardisation appears in the last years of the Momoyama period. The earliest master of the style was Kanō Eitoku (1543–90), who ran a workshop employing many painters. He was followed by his adopted son Sanraku, formerly a page of the shogun, who became famous for his decoration of the Momoyama palace. More varied than the Kanō was Hasegawa Tōhaku (1539–1610), who not only mastered the elements of coloured decorative painting, as shown by the famous examples of 1592 in the Chishaku-in temple

112 (left). **Main Gate (Sammon) to the Ninna-ji Temple, Kyōto.** Early Edo period, first half of the 17th century. Founded as early as 886 under imperial patronage this Shingon Temple gradually became a large complex. Big portals of this kind mark the entrance to the sacred precinct of important Buddhist temples, with a pair of overlife-size Guardian Kings *(Ni-ō)* fiercely protecting the entrance. Although built in the 17th century, this gateway demonstrates the conservatism of the Japanese architect, for in all its major features it is identical with structures that were being built ten centuries earlier.

113 (opposite). **Main building of Katsura Rikyū in the vicinity of Kyōto.** Momoyama and early Edo periods, late 16th and 17th centuries. This villa with its splendid gardens was probably designed by Kobori Enshū. Begun at Hideyoshi's order for Prince Tomohito, it was enlarged after 1642 by Prince Toshitada. The charm of the whole derives from its conscious simplicity closely linked with the aesthetic of the tea ceremony.

which come from a memorial temple for Hideyoshi's favourite son, but also achieved distinction as a painter in monochrome ink. His screen of the *Pine Trees in Mist* ranks among the finest and most powerful ink paintings of Japan, demonstrating that the black-and-white technique could also be effective in a decorative context.

The need for sumptuous display in the Momoyama period was balanced by the moderating influence of the tea ceremony and its aesthetic; Sen no Rikyū (1521–91) is its presiding genius. His ascendency even extended to the design of Hideyoshi's Jurakudai palace, which unfortunately has not survived. Moreover, Sen no Rikyū was one of the organisers of the celebrated tea ceremony staged in Kitano in 1587.

A fine example of the villas built near the capital is the Katsura Rikyū, erected by Hideyoshi for one of the princes. Begun in the Momoyama period, the villa was completed on an enlarged plan in the early Edo period. The skilfully composed garden reflects the influence of the garden designer Kobori Enshū. The rooms of the villa are intentionally sparsely furnished so that the fine proportions and the quality of the materials can be seen to full effect. The villa fits harmoniously into an artificial landscape setting. In the Katsura villa the sophistication and conscious simplicity of the age's romantic feudalism reached its height.

THE EDO PERIOD

After the death of the mighty Hideyoshi, the no less powerful Tokugawa Ieyasu, who was the guardian of Hideyoshi's son, made himself regent. In 1603 he was confirmed as shogun and after his final victory over the Toyotomi clan there were two and a half centuries of peace in Japan—an epoch which is called the Tokugawa or Edo period

(1615–1867). Ieyasu confined the feudal system within narrow limits, exercising close supervision over the *daimyō*. The government was strongly centralised, with the legitimate Tennō emperors reduced to playing the part of ceremonial figureheads even more than before. The seat of the shogun's government was moved to Edo, the present Tokyo, which gives it name to the period. A division of the people into four classes of warriors, peasants, artisans and merchants was rigidly imposed.

The dominant class, the warriors, favoured Confucian philosophy instead of Zen; Buddhism became mainly a popular religion under the supervision of the central government. After an initial toleration Ieyasu forbade Christianity in 1612 and introduced a policy of isolation from the outside world, that was to continue for many years. Although this worked for internal stability, it crippled the development of the country by cutting it off from intellectual stimuli from abroad. Despite restrictions imposed by the shogunate, the study of Dutch science *(rangaku)* began in about 1720, and from 1750 western medicine became increasingly known to Japanese savants.

The brisk international trade which had flourished at the beginning of the Edo period was soon stifled, and the subsequent growth of large cities made it inevitable that commercial intercourse should be concentrated in the cities. While the warriors tended to sink into relative poverty, a prosperous middle-class flourished among the *nouveau-riche* Edo, led by a number of merchants families. Dissatisfaction with the shogun's government strengthened the imperial party and shortly after Commodore Perry opened the country to foreign trade in 1854, they deposed the last Tokugawa, restoring the imperial house in the person of Meiji. The wise policies of this ruler, who

reigned from 1868 to 1912, followed paths that his natio-
nalist supporters had not anticipated. His reign saw the
beginning of the powerful political, social and cultural
revolution that made Japan a progressive and modern
state enjoying full equality with the western nations.

The art of the Edo period reflects the social changes of
the time. While craft work was mostly in the hands of
the established families supervised by the *daimyō*, the
rising bourgeoisie of the cities required new forms of art.

The official painting schools of the Kanō and Tosa
families became increasingly mannered, but in the hands
114 of a few gifted masters decorative painting enjoyed a new
flowering. The economic basis of this was provided by the
newly rich middle class. Honnami Kōetsu (1558–1637),
the first of these great masters of decoration came from a
prominent family of fencing masters. He was primarily a
calligrapher and a patron of the arts. A collection of pages
of poetry, written on paper prepared with a painted ground
design *(shikishi)* continued an old Japanese tradition, but
106 filled now with a new spirit. The ground designs, which
were often executed by Kōetsu's friend Sōtatsu, borrowed
their manner and themes from large-scale screens and
sliding panels. In this way they became attractive com-
posite works of art integrating poetry, calligraphy and
painting, which capture perfectly the aesthetic note of the
age. The recognition and appreciation of other artist's
qualities is reflected in Kōetsu's successful undertaking to
gather together a group of artists working in various styles
in the village of Takagamine near Kyoto where they could
live and work together.

The two other distinguished decorative artists of the
Edo period both come from the middle class. Sōtatsu,
Kōetsu's collaborator, belonged to a family of brocade

merchants and it is not unlikely that certain features of the
screen painting he practised with such mastery derive
from prior experience in textile design. Similarly, Ogata
Kōrin (1658–1716), who was active almost a century later, **105**
came from a family of rich cloth merchants. He squan-
dered a large inheritance and was compelled to earn his
living as a decorator for rich patrons. His screens are out-
standing in the subtlety of their composition. It is not sur-
prising in the circumstance that women's clothes and
theatre costumes of this period are rich in texture and **107**
colour, which often appear to us to be excessively sump-
tuous.

Apart from the mainstream of painting just described,
there flourished a more naturalistic school under the in-
fluence of Maruyama Okyo and a Chinese-oriented liter-
ary painting *(bunjin-ga)* favoured by educated dilettantes.
Finally, as early as 1789, Shiba Kōkan experimented with
European oil-painting and copper-plate engraving.

While pottery for the tea ceremony had long been free **108**
from dependence on Korean and Chinese models, creating
the underlying aesthetic of the tea cult, Chinese stimulus
lay behind the achievements of such porcelain factories as
Kutani, which was active as early as 1650, soon developing **110**
a bright surface painting that is unmistakably Japanese.
In this field Ninsei, a friend of Kōrin's brother Kenzan, **109**
combined technical brilliance with a subtle design to pro-
duce superb decorative effects.

Edo sculpture is generally stiff and cold. Of some
interest, however, is the work of certain wandering priests,
who chip-carved statues out of wood with an axe, leaving
them in a crude, half-finished state. The rustic charm of *115*
such pieces contrasts with the elegant traditional sculpture
of the period.

114 (left). **Miyamoto Niten.** *Crow on a Pine Branch.* Early Edo period, first half of the 17th century. Hanging scroll, ink on paper. 5 ft. (152 cm.). Formerly Viscount Matsudaira Collection. Niten, the son of a noble, was adopted by the *daimyō* family of Miyamoto and led a soldier's life. Renowned as a fencing master, he practiced ink painting as a hobby and the hand of the skilled fencer may be detected in the bold, sure strokes of his brush. The directness, simplicity and vigour of his painting make it an eloquent example of Zen art.

115 (right.). **Enkū.** *Self-portrait.* Edo period, second half of the 17th century. Wood. h. 18½ in. (47 cm.). Senkō-ji, Gifu province. The monk Enkū (1628–95) travelled as a wandering priest throughout the Japanese islands, including Hokkaido. Although not a professional sculptor, he left simple carvings in the villages and temples he visited as thank offerings for his rustic hosts.

116 (below right). **Kitagawa Utamaro.** *Women Amusing a Child.* Middle Edo period. Wood-block print. 14¼ × 9¼ in. (36 × 23 cm.). Victoria and Albert Museum, London. This print is one of a series called 'Popular collection of Seven Eyes'. It shows women in an intimate domestic scene, a favourite subject with Utamaro.

The art of Japan achieved a last autumnal flowering in the woodcut, which was closely linked to the writing of popular stories and to the theatre. In the 16th and 17th centuries the so-called city painters *(machi-eshi)* had done screens with popular genre scenes and in the second half of the 17th century scroll pictures appeared featuring beautiful women *(bijin)*. Finally, books with black-and-white illustrations showing the varied life of the pleasure quarter of Yoshiwara in Edo gave rise to the 'pictures of the floating world' *(ukiyoe)* of the woodcuts. The founder and perfecter of the technique is Suzuki Harunobu (1725–70), whose figures of women display an inimitable charm. Apart from courtesans, the world of the popular Kabuki theatre, which flourished as an alternative to the aristocratic Nō drama, furnished many themes for the masters of these prints. Among the many artists working in this field Sharaku stands supreme. Possibly himself an actor, Sharaku's highly expressive actor prints were all created in a period of ten months in 1794–95. The colourful life of Edo's middle class is clearly mirrored in the art of the woodcut print. Later masters, Hokusai, Hiroshige and Utamaro exercised an important influence on the French painters of the second half of the 19th century.

With the opening up of Japan, western art forms of all kinds began to modify or replace Japanese work. Some of the work produced under European influence is more 'western' than western art itself. Once more Japan has set out on an intense, perhaps over-intense process of assimilation, which is still continuing today.

THE WORLD
OF ISLAM

Introduction

THE BEGINNINGS OF ISLAM

The religion of Islam, which gave its name to a vast empire, governed from the first every aspect of its civilisation. Significantly enough, its founder, Muhammad, was not only a Prophet. He was also leader, judge, legislator and general, and the caliphs (khalifah) or 'successors' who came after him inherited and assumed all these roles.

Muhammad founded the nucleus of the Muslim empire not by religious conversion alone but by force, political manoeuvres and administrative ability. His famous flight (*hijra* or *hejira*) to Medina in 622 is taken as the date for the initiation of the Muslim era. When he took control of Mecca, it became the religious centre of Islam.

In the Koran (Quran), the Holy Book of Islam, which embodies all his teachings and in the Hadith (traditions), a collection of his sayings and decisions not recorded in the Koran and often, in fact, apocryphal, a whole system was laid down, covering every aspect of life—religious, social and legal, and on these writings the educational structure and whole administration were based. In this way, Islam (I submit—to the will of Allah) brought in its train a unifying and stabilising force. When East, West and Central Asia were subdued by the relentless campaigns of the Arabs in the late 7th and the 8th centuries, the leaders of the invading armies were given a voice of authority with which to bring political order to a vast area of countries and states.

The period following the death of the Prophet in 632 was one of successive victories for the Arab generals. In less than a century half the known civilised world, from Spain to the borders of China, was in the hands of the Muslims, unified under the new cultural force of Islam.

COMPLEX BLEND OF CULTURES

Islamic art, therefore, is not the art of a particular country or a particular people. It is the art of a civilisation formed by a combination of historical circumstances: the conquest of the Ancient World by the Arabs, the enforced unification of a vast territory under the banner of Islam, a territory which was in turn invaded by various groups of alien peoples. From the start, the direction of Islamic art was largely determined by political structures which cut across geographical and sociological boundaries. For this reason the art of the Islamic world is discussed in this book under the various dynasties who came to power, ruled over and segmented the original Muslim empire. Since Islam forms a greater coherent whole than any purely geographical concept, all parts of Islam, including those outside the bounds of Asia, are included.

The complex nature of Islamic art developed on the basis of pre-Islamic traditions in the various countries conquered and a closely integrated blend of Arab, Turkish and Persian traditions was brought together in all parts of the new Muslim empire.

The Arab element is probably the most important. Arabic writing became the greatest single feature of all Islamic art, leading to an infinite variety of abstract ornament and a system of linear abstraction peculiar to all forms of Islamic art. The Arabs were deeply interested in mathematics and astronomy, and applied their knowledge of geometric principles and their innate sense of rhythm (which also characterises their poetry and music) to the formulation of the complex repeat patterns seen in all their decoration.

The Turkish element consists mainly of an indigenous concept of abstraction among the Turkish peoples of Central Asia. Their tradition of figurative and non-figurative design created an unmistakably Turkish iconography. Most of the Muslim world was ruled by Turkish peoples from the 10th to the 19th century, and the influence of Turkish thought, taste and tradition on Islamic art can hardly be overestimated.

The Persian element in Islamic art is perhaps most difficult to define; it seems to consist of a peculiarly lyrical poetical attitude, a metaphysical tendency which in the realm of emotional and religious experience leads to an extraordinary flowering of mysticism. The major schools of Muslim painting developed in Iran on the basis of Persian literature. Not only an entire iconography but also a specific imagery, abstract-poetical in its realisation, was created in Iran in the later part of the 14th and in the 15th century that is without parallel in any other part of the Muslim world. The same attitude that creates in the field of painting an art form of the greatest beauty but of complete fantasy and unreality enters into architecture, creating forms of decoration that seem to negate the very nature of architecture and the basic principles of weight and stress, of relief and support, fusing all elements into a unity of fantastic unreality, a floating world of imagination.

Even though these separate elements of Islamic culture are clearly definable, they are often too closely interwoven and integrated to be clearly distinguished. All regions of Islam share fundamental artistic features that draw the whole vast territory together in a manner comparable only with the domination of the ancient world by Rome.

INFLUENCE OF RELIGION ON CULTURE

Of all elements in Islamic art the most important, undoubtedly, is religion. The multitude of small empires and kingdoms that had adopted Islam felt—in spite of racial prides and jealousies—first and foremost Muslim and not Arab, Turkish, or Persian. They all shared the basic belief in Muhammad's message: the recognition of the all-embracing power and absolute superiority of the One God (Allah). The creed of all Muslims reads alike: "There is no god but God (Allah) and Muhammad is his Prophet.' In all Muslims of every race and country there is the same feeling of being equal in the face of Allah on the day of judgment.

The experience of the infinite on the one hand, with the worthlessness of the transient earthly existence of man on the other is known to all Muslims and forms part of all Muslim art. It finds different but basically related expression. The most fundamental is the creation of the infinite pattern that appears in a fully developed form very early on

1. **View of Mecca showing the Great Mosque and Kaaba.**
The Kaaba, today in the centre of the Great Mosque, is a plain
cubic building, which is the focal point towards which all
Muslims turn in prayer all over the world. The holiest
sanctuary of Arabia, the Kaaba became the centre of Islam
after the change of the *kibla*, or the direction of prayer, from
Jerusalem to Mecca by the Prophet. It is also the centre of the
pilgrimage (hajj) which is one of the duties of every Muslim.

and is a major element of Islamic art at all periods. The
infinite continuation of a given pattern, whether abstract,
semi-abstract or even partly figurative, is on the one hand
the expression of a profound belief in the eternity of all true
being and on the other a disregard for temporary existence.
In making visible only part of a pattern that exists in its
complete form only in infinity, the Islamic artist relates the
static, limited, seemingly definite object to infinity itself.

An arabesque design, based on an infinite leaf-scroll
pattern that, by division of elements (stem, leaf, blossom)
generates new variations of the same original elements, is in
itself the perfect application of the principle of Islamic
design and can be applied to any given surface, the cover of
a small metal box or the glazed curve of a monumental
dome. Both the small box and the huge dome of a mosque
are regarded in the same way, differing only in form, not in
quality. With this possibility of giving equal value to
everything that exists or bringing to one level of existence
everything within the realm of the visual arts, a basis for a
unity of style is provided that transcends the limits of period
or country.

One of the most fundamental principles of the Islamic
style deriving from the same basic idea is the dissolution of
matter. The idea of transformation, therefore, is of the
utmost importance. The ornamentation of surfaces of any
kind in any medium with the infinite pattern serves the
same purpose—to disguise and 'dissolve' the matter, whe-
ther it be monumental architecture or a small metal box.
The result is a world which is not a reflection of the actual

object, but that of the superimposed element that serves to
transcend the momentary and limited individual appear-
ance of a work of art, drawing it into the greater and solely
valid realm of infinite and continuous being.

This idea is emphasised by the way in which archi-
tectural decoration is used. Solid walls are disguised behind
plaster and tile decoration, vaults and arches are covered
with floral and epigraphic ornament that dissolve their
structural strength and function, and domes are filled with
radiating designs of infinite patterns, bursting suns, or
fantastic floating canopies of a multitude of mukkarnas,
that banish the solidity of stone and masonry and give them
a peculiarly ephemeral quality as if the crystallisation of the
design is their only reality.

It is perhaps in this element, which has no true parallel in
the history of art, that Islamic art joins in the religious
experience of Islam and it is in this sense, and in this sense
alone, that it can be called a religious art. Characteristically
very little actual, religious iconography in the ordinary
sense exists in Islam.

Although a great many fundamental forms and concepts
remained more or less stable and unchanged throughout
Islamic art—especially in the realm of architecture—the
variety of individual forms is astonishing and can again be
called exceptional. Almost every Muslim country at every
period created forms of art that have no parallel in another,
and the variations on a common theme, that have been
carried through from one period to another, are even
more remarkable.

2a). **Simple Kufic** from an Egyptian tombstone. AH 174 (790 AD). Museum of Islamic Art, Cairo. Simple Kufic is characterised by straight vertical strokes and angular forms of letters.

b). **Foliated Kufic** from a tombstone at Kairouan in Tunis. AH 341 (952 AD). The vertical strokes end in leaves and half-palmettes.

c). **Floriated Kufic** from an Egyptian tombstone. AH 243 (848 AD). Museum of Islamic Art, Cairo. The ending of the letters is enhanced by the floral designs and half-palmettes, while the round forms are rendered as rosettes.

d). **Naskhi** from an Egyptian tombstone. AH 684 (1285 AD). Museum of Islamic Art, Cairo. Naskhi is a cursive form of Arabic writing, here the verticals are not so important; some of the foliation has been taken over from Kufic.

e). **Thuluth** from the drum of the Mausoleum of Princess Tughai in Cairo (died 1348 AD). Thuluth is a more cursive and more elegant form than Naskhi. The words are placed above each other in two or even more lines.

f). **Nastaliq** from the front page of Sadi's *Gulestan*, Bukhara. AH 950 (1543 AD). In nastaliq the horizontal lines and round forms are exaggerated, dots casually placed, lines are not always straight, all of which make the nastaliq a very elegant form of writing.

THE NATURE OF ISLAMIC DECORATION

Apart from the naturalistic, semi-naturalistic and abstract geometrical forms used in the infinite pattern, Arabic calligraphy played a dominant role in Islamic art and was integrated into every sort of decorative scheme. There are two main scripts in Islamic calligraphy: the angular *Kufic* and the cursive *Naskhi*.

Kufic, the earliest form, which is alleged to have been invented at Kufa, south of Baghdad, accentuates the vertical strokes of the characters. It was used extensively during the first five centuries of Islam in architecture, for copies of the Koran, textiles and pottery. There are eight different types of Kufic out of which only three are mentioned here: a) simple Kufic; b) foliated Kufic which appeared in Egypt during the 9th century and has the vertical strokes ending in lobed leaves or half-palmettes; c) floriated Kufic in which floral motifs and scrolls are added to the leaves and half-palmettes. This seems also to have been developed in Egypt during the 9th century and reached its highest development there under the Fatimids (969–1171).

From the 11th century onward, Naskhi gradually replaced Kufic. Though a kind of cursive style was already known in the 7th century AD, the invention of Naskhi is attributed to Ibn Muqla. Ibn Muqla lived in Baghdad during the 10th century and is also responsible for the development of another type of cursive writing: the *thuluth*, or *thulth*. This closely follows Naskhi but certain elements, like vertical strokes or horizontal lines, are exaggerated.

In Iran several cursive styles were invented and developed among which *taliq* was important. Out of taliq developed *nastaliq*, which is a more beautiful, elegant and cursive form of writing. Its inventor was Mir Ali Tabrizi, who was active in the second half of the 14th century. Nastaliq became the predominant style of Persian calligraphy during the 15th and 16th centuries.

Another important aspect of Islamic art, generally completely unknown, is its rich pictorial and iconographical tradition. The misconception that Islam was an iconoclastic, or anti-imagistic culture and that the representation of human beings or living creatures in general was prohibited, is still deeply rooted although the existence of figurative painting in Iran has been recognised now for almost half a century. There is no prohibition against the painting of pictures or the representation of living forms in Islam, and there is no mention of it in the Koran.

Certain pronouncements attributed to the Prophet and carried in the Hadith (the collection of traditional sayings of the Prophet) have perhaps been interpreted as prohibitions against artistic activity, although they are of purely religious significance. When saying that no angel will enter a house in which there are images, idols are meant, not figural representations. Artistic creation is perhaps included in a warning to the maker of images that he will be most severely punished on the day of judgment since he has tried to imitate God who alone can create living beings. He will be called upon to give life to his creatures and, failing, will be condemned. But even this statement seems to be directed mainly against idolatry rather than against artistic creation.

The fact remains that in practically no period of Islamic culture were figurative representation and painting suppressed, with the singular exception of the strictly religious sphere where idolatry was to be feared. Mosques and mausoleums are therefore without figurative representation. Elsewhere, imagery forms one of the most important elements and a multitude of other pictorial traditions were also assimilated during the long and complex history of Islamic art.

Author's note: in this edition it has not been possible to incorporate all the information made available by the most recent scholarship, but essential revisions have been carried out.

Umayyad Art

After **Muhammad's** death, the first caliphs were nominated and elected at **Medina** but soon a struggle ensued between two main factions—The Shiites (*Shiah* 'party of Ali', **Muhammad's** son-in-law) who regarded Ali and his descendants as the only rightful caliphs, and the Sunnites (*Sunna* 'path', the traditional practice of Muhammad as set down in the Hadith) who believed that the caliphate is an elective office open to any member of the prophet's tribe of the **Kuraish** (Qoraish). The family of Umayya of the **Kuraish** tribe emerged triumphant from this dispute and formed the first national dynasty of the Umayyads (661–750).

The Umayyads moved the capital from Medina to Damascus with the result that Muslim culture now had direct contact with late classical culture in the Roman provinces recently acquired by the Arabs. Umayyad art is characterised by the highly successful fusion of almost purely Roman and clearly hellenistic and Asian elements in which new interrelationships are created and entirely original forms of art evolved. In this fusion of cultural elements a process began that was to become typical of all Islamic art—that of merging, reformulating and producing something new out of widely varying artistic traditions.

ARCHITECTURE

The very first monument of Islamic architecture, the Dome of the Rock in Jerusalem, built by order of Abd al-Malik in 691, is a powerful example of this peculiar and quite original aspect of cultural galvanisation. Erected on a traditional pre-Islamic plan of a domed rotunda with ambulatories, it is at the same time highly original in its particular use of architectural and decorative elements. Basically 'Western' in tradition, it includes, particularly in its mosaic decoration and stone carvings, motifs of Eastern hellenistic (Sassanian-Persian) derivation, marking the beginning of a long line of hybrid art-forms.

The building is a political and religious monument, meant to establish right at the outset of Muslim rule, the final superiority of Islam over the 'people of the book', Jews and Christians alike, and in its location on the most sacred spot of the ancient world, symbolises the end of a tradition that was to be absorbed into the new culture of Islam.

The Dome of the Rock is in many ways a unique building, but in following an old prototype, it is the last manifestation of a pre-Islamic architectural form. In its decorative repertoire, however, it contains the germs for new and fertile developments in architectural decoration. Its great variety of motifs, ranging from the purely realistic, late classical, to the almost totally abstract 'modern Islamic', provides ample material for the pattern books used by craftsmen for the next fifty years to decorate the mosques and palaces of the Umayyads in Syria and Transjordan.

The Umayyad Mosque in Damascus, built between 705 and 715 into the remains of a Roman temple, introduces the most typical Islamic form of architecture—the open court mosque. This plan derives from the early encamp-

A. Plan of the Dome of the Rock, Jerusalem.

3. **Inner Ambulatory of the Dome of the Rock, Jerusalem.** Jordan. 691. This view shows the extraordinary richness of decorative detail, ranging from the marble incrustation and mosaic decoration of the pillars and arches to delicate gilded metal ornaments on the tie beams. The effect is entirely that of a late classical interior.

ment mosques of conquering Muslim armies, set up in the open field with nothing more to them than a ditch and a palm-trunk shelter on the kibla side. This simple concept of setting aside a primitively defined open space as 'place for prayer' seems to have determined once and for all the Arab form of mosque. Even though pre-Islamic basilical and palatial traditions enter into the design of later buildings, the original basic idea of a large open court, enclosed by simple arcades on three sides and the roofed-over prayer hall on the kibla side, remains unaltered throughout the Arab world and even forms the basic design of the Seljuk mosque in Iran.

In the Damascus mosque the old walls of the Roman temenos are used as the defining walls of the enclosure. Arcades in double storeys line the inner court on three sides, and a prayer hall, three aisles deep, appears on the kibla side, the aisles running parallel to the kibla wall. Even though there is a central aisle in the prayer hall cutting through the parallel aisles, at right angles to the kibla wall, there is no definite direction in the building design as a whole. The enclosure is considerably wider than deep, a characteristic that is retained in most Arab mosques throughout the history of Islamic architecture.

Deeply indebted to pre-Islamic tradition but of particular significance in the process of assimilation are the so-called 'desert castles' of the Umayyad period. There are many on record and excavations have made it possible to reconstruct their original form. With their often magnificent decoration in mosaics, wall-paintings and plaster carvings, they also provide the major source of information about Umayyad art.

These palaces did not serve as hunting lodges or desert retreats for the still desert-bound Umayyad rulers and nobles, as romantic interpretation has it, but as centres of economic development in now deserted but in Umayyad times fertile and highly prosperous estates. Their plan follows that of the Roman frontier fort of the region almost to the last detail. In fact, much of the technical detail in the sanitary installations, the thermae or bath-houses, and in the construction of walls, arches, apse-like niches and gate structures is almost purely Roman in design. But again, following the general trend within Umayyad culture, there is a strong Eastern element especially in the use of an entirely un-Roman, in fact, alien art-form—plaster decoration in coating, moulding and carving.

The plans of most of these palaces are designed around a central courtyard surrounded by arcades on two storeys. The outer almost square rectangular enclosure is fortified by massive corner towers and a series of semicircular towers along the sides. In the centre of one side is the heavily fortified entrance gate, often quite broad, and ascending to the full two-storey height of the building. Through this gate one entered a long hall that in turn opened into the inner arcaded courtyard. On the ground floor were usually the rooms for the entourage of the prince or ruler, and for the animals, while on the upper floor were the living quarters

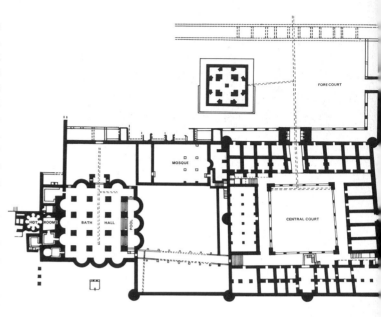

B. Plan of Khirbat al-Mafjar, Jordan Valley.

Author's note: The "bath-hall" of Khirbat al-Mafjar has since been more correctly identified as a ceremonial reception-hall of the palace complex.

and the reception hall of the prince. This reception hall seems often to have been placed above the main entrance gate and to have been in many instances a domed chamber.

The two most important buildings that can be reconstructed from their remains, particularly in their decoration, are the palace of Khirbat al-Mafjar, in the Jordan Valley, east of the ancient city of Jericho, and the palace of al-Mushattah, in the desert south-east of Amman.

Khirbat al-Mafjar, probably built during the reign of al-Hisham (724–43), follows the usual plan of desert palaces just described, but is unusual in that it is not free-standing and forms part of a complex of buildings. There seems to have been a large open court surrounded by arcades on the east side, stretching the full width of the entire building complex which extends to the north, covering an even larger amount of ground than the main palace itself. These adjacent buildings enclose a mosque, a large court and an elaborately designed and very richly decorated bath-hall. A bath-hall adjoining a palace is not unusual but what is extraordinary is its specific elaboration into an independent almost monumental structure with a vaulted domed hallway and a large high gate decorated with figurative sculptures—among them one that may be a representation of the caliph himself. In the north-west corner of the bath-hall a small domed divan-hall is inserted which must have been the private audience and assembly room of the owner of the palace. The unusual importance of this part of the entire

4. **Façade of the castle al-Mushattah** in the Jordanian desert south of Amman. First half of the 8th century. Staatliche Museen zu Berlin. This richly decorated façade is unique in the art of early Islam and has often been ascribed to the pre-Islamic period. The rich variety of floral and animal forms in the carved stonework derive largely from classical sources. At the same time the stylised form of some of the animal motifs is unquestionably oriental, demonstrating the two sources of Umayyad art.

in having a huge basilical reception hall at the end of the main central court. This feature has recently been shown to have appeared in early Islamic architecture (Dar al-Imara, al-Kufah, Iraq) and seems ultimately to go back to Sassanian palace architecture rather than to local Christian basilical tradition.

Built on a different plan and probably following a different pre-Islamic tradition is the much smaller palace of Kusayr Amrah (Qusayr 'Amrah) not far from al-Mushattah. It has a single storey only, the principal buildings comprising a reception hall and an adjacent bath-house complex which again includes a dome chamber, painted with a zodiacal design—undoubtedly of symbolical rather than purely decorative significance. But the most important feature of Kusayr Amrah is its series of wall-paintings of which only fragments survive, but which have been well documented.

ARCHITECTURAL DECORATION

As already mentioned, the main elements of architectural decoration in Umayyad times are derived from late classical tradition: stone carving, mosaic floors, wall-painting, but added to these traditional forms is the new and—for Syria and Transjordan—alien form of plaster decoration.

The decorative stone carvings of most Umayyad buildings—capitals, door-lintels, cornices, etc.—follow almost without change pre-Islamic Roman tradition in form and execution. Mosaic floors uncovered in Khirbat al-Mafjar and al-Minyeh, also display a great variety of geometrical abstract patterns, mainly on a white ground, that have their immediate antecedents in late Roman and early Christian Byzantine buildings of the region. Most of the patterns can be found in Palestinian, Jordanese and Lebanese buildings of the 4th to 6th centuries, and there can be little doubt that ancient pattern books used by the artists of the region for generations continued in use throughout the Umayyad period.

Only one figurative floor mosaic has survived from the palaces—that in the small throne-niche of the bath-hall divan in the palace of Khirbat al-Mafjar. Its design—a group of grazing stags, and a lion killing a stag under a magnificent large fruit-bearing tree—has been interpreted as a symbol of royal peace and royal power under Islam. Its style is entirely in the late hellenistic tradition of naturalism, with the tree and animals in shaded colours to give an indication of roundness and depth.

This same tradition, stylistically and iconographically,

building complex is emphasised not only through its ambitious design but also by the fact that it seems to have been finished first, while large parts of the actual palace seem never to have been completed.

Both the floor of the divan-hall and an apse-like niche opposite its entrance are covered with mosaics, but while that of the rectangular chamber is abstract and linear, following the patterns of the magnificent floor mosaics of the main bath-hall, the mosaic of the niche is figurative and possibly symbolic in intention. It must have served as a kind of 'carpet' where the prince sat to receive his visitors. The rich stucco decoration includes four medallions with winged horses in the squinches and a row of small birds below the circular cornice of the drum. Both features may again have a symbolic value: they unquestionably add to the general impressiveness of a throne room.

The most important feature of the much larger palace of al-Mushattah is its unusual plan and its unique stone façade decorated with magnificent floral and figurative carvings. It is a monument of great beauty and accomplishment although, apart from the façade, no other decoration survives.

The majority of Umayyad palaces follow the plan of Khirbat al-Mafjar. Al-Mushattah is quite different. Beyond the entrance gate there is an inner court with adjacent buildings before the vast main court and the palace complex lies at the far end. It is particularly unusual

5. **Mosaic decoration in the Umayyad Mosque, Damascus,**
Syria, built 705–715 inside a Roman temple enclosure. This is
the earliest Arab mosque to have survived intact. With its rich
decoration in coloured marbles and polychrome mosaics, it
shows how late classical traditions continued without a break
into Umayyad times. The landscape mosaics have been
interpreted in various ways. Most convincing is perhaps the
identification as a rendering of Paradise as described in the
Qur'an.

was followed almost unchanged in the early mosaics of the
Umayyad mosque in Damascus, where idyllic landscapes 5
are depicted with a great variety of trees, and cities and
country palaces beside swelling rivers and splendid lakes.
Much of the iconography can be traced to late Roman
wall-paintings and mosaics, and some of the cities depicted
can be found in identical form in the 6th-century Justinian-
Byzantine mosaics of Ravenna.

It has been pointed out that these mosaics had a distinct
meaning for the beholder of the time, celebrating the
golden age of peace that began with the rule of Islam—
hence the open landscapes, open palaces, unfortified open
cities—and each architectural setting represented a spe-
cific place.

The earliest surviving Islamic mosaics—those of the
Dome of the Rock in Jerusalem—are curiously and charac-
teristically enough the most hybrid. Combining classical
western and eastern hellenistic Sassanian elements they
demonstrate the complex nature of Umayyad art. There
are beautifully rendered fruit-bearing trees and magnificent
Roman acanthus scrolls, but there are equally prominent
palmette and candelabra trees of rather less classical, Sas-
sanian inspiration.

Almost a complete pattern book of early Umayyad de-
sign is preserved in the beautifully executed open work
metal bands that decorate the undersides of the massive tie-
beams connecting the arches of the ambulatory-colonnade.
Here the gradual development from the purely late classical
motif of the grape-vine growing out of an amphora to the
semi-abstract, disconnected palmette patterns of eastern
hellenistic inspiration can be observed.

The most astonishing variety of patterns occur on the
numerous plaster panels that have been reconstructed from
fragments excavated in Khirbat al-Mafjar and Kasr al- 6
Hayr (Qasr al-Hayr). Again much classical inspiration is
evident, but Sassanian elements are now more dominant.
Here again the general development is clearly visible from
floral and growing plant decoration to the more separated,
stylised abstracted motifs, based on the naturalistic forms.
The surface is now divided more and more into geometrical
sections and filled with a repeat pattern of rosettes or single
palmettes, creating an effect altogether different from that
of the western, late classical world.

In the medium of plaster decoration Umayyad art
evolved a wide variety of sculptural forms, from compara-
tively low relief to sculpture in the round. Although always
forming part of a wall decoration (figures in niches, etc.),
some of these sculptures are astonishingly finely modelled,
embodying late classical developments in Central Asia,
Nabatean Transjordan and Coptic Egypt. Elements from
all three cultural environments seem to have been fused in
the stucco sculptures of the Umayyads.

(Continued on page 249)

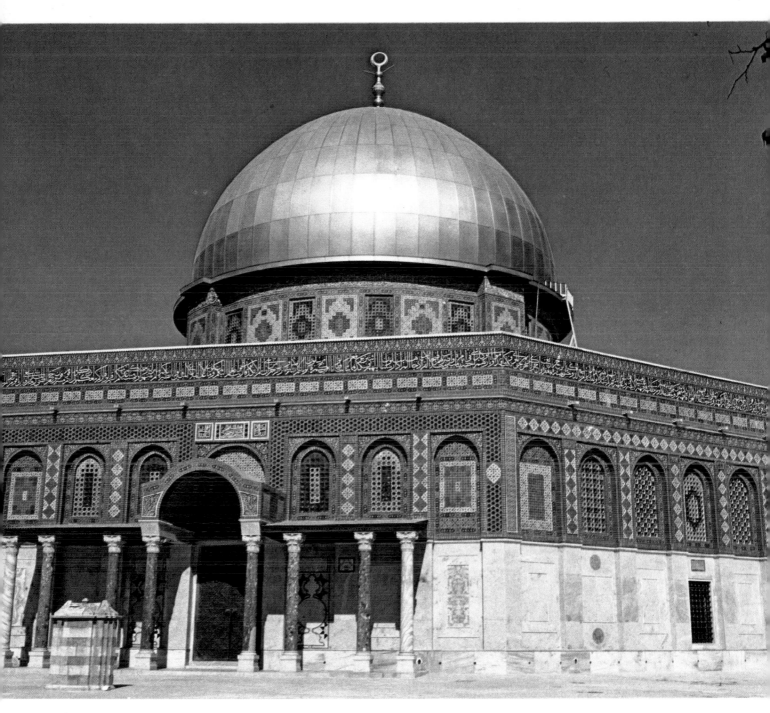

1. **The Dome of the Rock, Jerusalem,** Jordan. Built by Abd al-Malik in 691. The Dome of the Rock is the first monumental building erected by the Muslims that has survived almost intact except for some later alterations, particularly in the exterior decoration (the tile revetments are part of the Ottoman restoration of the monument carried out in the middle of the 16th century). The building was erected as a religio-political monument and it is situated in the heart of the old temple district (the Haram al-Sharif) in the centre of the city. It is built above a rock, the Sakkra, the highest point of Mount Moriah, giving the building its name, Kubbat al-Sakkra. The complex symbolical significance of this rock and the particular location in the temple area were undoubtedly decisive in the choice of the construction site. The notion that the Dome of the Rock was for a time intended to become the substitute for the Kaaba—the sacred shrine of the great mosque at Mecca—has been proved to be historically incorrect. The plan, a round canopied shrine, follows pre-Muslim local tradition.

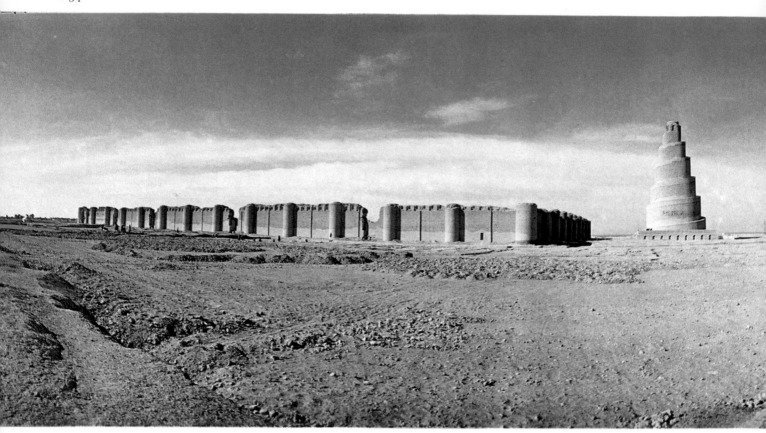

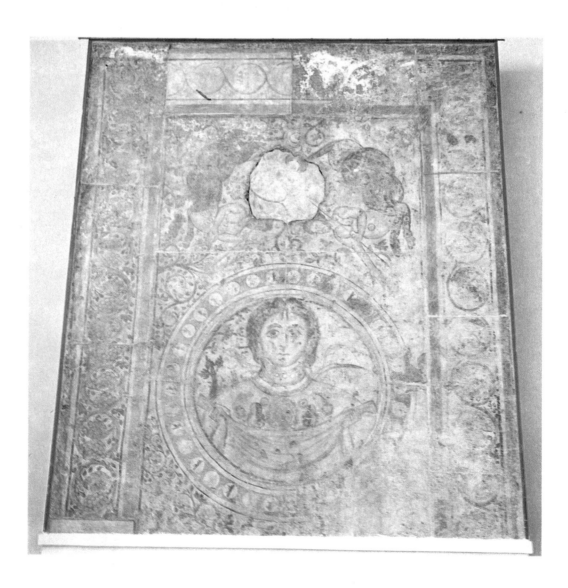

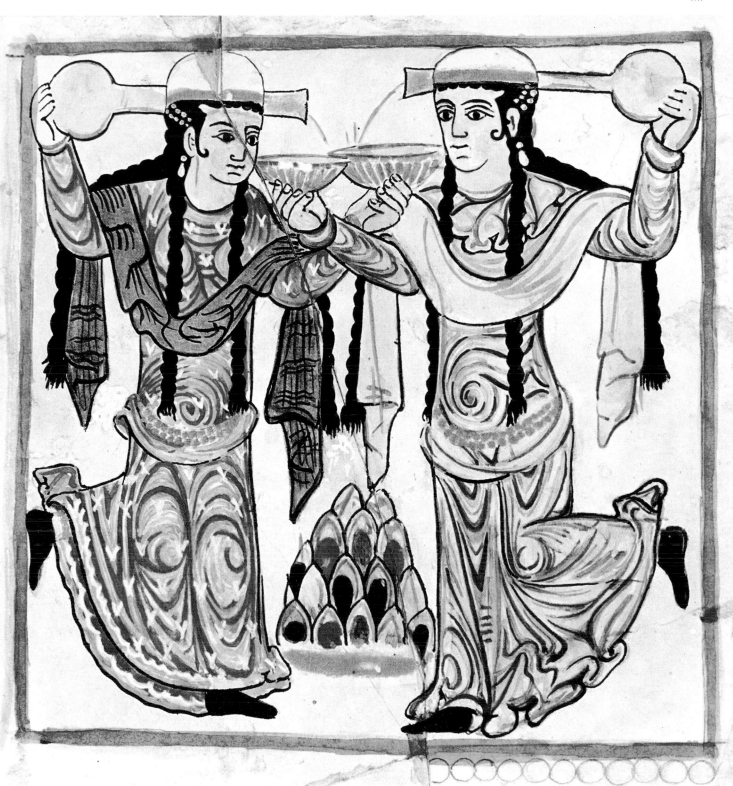

2 (opposite, above). **The Great Mosque of al-Mutawakkil, Samarra.** 848–852. This is the largest mosque built by the Muslims. It shows the change from the classical architectural tradition of Umayyad architecture to the Eastern tradition of monumental brick construction. The huge minaret, with its external spiral staircase, inspired others (Abu Dulaf, Samarra; Ibn Tulun, Cairo) but did not create a type.

3 (opposite, below). **Floor-painting from the Palace of Kasr al-Hayr, Syria.** First half 8th century. 10 ft. 8 in. × 8 ft. (3·25 × 2·45 m.). Damascus Museum. This painting from the Palace of Kasr al-Hayr in the Syrian desert was obviously a substitute for the mosaic decoration used in other Umayyad palaces (Khirbat al-Mafjar, al-Minyeh). In style and iconography it closely follows Roman models.

4. **Wall-painting from the Jausak Palace, Samarra.** 836–39. *Two Dancing Girls.* Reconstruction by Ernst Herzfeld. 19¾ in. sq. (50 cm.). This painting, only surviving in fragments (Museum for Turkish and Islamic Art, Istanbul), is one of many of court life from the ruins of the palace. The style seems to derive directly from Central Asian prototypes brought to Iraq by the Central Asian Turks.

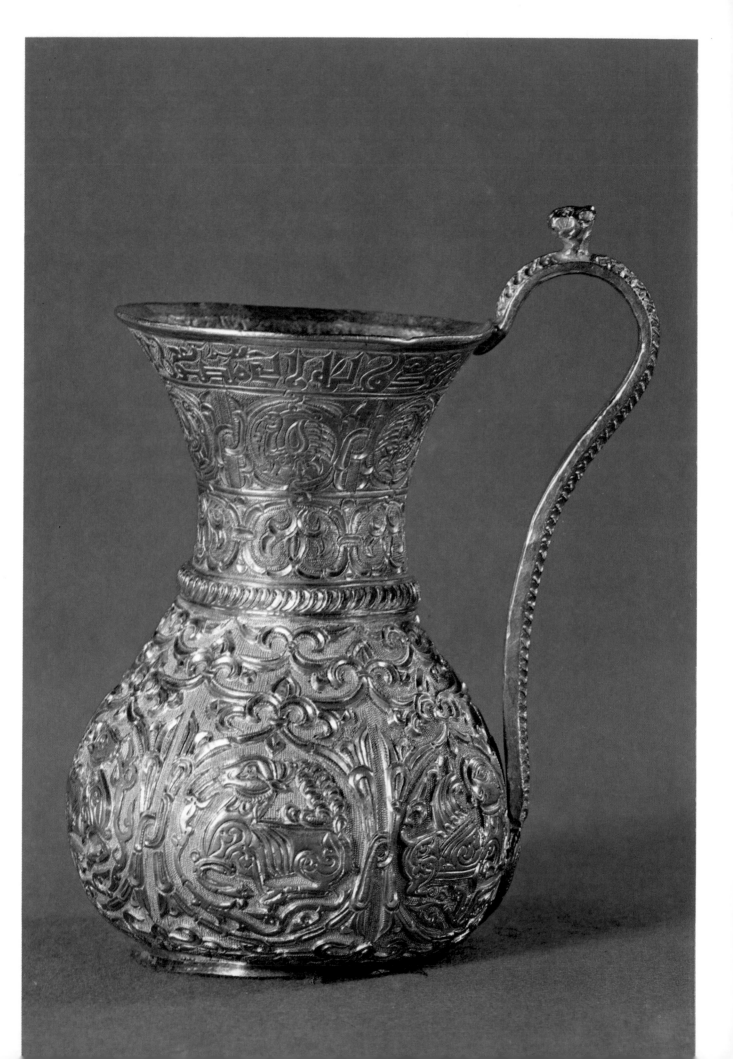

5 (opposite). **Gold pitcher from Iran or Iraq.** Second half 10th century. Chiselled relief decoration on granulated ground. h. (with handle) 6 in. (16 cm.). Freer Gallery of Art, Washington. This is one of the very few gold objects surviving from the early Islamic period. Its authenticity has recently been questioned, although definite proof of its being a modern forgery has yet to be provided. Precious metal objects have survived in small numbers, not as often believed because they were rare in Islamic art, but rather because through their intrinsic value they were vulnerable and therefore prone to be destroyed. During the Buyid period a special attempt seems to have been made to re-create the style employed by ancient Iranian silver and goldsmiths. Part of the imagery of the relief decoration of this small ewer—peacocks, ibex, and a winged human-headed creature in medallions formed of abstract floral motifs (palmette-arabesques)—is directly derived from ancient Persian tradition.

6 (above). **Ceramic bowl from Nishapur, Khurassan.** 10th century. Slip-painted polychrome decoration. diam. 14 in. (35·6 cm.). Museum of Art, Cleveland. This is one of the best examples of the peculiar figure style developed in Nishapur pottery painting of the 10th century. The origin of the style, which has no parallel anywhere in the Muslim world, is still unexplained. Often purely decorative in intent, many of these bowls are painted with what would appear to be meaningful symbolic subjects which in most cases have not so far been satisfactorily interpreted. The scene on this bowl has been identified as a bacchanalia which harks back to classical iconographical tradition; it has immediate forerunners in Iran in the Sassanian period.

7 (right). **Ceramic bowl from Iraq.** 9th century. Lead glaze and cobalt blue decoration. diam. 8 in. (20·3 cm.). Private Collection, New York. Muslim potters were always fascinated by Chinese pottery and porcelain. This bowl is clearly inspired by white T'ang wares, fragments of which have been found in Samarra. But the Muslim ceramicists were interested in colour and as their technical limitations (running glazes, clay bodies, low kiln temperatures) did not yet allow underglaze painting, they used glazes of different colours in an ingenious way to achieve polychrome effects. The use of blue on a white ground in this bowl is the earliest occurrence of one of the most popular forms of ceramic decoration in centuries to come.

8. **Wall tiles from Ghazni,
Afghanistan.** Mid-12th century. On loan
to the Metropolitan Museum of Art,
New York. Collection of Miss M. Schwarz,
N. Y. Recent excavations at Ghazni have
unearthed carved marble slabs and
tilework used in architectural decoration.
These tiles are typical of the general type:
monochrome glazed, they are decorated
with low reliefs of animal figures and have
a certain similarity to Chinese moulded
tiles of the Han period.

9. **Fragment of a wall-painting from
Nishapur, Persia.** Late 9th century.
h. 10¼ in. (26 cm.). Metropolitan
Museum of Art, New York. Few early
Islamic paintings in the East have
survived. These fragments demonstrate
the close connection between Persian
and Central Asian tradition at this time.
In the woman's face a great many Seljuk
features are anticipated: full roundness
of the face, almond-shaped slightly
slanting eyes, minute mouth and lobed
curls of hair across the forehead.

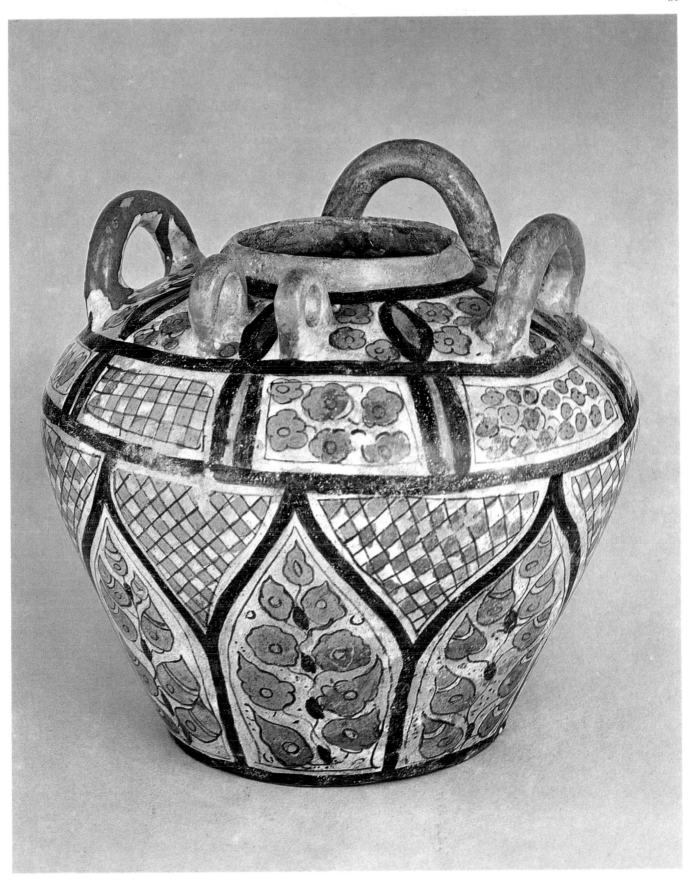

10. **Ceramic jar from Iraq.** Mid 9th century. Lustre-painted decoration. Art Institute, Chicago. The most remarkable creation of the Iraqi potters of the early Abbasid period was a metallic pigment (lustre) which could be applied to the glazed surface of a ceramic vessel creating brilliant polychrome effects according to the metal alloys used. The combination of abstract linear and naturalistic floral motifs is a notable feature of the period's decorative style.

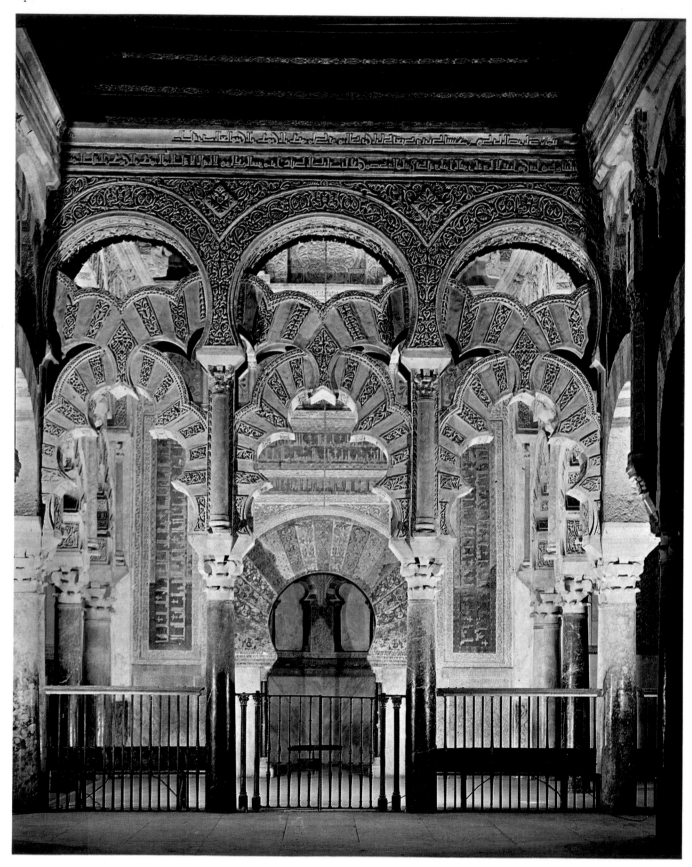

11. **Cappella del Mihrab, Umayyad Mosque, Cordoba.** The Umayyad Mosque in Cordoba, founded by Abd al-Rahman I, AH 169 (785 AD), and enlarged various times during the subsequent three centuries, is still one of the most beautiful religious buildings of Islam. The most important enlargement was that of al-Hakam II in 961; he extended the prayer hall to the present day kibla wall including the magnificent Cappella del Mihrab which was finished in 965. In its elaborate design with complex double-storey arcades and its sumptuous decoration with carved plasterwork, marble, and mosaic, the mihrab area of this mosque is unique in Muslim architecture.

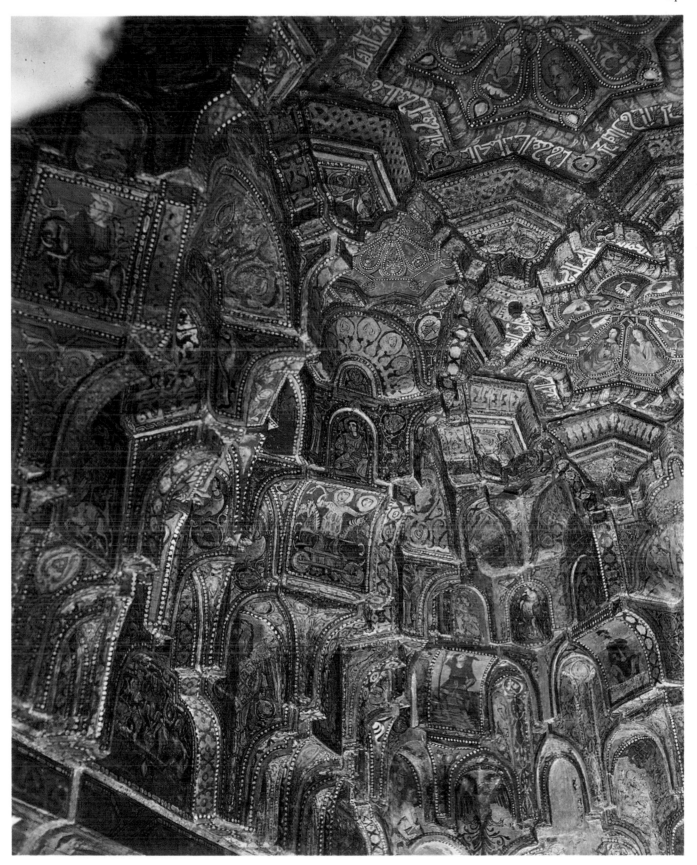

12. **Wooden ceiling with painted
decoration.** *c.* 1140. Cappella Palatina,
Palermo. The Royal Chapel in the
Palace of Roger II of Sicily was covered
with a wooden stalactite ceiling painted
with decorative and figurative subjects by
painters from Egypt or North Africa. The
style of the paintings follows entirely that
of the Fatimid school; in fact, the
paintings of this ceiling have rightly been
considered the main work of Fatimid
painting to have survived. Its appearance
in Sicily demonstrates the close ties
between Fatimid and Sicilian culture
at the time.

13. **Coronation robe of Roger II of Sicily.** Made by Fatimid artists, 1133–1134. Kunsthistorisches Museum, Vienna. One of the most beautiful and accomplished works of Islamic textile art to have survived. Highly abstract in general design, emphasised through the heraldic treatment of the two animal groups, the individual rendering of both the lions and camels is quite realistic in detail and full of an energy that seems to belie the stiff, heraldic composition.

14. **Bronze bucket from Herat.** Made by Muhammad ibn al-Wahid and Masud ibn Ahmad in 1163. Gold, silver and copper inlay. h. 17½ in. (19 cm.). Hermitage, Leningrad. Made for a local merchant, this is one of the first great works of Seljuk silver inlaid metalwork to have been produced outside the court for an ordinary townsman. In shape and general design it follows an established tradition reaching back into the 11th century. The complex use of figurative and calligraphic elements in the design, and the elaborate use of precious metals for inlay demonstrate the peculiar trend towards an artificially created ambiguity between formal and decorative values and between material substance and substance transformed into imagery and ornament.

15. **Ceramic bowl from Iran.** 12th century. Slip-carved decoration. diam. 7½ in. (19 cm.). Collection of Edmund de Unger, London. Black painting under a translucent blue or colourless glaze is a feature of pottery decoration that was first developed in Seljuk times. The use of both human and animal figures is common; the sphinx or harpy—the main element of the design of this bowl—is frequently encountered in Seljuk art in many media, but rarely has this fantastic creature been represented more skilfully. The quality of the design clearly indicates the close collaboration between master painters and master potters in the Seljuk workshops.

16. Ceramic bowl from Kashan, Iran,
dated 1187 and signed by Abu Zayd
al-Kashani. Polychrome overglaze
painted decoration. diam. 8½ in.
(21·6 cm.). Metropolitan Museum of Art,
New York. Overglaze polychrome
painted pottery of the so-called minai type
belongs to the most beautiful and refined
ware of the Seljuk period. Dated and
signed pieces are rare, giving special
significance to this bowl. The use of the
nisba, al-Kashani, in the artist's name
points to the place of manufacture of the
piece, Kashan, and it numbers among a
large group of minai ware that can be
attributed to the workshops of that city.
The subject is not altogether clear but it
seems to represent a ceremonial
procession scene of a prince with his
entourage recalling a Mosul school
painting (see plate 28).

17. **Ceramic bowl from Iran.** Early
13th century. So-called 'minai' ware.
Polychrome overglaze painted decoration.
diam. 18¼ in. (45·5 cm.). Freer Gallery of
Art, Washington. The painting on this
unique piece of minai ware undoubtedly
reflects a famous wall-painting in the
palace of the Seljuk rulers which has not
survived. It depicts a battle that took
place in Khalkhal, in north-western Iran,
at the beginning of the 13th century.

18. **Ceramic plate from Kashan, Iran.**
Dated jumada II AH 607. (November
1210 AD) and signed by Sayyid Shams
al-din al-Hasani. Lustre-painted
decoration. diam. 13⅞ in. (35·3 cm.).
Freer Gallery, Washington. The plate,
one of a small group of equally finely
painted pieces from the Kashan
workshops, is of particular interest as it is
not only dated and signed by the artist,
but also elaborately inscribed with Persian
poetry which throws some light on the
specific meaning of the scene represented.
The plate most probably belonged to a set
which included one piece showing the
ruler enthroned and surrounded by his
court. The scene on this plate probably
shows a royal groom, who has fallen asleep
and dreams of an adventure with a
mermaid-like creature who can be seen
in the water. He is supposed to be
guarding the ruler's horse; the people
behind the horse would belong to the
royal entourage. The piece is complex
both in subject-matter and in its
composition which is unusual in that it
extends beyond the confines of the piece
of pottery. It demonstrates the great
importance of the lustre-painted wares
from Kashan and is a key to our
understanding of painting in the Seljuk
period which has otherwise almost
completely disappeared.

19. **Painting from a copy of the Warkah wa Gulshah poem.** Early 13th century. *Gulshah reveals herself to Warkah who is led away as a prisoner.* 4¾ in. (11·7 cm.). Topkapi Sarayi Library, Istanbul. This is the only illustrated manuscript that has survived from the Seljuk period. Although it is not certain exactly where it was made, it is a document of major importance, proving the existence of a school of book-painting in the style known from minai painted pottery of the 12th and 13th centuries both in Iran and Anatolia. The painting is a particularly fine example of the highly decorative style developed by the painter who has inscribed his name on one of the paintings in this manuscript, Abd al-Mu'min ibn Muhammad al-Khoy al-Nakkash. His nisba would indicate that he was from Azerbaijan. Both the intricate design, placing the figures against a background of a large-scale palmette scroll, and the colour, particularly the deep purples of the background, are remarkable and demonstrate the great sensitivity and skill of this painter.

20. **Ceramic ewer from Kashan, Iran.**
1215. Black underglaze painted
decoration. h. 7¾ in. (19·7 cm.).
Metropolitan Museum of Art, New York.
Seljuk potters excelled in extravagant
techniques, constantly trying to give new

and special interest to their creations.
Some of their ceramic vessels are made
with a double shell, the outer one being
perforated to achieve a complete openwork
pattern, a technique clearly derived from
metalwork. Additional underglaze

painting and glazing in turquoise and
cobalt blue make this ewer particularly
appealing. The style of the figure drawing
as well as the typical feature of a willowy
scroll identify it as a product of the
workshops of Kashan.

6. **Carved and moulded plaster decoration from Khirbat al-Mafjar.** Ceiling of the reception-hall entrance-gate. Jordan. Mid 8th century. Jerusalem Museum. The extraordinary mixture of western and eastern traditions in early Islamic art is particularly clearly demonstrated in this work. While the acanthus rosette and the grape vine pattern of the frame are of purely western, Roman inspiration, the heads which form part of the design around the central rosette are of eastern hellenistic origin closely recalling Central Asian stucco sculpture of the 6th and 7th centuries.

PAINTING

No book painting from the first centuries of Muslim rule has survived, but enough wall-painting has come down to us, even though in a fragmentary state, to make an appraisal of this important and, apparently dominant art form possible.

The best preserved paintings of the period are the two floor paintings from Kasr al-Hayr. They demonstrate most clearly the typical duality of Umayyad art.

3 One of the paintings is entirely in the western classical tradition with a Roman motif—the earth goddess in a medallion with the symbol of a snake curling around her neck, and bearing fruit in a cloth. This central motif is surrounded by classical grape-vine scrolls and what have aptly been called maritime centaurs. The painting is in sombre greens, light browns, ochres and reds, with some touches of black and white, executed with a full brush. There is a considerable feeling for volume and space and the colours are applied in differing shades to give roundness and contrasts of light and shade to each form.

The second painting is of a completely different nature. Linear in design, divided into three horizontal sections, it is inspired by Sassanian painting in iconography and probably also in technique. In the upper part of the painting, under arcades of a non-classical nature, there are two musicians, while in the centre is a typically Sassanian hunting scene. Below, badly damaged, are the remains of what may have been a picture of the royal stables and deer-reserve.

Whether the contrast between western classical and eastern non-classical pictorial concepts in these two paintings was intentional and shows a contemporary awareness of the two major sources of inspiration is impossible to determine. The fact remains that these two paintings epitomise the cultural situation of the time. Other important fragments of wall-paintings from the palace have the same double style. Fragments of wall-paintings have also been found in Khirbat al-Mafjar, but the only other surviving series of paintings of any significance come from Kusayr Amrah. 7

Although largely destroyed, it is clear that the paintings of Kusayr Amrah formed a series of which the central theme was the glorification of the power of the Muslim ruler. Two of the surviving paintings in the reception hall illustrate this common theme particularly well.

One shows the enthroned ruler in frontal position, under a canopy resting on columns flanked by two attendants, one of whom seems to be holding a torch, while the other points towards the seated ruler. The ruler appears to be floating upon his throne between heaven—represented by the baldachin and a row of small birds all along the upper border of the painting which has an arcade shape—and the

7. **Painting from the Palace of Kusayr Amrah, Jordan.**
First quarter of the 8th century. The paintings of this small
palace show the continuation of late Roman iconography
and technique into the Islamic period.

8. **Bronze ewer with engraved design from Syria.** Mid-8th
century. h. 16⅛ in. (41 cm.). Museum of Islamic Art, Cairo.
This ewer was probably part of the treasure of the last
Umayyad Caliph, Marwan II. Its simple shape, fine linear
incised decoration and the high relief on the handle recall
Sassanian metalwork.

sea which is indicated below the throne. This is an un-
mistakable representation of the emperor as celestial ruler
of all the elements. (The bird motif is particularly notice-
able, appearing in identical form in the dome of the divan-
hall, used as a royal reception room, in the bath-hall of
Khirbat al-Mafjar.) The other picture represents the con-
quered kings of the world that was subdued by Islam. Here
the Negus, the Byzantine Emperor, the Sassanian Shah,
and the king of the Visigoths, Roderic, are depicted frontally
performing gestures of submission and acclaim. The ap-
pearance of Roderic who was defeated and killed by the
Muslims in 711 gives a terminal date for the painting and
the building.

Mention has already been made of the zodiacal design
in the cupola of the adjacent bath-hall. A great many other
scenes also appear there, illustrating various aspects of
royal life and power, which seem to form part of a scheme
linking all the paintings and culminating in the scenes of
the glorified ruler in the reception hall.

The style is entirely classical. Rich colours put on with a
full brush show the immediate contact with late Roman
painting and a great many of the minor decorative details,
such as the grape-vine patterns, animal scenes, musicians
and herms that appear in the low vaults of various rooms in
the small palace, closely follow late classical prototypes.

DECORATIVE ARTS

Almost nothing of the decorative arts of the Umayyad
period has come down to us. Pottery seems not to have been
produced in any quantity as a luxury object; a little glass
has survived that would indicate a straight continuation of
late Roman glass production in Syria and Egypt, and pos-
sibly some of the earliest pieces of metalwork that can be
identified should be attributed to the Umayyad period.
Most of these pieces—ewers, and possibly some silver plates
—are entirely in the Sassanian tradition.

8

Umayyad art, then, is the first manifestation of a new
cultural force in a world that is still fully under the spell of
late classical ideas. It makes use of traditional forms of
architectural design, but introduces new ones, as in the
mosque, that establish a tradition of their own. With the
use of plaster coating for architectural decoration, the re-
interpretation of various pre-Islamic traditions and the
creation of new formulae, the Umayyad period supplies
directives for centuries to come. The existence of a pictorial
tradition in Islamic art is already evident here, disproving
the common misconception that Islamic art is an icono-
clastic culture. Both minor and monumental painting and
a highly developed figurative iconography appear already
in Umayyad art and lead to the first great school of known
Islamic painting, that of Abbasid Samarra.

The Abbasids of Baghdad and the Local Dynasties in the East

In 750 the Umayyad dynasty was replaced by the Abbasids who removed the capital from Damascus and Syria to Iraq, where Baghdad, the first major city entirely built by the Muslims, was founded by al-Mansur in 762.

Theoretically, the Abbasids held the reins of power until the middle of the 13th century when the last Abbasid caliph was killed by the invading Mongols in the sack of Baghdad in 1258, but in fact various parts of the empire were taken over by rival factions. Spain became independent under the Umayyads of Cordoba, and Egypt under the Tulunids (868–904). Both in the East and the West local dynasties established themselves and became independent from the central government in Baghdad.

The most important event of the early Abbasid period was undoubtedly the removal of the capital from Damascus —and a late classical milieu—to Iraq and the newly-founded city of Baghdad. With this the emphasis shifts decidedly towards the eastern tradition—the new capital even being built on an ancient oriental round plan—and a first step towards a final division between eastern and western Islamic art and culture was taken.

With the constant influx of Turkish peoples from Central Asia into western Asia and the gradual substitution of the Arab army by a Turkish military cast, a new chapter in the history of Islamic art begins. In the early 9th century this new phase was marked by the removal of the court from Baghdad to Samarra, a new city on the east bank of the Tigris a few miles further upstream. The art of Samarra was the first manifestation of an entirely new taste in Islamic art that ultimately derives from the Turks of Central Asia.

The importance of the Turkish element in Islamic art, not properly appreciated so far, cannot be overestimated. From the 9th century on, Turkish groups dominated vast regions of the Muslim world and imposed on them their peculiar, highly original, and altogether unmistakable taste. Even though in many instances Arabs, Persians, Greeks, Armenians, Syrians and Egyptians may have been

9. **Great Mosque, Kairouan, Tunisia.** 7th-century but rebuilt 836 and 875–902. One of the oldest monumental mosques of Islam and the first major monument in North Africa, this mosque follows Arab design in its basic plan while its decoration is largely late classical. Many of the columns and capitals were taken from pre-Islamic buildings. This view shows the prayer hall; the façade and the first dome over the central aisle are of the period of Ibrahim's enlargement of the building. The central aisle running toward the kibla wall and the mihrab is wider and higher than the other aisles, a principle already employed in Umayyad times, as in the mosque at Damascus.

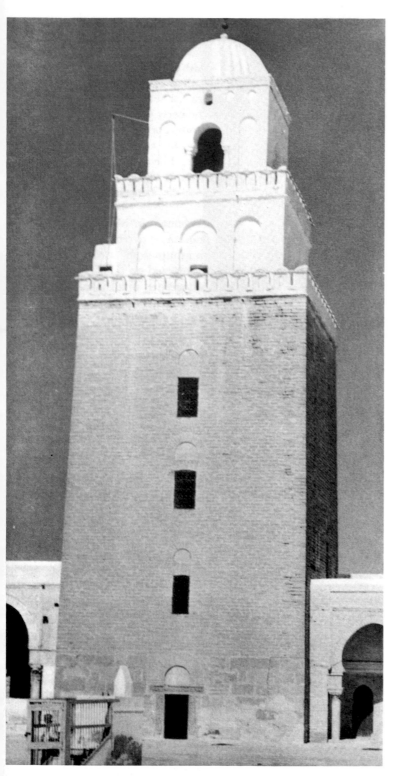

10. **Minaret of the Great Mosque of Kairouan, Tunisia.**
9th century. The huge square tower, built in three sections with
a small crowning cupola, is one of the oldest minarets to have
come down to us. In plan and general design it may well derive
from Syrian church towers.

the craftsmen and artists that produced the actual artefacts
of Islamic art, it was the Turkish rulers and their vast
entourage that determined the form and content of that
art. The Turks brought with them artistic traditions that
merged with the local, eastern hellenistic traditions of Iraq
and Iran producing what is called the Abbasid style.

ARCHITECTURE

Nothing of Abbasid Baghdad survives. But its marvels
have been described so extensively that some sort of recon-
struction is possible. The city, founded on August 1, 762, by
order of al-Mansur at an astronomically especially auspi-
cious moment, was built on a circular plan. There were four
gates at the cardinal points, and a vast central plaza. In the
centre of the plaza was the caliph's palace, the Kubba
(Qubba) al-Khadra, so called because of the tall green
dome that surmounted its centre. The dome could be seen
from a great distance and became the symbol of the capital
and of the rule of the Abbasids of Baghdad.

The fortification system was elaborate, with various deep
ditches round the city and five walls encircling the central
plaza. Between the third and fourth wall were the living
quarters so that the royal plaza was in the innermost part
of the city, separated by two walls with a wide ditch be-
tween them. A succession of heavily guarded gates, all with
complicated safety devices, protected the walls, with small
open courts corresponding to the width of the ditches be-
tween them. A long passage-way with forty bays of guard-
rooms linked the third to the fourth wall within the width of
the living quarters. The city thus had all the visible signs
of heavy fortification, an oppressive sight and certainly a
complete break with the open architecture of the Umayyad
period where, even in the 'desert palaces', the fortified
aspect was entirely decorative and non-functional. The
very idea of placing the royal palace in the centre of such a
succession of heavily guarded and fortified rings of protec-
tion is that of an oriental despot. Indeed much surviving
Abbasid architecture reflects this new concept of concen-
trated power in a vast and complex palace structure.

The form of al-Mansur's palace is not known, although it
is thought to have been similar to Sassanian palace designs
just as that of al-Mushattah and al-Kufah (see Umayyad
Art). Behind the palace was the great mosque—built, it
appears, entirely on the Arab court-mosque plan, the
prayer hall connecting directly with the palace in a way
that made the community of worshippers face the palace
when facing the kibla in prayer. In this feature the reli-
gious-political symbolism that governed some early Islamic
architectural design can be seen at work.

Of the vast city of Samarra which was founded by al-
Mutasim in 836, only two buildings survive, the mosque of
al-Mutawakkil, erected after 847, and the mosque of Abu
Dulaf, further east in the new quarter of the town and built
between 860 and 861. Nothing survives of the great palace
of the caliphs except the Bab al-Amma, the main gateway
that faces the river, but enough can be gleaned from the

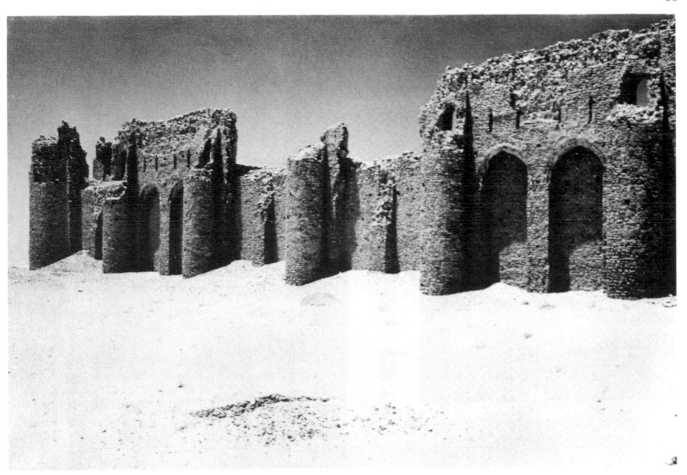

11, 12. **Desert palace of Ukhaidir.** *c.* 120 miles south of Baghdad, Iraq. Late 8th century. This is the only palace to have survived almost intact from the early Abbasid period. Built with stone rubble set in heavy mortar and largely coated with plaster in the interior, the building has survived in a remarkable state of preservation. Its vast size alone makes it extremely impressive. The almost square enclosure measures some 575 × 555 feet (175 × 169 metres). It has heavily fortified outer enclosing walls, the palace being built against the north side. In design and construction it follows the local tradition based on ancient oriental models. It thus represents a complete break with the late-classical Umayyad architecture that preceded it.

remaining foundations to reconstruct most of the immense building complex. The plans of most of the larger houses can be reconstructed, and, although no plan of the entire city has been published, it would be no exaggeration to say that Samarra was probably the most magnificent city the Muslims ever built.

In contrast to Syria and Transjordan where stone was used exclusively, the building material of Iraq is unfired brick; only in special instances, for the coating of undecorated walls, arches or other structurally crucial elements, was fired brick used. This largely accounts for the disintegration of the city after it was abandoned at the end of the 9th century.

The great mosque of al-Mutawakkil was the largest ever built by the Muslims. Built on an immense rectangular plan (measuring about 784 × 512 feet) the massive, bastioned brick walls still stand more than 30 feet high. The minaret, perhaps the most famous 'object' of all Islamic architecture, and over 89 feet high, is set to the north of the enclosure. Built on a square base, the round tower tapers off towards the top. One ascends it by an external spiral staircase that gave the structure its name, al-malawiya (the winding tower). The plan of the mosque follows that of the Umayyad period, organised around a large open court.

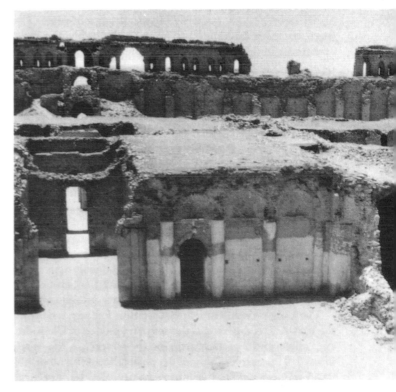

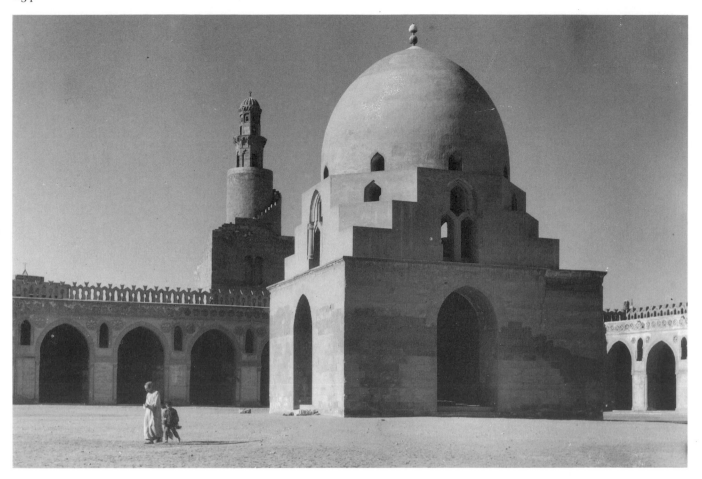

13. **Mosque of Ahmad ibn Tulun, Cairo.** 876–879. The mosque adopts the principles of building construction brought to Egypt by Ibn Tulun from Iraq. Brick piers and plasterwork, both alien to Egyptian architectural tradition are used and in the ornamental plaster decoration of the arches, capitals, and the two mihrabs the dominant influence of Iraqi Abbasid art can be seen. The minaret of the mosque is clearly inspired by the famous minaret of the Great Mosque in Samarra.

The most significant building of Samarra was undoubtedly the great palace, the Jausak al-Khakani, erected during al-Mutasim's reign, but added to in subsequent years. The huge complex covering 432 acres is probably the most ambitious building project ever undertaken by a Muslim ruler. Built in the tradition of the ancient Orient, the Jausak palace combines all the features of representational architecture that were developed in Iran and in Sassanian Mesopotamia (Iraq)—enormous ivan-halls, huge courtyards with water-pools and esplanades, domed throne rooms and complex intimate living quarters arranged around smaller courts with water basins and water courses, bath-halls and reception halls in ivan form on a smaller scale. The main element of the palace was the part that faced the river and of which the main triple gateway, the Bab al-Amma, is still standing. One approached it from the river level via a huge stairway. Its massiveness, complexity and size, and the extraordinary richness of its decoration (some of the finest paintings and stucco decorations come from the Jausak palace), made this building one of the most extraordinary achievements of early Islamic art.

The only monumental structure that has survived from the first Abbasid period is the majestic palace of Ukhaidir, 120 miles south of Baghdad, in the desert on the Wadi Ubayd. It preserves in the most perfect form the ideal Abbasid palace. Unlike the Jausak palace, it is built of large unhewn stones set into mortar and, due to this method of construction, has survived almost intact. This palace is again modelled largely on pre-Islamic models of Sassanian inspiration. Immensely large and totally isolated in the middle of an uninhabited desert, the palace of Ukhaidir still communicates something of the grandeur of the people that built it. In its simplicity of form and restraint of decoration, limited to some highly original and fascinating plaster-coated vaulting systems with abstract geometrical patterns, it is one of the most beautiful of early eastern Islamic buildings to have survived.

ARCHITECTURAL PLASTERWORK DECORATION

For the decorative arts and paintings in the Abbasid period, we are almost exclusively restricted to the finds in the ruined city of Samarra. Of the elaborate plaster decorations of the palaces and mansions of the city, enough has survived to give us a complete idea of the extraordinary richness of imagination and originality of the art of Samarra.

Three distinct styles can be identified that later combine with a gradual change in technique. While the earliest phase of the Samarra style follows almost without change the late classical tradition, the middle phase draws away from the classical style. Finally in the third phase the truly original style of Samarra achieves its full expression.

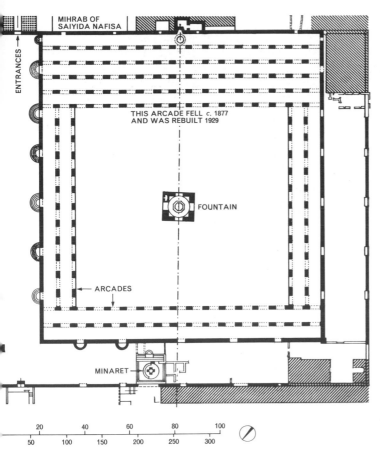

MIHRAB OF
SAIYIDA NAFISA

ENTRANCES

THIS ARCADE FELL c. 1877
AND WAS REBUILT 1929

FOUNTAIN

← ARCADES

MINARET

20 40 60 80 100
50 100 150 200 250 300

C. Plan of the Mosque of Ibn Tulun, Cairo.

The earliest plaster decorations are carved in high relief, deeply undercut, and depend for their effect almost entirely on the beautiful play of light and shadow, with sharp contrast between the brightly lit surface pattern and the impenetrably dark background. The patterns, consisting mainly of infinite variations of grape-vine scrolls, groups of decoratively arranged vine-leaves, acanthus scrolls and various other forms of floral ornaments, are cut by hand into the plaster in minute detail. Only thus could such a freshness and liveliness be achieved. Although often set within geometric panels or cartouches, the feeling for the natural growth of the plant form is always preserved. Only in rare instances does a purely abstract pattern penetrate into the still late classical concept of naturalistic ornament.

In the second phase the patterns become more abstract and the surfaces are filled tighter. Also a change from naturalistic floral growth to disconnected individually employed motifs, both floral and semi-abstract, often used in continuous repeat patterns, takes place.

In the third phase the final step towards complete abstraction is taken. While in the second phase some elements of the naturalistic late-classical ornament still survived, in the final stage all naturalistic form is eliminated in favour of a continuous abstract linear ornament that is entirely unclassical in feeling, and that changes the entire aspect of the decorative art of Samarra.

Also the technique changes. The patterns are no longer cut into the applied plaster but moulded which leads automatically to a continuous repetition of identical designs and does away with the light-and-dark contrast, the crispness and plasticity of the two earlier styles. The third style, without doubt, is due to a totally different attitude towards surface decoration and constitutes a complete break with the classical tradition.

The last Samarra style had an enormous influence on the way Islamic decorative motifs were treated in the ensuing centuries, not only in the East where it survived into the Seljuk period, but also in the West whither it was brought by the Tulunids, a Turkish slave dynasty in Egypt that became politically independent from Baghdad but depended artistically entirely on court tradition. In fact *13* Ahmad ibn Tulun's mosque in Cairo, completed in 879, is *C* modelled entirely on the great mosques of Samarra even to the point of having a spiral staircase minaret. The mosque is built in brick and decorated in the style of the last Samarra phase.

A number of tiles and tile fragments that have been found in the ruins of Samarra indicate that the plaster dadoes that decorated most lower wall surfaces, were at times combined with polychrome lustre-painted tiles. The important discovery of lustre-painting will be described later in the chapter.

The third form of architectural decoration widely employed was wall-painting, both of a decorative and a figurative nature—although mostly figurative.

WALL-PAINTING

The Samarra style of wall-painting, although undoubtedly rooted in Central Asia, combines Western and Eastern classical traditions in a particular way. The dominant element is a graphic style that ultimately seems to go back to Central Asia (Miran, 3rd century AD). A general immobility, even in scenes that represent action—a hunt, a struggle between man and animal, a dance—is a further altogether non-classical feature providing a strange contrast with the often classically inspired subject-matter. Perhaps the most interesting aspect of Samarra painting is the emergence of a facial type that had already made its appearance in Umayyad times, but became dominant only now. It seems to derive almost directly from an eastern hellenistic source which is best perhaps represented by the paintings from Miran.

The Samarra face is full and round with large, almond-shaped eyes with enormous pupils, a big, straight nose, only slightly curved at the very end, a small mouth composed of a very short straight line for the upper lip and a curved line drooping abruptly down at both ends for the lower lip. The hair is thick, black, and falls to the shoulders; it runs in a single scalloped line across the high forehead.

Most of the Samarra paintings have a linear quality. In a way they are more like coloured drawings than actual paintings, and are thus similar to the second floor-painting

14. **Ceramic plate with relief decoration from Iraq.** Early 9th century. diam. 11 in. (28 cm.). Freer Gallery of Art, Washington D.C. This is a typical example of the abstract linear style of ceramic decoration developed in Samarra. The combination of purely abstract interlace-band and floral elements is particularly characteristic of the early Abbasid period. The use of a very brilliant glaze with gold lustre elements is perhaps intended to imitate metalwork.

15. **Ceramic bowl with lustre-painted decoration from Iraq.** 10th century. Metropolitan Museum of Art, New York. diam. 12 in. (30·5 cm.). Figurative subjects began to appear on pottery only in the early 10th century. The lustre technique, a new creation of the Iraqi potters, developed into one of the most successful forms of ceramic decoration ever devised. It was employed throughout almost the entire Islamic world until the 19th century.

of Kasr al-Hayr. Only on rare occasions is colour used without the deep contour-line that defines almost every shape. The more pictorial style follows the technique of late Roman painting and adopts late classical motifs. A striking example of this type of painting is the large cornucopial scroll from the Harim of the Jausak palace.

POTTERY AND LUSTRE-PAINTING

Recent research has shown that pottery as luxury ware was made already in considerable quantities in the Umayyad period, inspired by local traditions that were often carried on for several centuries in the respective areas (Syria, Egypt, Iran, Iraq). During the Abbasid period the main stimulus was probably the arrival of Chinese pottery in the Abbasid court, for among the earliest vessels made in Baghdad are those that imitate white T'ang ware, or the splash-coloured pottery of the same period.

One ceramic group has fine relief-decoration of abstract linear forms, at times ending in half-palmettes or using decorative inscriptions, which find counterparts in China. In Egypt the same wares bore figurative motifs—animals and birds, in immediate reference to late classical iconography. But the most brilliant achievement of Baghdad potters was the development of a technique that was to revolutionise pottery decoration: the painting on the surface of the glaze with a metallic pigment called lustre.

The lustre pigment, producing a metallic sheen on the surface of the glazed and refired vessel, comes in shades of green, yellow, brown and red and in the earliest and most ambitious products of this new technique all those colours

are used on a single piece. The complexity of the process and the great risk of failure, quickly resulted in the simplification of the polychrome lustre technique and a monochrome green-brown lustre took its place.

The lustre technique must have been a secret of the potters of Baghdad because lustre-painting seems to have been practised nowhere else in the Muslim world at this early stage. In Nishapur, for instance, the cultural centre of Samanid Khurassan, a great school of pottery had been established in the 9th century, which together with Afrasiyab (Samarkand) in Central Asia became the leading pottery centre in the 10th century. But in both cities lustre-painting was unknown; they imitated openly the lustre wares of Samarra but in a technique that could never come near to the original lustre effect.

Polychrome lustre ware, it appears, was also made in Tulunid Egypt but only abstract patterns, as in Samarra, were used. Lustre pottery with figurative decoration appears only in the 10th century in Baghdad. The strange and somewhat primitive style of the designs is due to a sudden, strong influx of Central Asian traditions at that time. There is an immediate similarity between some of the figures on these lustre bowls and those on pottery made in Nishapur.

BUYID ART AND ARCHITECTURE

At the same time as Abbasid culture reached its height in 10th-century Baghdad, a number of local dynasties established themselves in Iran, Khurassan and Central Asia, creating important cultural centres of their own.

Among these the most important are the Buyids (or Buwayids), a Dailamite family that had maintained its independence from the central Muslim government in their region south of the Caspian Sea, and that had begun to take over large parts of western and southern Iran during the first half of the 10th century, reaching Baghdad before the middle of the century and forcing the caliph to resign from all political power.

Artistic life flourished under Buyid rule both in Iraq and Iran. Many important buildings were erected, among them the mosque in Nayin, which only partly preserves its original form—but which contains the only example of
16 plaster decoration on a large scale that has come down to us from that period. The plasterwork, still following in part late classical tradition in the grape-vine designs of the upper mihrab niche or the columns of the prayer hall, derives directly from the Samarra style.

The Buyids seem to have been particularly fond of fine and precious metalwork, an astonishing amount of which has been preserved. A complete silver treasure survives, probably made for a nobleman of Azerbaijan in the middle
17 of the 10th century. A quantity of silver plates with figurative scenes very much in the Sassanian tradition but clearly not in the Sassanian style, seem to have been made for
5 Buyid rulers both in Iraq and Iran. However, the authenticity of two gold pitchers and some gold medallions bearing portraits of the rulers have recently been questioned.

Outstanding among the products of Buyid art are their magnificently patterned silks. Some are decorated with lengthy historical inscriptions while others combine the
18 calligraphic with the figurative element. Animal motifs dominate, but there are also representations of the human figure in stiff, formal hunting scenes. Most of the textiles are woven in two contrasting colours, brown, blue or black with a buff white. Most patterns are reversible—an astonishing technical feat considering the intricacy of the designs—so that there is either a light pattern against a dark ground or vice versa.

A variety of pottery types seem to have been made in the Buyid realm. Among them two with partly figurative representation stand out. The first employs a mainly linear incised technique with an almost monochrome colour effect not unlike some of the simple textile patterns. The glazes are dull brownish-white while the unglazed incised design appears dark, or light red. The second type is more complex. With its vividly coloured glazes and elaborate figurative designs, it follows even more closely the general trend of figurative iconography that seems to have been particularly strong in the Buyid period. Some of the usually solidly made large bowls are decorated with fantastic animals, human-faced quadrupeds or birds, others with scenes that seem to illustrate stories out of the *Shah-nameh*. If such interpretations are correct, we would have here the
19 earliest illustrations of Firdusi's poem, practically contemporary with the creation of the poem itself. This pot-

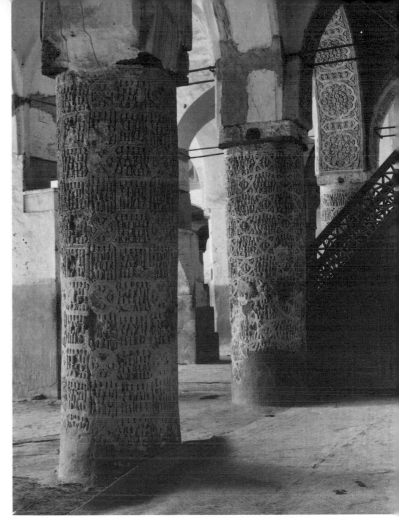

16. **Plaster decoration in the mosque at Nayin, Iran,** 10th century. In the prayer hall of this small mosque the earliest plaster decoration of Iran is preserved, following the tradition established about a century earlier in Iraq. During Buyid rule cultural relations between Iraq and Iran were very close.

17. **Silver plate with chased relief decoration from Iran.** *A Ruler enthroned with attendants and musicians.* 10th century. diam. 9⅞ in. (25 cm.). Hermitage, Leningrad. This plate is one of a large group of silver vessels that was long considered to be of Sassanian date but can now definitely be attributed to the period of Buyid rule in Iraq and northern Iran. Although they follow Sassanian precedents both in technique and iconography, they developed an unmistakable style of their own. Their low decorative relief, the often peculiarly Central Asian iconography and the static quality of their design are characteristic elements.

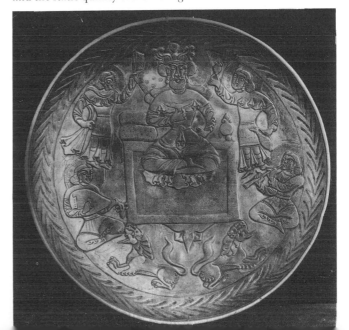

18. **Patterned Buyid Silk.** Persia. 10th century. Museum of Art, Cleveland. h. 19½ in. (49·5 cm.). w. 18⅝ in. (47·4 cm.). This is one of a large group of patterned silks that seem to have been made in or near Rayy for the Buyid rulers and princes of the 10th century. Their exceedingly fine technique, and often fantastic iconography place them among the most interesting and accomplished works of an art that seem consciously to have attempted to recreate the lost splendours of ancient Persian art. The motif of the design certainly goes back to at least the Sassanian period, and, although its meaning in Buyid times is difficult to interpret, it is not impossible that some of the symbolism, such as the particular representation of the bird of prey derives from an even earlier period.

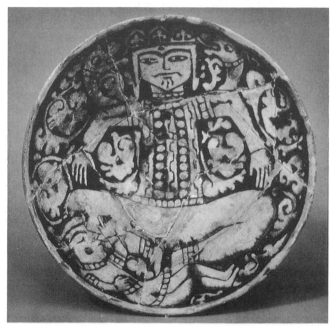

19. **Ceramic bowl with carved relief decoration from Persia** (Garrus District). 10th century. diam. 6½ in. (16·6 cm.). Metropolitan Museum of Art, New York. The decoration of this small bowl is remarkable both for its technique and iconography. Low relief, achieved by carving the heavy slip coating, is common to a group of pottery found in the Garrus area. Human figures are not often depicted. The figure here is probably Dahhak, son of Mardas and king of the Arabs, who invaded Iran defeating and killing Jamshid Shah, making himself Shah of Iran. He is identified with evil forces and with idolatry. His curious attribute is a pair of snakes that grow from his shoulders. If this interpretation is correct, we have here one of the earliest representations of a scene from the *shah-nameh*.

tery, usually referred to as 'Gabri' ware, has survived in great quantity and must have been made somewhere in northern Iran.

SAMANID ART AND ARCHITECTURE

In Khurassan and Central Asia the Samanids had established themselves, creating in the cities of Nishapur in Khurassan and Afrasiyab (Samarkand) flourishing centres of the arts.

Little has survived of their architecture, but a mausoleum erected in Bukhara early in the 10th century provides us with considerable information about their particular tastes and the special ability of the architects of the period. The small, square, domed building is entirely built of brick, a material that is used as a decorative medium. The entire surface of the tomb, inside and outside, is decorated with an abstract pattern created through a complex system of laying different layers of bricks in alternating positions. Dark recesses where light cannot penetrate emphasise an already powerful decorative scheme depending for its effect on contrasts between light and shadow. This is the first appearance of a formula that becomes central to the architectural decoration of the Muslim East.

The building is also the first example of a perfect 'canopy' mausoleum constructed in complete symmetry, each side being pierced by a pointed arch gate, recessed into the outer walls. The central dome is accompanied by four small decorative domes at the corners which do not appear in the interior. They correspond to four engaged columns at the four corners of the building. A curious gallery with a succession of small niches runs all around the top of the building hiding the drum of the main dome. This

20

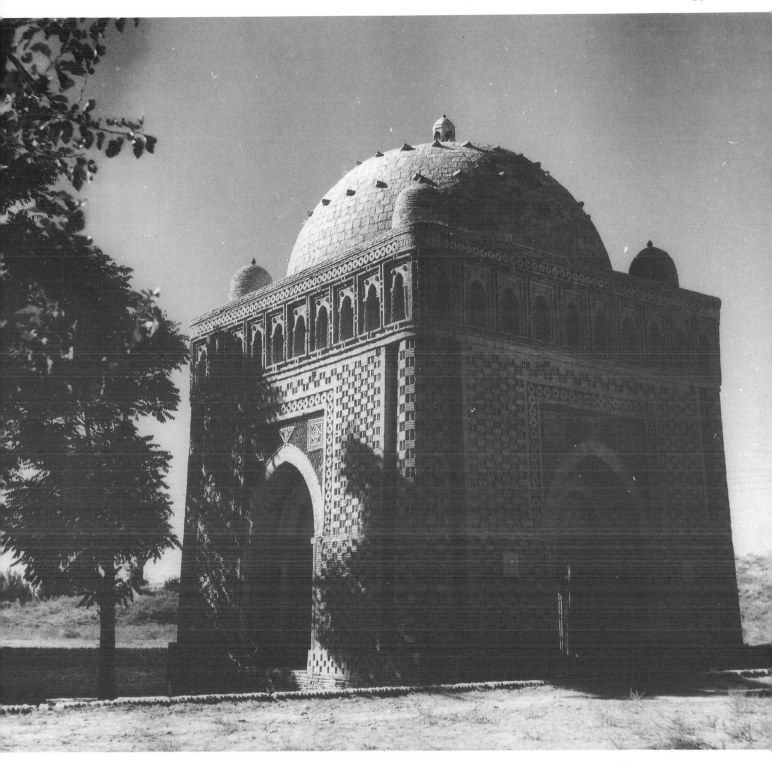

20. **Mausoleum of the Samanids, Bukhara,** Transoxiana,
First half of the 10th century. This building, although of modest
size, is the most perfect example of a particular style of
decorated architecture. Constructed entirely of brick, the
surface patterns are achieved by alternating the direction and
position of the individual bricks or rows of bricks. The
mausoleum is the earliest major example of a style that seems to
have originated in Central Asia, penetrating thereafter the whole
of the eastern Islamic world.

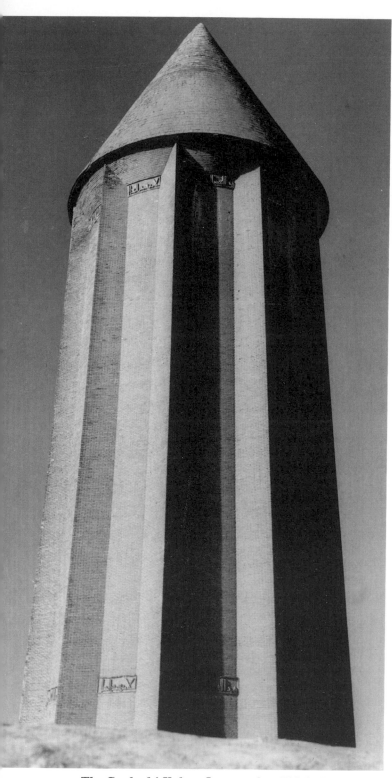

21. **The Gunbad-i-Kabus, Iran.** 1006–7. This building, which is over 200 feet (61 metres) high, was intended not so much as a mausoleum, (although the King did intend to have his sarcophagus placed inside the tower), as for a symbol of political power. Highly abstract in form, and with a plain brick surface, the building contrasts strongly with the usually small, elaborately decorated tombs or victory towers then common to both Central Asia and Iran.

is again a feature that seems to be entirely original, and that was followed repeatedly in the centuries to come in various-ly elaborated forms in Central Asia, India and Iran. The building is one of the most remarkable monuments of early Islam, unique in the perfection of its design and in its importance for later developments.

Another unusual and highly successful architectural construction, the Gunbad-i Kabus, belongs to this period. *21* It was erected by a minor local ruler in north-eastern Iran (Gurgan region) in 1007. Although planned to be used as a mausoleum, it was primarily erected as a monument of political power. Round in plan with a conical 'tent' roof, its only decoration consists of a series of inscribed panels be-tween the ten pointed-edge buttresses that run up from the base of the tower to the corbels that support the roof. The tower stands more than 165 feet high and measures almost 50 feet in diameter above the base. It is the largest building of its kind in Islamic architecture.

Although very little of the architecture of Nishapur has survived, a large quantity of decorative plasterwork from *22* its buildings has been recovered in excavations. It is im-portant to remember that plaster decoration of architec-ture was used from the very beginning of Muslim rule right up to the Mongol period. At Nishapur the patterns, semi-abstract and floral, with leaf forms and arabesque palmette arrangements, follow very closely those of Nayin and Sa-marra, indicating a unity of style in a vast area that is quite remarkable. A general tendency towards flatness of surface, deep undercutting and elaborate decoration of the surfaces with small geometrical forms (triangles, polygons, etc.)—also seen at Nayin—prepare the ground for later develop-ments in the Seljuk and Mongol periods.

Very little of Samanid painting is known. The fragments of wall-painting excavated at Nishapur are largely orna- *9* mental and also possess unusual quasi-magical qualities of an apotropaic (evil-averting) nature, it would appear. Stylistically they are not dissimilar from the abstract orna-mental paintings of 9th-century Samarra. The few frag-ments of figurative paintings that have been recovered reflect a tradition which can be traced back to Central Asian painting of the 6th and 7th centuries that was prob-ably of fundamental importance for early Islamic painting throughout the East and even influenced some western Islamic painting of the Seljuk and post-Seljuk periods.

The most important Samanid contribution to Islamic art is the school of pottery that flourished both in Nishapur and Samarkand. A great many types were produced, among them one with polychrome figurative representa-tion. The Samanid potters developed a polychrome under-glaze painting that would not run into the highly fluid glazes that were used at the time. To avoid the destruction of their designs by the running glaze they devised the ingenious plan of mixing their colours with parts of clay and earth to produce a substance similar to the slip (semi-fluid clay) that was put on the surface of an unfired clay vessel to smooth it and to give it a base for the application

22. **Plaster panel from Nishapur,** Khurassan, Iran. 10th century. h. 37½ × 8⅜ in. (186·5 cm. × 21·3 cm.). Metropolitan Museum of Art, New York. Plaster decoration, used since Umayyad times in architectural decoration, has not been recorded in Iran before the 10th century. The plaster panels recovered in the excavations in Nishapur are of the finest quality and, in their complex floral and abstract cut patterns, display close ties with the early Samarra style. They are remarkable both in the precision of the cut ornament and in the strict flatness of their surfaces.

of glaze. This 'slip-painting', as it has aptly been called, was an entirely new and original technique not known or used in other parts of the Muslim world.

6 The polychrome painted pottery of Nishapur preserves a style of painting that is not otherwise known but that very likely reflects wall and manuscript painting of the time. The usually small, heavily made steep-sided bowls are covered with a buff slip upon which dense, all-over patterns of animal groups, human figures, and abstract floral designs are painted in bright yellow, green, black and purple. Often the main motif—a seated figure, a horseman, an animal group—is surrounded by small-scale floral or animal motifs filling the entire background in an unsystematic way.

A second type of Nishapur pottery, also produced in Samarkand, is of different nature. Only two colours are used—white for the ground and black, dark brown or purple for the patterns. The designs are always abstract and in most cases calligraphic. Magnificent use is made of the 23 beautiful Arabic script. Often single lines of a fine, very stylish calligraphy runs across the surface of the bowl, or a single word appears in the centre. The most accomplished

23. Ceramic bowl with decoration from Nishapur,
Khurassan, Iran, 10th century. diam. 18$\frac{1}{16}$ in. (45·8 cm.).
Freer Gallery of Art, Washington. This bowl is probably the
finest of a group of highly sophisticated ceramic vessels that are
decorated with elements of calligraphy in black and purple on a
white or yellowish ground. Complete inscriptions, written in a
peculiar form of kufic script that has an astonishingly close
relationship to the forms of the Uighur writing of Central Asia,
often appear on such vessels. This is the first time that the Arabic
script is used as a major element in surface decoration.

24. Ceramic bowl with slip-painted decoration
Nishapur, Khurassan, Iran. 10th century.
diam. 13$\frac{1}{2}$ in. (34·3 cm.). Metropolitan Museum of Art, New
York. Lustre-painting was obviously unknown in Nishapur
and the Samanid potters developed a slip-painted decorative
style that imitated the brown monochrome character and certain
other features, such as the 'peacock-eye' motif of the Iraqi
models.

examples have large-scale letters in a special form of Kufic
writing that has an extraordinary similarity to the form of
Turkic Uighur calligraphy; often one or two lines of writ-
ing run round the rim of these large, finely potted deep
bowls or flat plates. The glazes are brilliant and quite pure
even though they have a tendency to crack and loosen from
the ceramic body. A great variety of types exists within this
group and additional colours, especially a bright red, are
sometimes used for the inscriptions or palmette designs that
appear either in combination with the inscriptions or by
themselves. It seems that these 'polychrome' pieces were
mainly made in Samarkand.

It is astonishing to find that the obviously highly ac-
complished Samanid potters did not master the lustre
technique. The result was the production of a type of
24 pottery that imitated lustre in a greenish- and reddish-
brown slip painting without, however, being able to match
the special effect of the original technique. Some of the
Samanid potters' imitation lustre pieces also have patterns
which are clearly copies of Iraqi lustre ware.

The art of the Early Abbasid period reflects the political
situation of the time. With the removal of the capital from
the sphere of influence of late classical tradition, eastern,
and eventually Central Asian traditions began to play a
dominant role. The line of royal palatial architecture of
Sassanian Iraq and Iran was continued. Eastern hellenistic
and Asian elements mingled to create both a style and an
iconography in painting that were basically non-classical
and became of crucial importance for the further develop-
ment of Islamic art. The general tendency towards an
abstract use of classical naturalistic ornament formed the
basis of all Islamic floral design, was brought to its first high
point in the 'bevelled style' of Samarra, transmitted to Iran
by the Buyids and adopted in Samanid Khurassan and
Central Asia.

The unity of the Umayyad style was replaced by the
complex style of the eastern Islamic development, reflect-
ing the complex ethnic and political situation of the eastern
empire in the 9th and 10th centuries. Abbasid art forms,
particularly in the realm of pictorial representation and
abstract ornament, invaded western Islam through the
Tulunid expansion of the Abbasid realm to the West.

With the development of lustre-painting, the early Ab-
basid period made a fundamental contribution to the art
of Islam as a whole, providing further generations, as we
shall see, with a most effective means of realising the main
objective of most Islamic art, the dematerialisation of
matter and the sublimation of this world.

The Umayyads of Spain

While in Persia and Central Asia the local cultural centres produced art forms of great imagination and variety, the only survivor of the Umayyad family, Abd al-Rahman I (756–88), established an independent kingdom in Spain. Spain had been conquered by the Arabs early in the 8th century but it was not before Abd al-Rahman's coming to Cordoba that the country achieved significance within the general development of Muslim art and culture. During the three hundred year rule of the Umayyads, Spain and Cordoba became the most important cultural centre of the Muslim world, rivalled only by Baghdad. The open rivalry between Cordoba and Baghdad manifested itself in the proclamation of the western caliphate under Abd al-Rahman III (912–61) in 929.

Although Cordoba always remained the centre of the Umayyad realm and its great mosque, founded by Abd al-Rahman I in 785, was constantly enlarged and enriched during the reigns of his successors, a palatial city, Madinat al-Zahrah, was built by Abd al-Rahman III and enlarged by al-Hakam II in the 10th century. It was during the reign of these two men that Cordoba became the equal of Baghdad and Umayyad power reached its greatest height in Spain and North Africa.

ARCHITECTURE AND ARCHITECTURAL DECORATION

D The great mosque in Cordoba is to this day one of the most remarkable monuments of Islamic architecture. Designed on the traditional Arab mosque plan, it consisted originally of a large rectangular enclosure of which the larger part was an open court with a covered prayer hall on the south side. This relatively simple building was enlarged four times in the following centuries; Abd al-Rahman III had a tall minaret added to the mosque around 950. But the most important modification of the building was that of al-Hakam who had seven aisles added south of the prayer hall. During the period of al-Mansur both the court and prayer hall were extended westwards. The present building is the third largest mosque in existence after the two at Samarra.

The court to the north is surrounded by open arcaded porticos; to the south the vast prayer hall has nineteen aisles, its roof resting on eighteen double-storey arcades running perpendicular to the kibla wall. Al-Hakam's new kibla wall is the most splendid part of the mosque with its mihrab magnificently set off by a number of highly so-

11 phisticated 'cappellas'. With this addition Hispano-Islamic art reached its highest achievement only to be matched by the Alhambra in Granada three hundred years later (see Nasrid Art). The lavish architectural design, the creation of the double- and triple-arch arcade, the extraordinary versatility in decorating the surfaces of the arches and niches, the mihrab and the cupola of the *Cappella del mihrab* with stucco and mosaics, the variety of designs employed and the perfect equilibrium between the richness of detail and the tranquillity of the total effect, is perhaps unparalleled in early Islamic art.

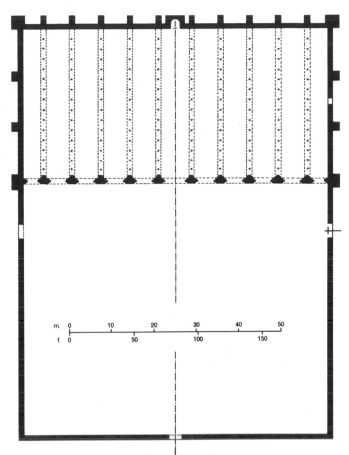

D. Plan of the Great Mosque of Cordoba.

The plaster and marble decorations in the mosque— which can be compared with those of the city of Madinat al-Zahrah—are as delicate as lace. The flat patterns, all based on classical naturalistic motifs, are reduced to a brilliant, precise tracery against a dark background.

DECORATIVE ARTS

The same technique of precisely cut floral ornaments on a fairly flat surface against a deeply receding dark background is used in the many fine ivory carvings of the period. 25a, b, c As many of these pieces are dated, or datable through historical inscriptions, a perfect chronology can be established for the development of the style. While the earliest pieces are almost exclusively floral-abstract, later objects include quite complex figurative designs with interesting subject-matter. A group of silk brocades, probably made in Almeria, proclaim the open rivalry with Baghdad. Although none of the ivories are thought to have been made in Baghdad, (as were two of the Spanish silks), some of the royal iconography employed has a clearly eastern Islamic connotation imitating typically Abbasid concepts of representational art, strange in a country that regarded no one with more enmity than the Abbasids of Baghdad.

25a, b, c. **Ivory box with carved relief decoration.** Made for Abd al-Malik in 1005. *c.* 10 × 20 in. (25·5 × 50·7 cm.). Cathedral Treasury, Pamplona. Ivory carving had been highly developed in Umayyad Spain and figurative representations, often following Iraqi models, were widely used. Abd al-Malik's carved ivory box is an outstanding example of this art.

The art of Umayyad Spain is the first manifestation of the new 'Islamic' attitude towards classical tradition in the West. Almost entirely unaffected by the impact of Central Asian tradition that was changing eastern Islamic art at the time, Spanish-Islamic art found a highly original way of adapting the traditional forms of classical architectural design (the double arcade of the mosque in Cordoba, for instance, was probably developed directly from the Roman double-storey aqueducts in Spain) and classical naturalistic ornament, to a new, and in its ultimate realisation, entirely non-classical taste. Spanish-Islamic art achieved in its first period a character of its own that it was never to lose. This consists of a strong tendency towards abstraction on the basis of an always clearly definable individual form. Naturalistic motifs are never abstracted to the point of becoming unrecognisable. In this Hispano-Islamic art does not follow the principles established in 9th-century Iraq, even though most of its figurative repertory is derived from there. The most remarkable achievement of this art was an extreme refinement both of design and technique which was applied to all forms of decoration. A unity of style was created, embracing both the monumental in architectural stone, marble and plaster carving, and the minute, in the carving of small ivory boxes and panels, a feature that is typical of Islamic art in general, but was developed to a particularly high degree in Umayyad Spain.

(Continued on page 281)

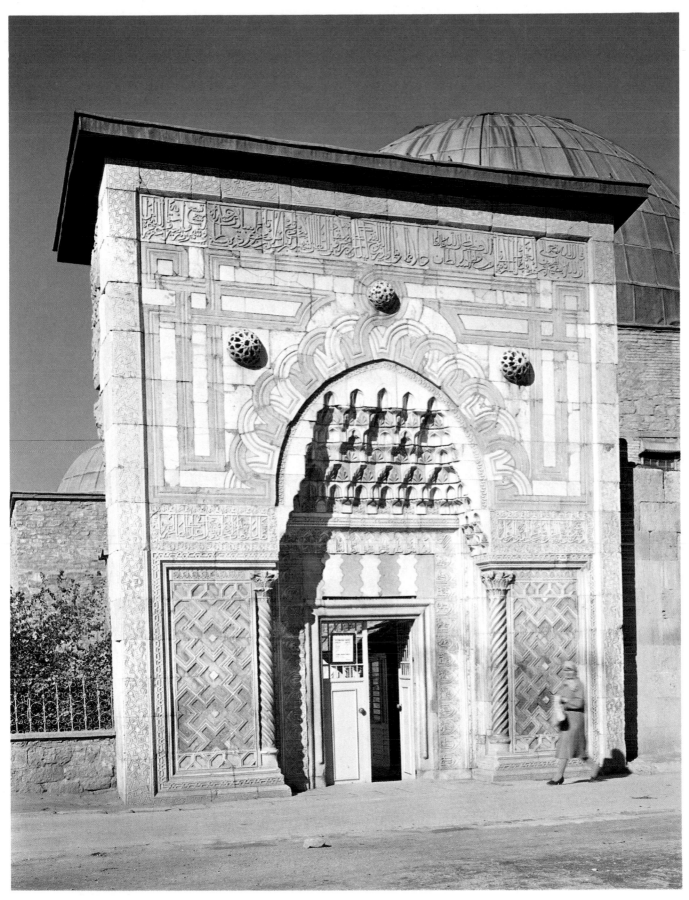

21. Karatay Madrasah (entrance). Built by order of the Amir Celaleddin Karatay, grand vizir of Kay Kaus II in 1251. Konya, Turkey. Only the entrance portal and the main dome chamber of the madrasah survive. The portal is a fine example of Seljuk decorative stone carving and the use of different coloured marbles for decorative purposes in architectural surfaces. The Karatay Madrasah is one of the finest surviving examples of the dome chamber type of building. The interior is particularly richly decorated.

22 (above). **Carpet from the Mosque of Alaeddin Kaykubad, Konya, Turkey** (detail). 13th century (possibly later-14th or 15th century). (Whole rug) 17 ft. × 9 ft. 4 in. (5·2 × 2·85 m.). Museum of Turkey and Islamic Art, Istanbul. This detail shows the strikingly bold border design, based on elements of kufic writing and a corner of the field filled with an infinite pattern of interconnecting abstract floral scrolls.

23 (above, right). **Interior of the Mosque of Alaeddin Kaykubad.** 1220 AD. This is the major mosque of the Seljuk rulers in Konya, their capital in Anatolia (Turkey). This view shows the colonnades of the prayer hall running parallel to the kibla wall and the use of rugs. These are modern replacements of the oldest surviving ancient rugs (see plate 22).

24 (right). **Enamelled brass basin** (inside). Made for an Urthukid Seljuk ruler, d. 1144, diam. 9 in. (23 cm.). Tiroler Landesmuseum Ferdinandeum, Innsbruck. Very few pieces of metalwork made for the Urthukids survive and this is the only known piece of Islamic metalwork with enamel decoration. Immediate contact with Byzantium accounts for its technique and the way Alexander is elevated on his 'throne'.

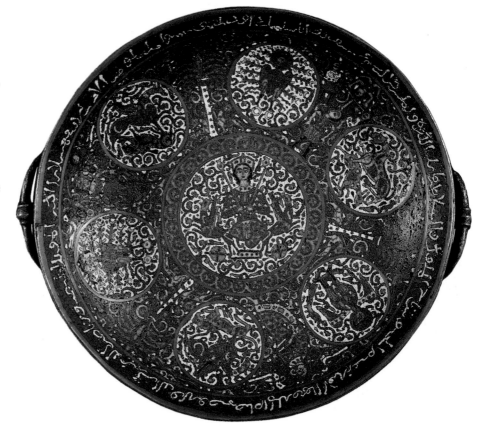

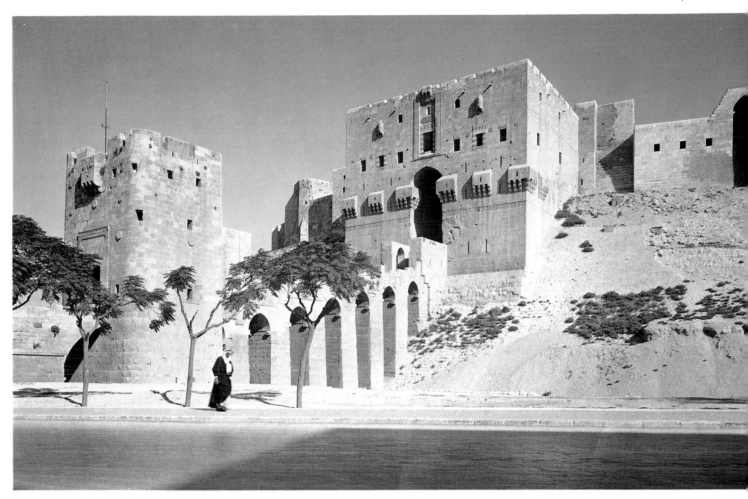

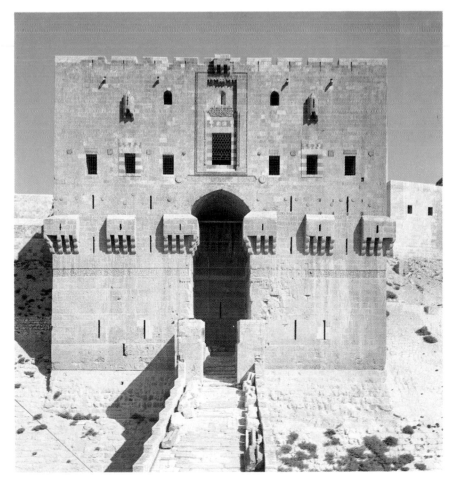

25, 26. **Aleppo citadel, Syria.** *c.* 1210,
with later additions. Built at the top of a
hill that dominates the city of Aleppo, the
citadel is one of the most remarkable
buildings of civic Islamic architecture. The
photographs show the formidable entrance
gate-tower and the bridge that crosses a
deep ditch to the actual gate, a massive
tower on the slope of the hill. This
building, a masterpiece of Syro-Islamic
architecture in its classical simplicity of
form and complexity of design, was
erected by the Ayyubid Sultan Malik
Zahir Gazi (there are two inscriptions in
his name, dated 1209 and 1212
respectively).

27 (opposite). **Frontispiece painting from the Kitab al-diriyak, Mosul, Iraq.** 1199. $7\frac{1}{8} \times 7\frac{3}{8}$ in. (18 × 18·5 cm.). Bibliothèque Nationale, Paris. In a number of important images such as the frontally, crosslegged seated figure in the centre of the medallion, and in the general rendering of facial features,

physical types and costume details, the painting demonstrates the appearance of pure Seljuk style in Iraq.

28 (above). **Frontispiece painting from the Kitab al-diriyak, Mosul, Iraq.** Mid 13th century. $12\frac{5}{8} \times 8\frac{7}{8}$ in. (32 × 22·5 cm.). National Library,

Vienna. Also following the Seljuk style, this later frontispiece painting is interesting because in spite of its abstract elements, it gives a fairly realistic picture of the court life of the period and closely resembles royal imagery on minai painted pottery from Seljuk Iran.

29 (opposite). **Ceramic vase from Damascus, Syria.** Late 13th century. Lustre-painted decoration. h. c. 12 in. (30·5 cm.). Al-Sabah Collection, National Museum of Kuwait. Following the form and basic design established in Syria in the first half of the 13th century, this vase combines the use of a dark coloured background (glaze) with yellow lustre decoration. The combination of small-scale leaf-scroll background decoration and large-scale interlaced pattern is equally original. It is inscribed "Made for Asad al-Iskandarani, the work of Yusuf in Damascus."

30 (above). **Ceramic vase and ewer from Rakka, Syria.** 13th century. Ewer: h. 9¼ in. (23·5 cm.). Vase: h. 7⅛ in. (18·1 cm.). Metropolitan Museum of Art, New York. These ceramic pieces represent the two most popular forms of pottery making and decoration developed in 13th-century Syria: black painting under a greenish-blue glaze and lustre-painting. The pear-shaped vase is typical of Syrian pottery and goes back several centuries; the small lustre jug is an equally original creation of Syrian potters but apparently does not appear before the 12th century.

The close contact between Syrian and Persian pottery can be seen particularly in the design of the half-palmette-leaf scroll and the whirl motif of the lustre-painted jug. With the destruction of Rayy by the Mongols in 1220, many Seljuk potters fled Iran and found new employment in Syria giving new impetus to ceramic making there.

31. **Painting from a copy of Hariri's Makamat.** Syria. 1222. Bibliothèque Nationale, Paris. The painting demonstrates the close relationship between the Syrian school of painting in the early 13th century with Byzantine and western, non-Islamic tradition. Contemporary and earlier Christian paintings must have served as models for the painters of this manuscript in particular as they seem almost entirely free of eastern Islamic influences. Miniatures of this type have justly been called hellenistic rather than Islamic in feeling.

32. **Painting from a copy of Hariri's Makamat,** Baghdad, Iraq. 1237. *Pilgrim Caravan.* 10 × 10½ in. (25·3 × 26·7 cm.). Bibliothèque Nationale, Paris. The illustrations of this codex form the main work of the Baghdad school of painting. They demonstrate the extraordinary impact of hellenistic painting. Although there was undoubtedly a continuous tradition of painting in Baghdad following late classical models, only 13th-century examples survive. The realistic representation of animals and human figures and choice of subject-matter from the actual life of people of the period is rare in other Islamic painting.

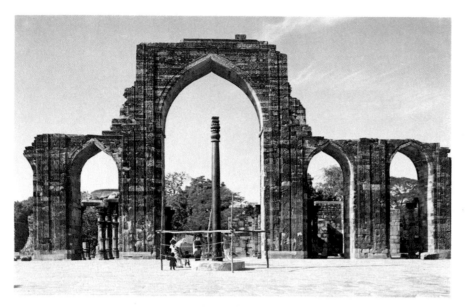

33. **Kuwwat al-Islam Mosque, Delhi, India,** built by Kutb al-din Aibak in his fortress of Lalkot near Old Delhi, 1193–1210. This mosque is the earliest surviving monument of Islamic architecture in India. In its combination of local, pre-Muslim traditions and imported architectural forms, it is typical of the earliest period of Islamic architecture in India. The mosque is built on to the ruins of a Jain temple, in front of which a screen wall with a large central pointed archway and smaller, lateral arches was built. The decoration is mainly carved low relief.

34 (below, left). **Pir-i Bakran, Linjan,** 30 km. S.W. of Isfahan. 1299–1312. Mausoleum of Shaykh Muhammad ibn Bakran, d. 1303. This small building was originally intended as a religious school consisting of a monumental ivan hall but was then changed into a mausoleum through the curious device of closing the open side of the ivan hall with a screen wall. It is particularly remarkable for its outstanding plaster decoration in which all the possibilities of Mongol architectural decoration are explored and applied. The astonishing variety of form ranges from plain, flat coating with linear incised designs, forming continuous patterns both abstract and epigraphic, to the almost baroque movement of the highly complex multiple level of the mihrab. The illustration shows one of the deep niches in the sides of the ivan hall walls, decorated with an abstract arabesque ornament recalling designs first developed in 9th-century Samarra.

35 (opposite). **Painting from Manafi al-Hayawan** (The Usefulness of Animals) a copy by Abu Sa'id Ubayd Allah ibn Bakhtishu. Maragha, Iran, dated 690/1291. *Adam and Eve.* $13\frac{1}{2} \times 9\frac{3}{4}$ in. 33.5 × 24.5 cm. Pierpont Morgan Library, New York. The paintings in this manuscript are the earliest known from Mongol Iran. Some clearly show the dependence of the Mongol painters on earlier models. This painting is of particular interest not only because representation of semi-nude human figures is rare but also because of the obvious fusion of at least two pre-Mongol painting styles: that of the Baghdad school which contributed the landscape element, and that of the Seljuk schools, which provided the models for the figures.

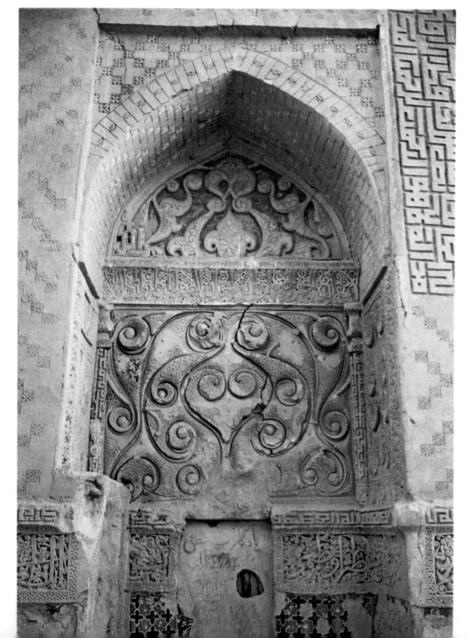

مقالت أولی اندر منافع من ورزن

أول بدانکه چون نطفه

دَرْ رَحِم مادّه حاصل شود

وقوای کردد ومینازد

قوّتِ وحرارَت

مِذا کردد واز دماغ

ودل وجگر بیاید

ونفش کلّی بدان رسد

ما مند زرده خایه باشد

دَمّ الطمث باز بندد

وهم حون سپیدِ خایه

مذا امنی در آید جمانک

بنیز مایه اندر سپیز تازه بین علقه کردد ما اوّل ۔۔۔ دَرْ تدبیر رحل باشد واذ به انک طبع دّ جلو نطفه

نه

دیرودنه خانه انذرخانه از بعد سه دور بدید آید وکه از سپیده خیزد و زد خوند و طعمه او باشد

اندر صورت سیمرغ

سیمرغ اندر دریا محیط باشد اندر جزیرها بیرد کی خط استوا و مردم بدان جای نشینند و هوای خوش دارد

میرودخر بهمرغ
جران جا مریزند
بدان جا بر است
زیبتحم خواص وتر
ازرگر احوضر

عنق

36 (opposite). **Painting from Manafi al-Hayawan** (*The Usefulness of Animals*) by Abu Sa'id Ubayd Allah ibn Bakhtishu. Maragha, Iran, dated 690/1291. *The Phoenix.* $13\frac{1}{2} \times 9\frac{3}{4}$ in. (33.5 × 24.5 cm.). Pierpont Morgan Library, New York. This painting from the earliest surviving Mongol manuscript shows the important influence of Far Eastern art on the development of the Mongol style. Not only the subject, the phoenix, but also the use of a great many conventions, such as those for the representation of trees, flowers, water and clouds, are largely inspired by Chinese paintings.

37 (above). **Painting from a copy of Firdusi's Shah-nameh** (Book of Kings). Tabriz (?), Iran. *c.* 1330. *Bahram Gur having killed the wolf.* page: $16\frac{1}{4} \times 11\frac{3}{4}$ in. 14.3 × 29.8 cm.). Fogg Art Museum, Cambridge, Mass. The illustrations of this dispersed copy of a *Shah-nameh* differ greatly in style and quality. They are the final masterpieces of the Ilkharid atelier of Tabriz. This is one of the most successful paintings of the series, combining almost magically realistic detail with an element of ceremonial symbolism, a combination typical of a large number of paintings in this manuscript.

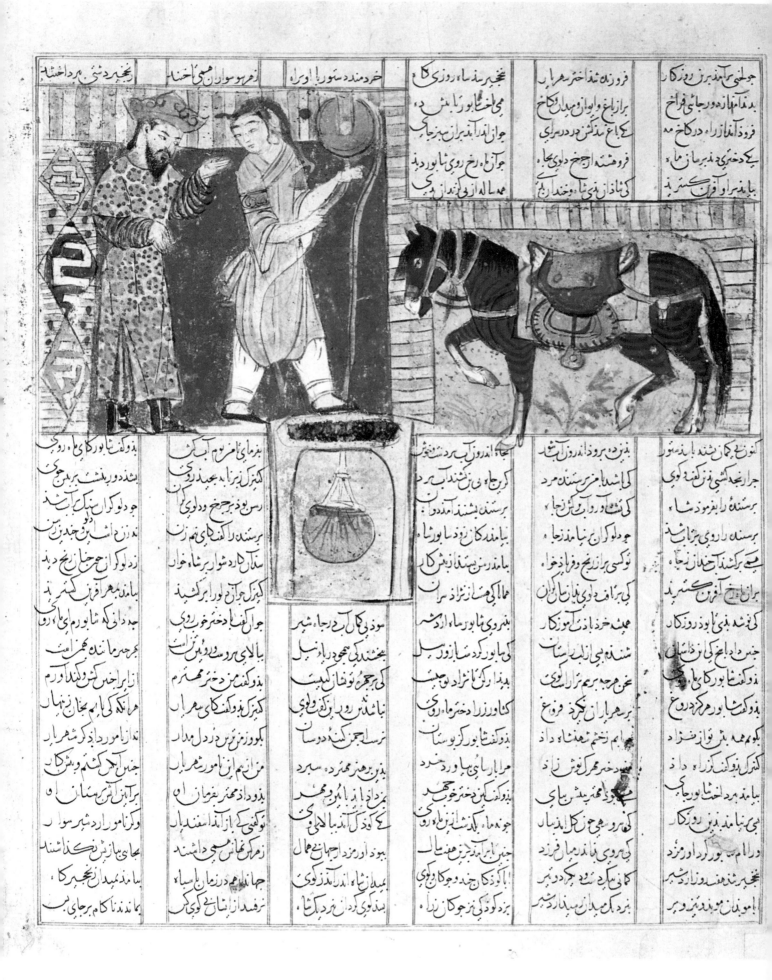

38 (opposite). **Painting from a copy of Firdusi's Shah-nameh** (Book of Kings), Shiraz, Iran. 1341. Made for the Vizir Hasan al-Kivam al-daula wa'l-din, vizir of the Inju rulers of Shiraz. *Shapur surprising a Chinese Woman at a Well.* 13 × 10¾ in. (33 × 27·3 cm.). Fogg Art Museum, Cambridge, Mass. This painting illustrates the typical features of the style of the Shiraz school in the Mongol period which differs fundamentally from that of the metropolitan style developed in Tabriz. There is a special emphasis on linear effect and the colours are thin, soft, and kept to a limited palette of reds, browns, yellows and soft blues. The paintings have often the quality of tinted drawings rather than actual paintings and they are sometimes rather sketchily, even carelessly executed.

39 (below). **Painting from a copy of Amir Khusrau Dihlavi's Khamsa.** India. Middle of the 15th century. *Majnun throws himself on Layla's tomb.* 5 × 8½ in. (12·7 × 21·6 cm.). Freer Gallery of Art, Washington D.C. This painting comes from a now dispersed manuscript which can be attributed to the Sultanate period in India on the basis of iconographic details which are typically Indian and do not appear elsewhere in Islamic painting. The intensity of colour and the bold, simple design are without immediate parallel outside India, while there seems to be an obvious link with contemporary Rajput painting. Contacts with both the Inju and Mamluk schools of painting may also have been equally instrumental in the creation of this particular style.

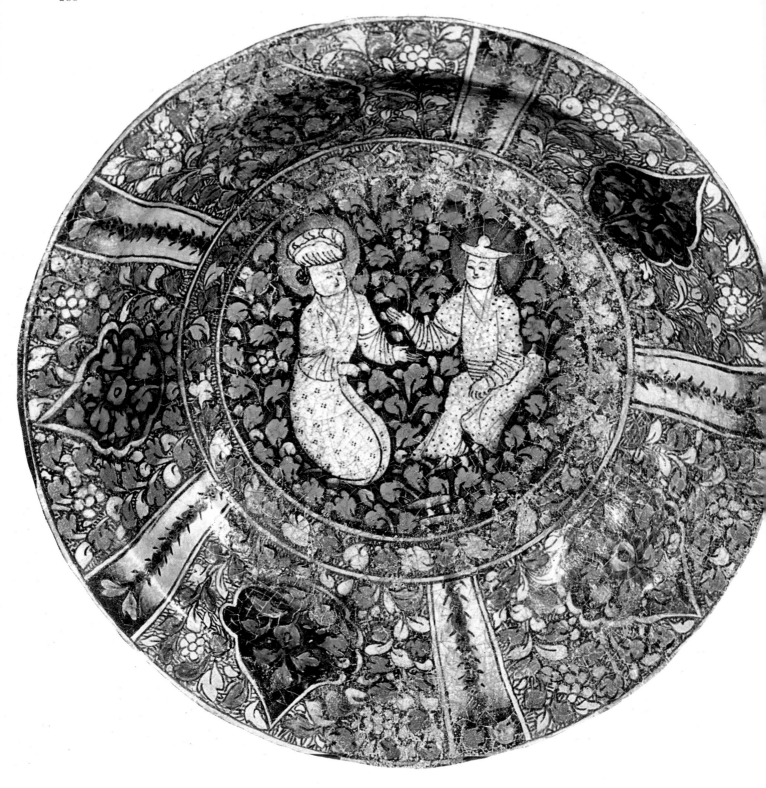

40. **Ceramic plate from Iran.** 14th
century. So-called Sultanabad district
ware. Underglaze painted decoration.
diam. 12¾ in. (33·6 cm.). Lehmann
Collection, New York. The representation
of human figures is rare on Mongol
pottery. The decoration of this plate is
typical of the so-called Sultanabad ware,
possibly of Kashan, in the use of two
colours, green and blue. The group of
figures is obviously taken from an
illustrated manuscript of the period, or
rather, executed by the same masters that
illustrated the copies of Rashid al-din's
History of the World and similar works of
the early Tabriz period of Mongol rule.

The Fatimids

After the fall of the Tulunids (905), a period of political chaos caused a rapid decline in the cultural life of Egypt. Only with the Ikhshidids (935–69) was order once more established so that a new development of the arts and crafts could begin. Then, during the period of Fatimid rule (969–1171), Egypt took the lead in the cultural life of western Islam.

The Fatimids, a Berber dynasty that had incorporated Egypt into their North African empire (formed at the beginning of the century, and subsequently lost when they removed the capital from al-Mahdiya, near Tunis, to Cairo), established an independent caliphate, being of the Shiah faction of Islam as opposed to the Sunnites of Baghdad. The Fatimids brought to perfection an artistic tradition that they had inherited from Iraq and from local Hellenistic-Egyptian art—figurative representation. In painting, wood and ivory carving, and even on glass, crystal, and textiles, a multitude of figurative subjects appeared that is unparalleled in Islamic art at that time.

ARCHITECTURE

Although nothing has survived of the two great Fatimid palaces in the centre of Cairo which faced each other across a large square, descriptions of them give some idea of their wealth and magnificence. The façade of the larger Eastern Palace—finished in 973—had nine monumental gateways. The Lesser, or Western Palace was completed only at the end of the century.

The earliest Fatimid mosque in Cairo, al-Azhar (970–2), although considerably altered in subsequent centuries, still retains enough of its original form to convey the special quality of early Fatimid religious architecture. The plan follows that of the standard Arab mosque, adopting the central, slightly elevated aisle in the prayer hall, emphasised through double columns that carry the pointed arches supporting the roof, and including two domes in front of the mihrab, a feature known from the mosque of Sidi Okba in Kairouan (Qairawan).

The great mosque of al-Hakim (996–1020), begun by his father but completed only in 1013, is an immense rectangle, with two tall minarets at the western and northern corners and the monumental main gateway between them. Other gateways appear in the centre of each side. The court is surrounded on three sides by open arcades. On the fourth is the large five-aisled prayer hall with an elevated central transept to the kibla and a dome in front of the mihrab. Similar domes appear in the southern and eastern corners of the prayer hall. The building closely follows the design of Ibn Tulun's mosque; the piers that support the roofs are even constructed in a manner similar to that of the earlier mosque with rough masonry, and one of the tie-beams in the transept is still decorated with an abstract floral pattern that follows directly the Tulunid tradition as derived from Samarra. Only very gradually did a new floral and particularly an abstract linear style of decoration develop. The new decoration can be seen on some carved stone orna-

E. **The Mosque of al-Hakim in Cairo.** 990–1013. Reconstruction of the original state (after Creswell). The Mosque of al-Hakim, following a tradition established in Egypt with the Mosque of Ibn Tulun, which in turn was directly derived from Abbasid Iraq (Samarra), is the outstanding example of religious architecture of the Fatimid period. Constructed mainly of stone, but also using brick as a building material, it combines and fuses the various building traditions in Egypt into a new unity. With its large scale, pronounced accent on the façade through a massive central gate-way and corner-tower minarets, the mosque achieved a monumental effect that was typical of Fatimid architecture.

26. **Conch-shell motif on the façade of the Mosque of al-Akmar, Cairo.** 1125. Fatimid architecture excelled in massive stone construction and large, blank surfaces placed in contrast to the deep-cut, powerfully carved design of an almost exclusively abstract nature. In its perfect balance of individual features and precise carving of both the conch shell motifs and the inscription bands, the façade of al-Akmar is a masterpiece of its kind.

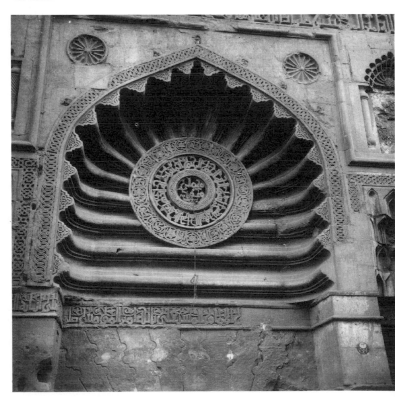

ments in the passageway leading through the main gate to the inner arcade and court.

Calligraphic elements became of great importance in architectural decoration; inscriptions appear around the windows and niches in narrow framing bands. The minaret towers in particular—one cylindrical, the other octagonal on a square base—are decorated with bands of kufic writing, abstract interlaced patterns and open grill windows.

One of the finest examples of this new and vigorous style of stone carving in architectural decoration is the façade of the mosque of al-Akmar which was completed in 1125. The façade, part of which is hidden today by modern houses, is characterised by a highly abstracted angular *26* version of the conch shell motif known from late antiquity and used in a large number of early mihrab niches. The particular form used here had been developed in Egypt, it seems, and can be specifically associated with the Fatimid period. Along the top of the façade is a beautifully carved inscription. A second narrow inscription band runs below. Minor decorative elements, such as small disks or squares filled with abstract ornaments, complete the simple but impressive design.

POTTERY AND PAINTING

Fatimid painting is mainly known through figurative decoration on pottery. Outside of Egypt a single major monument produced by Fatimid artists, has survived, the ceiling *12, 28* of the Cappella Palatina in Palermo.

Little is known about Egyptian pottery before the Fatimid period. The Tulunids had apparently imported potters from Iraq and with them a tradition of fine ceramic making was introduced. Fatimid vessels, mainly fairly large bowls and plates, are solidly made, nor are the shapes very elegant. The glazes, of a creamy white, are thick and tend to crack and dull easily. The main interest of this pottery lies in its decoration, painted in deep brown lustre. A variety of *27* floral and figurative patterns of great beauty demonstrate clearly the transmission of the Samarra style to the West.

A number of different styles can be distinguished and even artists' names are known. Although dated pieces are virtually non-existent, a certain chronology can be established. The earlier style follows exclusively the Samarra tradition in its heavy outline drawing, simplicity of iconography and conscious contrast between the main object of representation (usually a single figure) and the decorative background. The main motif is set off by irregularly shaped panels that follow the outline of the given figure represented, using up the undecorated space of the background, not dissimilar to the 'clouds' that fill out the space of the page in later forms of calligraphic exercises or in illuminated texts. These irregular filling elements or 'clouds' are decorated with abstract ornamental motifs, a peacock-eye pattern being most common, which was derived directly from the early polychrome lustre painted pottery of Samarra.

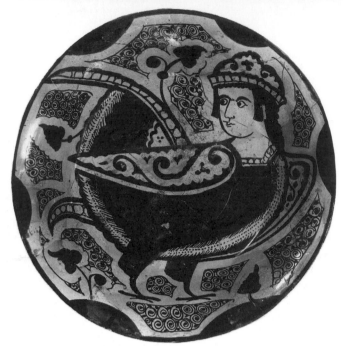

27. **Ceramic bowl with lustre-painted decoration from Cairo.** 12th century. diam. *c.* 12 in. (30·5 cm.). Museum of Islamic Art, Cairo. Fatimid painting survives mainly on lustre-painted pottery. The figurative style derives from Samarra painting. Although lively and realistic in detail, the subject-matter is often organised into formal, heraldic patterns.

28. **Painting from the ceiling of the Cappella Palatina, Palermo,** Sicily. Painted by Fatimid artists in 1142. This is one of numerous paintings on the wooden ceiling of the Cappella Palatina. There are also many scenes of court life in which the symbolisme and decorative motifs are equally typical of Roger's Sicily, Frederic's Aqulia, Fatimid Egypt, or Abbasid Iraq. The Cappella Palatina paintings are, in fact, eloquent proof of the cultural unity of the Mediterranean region in the 12th century.

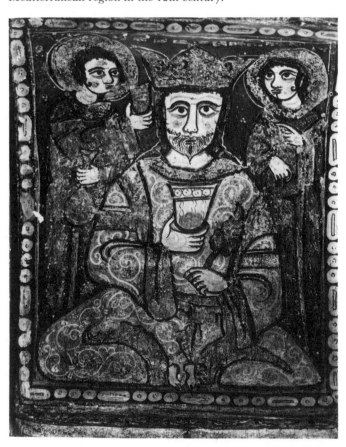

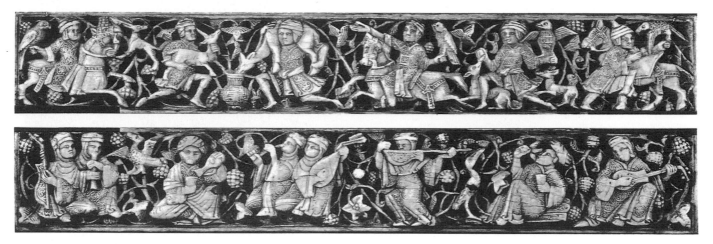

29. Two panels from a casket with carved decoration.
Ivory. 12th century. Egypt. *c.* 10 × 2½ in. (25 × 6·4 cm.).
Staatliche Museen, Berlin. Entirely Abbasid in tradition, the
figures of musicians and hunters on these small ivory panels
demonstrate once more the importance of cultural contacts
between the Fatimid and the Abbasid courts. The figures have a
remarkable freedom of movement, the faces an intense
individuality.

The second style is probably largely dependent on a
tradition of book painting developed in Iraq and Syria
from hellenistic models. Nothing of the contemporary
painting of this type is known directly, as the earliest surviv-
ing manuscripts made in Baghdad and in Syria date only
from the early 13th century. These, however, undoubtedly
follow a tradition first established in the 9th and 10th
centuries. At any rate a school of Islamic hellenistic paint-
ing must have existed in Egypt in the 12th century because
of the appearance of this second style in Fatimid lustre
pottery.

It is characterised by a general movement away from
traditional Iraqi iconography and by a new interest in
everyday life. The pottery bowls are usually decorated
with elaborate and very lively scenes, with groups of
people engaged in various activities: carrying loads, wrestl-
ing, working, conversing or fighting, etc. The figures in
these scenes are drawn in a sketchy, at times almost im-
pressionistic manner and there is no heavy, defining out-
line. There are few decorative details in the background
and secondary motifs are rare. The most striking feature,
apart from the obviously different pictorial tradition, is the
great realism and direct observation suggested by the
everyday subject-matter. This pottery is of interest in that
it preserves a style of figurative representation which gives
us a good idea of what the wall and book painting of the
Fatimid court school in Cairo must have been like, al-
though no actual examples survive.

Fatimid painting seems to have rivalled the painting of
the court in Baghdad and a report of a competition be-
tween an Iraqi and an Egyptian painter, in the middle of the
11th century has survived. At the invitation of Yazuri, the
Vizir of the Fatimid caliph al-Mustansir, the two painters
were asked to represent a dancing girl in a niche in a wall in
such a way as to make her appear either coming out of a
doorway or entering it. The problem was solved by both
painters in the same fashion, that is through a skilful use of
colour, contrasting the colour of the girl's dress with that
of the background. The Egyptian painter won. The story
demonstrates the high esteem in which painting was held
at the Fatimid court and it shows that there was apparently
no difference in style between Baghdad and Cairo at the
time — a fact amply borne out by the painting on pottery.

The painting on the ceiling of the Cappella Palatina, the
chapel in Roger II of Sicily's palace which was completed **12**
in 1140, are in most important details identical to the style
of Samarra. They must have been executed by Fatimid
painters whom Roger II had brought to Sicily. Among the
great many scenes of courtly life in the Cappella Palatina
paintings, we find all the typical features of Iraqi tradition.
The ruler is represented frontally with his ceremonial wine **28**
cup in his left hand, flanked by attendants. All have full
round faces with enormous almond-shaped eyes, and all
are shown frontally in the late classical manner, inherited
from the Central Asian hellenistic tradition.

CARVING AND THE 'INFINITE PATTERN'

Some other forms of Fatimid art are equally indebted to the
Abbasid tradition. Wood and ivory carvings, for example, **29**
which were produced in large numbers and were of high
quality, followed a tradition already established under the
Tulunids, the iconography being derived almost exclusive-
ly from Abbasid court art.

At the same time a form of abstract ornamentation of
larger surfaces was developed which was to become one of
the most successful forms of abstract Islamic art. Based on
the simple principle of infinite systems of linear patterns
that, being superimposed one upon another, create geo-
metrical forms, stars, polygons, and triangles, these designs
for the first time developed fully the most fundamental of

30. **Mihrab from the Mausoleum of Sayyiddah Rukhaiyah.**
1154–1160. Wood. $82\frac{3}{4} \times 43\frac{3}{4}$ in. (210 × 111 cm.). Museum of
Islamic Art, Cairo. While the floral and figurative elements in
Fatimid art were very realistic, a style of linear abstraction was
also developed that found its strongest expression in the
decoration of wooden objects for religious buildings: minbars,
mihrabs, doors, kursis, etc. This mihrab is one of the best
preserved examples of a style that has a long history in Western
Islamic art, reaching Seljuk Anatolia and the Atabek territories,
and finally, after the 13th century, all parts of the Muslim world.

31. **Bronze figure of a griffin, Egypt.** 11th–12th century.
c. 59 in. (150 cm.). Campo Santo, Pisa. Animal sculpture, rare
in Islamic art, seems to have been developed first in Umayyad
Spain and Fatimid Egypt. The Pisa Griffin is outstanding for
its highly decorative ornamental detail and the beautifully
sensitive shape of the animal's body. Bronze sculptures
like this probably served as models in Seljuk Iran for
similar but generally much smaller sculptures in the later
12th and 13th centuries. Many Fatimid craftsmen migrated to
Iran after the fall of the Fatimid dynasty in 1171.

all Islamic design concepts, that of the infinite pattern. The
infinite pattern becomes so much a part of all Islamic art
that one easily overlooks the fact that it was not created
accidentally out of a general desire for abstraction or to
solve the 'dilemma of a basically iconoclastic civilisation' as
Islamic civilisation has often been wrongly interpreted.
That figurative art existed at all times in Islamic art is by
now self-evident. But it was in the same Fatimid period, so
rich and varied in its figurative art, that the abstract linear
pattern was developed, being used particularly for stone
carving, architectural decoration, and the woodcarving of
30 mihrabs, minbars and doors, which could just as easily
have been decorated with figurative scenes as are the tie-
beams of the western Fatimid palace, which are entirely
decorated with court scenes and animals. The Fatimid

woodcarver excelled equally in the design of floral patterns
and arabesque compositions that often continue directly
the earlier Samarra tradition.

OTHER DECORATIVE ARTS

Of the decorative arts little besides pottery has come down
to us. The treasures of the Fatimids must have been extra-
ordinary and they have been extensively described. Gold
objects and precious stones and jewellery seem to have
existed in great quantities, and the few surviving magnifi-
cent wood and ivory carvings as well as some crystal cups
and ewers that were made in Cairo in the 10th and 11th
centuries demonstrate the high level of the arts and crafts
of the Fatimid capital.

Of Fatimid metalwork very little seems to have survived,

33 (right). **Glass beaker with cut relief decoration from Egypt.** 12th century. h. *c.* 5 in. (12·7 cm.). Veste Coburg Collection, Northern Bavaria. The best example of cut glass to have survived, this beaker imitates the more difficult technique of rock crystal carving. With its powerfully angled cutting it comes amazingly close to achieving the effect of cut crystal.

32. **Rock crystal ewer from Cairo,** Egypt. 10th century. Inscribed with the name of the Fatimid Caliph Al-Azis Billah (975–96) h. 7 1/16 in. (18 cm.). Tesoro di San Marco, Venice. This magnificent ewer is generally considered to be the masterpiece of a small group of pear-shaped rock crystal ewers with carved low relief decoration. As the inscription makes clear, it was made for the ruler himself and must have been fashioned by one of the leading masters of the royal workshops in Cairo.

apart from a few small bowls and ewers. All the more striking, therefore, are a number of cast bronze animal figures of which the most impressive is of monumental size and superb workmanship. The large griffin in the Camposanto in Pisa is probably one of the most ambitious pieces of cast metal ever produced by Muslim artists.

Rock crystal carvings seem to have been produced already in Tulunid times but the pieces that can safely be ascribed to that period are all small in scale and show purely abstract arabesque patterns in low relief. With the general development of a figurative style in the Fatimid period rock crystal beakers and ewers were decorated with a variety of animal groups among delicately designed arabesques. Some of these pieces are of exquisite workmanship and superb design. These objects were so much esteemed in the Muslim world that they gave rise to a school of cut glass in Iran that imitated, often quite successfully, the special effect of the carved rock crystal.

Embroidery and tapestry work of exquisite quality were made in Egypt at this time, employing mainly abstract patterns, using much gold, and some red. The most attractive examples are those that follow again the general line of figurative iconography.

Under the Fatimids the highest point in western Islamic art was reached, combining a variety of different traditions in a unique way only rivalled in the West by Spain. In the use of architectural forms both of the classical decorative and eastern (Iraqi) tradition, and in the application of classical decorative and eastern Islamic figurative forms to every kind of surface, the Fatimids created an art that in its beauty and interest is outstanding in the whole history of Islam.

The Art of the Seljuk Turks in Iran

Among the many local dynasties that had established themselves in the eastern part of the Muslim empire and gained more and more strength and importance as the central power of the caliphate declined, the Seljuk Turks, one of the groups of Turkish peoples that had migrated into Iran with the Ghuzz tribes of Central Asia, gained superiority and finally control of Iran in the middle of the 11th century, wresting control from the Buyids. Nominally protectors of the caliph in Baghdad, the Seljuks created an independent kingdom in Persia. During their reign, which lasted until the Mongol conquest in the early 13th century, Iran saw its highest form of cultural development in Islamic times. The art of the Seljuk Turks, who took over Anatolia in the 12th century, dominated most of the Muslim world in the 12th and 13th centuries.

ARCHITECTURE

The Seljuks were great builders. During their reign a number of classical architectural forms were established which persisted in Iran practically into modern times. Earlier Iranian mosques had followed the Arab model, but this plan was now changed in accord with the ancient Iranian tradition to a four-ivan court mosque, introducing the ivan-hall and dome chamber design of pre-Islamic Iranian palatial architecture. In the centre of each side of the courtyard a large ivan-hall is inserted that interrupts the two-storey running arcades. The prayer hall ivan, often considerably larger than those of the other three sides, runs into a square dome chamber in front of the mihrab emphasising the kibla.

The most important surviving mosque of this type is the Masjid-i Jami in Isfahan, built by order of Malik Shah (1072–92). Massive ivan-halls appear in the centre of the long sides, with a long, tall ivan-hall behind the entrance. Opposite it at the far end of the large court is the huge prayer hall ivan and dome chamber. Inside the enormous dome that surmounts the high, square chamber is an inscription in Kufic characters carried out in brick showing Malik Shah's name. Above the chamber itself are ingenious rows of blind niches with pointed arches which transform the square into the circle of the dome. This becomes the standard design for the intermediary zone and appears

34. **Dome of Malik Shah, Masjid-i Jami, Isfahan, Iran,** 1080. The Masjid-i Jami of Isfahan is probably the major monument of Seljuk architecture in Iran. Although not the earliest building of its kind, it is certainly the most sumptuous and monumental, and provides a model for almost all later mosque buildings in Iran. The main dome, above the chamber in the prayer hall in front of the mihrab, was raised by order of Malik Shah in 1080. Its classical form, pure and perfect in outline and devoid any decoration, is testimony to the particular concept of architectural form developed by the Seljuks in Iran.

with variations in all major buildings of the period. The new features exemplified in this building were later to serve as models for Mongol architecture.

The Seljuks developed a great number of architectural forms, notably the religious school complex (madrasah). This consisted of an open court surrounded by rooms, small ivan-halls that served as class-rooms, and often a domed chamber mosque on one side. Many tomb towers and shrines were built and numerous monumental mosques of which only a few survive intact, either because they were destroyed or because they were modified at later periods. The great mosques of Ardistan, Gulpayagan and Kazvin (Qazvin) still retain large parts of their original form, particularly the kibla-ivan-dome-chamber sequence.

ARCHITECTURAL DECORATION

Architectural decoration reached an especially high level. Although plasterwork, decorative brick-laying, or applied brick patterns had been used before, especially in Central Asia, it was only in the Seljuk period that these techniques, especially plaster decoration, were used on a monumental scale in Iran. Large surfaces of architectural structures are coated with plaster into which ornament is cut or moulded, and entire mihrabs are made out of plaster with elegantly designed inscriptions, frames and cornices, border bands, and magnificent floral filler ornament.

The most important of all architectural decoration developed in Seljuk times is the use of glazed brick- and tile-work. The lustre-painted tiles of Kashan, the main centre of pottery in the 12th and 13th centuries, were the result of centuries of experimentation. It may be remembered that in the Jausak al-Khakani palace in Samarra, lustre-painted tiles were used for wall decoration. But while there the polychrome and pictorial aspect of the tiles was still dominant, in the lustre tiles of Kashan a complete fusion between pictorial art and architectural effect was achieved. Lustre-painting with its extraordinary sheen outstrips any other medium of architectural decoration in its ability to dissolve the solid masses of architectural structures. Only lustre can create a complete optical illusion of insubstantiality. In reflecting light and making the surface of a wall shine like glass or gold, the effect of lustre-painted tiles is virtually to dissolve the matter that carries it—clay, mortar, brick and stone.

POTTERY AND PAINTING

Although important schools of pottery had previously been developed in Abbasid Iraq, Samanid Khurassan and Central Asia, and Fatimid Egypt, it was only in Seljuk Iran that pottery became a major art-form. Many different types were developed using highly sophisticated techniques. Among these the most important, as in architectural decoration, is that of lustre-painting. The technique was almost certainly imported from Egypt, from where Cairo potters had migrated in large numbers to the Seljuk court in Rayy in search of new employment after the fall of the

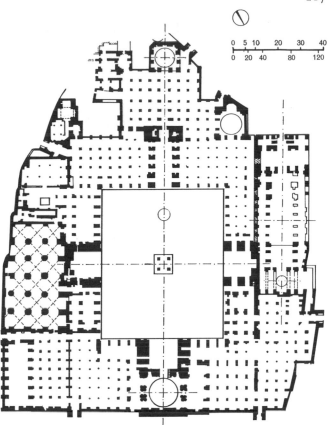

F. Plan of the Masjid-i Jami, Isfahan.

35. **View of the squinch in Malik Shah's dome chamber** in the Masjid-i Jami, Isfahan, Iran. 1080. This view, showing the link between the square plan of the dome chamber and the circle of the dome, taken from directly below the corner squinch, shows clearly the ingenious and complex way in which the problem of transition was solved. This form of squinch becomes standard in all later Iranian architecture.

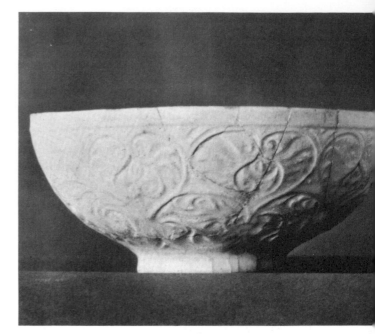

36. Ceramic plate with lustre-painted decoration from Rayy, Iran. 13th century. diam. 16⅝ in. (42·2 cm.). Metropolitan Museum of Art, New York. The plate preserves in its lustre-painted decoration a typical motif of official court painting of the early Seljuk period otherwise almost entirely lost. The princely couple of the characteristic Seljuk type is one of the favourite subjects of ceramic painters of the period and appears on many vessels and tiles particularly in lustre but also in underglaze painting.

37. Ceramic bowl with carved design from Iran. First half 12th century. diam. 6½ in. (16·5 cm.). Victoria and Albert Museum, London. Among the many monochrome glazed wares produced in the Seljuk period in Iran those with pure white surfaces are undoubtedly the most beautiful. With the carving and moulding of the ceramic body a very light relief pattern was created on the surface of the vessels, usually of a highly abstract character but almost always deriving from some plant form.

Fatimid dynasty in 1171 and the rapid decline of art and culture.

With their arrival, pottery making in the East changed completely. They not only brought the secret of lustre-painting; they also taught the Persians to make a new artificial ceramic body of quartz and other glassy matters, very similar to the material from which the glazes themselves were made. This created a much closer bond between body and glaze. Alkaline glazes, so far unknown in Iran, were also developed and made true under-glaze painting possible.

Most important and most immediately derived from *36* Fatimid Egypt is the lustre style of Rayy, near Teheran. The same Fatimid concept of figurative decoration against a solid lustre ground is found at Rayy. There is a clear contrast between light and dark, decorated and un-decorated areas, a conscious division between motif and background. The pictorial style obviously developed under the direct supervision of the Seljuk Turks. Facial features are entirely un-Iranian. The people represented are Central Asian Turks, such as are encountered for the first time in the 6th- and 7th-century paintings of Manichaean Turks in the Turfan area.

There are court scenes—princes and ladies of the royal household in gardens (shown by simple floral scrolls), horsemen hunting with falcons, playing polo or in battle.

Some pieces are decorated with small-scale arabesque patterns or animal friezes in lustre on a white ground.

Bowls of various shapes, plates, small ewers, bottle-shaped vases, and jugs range from thick, heavy ones to fine and delicate pieces. A large, flat, narrow rimmed heavy plate is quite common, usually decorated with large figures or animals with the outside often glazed a deep cobalt blue. Another typical shape is a small thin-walled light bowl with a narrow base and steep, slightly curved sides. Such pieces are often decorated with a single seated figure, or a series of small figures around the rim and a small group in the centre.

Tiles were also made in Rayy and although monochrome glazed tiles of a magnificently brilliant turquoise blue are more common, lustre tiles have survived in considerable numbers.

The second lustre style of the Seljuk period was that of the workshops of Kashan, especially famous for lustre- **18** painted tiles, decorated both with abstract floral and figurative designs, and known as *kashis* or *kashanis*. Many major buildings were decorated with kashanis, and mih-rabs were made from moulded, glazed and lustre-painted tile panels. The Kashan lustre style is of a peculiar and un-mistakable nature. All elements of the design form one intricate pattern creating an all-over, uniform effect. The background behind the floral, animal, or human forms is usually covered with solid lustre which is in turn decorated with dense incised patterns of fine spirals or short, curved lines and dots that break up the solidity of the brown lustre. Then every part of the actual design against this lustre

Author's note: the attribution of various manners of lustre painting on Seljuk pottery to Rayy and Kashan should now be attributed to the workshops of Kashan.

38. Ceramic vase with moulded relief design from Iran.
13th century. h. 25¾ in. (65·4 cm.). Freer Gallery of Art,
Washington D.C. Large pieces of pottery are uncommon in
Islamic art and it was only during the Seljuk period in Iran
that elaborately decorated pieces, combining relief moulding,
monochrome glazing, painting and gilding, were produced. This
piece is notable for the figures which appear in the relief
decoration.

39. Head of a Seljuk Prince. Part of a statue of stucco. Iran,
12th century. h. 10 in. (25·4 cm.). Metropolitan Museum of Art,
New York. Sculpture in the round is rare in Islamic art either in
the East or West. In this portrait of a Seljuk prince a facial type
can be recognised that was to become characteristic of Eastern
Islamic art throughout the 12th and 13th centuries. Although
highly stylised, it is undoubtedly based on the typical physical
features of the ruling class—the Seljuk Turks.

background is covered with similar patterns, painted in
lustre so densely and minutely that a distinction between
background and object is often difficult. Only the faces of
the groups of human figures remain as small, clear white
areas within the all-over design. Many tiles and vessels
decorated in this style are inscribed and dated, unusual in
medieval Islamic pottery. Kashan lustre ware continues
into the 14th century and carries a major Seljuk tradition
into the Mongol period.

Among many Seljuk ceramic wares that cannot with
certainty be attributed to any one pottery centre, the so-
16 called *minai* ware deserves special attention. This very fine,
delicate ware is one of the most beautiful types of Islamic
pottery. A polychrome, overglaze painted pottery, it seems
to have been made throughout the 12th and 13th centuries.
The style and subject-matter of its predominantly figura-
tive decoration reflect the otherwise almost entirely lost art
of Seljuk book and wall-painting. The variety of shapes of
the usually small and carefully made pieces, little bowls,
ewers, cups, vases, bottles, and plates, is amazing. Equally
varied are the brilliant colours, set off against an either buff
white or blue background. The richness of iconographic
detail is impressive evidence of a strong trend towards

figurative expression in Eastern Islamic art. Although most
minai pieces are small, a few monumental pieces exist.
Among them the large plate in the Freer Gallery in Wash- 17
ington is undoubtedly the most important. Its unique dec-
oration, an elaborate battle scene showing the siege of a
city by a large army led by a cavalcade of horsemen, is
probably taken from a wall-painting in the royal palace,
famous in its time. The reverse side has a large-scale group
of huntsmen in a forest and a variety of real and fantastic
animals. The facial type is again that of the Central Asian
Turks. The same slanting eyes, straight noses, minute
mouths in full round faces, the same long, black hair falling
in full tresses on their shoulders.

Only a single manuscript of this school of painting and a
few fragmentary wall-paintings have survived. The manu-
script of the *Warkah wa Gulshah* poem in Istanbul is un- 19
dated and gives no indication of where it was made, except
for the mention of the painter's name with a nisbah (usually
considered to show the origin of a person, but frequently
also a reference to a person's residence) that points to
Eastern Anatolia. The style of the paintings that illustrate
this text leave, however, no doubt as to its origin in the
12th-century Seljuk territory.

40. **Brass cup-bowl with silver inlay design,** the 'Wade Cup' from Iran. Early 13th century. diam. 6⅜ in. (16·5 cm.). h. 4½ in. (10·5 cm.). Museum of Art, Cleveland. One of a group of high stem cup-bowls, this piece is especially interesting because of its unusually elaborate figurative rendering of the inscription around the rim, and the intricate zodiacal patterning of the small diamond-shaped fields formed by an interlace band running over the body. The transformation of calligraphic forms into figurative decoration seems first to have been developed in the 12th century on metalwork in Central Asia and Khurassan from where it spread to the rest of Iran.

The paintings in the manuscript follow the same principle as those on minai pottery. Tightly packed scenes full of action and with many small figures engaged in battle or argument; few scenes have single figures and then they are almost always imbedded into a solidly coloured background or complex architectural framework. Only rarely do single figures or single objects stand alone in open, uncluttered space. Although this is a romantic-poetical text and does not really call for the inclusion of any royal iconography, there are scenes that give glimpses of that part of Seljuk pictorial art.

Scenes of court life and the royal entourage abound, however, on minai pottery which often recalls book illustration. A famous piece is a small beaker in Washington with scenes from the *Shah-nameh*. There are bowls with scenes showing Bahram Gur hunting, Dahhak being led away, single scenes from Firdusi's poem, which seems to have been a popular subject.

Possibly by the middle of the century a polychrome overglaze painted pottery was developed known as *Lajvardina* ware, easily identified by its deep cobalt blue background painted with abstract linear and floral designs in gold and red. This ware persists into the 14th century and belongs technically speaking to the Mongol period but so many

Seljuk art forms continued into the post-Seljuk period that strict divisions are difficult.

The pottery decorated with incised and carved design is extremely accomplished and has figurative decoration—mainly animal motifs—of the finest quality. Its balanced linear incised design is also seen in Seljuk metalwork. A particular type using carved, incised or moulded relief motifs, and specialising in monochrome glazes is of great beauty and interest. Brilliant turquoise blue, deep cobalt blue, an purplish colour of various shades, and white are the principle colours. Sometimes different colour glazes are used together, predominantly cobalt blue and white, white being the main colour, with details picked out in blue. The incised designs are largely abstract-floral. They often penetrate so deeply that they pierce the thickness of the walls of a bowl or a ewer. In some cases, small holes are pierced along the outlines of designs or all over the background. These minute openings are filled by the heavily running glaze and remain translucent when held against the light giving an appearance of translucency which the pottery does not actually have. With this technique the quality of the Chinese porcelain which could not be made in the Islamic world because of the lack of kaolin clay was imitated. It continued in use throughout the history of Islamic

41. **Engraved silver plate from Iran.** Made by Hasan al-Kashani for Sultan Alp Arslan in AH 459 (1066 AD). Diam. 17 in. (43·2 cm.). Museum of Fine Arts, Boston. This large silver platter, engraved with an elaborate arabesque and animal design above and below the bold inscription in the centre, is inscribed with the name of Sultan Alp Arslan (1063–1072) the second of the great Seljuk rulers of Iran. With a silver candlestick in the same collection it comprises a most important group of silverwork from the early Islamic period in the East.

pottery still being employed for 17th-century Persian white wares.

Among the moulded wares a group of monumental pieces stand out. These are very tall vases moulded in various registers in various degrees of relief and glazed either in deep cobalt or light turquoise blue. The most magnificent piece is again in the collection of the Freer Gallery in Washington and excels not only in a very high relief and perfect modelling of the individual features but also in the fact that its decoration is largely figurative. The entire surface seems furthermore to have been gilded. Other vases and moulded ware all share the stylistic features of Kashan.

A variety of other ceramic wares was produced in Seljuk Iran which, on the evidence of a unique medieval text describing the Kashan workshops, can also be attributed to that city. The most important ware has figurative patterns painted in black under a turquoise glaze. Many pieces are very similar to lustre-painted ware but some are extraordinary examples of the extremely difficult technique of openwork. They have a double shell, the inner one serving as the actual container while the outer one is pierced and cut out in a fashion that is more like metalwork than pottery.

SCULPTURE

Sculpture is generally rare in Islamic art, especially sculpture in the full round. But some of the stucco sculptures that survive from the destroyed palaces of Rayy come close to monumental proportions and are in part, particularly in the heads of human figures, worked almost in the full round, even though the figures always remain attached to the wall. Sculptural forms in the true sense have been developed, however, in other media, notably pottery and metalwork, and to a lesser degree in glass and ivory. A large number of pottery figurines survive which date mainly from the 12th and early 13th centuries. Many are hollow and serve utilitarian functions such as jugs, vases, or candlesticks, but others are made of solid clay, glazed in deep cobalt or light turquoise blue, with painted under-glaze or lustre, and modelled often with great sensitivity for their human or animal form. These objects are truly small sculptures, some continuing a formal tradition that reaches far back into pre-Islamic times.

METALWORK

The most important element of Seljuk metalwork, the enrichment of the metal surface, bronze or brass, through silver inlay, goes back to pre-Seljuk times, although it was

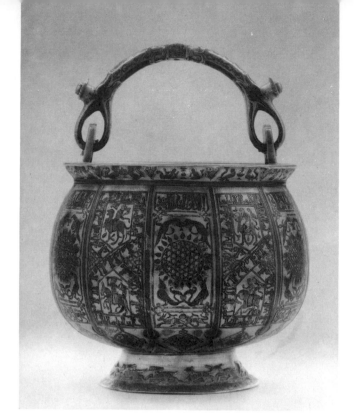

42. Bronze bucket from Iran. Made by Muhammad ibn Nasir ibn Muhammad al-Harawi. 12th century. h. *c*. 10 in. (25.5 cm.). Hermitage, Leningrad. This bucket is closely related in shape to the more famous Bobrinski Bucket but different in its unusual organisation of the surface into rectangular panels alternately filled with interlace band motifs and star-rosettes surrounded by animals. It is an excellent example of the flourishing school of metalwork in Khurassan. Highly original in its general design and individual detail, the piece demonstrates the various possibilities in metal design in the early Seljuk period.

43. Incense burner in form of a cat. Made by Jafar ibn Muhammad ibn Ali in 1181. Bronze with openwork decoration and engraving. h. 33½ in. (85.1 cm.). Metropolitan Museum of Art, New York. This Seljuk bronze incense burner is unusual both in its size and its quality. It can best be compared with the Fatimid bronze griffin in Pisa (figure 31). The extraordinary ornamentation of the animal's body which is entirely perforated in an elaborate palmette design, contributes to the dematerialising effect that the general ornamentation of the bronze surface is obviously meant to achieve. Generally thought to be of Iranian workmanship, it may be that the piece was actually made in Iraq or Syria.

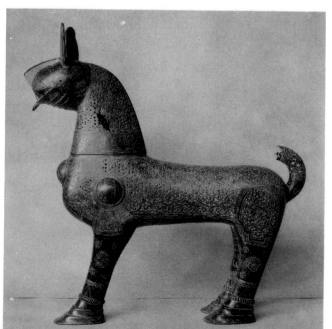

never developed very far before the 12th century. Early bronzes, of which a good number survive, have only engraved designs, usually limited to a few inscriptions, floral scrolls and arabesque patterns. *41*

The most famous among the early silver inlaid metal pieces is the so-called Bobrinski bucket in the Hermitage **14** made by Muhammad ibn Abd al-Wahid and Masud ibn Ahmad in Herat in 1163 for a rich merchant. This bucket closely follows earlier pieces in shape and general treatment *42* but it has abandoned the simple form of engraved decoration for an elaborate design in silver inlay at once abstract, calligraphic and figurative. This is the first silver inlaid piece that can with certainty be associated with a bourgeois milieu. Although largely following court iconography in its figurative decoration—drinking, hunting, and sporting scenes—it is not made for a prince or a noble of the realm but for a man who in his new wealth obviously attempted to imitate the grandeur and leisure of courtly life. The object is therefore doubly interesting and a perfect example of the taste and style of the day.

Seljuk artists created a number of impressive sculptures in bronze. Most of these pieces are aquamaniles or incense burners—utility objects, but with such a perfection of line and balance of shape in arrested movement that they may truly be called sculpture. They are usually decorated with fine incised patterns of semi-abstract floral nature, and in some instances bodies of feline animals or birds which are *43* perforated, again with floral patterns, forming a kind of lacework through which the incense could escape. Such an object in action must have been one of the most perfect realisations of the Islamic ideal of dissolving matter through artistic means.

The period of Seljuk rule in Iran (and Anatolia) is probably the most important of early Islamic culture. Fundamental forms of architectural design are developed and permanently formulated for later periods. The most important are the four-ivan court mosque, and the madrasah on a similar plan—also standard forms for tomb towers and square-plan domed mausolea, which, although going back to pre-Seljuk times, are fixed in their traditional designs for Eastern Islam only in the 11th century under the Seljuk Turks.

An enormous expansion of figurative representation and the development of an iconography based on Central Asian models, resulting in the creation of a special representational type for the ruler's image and another for the ruling class, is probably the most interesting achievement of the period. A vast territory, stretching from Central Asia to the Bosporus and the centre of Syria, is united in one culture that dominated both eastern and western Islam for at least a century after the downfall of the Seljuk rulers in Iran.

The Art of the Seljuk Turks in Anatolia

Anatolia was conquered by the Seljuk Turks and an independent dynasty established in 1078 with Sulayman ibn Kutlumish (1078–86) who became governor after the battle of Manzikert in which the Byzantines were decisively defeated. Konya in Central Anatolia became the capital during the reign of Masud I (1116–56). It was during the 13th century under the rule of Kay Khusrau and his successors, Izz al-din Kay Kaus I and Ala al-din (Alaeddin) Kay Kubad, that the Seljuk culture flourished in Anatolia reaching its peak in the mid-century when the Seljuks of Iran had already been annihilated by Chingiz Khan and those of Anatolia were engaged in a losing battle against the invading Mongols.

After the defeat of Kay Khusrau II's army in 1242, the Seljuks became vassals of the Mongol ruler of Iran. The result was a rapid decline of Seljuk power in Anatolia and the eventual collapse of a central government. Turkoman invasions and internal struggle weakened the realm and after a period of anarchy, the Seljuk line became extinct at the beginning of the 14th century.

Seljuk art in Anatolia, although closely related to that of Seljuk Iran, developed a very definite character of its own. Different forms of mosque, madrasah and *türbe* (tomb tower) were created and the *caravansarayi*—a resthouse for caravans and their entourage—was fully developed. Techniques and forms of architectural decoration were introduced that number among the most original and successful in Islamic art and were of great significance for the further development of western Islamic art and architecture. Much of the difference between Seljuk art in Anatolia and in Iran stems from the different cultural traditions in Anatolia. Byzantine and Armenian stone architecture provided the new rulers with a wealth of models and ideas and the country was rich in building materials. Much therefore survives of Seljuk architecture in Anatolia while little survives in Iran. But the pictorial tradition, judging from the exceedingly scanty remains, seems to have been identical and other art forms, such as lustre-painted and polychrome over-glaze painted tilework, also testify to the basic cultural unity of both regions in the 12th and 13th centuries.

ARCHITECTURE

The court-ivan mosque does not seem to have been favoured in Anatolia. The majority of surviving mosques have no court and focus on a multiple support prayer hall with one or more domes at the kibla wall. This domed area is not closed off as in the Seljuk mosques of Iran but forms an integral part of the design. From this the unified central dome of the Ottoman Turkish mosque develops.

In the Alaeddin Cami in Nigde (1223) three domes are placed at the kibla wall, corresponding to the three aisles of the prayer hall. In the Ulu Cami in Divrigi (1228–29) a single dome with a pointed tent roof on the outside appears in front of the mihrab at the end of the central aisle, slightly wider than the double aisles on either side. An important feature of these buildings is also that they are more often organised in a longitudinal direction rather than in the traditional lateral direction of the Arab mosque.

The Alaeddin Cami in Konya, founded by Rukhn al-din Masud (1116–56) but with modifications by subsequent rulers, consists of an irregular enclosure with an irregularly shaped prayer hall to the south and a court to the north. In front of a smaller prayer hall to the west, probably the oldest part of the building, (between 1156–92), appear two polygonal türbes, of which one is the sultan's mausoleum. This smaller prayer hall has a dome chamber tract that recalls somewhat Seljuk designs in Iran but the square room in front of the dome does not open in the form of an ivan to the court but to a long lateral aisle along the entire prayer hall. The prayer hall is closed to the court—a later addition—and actually separated from it by the türbes. The entire eastern part of the mosque, its large prayer hall with eleven aisles running parallel to the kibla wall and a court which again does not communicate with the prayer hall belong to the final building period of Alaeddin. Even though there are a court and a prayer hall in this design, their relationship is of an entirely different nature from that of the Arab or the Seljuk mosque in Iran. The court becomes a kind of atrium or plaza in front of the closed mosque and even though domed rooms are included there is no access to them from the court. An imposing entrance to the court becomes pointless and disappears, and instead there is a general elaboration of the exterior of the building with façades and gateways. This did not happen in Iran but was widespread in Seljuk Anatolia.

There are two types of madrasah in Seljuk Anatolia: the open court madrasah, as known in Iran, Iraq and western Islam, and the closed dome chamber madrasah, which seems to be a Seljuk development in Anatolia. The latter type dominates among the surviving 13th-century buildings, although major examples of the open court four-ivan madrasah also exist.

Of the dome chamber madrasah, the Karatay Madrasah and the Ince Minare, both in Konya, are undoubtedly the most perfect, built on a simple square plan with a large central room, surmounted by a monumental dome and flanked by oblong rooms. Smaller corner dome chambers are placed at the rear right and left of an ivan-hall opening onto the central dome chamber. Both buildings excel in rich decoration with glazed brick and faience mosaic both outside and inside, and count among the most remarkable achievements of Seljuk architecture in Anatolia. The Karatay Madrasah, built by Celaleddin Karatay, grand vizir of Kay Kaus II, in 1251, has one of the finest surviving marble portals with marbles of different colours and precise, linear relief carving, while the Ince Minare, built by Fahr al-din Ali in 1258, has in its carved light-red stone façade one of the most unusual forms of epigraphic and plastic decoration.

A great variety of türbe buildings have survived in Anatolia, based on those of Seljuk Iran. Built on square,

21, 44
45

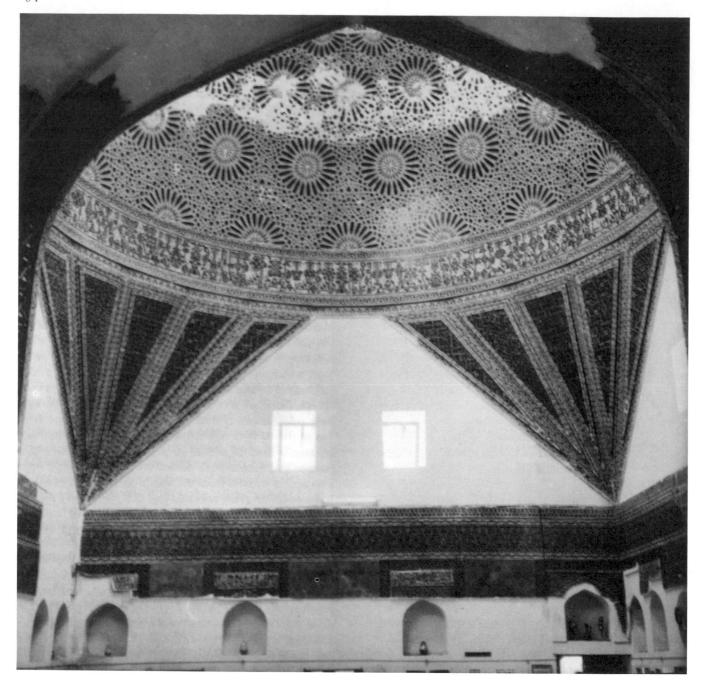

44. Interior of the Dome of the Madrasah of Celaleddin Karatay Konya, Turkey. 1251. The brilliant glazed brick and faience decoration of the Karatay Madrasah belongs to the finest ceramic architectural decoration in any age. The pattern of the dome interior, comprising very intricate interlacing band ornament producing, at certain points, staggered rows of 'bursting suns', together with the design of the squinches in the form of elongated triangles, also decorated with faience make this interior both delicate and astonishingly impressive.

polygonal or round plans, they are almost always vaulted by a shallow dome on the inside and a pointed tent roof on the outside, and decorated with fine stone carving, concentrated at the portal, the windows and the often elaborate corbel system that supports the overhanging roof. Türbes are known in Anatolia from the 12th century on and their form survives into the Ottoman period. A second specifically Anatolian type consists of an open ivan-hall. The actual tomb chamber is placed into an underground crypt, a feature common to all Seljuk türbes in Anatolia.

The caravansarayi was usually built on a single court plan surrounded by rooms serving obvious functions for man and animal. In Anatolia a special type was developed that had no parallel elsewhere. Even though there were Iranian caravansarayis of large or even monumental proportions, they were minor architectural works. The 13th-century Anatolian caravansarayi, however, is of great importance. It was usually very large, heavily fortified, with high, thick, well-constructed stone walls reinforced by bastion towers. A magnificent gate-structure led into a rectangular court; on the opposite side was a second gateway leading to an often monumental hall, comparable to medieval western European cathedral architecture. Divided into several aisles, the hall is covered by flat or pointed roofs supported by slender arches. The central aisle is raised and open to the sky in the middle.

These buildings obviously combine features of many different architectural designs, both religious and secular, but in their monumentality, solidity of construction and beauty of individual form and decoration they are among the masterpieces of Islamic architecture.

Of palatial architecture in Konya, Kubadabad and Diyar Bakr very little survives, but historical descriptions and recent excavations give some idea of their basic elements. They seem to combine traditional elements of ivan and dome chamber tracts for official reception and throne rooms, with a multitude of secondary rooms (the palace of Diyar Bakr is described as having fifty rooms) for the living quarters of the ruler and his entourage. A kiosk or pavilion from the palace of Alaeddin, Konya, which survived until early this century and finds of tilework and plaster suggest how richly the palaces were decorated. Polychrome stone and marble floors and mosaic decorations have been excavated on the site of Diyar Bakr and lustre-painted and black underglaze painted tilework both figurative and abstract has been found in the palace of Kubadabad.

The Seljuks of Anatolia were probably first to use coloured faience for architectural decoration on a monumental scale; tile mosaic and glazed bricks were only used in this way in Iran in Il-Khanid times. The style of tile and tile mosaic decoration developed in Konya in the 12th and 13th centuries was an inspiration for centuries to come, and was probably introduced to Iran from Anatolia.

Interiors of ivan-halls and domes, entire surfaces of walls, floors, portals, tombs, and even minarets were covered with glazed tiles, bricks, or combinations of both and finally with tile mosaic, using glazed clay plaques of different colours from which each individual form to be used in the design is cut. Leaves, letters, scrolls, flowers, and irregular shapes for background areas are pieced together in a clay and mortar bed directly onto the wall. This technique not only required consummate skill but much time and patience, an exceptional sense of design and the ability to organise a huge surface area. It also required an enormous supply of raw materials. The same technique was also used to construct mihrab niches. In short, although little Seljuk pottery has survived from Anatolia, there must have been large and active workshops to provide the builders with glazed tilework.

The main colours of these tiles and tile mosaics are blue, black and white, but there are also beautiful green tiles with black underglaze painted patterns or with patterns painted in gold on top of the glaze.

Tiles found in the ruins of the palace of Ala al-din in Konya also include overglaze painted polychrome ones of the minai type and it seems likely that minai ware in general was also produced in Anatolia.

Recent excavations of the palace in Kubadabad revealed a large number of star and cross-shaped tiles, mainly with figurative underglaze or lustre-painted decoration. Seated figures, animal groups and arabesque patterns, very much. like 13th-century pottery in Iran and Syria (Rakka), dem-

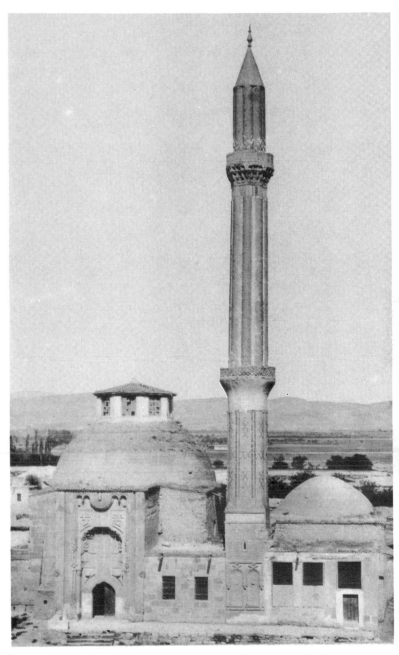

45. **The Ince Minare Madrasah, Konya,** Turkey, 1258. This is the most famous of the dome-chamber madrasahs of Seljuk Anatolia. Its name derives from the particularly graceful minaret with blue glazed brick decoration, the upper part of which is now destroyed. The most interesting feature of the building is its portal which is decorated with a curious band ornament filled with inscriptions in low relief.

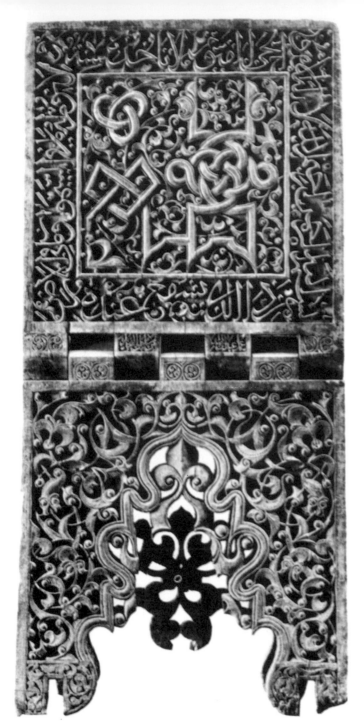

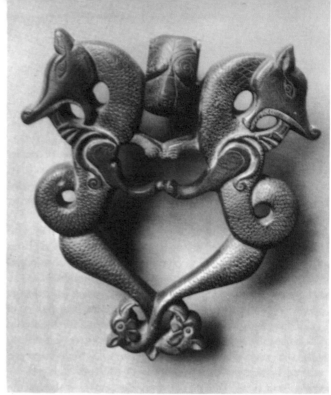

46. **Carved wooden lectern (rahle) from Turkey.** 13th century. Signed by Abd al-Wahid ibn Sulayman. w. 19¾ in. (50 cm.). h. 45½ in. (115.5 cm.). Staatliche Museen, Berlin. Woodcarving became a major art form in Seljuk Anatolia. This lectern decorated with high relief arabesque scrolls is a typical example of the high quality of design and craftsmanship of the period. The fact that the piece is signed shows the importance of the wood-carver's craft at the time. The lectern would have been made either for a mosque or a madrasah and would therefore have been particularly carefully made.

47. **Metal door knocker from Iraq.** 12th century. Cast bronze with engraved design. 1 11 7/16 in. (29 cm.). Staatliche Museen, Berlin. The motif of a dragon with a snake-like body and a tail ending in a griffin's head is quite common in Seljuk art in Anatolia, Syria and Iraq. Its special significance is not clear; it may have been heraldic, or it may have been cosmological-symbolical. This beautifully cast and unique bronze was very likely made in Iraq.

onstrate once more the cultural unity of the Seljuk-dominated part of the Muslim world.

Besides glazed tilework, simple brick patterns and moulded plaster relief were occasionally used, but the most important form of architectural decoration is stone-carving. Entire façades are covered with bands of inscriptions and floral and abstract linear patterns in various degrees of relief. At corners of buildings or at the base of minarets, and especially on entrance portals, the decoration is concentrated and sculptural. The most remarkable, if not altogether typical example is the gate of the Maristan in Divrigi where forms possibly originally conceived in plaster are translated into a unique sculptural stone-carving.

Among the finest Seljuk objects in Anatolia are the wood-carvings. Mihrabs, minbars and cenotaphs of large scale and intricate design are constructed of wood and decorated with inscriptions, abstract interlacing band ornament and floral motifs of a highly stylised nature. A

great many of these objects are signed and dated, which shows the pride the woodcarvers took in their work.

KNOTTED RUGS

The earliest known knotted rugs are also from Seljuk Anatolia. The woollen knotted rug, one of the art forms most intimately associated with the Islamic world and its culture, was probably brought to western Asia by the Turkish tribes that entered the Muslim empire in the 8th and 9th centuries, although the theory of a tribal, nomadic origin has recently been questioned, especially since the discovery of a knotted rug in a tomb at Pazykyk in the Altai mountains, dating from the 5th or 4th century BC. It originated in an attempt to imitate animal furs by adding to a flat woven fabric additional woollen threads resembling the long hairs of animal fur. These were knotted into the weft and warp to reinforce it and give it additional thickness and volume. These artificial furs seem mainly to have been used as floor coverings in tents. It is impossible to say at

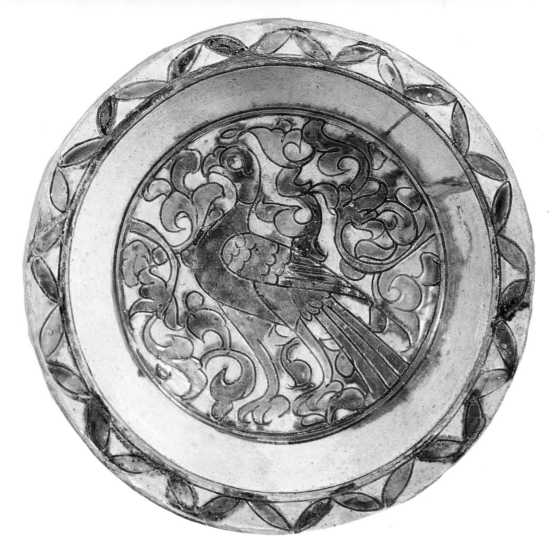

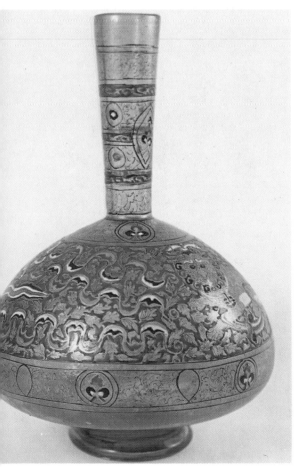

41. **Ceramic plate from Syria.**
12th–13th century. Incised design and
polychrome glaze. diam. $11\frac{1}{8}$ in.
(25·7 cm.). Freer Gallery, Washington D.C.
Incised designs appeared on Islamic
pottery from the very earliest periods, but
there is no evidence of figurative patterns
before the 12th century. The use of
different coloured glazes gives an added
liveliness of the design which has close
connections with a parallel tradition of
Byzantine ceramic decoration. There is a
close interrelationship between Islamic,
Byzantine, and Western European
ceramic decoration at this time.

42. **Enamelled glass bottle from
Aleppo, Syria.** 14th century. h. $15\frac{3}{4}$ in.
(40 cm.). Calouste Gulbenkian
Foundation Collection, Lisbon. This large
bottle, both in shape and in the colours
used in its decoration, is typical of
14th-century Syrian enamelwork.
Enamel-painted glass objects were
produced in great quantities from
the second half of the 13th century. The
decoration of this bottle, one of the finest
of the few pieces of equal size and richness
of decoration, consists of motifs of Chinese
inspiration, showing the strong cultural
influence of the Mongol civilisation
outside Iran. The kylin lion is taken
directly from Far Eastern iconography.

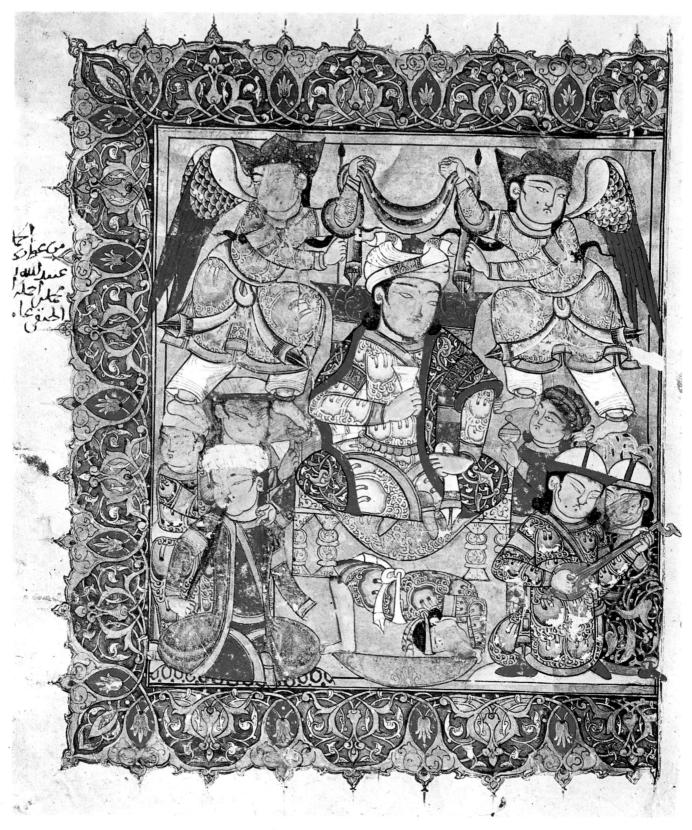

43. **Frontispiece painting from a copy of Hariri's Makamat** *(Assemblies)*. Egypt. 1334. 7⅝ × 6⅞ in. (19·2 × 17·5 cm.). National Library, Vienna. This scene of royal entertainment shows the importance of Seljuk iconography in Mamluk painting. The ruler, seated cross-legged on his throne, holding the ceremonial beaker before him in his right hand, is a recurrent image in Eastern Islamic art from the 9th century onwards. Equally Seljuk in iconography is the cosmological symbol of a baldachin, derived from late classical Central Asian art, here represented by the cloth held over the ruler's head by angels.

44 (opposite). **Spanish carpet.** 15th century 13 ft. 3 in. × 7 ft. 9 in. (4·2 × 2·4 m.). Museum of Art, Cleveland. Spanish carpets are a self-contained group. They employ a special technique, using a knot unknown elsewhere in carpet weaving, and possess original designs and colours, quite unequalled. This carpet, however, suggests a close contact with the Anatolian tradition. The octagonal medallions appear to derive almost directly from the so-called Holbein rugs. The curiously rigid organisation of the field into square compartments and the absence of a border are again typically Spanish features.

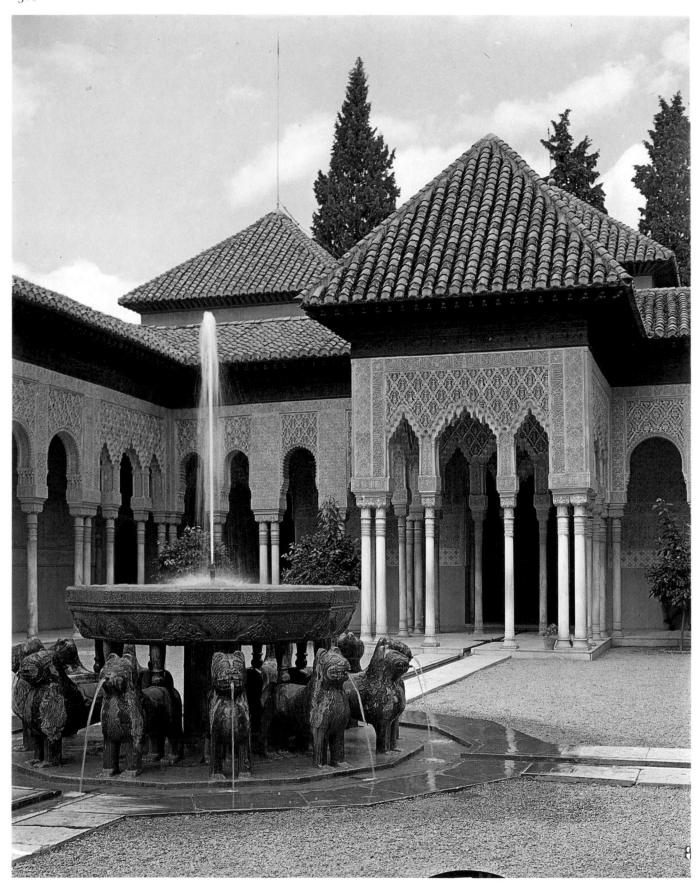

45. **The Lion Court of the Alhambra Palace, Granada, Spain.** 14th century. The Alhambra Palace, built by the Nasrid kings of Spain, remains one of the most remarkable creations of Islamic architecture. The Lion Court in the centre of the Harim area, named after its fountain supported by stone figures of lions, is surrounded by arcades resting on alternating single and double columns of extraordinary elegance and lightness. The lion fountain has been said to be of earlier date, forming part of a 12th-century construction on the same site, and this attribution has recently been convincingly reaffirmed. Free-standing stone sculpture in the round is unusual in Islamic art.

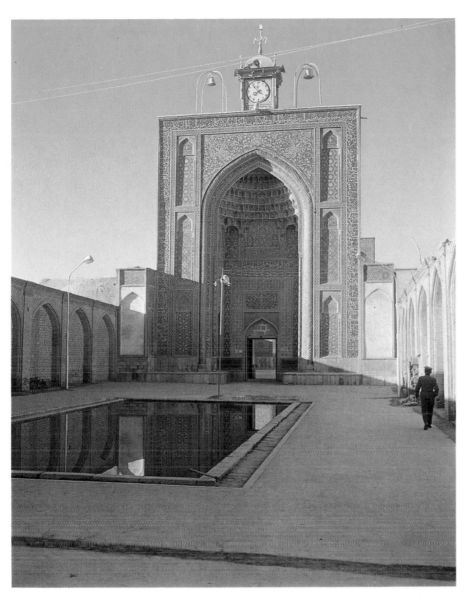

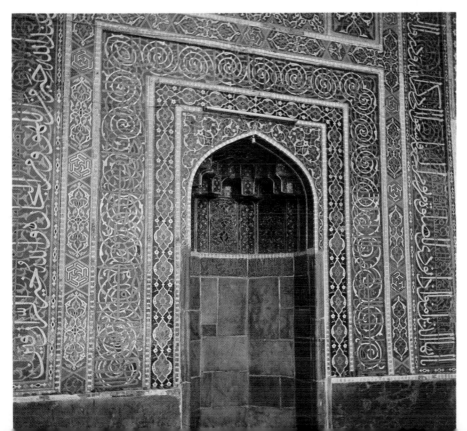

46. **Entrance portal of the Masjid-i Jami, Kerman, Iran,** dated AH 750 1349 AD. The faience mosaic decoration of this mosque is one of the earliest examples of its kind in Iran. In its elaborate design and perfection of technique, it anticipates much of later Timurid architectural decoration in glazed brick and tilework.

47 (below, left). **Mihrab of the Masjid-i Jami, Kerman, Iran.** 1349. The mihrab, occupying the end wall of the south-west ivan of the mosque, is typical of faience mosaic decoration in mosque interiors in the Muzzaffarid period. This technique is of fundamental importance for Timurid architectural decoration in Iran. There is a marked contrast between precise geometric designs in an angular framework and freely-moving arabesque and scroll patterns. The brilliant colour, blue and white dominating, is the first step toward the superb polychromy of the 15th century.

48 (below). **Entrance to the Tomb of Tshutshuk Bika** (detail), Shah-i Zindeh, Samarkand. 1371. The decoration of the façade and entrance gate of the tomb is characteristic of the entire Shah-i Zindeh group. Glazed bricks, moulded relief and deep cut, polychrome glazed tilework are applied to the brick surface, covering it completely with a multiform abstract geometrical, arabesque and floral design, outstanding in its finesse and brilliance of colour. The idea of total tile revetment, developed for the first time in Central Asia towards the middle of the 14th century, becomes a standard feature of Timurid architecture.

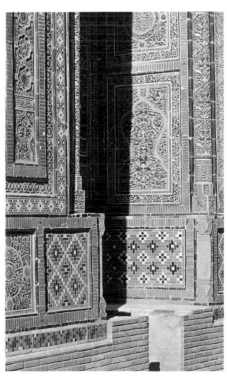

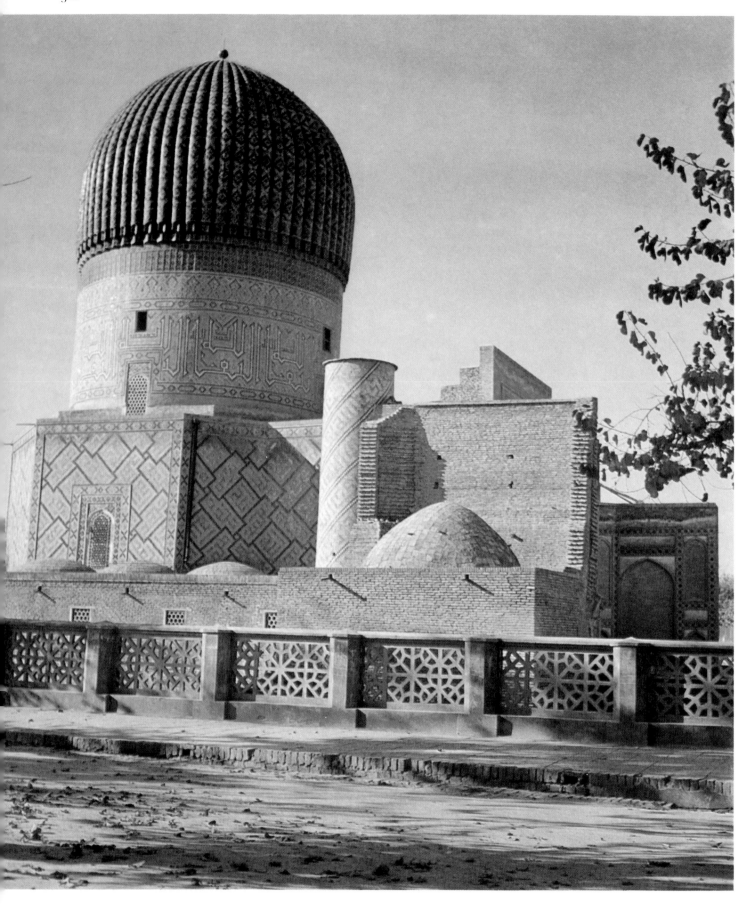

49. **Gur-i Amir, Timur's Mausoleum, Samarkand.** 1405. Originally planned as a mausoleum for Timur's nephew, Muhammad Sultan, who died in 1403, the building became the burial place of the ruling house. The emperor himself was buried here in 1405. Built on a polygonal exterior and square interior plan, with a double dome, the outer one being raised on a high drum, the mausoleum has features first developed in the Shah-i Zindeh (see plate 50). Unexpectedly it has a mosque-like façade. The magnificent decoration consists both of glazed brick and tilework and of carved marble.

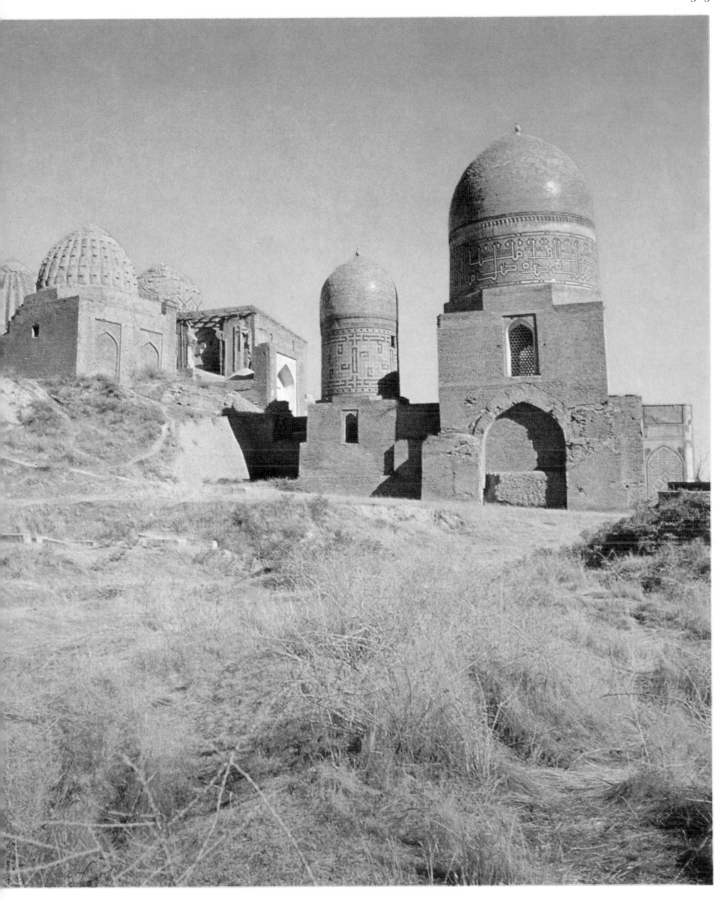

50. **Shah-i Zindeh, the necropolis of the 'Living King',** near Samarkand. The Shah-i Zindeh consists of a group of sixteen tombs built around the tomb of Kasim ibn Abbas, a cousin of the Prophet, who had lived here venerated as a saint and as the 'Living King'. His tomb, as it appears today, was erected in 1334–5. The latest addition to the necropolis are the two tombs erected by Timur about 1400 for Oldsha Ain, his nurse, and Bibi Sineb, her daughter, seen in the foreground to the right. In 1434 Ulugh Beg, Timur's grandson, added a monumental portal to the complex.

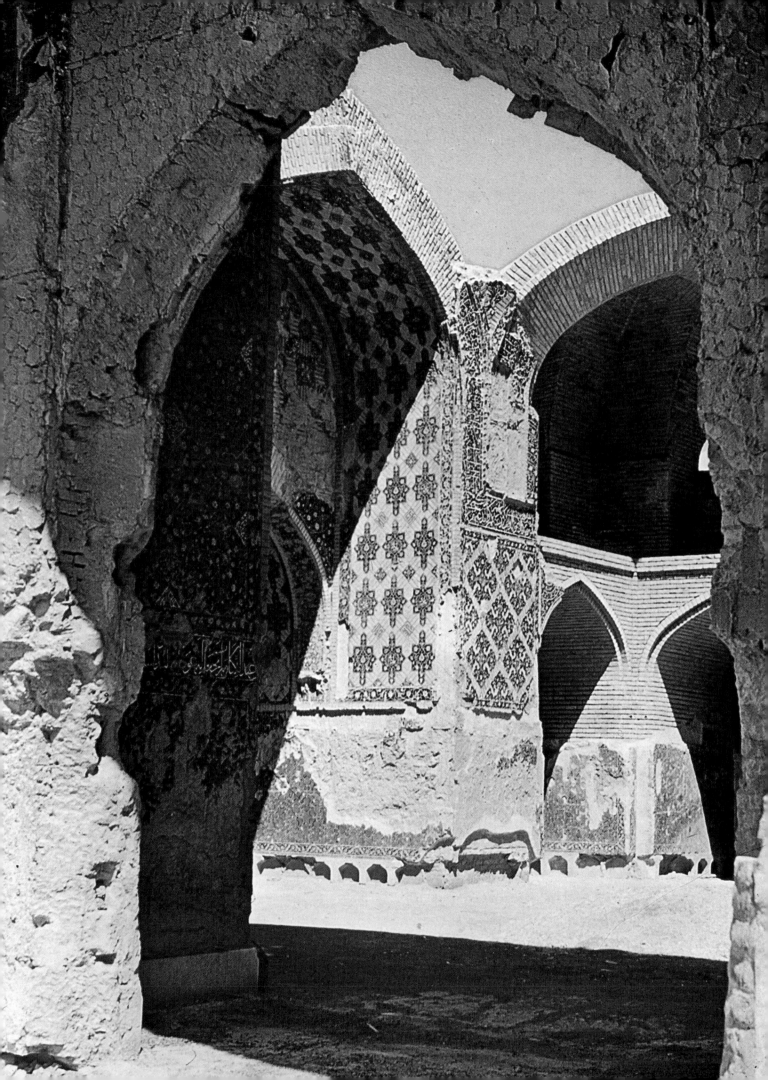

51 (opposite). **The Blue Mosque, Tabriz.** 1465. Interior of central dome chamber (partly restored). Although an almost total ruin, this is still a beautiful example of a work of the Turkman period; it follows in all its features the Timurid tradition, excelling in its rich decoration of blue faience and glazed brick.

52. **Painting from a copy of Khwaju Kermani's Mathnawi,** probably Herat. 1430–40. 12¾ × 9½ in. (32·5 × 24·1 cm.). British Museum, London. It is notable for its brilliant colour, rich detail, masterly composition and emphasis on landscape. The paintings in the British Library's Khwaju Kermani MS must be attributed, with the manuscript, to the Jalayirid

court atelier in Baghdad; the colophon of the MS states that it was made in Baghdad in Jumada I 798/February–March 1396. The MS is of the greatest importance for the transmission of the Jalayirid style to the Timurid ateliers of Samarqand and Herat, as painters from the Baghdad atelier were taken to Samarqand by Timur.

53, 54 (opposite and above). **Two paintings from a Timurid Anthology.** AH 813 (1410–11 AD). *Abraham's Sacrifice* and *Adam and Eve in Paradise.* Each 9¼ × 6¾ in. (23·5 × 14·6 cm.). Gulbenkian. Foundation Collection, Lisbon. This anthology was made for Shah Rukh's nephew, Iskandar Sultan, who lived in Shiraz where it is generally assumed to have been made. The paintings number among the finest produced in the Muslim East at that time.

55 (above). **Painting on silk from Herat.** *c.* 1400. 24¼ × 8 in. (61·5 × 20·5 cm.). Topkapı Sarayi Library, Istanbul. This painting belongs to a group preserved in an album forming one of the main works of the early Timurid style. The fine brushwork and the unusually mellow and subtle palette already anticipate the qualities of the Baysunghur workshop. The subject of the painting is not altogether clear but it might be an illustration for a text similar to the *Sulayman-nameh.* In fact, it could be that the princely couple carried by the servile monsters and accompanied by genii are Sulayman and the Queen of Sheba.

56 (below). **Painting in an album from Transoxiana or Herat.** *c.* 1400 9⅞ × 18⅞ in. (25 × 48 cm.). Topkapi Sarayi Library, Istanbul. This painting, possibly illustrating a story but more likely an assembly of various groups and figures out of different contexts is typical of the transitional style practised in Central Asia in the early Timurid period in its variety of different human types and the fine landscape consisting of a simple indication of rocky ground and shrubs. The different sources of inspiration were not yet fully assimilated but all the elements are already present that later appear in highly refined form in the first illustrated manuscripts that can be attributed to Herat.

57 (opposite). **Painting from a copy of Firdusi's Shah-nameh,** made for Baysunghur Mirza in Herat, AH 830 (1430 AD). *Isfandiyar slaying Arjasp in the Brazen Palace.* Page size 15 × 10¼ in. (38 × 26 cm.). Gulestan Palace Library, Teheran. The paintings in this manuscript are the main work of Baysunghur's workshop in Herat. This painting is unusual in the use of a complex architectural setting. Most notable is the contrast between static serenity and dramatic action, emphasised through the use of a curious system of quasi-perspective. The fine brushwork and the delicacy of both pattern and colour palette is also remarkable.

58 (above). **Painting from Mir
Haydar's Miraj-nameh,** copied and
illustrated in Herat in 1436. *The Prophet
Muhammad in Hell*. Page size 13½ × 14 in.
(34·3 × 35·5 cm.). Bibliothèque
Nationale, Paris. Painted after the death
of Baysunghur, the illustrations of this
unique manuscript continue the ideals of
the prince's workshop while on the other
hand a more immediate contact with the
pre-Baysunghur tradition of painting in
Herat and possibly Samarkand seems to
have been established. The subject,
depicting the various visions of the
Prophet on his *Night Journey through
Paradise and Hell*, is rare in Islamic
painting and constitutes one of the most
interesting cycles of religious painting.

59 (opposite). **Painting from a copy
of Nizami's Khamsa,** written in Herat,
AH 900, (1494-5 AD), painted by Abd
al-Razzak. *Muhammad's Ascension*.
8¼ × 5½ in. (21 × 14 cm.). British
Library, London. A particularly
splendid example of the Prophet's
Night Journey. Although following a
well-established iconography,
Abd al-Razzak, who collaborated with
Mirak-nakkash and Bihzad on this
manuscript, has created an especially
brilliant design in the large golden cloud
bands that surround the Prophet. The
immediate influence of Central Asian
models for the cloud forms is noteworthy,
demonstrating the close contact between
Central Asia and the Herat school
throughout the 15th century.

60. Ceramic plate from Northern Iran. Second half 15th century. Kubachi style. Black underglaze painted decoration. diam. 14¼ in. (36 cm.). Victoria and Albert Museum, London. A large amount of pottery from the late 14th and the 15th century has been discovered which gives us a completely new view of the art of pottery making in the Timurid period. Chinese blue-and-white porcelains of the Yuan and Ming periods appear to have been the main source of inspiration, and many of the renderings of such pottery in Timurid painting may well represent local production.

61. Timurid gold ring with jade seal-stone. Herat. *c.* 1430. diam. 1 in. (2·5 cm.). Metropolitan Museum of Art, New York. Surviving precious metal objects are exceedingly rare in Islamic art for they were easily destroyed. The dragon motif was particularly popular and jade carvings and bronze ewers with dragon-headed handles that can be dated and attributed through inscriptions to the Timurid period and Central Asia, survive in appreciable numbers.

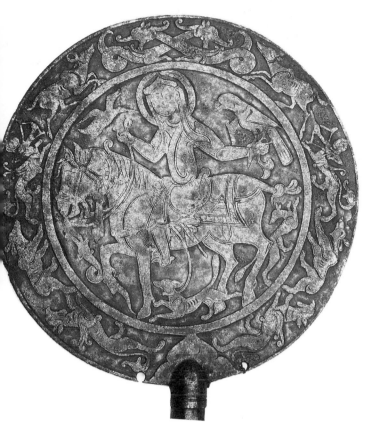

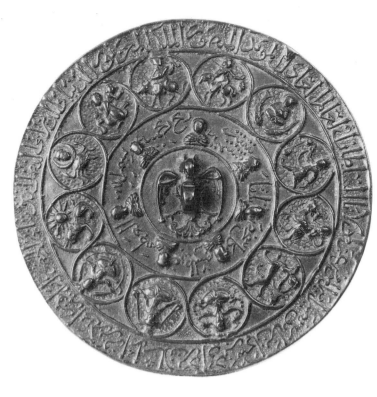

48. **Steel mirror from Turkey,** with relief and gold inlay decoration. 13th century. diam. 8¼ in. (21 cm.). l. (complete with handle) 16¼ in. (41·5 cm.). Topkapi Sarayi Museum, Istanbul. The central medallion of this mirror is decorated with a scene from the courtly life of the Seljuk period: a hunter on horseback, with his falcon on his left hand, accompanied by his hunting dog and surrounded by a fox, a duck, and a dragon-snake, probably the hunter's prey. In the narrow border a variety of real and mythical animals are placed running towards the symbol of a double snake-dragon.

49. **Bronze mirror with relief decoration from Iraq.** Mid 13th century. diam. 9½ in. (24 cm.). Collection of Fürst Öttingen Wallerstein. The decoration of this cast bronze mirror consists of a complex astrological complex, a popular subject in Seljuk metalwork particularly on mirrors. In the centre is a bird with outspread wings, a motif frequently found in the art of the Seljuks and Atabeks of Iraq and Syria. Around the birds are the busts of the seven planet gods. These busts have close links with classical antiquity. The twelve outer medallions show the signs of the zodiac combined with other planetary figures. The dedicatory inscription contains the name of an Urthukid, suggesting that the object belonged to the Urthukid rulers of northern Iraq. If so, it is one of the very few metalwork pieces of the period that can be associated with that particular region.

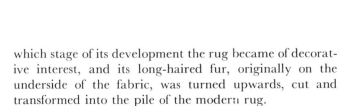

which stage of its development the rug became of decorative interest, and its long-haired fur, originally on the underside of the fabric, was turned upwards, cut and transformed into the pile of the modern rug.

The Seljuk rugs of Anatolia have recently been re-attributed to the 14th and even 15th century. The main fields have simple repeat patterns, based on highly abstracted floral forms, the borders much bolder abstract patterns based on Kufic writing. Their colours vary red, blue and white, however, dominating. The variety of patterns within the limited number surviving indicates a highly developed art, and the richness of colour and contrast of the striking border designs with the small-scale field patterns show again the fine sense of design that so often characterises Turkish Seljuk art.

Little is known of Seljuk metalwork in Anatolia, but it would appear that the inlay techniques so elaborately used in Iran were not adopted there. Plastic form seems to have been favoured and engraving is the main decoration.

Seljuk art in Anatolia continues many of the principal ideas developed by the Seljuk Turks in Iran. The cultural unity of the Seljuk-dominated art of the Muslim world is demonstrated by identical forms of ceramic painting and tile decoration. In architecture, however, highly original forms are developed that differ fundamentally from those of Iran. The closed prayer hall mosque, and the monumental caravansarayi show a new organisation of architectural space into large enclosed units, and a new attitude in designing buildings to be seen from all sides. Orientation towards the interior, characteristic of Iran, is abandoned and counterbalanced by equal attention to the exterior with special emphasis on the design of façades and general surface decoration. The Seljuk Turks excelled in stone-carving, widely used in architectural decoration, and with the development of faience mosaic they made a contribution to eastern Islamic art that can only be compared in importance to the invention of lustre-painting by the Abbasid potters of Baghdad and Samarra.

The Art of the Atabeks & the Ayyubids

With the division of Seljuk Iran after the death of Sultan Sanjar, 1157, between various of the Seljuks, the regions of Iraq and Syria became independent under the rule of their Atabeks (regents). Various cultural centres developed at the court of these Atabek dynasties. Mosul and Aleppo, capitals of the Zangids, and Damascus, seat of Nur al-din Mahmud ibn Zangi's court, became important in the 12th and early 13th centuries. Diyar Bakr, and later Kayfa and Mardin in Eastern Anatolia—seats of the courts of the Urthukids—became centres of a culture that combined elements of Seljuk tradition with a great many original ideas. Art forms of great interest and beauty were evolved and passed on to the Ayyubids who inherited an artistic tradition of the greatest significance for the further development of western Islamic art.

Egypt came under the sway of the Ayyubids in the second half of the 12th century when Salah al-din Ayyub (Saladin) (1169–93) seized power. An envoy sent to Egypt by Nur al-din Mahmud ibn Zangi (1146–73), Atabek of Syria, Salah al-din changed the kutba (Friday prayer) in Egypt in 1171 having the Abbasid caliph of Baghdad mentioned in it instead of the last, dying Fatimid caliph. With his death in the same year, the Shiah caliphate of Egypt came to an end.

Salah al-din added the Hijaz and the Yemen to his realm, took Tripoli from the Normans and in 1174 annexed Damascus after the death of Nur al-din Mahmud ibn Zangi. It took about ten years to subdue the rest of the country (Aleppo fell to Salah al-din only in 1183) and Iraq. In 1187 Jerusalem was taken from the Christians. The Ayyubid empire was consolidated. The Third Crusade failed to restore Jerusalem to the Christians. On the death of Salah al-din in 1193 the empire was divided between other Ayyubids with Cairo, Damascus and Aleppo as centres. But in 1250 Ayyubid rule came to an end in Egypt with the take-over by their vassals, the Bahri Mamluks, and Iraq and Syria were soon invaded by the Mongols.

ARCHITECTURE

Although little architecture built during Atabek rule survives unaltered or intact, surviving monuments indicate a combination of elements from Seljuk Iran and Anatolia with elements of local pre-Seljuk tradition, especially in Iraq, that provided the basis for the great flowering of architecture in the Ayyubid period.

The Great Mosque in Aleppo, begun in the Zangi period but completed only in 1190 after the take-over by Salah al-

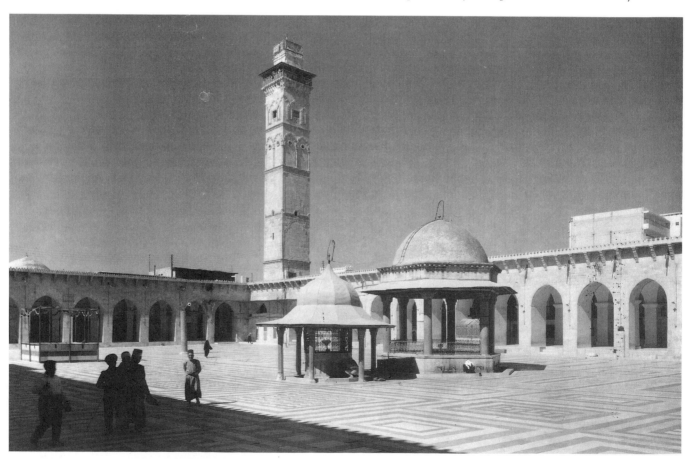

50. **The Congregational Mosque in Aleppo, Syria.**
12th–13th centuries. Probably going back to a very early foundation, this mosque dates mainly from the 13th century. Its minaret, one of the most beautiful in Syria, is also the earliest

monument of the Seljuk period in that country (1090). The marble pavement and the large fountain in the centre of the court, are very fine.

din, bridges both periods and shows a continued artistic tradition from the Atabek to the Ayyubid period in Syria. Its large prayer hall with a beautiful polychrome mihrab, its tall, square stone minaret, and its splendid marble pavement in the large court, are typical of a new simplicity in decorative architecture, with cubic outlines and large undecorated wall surfaces contrasting with delicate but powerfully carved or subtly coloured marble-inlay ornaments.

25 The most impressive monument of pre-Ayyubid architecture is the citadel of Aleppo although most of what survives dates only from the reign of the first Ayyubid sultan of Aleppo, Zahir Ghyath al-din Ghazi (1186–1216). Built at the top of a hill in the centre of the city, the citadel is one of the most formidable fortifications of the Muslim world.

26 Its elaborate entrance structure is most striking with two gate towers connected by a long bridge supported on high, pointed arches of great beauty. This enormous, cubic block has in its lower storey a complicated passage-way with a succession of doors and security devices, leading to a ramp and staircase up to the second storey, which consists almost entirely of a 15th-century reception hall. Partly altered in the Ayyubid and Mamluk periods, the unity of the citadel demonstrates clearly the strength of architectural traditions of this period which were to continue until the 16th century.

Important buildings were erected all through the 12th and 13th centuries both in Iraq and Syria during Atabek rule, among them the great madrasahs of Baghdad, Aleppo and Damascus are of special significance. The design of the madrasah, developed first in Seljuk Iran and adopted in Seljuk Anatolia, was brought to perfection in the Atabek and Ayyubid periods. Two-storey rooms for students and teachers were arranged around an open court with tall ivan-halls set into the centre of each side. Sometimes a single ivan plan is used, possibly following Anatolian models. The Ayyubids introduced the design into Egypt where it found monumental expression in Sultan Kalaun's and Sultan Hasan's buildings in Cairo.

Of Ayyubid secular architecture in Egypt Salah al-din's citadel in Cairo is undoubtedly the main example. With Fatimid-style walls, heavily fortified towers and gates, it rivals in many ways the citadel of Aleppo. Though not as elaborate—the Aleppo citadel has more substructures—and perhaps less formidable in its fortification, the Cairo citadel is among the most remarkable examples of military **51** architecture in the Muslim world.

Of many mausoleums, that of Imam al-Shafi'i (1211) is probably the finest. Although altered in the interior decoration during later Mamluk restorations by Sultan Kayt Bey, it still exemplifies the standard plan developed during the period, followed for almost three centuries without major changes. This consisted of a large square chamber surmounted by a tall often fluted dome built of brick or stone and usually resting on an intermediary zone of mukkarnas which became increasingly ornate. The mausoleum always contained a mihrab niche, sometimes triple niches or three individual mihrabs set into a richly ornate kibla wall. The plaster decoration of interiors is quite **52** elaborate, entire wall surfaces often covered with abstract and floral patterns. A dominant design feature are blind niches with magnificently powerful conch shells, as in the Cairo mausoleum of the Abbasid Caliphs (before 1242). Exterior decoration is relatively simple torus moulding running round the lower storey of al-Shafi'i's mausoleum, with a band of simple geometric ornament along the top, the upper storey pierced by double windows, blind niches with the stylised conche shells, with a band of openwork abstract interlaced ornament and triangular serrations along the top.

This type of Egyptian mausoleum continued into the Mamluk period.

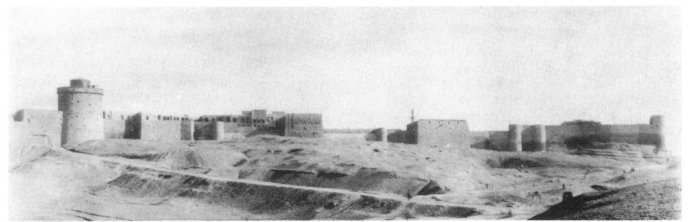

51. **The Citadel of Cairo.** Late 12th and 13th centuries, with some later additions. View of the south façade of the northern enclosure seen from the east. The Citadel of Cairo is one of the most formidable military installations of Muslim architecture. Its foundations, most of the present walls and some of its gates and towers go back to Saladin's time (1169–1193), although he did not complete the building himself, leaving Egypt in 1182. His brother and successor al-Adil carried out much of the final work. The most impressive part of the Citadel are its monumental defence towers and complex gate structures which are rivalled only by those of the Citadel at Aleppo. (See plates 25, 26).

PAINTING

During the 12th century a school of painting emerged in Northern Iraq possibly centred in Mosul. Its style is similar to that of the Seljuks although it also developed an iconography of its own (probably absorbing classical traditions of scientific text illustration) with a keener sense of realism.

27 The frontispiece of the Paris *Kitab al-Diryak* of 1199 is a perfect example of the complete adaptation of Seljuk royal and symbolical iconography. So is th frontispiece of an-

28 other copy of the same text in Vienna undated but probably early 13th-century, which shows Mosul realism in such details as horsemen and the preparation of a meal for the ruler.

Some 13th-century Syrian manuscripts are very close to classical tradition. The finest of the group, an illustrated copy of Hariri's *Makamat*, 1222, shows the absorption of a local Syro-hellenistic tradition into a brilliant new style of expression and movement, completely different in form and spirit from Seljuk painting.

In the school of Baghdad, only known from 13th-century works, both styles meet and to a degree merge, even though the eastern element always seems to dominate slightly. The paintings executed in a copy of the Makamat, 1237, now in Paris, by a painter whose name is recorded in the manuscript, Yahyah ibn Mahmud al-Wasiti, and in another copy in Leningrad, form the main product of the Baghdad school. In their animation and close observation of the details of everyday life these paintings surpass even the more realistic Mosul paintings or those of the 'hellenistic' Fatimid style.

Very little is known about mid-13th-century painting in Iraq and Syria but a double-page frontispiece in a Bagh-
53 dad manuscript dated 1287, now in Istanbul, proves that the school of painting survived until the very end of the 13th century, in spite of the newly emerging Il-Khanid style of the Mongols in Northern Iran.

This double-page painting demonstrates for the last time the special quality of the Baghdad school, in its realistic rendering of details such as the brick substructure of the building in which the philosophers appear with their scribes and attendants, or in the extraordinary expressiveness of facial features. But the colours have already acquired an abstract quality, with much gold and white and it is obvious that nothing was to follow from this last phase of the school. Soon painting in Iran took an entirely different direction and the strange mixed style that found its apogee in Baghdad survived only in the provincial Mamluk schools.

POTTERY

29 Little is known about pottery in the region during the Atabeks' rule. It seems to have been made in large quantities in Syria but of 12th- and 13th-century Iraqi wares nothing survives but a group of unglazed relief wares, mostly large vessels. Their main decoration is applied relief concentrated around the tall necks of the often monumenta:

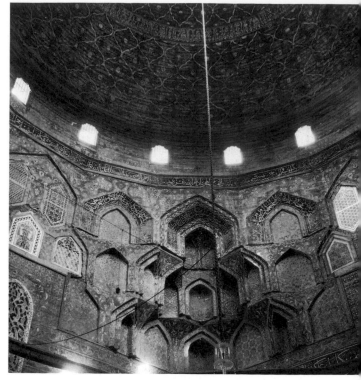

52. **Interior of the Mausoleum of the Imam Shafi'i, Cairo.** The interior of this building, erected in the 13th century was decorated in the 15th by Sultan Kayt Bey who placed a new, wooden dome over the square chamber. The design of the resulting intermediary zone and its elaborate decoration are typical examples of the late Mamluk decorative style in architecture.

53. **Painting from a manuscript of the Rasa'il ikhawan al-safa** *(Epistles of the Sincere Brethren)*, from Bagdad, Iraq. Dated AH 686 (1287 AD). *Authors and Attendants.* Library of the Suleymaniyeh Mosque, Istanbul. $7\frac{7}{8} \times 6\frac{7}{8}$ in. (20 × 17·4 cm.). This is one of the last paintings of the Baghdad school and shows how main characteristics survived to the end: realistic detail a concern with real life, and an exquisite sense of colour and design. It also shows how this style remained almost entirely free of both Seljuk and Mongol influence which had spread from the East to the rest of the Muslim world. Three of the six authors of the text are shown in this half of the double-page frontispiece.

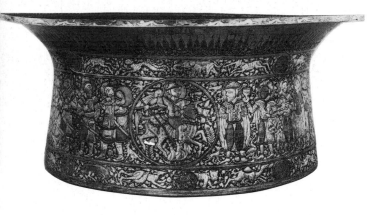

54. The 'Baptistère de Saint Louis' from Syria.
Metal basin with silver inlay decoration. 1290–1310. Made by Muhammad ibn al-Zayn. diam. 19⅞ in. (50·4 cm.), h. 9⅝ in. (24·4 cm.). Louvre, Paris. This superb piece of Mamluk silver inlaid metalwork is in the highly accomplished figurative style developed by the Ayyubids (following the Seljuk tradition.) It is one of the greatest masterpieces of its kind in Islamic art. The master, known only from one other signed piece, but probably the 'author' or at least two other pieces of a very similar kind, was one of the finest artists working in the field of metalwork. In its richness of figurative invention, fine detail, and perfect design, the basin has few equals. Decorated with a central frieze of figures and two narrow corresponding friezes of animals, it is also decorated along the inside rim with elaborate hunting scenes.

vases, mostly of the figurative iconography of Mosul painting but ultimately in the Seljuk tradition. Seated rulers in frontal position with drinking cup in hand, surrounded by courtiers, are set against a background of floral and abstract motifs often in complicated openwork of great beauty and technical skill. The most striking though unexplained feature is a large female mask that frequently appears on these ornaments. It may reflect ancient pre-Islamic traditions recalling masks in the architectural decoration of Hatra. Other pre-Islamic motifs suggest a long tradition of relief ceramic of which little or nothing is known. Unglazed relief decorated pottery has been found in most parts of the Muslim world some of it dating back to the 8th and 9th centuries. This group, however, is unrivalled in quality and interest.

30 The most important 13th-century pottery centre is Syria with Rakka possibly the main source. Of many different types, three are particularly important: one painted with deep brown lustre similar in effect to that used in Seljuk Rayy; a second painted in polychrome underglaze with both floral-abstract and figurative patterns; and a third with mainly floral patterns painted in black under a brilliant green and blue glaze. While the first two types are almost immediately derived from Seljuk pottery and may well have been inspired by the potters that escaped from Rayy at the advance of the Mongols, the last type is an outstanding and original invention by the 13th-century Syrian potters.

METALWORK

In Mosul an early 13th-century school of metalwork undoubtedly owes much to artists from Seljuk Iran but quickly develops an individual style. Some of its engraved and silver inlaid brasses count among the most beautiful and accomplished of the Muslim world. To differentiate between objects made in Mosul and Damascus is exceedingly difficult, especially as no complete study has ever been made of the large number of dated and inscribed pieces. A group of inlaid brasses, all from the first quarter of the 13th century, can be associated with Mosul through artists' signatures, also another group through the appearance of Badr al-din Lulu's (1233–59) name on some of them. The Ayyubids continued the tradition of richly inlaid and largely figurative designs on metalwork and probably produced the finest work of this type. The figurative style,
24 small-scale on most Seljuk and Atabek objects, increases in

size, and often a vessel, usually itself of large size, is decorated with large figures filling most of the surface area. Even the interiors of large basins are now elaborately decorated. The development of facial features, instead of the stereotype of Seljuk and still of Atabek times, is one of the main achievements of Ayyubid metalwork. The figures on Sultan Ayyub's basin or on the *Baptistère de Saint Louis* 54 are full of an extraordinary vitality and realism seldom found in the earlier metalwork.

ENAMELLED GLASS

Figurative decoration in enamel on glass was also developed in Syria in the later 12th and 13th centuries. In earlier pieces a great deal of gold was used especially for background decoration with foreground designs in red, blue, and white enamel, but equally often red was used alone as the colour to 'draw' both abstract and floral designs, and then both background and motifs were painted gold. Some pieces, probably mid-13th-century, literally transplant scenes from manuscript paintings or silver inlaid metalwork onto glass. This long continuation of Seljuk pictorial tradition is perhaps one of the most interesting and important aspects of the art of this period.

In the art of the Atabeks and the Ayyubids Seljuk tradition is brought almost unchanged to Iraq and Syria. It is particularly predominant in the painting of the Mosul school. Later on western tradition, both contemporary or earlier Byzantine, also became important and this dualism characterises much of the art of 12th- and 13th-century Iraq and Syria.

In both countries Seljuk architectural forms are developed and particularly in Syria monumental stone architecture is of great beauty in its simple, cubic forms and precise and highly abstract carved decoration, particularly in contrast with large, smooth, undecorated surfaces. This element of contrast continued in Syria and Egypt for many centuries with the use of polychrome stone inlay on plain walls that may have been derived from Seljuk Anatolia and that is handed down by the Ayyubids to generations of architects both in Syria and Egypt.

The art of 12th- and 13th-century Iraq and Syria forms 41 a bridge between East and West, combining elements of both, and paving the way for the development of the Mamluk style. 42

The Mongol Period

Early in the 13th century the conquest of the Muslim East by the Mongols under Chingiz Khan began. They reached the Seljuk capital of Rayy in 1220, destroyed Baghdad completely in 1258, slaughtering the last of the caliphs. A period of great disturbance and unrest was initiated in the Eastern Islamic world. Although Muslim culture was disrupted for a time (the Mongols adopted Islam only towards the end of the 13th century) western Asia as a whole was to be enriched by the first direct contact with the art and culture of the Far East. This contact was of decisive importance for the development of later Islamic art both in the East and the West.

Although several Persian cities were destroyed beyond repair—among them the capital, Rayy—the country recovered remarkably well from the devastations of the first Mongol assault, but it took the better part of the 13th century before the new Mongol-Islamic art established itself.

ARCHITECTURE

The Mongols made Tabriz their capital and the ruler Ghazan Khan (1295–1304) and his grand vizir, Rashid al-din, constructed entire new quarters with thousands of houses, baths, many mosques and entire university districts with libraries and research institutes. Ghazan Khan's city also contained his monumental mausoleum. Nothing of all this has survived and only a single major monument of the Mongol period, the mosque of Ali Shah, Rashid al-din's rival and successor, is still partly standing. Öljetü (1304–17), Ghazan Khan's successor, had a new capital built, Sultaniya, on a site southwest of Tabriz. Sultaniya was another elaborately planned and richly endowed city, which has also vanished save for the mausoleum of Öljetü, erected between 1307 and 1317. Although ruined, and in danger of collapsing completely, this magnificent domed structure is still one of the finest pieces of Mongol architecture.

Basically Il-Khanid architecture continues the Seljuk tradition. The mosque plan of the Seljuk period was adopted and continued without vital changes except for a gradual elongation of proportions tending towards a general vertical organisation of all decorative elements. Gateway structures were elaborated and the use of blind niche designs for the decoration of interior and exterior walls was perfected. At the same time intricate stalactite structures were employed for purely decorative purposes. Architectural decoration is mainly of plasterwork often applied to the whole building.

The particular plan of a centralised domed or vaulted building without secondary structures and without a court and ivan-hall part, which had been developed and used in Seljuk times, was also adopted by the Mongols. Ali Shah's great mosque in Tabriz, built between 1310 and 1320, is one of the most impressive buildings of the period. Although following Seljuk tradition structural features were often improved upon, especially in their decorative effect. A new widespread feature was a double-shell dome —as in Öljetü's mausoleum—allowing the elevation of an outer dome to a considerable height while covering the inner room with a shallow dome.

Other important forms of Mongol architecture are the tomb tower and Imamzadeh building (or saint's mausoleum), both following pre-Mongol patterns, but again invested with new decorative values. The use of the narrow, elongated blind niche, usually set into rectangular frames, both on the inside and the outside of these buildings, gives them, in addition to their generally slender proportions, a special elegance and appeal.

The mausoleum of Öljetü, originally part of a building complex, stands today as sole survivor of the vanished city. It consists of a monumental dome chamber with a small mortuary chapel on the south side. The gallery encircling the dome supports a platform that originally carried eight minarets. The interior chamber is octagonal in shape—enlarged with deep bays in the centre of each side. The entire building is decorated with a dado of blue glazed tiles in geometrical interlace band designs, with carved and moulded terracotta panels at intervals and painted plaster above the dado. (The mausoleum has recently been restored; the traditional explanation for the change of interior decoration of the building has been shown to be unfounded as there is no proof for a change of Öljetü from Sunni Islam to a follower of the Shia.)

In great contrast is the austere bareness of the immense vaulted ivan-hall of Ali Shah's mosque in Tabriz. Only the inside of the building is relieved to some extent by the upward movement of narrow blind niches counteracting the enormously heavy effect of massive brick walls.

PLASTERWORK

Even though Mongol architecture excelled in the variety of its buildings and in refining the traditional forms, its highest accomplishment lies in the unparalleled richness of its plasterwork in an astonishing variety of techniques. Plaster decoration covered entire wall surfaces and also emphasised certain structural features. The characteristically superb ornament in the interior of Pir-i Bakran—a small mausoleum near Isfahan—ranges from the simple incised line to deeply undercut high relief, from calm abstract linear patterns to almost baroque movements in the large floral and semi-floral abstract patterns. The typically rich and elaborate, carved and modelled mihrab also illustrates the frequent use of calligraphic designs. On one of its three frames of ornament, a beautifully designed double inscription in naskhi and angular Kufic is set against layers of floral scroll and arabesque patterns. Sometimes on walls, infinite linear patterns were created with calligraphic characters running diagonally, repeating again and again the same words—Allah, Muhammad or Ali.

PAINTING

Mongol paintings are the first to survive in large quantities and it is usually with these that histories of painting in the

55. **Masjid-i Jami of Taj al-din Ali Shah, Tabriz, Iran,** *c.* 1310–1320. The building is exceptional in many ways. It uses a mosque design rare in Iran, that of an open ivan hall without a dome chamber. In size it is matched only by the Mausoleum of Öljetü. Almost undecorated, the effect of the vast brick surfaces is nevertheless most impressive. Only minor adjacent buildings, such as a low open arcade running around a central pool in front of the ivan hall, are later additions.

Muslim East begin. Very largely, however, they follow earlier traditions, Seljuk influence being clearly visible, especially in local styles. The first examples demonstrate particularly well the complexity of pictorial traditions in Mongol Iran.

The earliest evidence of the composite transitional style is in the paintings of the *Manafi al-Hayawan* manuscript (1297, Marageh, near Tabriz). At least three major styles are evident, the traditional Baghdad style, the Seljuk style, and the new, progressive Il-Khanid style, greatly influenced by Chinese painting.

While the Baghdad style miniatures continue to cling to a certain decorative realism, especially in animals and figures, the Seljuk style paintings, of which a few very important ones survive, adopted some features of the Chinese form of landscape while still following their own Central Asian figural tradition as in the magnificent Adam and Eve painting.

Most paintings, however, are already in the new style. Painted with a full brush, in almost impressionistic manner, some of the miniatures come quite close to their Chinese models. A figure of the phoenix, set into a fantastic frame of elaborate foliage, is a brilliant expression of the new style.

Mannered, animated and full of unexpected movement, painted with a brilliant disregard for established traditions and with a zeal for depicting the world and its creatures in a new way, these paintings have an extraordinary freshness and intensity, altogether highly original. Chinese painting did not serve so much as immediate model to be slavishly followed but rather as a catalyst that set free unexpected forces in the artists of the period.

Rashid al-din's *History of the World*, survives in several early 14th-century illustrated copies that show the gradual evolution of an independent Mongol style—although elements of pre-Mongol, Chinese and even western European painting are fused in a strange and not always successful fashion. These illustrations resemble coloured drawings more than actual paintings, being basically linear in design, and often using thin and translucent colours of soft hues.

Very different are the paintings of the main work of the period, the illustrations for a monumental *Shah-nameh*, probably mid-14th-century but possibly later. With strong solid colours, and a fantastic realism unlike anything in Mongol painting in Tabriz, they would appear to have been done by painters of quite another artistic centre,

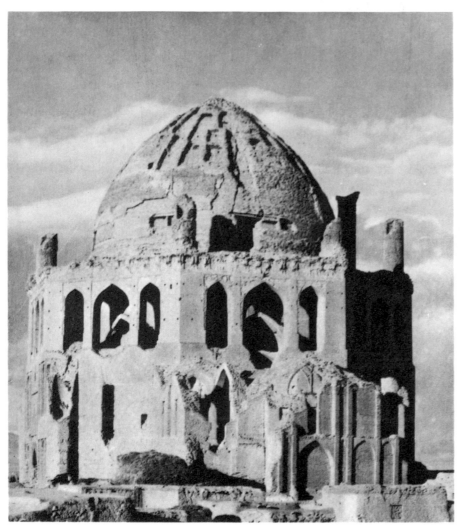

56. **Mausoleum of Sultan Muhammad Öljetü Khudabanda.** Sultaniya. 1307–1313. This building, originally part of a complex of structures in the city of Sultaniya, the new capital of the Mongols since 1305, has rightly been claimed to be the finest known example of Mongol architecture, one of the most competent and typical products of Persian Islamic building. It stands in the line of tradition of domed tomb chambers that had been built in the Muslim East since the 10th century. The ingenious distribution of the enormous thrust of the huge dome on a small number of points, making the piercing of the massive walls by niches and windows and gates possible, creates an effect of extraordinary lightness and grace. It served as model for similar mausoleum structures in both Iran and India.

probably fairly distant from Tabriz. The manuscript was split up and only a small number of the original paintings survive. Having fully absorbed the traditions of pre-Mongol Iran and eliminated elements that would not fit into the new imagery, the painters of this extraordinary series of *Shah-nameh* illustrations created an atmosphere of intense emotion and fierce action that is without parallel in Muslim painting. The human figure acquires an individual quality—facial types are abandoned for truly individual features—comparable only to the roughly contemporary Italian Renaissance painting. The combination of the realistic detail of human figures, animals and landscapes with a fantastic iconography, inherited from the tradition of the *Shah-nameh*, creates a unique pictorial style. Powerful in design, strong in colour and exceedingly **37** rich in detail—down to embroideries on a king's coat, a small flower, pebbles on the road or the peculiar twist of a shrub or branch of a tree—these *Shah-nameh* paintings are the highest achievement of eastern Islamic painting. Nothing created at the time, certainly none of the illustrations for some small *Shah-nameh* manuscripts, probably made in or near Tabriz in the 1340s, comes anywhere near them for quality and intensity.

The altogether different paintings of the Inju school of **38** Shiraz are mainly drawings, of a sketchy, almost careless nature, often stereotyped in facial expressions or landscape detail. Their main value lies in a highly developed decorative sense, both in design and colour.

Towards the end of the 14th century, on the basis of the pictorial tradition established by the great *Shah-nameh* and the local schools in Tabriz, Baghdad and Shiraz, the governor dynasties of the Jalairids and Muzzaffarids developed a form of painting that emphasised the new spatial concept of Mongol painting. A new form of perspective was created by using the larger part of the pictorial area for a landscape setting where groups of men and fighting armies could be displayed on different levels one above the other. This new technique freed the painter from the traditional rigid one-level concept. In the old system all the figures were firmly fixed to a bottom line and extended almost the full height of the picture making any suggestion of space impossible. The new method was of fundamental importance for the further development of painting in the Timurid period.

DECORATIVE ARTS

In the decorative arts the Mongols again followed earlier models to a great extent. In pottery especially they seem not to have been very inventive. Apart from the adoption of a few Chinese types of pottery—such as celadon ware which was probably first imitated in Il-Khanid Iran—the traditional forms of pottery, especially the Kashan lustre-wares, were continued.

Kashan seems only slightly affected by the Mongol conquest and the kilns continued almost without interruption to produce their wares. In the later 13th and early

14th century, the city supplied the country more than ever before with tilework. The famous set of tiles found in Damghan and Veramin, made in the 1260s, and a number of monumental mihrabs follow those of the early 13th century in almost every detail. The only important change is a general tendency towards a heavier lustre coating, a less delicate background pattern and an overall use of additional cobalt blue and turquoise glazes. Kashan lustre-painted pottery continued throughout the first half of the 14th century with only minor changes in style—a certain simplification of designs and background patterns just as in the tiles, and the adoption of a number of typically Chinese motifs.

Towards mid-century, a new form of pottery developed in Iran, usually called Sultanabad ware, as the first examples were found there. Sultanabad ware is, however, probably nothing more than the last stage of the Kashan workshops. There are two distinct types: one is decorated in blue, green and black under a clear glaze on a buff white slip with predominantly floral motifs. Plant or leaf motifs decorate the rims of the little shallow dishes, or the steep-sided bowls with heavy lips. In the centre of the bowl an animal motif or, in rare cases, human figures appear. There is a second variety which has the same shapes but different colours—white and shades of brown and grey. The pottery is almost in all cases heavy, the glaze thick, the designs rather rough in detail.

Of the other decorative arts of the Mongol period metal-work in particular should be mentioned as it again continues Seljuk tradition, but also makes use of the new repertoire of Far Eastern motifs. The elongated, Mongoloid figures, known from early 14th-century paintings in the Rashid al-din's *Jami al-tawarikh* and from Sultanabad pottery, also appear here.

The art of the Mongol period in Iran is characterised by a predominantly Far Eastern flavour, although the Seljuk tradition was continued almost without change in architecture and architectural decoration. Glazed tilework and faience mosaic, first employed in the Seljuk period, and especially a magnificent development of plaster decoration transformed the relatively simple traditional forms. But it is in painting and in the minor arts that the Chinese element is most prevalent, stimulating a new inventiveness rather than creating an eclectic attitude. The paintings of the late Mongol period number among the finest in the Muslim world, combining realism and attention to detail with inventiveness and fantasy in an entirely original form of pictorial expression. The Mongol period is of lasting importance for both eastern and western Islamic art providing a large repertoire of decorative forms and ideas to the artists of the Timurid and Safavid periods in Iran and to Ayyubid and Mamluk Syria and Egypt.

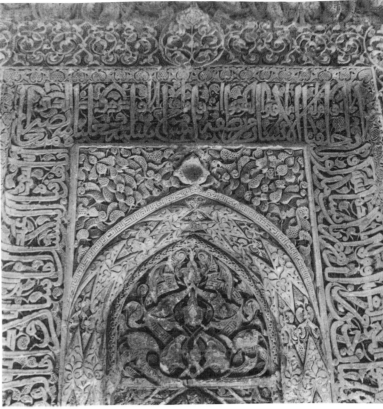

57. **Plasterwork decoration of the mihrab of Pir-i Bakran,** near Isfahan. Early 14th century. The rich and varied ornament of this mihrab shows the skill and beauty of carved and modelled plasterwork in the Mongol period, also the use of calligraphic design.

58. **Brass bowl with silver inlay design from Iran.** 14th century. diam. 9½ in. (24 cm.), h. 4⅛ in. (10.5 cm.). Staatliche Museen, Berlin. Very little metalwork of the Mongol period survives. It seems that with the exodus of metal-workers to Iraq and Syria before the conquering Mongols, the art form declined in Iran. This bowl follows a typical shape developed in the later part of the 13th century and its decoration is equally pre-Mongol. The design itself shows, however, subtle changes in iconography especially in the use of Far Eastern decorative motifs and the manneristic elongation of the human figure.

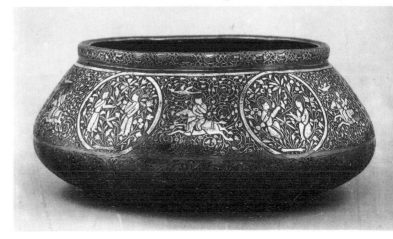

Mamluk Art

The Mamluks (Mamluk actually means 'owned') were the Turkish slaves of the Ayyubid rulers of Egypt. The first Mamluk dynasty, the Bahri, that came to power in 1250 with the fall of the Ayyubids in Syria and Egypt, were descendents of the slaves of Sultan Salih Ayyub (1240–9). They ruled Egypt and after the defeat of the Mongol army at Ain Jalut in 1260 under the leadership of Sultan Baybars al-Bundugtari (1260–77), also Syria for a century and a half, only to be superseded by the second Mamluk dynasty, the Burji, descendents of the Circassian slaves of the Bahri Mamluk Sultan Kalaun (1279–90). The Burji Mamluks ruled both Egypt and part of Syria until the conquest of the Ottoman Turks in the early 16th century.

The art of the Mamluk period is closely related to the arts and culture of the Ayyubid period. In fact, there is only a very gradual change in the artistic tradition of Western Islam in the (Seljuk) Atabek, Ayyubid and Mamluk periods.

ARCHITECTURE

Mamluk architecture continues almost completely the traditions of Iraq and Syria on the one hand, and of North Africa and Egypt on the other. Thus it combines elements of both the Fatimid and the Seljuk and Ayyubid traditions in evolving a new style of its own. Secular architecture as in the Cairo citadel, largely follows Fatimid models, while the great madrasahs are inspired by Syrian and Iraqi build-

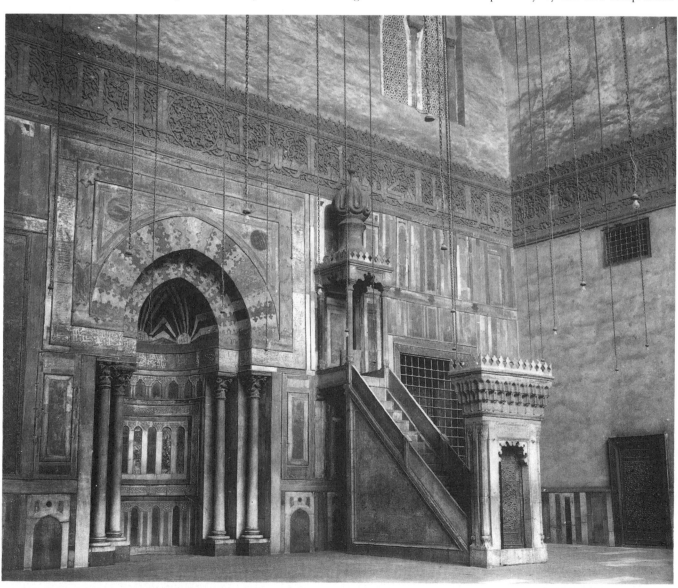

59. **Interior of the main ivan of the madrasah-mausoleum of Sultan Hasan,** Cairo. 1356–1363. The interior of the main ivan of the madrasah which served as a mosque is typical of decorative design in Mamluk architecture during the second half of the 14th century. There is a striking contrast between blank, undecorated wall space and decorative motifs such as the beautiful relief inscription which runs all around the square room. The mihrab is of particularly rich design with its double recess and double sets of columns. The stone minbar is of equally accomplished quality, particularly the door frame which repeats on a smaller scale the monumental entrance gate to the building.

ings, and the structure of the mosques, follows the local
C tradition, established with the mosque of Ibn Tulun. The
building material is mainly stone although brick is also used
especially for vaults, arches and domes.

The architecture of this period both in Syria and Egypt
is generally of monumental scale. It has great simplicity of
form and a distinctly sombre quality. Large, flat, un-
decorated surfaces are contrasted with deep carving both in
form of epigraphic or linear abstract ornament and in form
of deep niches often decorated with floral patterns and
arabesque work. The upper part of such niches—around
dome drums, on mosque façades, above gateways—is often
decorated with the traditional serrated conch-shell motif,
already encountered as an important element in Fatimid
architectural decoration and taken over by the Ayyubids in
Egypt. The Ayyubids also passed on smooth-surfaced,
precisely cut mukkarnas patterns in gateway or portal
designs, which they must have brought into Egypt from
12th-century Syria where these first appeared. Polychrome
59 wall decoration, using coloured stones and marbles, prob-
ably also came from Syria. At first used sparingly round
gateways, window frames and in mihrab niches, the
technique was then applied to large wall surfaces (still in
the 13th century) and became the main feature of the
decoration of exteriors. The best example of it is Kayt Bey's

madrasah-mausoleum of the second half of the 15th century.

Building activity reaches a new height in Egypt during
the reign of Sultan Baybars al-Bundugtari (1260–77). Of
his great mosque, built 1266–9, only the walls of the outer
enclosure are still standing but most of the original design
of the building can be reconstructed. The immense rectan-
gular mosque follows very much the design of al-Hakim's
mosque of more than two centuries before (see Fatimids E
chapter) which, in turn, followed closely the design of Ibn
Tulun's, demonstrating how strong the tradition of mosque C
design derived from Abbasid Iraq had been in Egypt. One
feature—a monumental dome chamber in front of the
mihrab with a triple aisle transept leading to it—is unique
in Egypt at the time and may well have been an import
from Iran, from where many artists had fled before the
invading Mongols. Dome chamber tracts of a similar
nature appear also, however, in some Seljuk mosques in
Anatolia from where they may have been transmitted
through Syria to Egypt.

Of the madrasah buildings that were erected both in
Syria and Egypt during this period and that were probably
brought to Egypt by Salah al-din from Syria, the monu-
mental complex of Sultan Kalaun (1279–90) built to- 60
gether with the sultan's mausoleum during the short span
of a year in 1284–5, is undoubtedly the most impressive. It

60. **Façade of the Madrasah and Mausoleum of Sultan Kalaun, Cairo.** 1284–5. This impressive complex unites two buildings behind one façade. Its simplicity is typical of early Mamluk style; the cubic quality of the main minaret contrasts strongly with the later slender and elegant minarets.

61. **Interior of the Mausoleum of Sultan Kalaun, Cairo.** 1284. Various materials, including carved and painted plaster, are used to achieve the exquisite richness of surface decoration. The screen on the right separates the central octagonal domed tomb enclosure.

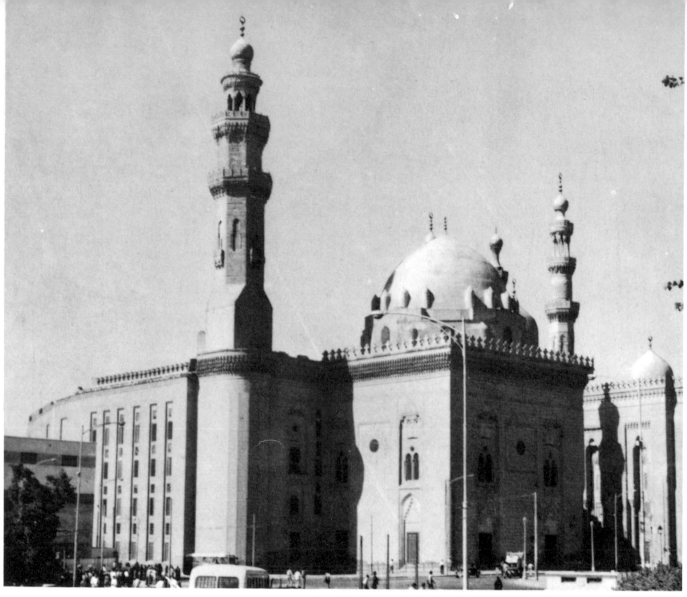

62. The Madrasah-Mausoleum of Sultan Hasan, Cairo.

Built between 1356–63. This is the most important of the four-ivan madrasahs of the Mamluk period in Cairo. At the end of the main ivan the square dome chamber of the mausoleum is placed. The dome is a modern restoration.

G. Plan of Sultan Hasan's Madrasah-Mausoleum, Cairo.

combines all the characteristic features of Mamluk architecture at its best—its cubic monumentality, its simplicity of form, the restraint and effectiveness of its exterior surface decoration and its great beauty and richness of interior decoration employing a great variety of techniques, including plasterwork.

The façade of the building, combines the fronts of both the madrasah and the mausoleum, which is set back slightly. A portal between them leads into a long corridor from which one can turn off into the court of either building. The spacious central court of the madrasah with its four ivan-halls—two large and two very small and shallow ones—has its main ivan-hall, a prayer room, at the south side arranged in a triple aisle basilical form with a façade in two storeys that repeats the triple arcade motif. Its particular design recalls earlier solutions of a similar form in Islamic palace architecture. It also has a certain similarity to the arrangement of a kibla transept in Sultan Baybars' mosque.

The most interesting feature of these two buildings is their decoration. Especially noteworthy is the rich application of carved plaster with both epigraphic and floral motifs. Particularly beautiful is the decoration of the entrance façade of the mausoleum, pierced by windows filled with linear grille work in plaster and framed by a succession of borders with outstanding arabesque work in clear, precisely cut outlines.

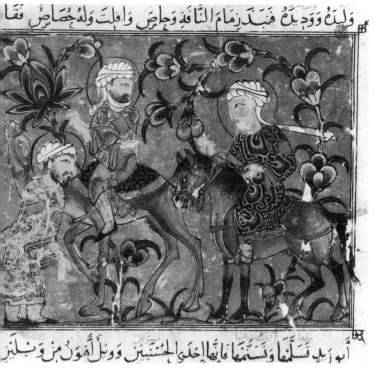

63. **Painting from a copy of al-Hariri's Makamat.** Egypt.
1337. *Abu Zayid helps al-Harith to regain his stolen camel.*
5¼ × 6¾ in. (13·5 × 17 cm.). Bodleian Library, Oxford. The
Bodleian Hariri paintings, although almost certainly creations of
the same school that produced the Vienna copy (see plate 43)
are much freer in the treatment of both the figures and the
decorative floral detail in the landscapes. There is also a more
immediate contact with Il-Khanid tradition, especially
noticeable in the decorative detail. The painting is full of
movement and free of the 'frozen' quality of the Vienna paintings.

64. **Ceramic bowl from Cairo.** First half 14th century.
Museum of Islamic Art, Cairo. This rare bowl is inscribed with
the name of an officer of Sultan Malik Nasir Muhammad (d.
1341). diam. 10¼ in. (26 cm.) h. 7⅛ in. (18 cm.). A typical
Mamluk ceramic vessel, heavy in body and shape and
decorated both inside and out with incised inscriptions and
monochrome glazes. Very few pieces of Mamluk ceramic ware
have survived intact which gives this bowl particular value.

Of 14th-century monuments, the massive complex of the
madrasah of Sultan Hasan (built 1354–62) is undoubtedly
the most important. Its cruciform shape is made up of four
deep ivan-halls with secondary rooms in between, the main
ivan leading to a huge dome chamber. The façade is dec-
orated with a series of narrow recessed niches running
almost to the full height, giving a vertical direction and
rhythm to the heavy cubic block. Its portal is dominated by
a colossal central niche filled with elaborate mukkarnas
design above and pierced by the entrance gate below. Else-
where the portal is faced with simple recessed panels and
squares of geometric ornament, or small deep niches cut
into the lower part of the sides of the entrance hall. The
sheer size of the portal structure and the austere simplicity
of its decoration make it one of the most powerful pieces of
Islamic architecture in Egypt.

During Sultan Kayt Bey's reign (1468–96), a great
number of especially magnificent buildings were erected
while some buildings of earlier periods were restored and
redecorated, including the mausoleum of Imam Shafi'i
(see Ayyubid period) which owes its particularly rich
surface treatment in the interior to the Mamluk period.
Kayt Bey's madrasah-mausoleum has a complicated
design. It includes a tomb dome chamber, a four-ivan
madrasah, a group of rooms for students and teachers to
live in, a public fountain with a school built above it on a
second storey, with an open loggia. The wall decoration is
extremely fine and sophisticated, using different coloured
stone to brilliant effect on both the exterior and the interior
of the building. It is probably the best and most accomplish-
ed example of the style developed in the later 15th century.

PAINTING AND DECORATIVE ARTS

Painting in western Islam was deeply influenced by the
Far Eastern experience of Iran and a great many motifs
and concepts were transmitted from there to the Mamluk
realm merging with the local traditions established in the
late 12th and early 13th centuries in Iraq, Syria and Egypt.
Out of this mixture of traditions, Mongol and pre-Mongol, a
strange and powerful style developed that, even though to a
certain degree provincial, and eclectic, can still claim a
great deal of originality and individual quality. The main
body of Mamluk paintings that have survived follows a
tradition that is primarily based on the Baghdad style in a
considerably abstracted form. In these paintings we en-
counter a world altogether removed from real life. The
contrast is particularly striking since the majority of the
Mamluk paintings that have come down to us illustrate the
same Makamat text that formed the basis for the great
masterpieces of the Baghdad school. Nothing of the almost
impressionistic rendering of everyday life that characteris-
ed these paintings has been transferred to the Mamluk
school. Here all figures are types and all settings ornamen-
tal abstractions, representations of ideas rather than real

65. Brass tray with silver inlay decoration from Egypt. End of 13th or early 14th century. The inscription contains the name and titles of Sultan Kalaun (1293–1309). Victoria and Albert Museum, London. Diam. 31 in. (78·8 cm.). The tray, one of the most sumptuous of its kind, is a perfect example of the elaborate metalwork of Mamluk Egypt. An entirely new style, only very loosely connected with the Seljuk tradition of Iran and Syria has been created, and the patterns, now exclusively abstract, have taken on a new vitality quite different from the pictorial traditions of Syrian metalwork in the 13th century. The large, radiating inscriptions have the quality of bursting light and lend an element of movement and energy.

66. Bronze mirror with silver and gold inlay from Syria. Made by the Master al-Waziri for a Mamluk governor. Mid-14th-century. diam. *c.* 6½ in. (16·7 cm.). Topkapi Sarayi Museum, Istanbul. The unusually well preserved silver inlay of this mirror gives a particularly good idea of the high quality of design and craftsmanship of Syrian metalworkers in the 14th century. The tradition of the 13th century is carried on without interruption but at the same time a richness of detail and a perfection of figure drawing developed that has few counterparts in the earlier work.

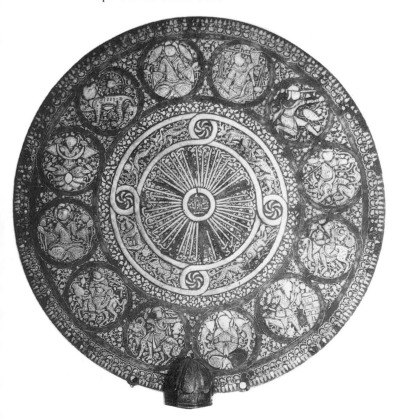

objects or landscapes, a fact that is emphasised by the strict use of a highly polished gold background.

In some of the miniatures the important influence that Il-Khanid art had on all 14th-century Islamic painting can be clearly felt. There are floral scrolls with heavy peony blossoms on cloud band forms that are directly derived from Mongol Iran, and even the figure style is somewhat less rigid and abstract.

Very little Mamluk pottery has survived. Again following pre-Mamluk and non-Egyptian traditions, the greater part of Mamluk pottery is distinctly hybrid. There are monochrome glazed wares with carved or incised decorations, and there are polychrome underglaze painted wares that use mainly black and blue, following in their floral and animal designs Syrian and Persian models.

Mainly produced in Syria, and continuing an earlier tradition, but equally common in Egypt, was a very fine sgraffito ware with bright yellow or a buff white as the main colour and brilliant greens, blues and a brownish red as its palette. The incised designs are largely floral in the background, often with a large figure, human or animal, as the main motif.

The most original and unmistakably Egyptian Mamluk ware is of an entirely different nature. It is heavy, thickly glazed and of a very distinct intense colouring, green, brown, yellow, one colour usually being used for the main

41

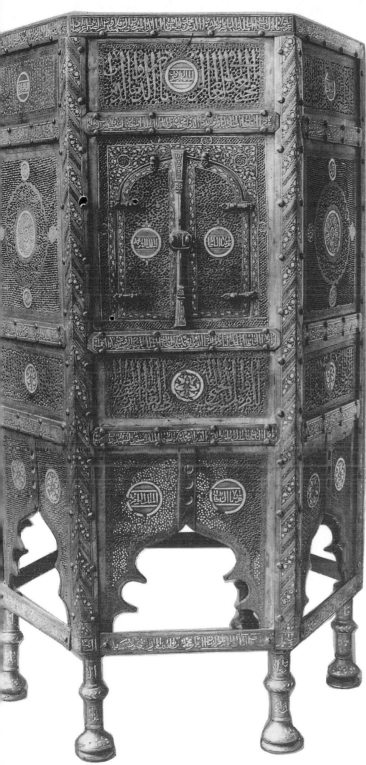

67. **Kursi (cupboard for a Koran) from Cairo.** Made for Sultan Kalaun in AH 728 (1327–8 AD). diam. 15⅜ in. (39 cm.) h. 27½ in. (70 cm.). Museum of Islamic Art, Cairo. Egypt took the lead in metalwork in the late 13th century and throughout the 14th and 15th centuries objects were produced there in great quantity and of the finest quality. This tall *kursi*, engraved, silver inlaid and perforated with arabesque designs, is not only complex, but also extremely accomplished.

part of the glaze with details of the pattern in another. The decoration consists almost exclusively of inscriptions and typically Mamluk heraldic emblems, being picked out in a second and third colour. The effect is sombre and powerful in the simplicity of design and the intensity of the deep colours. The shapes, steep walled bowls, round pots and footed cup-bowls, are fairly heavy and not terribly elegant, but they add to the effect of solidity and strength, qualities characteristic of all Mamluk art. *64*

During Mamluk rule Cairo took the lead in the production of metalwork. Inheriting the early 13th-century tradition of inlaid brasses transmitted to Egypt by the Ayyubids, Mamluk metalwork quickly developed a style of its own. The rich figure style of the Seljuk tradition, continued and brought to unsurpassed height by the Ayyubids, was abandoned and replaced by a purely non-figurative style. The objects, basins, ewers and trays, candlesticks and incense burners of circular form, become large in scale and powerful in design. The areas of silver and gold inlay with their monumental inscriptions and rich floral design, a repertoire largely of Mongol or Far Eastern inspiration, give these objects a truly magnificent appearance. A great many pieces are inscribed with the name of the sultan for whom they were made or with the names of officers of the Mamluk court, making a precise dating of individual pieces or of groups of objects possible. It seems that the highest achievement was in the 14th century and there was a decline in the 15th century. Inlay technique was abandoned and instead a rather coarse and limited engraving technique was developed. The shapes of the vessels got clumsier and heavier, in strange contrast to the magnificence of architectural decorations of the 15th century, under Sultan Kayt Bey. Finally the decoration of metal objects fell into almost complete decline. *66 65 42 67*

During the long period of Mamluk domination of Syria and Egypt a style of architecture and architectural decoration was developed that united the various elements derived from Fatimid, Seljuk, and Ayyubid art. The building material was again largely stone, and the basic forms are of monumental and highly abstract cubic design. A contrast was created between austere exteriors and richly decorated interiors but in the later Mamluk period the principle of rich decoration in a variety of media—plaster, relief carving, decorative painting, stone and marble polychrome—was extended to the exteriors as well as the interiors of buildings.

The decorative arts also followed the principle of simple and relatively austere forms developing however very sumptuous effects in the rich silver inlaid brasses of the 14th century. Painting has only a short period of flowering in the 14th century again reflecting in its abstraction of the Baghdad tradition the non-figurative nature of Mamluk art which achieved its most succesful forms in the realm of abstraction.

Nasrid Art in Spain

After the fall of the Umayyad dynasty of Cordoba before the middle of the 11th century, a series of minor dynasties came to power in Spain which ruled the country with various degrees of success throughout the remainder of the century. During the 12th century Spain became largely dependent on or actually part of North Africa under the rule of the Berber dynasties (Almoravides and Almohades). It was only with the Nasrids (1232–1492) that a new cultural impetus was given to the once more unified and politically stable country. At their court in Granada the Nasrids created a culture that reached a level of magnificence unparalleled in Muslim Spain, recapturing the splendour of the first great Islamic period under Umayyad rule. Muslim rule came to an end in Spain in 1492 with the expulsion of the last Nasrid king, Muhammad Buabdil, by Ferdinand and Isabella of Castile.

ARCHITECTURE AND ARCHITECTURAL DECORATION

The most remarkable achievement of Nasrid Spain is the

H. Plan of the Alhambra Palace, Granada

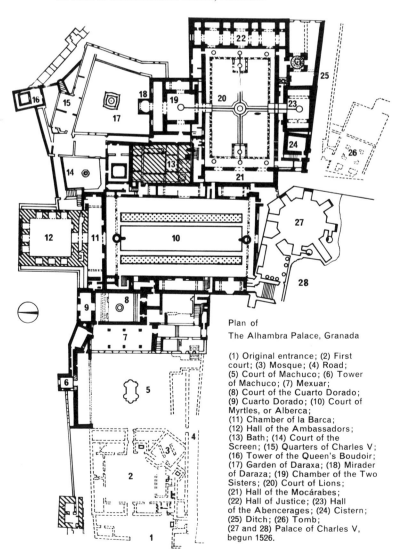

Plan of
The Alhambra Palace, Granada

(1) Original entrance; (2) First court; (3) Mosque; (4) Road; (5) Court of Machuco; (6) Tower of Machuco; (7) Mexuar; (8) Court of the Cuarto Dorado; (9) Cuarto Dorado; (10) Court of Myrtles, or Alberca; (11) Chamber of la Barca; (12) Hall of the Ambassadors; (13) Bath; (14) Court of the Screen; (15) Quarters of Charles V; (16) Tower of the Queen's Boudoir; (17) Garden of Daraxa; (18) Mirader of Daraza; (19) Chamber of the Two Sisters; (20) Court of Lions; (21) Hall of the Mocárabes; (22) Hall of Justice; (23) Hall of the Abencerages; (24) Cistern; (25) Ditch; (26) Tomb; (27 and 28) Palace of Charles V, begun 1526.

building of the Alhambra Palace in Granada. The palace, built at the top of the hill overlooking the city of Granada during the rule of Yusuf I (1333–53) and Muhammad V (1353–91), is of curiously irregular plan, possibly following North African models. It is divided into various separate units each arranged around a central court. The original entrance to the palace was on the west side and the first succession of courts with their adjacent structures runs from west to east. The second part of the palace changes direction, running from north to south. Its main element is a large, oblong rectangular court, the Court of Myrtles, and the Hall of the Ambassadors at the north end. The last part of the palace, arranged around the famous Court of Lions, is again on a west-east axis. It was reserved for the harim and was inaccessible to anyone but the king, his family and their servants. Between these two main palace complexes there was a bath hall, and, in the north-east, a beautiful garden, accessible only from the Court of Lions. The most magnificent of the rooms in the Alhambra, the square Chamber of the Two Sisters, adjoins the private garden its doors opening onto porticos on every side.

In its intricate succession of rooms and courts, constantly changing direction, the richness of surrounding arcades, water basins and water courses, that penetrate into the interior of the building, and with its multitude of fountains, the Alhambra Palace is like a splendid oasis remote from the reality of this world. This effect is especially emphasised through the contrast between an almost entirely undecorated exterior and the unparalleled richness of the interior.

In the Alhambra the fundamental elements of Islamic architecture and basic ideas of architectural design and decoration, developed over many centuries, found their highest form of realisation. In this sense the Alhambra is probably the most perfect piece of Islamic architecture.

Above a tile dado every wall surface is covered with a plaster coating that is decorated with patterns of astonishing intricacy. A great variety of floral, and semi-abstract floral forms (arabesques) are combined with a succession of arch and cartouche motifs, and enriched by highly decorative epigraphic patterns that often merge completely with the abstract linear elements of the patterns, though still remaining readable. There is a strange but highly successful contrast between this intricacy of pattern and the linear and geometric organisation of large units of the walls into panels, bands, cartouches, or frames for doors and windows. The low relief patterns, superimposed in various layers one upon the other, were all gilded and painted in various shades of blue, red and green, transforming the walls into brilliant lacework, an effect heightened by actual openwork in some of the mukkarnas arches of the court arcades. While the material substance of the walls is thus dissolved, the vaulting system, consisting in the main rooms of the most intricate and elaborately designed

H

45

(Continued on page 345)

62. **Sulaymaniyeh Cami, Mosque of Sultan Sulayman, Istanbul.** Founded on July 15th, 1550, and erected by Sinan. Centre of a vast complex of pious foundations, türbes (tombs), hospitals, caravansarayis (rest-houses for caravans), etc., the Suleymaniyeh has since its foundation been the main mosque of the city of Istanbul. Sulayman waited thirty years after becoming Sultan before commissioning the mosque; he obviously had in mind a building of exceptional quality and magnificence and he commissioned the greatest master of his day. This is, moreover, undoubtedly Sinan's finest building. The mosque is placed in the centre of a rectangular enclosure of which the sides are in the proportion of 2:3. The entire organisation of the mosque follows strict proportional relationships (the relationship of the distance between the main gate of the enclosure to the gate of the forecourt, forecourt to mosque, mosque to graveyard behind the mosque is 4:5:5:7). In this respect it is perhaps the most carefully designed of Sinan's building complexes.

63 (opposite). **Entrance wall to the Sünnet Odasi (Circumcision Room),** Topkapi Sarayi Palace, Istanbul, Turkey. 16th century. The tile decoration of the entrance wall of the Sünnet Odasi, dating from the middle of the 16th century (even though the room itself was not built before the 17th) is the main surviving example of early Ottoman Turkish blue-and-white tilework. The abstract floral design of these tiles is particularly beautiful in its movement and precision of pattern. The deep cobalt blue forms a magnificent contrast to the pure and brilliant white of the ground. In the lower register of the wall's decoration a series of tall tile panels are decorated with large lancette leaf motifs combined with birds and kylins. Albums in Istanbul and Vienna contain drawings of a similar nature, many of which were probably specifically intended as a guide for tile and pottery decoration.

64 (right). **Ceramic mosque lamp from the Dome of the Rock, Jerusalem.** Isnik, Turkey. Dated 1549. h. 15 in. (38·1 cm.). British Museum, London. An important landmark because of its date and its affiliation with the Dome of the Rock, this mosque lamp is a perfect example of Isnik work. The quality both of design and technique, employing polychromy and a brilliant translucent glaze over a semi-porcelain body of high purity and hardness, is unsurpassed.

65 (left). **Ceramic mosque lamp from Istanbul.** Isnik, Turkey. *c.* 1557. h. 19 in. (48·2 cm.). Victoria and Albert Museum, London. Exuberant in decoration and curiously expansive in shape, adding to the fairly large body of the lamp protruding bosses of a strongly sculptural quality, this piece demonstrates the full force of Ottoman Turkish ceramic design in the second half of the 16th century. It announces the magnificence of architectural ceramic decoration which found its highest development in the 1560s in the Istanbul mosques. It was made for the major mosque of the city

66. **Kaftan.** Turkey. Topkapi Sarayi Museum, Istanbul. Attribution to Bayazid II (1481–1512) has been questioned and the period of Sulayman the Magnificent (1520–66) proposed. Its magnificent floral pattern consists of a lancette leaf scroll beset with enormous multiform and coloured palmettes and is similar in style to early 16th-century decoration in drawings, pottery and tilework.

67 (below, left). **Isnik ceramic plate, Turkey.** Late 15th century. diam. 17 in. (43·2 cm.). Topkapi Sarayi Museum, Istanbul. Simple in shape and forceful in its deep blue decoration, this plate shows the effect of Chinese blue-and-white porcelain on Ottoman Turkish pottery but the delicate half-palmette arabesque work is typically Islamic.

68 (below, right). **Isnik ceramic plate.** Turkey. 16th century. diam. 11¼ in. (28·5 cm.). Metropolitan Museum of Art, New York. Realistic flowers, notably tulips, roses, carnations, and hyacinths, are typical of 16th-century Turkish pottery decoration. The addition of two birds here is unusual, animal motifs being quite rare.

69 (opposite). **Painting from a copy of Siyar-i Nabi** (*Life of the Prophet*). 1594. *The Prophet Muhammad, Abu Bakr, and Ali on the way to Mecca.* 7¾ × 7½ in. (19·6 × 19 cm.). Spencer Collection, Public Library, New York. All in the Ottoman court school style, a mixture of hieratic abstraction and almost popular realism in detail, the *Siyar-i Nabi* paintings are unique in Islamic art in the way their intensity of religious feeling transcends the historical events depicted.

وقال يا محمد ربك يقرئك السلام ويخصك بالتحية والاكرام

حق تعالى سنكا سلام قلدى ايندى ايشته جبرائيلى

سنكا كوندردم كه سنوك امروكه مطيع اولنول

دوشمنلرو كى هلاك ايليه بنرنكه كوكل ديلر

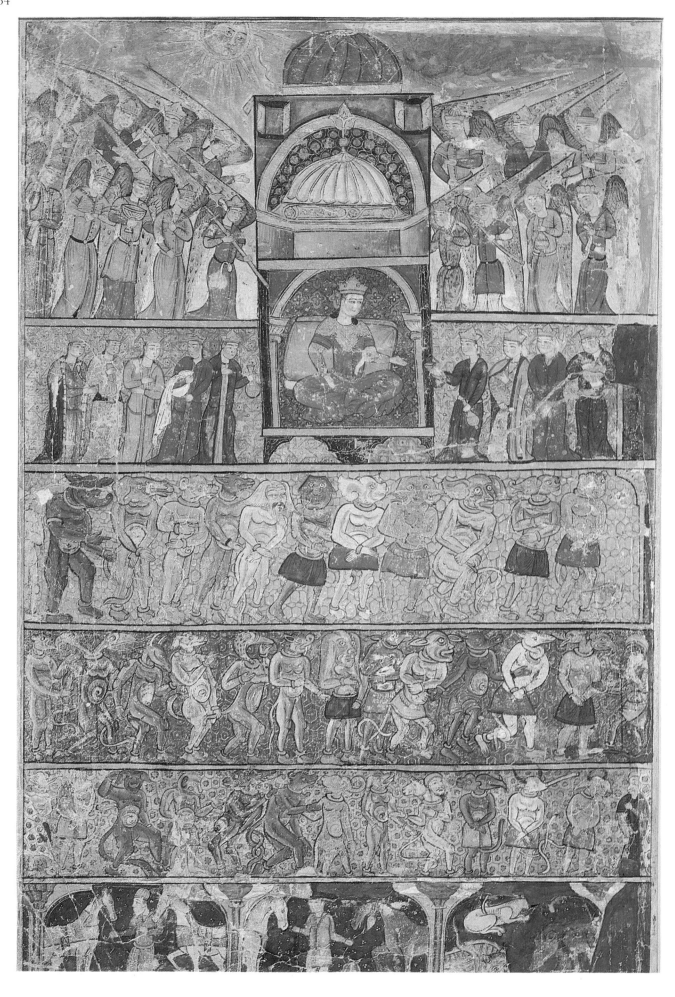

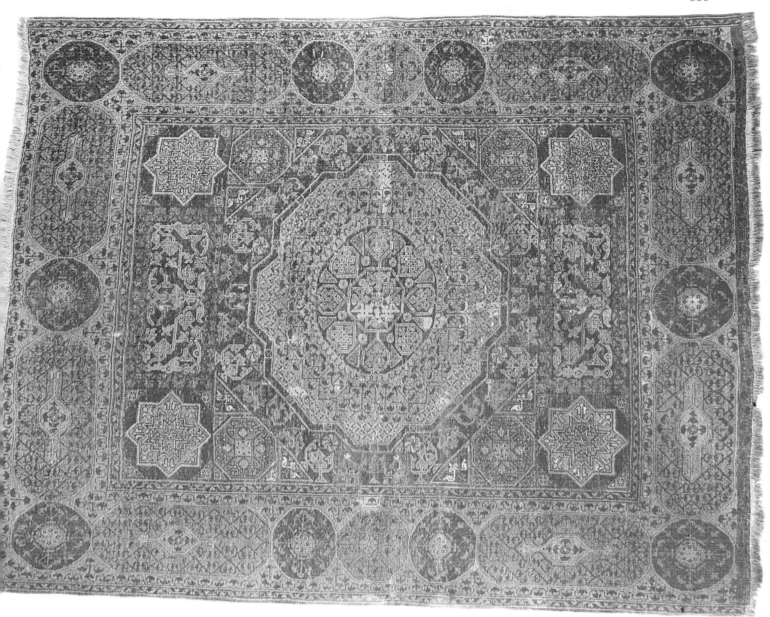

70 (opposite). **Frontispiece painting from a copy of Firdusi's Sulayman-nameh,** probably made for Sultan Bayazid II (1481–1512), from Bursa, Turkey. *c.* 1500. *King Sulayman (Solomon enthroned).* $9\frac{7}{8} \times 7\frac{1}{2}$ in. (25 × 19 cm.). Chester Beatty Library, Dublin. The upper part of the painting shows Sulayman seated upon his throne which is surmounted by a dome. He is surrounded by attendants and angels. Below his throne, in three registers, are various monstrous beings that appear to be in his service. At the bottom of the painting in the last register are what appear to be the royal stables. The introduction of monstrous beings into Sulayman's entourage is particularly interesting in view of the possible interpretation of some Herat paintings of about a century earlier (see plate 55). The painting is one of the earliest to have come down to us from the Ottoman court school in Istanbul.

71 (above). **Mamluk rug from Cairo.** 16th century. 6 ft. 6 in. × 4 ft. 6 in. (1·98 × 1·37 m.). Victoria and Albert Museum, London. A typical example of Mamluk rug weaving towards the middle of the 16th century, when the Ottoman Turks had already taken over Egypt but the traditional design was still in use. It is notable that in this carpet there is a stricter division between field and border and a clearer organisation of the design, differentiating between major pattern elements in the central medallion and minor pattern elements in the octagonal and star medallions of the field.

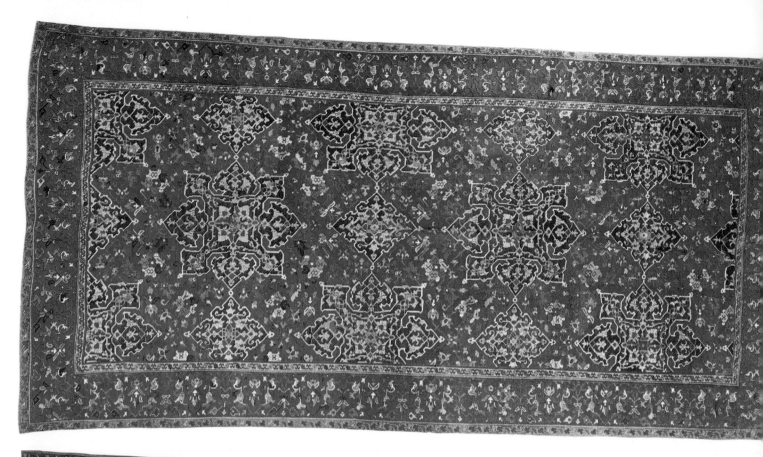

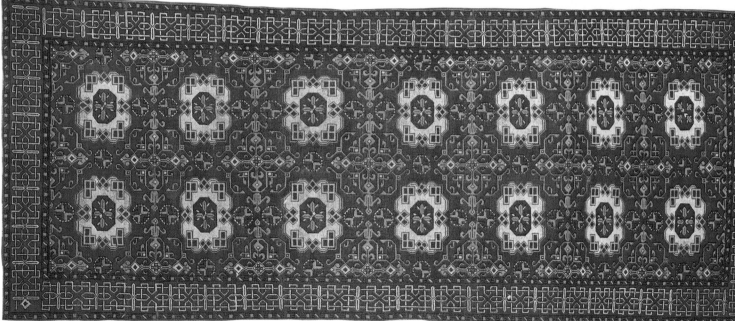

72 (top). **'Star Ushak' carpet from Turkey.** *c.* 1600. 14 ft. 7 in. × 7 ft. 7 in. (4·27 × 2·31 m.). Ex Collection of Joseph V. McMullan, Metropolitan Museum of Art, New York. These rugs, using a colour scheme of brick red, cobalt blue, yellow and white, are attributed to the workshops of Ushak in Central Anatolia. The alternate rows of larger and smaller star medallions reflect the influence of Safavid Persian rug design that broke with the abstract linear tradition and introduced cartouches and floral elements as main pattern elements. The total absence of figurative motifs, however, is typically Turkish.

73 (above). **'Holbein' carpet from Turkey.** *c.* 1600. 10 ft. × 4 ft. 3 in. (3·50 × 1·29 m.). Ex collection of Joseph V. McMullan, Metropolitan Museum of Art, New York. 'Holbein' carpets are so called because they appear in some of Hans Holbein's paintings. The strictly abstract linear design continues an uninterrupted tradition first developed by the Central Asian Turks and carried into Western Asia as early as the 10th century. Limited colours emphasise its simplicity. Its perfect balance and the unusual use of light blue for the alternating arabesque motif make this rug particularly attractive.

74 (opposite). **Ottoman-Egyptian prayer rug.** 16th century. 6 ft. × 3 ft. 7 in. (1·83 × 1·10 m.). On loan to the Metropolitan Museum of Art, New York. Collection of Joseph V. McMullan. The design of this rug is a product of the sudden contact between Egyptian and Ottoman-Turkish traditions in Cairo, conquered by the Ottomans early in the 16th century. The basic colours, green and red, are Mamluk-Egyptian, while the yellow and white and exuberant floral design are Ottoman-Turkish. The rug is of fine quality technically: the design is executed with precision and the surface impeccably smooth.

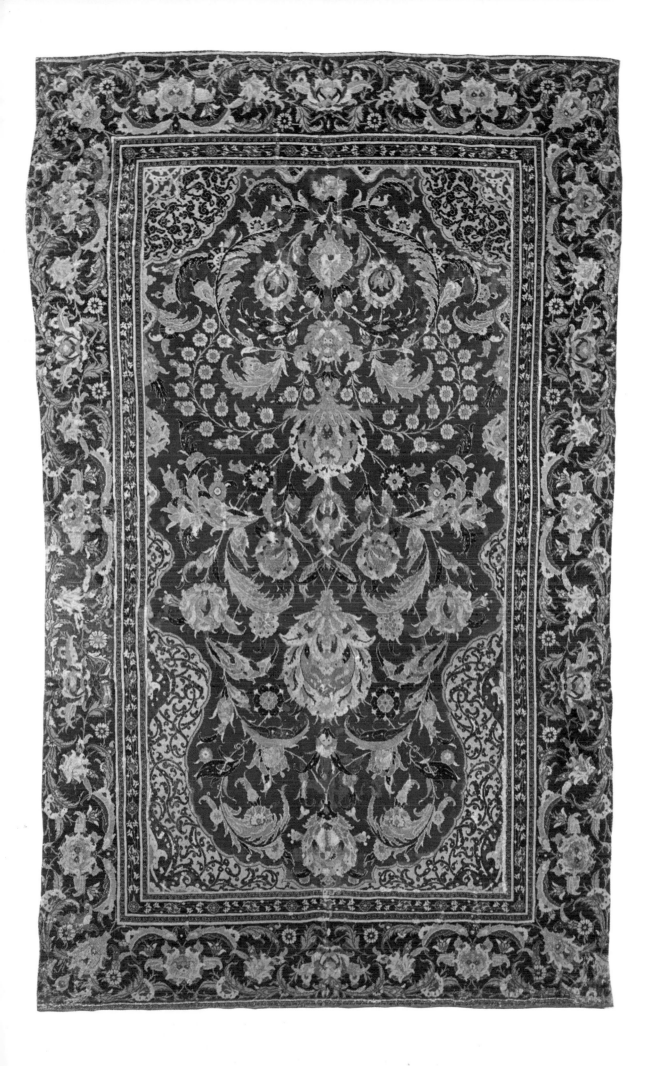

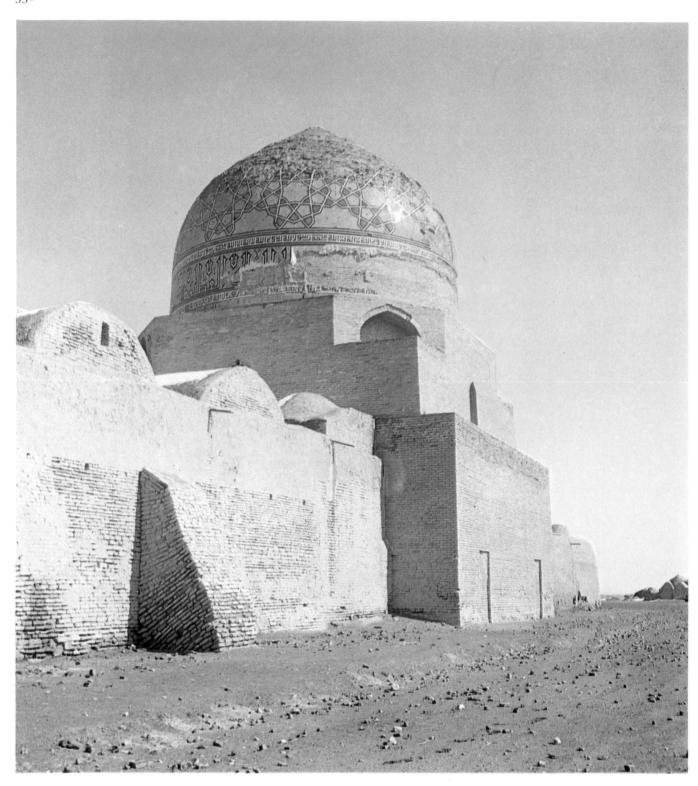

75 (above). **The Safavid mosque in Saveh, Iran.** Early 16th century. Dome chamber (seen from the outside of the enclosure). The mosque in Saveh is one of the earliest Safavid buildings to have survived almost intact. As hardly anything has come down from the period of Shah Ismail, the building acquires a special significance. The mosque is built on the traditional four-ivan plan and the dome chamber set into the centre of the prayer

hall against the kibla wall faithfully follows in its design the tradition established in the Seljuk period. The profile of the dome, in fact, resembles much more those of the Seljuk domes than those of the Timurid which eventually are copied in later Safavid domes. The faience decoration of the exterior becomes a standard feature of Safavid architecture.

76 (opposite). **Prayer hall of the Masjid-i Shah** (interior view). Isfahan, Iran. Early 17th century. This view shows the typical decoration of the arches and vaults, the walls and niches of the prayer hall of the great mosque of Shah Abbas with polychrome tilework. The contrast between the undecorated stone base of the walls and the stone columns and the highly ornate effect of the decoration of the rest of the room is a typical element of late Safavid architecture in Iran.

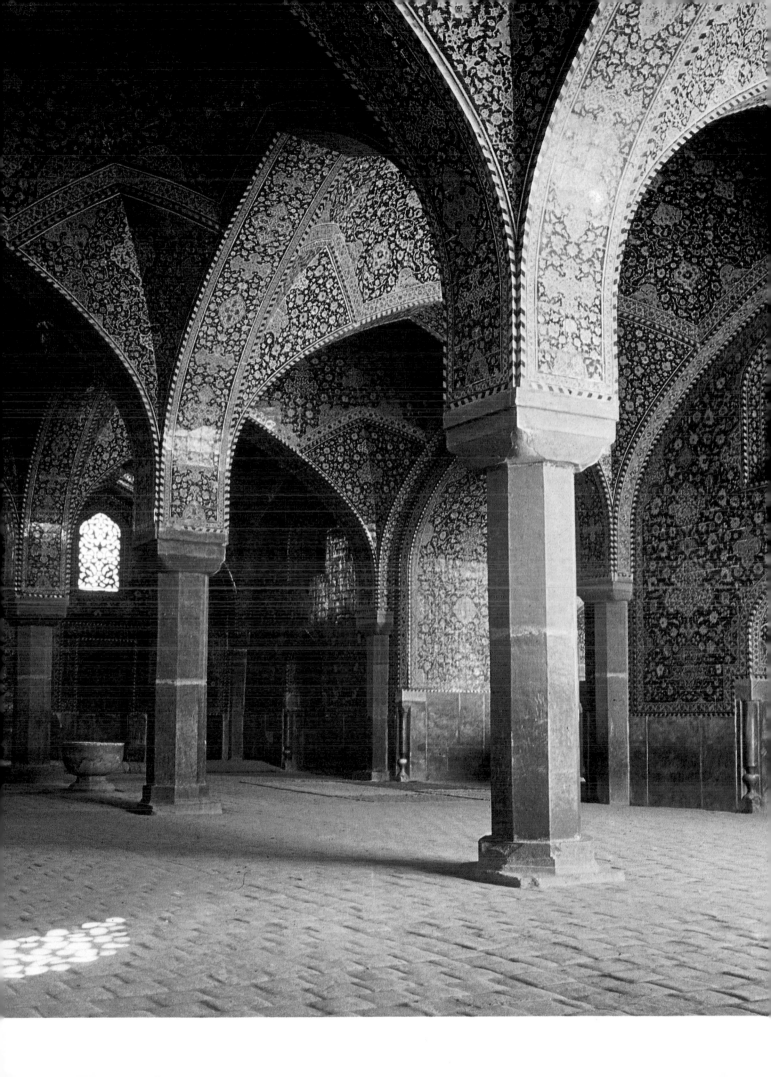

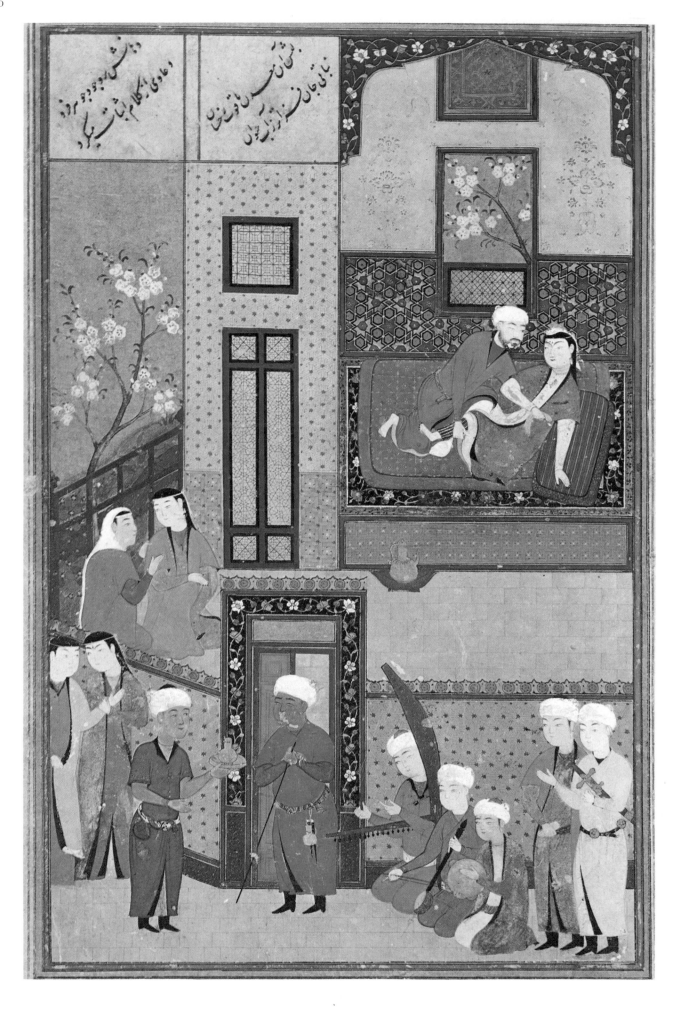

79, 80 (over page). **Double-page composition,** probably from the copy of Nizami's *Khamsa* in the British Museum by Mir Sayyid Ali. Tabriz, Iran. *c.* 1540. *Life in the City* and *Life in the Camp.* Each painting: 10⅞ × 7½ in. (27·7 × 19·1 cm.). Fogg Art Museum, Harvard University, Cambridge, Mass. Mir Sayyid Ali, one of the best painters of the early Tabriz school, had a particular interest in realistic detail and his paintings, masterpieces of genre representation, show all the minutiae of everyday life. When the Mughal Emperor Humayun visited Tabriz in 1544 he was so impressed with this artist's work that he invited him to India where he became one of the initiators of the Mughal style of painting.

77 (opposite). **Painting from a copy of Assar's Mihr-u Mushtari,** copied in Bukhara in 1523. *The Marriage of Mihr and the Princess Nawhid.* Size of page: 10⅜ × 6⅝ in. (26·5 × 16·8 cm.). Freer Gallery of Art, Washington D.C. The painting is an excellent example of the early Bukhara style. It demonstrates the immediate dependence of the Bukhara painters on the Herat style and it is very likely that the exquisite paintings in this manuscript were actually executed by painters that had been brought from Herat to Bukhara by the Uzbeks.

78 (above). **Painting from a copy of Nizami's Khamsa,** probably by Sultan Muhammad, made for Shah Tahmasp in Tabriz between 1539 and 1543. *Miraj Muhammad.* Size of page: 14½ × 10 in.

(36·8 × 25·4 cm.). British Library London. The Prophet, in a magnificent flaming halo, is shown riding Burak, the fantastic human-faced horse-like creature, surrounded by angels, ascending through the clouds of a starry sky to the Seven Heavens in the *Night Journey* that brings him to see the *Pleasures of Paradise and the Punishments of Hell.* This popular motif, first recorded 14th-century painting, has hardly ever been illustrated in a more magnificent way. The liveliness of the movement, the intricacy of the composition and the sumptuousness of the colour are outstanding and the attribution of this work to the greatest master of the early Tabriz school seems fully justified.

344

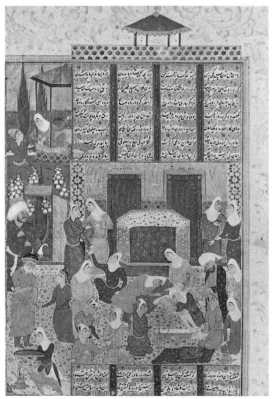

81. **Painting from a copy of Firdusi's
Shah-nameh,** copied in Tabriz for Shah
Tahmasp in 1537. *Rustam defeating the
Khakan of Cin.* page: 18½ × 12½ in.
(47 × 31·7 cm.). Collection of
Arthur H. Houghton, Jr., New York. The
paintings in this manuscript, the most
sumptuous of the entire period, executed
by the leading masters of the Tabriz
school, are perhaps the finest ever
produced in Shah Tahmasp's workshop.
This painting is outstanding in technique,
balance of composition, and subtlety of
colour. The dramatic combat between the
hero, Rustam, and the Emperor of China
in the foreground is counterbalanced by
the static effect of the two armies arranged
to the right and left of the landscape.
A tall tree in the centre gives a final accent
of symmetry to the composition.

82. **Painting from a dispersed copy of
Firdusi's Shah-nameh,** made in Shiraz.
Second half of the 16th century. *The Birth
of Rustam.* 11¼ × 7¼ in. (28·6 × 18·4 cm.).
Metropolitan Museum of Art, New York.
This is a typical product of the later
Shiraz school following a tendency toward
abstract pattern and vivid colour already
established in the late 15th century. The
extreme realism of this subject is unusual
in Islamic painting and its choice
demonstrates the interest in realistic
detail developed by the Shiraz painters
in the 16th century.

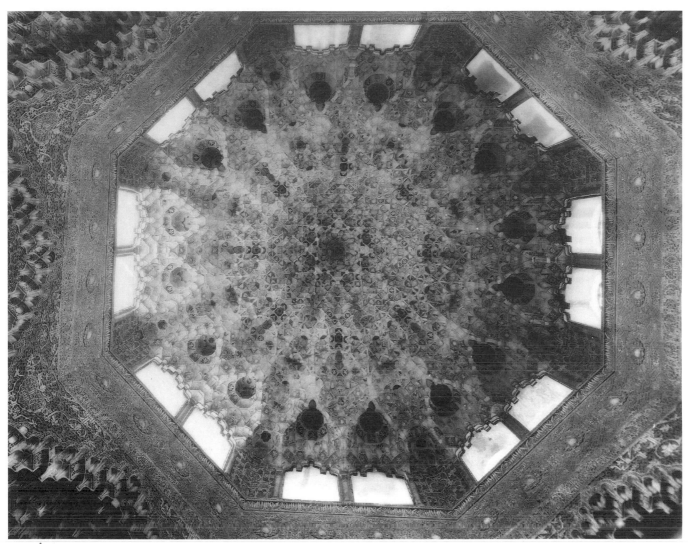

68. **Stalactite cupola in the Alhambra Palace in the Chamber of the Two Sisters** (room 19 on plan H). 14th century. Granada, Spain. This is undoubtedly the most elaborate use of stalactites (mukkarnas) in architectural design devised by Muslim architects. The complete dissolution of the vault and cupola into a fantastic honeycomb of hanging stalactites, gives the effect of a floating canopy. It demonstrates most eloquently the Islamic preoccupation with the dissolution of matter. It also corresponds perfectly to the cosmological symbolism of the cupola alluded to in a poem inscribed on the walls of the dome chamber.

68 mukarnas domes in the history of Islamic architecture, furthers the immaterial nature of the building.

One of the most profound aspects of Islamic architecture, the illusion of a building floating above the ground, was perfectly realised at the Alhambra. The repetition of motifs, such as the mukkarnas arches in the Hall of Justice, the double, triple, and quadruple finger-thin columns in the main court of the eastern palace, enhance the effect of insubstantiality.

THE DECORATIVE ARTS

This particular quality of Nasrid architecture in 13th- to 15th-century Spain, only equalled in Maghrib architecture, to which the Nasrids are undoubtedly indebted, can also be found in the decorative arts of the same period. Lustre-painting, for instance, with its dematerialising sheen was developed to a new height in Spain, especially in Granada. The technique was probably imported from Egypt, and it is not impossible that lustre ware was actually already made in pre-Nasrid times in Spain, but most of the finds of pottery of this type seem to be imports from Iraq and Egypt. In the 14th and 15th centuries ceramic workshops developed in Malaga, where the tiles that were used in the decoration of the Alhambra and other Nasrid palaces were also made. They are of plain, dull colours, red, brown, green, blue and white, with simple, purely abstract linear decoration. They often have in slight relief the coat of arms of the Nasrids, 'No victory but God's'. The earliest lustre vessels made in Malaga—usually large vases with 'wing'-shaped handles, tall necks, and pointed bases, suggesting that they usually hung in stands—are decorated with various floral (arabesque) and figurative patterns, the latter consisting of confronted animals, in a reddish lustre of beautiful sheen. The decoration is organised in bands,

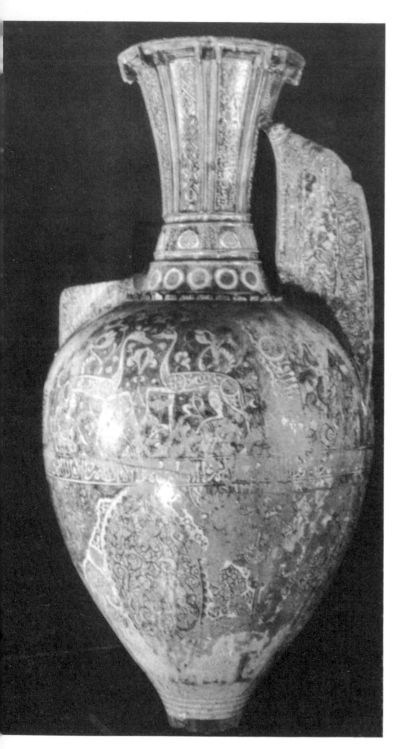

69. **Ceramic vase with lustre-painted decoration.** 14th century. Malaga (?), Spain. h. 47¼ in. (120 cm.). Alhambra, Granada. Painted in gold lustre with arabesque and animal motifs, using additional cobalt blue to heighten the colour effect, this is one of the earliest of the so-called 'Alhambra Vases', using a form that seems not to have been in use anywhere else in the Muslim world and the most ambitious ever undertaken by Islamic potters. The pear-shaped body, the high, narrow, funnel neck, and the wing-shaped handles on the shoulders of the vase (only one handle is preserved in this piece) are characteristic.

not dissimilar to the geometrical units into which the walls of the Alhambra palace were divided. The most famous piece of this type is the large vase in the Alhambra palace 69 and the entire group are often referred to as 'Alhambra Vases'.

A large number of pieces with coats of arms of the leading families of Europe show the popularity of the ware outside Spain. In Sandwich, Kent, papers have been found recording the export of lustre-painted ware from Malaga in the early 14th century. It seems that interference of the Christian navies with the export of this pottery in the 14th century forced the potters to migrate to the north where they settled near Christian Valencia which then became the main centre of lustre-painted pottery throughout the 15th century.

These vessels are solidly made and the clays are red, porous and not very pure. The glazes are thick, tend to run, and are again impure. But the quality of the lustre, and especially of the lustre-painting is superb and has few rivals in the long and complex history of lustre-painting in the Muslim world. Magnificent grape-vine patterns, abstract linear and heraldic patterns, and occasional large-scale representations of magnificent heraldic beasts, bulls, lions, eagles and falcons, cover the entire surface (often also the outside) of large plates, which are a favoured shape. Cobalt blue is sometimes added which give the plates a most sumptuous and highly decorative air.

Textile weaving, especially of gold brocade but also in tapestry and embroidery, were equally highly developed during this period, and a great variety of other decorative arts testify to the magnificence of this small but remarkably stable and active court.

It is also from this period that the earliest knotted rugs, preceded only by the small group of rugs from Seljuk Anatolia, have survived. They are of great beauty and originality in design, using few and subdued colours, mainly a dull grey, some green, brown, red and blue, a little white and a bit of black for details. Their small-scale repeat patterns, entirely abstract in nature and reminiscent 44 of the complex wall decorations of Nasrid palaces, are of great fascination and have few parallels in other Islamic carpets that we know. Small stars, knots, and other geometric and linear motifs cover the long narrow fields in rhythmic order, while in the narrow borders, usually treated in a somewhat livelier and more colourful manner, a curious and not altogether explained figurative iconography is developed that may have connections with the art of Coptic Egypt.

Nasrid art excels, then, in highly refined decorative effects; a sublimation of architectural decoration that led to a near perfect realisation of that most ardently desired result, the complete dematerialisation of matter; and a variety of decorative arts that number among the most successful in the art of Islam.

The Timurid Period

Mongol culture came to an end and a new era began in eastern Islamic art with the invasion of Iran by Timur (Tamerlane) from Kesh, south of Samarkand. Having consolidated his power among his own people, the Chagatay Turks in Central Asia, Timur descended upon the Islamic world in the second half of the 14th century. He raided Iran and Iraq taking Shiraz, Tabriz and finally Baghdad, and defeated the Ottoman Turks who had just established a new unified empire in Anatolia after a period of unrest after the fall of the Seljuks. ·

At first Timurid art drew heavily on pre-Timurid tradition and it is not before the consolidation of Timur's conquests by his son, Shah Rukh, who ascended the throne after his father's death in 1405, that Timurid culture came into its own.

ARCHITECTURE

Many features of Timurid architecture, especially in architectural decoration, can already be found during the rule of the Muzzaffarids and Jalairids, local governor dynasties in western and south-western Iran that developed in the later part of the 14th century a culture of great refinement in almost all fields of the visual arts. Particularly close to the later Timurid solutions of architectural design and decoration are the mosques in Kerman of about 1349 and in Yezd, built around 1375, but there is an equally important local (Central Asian) tradition of pre-Timurid art that furnished the Timurids with an abundance of models—especially in architectural design.

The first important monuments of Timurid architecture stand in Central Asia. In Samarkand, Timur's capital, buildings of all phases of Timurid culture have survived although some are now in ruins. Samarkand continued to be a flourishing centre of the arts throughout the 15th century although no longer the capital of the Timurid empire, after the conqueror's death, when Shah Rukh moved his court to Herat.

Shah-i Zindeh, the necropolis outside the city of Samarkand, preserves a variety of small tomb-buildings of simple plan but most exquisite decoration. Built on a square plan with a dome, most buildings have a shallow ivan-hall entrance gate in the centre of an elaborately decorated façade, the whole surface being covered with glazed tilework, usually moulded in relief and glazed in deep cobalt and turquoise blues; carved tilework of metallic abstract arabesque designs, glazed greenish-blue or green; carved and moulded tilework of intricate composite patterns, inscriptions glazed blue and green; and finally plain glazed tiles, green, blue, white and bright yellow.

The domes, often fluted, are decorated with either plain blue and turquoise glazed tiles or bricks or with linear patterns of different coloured tiles. In some tombs even the larger part of the interior is decorated with carved and moulded tilework. But also stucco reliefs and painting were used to complete the richness of the effect. It is from these buildings that one has to reconstruct the lost splen-

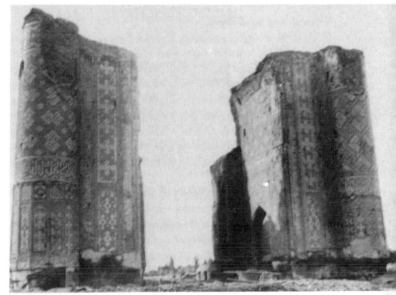

70. **Ruin of a gate structure of the Ak-Saray, Timur's Palace, Kesh** (Shahr-i Sabz, the Green City). Built between 1390 and 1405. Shahr-i Sabz was the second capital of Timur's empire and it appears that he intended to transfer the capital there permanently from Samarkand. Of the many important buildings erected by Timur only a few remain and those are in ruined state. The palace, of which this monumental gate structure originally formed a part, was observed by Clavijo, the Spaniard who accompanied an embassy to Timur's court in the early 15th century, and it is through his description that we have an idea of its general appearance although it was unfinished when Clavijo saw it. Apart from its size, the most remarkable feature of this architecture is the delicacy of the surface decoration carried out in glazed brick, marble, and faience mosaic.

I. Plan of the Bibi Khanum, Samarkand.

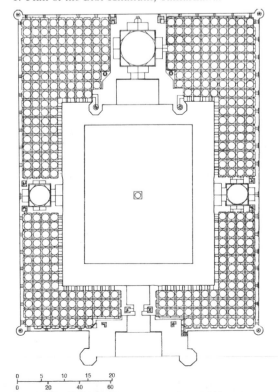

dours of Timur's, Shah Rukh's and Ulugh Beg's palaces in Samarkand and Herat.

Of Timur's great palace, the Ak-Saray in Shahr-i Sabz (Kesh), built around 1400 and still unfinished when Ruy Gonzalez de Clavijo, Spanish envoy and traveller, saw it in 1403, only the towering ruin of the inner gateway, which led to Timur's audience hall, still stands and shows some magnificent tile-mosaic decoration. According to Clavijo's description, the palace had a succession of enormous gateways with domed reception halls leading into huge courtyards with water basins and fountains and tall buildings on all sides.

Of Timur's Great Mosque in Samarkand, popularly known as the Bibi Khanum mosque, begun in 1399, only ruins remain but they convey once more the monumentality of design and magnificence of decoration in the original building. It has a number of remarkable features. The main portal is unusually large and is on the same axis as the main ivan at the other side of the vast court which has the same design. It has the Seljuk mosque four-ivan plan but with elevated dome chambers behind the two side ivans. These differences in design all add to the imposing character of the mosque which with its rich decoration and enormous proportions must have been one of the greatest achievements of Timurid architecture.

The Gur-i Amir, Timur's tomb in Samarkand, which he intended as a tomb for his nephew but then converted into a family mausoleum, was completed in 1405, the year of his death. Here again traditional architectural concepts are writ large. A huge, fluted, slightly bulbous overhanging dome, rises above a simple polygonal chamber, square on the inside. Its main feature is again a particularly highly developed scheme of coloured faience decoration.

Of the great mosques and palaces that were built by Timur's sons and grandchildren in Samarkand, Herat and in Iran very little survives. Gauhar Shad, Shah Rukh's wife had a family mausoleum built near the city: its beautiful central dome-chamber still stands, testifying to the refinement of architectural design and decoration of the period. The plan, a simple square chamber surmounted by a high fluted dome on a polygonal drum, takes up an earlier concept (also in the idea of a double-dome) that had been inherited from the Mongols, used widely in Shah-i Zindeh and in Timur's mausoleum, and continued to be used in eastern Islamic art in the following centuries. In its particularly fine vaulting system and the beautiful painted interior and faience mosaic exterior decoration the building surpasses all earlier structures.

Little has survived of later Timurid architecture. Incessant warfare between the princes of the realm after Shah Rukh's death in 1447, and the invasions of Uzbeks and Turkomans who gradually took over large parts of the Timurid empire, caused great destruction.

The most important monument of later Timurid architecture was actually not built by a Timurid prince but by the daughter of Jahan-Shah, ruler of the Kara-Kuyunlu Turkomans who had taken over most of western and southern Iran. The Blue Mosque in Tabriz, erected in 1465, has no court and centres around a large dome chamber surrounded by smaller domed rooms. All in all there are eight domes, plus one above a dome chamber that is placed on axis with the main central dome at the rear. The design, although finding certain parallels in Central Asia, is quite original and unusual in Iran. It has been suggested that Byzantine church designs may have served as models, but it seems more likely that contact with Turkish Anatolia is responsible for the plan, as it was in Anatolia that multiple dome structures were first developed in Islamic architecture. The faience decoration of the Blue Mosque is of dazzling beauty and its individual floral and calligraphic designs most delicate.

PAINTING

Little was left of the Mongol school of painting when Shah Rukh ascended to the throne, but he collected what he could still find of Rashid al-din's manuscripts of the *World History* which he ordered to be copied, enlarged and illustrated in his court workshop at Herat. Much of the style of painting of Shah Rukh's court is therefore a somewhat archaicising and slightly modified version of the Mongol style of the early 14th century.

The true Timurid style developed, however, on the basis of a different tradition. After the collapse of Mongol power, the local governor dynasties, the Jalairids and Muzzaffarids, had developed a style of painting in Shiraz and Baghdad, that must be considered one of the sources of inspiration for the new Timurid style at Miran Shah's court in Tabriz, in Shiraz, and a little later in Herat where Baysunghur, Shah Rukh's youngest son, had taken up residence. It is, in fact, the Herat school, under Baysunghur's guidance, that finally develops the classical Timurid court style.

The most important element of the initial new style is the emphasis on a new concept of space. The entire pictorial area was used, showing numerous figures, either singly or in groups, on various planes, through the simple device of introducing a high horizon. This technique of making most of the pictorial area a landscape ground meant that different levels of perspective were represented one above the other on the page. The entire surface of the page could become a flowery meadow or garden in which trees and shrubs would appear in different positions leading up to the high horizon. Mountain ranges were introduced into landscapes behind which further stretches of physical space could be imagined, often suggested by having entire armies emerging from behind the hills. Although the principles of this technique were derived from the pre-Timurid Muzzaffarid and Jalairid painting, space was first conveyed in this way in mid-14th-century Mongol miniatures.

The first phase of the Timurid classical style is encountered in a number of manuscripts that were made for Iskandar Sultan at the beginning of the 15th century. The finest

71. **Painting in a copy of Sadi's Bustan,** painted by Bihzad in 1489, Herat School. Second half 15th century. Page size 11⅞ × 8½ in. (30 × 21·5 cm.). National Library, Cairo. The paintings in this manuscript are generally considered to be the major work of the leading master of the Herat school, Bihzad. This particular painting is signed by the painter and dated. Perfecting and revitalising the style and adding a certain amount of realistic detail, Bihzad's work represents the quintessence of the Herat school of painting which had developed over a period of more than a century starting with Jalayirid-Iranian and Timurid-Central Asian ateliers of the late 14th century.

of these is an Anthology made in 1410. In the paintings of this manuscript there are all the qualities that became the standard of excellence in early Timurid painting: the new fully developed spatial concept; a figure style of great elegance and animation; finely observed individual characterisation; the highest technical skill in composing complex groups or postures of individual figures, and a convincing relationship between the individual figures or groups.

The figures are tall and slender. They have oblong heads often with pointed beards, slanting eyes, straight delicate noses and small mouths. They are shown in a great variety of postures, and although their gestures are rather stereotyped, they are extremely animated, always participating fully in the action of a given scene or situation.

The colours are bright without being loud. There is great subtlety of shades and the colours are always used with an eye to the general effect. Much gold is used, and occasionally silver for the representation of water.

The paintings in the Iskandar Sultan Anthology rep-

resent what one might call the 'Imperial Timurid style', that is the style that dominated the Timurid realm before the local schools of Shiraz, Tabriz, Herat and the northern provinces developed.

Already around 1420, Shiraz artists were producing paintings of a highly personal nature, closely related to the earlier tradition but different enough to be immediately recognisable. The Shiraz painters of the 1420s and 1430s, working for Ibrahim Sultan, another of Shah Rukh's sons, used fewer figures and developed a highly mannered landscape. Single figures and small groups of fairly large individual figures are set against mountains and curious rock formations of fantastic shapes and colours. The bodies of the figures are elongated and mannered in pose and gesture; the facts are standardised, expressionles, remote. The colours, pale blues, greys, pinks and whites, dominate landscapes that are almost without vegetation. A few strong local colours are used for animals, human figures, their costumes, and minimal architectural settings.

In about 1420 Herat took the lead. Baysunghur assembled at his court the major talents of his time, producing in quick succession a series of illuminated manuscripts of the highest order. He had various sources to draw upon—the archaistic Mongol-Timurid style of Shah Rukh's workshop, the Imperial Timurid style of ten years earlier, the Shiraz style so well known to him from his residence in his brother's city and from an Anthology made in Shiraz for him on his brother's order, and a local Central Asian tradition that had developed from the immediate contact with Chinese painting.

Of this local tradition, which must have been established at Timur's court in Samarkand and continued there under his grandson Ulugh Beg, and at Shah Rukh's court in Herat, very little is known; a great many paintings have survived in albums in Istanbul that seem to have been painted around 1400 in Samarkand and Herat. We know that various delegations went to and fro between the Timurid and the Chinese court and that Timurid and Chinese painters met and knew each other's works. Copies of Chinese paintings and studies of Chinese motifs in new combinations to be joined into a new pictorial unity, have survived in great numbers.

It is into this line of tradition that the Iskandar Anthology and related illustrated manuscripts of the late 14th and early 15th century fit best. On this basis, Baysunghur's artists formed a new kind of painting. The Baysunghur style perfects the ideals established in the first twenty years of Timurid rule. The refinement of brushwork is unsurpassed, and the sense of subtle colour combinations sublime. There is a further emphasis on well-balanced compositions, a full use of the decorative ideas of landscape design first developed in Shiraz at the end of the 14th and in the early 15th century and a serenity of mood that can truly be called 'classical'. The Gulestan Shahnameh, made for the bibliophile prince in 1430, contains the most brilliant series of paintings in this style.

The ideals formulated in the Gulestan *Shah-nameh* miniatures became those of all later eastern Islamic painting. The immediate continuation of Baysunghur's style is demonstrated by a number of manuscripts that were produced after the prince's death. Among them the most **58** extraordinary is the copy of the Mir Haydar's *Miraj-nameh* written in eastern Turkish in Herat in 1436. The paintings follow in all major elements the Baysunghur style, but have a more dramatic quality.

The figures are greatly enlarged, very likely a reflection of a tradition of monumental wall-painting carried through from the early Timurid period, of which nothing has survived but which we know of through contemporary reports; and there is an intensity of expression, an emphasis on fantastic-realistic detail, that is so far unique in Islamic painting. It is important to realise that the Turkish (Central Asian) element in Timurid culture was always very strong and it seems that old Central Asian traditions were revived in these paintings.

The disturbed political situation of the mid-century, after Shah Rukh's death in 1447, did not favour the art of painting which flourished again only later in the century after Sultan Husayn Bayqara once more consolidated Timurid power in Herat. The late Herat school is a final flourish of the Baysunghur style. Many elements of the early style that, by the middle of the 15th century had become stereotype formulas, are filled with new vigour and expression. Bihzad, the greatest name in eastern Islamic painting, worked at Sultan Husayn's court and in the paintings of Sadi's *Bustan* in Cairo, of around 1495, the late Herat style achieves its finest form. Bihzad, who lived on into the following century, carried the Timurid style and its ideals into Safavid painting. He surrounded himself with many painters of the greatest skill who collaborated with him in a series of manuscripts made for Sultan Husayn's library. Among these, Mirak-nakkash, Abd al-Razzaq, and Kazim **59** Ali (Qazim Ali) may be mentioned, artists who, between 1480 and 1495, created miniatures for a number of Nizami, Saadi and Mir-Ali Shir Nevai manuscripts that are among the finest products of Muslim art.

In contrast to the Herat tradition which undoubtedly dominated the scene in Central Asia and eastern Iran, the Shiraz school went its own way. The post-imperial style gradually developed into a strange, lifeless stereotype of purely provincial quality—only to be revived and channelled into a new and highly original direction by the Turkoman rulers who took over Shiraz in the mid-15th century.

The Turkoman style, in its vigorous colours, lively scenes of action, bold patterns of design, and highly original iconography, belongs to the best and most interesting of the minor schools of Islamic painting. The major work is the series of more than a hundred large and powerful paintings of completely new design which illustrate a text by Ibn Husam, the *Khavaran-nameh*, copied in Shiraz around 1480.

72. **Binding of a copy of Jalal al-din Rumi's Mathnawi,** Herat, AH 887 (1483 AD). Leather. $10\frac{1}{4} \times 7$ in. (26 × 17·6 cm.). Museum for Turkish and Islamic Art, Istanbul. The technique used for this bookbinding was first developed in the early 15th century in Herat. The entire pattern is cut out in a kind of filigree technique and pasted upon a coloured leather background. The landscape with various animals—monkeys in trees and flying ducks above—is repeated in the border, thus following the bookbinding traditions of the early 15th century. Such bindings must have been produced in large numbers since albums at the Sarayi in Istanbul contain numerous decorative drawings which must have served as models.

73. **Bronze cauldron with relief decoration.** Inscribed with the name and titles of Timur. AH 801 (1399 AD). diam. $7\frac{1}{2}$ feet (245 cm.). Hermitage, Leningrad. The magnificent cauldron in the form of a large bowl on a high foot (a shape known in Islamic metalwork for several centuries, see also fig. 40) was originally in the Mosque of Ahmad Yassavi in Turkestan. It was obviously a pious donation of the emperor to the mosque which he had erected in 1397.

75. **White jade ewer, inscribed with the name and titles of Ulugh Beg,** Shah Rukh's son and Timur's grandson. Made for the prince probably in Samarkand, between 1417–49. Calouste Gulbenkian Foundation Collection, Lisbon. Jade appears to have been a favourite material of the Timurids and a number of pieces survive that, either by inscription or by stylistic similarity, can be associated with Ulugh Beg.

74. **Brass ewer with gold and silver inlay.** AH 903 (1497 AD). h. 5⅛ in. (13 cm.). British Museum, London. The group of metalwork of which this small ewer forms part has long been considered to be of Islamo-Venetian origin. This piece can be ascribed to the late Timurid period and to Herat, because, in an inscription on the piece the name Sultan Husayn is mentioned who ruled in Herat from 1468 to 1506. In form it is almost identical with Ulugh Beg's jade ewer in Lisbon (fig. 75). In contrast with the tradition of figurative representation in metalwork decoration of the preceding centuries, Timurid metalwork uses exclusively floral and epigraphic elements in its design.

DECORATIVE ARTS

With the continuing tradition in painting, a parallel tradition in book production can also be observed in Herat where the arts of illumination, calligraphy, and bookbinding were developed to the highest degree becoming standard models of excellence.

It was most probably in Baysunghur's workshop that the complicated and highly refined art of leather filigree was developed in bookbinding. In combination with pressed and stamped gilded designs, the cut-out patterns, set against coloured background, achieve an astonishing complexity of forms and surface treatment. Often abstract, or semi-abstract floral, many of the relief as well as filigree designs are figural in subject and correspond to a school of decorative drawing that seems to have developed at the end of the 14th century in Samarkand and continued into the 17th century in Ottoman Turkey.

There is very little difference in style, imagery, or technique between a binding made for the library of Shah Rukh in 1438, and one made for Sultan Husayn Baykara almost fifty years later. There is the same delicate landscape design with small rocks, blossoming trees, birds and butterflies, stags, bears, and lions, and the same filigree pattern with dragons, kylins, monkeys and cranes. There is the same highly refined surface treatment, counterplay between light relief, gilded, and cut-out filigree lace-patterns set off against coloured grounds.

76. **Carved wooden Koran stand (Rahle) from Transoxiana.** AH 761 (1360 AD). $51\frac{1}{4} \times 16\frac{1}{8}$ in. (127·6 × 41 cm.). Metropolitan Museum of Art, New York. This is a fine example of the art of woodcarving as developed in Central Asia in the 14th century. The type of decorative carving, using both floral and epigraphic motifs in various layers of relief as main features of design, became the prototype for both Timurid Central Asia and Iran. The inscription contains the names of the Twelve Shia Imams and both a date and signature, ample evidence of the importance attached to the lectern.

Although early 16th-century bindings in Safavid Tabriz continued the tradition, nothing was produced in the 16th or 17th centuries to surpass the Timurid achievement.

Little of early Timurid metalwork has survived. It seems that the silver inlay technique so highly developed in Seljuk and Mongol Iran, and so brilliantly continued in Iraq, Syria and Mamluk Egypt, suffered a rapid decline in the 15th century. Of the early period only a few heavily cast candlesticks and cauldrons that bear Timur's name 73 and titles are known—large objects of simple shape with limited incised and cast relief decoration. All smaller objects seem to have been made of precious metals and have vanished, although a few surviving pieces of jewellery, gold 61 and silver, show the same high skill and refinement as seen in Timurid architecture and the art of book design. A group of small ewers and bowls has also survived which seem to 74 have been made during the 15th century, one being dated 1497 and inscribed as having been made for Sultan Husayn in Herat. That this piece follows an established form is shown by the fact that a jade-carved ewer, made according to the inscription for Ulugh Beg, has exactly the same form and the same typical dragon handle. A number of fine jade carvings, probably made at various times during the 15th 75 century, are the token survivors of a great tradition of decorative arts in Timurid times. The art of decorative surface carving, highly developed in stone and wood both 76 in Samarkand and Herat from the late 14th century on, continues again pre-Timurid traditions but reaches new forms of perfection in balanced arabesque designs of highly abstract nature, or elegant floral and calligraphic design of often astonishing realism.

Little has survived of Timurid pottery, and it may well be that most of the potters' efforts went into the production of magnificent tilework. But a few pieces, painted in blue and black on a white ground in imitation of Chinese porcelain, have been preserved. A whole group of pieces that were found in the 19th century in the Caucasian city of Kubachi, can be attributed to the 15th century. There are 60 even some dated pieces, all of the 1460s, painted in black under a deep green glaze of high purity and brilliance—heavily made dishes and deep bowls, rather crude in form but with abstract floral designs and calligraphic decorations of great beauty and sensitivity.

Timurid art in general can perhaps be recognised as a sublimation and ultimate refinement of the basic ideals of eastern Islamic art formulated at the beginning of its cultural history and worked on for many centuries. In particular, the imaginative handling of traditional features in architectural design and the unparalleled sumptuousness of applied decoration, especially in polychrome faience, transforms architectural construction, making it an almost perfect realisation of the Islamic ideal of dematerialisation, which, although common to all Islamic art, found its most beautiful expression in Persia and Central Asia during this period.

The Art of the Ottoman Turks

77. Selimiyeh Cami, Edirne, Turkey. Built by Sinan between 1569–75. This is the masterpiece of the architect, Sinan, and the final apogee of Ottoman-Turkish architecture. The mosque, built, as usual, inside a large enclosure is conceived as a compact mass surmounted by a huge dome.

The concentration on the dome chamber is emphasised by the fact that the four minarets are placed at the corners not of the fore-court but of the mosque itself. The minarets are especially tall, emphasising the upward thrust of the whole building.

With the decline of Seljuk power in Anatolia at the end of the 13th century, the country was ruled by a number of small local dynasties. Of these the Osmanli or Ottoman Turks eventually took control. When the Seljuk sultan had been hard-pressed by the Mongols he had been given military aid by Ertughrul, a leader of the Turkish *ghazis* (fighters for the faith), who was therefore given control of part of the realm. When Ertughrul died in 1281, his son Osman succeeded him and gave his name to the new dynasty—'Ottoman' being derived from the Arabic form of his name 'Othman'. Orkhan (1324–62) succeeded him, capturing Bursa (Brussa) and Isnik (Nicaea). From then on the Ottoman empire grew rapidly in size until most of western Islam was permanently subjugated with only a minor setback with Timur's invasions at the end of the 14th century.

Under the Ottoman Turks a new phase of art and culture began in Anatolia and with the conquest of Constantinople in the middle of the 15th century, the city on the Golden Horn, once the centre of Byzantium, became the focal point of western Islamic civilisation.

ARCHITECTURE

The greatest achievement of Ottoman architecture is the domed mosque plan. An early form around 1400, is the Ulu Cami in Bursa, a rectangular building with four rows of five domes each. The subdivision of a given space into smaller units each of which could be covered with a dome was the first and most primitive step toward a unification of the space of the prayer hall by using the same kind of vaulting system throughout. The main problem that faced Turkish architects was how to eliminate the multitude of

78. **Sultan Ahmet Cami, mosque of Sultan Ahmet I, in Istanbul.** Built 1609–16 by Muhammad Aga ibn Abd al-Mu'in. The problem of creating a unified domed space was one which occupied the Ottoman-Turkish architects particularly. In the Selimiyeh interior, Sinan triumphed. Muhammad Aga was possibly a pupil of Sinan and follows closely his example at Edirne, where the thrust of the huge dome was so skilfully distributed among its eight columns that an effect of utter weightlessness was achieved, the supporting columns being positioned close to or made visually part of the walls.
The mosque of Sultan Ahmet in its magnificent proportions carries this great Ottoman achievement into the 17th century and the interior is one of the most impressive in Istanbul.

J. Plan of the Selimiyeh Cami, Edirne.

supports for all the domes which also subdivided the space below interfering with the concept of unity. From the first attempt in Bursa to the final solution in the Selimiyeh Cami in Edirne, erected by Sinan between 1569 and 1575, goes a straight line of thought. Each step is taken carefully, noting all problems involved; few look back to the more primitive form of vaulting or subdivision of the given space.

The final solution in the Edirne mosque is achieved by putting the columns that support the huge central dome so close to the walls and so far to the right and left end of the main hall that they seem to become part of the walls. The extensive use of large windows, converting the walls and supports into airy screens, finally achieves the desired effect—the creation of an enormous floating dome over a unified, intensely light room. The vastness of the space embraced in the Selimiyeh reaches the limit of the possible, and the extent of dematerialisation of substance in the way the abundant light dissolves the massive columns supporting the dome has hardly ever been surpassed in Islamic architecture and has never been done by simpler means.

Tile decoration in Ottoman architecture serves the same function as Seljuk lustre and minai painted tiles, and Seljuk and Mongol plaster carving—to disassociate the appearance of wall and column from its function. When looking into the interior of an Ottoman mosque, one gazes into a magnificent flower garden or an elaborate arrangement of continuous semi-abstract and abstract ornaments on brilliant white grounds which lead the eye to infinity.

The tiles of the various rooms in the Top Kapi Sarayi Palace serve the same function. Mostly floral and polychrome, there are also dazzling blue and white tiles of semi-abstract lancette and rosette designs that seem to have continued in fashion since the end of the 15th century. There are also figural patterns combined with beautiful lancette leaf ornaments, closely resembling those on album sheets of the Sultan's library which may have served as models. Some of these derive from a school of decorative design first developed in early 15th-century Herat and were also used as models for bookbindings, pottery and probably tile-painting, and for textile designs. Some of the finest 16th-century ceramic vessels made in the court factory of Isnik follow the style of floral designs used for silk brocades, such as the kaftan of Sultan Bayazid (now attributed to the period of Sultan Sulayman, 1520–66).

POTTERY

Until recently little was known about early 15th-century ceramic or tile production in Anatolia. It seems that much of the tilework in the Green Mosque in Bursa was made by potters from Tabriz which would indicate a sharp decline in local workshops. The gap between the pottery of the Seljuq period and Ottoman pottery of the 16th century has since been filled by excavations and the documentation of a continuous tradition of pottery making in Anatolia from the 13th to the 16th century.

The earliest wares, entirely decorated in blue on a white ground follow the general 'Chinese' fashion firmly established in the Mongol period and continued into the later Safavid period. The vessels, mostly large rimmed plates, deep stemmed bowls, vases, candlesticks and mosque lamps, are decorated with floral and arabesque patterns of great elegance and precision. The glazes are of a beautifully brilliant quality, the ceramic bodies fine, hard, porcelain-like. It is astonishing to find such accomplished pottery at what appears to be the beginning of a new school of ceramics. It is likely, although impossible to prove, that the early Isnik blue and white ware is the end product of a fairly long tradition of ceramics in Anatolia. A little later a group of pottery is made, known as 'Golden Horn' ware, that uses as its main decorative feature thin spirals studded with

79. **Drawing of a dragon in foliage from Istanbul,** Turkey. Mid-16th-century. $6\frac{7}{8} \times 15\frac{3}{4}$ in. (17.5 × 40 cm.). Museum of Art, Cleveland. Following a tradition going back to at least the early 15th century in Central Asia, this drawing belongs to a school of decorative design that had reached a high level in Herat, and then was transferred at the beginning of the 16th century to Tabriz. From Tabriz it was transmitted to Istanbul in the first half of the 16th century. The drawing was undoubtedly appreciated at the time since it was included in a selection of miniatures, drawings and calligraphy assembled in one album. The famous album in Vienna made for Murad III in 1572 contains a number of such designs.

minute floral rosettes in a pale or blackish blue on a white ground.

The blue and white wares give way to pieces of more elaborate, less abstract, and eventually mainly floral **68** designs of a fairly realistic nature. Large lancette and palmette designs and arabesque patterns come into fashion and purple, green and various shades of blue are added to the palette. Important works of this phase are a number of **64** large mosque lamps made for the Dome of the Rock in Jerusalem, which was restored by the Ottomans in the middle of the century and extensively redecorated with tiles on the outside, giving new impetus to the production of tiles, also made for the mosques in Istanbul. Some of these mosque lamps are dated around the mid-century, providing a useful chronology otherwise almost completely lacking in Ottoman pottery.

The final development of Ottoman pottery is a poly-chrome style of decoration. The motifs are almost exclusively floral, realistic, and particularly sensitive in design. In a few rare pieces animal and bird motifs are included. A brilliant red, applied so thickly as to create a slight relief effect, is one of the most remarkable achievements of the Isnik potters. The secret of this particular colour seems to have been well-guarded as it appeared in no other school of ceramics of the period. Safavid workshops that produced the polychrome 'Kubachi' wares tried persistently to imitate the Ottoman red; they struggled equally unsuccessfully to produce a glaze that would match the purity, brilliance, and durability of the Isnik wares. Isnik pottery, in fact, is unrivalled in the 16th century.

PAINTING AND DRAWING

Little is known of early Ottoman painting and although undoubtedly paintings were produced at the Ottoman court in Bursa before the conquest of Constantinople it is difficult to determine which of the small number of early Turkish paintings date from the pre-Istanbul period. After this conquest and the establishment of a court school under Mehmet's patronage in the palace, Ottoman painting took a distinctive step of its own.

A large group of decorative drawings—mainly of dragons in landscapes or battles between dragons, the phoenix and other real and fantastic animals—and dec-orative studies of lancette leaf motifs with palmette blossoms of a decidedly calligraphic quality, undoubtedly belong to the court school in Istanbul since there are similar studies in an album made for Murat III in 1575. The Cleveland Dragon drawing, one of the finest of the group, **79** almost certainly came from such an album. Its brilliantly animated design, with the characteristic grey-brown monochromism, and purely decorative quality are typical of these drawings. As already mentioned many of them were probably made as models for tile and pottery painters, textile designers or perhaps bookbinders. Their close relationship with Timurid drawings and book-bindings indicates a possible derivation from the style of Herat, Tabriz, which was conquered by the Ottoman Turks at various times in the early 16th century, serving as an intermediary.

Ottoman painting, however, generally has an entirely different form. Blunt in colour, austere in composition, and entirely Ottoman-Turkish in iconography, the paintings illustrate historical texts of the period, the *Selim-nameh*, the *Sulayman-nameh*, the various books of Festivals (*Sur-* **70** *nameh*, etc.). There are also some that illustrate an extraordinarily important text—a lengthy version of the life of the Prophet (*Siyar-i Nabi*) produced by a Turkish poet for a Mamluk sultan in 14th-century Cairo, but known in an illustrated version only from late 16th-century Istanbul. The paintings of this edition which seems to have been prepared in six volumes for Sultan Murat III in 1594, are in the typical Ottoman court style of large figures in brilliantly coloured costumes, fine, expressive faces, simple landscapes or highly decorative architectural interiors and an original and intensely pious quality that is truly remarkable.

The paintings of the *Sulayman-nameh* are more typical in both iconography (battle and court scenes of the day) and style—compact, densely designed compositions with many human figures. Entire armies fighting in an open landscape or around a city are often represented in one small painting. They are colourful and undoubtedly tell the story they are supposed to tell clearly and directly, but they lack the intensity of feeling or the simplicity of expression that so many of the *Siyar-i Nabi* paintings have. **69**

Ottoman painting has often been regarded as a poor imitation of Persian painting. In fact Persian painting

exerted very little influence on the early Ottoman school and none on the court style of the 16th century, which had different aims and followed entirely different principles. While most Safavid Persian painting is not concerned with the real world, but follows a romantic, poetical ideal, illustrating the poems of the past according to long-established pictorial traditions, Turkish painting is intensely and almost exclusively interested in the actually existing world. The history of the day and the actions and events of court and city, the life of the Sultan, his battles and victories, his absolute government are illustrated repeatedly, together with the almost ritualistic audience scenes, and the individual characteristics of the sultan reflected in many portraits. The Persian romantic and poetic subject-matter resulted in a romantic, poetic and sinuous style, while Ottoman court painting is almost harsh by comparison and reflects the rigidity of the centralised power of the Ottoman rulers.

THE TURKISH RUG

The most famous of Ottoman art-forms and that most intimately related to the Turkish spirit is the knotted rug. It came with nomadic Turkish tribes from Central into western Asia, and yet the knotted rug, developed from their primitive fur-imitation floor covering, became the most 'Islamic' of Islamic art-forms. In the use, form and decoration of the rug are embodied most of the fundamental elements of Muslim culture. It reflects the nomadic origin of most of the ruling peoples of the Muslim world; it continues throughout the ages to be a main element of interior decoration being used as floor covering, tent ornament, baldachin and symbol of the royal throne and embodies the most typical of Islamic art-forms, the infinite pattern, in a most perfect way.

Up to the late Timurid period the rug has an abstract repeat pattern of which only part can be seen within the borders, suggesting its continuation beyond that into limitless space, the 'infinite'—such patterns being at all times a symbol of the Muslim concept of the transient quality of all finite forms. Then at the end of the 15th century, the pattern becomes floral (and eventually at the 16th-century Safavid court in Tabriz, pictorial). But at all times—with very rare exceptions in India—the principle of infinite repetition of all pattern elements in all directions is maintained.

Hardly anything is known about rug-weaving centres in Anatolia. Most of their names are trade names, or really 'nick-names' derived from peculiar (often misunderstood) individual elements of rug patterns, or are called after 16th-century European painters who included such rugs in their pictures, or simply places where certain rugs were collected and sold.

73 The 'classical' Turkish rug is the so-called Holbein type, abstract in pattern and restricted in colour palette. The designs are usually based on interconnected staggered rows of polygonal medallions composed of white interlaced

80. 'Bird' Carpet from Turkey, c. 1600. 14 ft. 7 in. × 7 ft. 7 in. (4·27 × 2·14 m.). Metropolitan Museum of Art, New York. Ex collection Joseph V. McMullan. These rugs, probably also made in or near Ushak, take their name from the curious resemblance of the continuous leaf motif arranged around a central floral rosette, to small birds. The particular feature of this type of rug is the use of white as a dominant colour.

derived not from abstract linear ornament but from natural bands and highly stylised abstract blue, green or black arabesques on a brick-red ground. This rug is the final product of a long line of tradition that goes back to Seljuk and very likely pre-Islamic Central Asian times.

A fundamental change took place in 16th-century Iran with the introduction of the large-scale medallion pattern developed in Herat (seen in some of Bihzad's paintings). The rugs from Ushak following the Persian concept are **72** designed on the basis of successions of large oval medallions. Those adhering to indigenous tradition have rows of beautifully drawn stars, filled with floral elements or more often abstract arabesques in white and yellow on a deep cobalt blue ground, outlined in white against the magnificent red that distinguishes the classical Anatolian carpet.

Of a very special design are the so-called 'bird-carpets', *80* named after a characteristic floral motif that does indeed resemble a bird. Here again the ancient, abstract concept of a continuous small-scale pattern in the purely Turkish tradition prevails, but almost all the pattern elements are

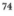

81. **Great Mamluk silk rug from Egypt.** 16th century. Österreichisches Museum für Angewandte Kunst, Vienna. Following an ancient local tradition of abstract design, based both on classical and late classical models, the designers of the Mamluk rugs created patterns of great originality and imagination. Strictly abstract-geometric in their basic floral forms. The peculiar colour scheme of an ivory white background and deep blues and reds for the pattern elements is unique among Islamic rugs.

Egypt was conquered by the Ottoman Turks early in the 16th century. The Mamluks had created a rug form of their own, independent from any of the major traditions established in Turkey and Persia. Relying largely on ancient, pre-Islamic traditions of textile design, the Mamluk rug weavers developed a kaleidoscopic rug-pattern making use of classical floor mosaic designs, Coptic textiles and contemporary marble-floor designs that followed ancient classical tradition. The field of the rug was divided into small geometric units all of which are equally filled with two kinds of motifs: a small papyrus shrub, and a rolled leaf. Secondary decorative elements are what appear to be highly stylised cypress trees and interlace-band ornaments and arabesques. Usually organised around a large polygonal or star-shaped central medallion, no part of the rug's surface is left undecorated, or 'unorganised', that is, independent of the geometric pattern.

The colouring of these rugs is as unique as their design. The ground is deep burgundy red, the main pattern elements light grass green, the secondary ones light blue. Only occasionally white and yellow are used. As there is no colour contrast between field and border hardly any difference between the two areas exists, although the borders are designed in a more conventional, traditional way, with successions of small multi-lobal and large oblong cartouches.

The Mamluk rug did not survive the Ottoman conquest.

organisation the only relieving element in these severe designs is the small repeated floral motif of a papyrus shrub, a rolled leaf, and a cyprus tree. They are remarkable in that there is often virtually no division between the border and the field. Mamluk rugs also have a highly original colour combination.

At first Ottoman floral patterns entered into a strange marriage with the Mamluk-Egyptian concept of unified colour scheme and general abstraction. But soon the Ottoman concept entirely transformed the Mamluk rug. The beautiful wine red remained as a basic ground colour, but the pattern elements, now floral in design, were bright white, yellow, blue and green.

Ottoman art shows an entirely original style in every sphere—the new dome-chamber mosque in architecture, new floral polychrome decoration in tilework and pottery and the application of a new, and, in its results, highly successful canon of colour, composition and iconography in painting. Although highly decorative and following the general tendency of Islamic architecture in dissolving the solidity of building materials and disguising structural feature by means of magnificently elaborate tile decoration, their architecture has an imposing strength and masculine quality altogether different from the effeminate sweetness, floral and arabesque fantasy and colour spectacle of the contemporary Safavid architecture. The main achievement in Ottoman architecture is the illusion of a floating architectural interior with truly architectural means—through ingenious design and the perfect mastery of constructional problems. A major feature of Ottoman art is the play on contrasts—between tectonic qualities and the dissolution of materials, between realistic forms with closely rendered details and abstraction in colouristic effects or in the traditional infinite pattern. In its richness of invention, excellence of technique and beauty of design, Ottoman art stands out from Islamic art as a whole.

Safavid Iran

With the Safavids, a Persian dynasty ruled Iran once again. Shah Ismail who ascended the throne in 1502 at the age of fifteen, defeated the Turkomans and Uzbeks alike and united Iran, creating the basis for a new, national culture. He was followed by Shah Tahmasp (1524–76) who moved the capital from Tabriz to Kasvin in 1548 to evade the constant raids of the Ottoman Turks. Safavid culture reached its peak during the reign of Shah Abbas I (1587–1629), who in 1598 moved the capital to Isfahan, in the heart of ancient Persia, where it became the centre of eastern Muslim art and culture for almost two hundred years.

ARCHITECTURE

Almost nothing of early Safavid buildings, of palaces or mosques in Tabriz or Kasvin, has survived. Only descriptions can give us an approximate idea of the lost splendours of Shah Ismail's gardens and Shah Tahmasp's pavilions decorated with tilework and paintings, and filled with rugs and precious objects of all kinds.

75 In Saveh, one major mosque from Shah Ismail's time survives: it was erected in the early 16th century on the traditional court and four-ivan plan with a beautiful prayer hall and dome-chamber. The mihrab, following long tradition, is in carved and painted plaster. The decoration of wall surfaces with painted plaster and glazed brick and tilework, using calligraphic and abstract-linear elements for both inside and outside the dome also follows a tradition that goes back at least three centuries. The building is of a peculiarly archaic nature—especially beside the dazzling splendour of Timurid antecedents and later Safavid monuments in Isfahan.

Safavid architecture is mainly known to us through the 17th-century buildings of Isfahan. When it became the capital, the city was greatly enlarged. A huge palace complex was erected of which only the gate-structure and a few garden pavilions survive. The entire city was re-organised on a grandiose plan. City-planning on a large scale is very rare in the Muslim world and only in a few instances was the usual concept of natural growth, or simple conglomeration of buildings around an important existing structure, abandoned and an all-out effort made to build an entire town according to a plan.

The Maidan-i Shah, a polo-ground designed as part of the royal city complex, is a huge open space surrounded on all sides by screen walls which are decorated with the traditional Seljuk pointed arch-niche motif on two storeys. The square is so enormous that it does not create a feeling of organised space. Only three major building complexes lead on to the Maidan-i Shah: the Ali Qapu, the main gate structure of the Shah's palace that served as grandstand for the emperor and his entourage, the mosque of Shaykh Lütfüllah and the Masjid-i Shah. The Ali Qapu and the Shaykh Lütfüllah face each other across the southern half) of the square. The Masjid-i Shah's great gateway takes up a good third of the southern side. Opposite the Masjid-i

Shah, but dwarfed by the vast distance between the two structures, is the main gateway to the bazaar.

The Masjid-i Shah follows Seljuk tradition in all its 82 major elements. The large central court is surrounded by open pointed-niche arcades on two storeys, as in the Maidan, repeating a motif used in the same city in the great Seljuk mosque, and which is also the main feature of the screen wall of the Maidan. In the centre of each side is the traditional ivan-hall, each leading to a domed chamber, a 76 feature already used in the Bibi Khanum in Samarkand in 1 the 14th century. The main ivan on the kibla side is of extraordinary size, its framing portal flanked by tall minarets; the dome chamber is immense and the main dome has a bulbous cupola upon a high drum of monumental proportions. The large rectangular areas between the side ivan-halls and the prayer hall are filled with two open-court madrasahs. The brilliance of the faience coating of the entire surface, dominated by a bright light blue, compensates for the relatively inferior detail. The vast surfaces that must have been covered in a very short time—the mosque was begun in 1616 and completed in 1620—required a simpler technique than the faience mosaic of earlier periods, which was only used for especially important details. The majority of the interior is covered with polychrome painted tiles, usually square. The patterns, all floral abstract, are of brilliant whites and yellows. The total effect of the building is that of a floating world in which all material qualities have been eliminated.

The Masjid-i Shaykh Lütfüllah, built between 1602 and 83 1618 has an entirely different plan, without court and ivan-halls, a simple, large, square dome chamber being the main feature. Its decorative principle is similar, however, with the interior of the chamber decorated with magnificent coloured faiences, blue and yellow dominating, and the outer surface of the dome decorated with an arabesque design not dissimilar to that of the Shah's mosque. It uses a 84 soft yellow as the main background colour, contrasting with the dazzling blue of the interior. Both domes, that of the Masjid-i Shah and that of Shaykh Lütfüllah are designed on the double dome principle with a low shallow inner shell and a higher elevation on the outside. While Shaykh Lütfüllah's dome is of moderate height and recalls the more restrained Seljuk form, that of the Shah's mosque resembles Timurid domes in its bulbous outline.

PAINTING

Tabriz, seat of Shah Ismail's court and centre of Safavid culture for almost half a century, benefited greatly from painters who were brought to Tabriz by the Shah after he had taken Herat from the Uzbeks in 1510. They brought with them a great many illustrated manuscripts and albums filled with miniatures of the Herat school. It is therefore only natural that the early Tabriz style is very similar.

The true heir to the Herat style was, however, the Uzbek court in Bukhara. The Uzbeks had taken Herat at the beginning of the 16th century and Shaybani Khan, reputedly,

82. The Masjid-i Shah in Isfahan, seen from the terrace of the Ali Qapu. Placed at the narrow east end of the huge Maidan-i Shah, (the main square in the centre of Safavid Isfahan, planned and contained within screen walls by order of Shah Abbas in 1611–1612), the Great Mosque of Shah Abbas was erected between 1612 and 1620. The decoration, mainly blue tilework and partly faience mosaic, was, however, not completed before 1630. Possibly it was only at this date that the immense inner

courtyard with its massive ivan halls was completed. The design of the mosque follows the traditional Seljuk pattern, but adds dome chambers behind the ivan halls and at the sides of the courtyard, a motif that had first been employed in Central Asia in the late 14th century, (the 'Bibi Khanum' in Samarkand). Of immense size and sumptuous decoration, this building epitomises the aspirations of Safavid architects. The principle architect was Ustadh (Master) Abu Ali Akbar al-Isfahani.

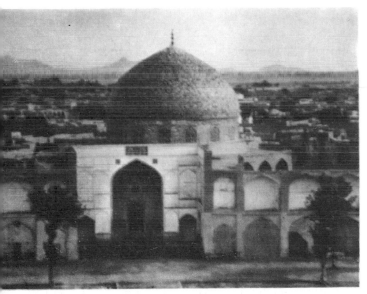

83. The Masjid-i Shaykh Lütfüllah in Isfahan. Exterior view. Iran. Early 17th century. This beautifully designed small mosque on the north side of the Maidan-i Shah, opposite the Ali Qapu, the entrance gate to Shah Abbas' palace, is one of the most successful buildings of the Safavid period. It was built by order of Shah Abbas between 1603 and 1618. Only the mihrab in the interior, dated 1028 (1618), is signed by a certain **Muhammad Riza ibn Husain.** It is not certain whether he was also the architect of the building. The mosque follows a plan totally different from that of the traditional four-ivan court mosque pattern, dispensing altogether with the court and concentrating on a magnificent central domed room.

took great personal interest in the art of book design, so much so that he seems even to have interfered with Bihzad's own work. Bihzad, the greatest master of the late Herat school must have gone to Bukhara as Ismail would certainly have taken him to Tabriz if he had still been in Herat. He must have returned there and then gone to Tabriz, at a later date, probably shortly before 1521, when Shah Tahmasp decided to reorganise the *Kitab-khane* (the bibliophile academy), making the great Herat master *kitabdar*, or general director.

The Bukhara school continues the Herat style far into the 16th century without any major change. In fact many of its early 16th-century works are difficult to distinguish from those of the Herat workshop. Gradually a certain stiffness of design and a tendency toward stereotyped figures invade the style which eventually becomes highly decorative, brightly coloured and largely unnaturalistic— quite different from the Herat style.

Bukhara painting had, however, a certain sumptuousness, successfully elaborate compositions, highly decorative and stylised landscapes and architectural settings, and a magnificence of colour treatment that went far beyond the subtlety and restraint of the Herat school.

Only a few Tabriz painters continued the tradition of realism and it was their work that maintained the vitality of the Tabriz school and brought eventual success.

Mir Sayyid Ali was one of the two masters who accompanied the Indian emperor Humayun, who spent some years in Tabriz, to Kabul whence they proceeded to India and created the Mughal style (often incorrectly called the Indo-Persian style). He was perhaps one of the finest painters in the realistic tradition in Tabriz. The double-page composition of city life and life in the nomad camp is a

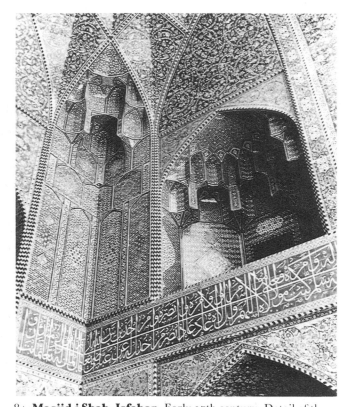

84. **Masjid-i Shah, Isfahan.** Early 17th century. Detail of the
faience decoration showing the extraordinary richness and
variety of the decorative motifs and the complexity of vaulting
systems largely employed for purely decorative effect.

85. **Drawing by Sadiki-beg.** *Portrait of a Turkman.* 6¾ × 4⅛ in.
(17·2 × 10·5 cm.). Museum of Fine Arts Boston. Sadiki-beg, one
of the finest draughtsmen of his time and particularly famous for
his portraits, must be accepted as the author of this remarkable
pen drawing even though the 'signature' in the lower left hand
corner is probably a note of attribution perhaps made at the
time. The masterly handling of the wavy outline creating effects
of volume and light and shade through varying the thickness of
the line, betrays the great artist's hand.

brilliant example of his work. In spite of its mannerism and
decorative effects, it is principally based on actual observa-
tion of everyday life. His men and women are individuals,
almost portraits of real human beings encountered in or
around 16th-century Tabriz. There is the same realism in
the animals, the landscape, or the innumerable minor
details of the paintings. The tents and the houses, the
implements of everyday life, the costumes and activities all
have a precision and accuracy that reveals close study
of the real world. This is an exceptional moment in Persian
painting, but it is of great significance. Although it does not
last and although the main talents seem to have passed to
India, some of the spirit of this painting survives later in the
century when the court moves to Kasvin.

Painting in Kasvin continues the Tabriz style at first, not
so much the later phase but the earlier, more mannered
court style. The realistic tradition of the later Tabriz style
is followed in drawing. Although fine drawing was already
produced in Tabriz as an independent art-form, it was only
in Kasvin that a drawing style developed that was basically
independent of painting.

Sadiki-beg, one of many artists of Turkish origin at the
Persian court, who later became *kitabdar* of Shah Abbas in
Isfahan, was probably the greatest master of the new style
of drawing that became a major art-form in Kasvin and
greatly inspired the art of drawing in 17th-century Isfahan.
He is said to have produced thousands of portrait drawings
such as that of a seated Turkoman in the Boston museum.
This drawing shows all the stylistic elements of Kasvin—
the highly energetic line, varying in thickness to indicate
light and shadow and giving volume to the forms it defines,
the extraordinary economy of technical means and the
almost fierce attention to individual features. Many of
these drawings are masterly portraits, often with a critical,
almost satirical note.

(Continued on page 377)

83 (opposite). **Painting from a copy of Jami's Haft Aurang**
(Seven Thrones), copied for the library of Abu'l Fath Sultan
Ibrahim Mirza, cousin of Shah Ismail II, between 1556 and
1565 in Meshhed. *Majnun before Layla's Tent.* Size of page:
13½ × 9¼ in. (34·2 × 23·2 cm.). Freer Gallery of Art,
Washington. The painting illustrates an episode from the story
of Layla and Majnun which was copied in 1565. It is one of the
most remarkable paintings of the later Safavid period. The
painter, in bringing the Kazvin style to perfection, has broken
entirely with the conventions of Persian painting of his time.
He has disregarded the generally clearly defined outline of the
written surface of the page, and has built up his composition in a
most unorthodox way. The fine brushwork, exquisite colour
balance, extraordinary realism of detail, and audacity of
complex patterns emphasised through the arrangement of the
tents and baldachins make it both original and highly
successful.

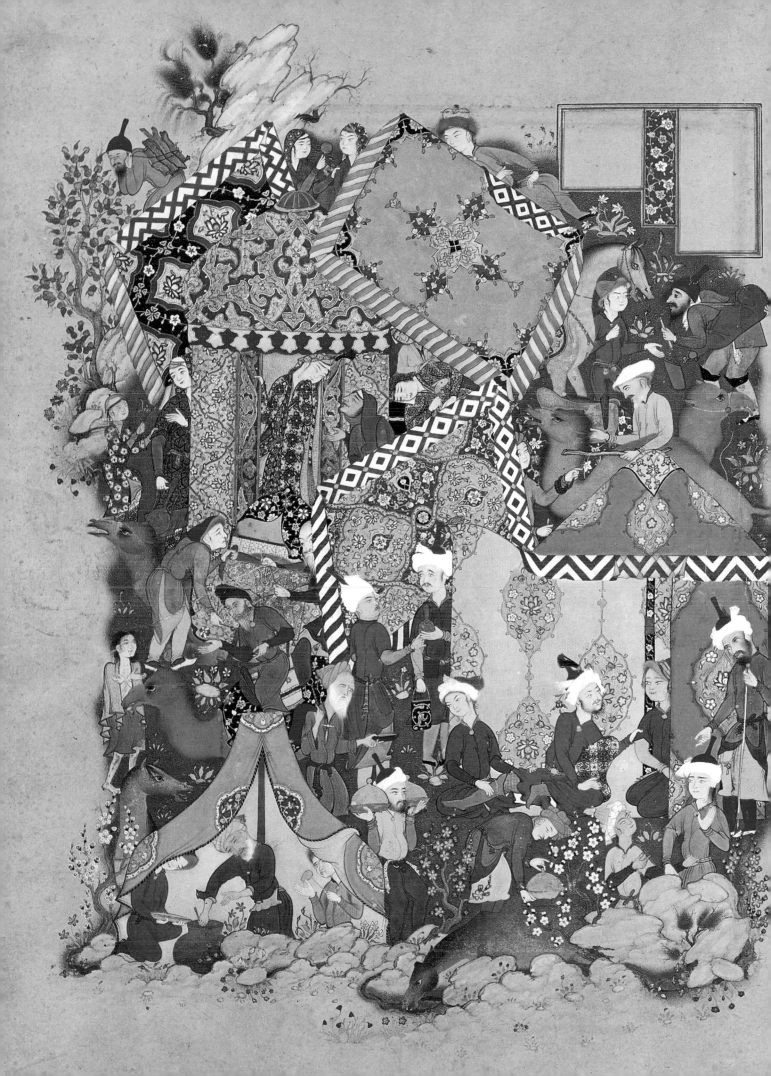

362

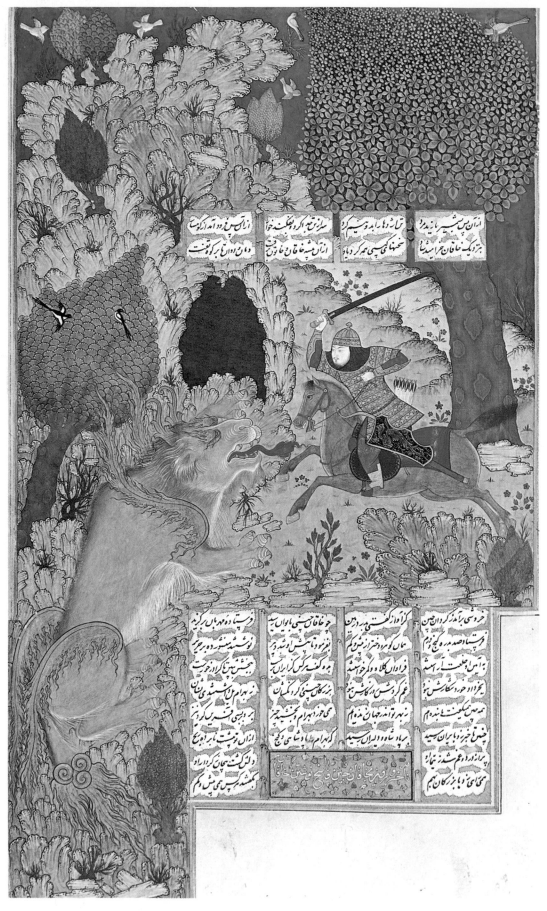

84. **Painting from a copy of Firdusi's Shah-nameh,** 1614. *Bahram Gur killing a lion in China*. Page size: 14¾ × 8 in. 36·4 × 20·5 cm.). Spencer Collection, Public Library, New York. The paintings in this manuscript, modelled on the

famous Gulestan *Shah-nameh* (see plate 57) are a conscious attempt to work in the tradition of the Herat School of almost two centuries before. This painting, not based on any one painting, must be a free creation in the early Timurid style.

This manuscript, though dated 1023/1614, has now been identified as a late 19th-century copy. It is possible that the model for the manuscript was, in fact, one made at that date, which in turn was based on the 15th-century Gulestan Palace *Shah-nama* made for Baysunghur.

85 (right). **Lacquer-painted bookbinding from a copy of Ali Shir Navai's Divan** from Tabriz, Iran. Early 16th century. 9½ × 6 in. (24 × 15 cm.). British Library, London. Among many fine bookbindings from Tabriz, those in painted lacquer are undoubtedly the most beautiful. The scene here is probably part of a garden reception.

86 (below, right). **Painting by Riza-i Abbasi from Isfahan, Iran.** 1630. *Two lovers.* 7⅛ × 4¾ in. (18·1 × 11·9 cm.). Metropolitan Museum of Art, New York. This leading master of the Isfahan school excelled in painting the human figure and, despite stylisation, came close to actual portraiture. This painting of an embracing couple is one of his most delicate and accomplished works.

87. **Ceramic bottle from Isfahan, Iran.** Early 17th century. Lustre-painted. h. 15 in. (38 cm.). Metropolitan Museum of Art, New York. Much lustreware was made at Shah Abbas' court in Isfahan, reviving an ancient tradition. Animal and floral motifs are typical. The unusual yellow glaze heightens the effect of the lustre-painting.

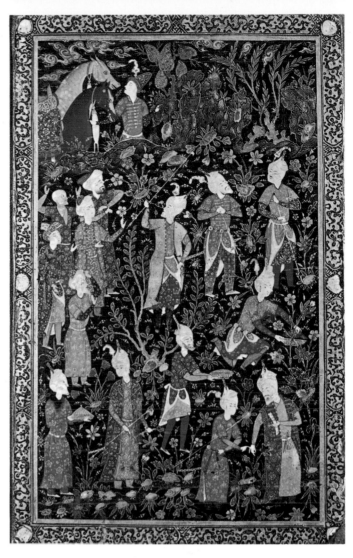

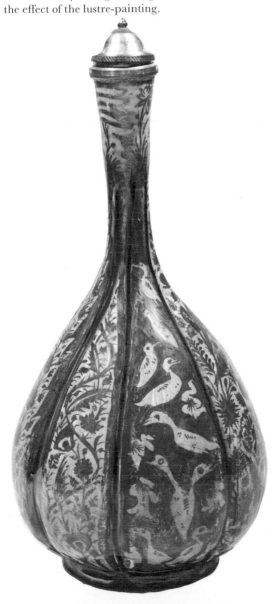

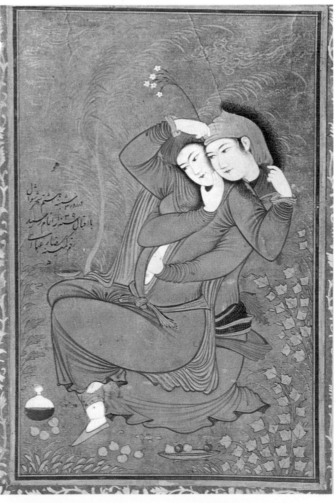

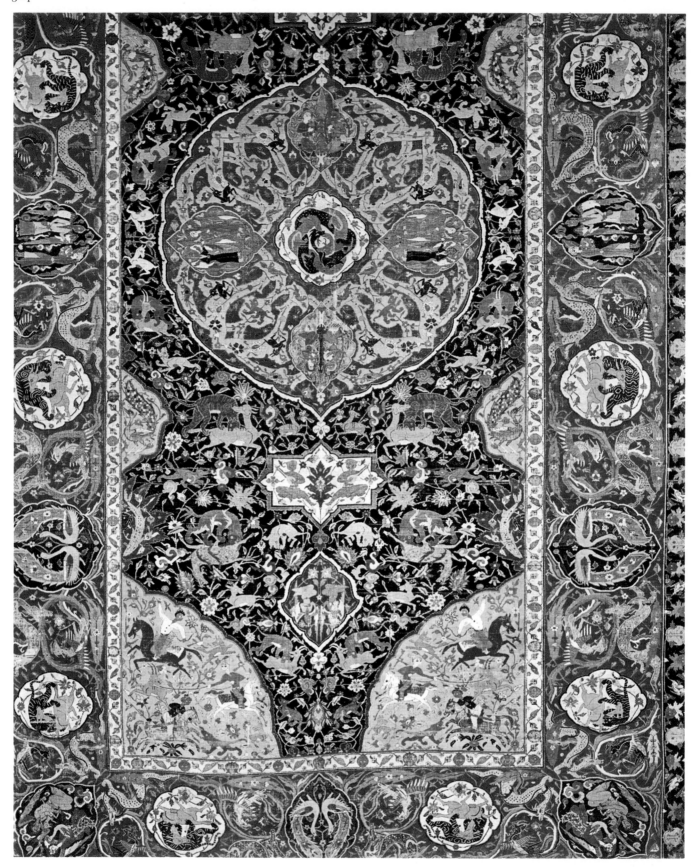

88. **Rug with figurative pattern from Kasvin, Iran.** Second half 16th century. 19 × 10 ft. (5·9 × 3·1 m.). Collection of the Prince Roman Sanguszko. On loan to the Metropolitan Museum of Art, New York. Elaborate for the period, this rug's pattern, traditional in its staggered rows of medallions and cartouche borders, is predominantly figurative. It may have influenced Mughal rug designers. The figures are very similar with those in drawings and paintings of the Kasvin school.

89 (opposite). **'Garden' carpet from north-western Iran.** c. 1700. 22 × 8 ft. (6·7 × 2·4 m.). Fogg Art Museum, Harvard University, Cambridge, Mass. Ex Collection Joseph V. McMullan. Even though the garden design forms an important element in many Persian rugs of the Safavid period, it is only in this particular group that a bird's eye view is given of the actual lay-out of a formal Persian garden with water courses, ponds, flowers and trees.

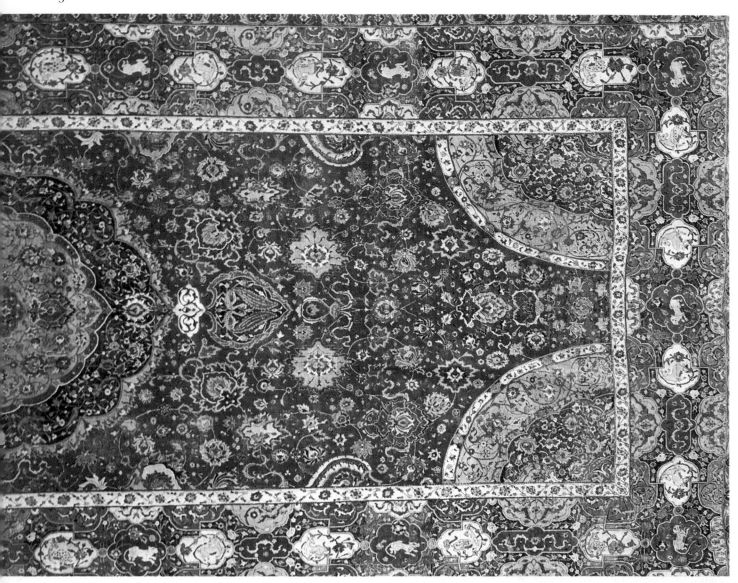

90. **Arabesque carpet from Herat, Afghanistan.** 16th century. 24 × 10 ft. (7·3 × 3 m.). Collection of Mr and Mrs Louis E. Seley, New York. On loan to the Metropolitan Museum of Art, New York. This is the finest and best preserved of the Herati carpets, combining most successfully the idea of an abstract floral field pattern with beautifully designed cartouche patterns with animals in the border. In this way the carpet actually embraces two different principles of design.

91. **Patterned silk from Iran.** 16th century. 47½ × 26½ in. (120·7 × 67·3 cm.). Metropolitan Museum of Art, New York. Silks with figurative patterns were first made in 15th-century Central Asia, judging from representations in miniature paintings but examples survive only from the Safavid period. The curious design of this silk, possibly copied from a popular drawing, shows a Safavid prince on horseback accompanied perhaps by a page, leading a Turkoman or Uzbek prisoner. The Safavids defeated both these tribes on coming to power.

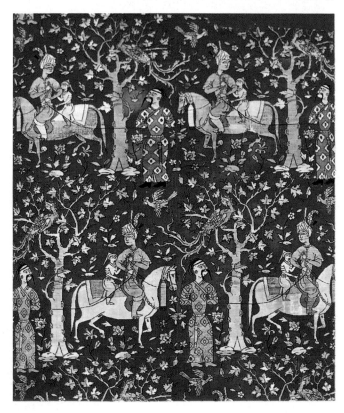

92. **The Taj Mahal at Agra, India.**
Erected by the emperor. *c.* 1635.
Mausoleum of Mumtaz Mahal, Shah
Jahan's wife. The building is one of the
most famous in Islamic architecture. The
design is simple, harking back in its basic
ideas to such mausolea as that of the
Samanids in Bukhara and more
immediately to the mausoleum of
Humayun (plate 95). The most
remarkable feature of the building is its
brilliant white exterior and its rich
decoration both in realistic floral relief
carving and polychrome *pietra dura* inlay.
The use of the latter technique has given
rise to the theory that Italian designers
were responsible for the construction of
the Taj Mahal.

93. **Emperors and Princes of the House of Timur.** *c.* 1555 (some later additions). Fragment of a painting on cotton. $44\frac{7}{8} \times 38\frac{1}{4}$ in. (114×107 cm.). British Museum, London. Probably the first important painting executed for Humayun in India, this may have been the work of the two Tabriz masters, Mir Sayyid Ali and Abd al-Samad, who came to his court. Unusual both in size and subject-matter, it demonstrates the major features that were to become characteristic of the Mughal school: realism, leading directly to portrait painting, and a most polished technique. True portrait painting is virtually unknown elsewhere in the Muslim World. The composition and almost all the main iconographic features are directly derived from Persian models.

94. **Painting from the Dastani-i Amir Hamza (Hamza-nameh).** India. *c.* 1575. *Assad ibn Kariba attacks the army of Iraj at night.* $27 \times 21\frac{1}{4}$ in. ($68\cdot5 \times 54$ cm.). Metropolitan Museum of Art, New York. This is a painting from the first major work of the Mughal school. Originally begun under Humayun in Kabul, the *Hamza-nameh* was made for Akbar. In its paintings the first synthesis was created between Persian and local pre-Mughal Indian styles forming a new, original style that can justly be called Mughal, outstanding in its combination of realism with a sense of composition and pure colour values.

95. **Humayun's Tomb, Delhi, India.**
1565. This is one of the first buildings on
the plan of a central dome chamber with
four monumental entrance gates and four
corner pavilions. The design is not yet
fully worked out—the dome sits too low,
the small rotundas (chattris) are ill-related
to the main block of the building, and
some of the decorative detail, especially
the guldastas (a kind of corner finial
placed at junctions of walls meeting in an
angle) are not very successful. The use of
a bulbous 'Timurid' dome (see plate 49)
and the combination of white marble
with red sandstone in the facing of the
building are elements that had a decisive
influence on later Mughal architecture.

96. **Painting from a copy of Anwari's
Divan,** written in Lahore in 1588.
A Prince riding to Hounds. $2\frac{7}{8} \times 1\frac{3}{4}$ in.
($7{\cdot}4 \times 4{\cdot}5$ cm.). Fogg Art Museum,
Harvard University, Cambridge, Mass.
This delightful little painting, probably by
Miskin, is a fine example of the early
Akbar style illustrations in the minute
pocket size codices made for the emperor
at his court school in Lahore. While some
of them still show a close relationship with
Persian and local, pre-Mughal Indian
tradition, this painting has achieved the
purety of a new style which becomes the
basis for all later Mughal painting.

97. **Painting by Abul Hasan.** India.
c. 1599–1605. *Jahangir holding the portrait of
his father, Akbar.* 4½ × 3¼ in.
(11·5 × 8·1 cm.). Musée Guimet, Paris.
The painting is not dated but in the
inscription it is stated that Jahangir was
thirty years old when it was painted.
Jahangir was born in 1569 and became
emperor in 1605. As he is represented as
emperor it is likely that the halo and the
portrait of Akbar were added at that date.
The painting is an exquisite example of
official portraiture of the period.

98 (opposite). **Painting designed by
Miskin, painted by Paras, for the
Akbar-nameh.** c. 1600. *Bullocks
dragging siege guns for an attack on the Fort at
Ranthambhor, Rajastan, in 1568.* 13 × 8⅜ in.
(33 × 21·2 cm.). Victoria and Albert
Museum, London. This dramatic action
painting depicts an actual historical
incident during Akbar's campaign in
Rajastan. This is in itself remarkable and
has parallels only in Ottoman Turkish
painting. The scene is represented with
great realism combined with an exquisite
sense of colour and design.

99. **Painting from the Minto Album, India.** *c.* 1630. *Shah Jahan out riding with his son, Dara Shukoh.* 8¾ × 5½ in. (22·2 × 14 cm.). Victoria and Albert Museum, London. Mughal painting becomes highly ceremonial in this period. The emperor is shown in a static pose; Dara Shukoh is holding, equally immobile, the ceremonial umbrella over his father's head.

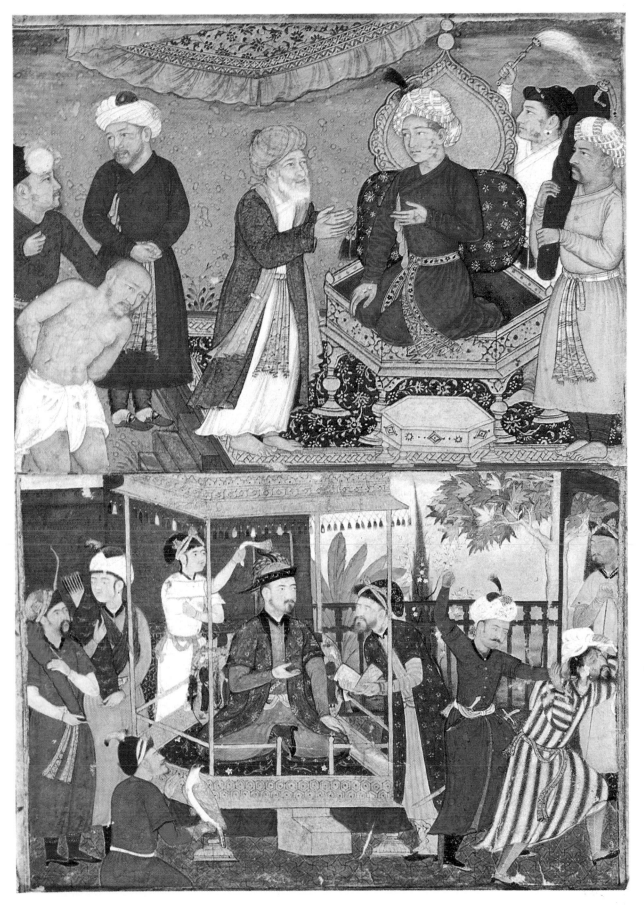

100. **Two paintings from a dispersed copy of Sadi's Gulestan,** by Manohar and probably by Ghulam Mirza. India. *c.* 1610. *The Undoing of an ill-natured Vizir* and *A fraudulent pilgrim evicted from Court.* Each 2½ × 3½ in. (6·3 × 8·9 cm.).

Private Collection. Fine examples of of the early Jahangir style, these paintings still show Persian influence (landscape and architectural detail) but have new realism and mellowness of colour.

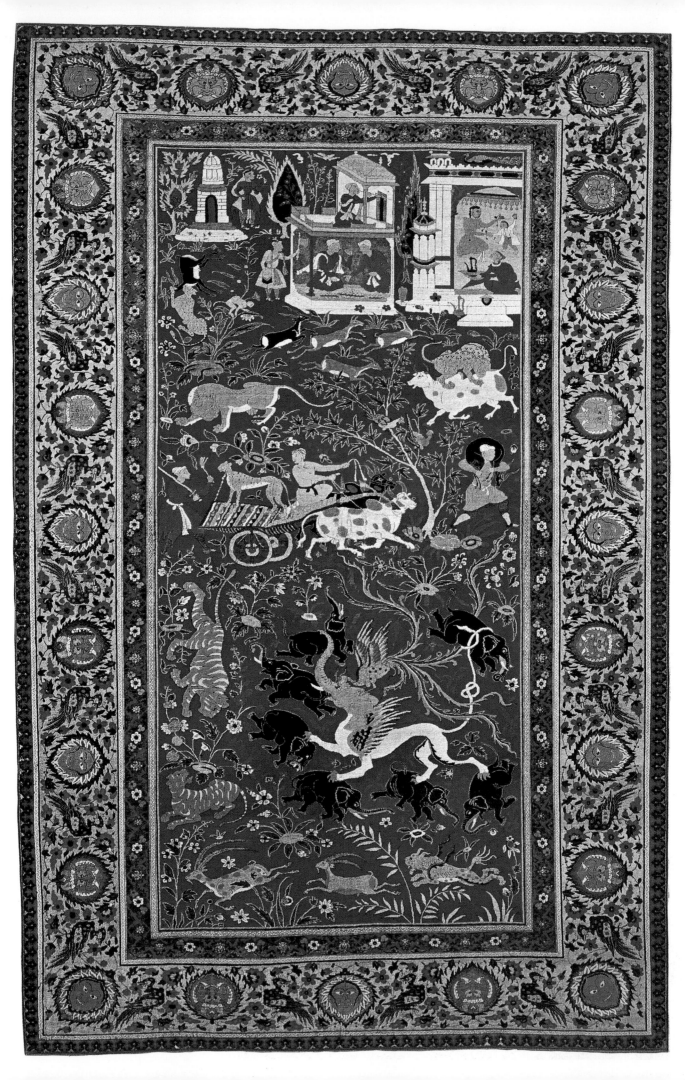

101 (opposite). **Mughal carpet, India.**
Late 16th century. 7 ft. 11½ in. × 5 ft. 1 in.
(2·23 × 1·75 m.). Museum of Fine Arts,
Boston. Mughal India produced a variety
of carpets of great originality, both in
colour and design. The characteristic
deep burgundy red and an intense dark
green, as seen in this rug, are unknown
elsewhere in the Muslim world. The
decoration of the field of this rug with its
pictorial design breaks with the tradition
of abstract, continuous floral patterns
which was standard in carpets before the
Safavid period. It is really more like a
monumental painting in coloured wools
than a carpet in the true sense. The
pictorial rug, first developed in Safavid
Iran, reached its final form in Mughal
India.

102 (above), 103 (detail). **Court coat of a
Mughal prince or emperor,** India.
First half 17th century. 40⅛ × 38¼ in.
(102 × 97 cm.). Victoria and Albert
Museum, London. This coat,
embroidered in polychrome silks upon a
delicate monochrome background, is a
most sumptuous example of Islamic court
dress. The design, consisting of a complex
landscape with animals and birds of many
kinds, follows contemporary landscape
paintings of the Mughal school.

104. Jade cup in form of a gourd, India. 17th century. Inscribed with the name of Shah Jahan and a date corresponding to 1647. l. 6¾ in. (17 cm.). British Museum, London. Jade carving, first fully developed in India during Jahangir's rule, continued into the 17th and 18th centuries at the Mughal court. This is a particularly beautifully carved piece, original in shape and beautifully balanced in design. The piece has special significance as it is both inscribed with the emperor's name and dated.

105. Jade mirror back from India. 18th century. 5¼ × 4½ in. 13·5 × 11·5 cm.). Victoria and Albert Museum, London. The green jade is inlaid with white jade in a continuous cartouche of gold. The white jade inserts are outlined in gold and decorated with a ruby in the centre. Rubies are also placed at the junction of the cartouches. It is typical of the later jades of the Mughals where gold and incrusted juwels have replaced relief carving.

Muhammadi, painter, calligrapher and draughtsman, teacher of Shah Tahmasp and prominent member of the Tabriz academy, excelled equally in painting and drawing. His miniatures became master models for the entire Kasvin school and it is often to him that one accredits the particular qualities of the Kasvin style.

86

The Kasvin style, successful for more than half a century, spread to the provincial centres of Iran. Some of these rivalled the capital, particularly in the development of arts and crafts. Among them, Meshhed was very important and here the finest work of the Kasvin style is painted. The copy of Nizami's *Haft Aurang*, now in the Freer Gallery in Washington, is indeed unsurpassed in later 16th-century painting. It is of the highest quality as a manuscript and its miniatures show great finesse and originality.

Shiraz, by contrast, remained independent of the metropolitan style. Even though Tabriz models were sometimes imitated, the Turkoman style was continued into the 16th century, eventually developing into an individual style, which in its best examples, matches that of the capital in quality and imagination.

The Kasvin style, that produced its final flourish towards the end of the century, moved to Isfahan. The calligraphic drawing style, developed by Sadiqi-beg was perfected by Riza-i Abbasi, the leading master of the Isfahan school. His

86 paintings follow a similar style with almost impressionistic drawing of hands, costume details, and elaborate coiffures, both of the young ladies and of the effeminate gentlemen of the late Safavid court, and became the models of all later 17th-century painting in Isfahan and the provincial centres.

At the beginning of the 17th century a curious phenomenon occured. A number of manuscripts were illustrated with paintings in the Timurid style of Herat. The Gulestan *Shah-nameh*, made for Baysunghur in 1430, in the possession of Shah Abbas, must have inspired him to order his major painters to create a manuscript that would match the earlier work's particular qualities. However, the Spencer Collection copy of the *Shah-nameh* of 1614 is not of that period, although it may be based on a 17th-century copy of a 15th-century original. The miniatures of this manuscript, painted in 1614 in Isfahan, are nevertheless of great originality in many details, and of a finesse and brilliance of technique that matches the earlier masterpiece. There are also many paintings in this and other manuscripts of about the same period, that follow the Timurid style, demonstrating the ability of the Isfahan painters to revive almost faultlessly a style that had fascinated Muslim artists for more than two hundred years.

THE DECORATIVE ARTS

The Safavid period excelled in all the arts of the book— paper-making, gilding, illumination, calligraphy and bookbinding. To the various forms of stamping, pressing, cutting and gilding of leather, developed in Timurid times, still another brilliant technique was added, lacquer-painting. Although this probably also went back to the

86. **Drawing by Muhammadi,** dated AH 986 (1578 AD). *Life in the Country.* 10¼ × 6¼ in. (26 × 16 cm.). Louvre, Paris. This drawing is an excellent example for the interest in everyday life developed by the masters of the Kazvin school, an element that became of fundamental importance for all later Safavid painting. The drawing is particularly delicate and appealing in its vivid observation of peasants and shepherds in the countryside.

15th century, it was in Tabriz and Kasvin that the first figurative lacquer bindings were created: in their brilliance *page 7* of colour and variety of design, they rivalled the finest **85** products of the painter's brush.

Equally luxuriant are the patterned silks and brocades **91** of the Safavid period. As little has survived from Timurid times, it is impossible to say whether Safavid textiles go to the credit of Timurid tradition, but it seems from miniatures that the figuratively patterned silks like those from the Tabriz court looms were unknown in Timurid times when gold embroidery seems to have been the main feature. Already in the early 16th century, richly patterned silk brocades seem to have been made for hangings, tent covers, cushions, saddle-cloths, and for garments of the nobles at the Safavid court. They can be seen in many miniatures and some magnificent pieces have survived.

But the most famous textile products of the Safavid period are undoubtedly the large knotted rugs. Persian rugs, abandoning entirely the Turkish tradition of abstract textile design that had dominated rug patterns right throughout the 15th century, are developed on the basis of floral and figurative designs. **88**

The great arabesque rugs of the early Tabriz school, magnificent in their intricate scroll-patterns and strong but

87. **The Ardabil Rug from Tabriz, Persia.** Made by Maksud al-Kashani in 1539–40 for the Shrine of Shaykh Safi in Ardabil. First half 16th century. 36 ft. 6 in. × 17 ft. 6 in. (11·52 × 5·34 m.). Victoria and Albert Museum, London. This is probably the most famous of all Safavid carpets. It is dated and signed and it was made by order of Shah Tahmasp for the Shrine of the family sanctuary in Ardabil. Its sombre colours and elaborate floral design are relieved by the magnificent central medallion that has been rightly compared with the patterns in the domes of Safavid mosques. The reflection of a dome design is emphasised by the appearance of mosque lamps hanging from the central medallion.

88a, b. **Hunting carpet from Kashan (?), Iran.** Woven in coloured silk. 16th century. Size of the complete rug: 22 feet 4 in. × 10 ft. 6 in. (680 × 320 cm.). Österreichisches Museum für angewandte Kunst. Vienna. This elaborate carpet has a richness of figurative detail both in field and border, a sumptuousness of colour and a fine technique that make it the highest achievement in an art form that, after centuries of development along traditional lines of abstract textile design had taken an entirely new turn in Safavid Iran. The rug was clearly designed by one of the leading court painters and many of its numerous figures can be found in the paintings made in Tabriz during the first half of the 16th century.

dark colours are still fairly abstract in nature. A few figurative motifs, birds and small animals, are included, but most of the design is based on large-scale systems of superimposed spirals that form an infinite pattern. Central medallions create the illusion of a centralised composition but sections of other medallions in the corners of the field show that they are only part of the composition of staggered rows of enormous stellate forms with cartouches and pendants filled with floral and arabesque designs. The huge rug from the shrine in Ardabil, of 1539, is probably the major work of this type.

It appears that in Tabriz the masters of the *Kitab-khane* began to assume primacy among the creative artists, pushing the weaver into a secondary, craftsman's position. This movement towards the pictorial rug, designed not by textile weavers, but by painters and book-illuminators, leads eventually to a complete change and decadence in rug patterns. Although magnificent in their sumptuous effect, Safavid rugs are actually products of a highly manneristic and decadent era that had entirely lost touch with the strength and simplicity of earlier tradition. Figurative carpets of the type so well represented by the piece in the collection of Prince Sanguszko, clearly illustrate this. Although usually attributed to Kashan, there seems no reasonable doubt that these rugs were made in Kasvin as their figurative patterns seem to have been almost exclusively drawn by the court painters there. The Sanguszko rug is, in fact, no longer a carpet but a monumental painting in coloured wools. The same applies to the large hunting carpets often in silk, like the largest and most elaborate piece in Vienna. Again usually attributed to Kashan, they could equally well have been made in Tabriz and Kasvin. They follow patterns from the two Safavid capitals, their designs being executed by leading painters of the court workshops who again only use the incredibly refined technique of rug weaving to create paintings in wool and silk.

The Caucasus, somewhat remote from the whims of the metropolis, continued an austere and more traditional form of textile design, creating rugs of greater simplicity with stronger design elements. Among them are the formal garden rugs, developing a beautifully balanced and relatively simple pattern of great force, based on a bird's eye view of a Persian garden, with central water courses, lateral canals, trees, flowers and highly stylised pavilions. From here it is only a step towards the more abstract and truly infinite textile pattern such as appears in a carpet which seems to be a unique survivor of its kind. Although closely related to the so-called vase carpets, usually associated with south Persia, it was probably produced in Isfahan. Its field is divided into a continuous pattern of small, geometrical compartments, of different brilliant ground colours, filled with beautifully drawn palmette blossoms of an extraordinary range of colours and shapes.

As in Timurid times the Safavid potter's main achievement lies in immense quantities of polychrome tiles for

89. **Woollen carpet with interpenetrating cartouche design from Iran,** southern school or Isfahan, 17th century. 16 × 9 ft. (4·87 × 2·74 m.). Metropolitan Museum of Art, New York. This rug is technically closely related to the so-called 'vase' carpets that are woven on a double weft and warp structure and it also employs a colour scheme normally found in those carpets. In its particular cartouche design and in its richness of colour it may, however, be the only piece combining the traditions of the north-west and east Persian compartment designs with the floral patterns of the vase carpets which are generally believed to have been made in the south, perhaps in Kerman.

90. **Ceramic plate with a zodiacal design from Iran.** Dated AH 971 (1563–64 AD). Signed by Abd al-Wahid. diam. 16⅛ in. (41 cm.). Staatliche Museen, Berlin. Persian pottery of the 16th century is rare. Dated pieces like this are almost non-existent. This large plate with a zodiacal design and arabesque patterns in black and blue probably represents an entire school of Safavid ceramic making of which nothing else has survived. It shows particularly well the peculiar way in which the Safavid ceramic painters reacted to the blue and white fashion. The design is practically free of references to Far Eastern motifs.

91. **Wall tile panel with a garden scene from Isfahan,** Iran. *c.* 1630. l. 6 ft. 6 in. (19.8 m.). Metropolitan Museum of Art, New York. The design of this tile panel follows the style established at the Isfahan court school by the leading painter Riza-i Abbasi in the early 17th century. That Riza and his master pupils worked for the ceramic factories is known and a close follower may have painted this garden scene. The inclusion of a European in the painting shows how the European element had become part of the late Safavid court in Isfahan.

92 **Ceramic bottle from Kerman, Iran.** *c.* 1550. h. 12⅝ in. (32 cm.). Museum of Decorative Arts, Berlin. Typical of Safavid pottery of the period, the figurative element plays a predominant part in the decoration of this bottle. The bold contrast between the undecorated white ground and the single energetic figure of a lion-kylin make this piece unusually successful. It also shows that the Far Eastern element, prevalent in all other Safavid design, also entered into pottery decoration.

architectural decoration. Although tile mosaic had passed its peak in the late 15th century, it was still used, especially in early Safavid buildings, soon to be replaced by a less delicate polychrome glazed tile decorated with a section of a given design—a whole panel of tiles making up the complete pattern. This simpler, much cheaper technique was widely employed in Isfahan. Entire surfaces, inside and out, of Shaykh Lütfüllah, Masjid-i Shah, and the Madrasah Madar-i Shah and others, are so covered, creating a dazzling effect of cobalt blue, white and yellow colour and pattern quite unique in Muslim architecture.

90 Of actual pottery, only few early 16th-century types are known, continuing the blue and white fashion. Most known pieces—small plates, bowls, bottles, vases and large dishes—seem to belong to the 17th and even 18th century and only few later 16th-century pieces survive. The so-**60** called Kubachi ware of the 15th century is continued but changed in colour with designs at first largely based on Far Eastern motifs. Eventually Chinese motifs give way to Safavid-Persian iconography. Portrait busts of young men and women, holding flowers, or just gazing out at the beholder follow entirely official Isfahan court painting and the pottery was probably made there in the late 16th–17th centuries. Large numbers of figurative tile panels also repeat subjects and compositions of the court style associat-*91* ed with Riza-i Abbasi. The Chinese fashion, although not continued in Kubachi ware, was carried on throughout the Safavid period in the pottery centres. Kerman and Meshhed seem to have been the main centres of fine semi-porcelain production. On brilliant white ground, Chinese motifs such as lion-kylins, dragons, the phoenix and flying

crane are painted in blue, green and yellow. In Meshhed figurative and abstract motifs were mixed, but the deep cobalt blue colour always dominated the design.

The technique of lustre-painting was rediscovered in Safavid times and a great variety of types was created.

Of great charm and interest are the flat-sided bottles created by the Safavid potters, following to some extent ideas from China but endowing them with great originality. These bottles are decorated with low carved and moulded relief on all sides, sometimes with figurative subjects reflecting themes of contemporary painting, but often of an abstract nature, composed of a variety of arabesque motifs. The glazes are brilliant and of intense colours, brown, yellow, green and a combination of purple, rose and white.

Safavid architecture, the last stage of the development of Seljuk forms, was transformed by decoration. The great mosques in Isfahan are entirely in the traditional design but they carry to an ultimate height the Persian ideal of colourful decoration. The dissolution of tectonic qualities and the disguise of structure reaches its final perfection. Safavid art excels in sumptuous forms of decoration as in its treatment of the knotted rug and in silk-weaving. In these and other forms of decorative art the figurative element, highly developed in three great schools of painting, comes to the fore. It is in the realm of figurative painting, which develops a richness and variety unparalleled in Islamic art, that Safavid art makes its most remarkable contribution. The emergence of the individual artist and the creation of a personal style is entirely new.

Islamic Art in India

India had already been partially conquered by the Arabs in the 8th century. This first contact was maintained and eventually in the late 16th century the larger part of the country came under the rule of the Mughal emperors, descendents of the Timurids of Central Asia, and a unified Indian-Islamic culture was created.

The first important phase of Muslim art in India developed during the reign of Mahmud of Ghazna, Afghanistan, (998–1030) who annexed a large part of north-western India and the Punjab to his large Central Asian empire. With the coming of the Turkish nomads, the Ghuzz, and the Ghorid Sultans to India in the later 12th century, the establishment of slave governors and eventually slave king dynasties at the beginning of the 13th, Muslim art began to become an integral part of Indian art. In 1192 Delhi became the capital of a unified Muslim-Indian empire under Kutb al-din Aibak which, however, did not last very long. The Khalji and Tughlak dynasties ruled the better part of India from the end of the 13th to the beginning of the 15th century. The Delhi sultanate came to an end with the sack of Delhi by Timur in 1399 and after a brief period of intermediary rule of the Sayyids and Lodis, and complete independence of the provinces, the Punjab, the Bengal region, and Jaunpur, which had been taken over after 1480 by the Lodis, India was conquered by the Mughals, descendents of the Timurid Prince Babur at the beginning of the 16th century.

The first period of Mughal rule (1526–40) was brief and troubled, and Humayun, Babur's son, left the government in the hands of Afghan generals while he went into exile to Safavid Tabriz (1540–55). Humayun returned to India in 1555 only to die the year after leaving his still unconsolidated empire to his son Akbar (1555–1605). During the period of Akbar's reign and the reign of his two successors Jahangir and Shah Jahan (1605–58) the Mughal style of Muslim India was developed, surpassing anything done before in India under Muslim rule. In painting especially a new standard of excellence was set and one of the finest schools of Islamic painting created.

ARCHITECTURE

At the beginning, Muslim art in India was totally dominated by Hindu forms and building materials. Temples were converted into mosques or Hindu buildings are dismembered and stone pillar mosques erected from the spoils. Very little of these early buildings and their decoration survives, for the Ghorid Sultans systematically destroyed the Afghan cities of the Ghaznavids in India; and Lahore and many of the early Punjab palaces were destroyed by the Mongols in their invasion of 1241.

33 The earliest surviving monumental Indian mosque is the Kuwwat al-Islam, built by Kutb al-din Aibak in his fortress of Lalkot near Old Delhi in 1193. The colonnades of a destroyed Jain temple, and building spoils from nearby Hindu temples were used to create an ivan-court mosque. A new façade was erected in front of the Jain temple court,

93. **Kutb Mosque (Quwwat al-Islam), Delhi,** built by Kutb al-din Aibak in his fortress of Lalkot near Old Delhi in 1193. This mosque is the earliest extant monument of Islamic architecture in India and its combination of local, pre-Muslim traditions and imported architectural forms is typical of the earliest period. The mosque is built on the ruins of a Jain temple in front of which a screen wall with a large central pointed archway and smaller, lateral arches was built. The main feature of decoration is the low carved relief.

94. **Mausoleum of Iltutmish, near Delhi,** 1235. Built entirely of stone (the dome has collapsed or was never finished) the small building is particularly remarkable for its simple, precise design, and its elaborate but controlled, low relief decoration.

the principal nave of the temple being used as the centre of the prayer hall, and a mihrab inserted into the end wall. The most important feature of this mosque is a monumental minaret, 240 feet high, built in 1199. The Kutb Manar is a ribbed tower built in five storeys of red stone, decorated with beautifully carved inscriptions and floral bands and four elaborately designed balconies, supported by a richly decorated system of corbels. The mosque façade is decorated with similar low relief stone carving. This monumental stone architecture with finely carved surface decoration, to which inlay of different coloured stones and marbles was added during the rule of the Tughlaks, is the standard form of Islamic architecture in India.

94 Tomb buildings and palaces are the two main forms of architecture besides the mosque. Already in the 13th century a peculiar square or polygonal tomb chamber or mausoleum in stone—usually vaulted with a dome made of cement and rubble—was developed, decorated over its entire surface with delicate highly abstract reliefs. Possibly derived from Central Asian prototypes are the oblique walls in the tomb of Ghyas al-din Tughlak in Tughlakbad built inside a heavily fortified walled complex about 1325. Here also the use of white stone in decorative blind niches and band ornaments in the upper part of the four façades of the free-standing, domed mausoleum anticipates the further development of this feature. In Jaunpur, independent of the central Delhi sultanate for more than a century, only taken over in the later 15th century, a form of monumental mosque combined traditions of pre-Islamic Indian fortification and temple designs with a highly original use of domes and high gateways, not dissimilar to the frames of ivan-halls in the Seljuk ivan-hall court mosque. Decorative forms of blind niches, decorative bands dividing the gate façades into three storeys and defining the frames of niches and doorways, derived from 12th-century forms in Delhi, were widely used in these mosques.

95

 Other buildings, especially tomb monuments made use of the old pavilion form often employing a multiple dome design. Probably the most accomplished of these is Sultan

96 Sher Shah's Mausoleum. A central dome surrounded by smaller, secondary domes was also adopted in the Mausoleum of the Emperor Humayun in Delhi, completed 1572, though substantially altered. The open pillar hall of Sher Shah was replaced by a complex substructure consisting of four monumental gateways, one in the centre of each side of the dome chamber and a pavilion-like polygonal room at each corner, surmounted by a small domed pavilion. The main central dome is raised on a fairly high drum reminiscent of Timurid domes in Central Asia. The entire building is set on a large terrace, that has the effect of a platform with the mausoleum in the centre. The pointed niche arcade motif, traditional in eastern Islamic architecture is used here on the terrace façades of the mausoleum, most noticeably in the double storey design of the corner pavilions. Particularly interesting is the elaborate use of white marble 'inlay' both on the terrace façades in fine linear

95. **Main ivan of the Atala Mosque, Jaunpur, India.** 1408. The enormous height of the ivan hall completely obscures the dome behind it. These high, pylon-like ivan hall structures with massive frames in the form of multiple-story towers and a joining arch, are a typical feature of Jaunpur architecture of this period. In spite of a certain awkwardness of the design and the decorative detail, there is an unquestionable grandeur and monumentality to this architecture.

96. **Mausoleum of Sultan Sher Shah, Sahsaram, India.** 1540–45. This mausoleum is the most important pre-Mughal monument of its type in India. It leads almost directly to the Mughal style proper but retains closer ties with purely Indian tradition than any other Mughal buildings. The mausoleum is built on an octagonal plan in two storeys surmounted by a dome. Both terraces are decorated with *chatris*, Indian-style pavilions. There are seven entrance gates creating the effect of a monumental pavilion. The mausoleum, built in sandstone, is placed upon a granite platform with corner pavilions. The entire complex is built on an island in an artificial lake. There is evidence that the building was originally decorated with paintings and coloured tilework.

97. **View of the Delhi Gate of the Red Fort, Agra.** *c.* 1635. The major building complex of the period the Agra Fort combines in its design in an almost perfect way both Hindu and Muslim traditions in India. The formidable fortification consists of a wall over a mile (2 km.) long, and standing nearly 70 feet (21 metres) above the surrounding terrain from which it is separated by a ditch about 33 feet (10 metres) deep. The fort contains the palaces of the Mughal emperors.

bands of cartouches and on the main building where one can hardly call it inlay or incrustation. The white stone is so dominant that it becomes an integral part of the entire design and this is the first fully developed example of the 'polychrome architecture' characteristic of the entire Mughal period.

The highest peak of Mughal architecture is reached in the Taj Mahal at Agra, built by Shah Jahan for his wife Mumtaz-i Mahal (the Jewel of the Palace) *c.* 1635. This building, possibly one of the most famous in world architecture, and undoubtedly the most renowned of Muslim architecture in the East, is built on a plan almost identical to that of Humayun's tomb. The whole building is placed upon a platform terrace decorated with a (blind) niche design. Four tall minarets are added at the corners of this terrace and the entire complex is enriched by an elaborate gate construction at the enclosure wall. The most extraordinary feature is its dazzling decoration, far outstripping that of the tomb of Humayun. The entire building is covered with white marble inlaid with coloured stones of all kinds in beautiful abstract and floral patterns, a technique also employed in the interior especially in the decoration of the tombs, the screens around them and large parts of the wall surfaces. The effect is that of a precious object, not unlike the jewel-encrusted jades and the enamelled gold cups that Shah Jahan had produced in his court workshops and that number among the finest in the Muslim world.

Grille marble work, perhaps most richly developed in the mausoleum of Itmad al-Daula in Agra, built for her father in 1622–28 by Nur Jahan, Jahangir's wife, is also used in the Taj Mahal, just as almost every known technique of architectural decoration appears there.

The two royal palace cities, Fatehpur Sikri built by Akbar between 1569 and 1572, and the great Red Fort in Agra, also built by Akbar, with later additions by Jahangir and Shah Jahan, combine again the full variety of building types, architectural design and especially architectural decoration of their periods. Both epitomise respectively the aspirations of the early Mughal empire and Akbar's ideal of a synthesis of all Indian cultural traditions and the final sumptuous fulfilment of Islamic culture in India.

Fatehpur Sikri, built near Agra, has a palace complex consisting of a multitude of pavilions, terraces mosques and mausolea which are extraordinarily varied in design and decoration. Both Hindu and Muslim traditions were freely used and the result was a highly successful synthesis of a great many different styles and forms. Individual buildings are placed on a series of interconnected platforms, offered in an almost abstract way without the aid, or perhaps more correctly from the Mughal point of view, without the interference of a natural setting. Yet the decoration is full of the most sensitive reference to natural forms, flowers in particular. The elevation of the palace city above the ground upon which it stands (practically as well as metaphorically) is a very original achievement.

While the palace complex of Fatehpur Sikri is predominantly built of red stone and decorated almost exclusively in a restrained flat relief carving with abstract linear scroll work as a main feature, many parts of the Red Fort in Agra are most sumptuously decorated with polychrome and elaborate inlay patterns. The tomb of Itmad al-Daula, Jahangir's father-in-law, has already been mentioned. Its design is relatively simple compared with other con-

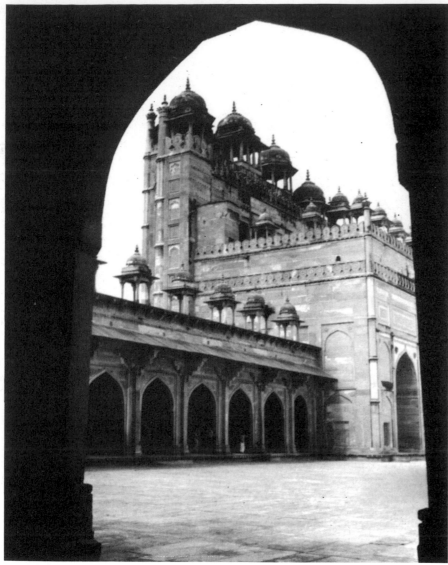

98 (left). **View into the entrance courtyard, Fatehpur Sikri,** near Agra. Built by Akbar, 1569–72. This imposing entrance to Fatehpur Sikri shows something of the impressive Mughal style of architecture, incorporating both Hindu and Muslim traditions. The rows of raised bell towers are typical of the general aspect of Indo-Muslim architecture, abounding in raised terraces and pavilions.

99 (opposite). **The Pearl Mosque, Agra** The Pearl Mosque was built inside the Red Fort in Agra by order of Shah Jahan in 1648. This view shows the prayer hall from the courtyard. A perfect blending of Indian and Islamic tradition in architecture, especially apparent in the combination of the small *chatris* or Indian-style pavilions with the large bulbous 'Timurid' domes on the prayer hall.

temporary or even earlier structures—a central, square pavilion with a roof entirely in the Hindu tradition on a low one-storey block that seems to serve mainly as substructure for a terrace, with four corner towers, polygonal below, round at the top, surmounted by a modified round dome. The entire building is covered with white marble and inlaid with polychrome stone, both forming abstract and floral patterns. Very fine grille work is used in all the balustrades and in the screens that enclose the ground-floor tomb-chamber. Exceedingly rich inlay also decorates the interior, making the building comparable in richness to the Taj Mahal which it closely resembles. Other parts of the palace complex are less rich in decoration but equally magnificent in the use of white marbles, grille work and relief-carving. Beautiful flowers and floral shrubs are carved into panels on the lower parts of walls; abstract ornamentation also decorates walls and ceilings. The Jahangir Mahal is incredibly rich in its detail and is also remarkable in its predominant use of Hindu forms of construction, largely imitating wooden architecture. An important achievement of the Agra Fort is the complete fusion of Hindu and Muslim elements into a unity.

PAINTING AND DECORATIVE ARTS

Mughal painting begins with the invitation of two leading masters of the Tabriz school to Kabul where Humayun kept his court before he returned to India. Abd al-Samad and Mir Sayyid Ali seem to have been the leaders of the

groups of painters assembled by the emperor in the work of probably the most ambitious undertaking of book-production in the Muslim East. The copy of the sumptuous *Dastan-i Amir Hamza*, probably begun in Kabul and completed under Akbar in India, is the largest known Muslim manuscript illustrated with full-page paintings—though only a small number of the original paintings survive, as the manuscript was split up. It took fifteen years to complete and can indeed be called the greatest work of the early Mughal school. Even though reflecting Persian traditions—especially in the architectural settings and decorative elements both in landscape and architecture—these miniatures are already of a decidedly non-Persian style. They are of a realism in detail and an intensity of emotion, both in human figures and in the general composition of groups engaged in various activities, quite unparalleled in Persian painting.

Probably earlier and still closer to the Persian tradition are a number of paintings of which some can be attributed to Abd al-Samad. Extremely delicate in brushwork, small in size and with beautifully painted figures, these paintings provided the Mughal school with models for many similar miniatures showing scenes from the emperor's life. The most remarkable is the so-called 'House of Timur' painting. It is unusually large, anticipating the monumental scale of the *Amir Hamza* manuscript, but with all the delicate qualities of the small painting. Minute attention is given to the landscape, particularly the architectural details of the

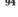

garden pavilions. Nevertheless, the human figure is also important, and the subject of the painting—the princes and rulers of the house of Timur—is in itself proof of a growing interest in portraiture. Although very Persian in its general appearance, the beginning of a new art of painting can already be discerned.

The Mughal style develops, however, not only on a Persian basis, but equally strongly under the impact of local, pre-Mughal tradition in India. Some of the greatest painters of the early Mughal school, such as Basawan, were undoubtedly trained in the Hindu tradition. This contact with the local Indian tradition can be observed throughout the history of Mughal painting in a mutual exchange of influence with the local schools in the Rajput hills.

Some of the finest paintings of the Mughal school whose style was developed to perfection during Akbar's reign, are to be found in some small manuscripts of great delicacy. Very fine polished paper is used, margins are often decorated with delicate paintings in gold landscapes with animals and flowers—and an exquisite form of calligraphy is used that, in its balance and grace, matches the perfection of the paintings. The three greatest Mughal emperors, Akbar, Jahangir and Shah Jahan were avid admirers and collectors of Herat manuscripts both of the Baysunghur and of the later school (Bihzad) and it is possible that some small and delicate volumes from Herat, at one time in the Indian emperor's possession, had a decisive influence on the formation of this aspect of Mughal style.

Following the general tendency towards realism in painting, 'historical narrative painting' grew up at this time, a phenomenon otherwise only known from the Ottoman period. Paintings of battle scenes, court life, hunting scenes, intimate representations of the emperor and his harim or his family, and actual portraiture record the real lives of the emperors and their times. Akbar had an *Akbar-nameh* produced, illustrated with a great many paintings of events in the emperor's life, especially his military and political exploits. While many compositions are elaborate, with many animated figures in a landscape, or in a court-hall, there are more intimate paintings of less complex nature with more attention paid to the individuals represented. During Jahangir's reign the art of portrait painting seems to reach its height, even though there are the first elements of ceremonial art that eventually dominated the style of Mughal portraiture, removing the image of the emperor from the sphere of everyday life to that of a court ceremonial that places him on an elevated level of symbolic representation. The emperor's head is encircled by a halo and he is shown mainly in profile in a stiff position, almost as an abstraction rather than a real person. Official court scenes, especially the Durbar (the appearance of the emperor at a court reception), became favourite subjects. Eventually in Shah Jahan's time this abstraction and remoteness of the emperor was further emphasised by adding ceremonial symbols, such as the nymbus and the umbrella.

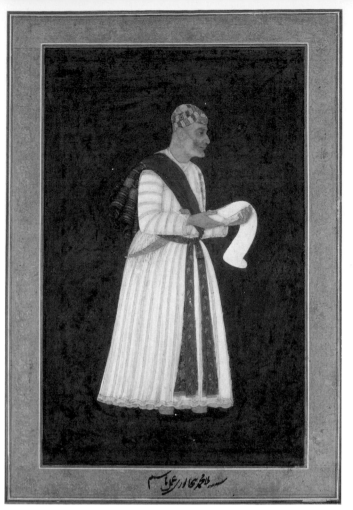

100. **Painting by Hashim in an album made for Shah Jahan.** 15⅜ × 10¼ in. (38·8 × 25·8 cm.). India. *c.* 1635. Portrait of the Mullah Muhammad of Bijapur. Metropolitan Museum of Art, New York. In contrast with the rigid official portraits of the emperor, portraits of nobles of the court or local rulers were often painted in the more lively and informal fashion of the earlier period. This is one of the finest examples of semi-official portraiture of Shah Jahan's time, in which the Mullah's features are most sensitively rendered.

101. **Jade box in mango shape from India.** Mid-17th century. 5½ × 4¼ in. (13·9 × 10·8 cm.). Collection of Alice and Nasli Heeramaneck, New York. Unparalleled in its delicate relief carving, this jade box reflects in its design the marble reliefs of flowers and plants at the Taj Mahal, built about 1635 by the emperor Shah Jahan (see plate 92).

In spite of this stylistic development, realism is always one of the most fundamental forces in Mughal painting, at its strongest in general portrait painting, or in scenes of the intimate lives of the people of the day. It even dominates the 'historical' paintings of later periods and can certainly be observed in battle scenes or scenes of individual combat, or in executions and the like, and it is particularly successful in the great many beautiful animal paintings that become an important feature of Mughal art from Jahangir's time.

A similar realism can be noticed in the floral forms of textile art of the Mughal period. Although again dependent to some degree on Persian models at first, Mughal silk
102, 103 brocades or embroideries, and especially Mughal rugs, are
101 full of realistic pictorial detail. Technically extremely fine, often using silk, the Mughal rugs of Jahangir and Shah Jahan are of great beauty and originality. A luxuriant red is frequently used for the field and a rich polychromy for the floral and figurative designs.

The Mughal emperors were, it appears, especially fond of precious metals, gold with niello and enamel decoration,
105 silver, and precious stones. Among the many exquisite objects that have been preserved, a group of very sensitive

jade carvings stand out. Here again it appears that the Mughals followed their Timurid ancestors as a few Timurid style jade carvings bear the Mughal emperors' names. Of **104** great delicacy of form and with relief decoration of exclusively floral nature, some of the pieces imitate fruit or *101* shells, and some again add animal heads for handles. Still others are encrusted with jewels and gold thread.

The most characteristic element of Indo-Islamic art is probably the fusion of Hindu and Islamic traditions, in contrast to other parts of the Muslim world where the pre-Islamic traditions are usually completely assimilated. The general tendency towards rich decoration, both in architecture and in the decorative arts, finds its counterpart even in painting in the use of strong decorative colours inherited from Hindu tradition and in the elaborate use of gold in later Mughal painting. Mughal painting is one of the most successful applications of Islamic principles to a basically non-Islamic tradition. The development of a realism that goes so far as to include portraiture is unique even within the great variety of pictorial forms in Islam.

Chronological Chart of Islamic Dynasties

|600|700|800|900|1000|1100|1200|1300|1400|1500|1600|1700|1800|1900|

● Muhammadan era initiated

ORTHODOX CALIPHS (MECCA)
(period of conquests and rapid expansion)

UMMAYADS
(first caliphate, capital Damascus, Syria)

ABBASIDS
(capital Baghdad, then Samarra; last caliph killed in 1258)

UMMAYADS OF SPAIN
(capital Cordoba, palatial city Madinat-al-Zahra)

SAMANIDS
(art centres Nishapur and Samarkand)

TULUNIDS OF EGYPT
(capital Cairo)

IKHSHIDIDS (EGYPT)

BUYIDS
(area south of Caspian Sea: took control of Baghdad by mid 10th century)

GHAZNAVIDS OF AFGHANISTAN

FATIMIDS OF EGYPT
(also in control of North Africa 900-972, and of Sicily 909-1071)

SELJUK TURKS IN IRAN
(capital Rayy)

ALMORAVIDES AND ALMOHADES
(minor dynasties in Spain and North Africa)

SELJUK TURKS IN ANATOLIA
(capital Konya)

GHORID SULTANS OF INDIA

URTHUKIDS
(Atabeks of Diyar Bakr, Upper Mesopotamia)

ZANGIDS
(seat of court, Damascus, capitals Mosul and Aleppo)

AYYUBIDS IN EGYPT
(dynasty of Saladin)

SLAVE KINGS OF DELHI
(founded by Kutb al-din Aibak)

MONGOLS (ILKHANS)
(capital Tabriz, then Sultaniya)

NASRIDS OF SPAIN
*(Alhambra Palace, Granada; last Muslim rulers of Spain, succeeded by
Ferdinand and Isabella of Castile)*

MAMLUKS (EGYPT *and part of* SYRIA)

KHALJI DYNASTY (INDIA)

OTTOMAN or 'OSMANLI' TURKS
*(Turkey and Asia Minor; capital from 1326 Bursa, from 1453 Istanbul;
in control of Egypt 1517-1805)*

MUZZAFARIDS AND JALAIRIDS
(local governor dynasties, west and south Iran)

TUGHLAK DYNASTY (INDIA)

TIMURIDS
(capital Samarkand, then Herat)

KARA-KUYUNLI TURKOMANS
(Tabriz; took over west and south Iran from Timurids)

SAYYIDS (INDIA)

LODIS (INDIA)

UZBEKS
*(took over from Timurids in Transoxiana, now Uzbekistan,
U.S.S.R.)*

SAFAVIDS OF PERSIA
(Tabriz, Kazwin, Isfahan)

MUGHAL EMPERORS OF INDIA
(Delhi, Fatehpur Sikri, Red Fort, Agra)

Reference is sometimes made in this book to Muslim dating.
The Islamic era began in 622 AD which corresponds to AH 1 (anno hijra or hejira—
year of the flight of Muhammad to Medina).

Glossary
Ancient Civilisations of Western Asia

Achaemenians (or *Achaemenids*). Persian dynasty, named after its founder Achaemenes, of whom Cyrus (546 BC) was the first king to reign over the whole country. The dynasty ended in 330 BC with the death of Darius III Codomannus.

Addadians. Name applied to the kings of the Semite dynasty founded by Sargon 24th century BC; also to the subjects of their state, centred at Agade (Akkad) in central Mesopotamia. The dynasty ended in 23rd century BC.

Amorites. Semitic people of the region west of Mesopotamia who infiltrated into Mesopotamia from the north at the end of the third and the beginning of the second millennium, later to found the Amorite kingdom of Babylon in about 1900 BC which eventually fell to the Kassites *c.* 1540 BC.

Aramaeans. Semitic people of central and northern Syria, their three main cities being Damascus, Hama and Aleppo. They appeared in the Near East in the 12th century BC, spread into Mesopotamia and later established their rule in Babylon (Chaldaean dynasty).

Assyrians. Inhabitants of Assyria, in the middle course of the Tigris, with successive capitals at Assur Kalah and Nineveh. Assyria was an Amorite kingdom (20th century BC). Towards the beginning of the 13th century BC Shalmaneser I moved his capital from Assur to Kalah. This middle Assyrian period, to which Tiglathpileser I belonged, ended *c.* 1000 BC. Then a brilliant period of expansion followed with Assurnasirpal II (883–859), Tiglathpileser III (745–727 BC) and Sargon II, 722–705 BC, and later Assurbanipal (668–626). The Assyrian kingdom fell in 612 BC to the Medes and Babylonians.

Babylonians. Semitic Amorites who unified Mesopotamia in the Isin-Larsa period at the end of the third millennium introducing the Semitic language to the area. During the Old Babylonian period (end of third to middle of second millennium) the Babylonians erected important buildings at Mari and Ishchali. They were overcome *c.* 1540 by the Kassites. Following the defeat of the Assyrians by the Medes and the Babylonians in 612 BC, the Neo-Babylonian period came into being and the city of Babylon was built under Nebuchadnezzar II (see *Chaldeans*). The Neo-Babylonians were overcome by the Achaemenians in the 6th century BC.

Canaanites. Large ethnic group of Semitic origin which lived in the western part of the Near East from late prehistoric times and whose culture, with the many Amorite features introduced *c.* 2000 BC, lasted until the Phoenician and Israelite period.

Chaldeans. (Biblical name for the Babylonians). Name incorrectly used in many books to designate the Sumerians and also the peoples of Mesopotamia in general. Strictly speaking it only applies to the ruling tribes of Aramaean descent that settled in Lower Mesopotamia and founded the Neo-Babylonian dynasty in the 7th and 6th centuries BC.

Cimmerians. Tribe of skilful bowmen living south-east of the Black Sea, who penetrated into Urartu at the end of the 8th century.

Elamites. Inhabitants of Elam, with their capital at Susa, from the first half of the third millennium continually in contact with the inhabitants of Mesopotamia. Their language was, with Persian and Babylonian, one of the official languages of the Empire of Darius. They had a system of writing of their own as early as the third millennium BC.

Gutians. Nomads from the highlands east of Mesopotamia who put an end to the Akkadian dynasty in the 22nd century BC, and ruled the country for nearly a century.

Hittites. People of Indo-European tongue who settled in Anatolia in the early 2nd millennium superseding a non-Indo-European people called the Hattites. From their capital of Hattusas (modern Boghazköy), they ruled over an empire which during the 19th and 18th centuries BC extended as far as Babylon and was overthrown by the 'Peoples of the Sea' *c.* 1200 BC.

Hurrians. See *Mitannians.*

Hyksos. Mistakenly called 'shepherd kings', these people of mixed but predominantly Semitic origin advanced from Syria and Palestine into Egypt in the 18th or 17th century BC and dominated the country for over a century.

Kassites or *Cossaeans.* People originating from the north-eastern highlands of the Zagros mountains, who ruled the whole of Mesopotamia for about three hundred and fifty years after the fall of the first dynasty of Babylon in 1540 BC.

Lullubians. People inhabiting the Zagros mountains, related to the Elamites who made incursions on the Mesopotamian borders *c.* 2300 BC. Naram-Sin erected a stele in honour of a victory over them.

Medes. Indo-European people who, under King Cyaxares destroyed the Assyrian Empire in 612 BC.

Mitannians. Indo-European-speaking tribes (Aryans in the strictest sense), who ruled the Arianic people called Hurrians or Hurrites and created an independent kingdom in Syria, Mitanni, centred on the Khabur river. They were particularly powerful during the second millennium down to the 14th century BC, when they were conquered by the Hittites.

Neo-Sumerians. See *Sumerians.*

Persians. Federation of agricultural and nomadic tribes of Indo-European tongue, of which the Achaemenians formed one clan. Inhabiting Persia (modern Iran) they conquered the Medes, Babylonia and Asia Minor in the 6th century BC under Cyrus and reached their apogee under Darius I (521–486). The fall of the Persian empire came in 331 BC with Alexander's conquest of the East.

Phoenicians. Ancient Semitic people of seafarers and traders, inhabiting the north-west coastal district of Palestine and Syria. They were the inventors of alphabetic writing and had an extensive influence throughout the Mediterranean at the beginning of the first millennium BC.

Phrygians. Indo-European people whose capital was at Gordium in western Anatolia. They spread east across the central plateau displacing the Hittites from their capital at Hattusas (Boghazköy), and were usurped by the Lydians in the 7th century BC.

Scythians. Nomadic horsemen originating in the district north of the Caspian Sea, who at the end of the 7th century penetrated deep into Palestine.

Semites. Linguistic group of several peoples among whom numbered the Babylonians, Assyrians, Hebrews and Arabians who from prehistoric times lived in the 'Fertile Crescent' and later entered into Arabia and Ethiopia.

Sumerians. Non-Semitic people who settled in Lower Mesopotamia in the middle of the fourth millennium BC, probably during the al'Ubaid period, and created one of the two oldest known civilisations. They disappeared at the beginning of the second millennium. The Neo-Sumerians were the Sumerians who regained political control of the country between the overthrow of the Gutians (23rd century BC) and the fall of Ur 2061 BC.

Glossary
India and South-East Asia

Abhaya-mudrā. Buddhist ritual gesture of fearlessness.

Ahimsā. Jain, Hindu and Buddhist doctrine of refraining from harming others or taking life.

Āmalaka. Name of a fruit. In architecture, the crowning finial in the shape of a ribbed cushion (see plate 25).

Antarāla. Vestibule of a sanctuary.

Āranyaka. One of the Vedic commentaries that formed the basis of Brahmanism.

Ardhanari. Siva and his female energy united in a single person.

Asura. Originally Vedic demons, enemies of both gods and men, controlled by prayers and magic words.

Atman. The individual soul (Vedism and Brahmanism).

Avadāna. The edifying stories of the Buddhist tradition.

Avalokitesvara. The merciful Bodhisattva.

Avatāra. The incarnation of a god, especially associated with Vishnu.

Bhairava. 'Frightful, terrible, horrible' (see also *Siva*).

Bhakti. 'Trusting worship' or personal devotion to Vishnu or Buddha or Krishna. In Brahmanic thought one of the three pathways to salvation (see also *Jñāna* and *Yoga*).

Bodhisattva (bodhi = enlightenment + sattva = essence). A being that compassionately refrains from entering *Nirvana* in order to minister to the needs of others. In Mahāyāna Buddhism the Bodhisattvas are worshipped as deities.

Brāhma. Chief god of the Hindu Trinity and absolute creator of all things. The universal self.

Brāhmana. One of the Vedic commentaries that formed the basis of Brahmanism.

Brahmanism. Evolving from Vedism, the Indian religion which stressed the pre-eminence of Siva, Indra and Vishnu, the identification of *atman* and *brāhma*, and service as the principal path leading to escape from *samsāra*.

Candi. Javanese commemorative structure or shrine.

Chaitya. Buddhist sanctuary.

Chakra. In Buddhist iconography the wheel which symbolises the first sermon of the Buddha and the progression of the Law.

Dhotī. Pleated skirts such as Hindus now wear.

Garbha griha. The cella of a sanctuary.

Gopuram. The gateway of an Indian temple; the massive pyramidal tower over the gateway.

Harihara. Siva and Vishnu united in one god.

Harmikā. The small railed balcony surmounting the dome of a stūpa.

Hasta. Speaking gesture, ritualised like the *mudrā*.

Indra. King of the Vedic gods, personification of the Aryan warrior and god of the atmosphere and thunder.

Jainism. Indian religion traceable to Vardhamāna Mahāvira in the 6th century BC, based on *ahimsa* and asceticism.

Jātaka. Previous lives of the Buddha.

Jñāna. Spiritual knowledge, one of the three pathways to salvation in Brahmanic thought.

Kāla. Monster-head motif.

Kalan. Isolated towers in Khmer architecture.

Kudu. In architecture the decorative motif which evolved from a window form (see plate 26).

Mahāyāna. 'The Great Vehicle' of Buddhist thought, that is, the later branch of Buddhism which emphasised the worship of the Buddha rather than concentration on his doctrine and which is distinguished from Theravadic Buddhism by the appearance of the Bodhisattva and universal salvation.

Maheshamūrti. Brahmanic triad which unites on one body the three heads of Siva representing his three aspects, the majestic one, the feminine one, and the terrifying god.

Makara. Indian sea-monster motif.

Mandala. The magic circle, the imagined shape of the cosmos; the diagram of the Buddhist hierarchy.

Mandapa. Columned porch evolving later into a pillared hall (see plate 21).

Māra. Buddhist 'Evil One', tempter of Sākyamuni.

Matrikā. The Seven Mothers, each embodying a different female power (see figure 48).

Mithuana. Sculptural group of a loving couple.

Mudrā. Ritual gesture, which grew out of a simple gesture of the Buddha, symbolising in mime or dance mystical power or action.

Nāga. Water spirits of serpentine form, the protectors of cisterns and sacred waters.

Nataraja. See *Siva*.

Nirvana. The final escape from *samsāra* into a state of perpetual enlightenment.

Pancha yatana. The arrangement of five sanctuaries, in a quincunx, i.e. one at each corner of a square and one in the centre.

Parvati. Siva's wife.

Prajñāpāramitā. Perfect Wisdom.

Rāgmāla. Music-painting, translation of a poetic theme into pictorial terms according to a melodic mode.

Rudra-Siva. The Rudras were pre-Vedic gods of destruction. Siva's dual nature was always that of destruction and regeneration.

Sakti. The 'female energy' of a god which completes his power.

Sākyamuni. 'Sage of the Sākya', the earthly and historical Buddha.

Samsāra. The soul's wandering through the unending cycle of life and rebirth.

Sāstra. Canonical treatise on art, a compendium of aesthetic and iconographical rules.

Sikhara. The tall, curved roof of a sanctuary.

Siva. Third member of the Hindu Trinity, repository of great destructive and procreative power. Also known as Bhairava, 'frightful, terrible, horrible'; Natarāja, 'master of the dance'; and Vīnādhāra, 'master of the arts'.

Stūpa. A reliquary based on the Vedic funerary mound; in Buddhist and Brahmanic architecture, the stūpa represented the cosmic mountain, the pivot of the world. It was designed to contain holy relics or to commemorate the sacred character of the place or an important event.

Sūrya. The sun god who, like Apollo, drives a four- or seven-horse chariot across the sky trampling upon the powers of darkness.

Tārā. Female counterpart of Avalokitesvara.

Theravada. The earlier form of Buddhism (Hinayana) from which the Mahāyāna branched off. It presents a much more dogmatically doctrinal interpretation of the way to salvation.

Torana. The monumental gateway of a stūpa (see plate 3).

Tribhanga. Attitude of triple flexion—one of the attitudes laid down in iconographical treatises as a graceful, ritual pose (see figure 13).

Upanishad. A class of philosophical writings which gave rise to Brahmanism.

Ūrnā. One of the distinctive signs of the sacred nature of the Buddha, the curl of hair on the brow.

Ushnīsha. The cranial protuberance of the Buddha; its representations in art grew out of a mistaken interpretation of the knot of hair at the crown of his head.

Vajrapāni. The Bodhisattva called the 'Bearer of Lightning'.

Vedism. The basis of Vedism is the Veda, the collection of earliest known Indian religious texts. Pantheistic and animistic, Vedism was very broad in emotional and philosophical scope. The essential expression was sacrifice, which consisted primarily in a libation of a liquor made of vegetable matter, called *soma*.

Vihāra. Buddhist monastery.

Vimāna. Sanctuary, including porch and surrounding buildings.

Vinādhāra. See *Siva*.

Vishnu. The Preserver, second member of the Hindu trinity, mild and benevolent, offering through Krishna, one of his incarnations, and through his eternal benevolence, salvation to the devout.

Wayang. Javanese shadow theatre.

Yaksha (male), **Yakshi** (female). Nature and tree spirits. The female aspect is associated with fertility and the male with wealth and natural richness.

Yoga. Asceticism leading to absolute self-control, one of the three Brahmanic pathways to salvation.

Glossary
China, Korea and Japan

Amida Buddha. The Buddha of the Western Paradise. In 11th-century Japan his saving grace was believed to be so potent that mere repetition of his name was sufficient to ensure salvation.

Be. In early Japan, closely-knit guilds of craftsmen.

Bijin. Japanese scroll pictures of the 17th century, featuring beautiful women.

Bosatsu. Japanese word for bodhisattva.

Bunjin-ga. Chinese-oriented literary paintings of the Edo period in Japan.

Celadon. North Chinese and Korean porcelain characterised by a pale grey or bluish green glaze derived from iron.

Ch'an. Buddhist sect, known as Zen in Japan, emphasising contemplation and self-discipline and the teaching that the Buddha is inherent in all things. The followers of the Ch'an sect believed that spiritual enlightenment could be achieved directly by the unaided human mind.

Chinzō. Japanese Zen priest portraiture (see figure 105).

Chiphyon-jon. Korean scholarly academy.

Chung'in. The lower division of the Korean upper class from which came less important officials than those from the *Yangban*.

Chung-kuo. The 'Middle Kingdom', i.e. the kingdom which is at the centre of things. From the earliest times, China's conception of herself.

Daimyō. Provincial feudal lords of Japan.

Dōtaku. Prehistoric Japanese bronze bells of religious significance (see plate 87).

E-busshi. Japanese priest-painters who worked for Buddhist temples.

E-dokoro. Painting bureau of the Japanese court, founded in 886.

E-makimono. Horizontal scrolls which were illustrated by court painters in the Yamato-e style.

Haniwa. Ceramic cylinders, sometimes with human or animal heads, found around burial grounds of prehistoric Japan (see plate 88).

Hiragana. A cursive Japanese syllabic script which was developed in the 8th and 9th centuries through a refinement of rapidly written Chinese characters. Also called *Onna-de* or 'Women's Style' because it was used predominantly by women.

Hokke-shū. Fanatical Japanese Buddhist sect founded by Nichiren in 1252.

Hokkyō. 'Bridge of Doctrine', a high Japanese ecclesiastical title.

Hua-yüan. The Academy of Painting, attached to the Imperial Chinese court, whose members bore official titles.

Kannon. The Japanese name for Avalokitesvara.

Kara-yō. The 'Chinese style' of architecture in which Japanese Zen monasteries were built.

Kare-sanzui. The 'dry-landscape' of a Japanese garden, created by Zen monks (see plate 101).

Katakana. Angular Japanese script abstracted from the graphic components of regular Chinese characters.

Kokubun-ji. The Japanese provincial monasteries which were founded by the Imperial decree of 741.

Kondō. The main hall of a Japanese monastery.

Lalitāsana. Buddhist pose of Indolence (see plate 60).

Li-chi. The compendium of detailed ritual prescriptions as composed by Confucius out of the prevailing Chou ideology.

Liu-i. The 'six accomplishments' of the Chou nobility: ritual music, the script, calculation, chariotry, archery, poetry.

Machi-eshi. Japanese painters of the 16th and 17th centuries who did city genre scenes.

Maitreya. The Bodhisattva who will appear as the next Buddha. In Japanese, Miroku.

Mandara. See *Mandala* p. 389.

Mikkyō. Esoteric doctrines of the Buddhist sects, *Shingon* and *Tendai*, which derived from Indian Tantrism.

Mokoshi. Mezzanines with their own roofs between the actual storeys of a pagoda (see plate 89).

Mono no aware. A sentimental sympathy with 'things'. Part of the highly aesthetic attitude of Heian Japan.

Namban. Japanese name for 'southern barbarians', i.e. Europeans.

Ni-ō. The two protectors of the faith in Japanese Buddhist art.

Nō. The classical Japanese drama originating in the 14th century and deriving from ritual temple dances. There are two main actors, no scenery, but rich costumes, and the presentation is highly stylised.

Sanggam. Korean technique of black and white slip decoration beneath the glaze.

Sesshō-kampaku. The regents and councillors of Heian Japan who were the real power behind the throne.

Shên-tao. 'Spirit path'. In China the avenue of approach to a tomb.

Shi-awase. Poetry competitions in the Chinese style held in Heian Japan.

Shih. Social class to which Confucius belonged. Called 'the proletariat of the nobility', the clan arose from the changing fortunes of the Chou dynasty and was made up of political advisers, scholars, philosophers and knights errant.

Shikishi. Japanese painted-ground designs on which were written poems.

Shikken. Japanese regents, such as of the Hōjō clan in the Kamakura period.

Shimbashira. The mast which acts as the central support of a pagoda (see plate 89).

Shinden-zukuri. Style of Japanese domestic architecture where the buildings were built composed within the context of a garden and a lake.

Shingon sect. Founded by Kūkai, the *Shingon* sect, with the *Tendai*, was the major centre of esoteric Buddhism in Japan.

Shintō. The indigenous religion of Japan characterised by the reverence for deified nature spirits and spirits of ancestors.

Sowen. Private, but state supported, Korean academies where would-be officials could learn Confucianism.

Suiboku-ga. Japanese monochrome ink painting of Zen inspiration.

Tantrism. A school of Mahāyāna Buddhism originating in Northern India and incorporating Hindu and pagan elements, such as pantheistic mysticism, spells, the worship of female divinities, and teaching that the individual can obtain essential Buddhahood and earthly benefits by invoking and communicating with spirits and deities.

Taoism. Traditionally founded by Lao-tzu in the 6th century BC, Taoism teaches conformity to the Tao and retirement from the world in order to pursue a life of utter simplicity. The Tao is the unitary, first principle from which all existence and all change in the universe spring.

T'ao-t'ieh. Fantastic glowering mask, made up of animal motifs and called the 'glutton'. In prehistoric China it was believed to ward off evil.

Tendai sect. Founded by the monk Saichō, the *Tendai* was one of the two major esoteric Buddhist sects which came to Japan *c*. 800. Like the *Shingon* sect it derives from Indian Tantrism.

Tenjiku-yō. 'Indian style', actually from South China, which was used in Japanese Zen monasteries and in the rebuilding of Tōdai-ji.

Tennō. 'Exalted Heavenly Ruler', the Japanese emperor who was regarded as a direct descendant of the Sun Goddess.

Tohwa-so. Official Korean art bureau made up of professional painters from the *Chung'in* class.

Tok-no-ma. Alcove in a Japanese house where a work of art is displayed.

Ukiyo-e. Pictures of the Floating World', i.e. of the Edo pleasure quarters, mainly done in woodcuts.

Uta-awase. Poetry competitions in the 'Japanese' style held in Heian Japan.

Waka. A native Japanese form of lyric poetry.

Waka dokoro. A bureau set up by the Japanese emperor in 951 to preserve and collect *waka*.

Wa-yō. A Japanese style of sculpture which is best seen in the work of Jōchō and is typically Heian in its lightness and elegance.

Wên-jên. Chinese 'literati' officials who in their private lives practised poetry, calligraphy, painting and music.

Yakushi. The Buddha of healing.

Yamato-e. Literally 'Japanese painting'. The delicate native style which developed in the 9th century from the earlier Japanese style, the heavily derivative *Kara-e* ('Chinese painting').

Yang. In Chinese cosmology the bright, masculine, positive principle in nature that with its opposite *yin*, the feminine and negative principle, combine to produce all things.

Yangban. The Korean upper class was divided into two sub-classes, the higher of which, the *Yangban*, produced the most important officials and bureaucrats.

Yosegi. Technique of carving a piece of sculpture from several blocks of wood joined together.

Zōbutsu-jo. The sculpture department of a Japanese temple in which many artists were employed to make cult images.

Glossary
The World of Islam

Amir. The most common title for an administrative officer in early Islamic times; after the 10th century the title was used more generally by the feudal or semi-feudal overlords.

Caliph. The leader of all Muslims; at the beginning the caliph was both the spiritual and political leader of all 'the faithful'. He loses his power in the 10th century and becomes more a religio-political figurehead. The caliphate of Baghdad lasted until 1258 when the last caliph was murdered by the Mongols; but other caliphs were instated in various parts of the Muslim world long before that date (the Umayyad caliphate of Cordoba, 10th century, was the earliest).

Caravansarayi. A resthouse for the caravans along the main trade routes, built both in Iran and Anatolia in large numbers and on a monumental scale.

Chattri. A pointed umbrella-shaped dome in Indian architecture.

Divan hall. A council chamber.

Ghazi. An organised group of Muhammadans, mainly among Turkish tribes, fighting for the Islamic faith, intent on conversion or else the destruction of infidels.

Guldasta. A pinnacle-like motif which appears in all Indo-Islamic architecture after the 14th century. It is usually used where two walls meet, either in a balustrade or at the juncture of two construction walls.

Hadith. *The Traditions* (traditional sayings of the Prophet Muhammad); not by any means as important as the Koran but of considerable influence for the development of all forms of Islamic thought on almost any subject. As they were recorded verbally for a long time, the 'chain' of transmission is of vital importance in determining the authenticity of a hadith. An entire field of study with various schools eventually grew up around this scrutiny of the 'chain'. Often this was found to be inaccurate and a hadith was discarded as apocryphal. Because this was always likely to happen, the hadith never acquired any absolute authority. This is important as it is only in the hadith that objections against representational art or art in general are attributed to the Prophet.

Hajj, hajji. The pilgrimage, one of the religious duties that any devout Muslim had to fulfil during his lifetime, is called the hajj. The object of the pilgrimage is the Kaaba in Mecca. The pilgrim is called the hajji; this title is very often added to a man's name after he has completed the hajj.

Hariri's 'Makamat'. *Assemblies*—a popular story book narrating the travels and adventures of al-Hariri and his companions.

Hejira (or hijra). The flight of Muhammad from Mecca to Medina in 622 AD. The Muslim era is reckoned from that date.

Imamzadeh. The word actually means 'the son of an imam'. It is, however, used in Iran to signify the burial place or mausoleum of either a local saint or an actual descendant of an imam.

Imam. Religious leader of the community.

Ivan (iwan). The ivan hall, a large vaulted hall open on one narrow side and enclosed by walls on three sides, is one of the main features in Eastern Islamic architecture but also occurs in the West (Syria, Egypt). It becomes a standard feature of the 'Persian', that is really the Selfjuk Mosque, where it is placed in the centre of each side of the court. The main ivan is the one in front of the dome chamber at the kibla wall in the centre of the prayer hall. The earliest uses of this four-ivan plan, however, go back to Ghaznavid times (Palace of Lashkari Bazaar, Afghanistan).

'Jami al-Tawarikh'. *History of the World*, a monumental work in four volumes, written by Rashid al-din, often copied and illustrated. Many of the scenes are mythological.

Kaaba (Caaba). Sacred shrine of Islamic containing the 'black stone' in the middle of the great mosque at Mecca. Literally a square (cubic) edifice.

Kaftan. Long oriental tunic tied at the waist.

Khamsa. Five poems, a group of epic poems by Nizami on mystic, romantic and heroic themes.

Kibla (qibla). The direction towards Mecca; the wall in the mosque that faces Mecca is therefore called the kibla wall; it is always in the kibla wall that the main mihrab of a mosque appears and it is against the kibla wall that the covered prayer hall (often curiously called in western publications 'sanctuary') of the mosque is placed. In the Seljuk mosque, the main ivan and the dome chamber are set against the kibla wall.

Kitab-khaneh. Literally 'house of the book'. Name of the scriptorium at the court in which all arts of the book, from paper making to calligraphy, painting and binding were practised. The head of the Kitab-khaneh is the kitabdar.

Kiosk. A light, open pavilion or summer house often supported by pillars.

Kutba. The *Friday Prayer*; it was of political significance as the name of the officially acknowledged ruler was mentioned in it, and, of course, the name of the caliph. To be mentioned in the kutba was equivalent to being 'crowned', a ceremony that did not exist in Islam.

Kylin (Kilin). A mythological creature of composite form appearing on Chinese and Japanese pottery and other Eastern decorative objects.

Madrasah. Actually meaning just school, but it is usually applied to the theological school for orthodoxy. The madrasah becomes one of the main building forms in Islam; its origin is disputed but may well have to be traced to Khurassan where very likely the first madrasahs were instituted by the Nizam al-Mulk, the Grand Vizir of the Seljuks. The form follows very much that of a mosque.

Maidan. Square or plaza.

'Manafi al-Hayawan'. *On the Usefulness of Animals*, a natural science treatise written by Ibn Bakhtishu, one of many scientific or learned treatises chosen for illustration by Persian artists.

Manar (Minaret). Manar means actually 'tower' and is used in this sense, but it more specifically refers to the tower from which the call to prayer was chanted, a practice going back to Umayyad times. The earliest minarets were probably the remnant towers of the Roman temenos of the Umayyad Mosque in Damascus. The more frequently used form is 'minaret' (diminutive of manar).

Maristan. The Persian word for hospital.

Mihrab. The mihrab is a niche, or an indication of a niche in the kibla wall or any other part of a mosque facing Mecca. The origin of the form is complex and not altogether clear; it has certain connections with the 'apse' in the classical basilica and a connection even in its symbolic meaning with late classical palatial architecture is not impossible. Also the mihrab seems at the very beginning to have been connected with a burial place (The Prophet is buried in the mihrab of his mosque in Medina).

Minbar. A kind of pulpit, built both of wood (the earliest one in the Mosque of Sidi Okba in Kairouan, Tunisia, dates from the 9th century) and stone. It always consisted of a flight of steps leading up to a pulpit often covered by a small dome. It was also on the minbar that the governor or ruler took position if he decided on questions of law or general policy.

Mukkarnas (Muqqarnas). A design that has been developed by Islamic architects, possibly from the squinch arch, or independently. It consists of various combinations of three-dimensional shapes, among them the plain niche as basic element. The patterns created both in the squinch areas of a dome chamber or in almost any kind of vault (and eventually used in complete freedom from any even tentatively structural connection) are usually referred to as stalactites or honeycomb.

Nameh. Writing, epistle or book.

Nisbah. Part of an Arabic name designating family lineage or territorial connection.

Riwaq. An arcade surrounding the central courtyard of the mosque.

Sadi's 'Bustan' and 'Gulestan'. *Orchard* and *Rose Garden*, two of the didactic poems, written by Sheikh Sadi (d. 1292 AD), which were adored by the Persians and often illustrated.

Shah. A Persian title equivalent to a king.

Shiah. The movement in Islam that is supported by the followers of Ali and the belief that only a member of the Prophet's tribe of Ali could rightfully become a successor to the Prophet (caliph). The Shiah movement is widespread in Islam and it was not until a later period that it became predominant mainly in Iran and parts of Iraq.

Sultan. This was originally a title which was only used by the main leaders or rulers of the Muslims world; in later periods the title is used by almost any of the innumerable petty princes of the local dynasties both in the East and the West.

Sunna. The movement in Islam that follows the tradition established by the Prophet that the successor to the Prophet should be elected rather than hereditary and any Muslim was eligible rather than just members of the Kuraish, the tribe of Muhammad.

Türbe. A Turkish term for a tomb building or mausoleum.

Vizir. A high state official or minister, sometimes given the authority of a viceroy. Grand vizir—chief minister or administrator of a Muhammadan ruler.

Index

The index entries in *italic* type refer to the captions to the black and white illustrations; those in **bold** type refer to the captions to the colour illustrations. The codes preceding these references indicate the section of the book within which they fall. The illustrations in each of the three main sections are numbered independently, and the codes for the sections are as follows:

AC Ancient Civilisations of Western Asia, pages 7–64
OW The Oriental World, pages 65–224
WI The World of Islam, pages 225–387

Acknowledgements

Photographs

ANCIENT CIVILISATIONS OF WESTERN ASIA

Colour

Erwin Bohm 2, 13; British Museum, London 6, 8, 19, 20; Photographie Giraudon, Paris 14, 47; Hamlyn Group Picture Library 15, 30; J. Hinnells 64; Hirmer Verlag, Munich 3, 7, 29, 54, 59; Michael Holford, Loughton 23, 24, 36, 37; A. Perissonotto, Padua 43; Josephine Powell, Rome 57, 58; Scala, Antella 42; Staatliche Museen, Berlin 41.

Black and white

Archives Photographiques, Paris 21, 66, 73; Ashmolean Museum, Oxford 12; E. Boudot-Lamotte 38, 44, 65; British Museum, London 16, 17, 26, 27, 33, 34, 35, 39, 40, 45, 52, 53, 67, 69, 72; J.E. Bulloz, Paris 22, 25; Directorate General of Antiquities, Baghdad 10, 11; Photographie Giraudon, Paris 28; Hamlyn Group Picture Library 48, 49, 50; Hirmer Verlag, Munich 4, 5, 9, 32, 60, 63; Bildarchiv Foto, Marburg 31; Musées Nationaux, Paris 55; Oriental Institute of the University of Chicago, Illinois 18; A. Perissinotto, Padua 56b, 70, 71; Raimat Rahel Expedition, Jeusalem 68; Staatliche Museen, Berlin 46, 51, 56a, 61; Warburg Institute, London 62.

THE ORIENTAL WORLD

Colour

Jeannine Auboyer, Paris 1, 2, 23, 24, 26, 31, 32, 45, 53; R. Braunmüller, Munich 55, 69, 71; British Museum, London 57, 68; J. Allan Cash Photo-Library, London 66; Percival David Foundation of Chinese Art, London 67, 77; Freer Gallery of Art, Smithsonian Institution, Washington D.C. 58; Friedrich W. Funke, Cologne 22; Roger Goepper, Cologne 82, 84, 97, 98, 101; Hamlyn Group Picture Library 4, 5, 6, 7, 8, 9, 10, 11, 12, 13, 14, 27, 28, 33, 37, 38, 41, 42, 43, 46, 47, 48, 49, 50, 51, 56, 59, 61, 75, 78, 81, 83, 85, 103, 110; Holle Verlag, Baden-Baden 79, 80; Erhardt Hursch, Zurich 72; Institut Pédagogique National, Paris 44; Prem Chand Jain, Delhi 36; R. Lakshmi, New Delhi 29, 30; Museum für Ostasiatische Kunst, Cologne 87; Museum of Fine Arts, Boston, Massachusetts, 95, 99; Museum Rietburg. Zurich 60, 65; National Museum, Tokyo 94, 107, 109; Orion Press, Tokyo 88, 89, 102; Colin Penn 73; Josephine Powell, Rome 3, 19, 20, 21, 25, 34, 35; Rapho, Paris 52; Sakamoto Photo Research Lab., Tokyo 90, 92, 96, 104, 105; Shōsō-in, Nara 91; Madanjeet Singh 15, 16, 17, 18; Staatliche Museen Preussischer Kulturbesitz, Ostasiatische Kunstabteilung, Berlin 54, 63, 64, 70, 74, 76, 86, 100, 106, 108, 111, 112; Wim Swaan, New York 39, 40; Tokugawa Reimeikai Foundation, Tokyo 93; Victoria and Albert Museum, London 62.

Black and white

Archaeological Survey of India, New Delhi 2a, 2b, 25, 29, 31, 41, 42; Editions Arthaud, Grenoble 81; Jeannine Auboyer, Paris 3, 8, 9, 10, 20, 23, 26, 33, 47; Benrido Company, Tokyo 97, 101, 110, 113; E. Boudot-Lamotte 5, 7, 22, 46; British Museum, London 61, 62a, 62b; China Tourist Service Company, Beijing 63; Cleveland Museum of Art, Ohio 83, 84; Yves Coffin, Fontenoy-aux Roses 52, 53; Dominique Darbois, Paris 66; Gemeentemuseum, The Hague 89; Photographie Giraudon, Paris 16, 17, 18; Roger Goepper, Cologne 67, 69, 70, 71, 72, 82, 85, 87, 90, 102, 112, 115; Hamlyn Group Picture Library 21, 32, 34, 40, 48, 49, 50, 60, 78, 86, 88, 91, 92, 93; Holle Verlag, Baden-Baden 95; Martin Hurlimann © Conzett & Huber, Zurich 19, 27, 30; India Office Library, London 12, 43, 45; Prem Chand Jain, Delhi 6, 28, 37, 38; Musée Guimet, Paris 11, 15, 24, 35, 36, 51, 55, 56, 59, 64; Museum Rietburg, Zurich 65, 68; National Museum, Tokyo 76, 104, 106, 111; National Museum of India, New Delhi 2c, 2d, 4; National Palace Museum, Taipei 73, 74, 77; William Rockhill Nelson Gallery of Art, Kansas City, Montana 75; Nezu Institute of Fine Arts, Tokyo 109; Orion Press, Tokyo 96, 99, 103, 108; Penguin Books 114; Josephine Powell, Rome 1, 13; Rapho, Paris 39, 58; Marc Riboud — Magnum 79, 80; Royal Academy of Arts, London 14; Sakamoto Photo Research Lab., Tokyo 98, 105; Staatliche Museen Preussischer Kulturbesitz, Ostasiatische Kunstabteilung 94a, 94b; Wim Swaan, New York 44; Victoria and Albert Museum, London 116; Leonard von Matt, Buochs 54, 57.

THE WORLD OF ISLAM

Colour

Art Institute of Chicago, Illinois 10; Bibliothèque Nationale, Paris 27, 31, 32, 58; E. Boudot-Lamotte 62; British Library, London 52, 59, 78; British Museum, London 64, 93; Camera Press London 92; Cleveland Museum of Art, Ohio 6, 44; J.E. Dayton 1, 2, 34; Direction Générale des Antiquités et des Musées, Damascus 32; John Donat 51; Feature Pix — Van Phillips 45; Fogg Art Museum, Harvard University, Cambridge, Massachusetts 37, 38, 79, 80, 96, 100; Olga Ford 23, 76; Werner Forman 57; Freer Gallery of Art, Smithsonian Institution, Washington D.C. 5, 17, 18, 39, 41, 77, 83; Fundação Calouste Gulbenkian, Lisbon 42, 53, 54; P.B. Gotch 46, 47, 75; Hamlyn Group Picture Library 4, 7, 8, 9, 13, 15, 16, 20, 24, 29, 30, 40, 60, 61, 65, 68, 69, 70, 71, 72, 73, 74, 81, 82, 84, 85, 86, 87, 88, 90, 91, 94, 97, 98, 99, 102, 103, 104, 105; Hermitage Museum, Leningrad 14; Prem Chand Jain, Delhi 95; A.F. Kersting, London 21, 25, 26; Mas, Barcelona 11; Museum of Fine Arts, Boston, Massachusetts 101; Österreichische Nationalbibliothek, Vienna, 28, 43; Pierpont Morgan Library, New York 35, 36; Josephine Powell, Rome 33, 48, 49, 50; Realités, Paris 12; Wim Swaan, New York 63; Topkapi Sarayi Müzesi, Istanbul 19, 22, 55, 56, 66, 67.

Black and white

Alinari, Florence 31; Archives Photographiques, Paris 86; Lala Aufsberg 13; Roloff Beny 11, 12, 98; Bodleian Library, Oxford 63; E. Boudot-Lamotte 26, 44, 52, 59, 62, 77, 78; Museum, London 74; Vincent Brown 84; Cleveland Museum of Art, Ohio 18, 40, 79; J.E. Dayton 6; John Donat 16, 34, 35; Fondazione Giorgio Cini Istituto di Storia dell'Arte, Venice 32; Freer Gallery of Art, Smithsonian Institution, Washington D.C. 14, 23, 38; Fundação Calouste Gulbenkian, Lisbon 75; Hamlyn Group Picture Library 2, 5, 7, 28; S. Harrison 10; Hermitage Museum, Leningrad 14; Derek Hill 57; Fotohaus Hirsch, Nordlingen 49; Prem Chand Jain, Delhi 95; A.F. Kersting, London 50; Kunstsammlungen der Veste Coburg, Coburg 33; R. Lakshmi, New Delhi 96; Bildarchiv Foto Marburg 3, 61; Mas, Barcelona 25a, 25b, 25c, 68, 69; Metropolitan Museum of Art, New York 15, 19, 22, 24, 36, 39, 43, 51, 54, 55, 56, 70, 76, 80, 82, 83, 89, 91, 93, 94, 100; Museum of Fine Arts, Boston, Massachusetts 41, 85; Museum of Islamic Art, Cairo 8, 27, 30, 64, 67; National Library, Cairo 71; O.E. Nelson, New York 101; Österreichisches Museum für Angewandte Kunst, Vienna 81, 88a, 88b; Paul Popper, London 1; George Rodger — Magnum 9; Roger-Viollet, Paris 20, 21, 45, 60, 97, 99; Staatliche Museen Preussischer Kulturbesitz, Islamisches Museum, Berlin 29, 47, 58; Staatliche Museen Preussischer Kulturbesitz, Kunstgewerbemuseum, Berlin 92; Staatliche Museen, Berlin 4, 46, 90; Süleymaniye Kütüphanesi, Istanbul 53; Topkapi Sarayi Müzesi, Istanbul 48, 66, 72; Victoria and Albert Museum, London 37, 65, 87.

Plans and drawings

Choisy, A. *Histoire de l'architecture*, Georges Baranger, Paris, 1929 A; Creswell, K.A.C. *Early Muslim Architecture*, Clarendon Press, Oxford, 1940, C, D; Creswell, K.A.C. *The Mosques of Egypt*, The Survey of Egypt, Orman, Giza, 1949 G; Creswell, K.A.C., *The Muslim Architecture of Egypt*, Clarendon Press, Oxford, 1952 E; Torres Balbas, Leopoldo, 'Arte Nazari', *Ars Hispaniae*, IV, Madrid, 1949 H.